Homage to Barcelona

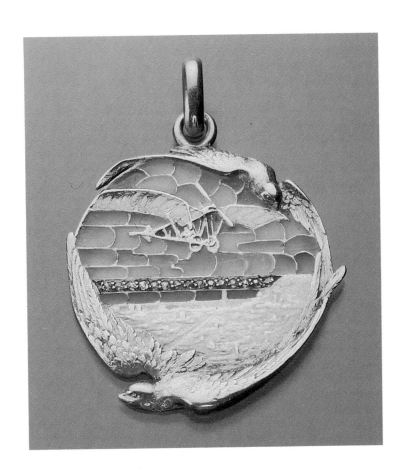

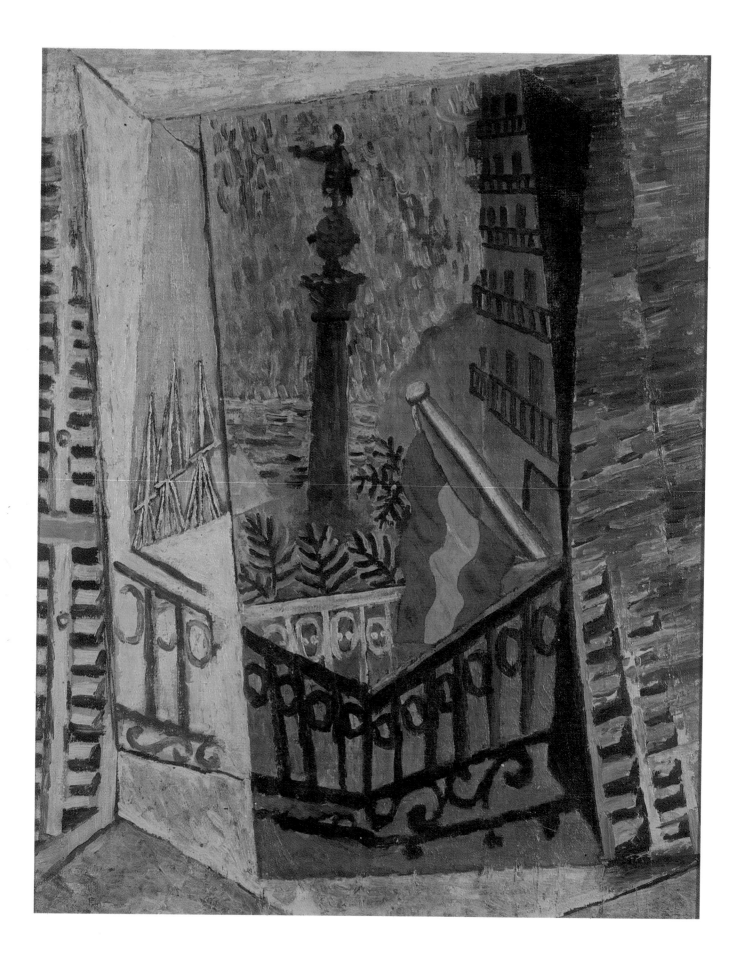

Homage to Barcelona

The city and its art
1888–1936

Hayward Gallery, London
14 November 1985–23 February 1986

Organised by the Generalitat de Catalunya, the Ajuntament de Barcelona
and the Arts Council of Great Britain

ARTS COUNCIL OF GREAT BRITAIN

Dedicated to Joan Miró (1893–1983) and Roland Penrose (1900–1984)

Exhibition and catalogue sponsored by ꓱ∃ΛT

ISBN 0 7287 0478 1

© the Arts Council of Great Britain and the authors 1985

Catalogue edited and produced for the Arts Council of Great Britain by Michael Raeburn
Catalogue design Trevor Vincent
Cover design Joaquim Nolla and Josep M. Mir
Cover photograph Manolo Laguillo
Catalogue printed by Jolly & Barber Limited, Rugby, Warwickshire
Translations by Sylvia Cardús, Ruth Gore, Tess Knighton, Marilyn McCully, Michael Raeburn, Ita Roberts

Illustration on half-title:
1. Masriera. *Pendant: Aeroplane over the city of Barcelona*, 1905 (no. 136).
Gold, enamel, diamonds, diam: 3.2cm. Private collection.

Frontispiece:
2. Picasso. *El Passeig de Colom*, 1917 (no. 186).
Oil on canvas, 40.1 × 32cm. Museu Picasso, Barcelona.

CONTENTS

Artistic contact between the English and the Catalan peoples has a long and continuing history. The illumination of the *Canterbury Psalter*, which was shown in last year's Hayward Gallery exhibition of English Romanesque art, was begun in Canterbury in 1180–90 and completed in Catalonia in the mid-fourteenth century; Joanot Martorell's great Catalan novel *Tirant lo Blanc*, published in 1490. opens in England with the exploits of William of Warwick defending the country against Saracen invaders. At the beginning of the period covered by this exhibition, the example of William Morris and the Arts and Crafts movement was especially important for the artists and architects of Catalan *Modernisme*, though later English reactions, to Gaudí's Sagrada Família for example, were sometimes less than enthusiastic. George Orwell thought the Anarchists had shown bad taste in not blowing it up when they had the chance, and Gerald Brenan sought in vain in contemporary European architecture for anything 'quite so vulgar and pretentious', not a view shared today when this building has become one of the most resonant of architectural monuments.

But this exhibition is not the result of any special relationship. No such excuse need be brought forward. *Homage to Barcelona* examines one of the most vital centres of art in the modern period. What we are celebrating is the energy of the city of Barcelona and the creativity of the Catalan peoples. Gaudí, Picasso, Miró and Dalí are acknowledged as major figures, but we know too little of the context out of which they emerged. It is this lack of knowledge that the exhibition sets out to remedy. Along the way we have 'discovered' many artists, designers and architects who deserve to be known well beyond the borders of Catalonia. While the exhibition concentrates on the visual arts, this catalogue provides an opportunity to broaden the picture to include music, theatre and literature and to provide an account of the extraordinary history of the city from the turn of the century until the outbreak of the Spanish Civil War.

The preparation of any international exhibition is a lengthy and complicated affair, and this has been no exception. However, it has all been made a great deal more enjoyable by the many new friends we have made; so that we would heartily endorse Cervantes's description of Barcelona as 'the abode of firm and reciprocal friendships'. At the outset we received the kind of encouragement which gave impetus to our project from both the Mayor of Barcelona, Sr Pasqual Maragall, and the Conseller de Cultura of the Generalitat, Dr Max Cahner (whose successor, Sr Joan Rigol, has continued this support). Early encouragement was also given by Dr Joan Ainaud de Lasarte, former Director of the Museu d'Art de Catalunya, who has been such an important figure in the development of Barcelona's magnificent museums.

A committee, the membership of which is given on the page facing this foreword, was set up to oversee and coordinate the development of the exhibition. An early and crucial decision of this committee was to entrust the selection to one person, Dr Marilyn McCully, albeit with the advice of many Catalan and a few English scholars. Dr McCully devised the structure of the exhibition and has worked on every aspect of the detailed selection. We are greatly indebted to her for the way in which she has retained the clarity of her original conception when the wealth of material and the complexity of the subject might have created confusion. Another early decision of the committee was to commission the Barcelona architects Martorell, Bohigas, Mackay to design the Hayward installation. Quite apart from the distinction of this firm's work, it seemed especially appropriate to have David Mackay, an English architect who has made his career in Barcelona, closely involved in the presentation of Catalan art to his countrymen. This is the kind of exhibition in which the designer's role is crucial, and we should like to thank David Mackay and his partners, as well as Laia Martorell and Lluís Pau who did much of the detailed design work, for their major contribution.

The organising of the exhibition in Barcelona has been undertaken by Carmen Huera, Head of the City's Museums. Since it has seemed at times as if we were borrowing from every museum in Catalonia and requiring material from countless libraries and archives, this has been a massive task for which we are extremely grateful to Carmen Huera and her staff. And, of course, we are greatly indebted to the museums themselves, most especially to the Museu d'Art Modern and its Director Cristina Mendoza, to the Fundació Joan Miró and its Director Rosa Maria Malet, and to the Museu Picasso and its Director Maria Teresa Ocaña. To these institutions, to the other museums, and to the many Catalan private collectors who have lent to the exhibition, we offer our thanks and the hope that this exhibition and its catalogue will be some recompense for their generosity. But our exhibits have not only come from Catalonia. A most important intention has been to assemble works which have found their way into European and American collections and museums. This has been the case particularly

with works by such key artists as Picasso, Miró and Dalí. Here the response of museums and private individuals has been one of exceptional generosity, for which we are very grateful.

This catalogue has been edited and produced by Michael Raeburn. It is an ambitious publication, designed not so much to supplement existing literature on the subject in English as to fill a very evident gap. Its production has required a prodigious amount of work in an impossibly short time by Mr Raeburn and the authors. We are most appreciative of their work and of that of Sr Joaquim Horta who performed an important coordinating role in Barcelona. Much essential research was contributed by Julia Engelhardt and Pilar Sada.

We owe a very special debt to Sr Josep Codina of the Ajuntament de Barcelona, whose primary task has been to advise on the programme of music and theatre accompanying the exhibition but who has been involved in one way or another in virtually every aspect of our planning. The Arts Council would also like to acknowledge the very special role of Rosa Maria Subirana, who helped us to locate many important collections and who worked with Dr McCully during critical stages in the devising of the exhibition. Our own first steps in establishing the project were guided with customary adeptness by British Council representatives in Barcelona; our grateful thanks to Jeremy Hughes, the British Council's Regional Director in Catalonia and to his colleague Montserrat Pau.

When the costs of the exhibition were escalating alarmingly we were rescued by SEAT, the Spanish car manufacturing company, who came forward as sponsors of the London exhibition.

We cannot hope to mention every one of our collaborators in a short preface. The lists which follow indicate just how many people have been involved and have contributed to our exhibition.

Joanna Drew
Andrew Dempsey
Arts Council of Great Britain

Public collections in Catalonia

Ajuntament de Barcelona
Arxiu Administratiu
Biblioteca dels Museus d'Art
Institut Municipal d'Història
Museu d'Arts Decoratives
Museu d'Art Modern
Museu de Ceràmica
Museu Clarà
Museu d'Història de la Ciutat
Museu Picasso

Generalitat de Catalunya

Diputació de Barcelona
Biblioteca de Catalunya
Biblioteca Popular Santiago Rusiñol, Sitges
Museu de les Arts de l'Espectacle
Museu Cau Ferrat, Sitges

Ajuntament de Santa Coloma de Cervelló
Colònia Güell

Ajuntament de Tossa de Mar
Museu Municipal de Tossa

Ajuntament de Valls
Museu Municipal d'Art

Ajuntament de Vilanova i la Geltrú
Museu Victor Balaguer

Private Institutions and Foundations in Catalonia

Casa Museo Gaudí (Amics de Gaudí), Barcelona
Col.legi Oficial d'Arquitectes de Catalunya, Barcelona
Fundació Joan Miró, Barcelona
Fundación Gala-Salvador Dalí; Teatro Museo Dalí, Figueres
Institut d'Estudis Catalans, Barcelona
Instituto Amatller de Arte Hispánico, Barcelona
Palau de la Música Catalana, Barcelona

Private collections in Catalonia

Pere Aguirre Gili
Antoni Argullol
Oriol Bohigas
Gustau Camps
Delmiro de Caralt
J. B. Cendrós
Casa Codorniu (Collection 'Cartells d'Ahir')
Leandre Cristòfol
Família Domènech
Francisco Godia Sales
Juan Pablo Marin
Ramon Marinel.lo
Carolina Meifrén de Jimenez
Jaume Mercadé
Jordi Muñoz
Myrurgia S.A.
F.X. Puig Rovira

Arturo Ramón
Manuel Rocamora Foundation
Jaume Sans
Eudald Serra i Güell
Jordi Serra
Família Sunyer
Enrique Torelló Enrich
R. Torres i Torres
Marqués de Villamizar
and anonymous lenders

Public collections outside Catalonia

CANADA *Toronto*
Art Gallery of Ontario

FRANCE *Paris*
Musée Picasso

FEDERAL REPUBLIC OF GERMANY *Hamburg*
Museum für Kunst und Gewerbe

GREAT BRITAIN *London*
British Library
British Museum
Theatre Museum, Victoria and Albert Museum
Victoria and Albert Museum

HOLLAND *Rotterdam*
Museum Boymans-Van Beuningen

SPAIN *Madrid*
Museo Español de Arte Contemporáneo

SWEDEN *Stockholm*
Moderna Museet

URUGUAY *Montevideo*
Museo Nacional de Artes Plásticas

U.S.A. *Evanston (Illinois)*
Northwestern University Library
New York
The Solomon R. Guggenheim Museum
The Metropolitan Museum of Art
The Museum of Modern Art
Philadelphia
The Philadelphia Museum of Art

Private collections outside Catalonia

Max G. Bollag, Zurich
Eikoh Hosoe, Tokyo
Galerie Louise Leiris, Paris
Mizné-Blumental Collection
S. Romain, Paris
Allan Stone, New York
and anonymous lenders

ACKNOWLEDGMENTS

The organisers of the exhibition would like to express their appreciation of the help they have received in preparing this *Homage to Barcelona*. To any whom we may have inadvertently omitted from the following list we offer our apologies:-

Santiago Alcolea, *Instituto Amatller, Barcelona*
Pedro Azara
Simon Beer, *Integrated Circles, London*
Aureli Bisbe
Annie Bridges
Antònia Bonet, *Generalitat de Catalunya*
Professor William Camfield, *Rice University, Houston*
Joaquim Capdevila
Christie's, London
Chromacopy Ltd
Codorniu S.A.
Francesc Fontbona
Guillem-Jordi Graells, *Institut del Teatre, Barcelona*
Hannah Horovitz, *Visiting Arts Unit, London*
Darryl Johnson, *Triangle Audio Visual, London*
John Johnson
Tess Knighton
Monica Mackay
Joan A. Maragall, *Sala Parés*
Carlos Martí
Adolfo Martínez
David Medalla
Henry Meyric Hughes, *Visiting Arts Unit, London*
Philip Miles
Antoni de Moragas
Noriko Nomura, *Teshigahara Productions*
Francesc Parcerisas
Edmund Peel, *Sotheby's, Madrid*
Antoni Pladevall, *Generalitat de Catalunya*
Roy Reed, *Triangle Audio Visual, London*
Michèle Richet, *Musée Picasso, Paris*
Enric Roig, *Konic Audio-Visuals, Barcelona*
Ignasi de Solà-Morales
Sotheby's, London
Sotheby's, New York
Cecilia de Torres
Nissa Torrents
Eliseu Trenc Ballester
Josep Trullén, *Generalitat de Catalunya*
Cecilia Vidal, *Museu d'Art Modern, Barcelona*
Clive Wainwright.

The organisers wish to acknowledge their indebtedness to the artists and their heirs for permission to reproduce the works in this catalogue. Every effort has been made to contact copyright holders, but those we have been unable to reach are invited to contact the publishers so that acknowledgment can be given in subsequent editions. Photographs were, in general, supplied by the owners of works, for whose help we are most grateful; their names are given in the captions to each reproduction.

Many of the photographs of works of art from Catalonia and the majority of the historical photographs of the city's architecture (figs. 7, 11, 29, 30, 42, 103, 110, 118, 135, 138, 186, 187, 245, 267, 297, 307, 308; pp. 298 *top right*, 299 *top*) come from the files of Arxiu Mas, whose assistance has been much appreciated.

A number of photographs of architecture (figs. 3, 8, 9, 95, 96, 105, 106, 114, 122, 123, 126, 133, 188, 256, 260) were taken specially for this catalogue by Lluís Casals, to whom special thanks are due.

Except where noted otherwise, the photographs in the Chronology are from the Arxiu històric of the Institut Municipal d'Història de Barcelona, who also supplied the following illustrations: figs. 63, 85, 86, 87, 88, 89, 92, 93, 97, 98, 101, 104, 108, 130, 143, 291, 292, 294, 316.

Other photographs were taken or supplied by the following:
Roger Aliér, fig. 312
Derek Balmer, Bristol, fig. 253
Studio photo Baudouin, fig. 50
Biblioteca de Catalunya, pp. 300, 307 *bottom right*
Francesc Català Roca, figs. 73, 109, 111, 115, 116, 117, 119, 127, 204, 235
Centre Excursionista de Catalunya, fig. 142; p. 290
Cercle del Liceu, fig. 140
Arxiu històric del Col.legi d'Arquitectes de Catalunya, figs. 132, 134, 136
Cuadernos de Arqueologia no. 16, 1975, fig. 108
Fisa industrias gráficas, fig. 124
Arxiu Estudi Martorell-Bohigas-Mackay, cb Fotografia, fig. 100
Robert E. Mates, fig. 191
Mies van der Rohe Archive, The Museum of Modern Art, New York, 13.318, fig. 66
Lee Miller Archives (copyright), figs. 68, 71
Eric E. Mitchell, fig. 69
Musées Nationaux, fig. 277
Museu d'Art Modern, Barcelona, p. 292 *top left*
Museu de les Arts de l'Espectacle, Barcelona, figs. 305, 306
Museu d'Història de la Ciutat, Barcelona, fig. 107; pp. 291 *left*, 303
Larry Ostrom, Art Gallery of Ontario, fig. 35
Sala Parés, p. 289 *top right*
J. Porta, figs. 226, 233
Queralt, Valls, fig. 52
Rainsville Archive, pp. 288, 293 *right*
Roy Reed, Triangle, figs. 79, 80, 81, 125, 131
Judith Rohrer, fig. 94
Serrano, fig. 28
J. Vidal Alcover, fig. 298

In seeking to make this catalogue a real complement to the exhibition, we have given over the greater part of it to the collection of essays, followed by a chronology and the actual catalogue of works exhibited (in which biographies of the artists are incorporated).

We have tried, wherever possible, to illustrate the essays with works of art that are in the exhibition, although other material has also been used (photographs of architecture, in particular) as necessary. All works exhibited have their catalogue numbers given in the caption, following the date, and fuller details can be found in the catalogue on pp. 309ff.

The Catalan language, though spoken by several million people, is not widely known in Britain; nevertheless, its similarities with other Romance languages give it the appearance of familiarity, and many words and phrases will be quite easily understandable. For this reason, we have often left the titles of works and the names of institutions, political parties etc. in the original language (though normally providing a translation, at least when they are first mentioned), and the same policy has been followed with some other Catalan words, including the names of the most important intellectual and artistic movements, *Modernisme* and *Noucentisme*.

A word of explanation is also necessary about names. The full version of a Catalan name includes the names of both father and mother (in the form, e.g., Domènech i Montaner), with the father's name first and normally used on its own, although it was not uncommon to keep both names in general use. Spanish names follow a similar practice (often without the connecting 'i'). Names of artists whose work is in the exhibition are given in full in the catalogue (pp. 309ff.), although the shorter form is as a rule used in the text of the essays.

The alternating use of Catalan and Castilian throughout the period covered by the exhibition, and the fact that a Catalan spelling reform was underway at the time, means that contemporary sources are frequently inconsistent, and anomalies are inevitable. To try and keep confusion to a minimum, we have normalised spelling, except of proper names, and for these we have tried to follow the individual's own practice, with a preference for the Catalan version when in doubt.

As it is much easier to assimilate words and names by imagining their sound, the following brief notes on Catalan pronunciation are given as a very rough guide to the reader (anyone interested in a thorough introduction to the language should consult Alan Yates's *Catalan* in the 'Teach Yourself' series).

Most consonants in Catalan have a value fairly similar to their use in English, including **c** (pronounced hard – sometimes written **ch** in names – or soft, but never as in Castilian or Italian), but with the exception of **g** (pronounced hard or soft – = **j** – as in French, but like English *tch* in the combination **ig** at the end of a word); **ll** (which has almost a *y* sound, though **l** and **l.l** are more like English *l* and *ll*); **ny** (like Castilian *ñ*); **qu** and **gu** (in which the **u** is silent unless written **ü**); and **x** (often pronounced *sh*); **h** is silent, and **r** is often silent at the end of a word. **b**, **d** and **g** have a softer sound in mid-word and are pronounced like *p*, *t*, *k* at the end of a word, and in the following combinations – **mb**, **mp**, **nc**, **nd**, **ng** – the second consonant may often be virtually silent.

Stressed vowels are pronounced clearly with the values that one would expect, while unstressed vowels have a neutral sound like English 'the' (Catalan **a** or **e**) and 'to' (**o** or **u**) when unstressed. When **i** and **u** follow another vowel they are more like *y* and *w*, though **ï** and **ü** retain more of their full value. Accents are primarily indications of stress.

Thus, to give a very few crude examples (the unstressed vowel sounds are indicated by ě and ŭ): Puig i Cadafalch is pronounced roughly at Pootch ih Kěděfáhlk, *Noucentisme* as Nohwsěntízmě, Lluís as Yooíhs, Casas as Káhzěs, Nogués as Nŭggéhs, Nonell as Nŭnéhy, Riquer as Rikéh, Güell as Guéhy, Foix as Fohsh.

Introduction

Marilyn McCully

Barcelona, *fin-de-siècle* city; Barcelona, capital of Catalan separatism; Barcelona, refuge for artist-exiles during the First World War; Barcelona 1929, a city of the future – these are some of the different faces of Barcelona during the period 1888–1936, moments in the history of the city, its people and its art. For many different reasons, what occurred there during those years sets Barcelona apart from the rest of Spain. Even as a casual visitor today, one is struck by the dissimilarity to other Spanish cities, especially because of the turn-of-the-century character of Barcelona's architecture, because of its own language – and, as Gerald Brenan described it, its 'active and enterprising character and European outlook'. And greater familiarity raises questions about the conditions which produced this dissimilarity. Once bitten by the Gaudí bug, for instance, the curious outsider will begin to ask how on earth such architecture could come about, who was its creator and how do his buildings relate to other architectural currents of the time? Then again, Picasso, Miró and Dalí as young painters and De Falla, Casals and Gerhard as musicians all spent artistically formative years in Barcelona, and if one of the principal creators of Cubism and two major Surrealists, as well as pioneer composers and performers, started out in the Catalan capital, what were the artistic conditions there which stimulated their individual modes of expression?

The present exhibition is an exploration of these moments in the history of the city of Barcelona and its people as expressed in art and architecture, and one of its aims is to answer the questions concerning the artistic context during these eventful years. Whilst featuring the works of artists who have become household names – Gaudí, Picasso, Miró, Dalí – we also wish to place them in their cultural setting by showing them side-by-side with those of their contemporaries whose names may be unfamiliar but whose art is of remarkable quality and originality. The catalogue is designed to broaden the scope by including discussion of the political and literary background as well as essays on the main developments in architecture and the visual arts. From the various texts, the intimate connection between artistic, philosophical and political ideologies will become apparent, while the at first unfamiliar names of the leading figures of the time, the dominant intellectual and artistic movements – *Modernisme* and *Noucentisme* – and the artistic groups – Cercle Artístic de Sant Lluc, GATCPAC, ADLAN – will be placed in context. The Chronology (pp. 287ff) is designed to give a schematic framework for this same

subject-matter, in particular highlighting the political evolution of the period, where patterns were so different from those of other parts of Europe – for example, Spain had its own wars and was not directly involved in either of the two World Wars – and which is so significant for an understanding of the intellectual and artistic developments.

Nevertheless, it is easy to see associations between the art movements in Barcelona and international movements – *Modernisme* readily calls to mind *Art Nouveau*; *Noucentisme*, early twentieth-century classicism; and the GATCPAC were closely involved with the leaders of the International Style in architecture – although the local movements often have a quite different character and occur at a different pace from the rest of Europe.

This accounts for the paradox implicit in the work produced by Barcelona artists and architects during this period, reflecting the inward-looking character of the local Catalanist movement on the one hand and the outward-looking desire to be modern and cosmopolitan on the other. It should be remembered that the Catalanist movement, like other regionalist movements in the late nineteenth century, was aimed at preserving a local language and culture that kept it apart not only from the rest of Spain but also to some degree from foreign influence. Because of this paradoxical situation, Barcelona as a city emerges as a kind of breeding ground of artistic stimulation for locals and outsiders alike, some of whom remained there while others eventually left. Although throughout the period of the exhibition parallels with artistic developments in other European cities, such as Paris, Munich or even Zurich (during the First World War) can be clearly drawn, the work produced is almost always interpreted in Barcelona in a specifically local way.

The work of an individual like Gaudí, for instance, must be considered in the light of this inward-looking character. Although his buildings appear to us as futuristic, or as a highly personal form of international *Art Nouveau* architecture, Gaudí himself was deeply attached to local tradition, which greatly affects his buildings. And in his personal beliefs, he actually represented the reactionary wing of Catalan politics during his lifetime. In the case of an exceptionally brilliant painter such as Ramon Casas, whose recordings of major political events on canvas seem such a powerful expression of protest against tyranny, we find the typical Catalan bourgeois, whose local attachments essentially turned him into a society portraitist. By contrast is the case of Joan Miró, who, out of artistic

3. Gaudí. Parc Güell, 1900–14: terrace above the hypostyle market.

necessity, chose the outward-looking view and eventually realised works not only of international artistic importance but also of universal meaning, still without ever giving up their Catalan origins and personal significance.

The exhibition of 1888

Our starting point is the 1888 Universal Exhibition, which was a deliberate attempt on the part of its organisers, especially the mayor Francesc Rius i Taulet, to present the image of the city of Barcelona to the world as an independent, prosperous and industrially strong urban centre with its eyes on the future. The fair, the first in Spain, was planned on the model of earlier international exhibitions in cities like London and Paris (Glasgow also held an exhibition in 1888 and Paris followed in the next year with the greatest of all these exhibitions, which featured the Eiffel Tower and the Salle des Machines). Located on the site of the old Barcelona citadel, a major building programme was undertaken, which included a triumphal arch (designed by Josep Vilaseca) and several structures, such as Domènech's huge Hotel or the fan-shaped Palace of Industry, which were designed to reflect the modern techniques and production methods with which Barcelona hoped to identify itself in this event.

The 1888 exhibition was also part of the general urbanisation of Barcelona during these years, and while some of the exhibition buildings, notably Domènech's Hotel, were taken down once the fair was over, others such as his Café-Restaurant were converted for other use – in this case for a kind of arts and crafts workshop. Thus, not only did the event represent an actual extension of the growing city and a stimulus to architects who were carrying out the great building programme, but it was also a declaration of Barcelona's outward-looking desire to communicate to the world a new, modern self-image as well as an expression of local pride in a great cultural tradition.

All the arts – literature, music, theatre, painting as well as architecture – began really to flourish in Barcelona in the last decade of the nineteenth century; and because of this Barcelona can be compared to other important *fin-de-siècle* cities. Miquel Utrillo, for instance, in an article for the little art journal *Luz* in 1898, compared the artistic regeneration of Barcelona to the activities centred around Brussels in the preceding few years. While responding in a similar way to the artistic currents which emanated from Paris, regional pride in language, literature and art resulted in new work, which in turn had acquired international significance. Utrillo's example of Brussels is a good one; the *Art Nouveau* architecture of Horta and furniture designs of Van de Velde, for example, or the symbolist theatre of Maeterlinck and the artistic group Les Vingt, all have parallels in the architecture and art of the turn of the century in Barcelona; in both cases artistic innovation resulted from the combination of shared international *fin-de-siècle* artistic and literary concerns and, importantly, the general trend towards regionalism in the late nineteenth century.

During this period, as the chief city of Catalonia, Barcelona had become both the centre of Catalan political separatism and also the focus of that movement's artistic expression. The region of Catalonia is situated in the north-eastern corner of Spain and occupies an area whose borders have fluctuated since the Middle Ages but have been largely determined linguistically. The suppression of the Catalan language, as part of the general, repressive attitude on the part of the central government early in the nineteenth century, was one of many reasons for the emergence of a Catalan separatist movement. As part of the desire for self-determination and expression, not only was there a conscious revival of interest in great moments of Catalan history but also a contemporary linguistic revival, which led in the second half of the nineteenth century to the production of a new body of literature. In general this cultural movement was called the *Renaixença* (rebirth – renaissance) and it should be remembered that it functioned both as part of the political, separatist movement and, importantly for the arts, as part of an intellectual movement, in which writers and critics as well as artists and architects were involved.

Modernista architecture

In the case of Catalan architecture, in 1878 the architect and politician Lluís Domènech i Montaner, like so many European architects of the late nineteenth century, had challenged his generation of architects to search for a national style. Although at this time he thought in terms of a Spanish 'national' style, he urged them to consider especially the Catalan architectural tradition founded in the Romanesque and Gothic. At the same time, he warned that the architects of the future must not be superficially eclectic but must create buildings which express their own time and utilise new materials such as iron. In such statements we find evidence of the influence of general nineteenth-century trends and specifically of the rationalism of Viollet-le-Duc. Yet the essentially Catalan character of the new *modernista* architecture was perceived as an expression of regional identity, and in this way Barcelona as a growing city became the focus for the realisation of a Catalan 'national' style.

The city of Barcelona itself was in the process of change during this period – urban expansion plans had been initiated from the time the medieval city walls began to be taken down in 1854. Thereafter, the replanning of the city became an almost constant obsession, not only at this time but right up to the 1930s, when Le Corbusier collaborated with Barcelona architects on plans to develop the city and its surrounding coastal area.

Beginning in the 1860s, using the plan by Ildefons Cerdà known as the *Eixample* (extension), the shape of a new Barcelona was established. City limits were increased,

4. Domènech i Montaner. *Editorial Montaner i Simon (decorative details), c.*1881 (no. 64).
Ink on paper, 44 × 22 cm. Collection Domènech Family, Barcelona.

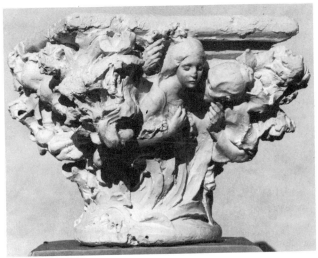

5. Arnau. Capital on circular base, *c.*1900; model for a capital in the dining room of the Casa Amatller (no. 5).
Plaster, 49.5 × 65 × 65 cm. Museu d'Art Modern, Barcelona.

neighbouring villages such as Gràcia were joined to the centre, and all of this led to much building activity to accommodate a population that was growing rapidly as industry expanded. There were plentiful opportunities for architects, many of whom were directly involved in the political movement, not only to experiment with new materials and to create new forms but also to express the goals and aspirations of their people in buildings.

Lluís Domènech i Montaner, Josep Puig i Cadafalch and Antoni Gaudí were the principal architects of the *modernista* period – i.e., in architecture, a period which begins in the 1880s and continues well into the second decade of the twentieth century – and their buildings for the large Catalan bourgeoisie and also the growing non-Catalan worker class in Barcelona embodied the optimism of the Catalanist movement. The problem of being both modern and traditional, and independent at the same time, in part found architectural resolution in the revival of local arts and crafts, which had an important precedent in England in the preceding years.

The impact of William Morris and the English Arts and Crafts movement was particularly significant in Barcelona during the *modernista* period, not only for architecture but also for graphic design and for the design of domestic objects, primarily because the ideas behind the English movement were so well suited to the political as well as artistic aims of the Catalans. For architects, pride in local craft tradition and workmanship led to a great revival of decorative ceramics, ironwork and stained glass, as well as to a preference for local materials such as red brick. Moreover, the nineteenth-century taste for Gothic forms was also prevalent among Catalans, who consciously sought to link their work with a period of cultural and political greatness in their own past. Ruskin's writings, too, were known in Barcelona, and local architects, such as Puig i Cadafalch and Domènech were well acquainted not only with his attitudes towards historical references in buildings but also with general medieval sources. The mixture, then, of local tradition – essentially based upon the Arts and Crafts model – and references to the Catalan Gothic period was the basis upon which Barcelona architects began their search for a new, 'national' style.

Another significant influence was that of *Art Nouveau* architectural design and decoration – inspired principally by French, German and Viennese, as well as Scottish and English examples, and the proliferation of the *modernista* style of Catalan architecture as it was understood by a great number of local architects incorporates many elements of *Art Nouveau* design. This brings to mind a comparison with other cities, such as Brussels, Nancy or Brno, where the character of the city was given new life at the turn of the century by *Art Nouveau*. But it would be a mistake to generalise and see *Modernisme* merely as the Catalan version of *Art Nouveau*. *Modernisme* was a movement firmly rooted in local tradition, despite the

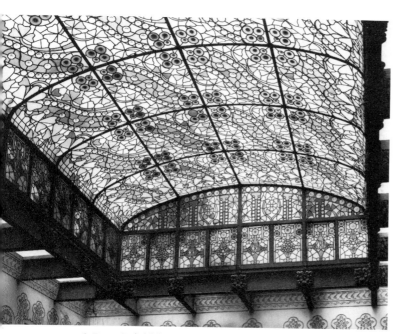

6. Puig i Cadafalch. Casa Amatller, 1898–1900: stained glass ceiling above stairwell (no. 216).
Glass and metal panels (attributed to Rigalt, Granell & Cia.), 350 × 450 cm. Instituto Amatller de Arte Hispánico, Barcelona.

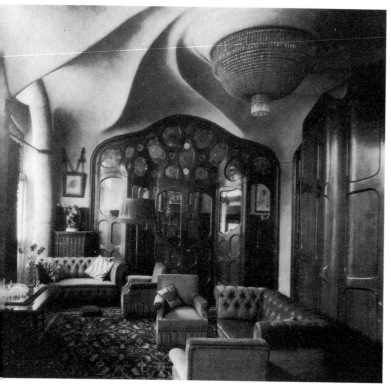

7. Gaudí. Casa Batlló, 1905–7: drawing room; photographed c. 1925.

fact that the desire to be modern led architects to look beyond Catalonia's borders not only for stimulation but also for sympathetic architectural movements. In the work of Puig, for example, Catalan Gothic features predominate, even though there are elements of *Art Nouveau* influence: in the façade sculpture of his Casa Amatller (1898–1900, fig. 9) a young woman with flowers entwined in her long flowing hair – a typical *Art Nouveau* motif – appears among specifically medieval sculptural references; and when one enters the front doorway, the form of the open courtyard and great staircase (fig. 10) suggests the entrances of Catalan Gothic palaces of the fifteenth century, though stylised floral motifs in the stained glass ceiling at the top of the stairs (fig. 6) hint again at northern *Art Nouveau* influence. Puig's designs extended to light fixtures (for example, his innovative gas lamp incorporating stained glass) and Neo-Gothic furniture (figs. 245, 246), and it is this activity which links him to the European Arts and Crafts movements, where architect was also designer. For Puig and so many who imitated him, the idea of *Modernisme* signified the renewal of indigenous styles and craft traditions more than a fashionable 'new art'.

In Domènech's Palau de la Música (1908, figs. 123–5) the revived craft of ceramic decoration is used profusely, both on the exterior and interior, and the colour and patterns of ceramic columns on the upper balconies create a rhythm which complements the red-brick pointed arcades. Every decorative feature is given specific meaning, while typically *Art Nouveau* floral motifs – such as sunflowers and roses in ceramics (or in stained glass inside the building) – give an organic symbolism to the overall structure. Inside, above the auditorium of the concert hall, long slender irises are held by the thin 'Pre-Raphaelite' looking girls who radiate like petals around the amazing central ceiling lamp. The hall itself is a daring and innovative experiment with its use of glass walls; but at the same time its decorative scheme with its free use of heraldic motifs also echoes medieval forms and materials, while the sculptural groups celebrate both the legacy of musical history (and Wagner in particular) and the tradition of Catalan popular song. This is a building which, with its heavy reliance on contemporary foreign sources and historical Catalan techniques and styles blended into a flamboyant and unselfconscious entity, sums up one strain of *modernista* architecture.

If one looks at the other main tendency, that of Gaudí, his use of flowing line in the overall form, interior floor-plans, ceilings, etc. of the Casa Milà (figs. 11–13), for instance, results much more from his personal view of the way architectural form should relate to nature than from the international, *fin-de-siècle* taste for the organic, whiplash or serpentine line. And certainly Gaudí, more than any other architect of this period anywhere, handles architectural form in an organic way that approaches

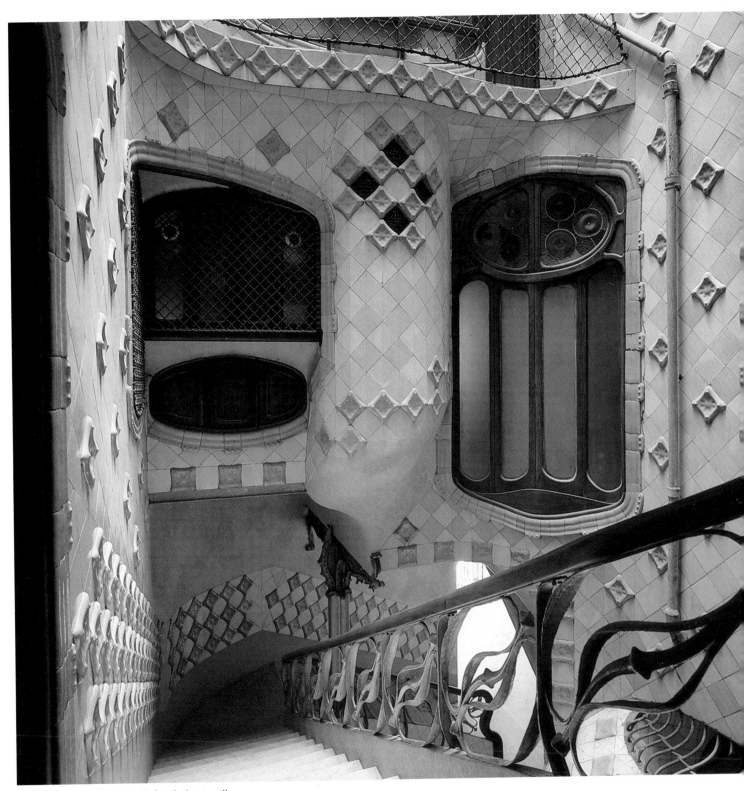

8. Gaudí. Casa Batlló, 1905–7: detail of stairwell.

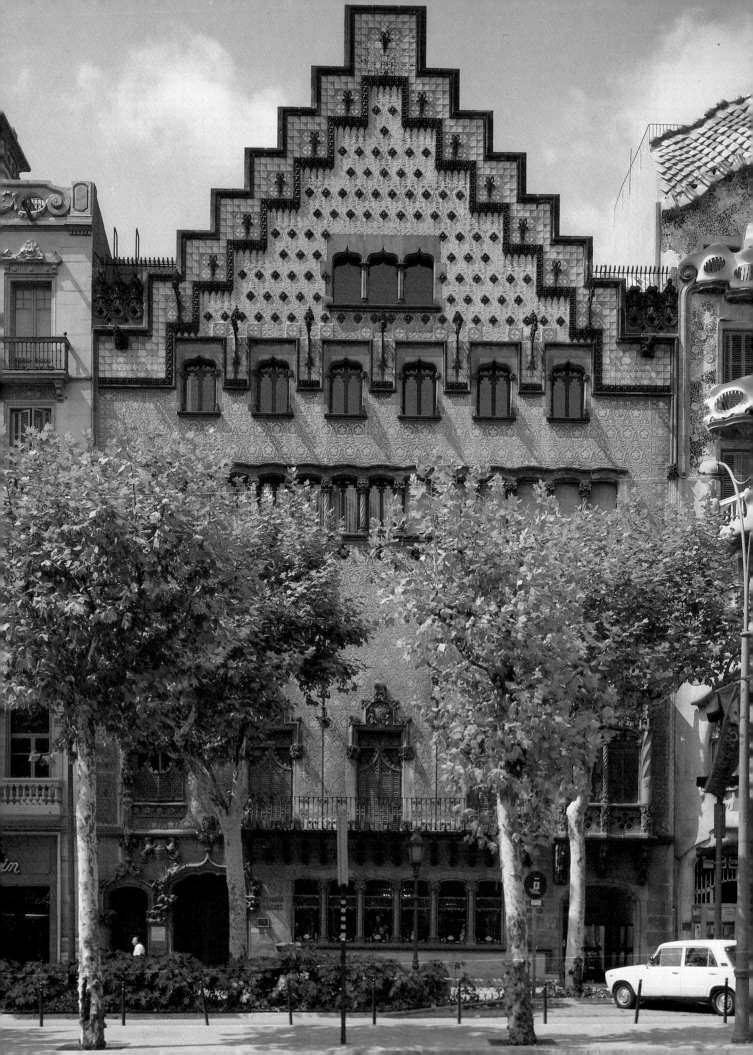

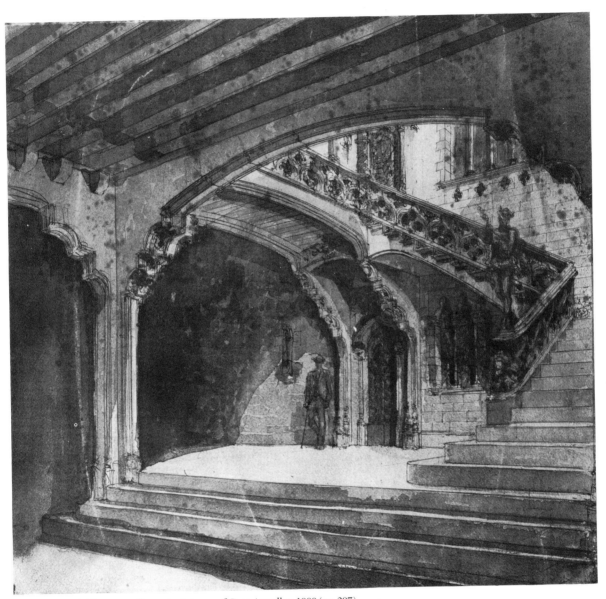

10. Puig i Cadafalch. *Project for main staircase of Casa Amatller*, 1900 (no. 207).
Ink and watercolour on paper, 26.2 × 28.5 cm.
Instituto Amatller de Arte Hispánico, Barcelona.

9. Puig i Cadafalch. Casa Amatller, 1898–1900: façade.

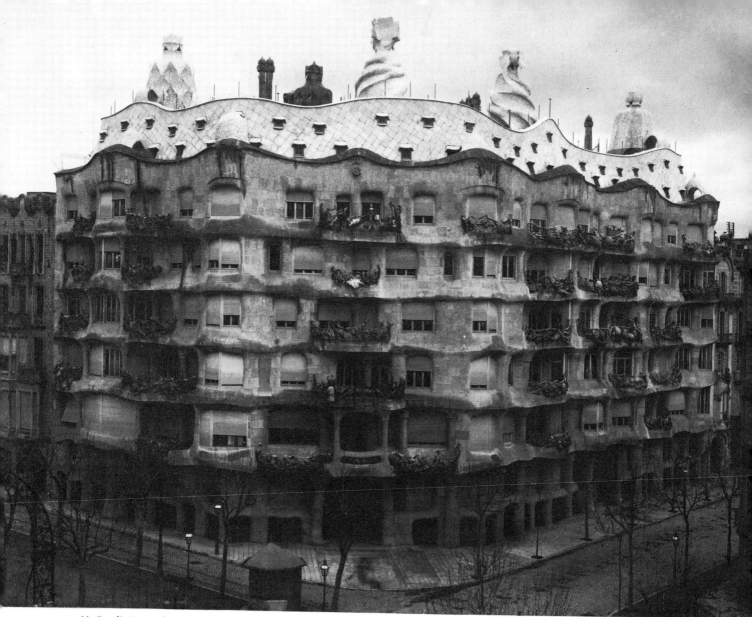

11. Gaudí. Casa Milà ('La Pedrera' – the stone quarry), 1906–10; photographed in 1909.

12, 13. Gaudí. *Casa Milà (plan of basement and section)*, 1906 (no. 91).
Ink on linen, 47 × 80, 48 × 38 cm. Arxiu Administratiu de l'Ajuntament de Barcelona.

sculpture. For many foreigners, Gaudí's buildings have become almost synonymous with the city of Barcelona. Although his expressive architectural forms and his personal decorative schemes distinguish him from his contemporaries, both his work and his attitudes fall well within the context of the period. Gaudí himself was a strong Catalanist (he refused to speak Castilian) as well as a fervent Catholic. As a member of the conservative Cercle Artístic de Sant Lluc he supported a moral view of art, which stood in opposition to what the Cercle believed to be the decadent influence among Barcelona artists of late nineteenth-century – i.e., avant-garde – European art and literature. Gaudí was also a very private individual, who attracted only a few faithful followers, such as the architects Jujol and Berenguer. Furthermore, he never saw his role as architect in the way Puig or Domènech did theirs, as politicians or influential historians. Among many young artists, he was even considered something of a fanatic. When Picasso went to Paris for the first time, he and his friend Casagemas wrote back to their mutual friend Reventós: 'If you see Opisso [a fellow Barcelona artist who occasionally worked on Gaudí's Sagrada Família], tell him to come here as it is good for saving the soul – tell him to send Gaudí and the Sagrada Família to hell . . . Here there are real teachers everywhere.'

In spite of Gaudí's individual personal posture, the actual presence of his buildings during the *modernista* period and the on-going construction of the Sagrada Família church up until his death in 1926 were important physical features of the growing city, and in all of them there is a conscious desire not only to be innovative but also to be Catalan. In the beginning Gaudí turned to Gothic sources – the Sagrada Família is essentially Neo-Gothic – and to local styles, such as Islamic (Casa Vicens), for inspiration, as well as to traditional materials, such as red brick, ceramic tiles and ironwork. Yet as he developed as an architect, he moved away from historically specific motifs or forms towards a unique, sculptural handling of materials, forms and spaces, which characterises most of his buildings from after the turn of the century. While individualistic and highly creative, Gaudí's work remains essentially Catalan in inspiration and meaning.

Modernista painting

In late nineteenth-century Catalan painting, regionalism was first expressed not in subjects of folklore, popular customs or historical events (as was often the case with other European regional movements) but in the development of a local school of landscape painting – first in the 1880s in the countryside around Olot and soon after in the seaside village of Sitges just south of Barcelona. The celebration of the land itself – *la terra catalana* – was the subject of the Barbizon-inspired Olot artists, and the depiction of Catalonia's Mediterranean coast of the so-called Sitges Luminists. Just as writers who wished to renew the use of the Catalan language earlier in the century had used images of nature to express regional pride, painters began to experiment with new techniques connected with landscape painting – in a sense developing their own language – especially the recording of atmosphere and light. In the context of French art this seems a rather late phenomenon, but for Catalan painting it signalled revolution.

For the Olot painters, led by Joaquim Vayreda (fig. 14), effects of mood and atmosphere depended primarily upon the quality of brushstroke; for example, a variety of strokes was used to suggest the motion of leaves or grasses and to establish compositional planes. Vayreda then generally unified his compositions (in a manner not unlike French Barbizon painters) with an overall thin application of paint – usually tones ranging from cool browns to dark greens – as if the landscape were filled with mist or late afternoon light. By contrast, the bright palettes and the preoccupation with light of the Sitges Luminists, represented principally by Arcadi Mas i Fontdevila (fig. 157) and Joan Roig i Soler, were occasionally compared to those of French impressionist canvases by contemporary critics. Yet their work actually had more to do with the influence of Marià Fortuny, the artist from Reus who had lived and worked in Rome for many years and had acquired success in Paris at Goupil's for his small canvases covered with jewel-like glittering surfaces. Moreover, both Mas i Fontdevila and Roig i Soler had also studied in Rome, where they were impressed by the brilliant colours and rapid recording techniques of the Italian *Macchiaioli*.

In 1892 Mas i Fontdevila organised an exhibition in Sitges which came to be regarded as the first *Festa modernista*, grouping together the Olot painters, the Sitges Luminists and featuring Santiago Rusiñol and Ramon Casas, who showed works they had made both in Paris and Barcelona. In his review of the show for the Barcelona daily *La Vanguardia* the critic Raimon Casellas pinpointed as the crucial stylistic factor which was new to Catalan painting and which all the canvases had in common their concern with light. Furthermore, the painting of contemporary urban experience – in works by Rusiñol and Casas – represented an equally new departure and introduced their awareness and contact with contemporary Parisian artistic movements.

Rusiñol and Casas were the outstanding painters of their period, and while today their canvases still look less advanced than works by their French contemporaries, they were understood in the 1890s by the Catalan public as new and up-to-date, i.e. *modernista*; and by the younger generation of Barcelona artists, who in 1895 would include the art-student Picasso, they were thought to be potentially revolutionary. The reason for this is found both in choice of subject-matter – café and street life, for example – and to some degree in technique, especially in the use of

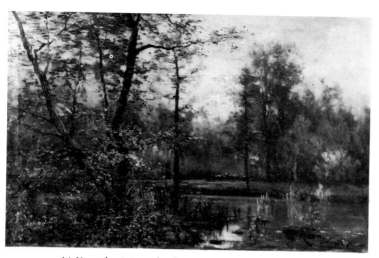

14. Vayreda. *Autumn landscape, c.*1888.
Oil on canvas, 52.5 × 84 cm. Museu d'Art Modern, Barcelona.

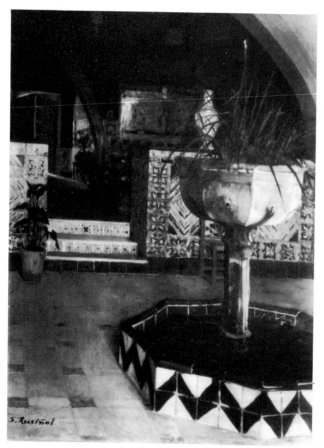

15. Rusiñol. *Interior of Cau Ferrat, c.*1895.
Oil on canvas, dimensions unknown.

colour and space to create mood. In this sense, in spite of generally rather conservative painterly technique, *modernista* canvases reveal affinities with the literary and artistic currents of symbolism in the nineties.

Rusiñol was one of several *modernistes* to engage in both literary and artistic activity. His own literary efforts, primarily in his plays and prose writings such as *Oracions* (Prayers) and *Fulls de la vida* (Pages of life), are evidence through their evocative imagery and language of the important impact during that period of literary symbolism. In addition, Rusiñol was particularly interested in the spare, suggestive theatre of the Belgian playwright Maeterlinck, for whom he had a great personal admiration; he even acted in the first performance of Maeterlinck's *L'Intruse* performed in Catalan translation in Sitges in 1893 at the second *Festa modernista*, just two years after its first performance in Paris.

After the success of the first *Festa modernista* in 1892, Rusiñol (the son of a well-to-do bourgeois family) had decided to purchase an old wreck of a house overlooking the sea in Sitges and to remodel and convert it into both a studio space and especially a place to house his fine collection of antique ironwork (several pieces of which had been shown at the 1888 exhibition). Known as the Cau Ferrat (Den of iron), Rusiñol's studio-museum began as a friendly, social gathering place, but ended up in just a few years' time as a kind of temple devoted to the new art and as a retreat for artists, musicians and writers, who were invited by Rusiñol as the initiator of the new artistic 'religion'. Sitges even came to be known in the press in the nineties as the 'Mecca of *Modernisme*', because of the events of real avant-garde inspiration which were organised by Rusiñol and his artist friends.

One of these, the third *Festa modernista* (November 1894) featured a procession in the style of Spanish Holy Week processions, but instead of a life-like sculpture of the Virgin or Christ, two El Greco paintings of saints (recently acquired by Rusiñol in Paris) were placed on a platform, which was carried by artists through the streets of Sitges to the Cau Ferrat, where the works of art were solemnly installed. This event, along with a literary evening afterwards, marked the official dedication of the building, which over the years would also be the site of numerous artistic gatherings (Rusiñol's own paintings were hung in the building alongside those of a number of his contemporaries as well as the two El Grecos), banquets, musical performances and other unusual events, such as the Loïe Fuller-inspired dances performed in the summer of 1895. On that occasion Rusiñol, along with his friend Miquel Utrillo, arranged for a Barcelona dancer (a certain Pilar Arcas) to perform the *dansa serpentina* in a boat on the sea in the evening, while a coloured light show was directed on her from the Cau Ferrat windows. Because of such capers carried out with the utmost seriousness, Rusiñol won not only the dubious reputation of being the

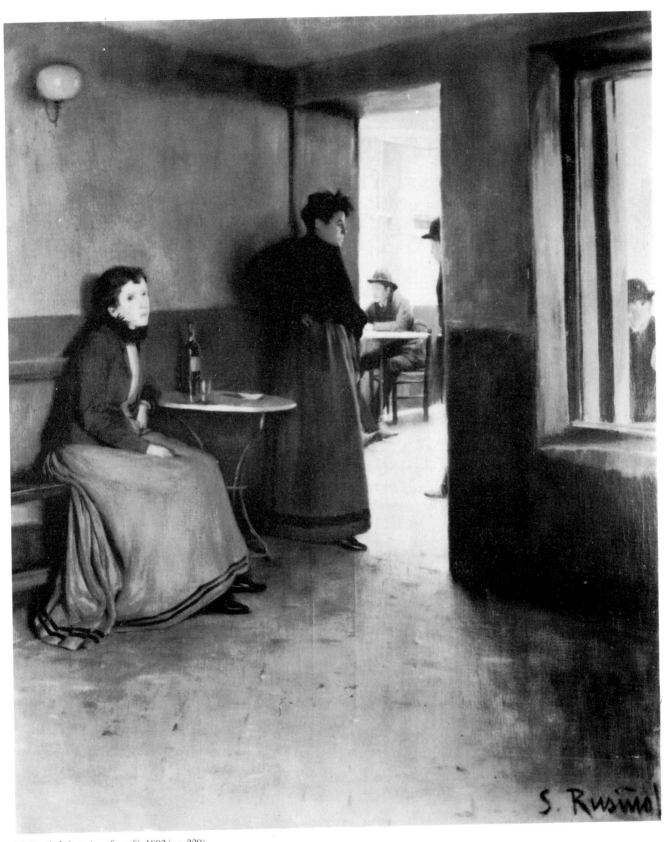

16. Rusiñol. *Interior of a café*, 1892 (no. 229).
Oil on canvas, 100.3 × 81.9 cm.
John G. Johnson Collection at the Philadelphia Museum of Art.

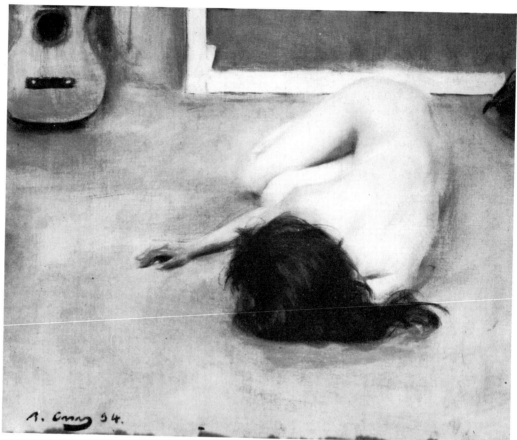

17. Casas. *Nude*, 1894 (no. 21).
Oil on canvas, 46 × 54.7 cm. Museu Cau Ferrat, Sitges.

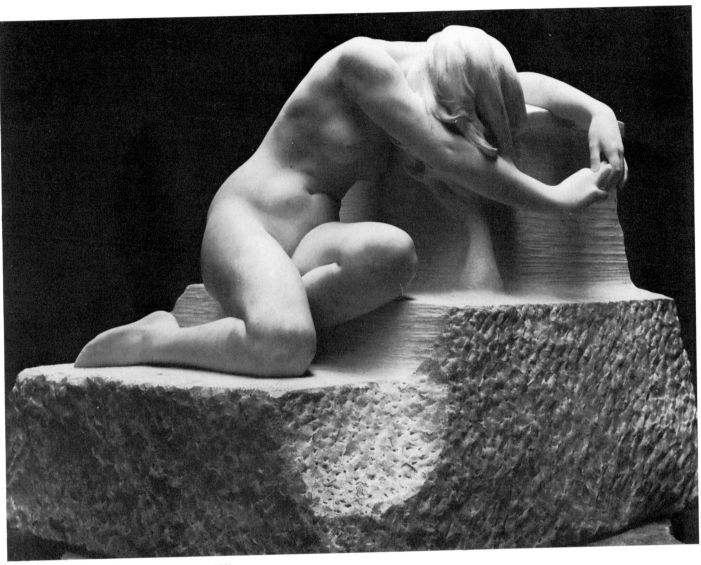

18. Josep Llimona. *Grief (Desconsol)*, 1907 (no.123).
Marble, 67 × 76 × 80 cm (third version). Museu d'Art Modern, Barcelona.

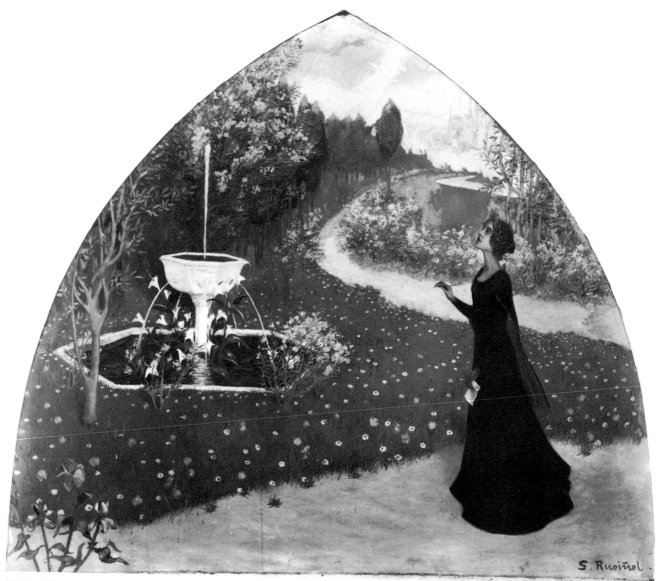

19. Rusiñol. *Poetry*, 1895 (no. 232).
Oil on canvas, 140 × 194 cm. Museu Cau Ferrat, Sitges.

impresario of *Modernisme*, thought by many to be the equivalent of pure decadence, but also the important role as leader (along with Casas) of the new *modernista* movement in Catalan painting.

In Rusiñol's painting there are two kinds of symbolist influence. One is the expression of psychological mood through form, colour and space, which characterises his Parisian work and his paintings of gardens around the turn of the century. Figures occupy the middle ground of his empty compositions, while foreground space is given equal attention. The result is a kind of ambiguous mood, where traditional narrative is given up for the idea of suggestion or of evoking psychological states. When he first began to exhibit his Parisian canvases in Barcelona Rusiñol was, in fact, criticised for these ambiguities – especially the almost incidental presence of figures – and for their overall grey tonality. The use of a thin layer of paint to unify the scene – sometimes grey or turquoise – derived not only from Rusiñol's earlier contact with Vayreda but also from the idea of symbolist suggestion through colour and Whistlerian atmosphere.

Secondly, there is the decorative style which Casellas in 1895 called 'pintura simbólico-decorativa', and this is best represented in the three allegories, *Painting*, *Poetry* (fig. 19) and *Music*, which Rusiñol painted for his 'temple' of art. In these three canvases Rusiñol employed a pale palette and linear style, which derives primarily from the copies he made while he was in Italy of fifteenth-century Italian painting (Botticelli in particular). They are given a kind of pseudo-religious setting in their pointed-arched frames, which were designed for specific places on the upper floor of the Cau Ferrat. There is a simplicity reminiscent of Puvis de Chavannes (an artist Rusiñol personally knew and admired) and a feeling for idyllic mood and something of Nabi ritual in the patterns of flowers and figures beyond, which again connects his work to French as well as English (Pre-Raphaelite) artistic currents. While for Rusiñol this decorative style never really went much further, as a kind of typical *fin-de-siècle* design it was taken up by other Catalan artists, and it appears often in the many decorative schemes executed in glass, ceramics or fresco after the turn of the century in *modernista* houses and public buildings.

Although the names of Rusiñol and Casas were linked from the very beginning as the leading exponents of *Modernisme*, there are fundamental differences in their work. Some of Casas's French canvases of the early nineties do indeed share many of the typically *modernista* characteristics associated with both artists. His use of empty foreground spaces and darkened interiors, for example, creates an unexplained atmosphere – not unlike Rusiñol's use of atmospheric colour – while indirect, subdued light can also contribute to the evocation of mood. However, Casas's work generally was much more strongly influenced by the training he had received earlier

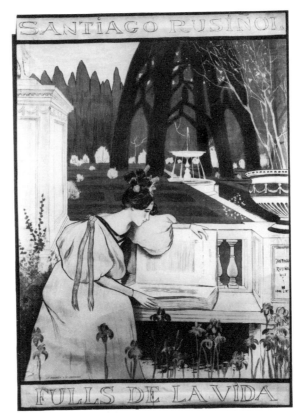

20. Rusiñol. *Fulls de la vida*, c.1898; poster (lithography by M. Utrillo) advertising his own book (no. 235). 102 × 72 cm. Museu d'Art Modern, Barcelona.

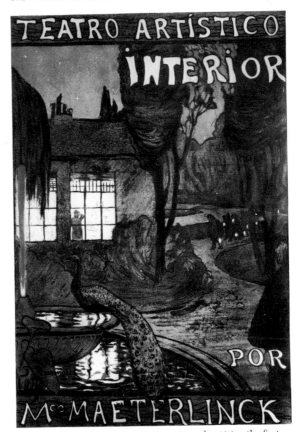

21. Rusiñol. *Teatro artístico*, 1900; poster advertising the first Catalan production of Maeterlinck's *Interior* (no. 236). 85.5 × 58.5 cm. Museu de les Arts de l'Espectacle, Barcelona.

in Paris in the studio of Carolus Duran and by his contact with the style of painting associated with Sargent, Zorn, De Nittis and the others who made up the foreign community of artists in Paris in the 1880s. The majority of his paintings, particularly his many portraits of fashionable women, are characterised by a general elegance of composition and bravura brushwork over a quite thinly painted background, while in his sometimes more adventurous depictions of Montmartre and café life, sharply tipped-up space or abruptly cut-off elements in the foreground are reminiscent of compositional effects and devices in the work of artists such as Degas.

linking each figure to the next he gave a collective character to the mass, so that individual anxiety is masked by the anonymity of the crowd.

Another work of political connotation, Casas's *La Carga*, or *Barcelona 1902* (fig. 22), which is his largest painting, is particularly impressive for its bold composition and suggestion of motion. Almost two thirds of the canvas is opened up, producing the sensation of the crowds being pushed back by the mounted police. Casas's depiction of the confrontation of government authority, conveyed by the proud mounted *Guardia*, and the workers – a fallen worker is painted in a startling foreshortened posture at

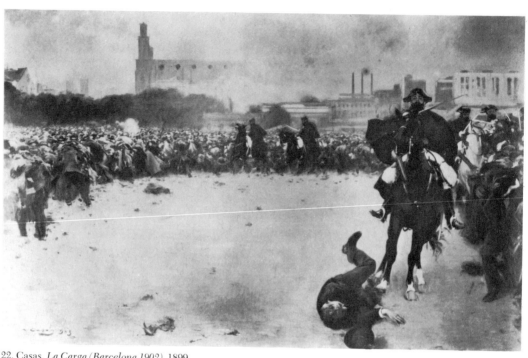

22. Casas. *La Carga (Barcelona 1902)*, 1899.
Oil on canvas, 298 × 470.5 cm. Museu d'Art Modern, Olot.

As an observer of modern life Casas did do a number of politically inspired works, which at the time they were exhibited actually caused public sensation. The most famous instance was the exhibition at the Sala Parés of *Garrote vil* (The Garroting, fig. 23) in 1894, when a spectator reportedly fainted upon seeing the chilling scene depicted on the relatively small canvas. In the composition, based upon an execution following the anarchist trials of the previous autumn, Casas chose to represent the circus-like spectacle of the awesome event. The foreground is crowded with a sea of heads of men and women, who are kept at a distance by mounted civil guards, separating them from the platform where the solitary condemned man awaits his executioners. Probably working from a photograph, Casas indicated the public clamour with rapid brushstrokes and loose application of paint, and by

the feet of the horse – was not based on any specific event, in spite of its title. Yet in the great tradition of monumental heroic works – and looking ahead to *Guernica* – the work achieves a kind of universal meaning through the power of the whole image.

One of the paradoxes of Casas is that he should have been doing these almost propagandistic paintings at the same time as he was doing portraits of so many of his bourgeois friends, members of his own social class. While there are only a small number of works which have an apparently strong political message, together with some drawings, they do represent a phase in Casas's work which is difficult to account for in the context of his Parisian canvases and society portraits, except as paintings of modern life. It may well be that at a time when his reputation as the leading Barcelona painter was unchallenged

23. Casas. *The Garroting (Garrote vil)*, 1894 (no. 20).
Oil on canvas, 127 × 166.2 cm. Museo Español de Arte Contemporáneo, Madrid.

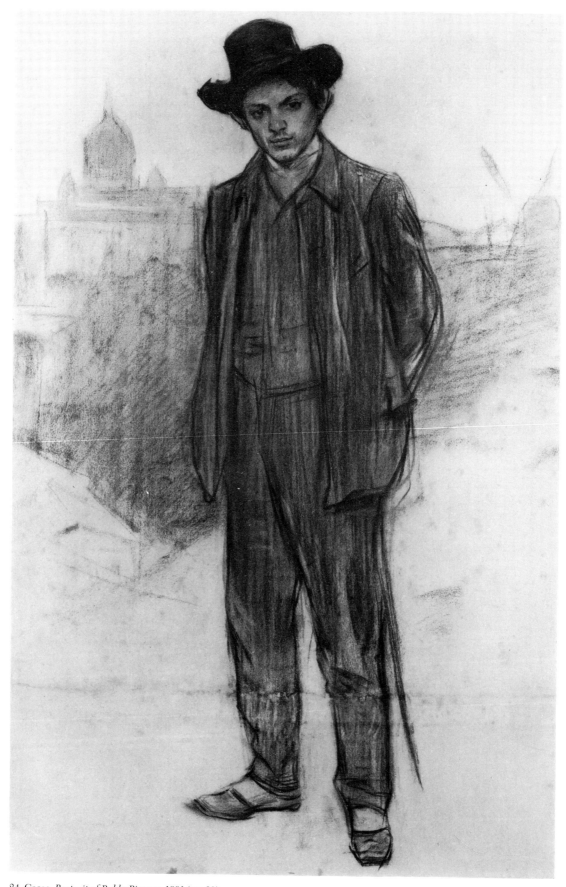

24. Casas. *Portrait of Pablo Picasso*, 1901 (no. 38).
Charcoal and conté crayon heightened with pastel on paper, 69 × 44.5 cm. Museu d'Art Modern, Barcelona.
This portrait was published in *Pèl & Ploma* no. 77 (June 1901) with Utrillo's article on Picasso.

he was looking to emulate Goya and to broaden the scope of his art. Whatever their origins or Casas's own political commitment, these few works manage to express political meaning in a tremendously powerful way.

Casas was also one of the two directors of the important illustrated art journal *Pèl & Ploma* (1899–1903) – Utrillo concerned himself with the literary side while Casas looked after artistic direction. The journal was devoted to essays on specific artists (foreign and Catalan alike), to news of artistic events, such as the 1900 Paris Exposition Universelle, and to recent literature and musical events. Casas's many illustrations for covers (fig. 165) and articles in the journal show his inherent taste for elegant design and great facility for drawing to advantage. Moreover, a number of his splendid charcoal portraits of Catalan intellectuals, writers and artists – many of whom represented his own social world – also appeared on the pages of *Pèl & Ploma*. Taken together, these fine portraits (figs. 151–3 etc.), made both from life and from photographs, which run into some hundreds (132 were shown in the painter's retrospective exhibition at the Sala Parés in 1899), provide a unique record of the intellectual and artistic world of Barcelona during the period.

In the case of *modernista* graphic design generally, the international *Jugendstil* or *Art Nouveau* style was the most important source of influence on most Catalan graphic artists, although Casas's work is perhaps less affected by *Art Nouveau* than by his own fashionable painterly style. Certainly, in the area of advertising imagery, Casas was unsurpassed as a poster artist in Barcelona during the *modernista* period. But with new techniques of colour lithography, which were quickly taken up by Barcelona printers, many young artists produced posters and other printed imagery in a great flurry of activity, which paralleled the prolific graphic production in the nineties in cities such as Paris and London. Casas not only represented for Barcelona artists a link with European trends in both painting and graphic design, but he was also someone who, together with Rusiñol, had opened the doors to a new direction in the arts at the turn of the century.

Picasso and Els Quatre Gats

It was left to the second generation of *modernista* artists in Barcelona to revolutionise painterly form. Many of them, like Isidre Nonell or the young Andalusian outsider Pablo Picasso, came from a social class a rung lower than their mentors, but they spent their time at music halls and cafés, such as Els Quatre Gats and Eden Concert, playing at a kind of bohemian life which the older artists had known first hand in Paris. The tavern Els Quatre Gats (The Four Cats), which opened in 1897, was, in fact, a joint effort of the older generation, principally of Rusiñol, Casas, Utrillo and the colourful Pere Romeu. All four of them were Montmartre enthusiasts and had themselves taken a lively part in bohemian café life there since the

25. Casas. *Rusiñol seated on an iron lamp*, c.1895 (no. 23). Oil on canvas, 200 × 100 cm. Museu Cau Ferrat, Sitges.

26. Casas. *Self-portrait*, 1908 (no. 43). Charcoal and pastel on paper, 55 × 42 cm. Museu d'Art Modern, Barcelona.

27. Ramon Pichot. *Maria Gay singing* (design for a poster advertising one of her concerts at the Sala Parés), 1900. Pencil on paper, dimensions unknown.

28. Gargallo. *Leda, c.*1903 (no. 82). Marble, 25 × 26.2 × 18.5 cm. Private collection.

1880s. Rusiñol (who was a devotee of the Divan Japonais), Casas and Utrillo had actually lived above the famous Moulin de la Galette dance-hall.

Miquel Utrillo had gone to Paris in 1880 as a young engineering student but soon became involved in the circle of artists who regularly gathered at Rodolphe Salis's Chat Noir, where he met the artist and model Suzanne Valadon. (Her son, Maurice, born in 1884 – in due course to become the well-known painter – was later recognised by Utrillo as his own and thereafter took his name.) At Salis's establishment Utrillo not only acquired a taste for a life in the arts (he soon gave up his engineering career), but he also learned the art of shadow-puppet theatre, then the vogue in Montmartre cafés. In 1891 he set up his own puppet theatre, in which he experimented with coloured light and movement, at the Auberge du Clou, where the pianist was none other than Erik Satie. Two years later, Utrillo and Romeu joined Mârot's troupe of puppeteers, *Les Ombres Parisiennes*, and went to Chicago to present the little experimental theatre at the World's Columbian Exposition. When the feature was introduced, certainly at Utrillo's instigation, as *sombres artístiques* at Els Quatre Gats in Barcelona in December 1897, he gave an inaugural speech explaining the history of the theatre, entitled 'La sombra arqueològica, l'éléphant'. The serious but humorous character of the enterprise proved to be an important way of introducing the ideas of avant-garde experimentation to a Catalan audience.

Pere Romeu, who apparently had begun as a painter in Catalonia, seems to have arrived in France some time in the mid-1880s, and he too was attracted to the world of Montmartre, to the Chat Noir and especially to the personality of Aristide Bruant, the *cabaretier* of Le Mirliton. In fact, Romeu's own style at Els Quatre Gats, not only in attire – a long waistcoat and flat-brimmed hat – but also as a bohemian spirit, owed much to the notorious Bruant.

When Els Quatre Gats opened in July 1897, the Casa Martí building on Carrer Montsió designed by Puig i Cadafalch, which housed the café on the ground floor, provided quite a suitable *modernista* setting for the new venture. Paintings by Rusiñol and Casas were hung on the walls, including Casas's mural-sized canvas showing himself and Romeu riding through Barcelona on a tandem (fig. 163; this was replaced after 1900 with a similar-sized work showing the two in an automobile). Popular as well as *modernista* ceramics filled the walls and table tops, along with Puig's Neo-Gothic designs in furniture, light fixtures, floors and ceilings. The main room – *gran saló* – was utilised over the years for a variety of purposes (in addition to eating, drinking and conversations late into the night) which ranged from painting and drawing exhibitions, poetry recitations and musical performances to meetings of various groups, such as the newly-formed Wagnerian Society (1901) or the Print and Postcard

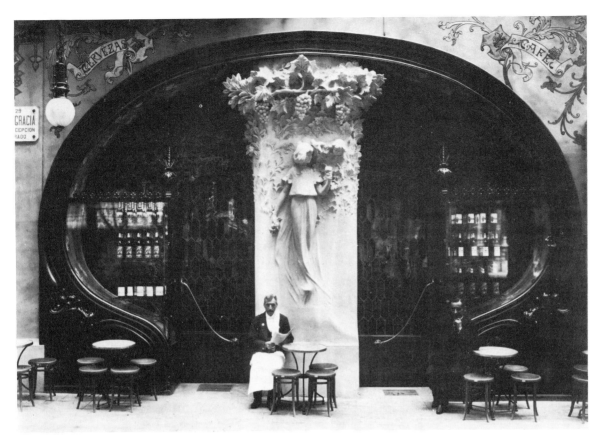

29. Cafè Torino on Passeig de Gràcia, 1902, designed by Ricard de Capmany,
with sculpture by Dídac Massana and Buzzi; photographed c.1905.

30. Interior of Els Quatre Gats in the Casa Martí; photographed c.1899.

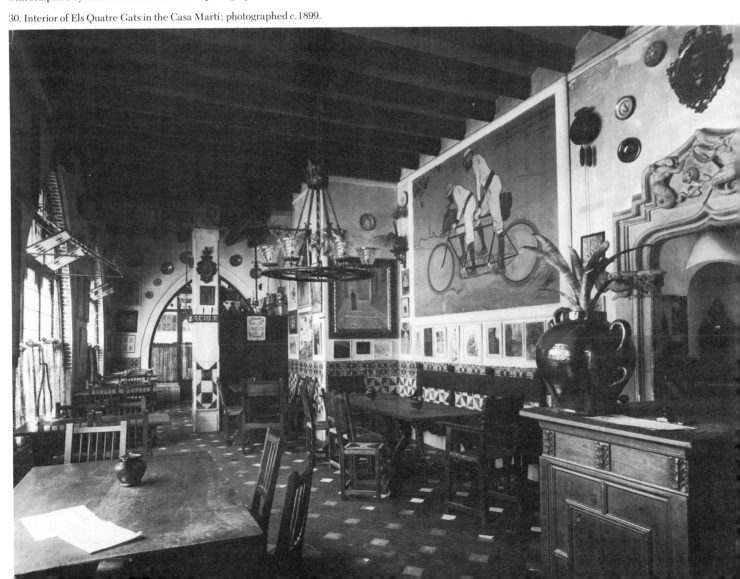

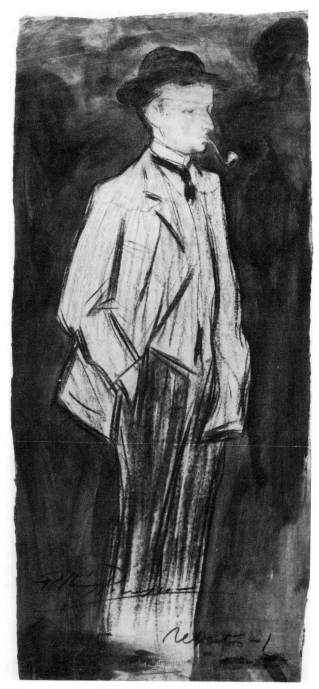

31. Picasso. *Portrait of the writer Ramon Reventós*,
1899–1900 (no.194).
Charcoal, conté crayon and watercolour on paper, 66.5 × 30.1cm.
Museu Picasso, Barcelona.

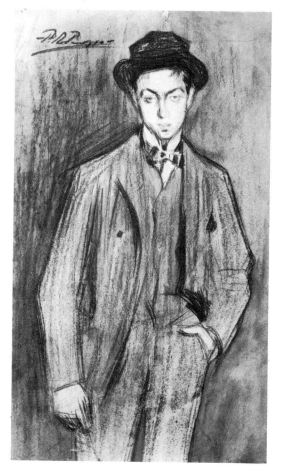

32. Picasso. *Portrait of the photographer
Joan Vidal i Ventosa*, 1899–1900 (no.193).
Charcoal and watercolour mixed with coffee
on paper, 47 × 27 cm. Museu Picasso, Barcelona.

33. Picasso. *Portrait of Rusiñol*, *c*.1900 (no.192).
Charcoal and watercolour on paper, 33 × 23 cm.
Collection Francisco Godia Sales, Barcelona.

34. Nonell. *Two gypsy women*, 1903 (no.168).
Oil on canvas, 136 × 136 cm. Museu d'Art Modern, Barcelona.

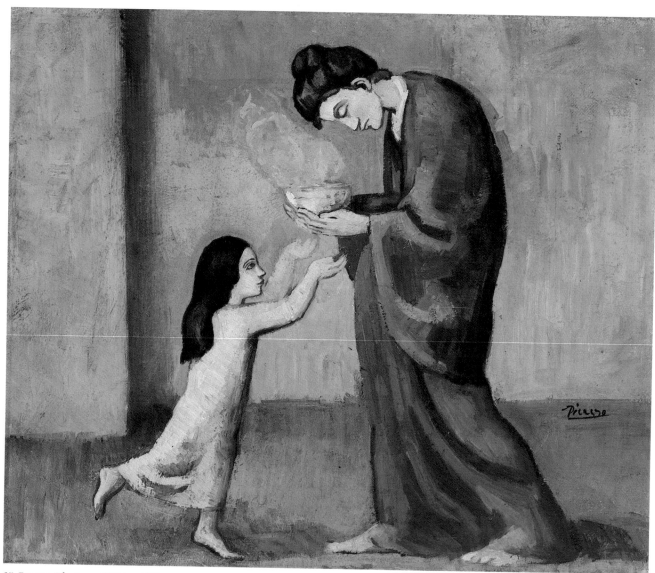

35. Picasso. *The Soup*, 1902 (no. 182).
Oil on canvas, 38.5 × 46 cm. Art Gallery of Ontario, Toronto,
Gift of Margaret Dunlap Crang, 1983.

Collectors Group (1902). Two of the special features at the café were the *sombres artístiques* – which involved poets, musicians and artists in their production – and the children's puppet theatre *Putxinel.lis* (run by Juli Pi with the assistance for a time of the sculptor Manolo Hugué).

The café generated a certain amount of publication, including – aside from posters and menus – a little art journal, *Quatre Gats*, in 1899 (following the model of Le Chat Noir which had originated a journal under the same name as the cabaret more than a decade before). The various issues (fifteen appeared) featured covers by different artists (fig. 164); and the contents were aimed at covering artistic and literary events, especially those held at the tavern itself. *Quatre Gats* was succeeded later the same year by *Pèl & Ploma*, which was published from Casas's studio. The opportunity for artistic and literary collaboration which was encouraged at the café was to be an important feature of *modernista* activity for the younger generation throughout this period.

Exhibition opportunities for young artists at the turn of the century were fairly limited: there were the huge, official salons or, for the most promising, the chance to show at the most prestigious commercial gallery, the Sala Parés. The dealer Juan Bautista Parés had originally founded a small gallery in 1877, but he moved to a new larger location on Carrer Petritxol in 1884. During the nineties Rusiñol and Casas, along with the sculptor Clarasó, had in fact exhibited almost yearly at the gallery, which was also the location for occasional musical and theatrical performances, as well as an artistic *penya*, or regular club, of the more established Barcelona painters and sculptors. Works by foreign artists, such as Vogler in 1900, and two important foreign poster shows (1896, 1898) made the gallery the single most important exhibition space throughout the period.

The more informal setting of Els Quatre Gats gave Picasso, Nonell, Casagemas and many others among the younger group of *modernistes* an opportunity to tack their drawings up on the walls, or hang a few paintings alongside works by Rusiñol and Casas, and to hope for a favourable word in the press. In 1900 Picasso, for example, held two shows there, and in the first (February), which was given mixed reviews, he exhibited charcoal and coloured portraits of his friends – most of whom were artists and writers of the second generation of *modernistes* – as a kind of challenge to the older Casas. Despite the mixed reaction of the press, his role as artistic provocateur was well secured within the group, and soon afterwards he seems to have achieved a personal goal when one of his paintings was selected for the Spanish section of the 1900 Exposition Universelle in Paris.

Without a doubt the Paris exhibition was the biggest attraction of 1900 to Barcelona artists, and with the encouragement of Casas and Utrillo, who served as correspondents for the journal *Pèl & Ploma* and were sending

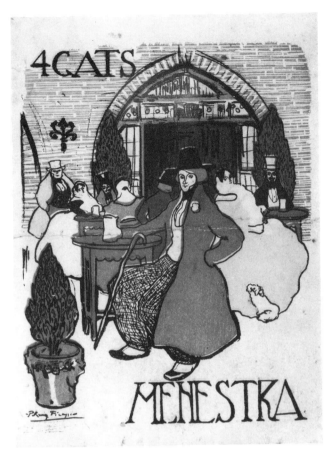

36. Picasso. Cover of menu from Els Quatre Gats, 1899–1900 (no. 200). Printed card, 21.8 × 32.8 cm. Museu Picasso, Barcelona.

37. Attributed to Picasso. Sign for Els Quatre Gats, *c.* 1899 (no. 201). Painted metal, 35 × 34 cm. Manuel Rocamora Foundation, Barcelona.

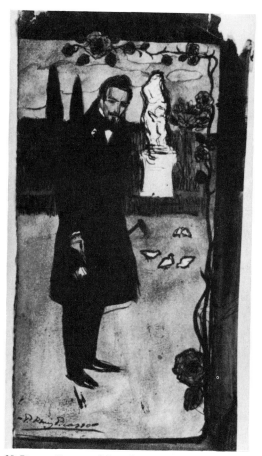

38. Picasso. *Portrait of the tailor Soler*, 1900 (no.195).
Gouache, ink, watercolour on paper, 22.2 × 10.8 cm.
Private collection.

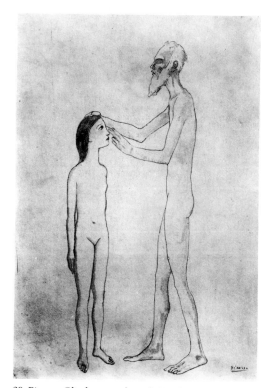

39. Picasso. *Blind man and a girl*, 1904 (no.198).
Ink and watercolour on paper, 46 × 31 cm.
Collection Max G. Bollag, Zurich.

back glowing letters describing the event, many of the younger artists followed the example of their mentors and went to Paris. Picasso and his friend the poet-painter Carles Casagemas went together in October and quickly established themselves in the Catalan community there, moving into a studio which Nonell and Ricard Canals had been using prior to their arrival. The stories of their adventures and their successes and failures are many, but the artistic significance of the journey for Picasso was to bring about a true revolution in painterly form.

In many ways Picasso's early development as an artist can be considered very much in the mode of a Barcelona *modernista*: his canvases often depicted café life and street people, and he concerned himself increasingly with the expression of subject or mood through colour and form. But in Picasso's case, and to some extent the same can be said for Nonell, not only were these basically *modernista* ideas enriched by their exposure to painting seen in Paris – Nonell had exhibited in the nineties at Le Barc de Boutteville in the company of artists such as Gauguin, and at the time of the 1900 exhibition Picasso was attracted especially to Van Gogh, Munch and Toulouse Lautrec – but the new generation which they represented naturally produced a different view of the world from that of their predecessors.

As stated earlier, the second generation of *modernistes* generally came from a lower social class than their bourgeois mentors. Picasso's father, for instance, was neither Catalan nor upper middle-class (no matter how much he longed to be), rather he was an Andalusian drawing professor at the local art academy; and Nonell's family ran a small pasta shop. The two artists' depictions of the lonely street people, prostitutes and gypsies during the early years of this century convey not only their sympathy with an underprivileged class but also their response to the impact of the changing social structure of the growing city.

The subject of people who lived on the margins of society was powerfully communicated in the moving canvases of Picasso's so-called Blue Period between 1901 and 1904, a period he spent both in Paris and in Barcelona. In many of these works Picasso chose the subject of women (sometimes with children) who lived on the street as society's cast-outs (figs. 35, 40). Their loneliness is expressed not only by the use of a dark, restricted palette but also in the spatial tensions which seem to trap his figures into shallow corners. Withdrawn, self-absorbed creatures are often contained within the overall contours Picasso creates and in this way they exist apart from us in a modern world of alienation.

In other works of the Blue Period Picasso dealt with the subject of beggars, street musicians or blind men (figs. 39, 43), who occupy empty settings which sometimes, because of a kind of haunting light, recall the mystical light of paintings by El Greco, the artist who was so

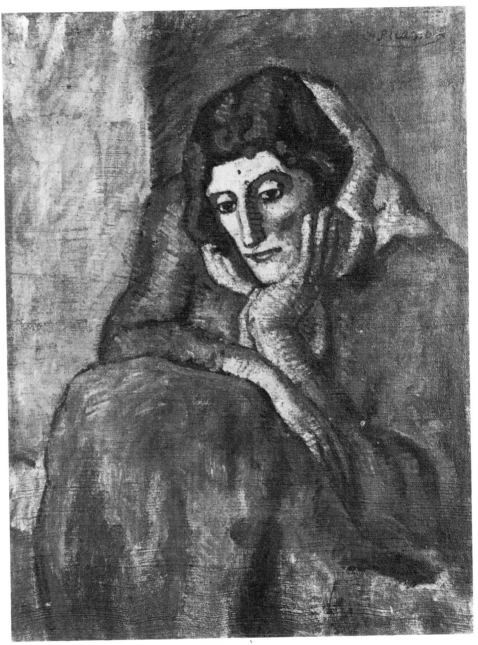

40. Picasso. *Crouching woman, meditating*, 1902 (no. 180).
Oil on canvas, 63.5 × 50 cm. Private collection.

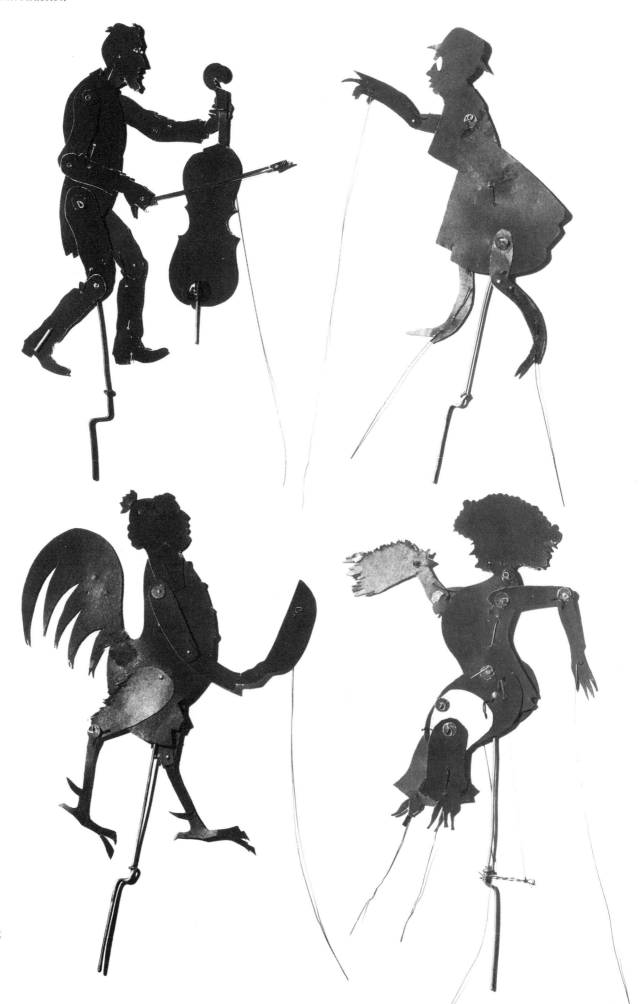

41. Attributed to Meifrèn. Four shadow puppets, *c.*1897, from
Els Quatre Gats: caricatures of a cellist and another local figure,
'Mossèn Pollastre' and a woman with heaving breast (no.137).
Black card, metal rods and wire, h: appox. 20 cm.
Collection Carolina Meifrén de Jimenez.

42. Puppet theatre at Els Quatre Gats with its painting by Miquel
Utrillo showing the glove puppets that featured in the children's puppet
show *Putxinel.lis* (advertised on the handbill to the left of the stage);
the tiles below the stage, designed by Casas, show the head of Romeu
and four cats – an image that was used in printed advertisements and
on the tavern's beer mugs; photographed *c.*1899.

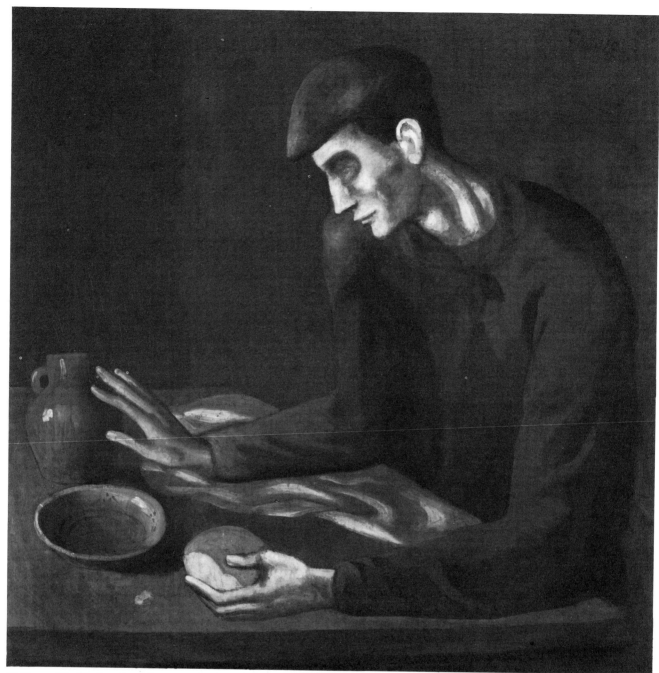

43. Picasso. *The Blind man's meal*, 1903 (no. 183).
Oil on canvas, 95.3 × 94.6 cm. The Metropolitan Museum of Art, New York,
Gift of Mr and Mrs Ira Haupt, 1950.

admired by the first *modernistes*. But Picasso's 'beggar prophets' are the product of the new century, and their pathetic situations are given powerful expression through exaggerated forms and colour. Certainly what Picasso drew from Barcelona *Modernisme*, especially its symbolist character, and from Spanish art history is given new, contemporary meaning in a revolutionised form.

Nonell's devotion to the sub-culture of gypsies – also appreciated by *modernista* writers such as Vallmitjana – preoccupied him personally (he increasingly lived most of his time among them), and their marginal lives were given great dignity in his canvases (figs. 34, 46). His limited, fairly dark palette and thick, impasto brushstroke produce figures of striking beauty. Theirs is not a pathetic kind of isolation but a mysterious one.

Nonell also frequently contributed drawings for publication to various Catalan journals, including *Pèl & Ploma* and *Papitu*, and on occasion he produced works based upon experimental techniques. For example, he reportedly made a series of 'fried' drawings around 1898–1900, probably in the studio of Carles Casagemas, at a time when various artists (including Picasso) gathered there and not only discussed artistic theories but worked on new ideas together. These drawings were actually fried in heated olive oil to give qualities of ageing and texture to the paper itself (fig. 47).

Another painter of this circle who radicalised the techniques of *modernista* landscape painting was Joaquim Mir. Following the inspiration of the school of Olot, he and a few of his art academy friends, who included Nonell, Canals, Vallmitjana and Gual, formed a group in 1893 called the Colla de Sant Martí (or the Colla del Safrà) dedicated to outdoor painting. Attention to the effects of flickering light and the rapid brushwork which they introduced in their canvases led in Mir's work to a generally lush palette and loose brushwork that produced imaginative and often evocative views of nature. Mir eventually moved to Mallorca (he and Picasso had planned a trip there together in 1900 which never materialised), and there the dramatic coves of the coastline and rock formations gave him a rich source of material for the development of his mature style (fig. 161).

Noucentisme

Nonell's early death in 1911, commemorated by a gypsy burial procession, in many ways marked the end of the *modernista* period in painting, although with the breaking up of the group at Els Quatre Gats in 1903 and Picasso's final move to France in the following year, *modernista* artistic activity had already begun to decline. For Picasso, his artistic future lay in France, although his special connection with Barcelona and his formation there remained a constant source of pride to him throughout his life, but the goals he had as an artist needed wider horizons. Moreover, the artistic and intellectual climate

44. Picasso. *Portrait of Carles Casagemas*, 1899–1900 (no.179). Oil on canvas, 55 × 45 cm. Museu Picasso, Barcelona.

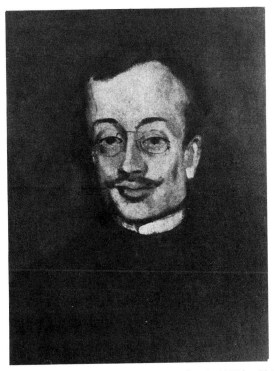

45. Picasso. *Portrait of the poet Jaume Sabartés*, 1904 (no.184). Oil on canvas, 49.5 × 38 cm. Private collection.

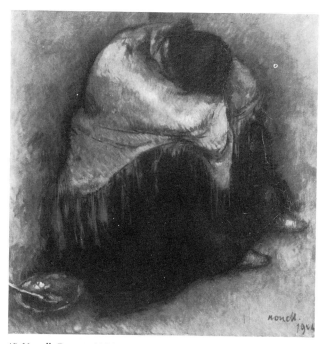

46. Nonell. *Repose*, 1904.
Oil on canvas, 120 × 120 cm. Museu d'Art Modern, Barcelona.

47. Nonell. *Seated woman, c.* 1899 (no. 171).
'Fried' drawing, 28 × 22.5 cm.
Collection Sr Antoni Argullol, Barcelona.

was changing in Catalonia, and new ideas on the political stage began to be reflected in the hands of artists and writers alike.

After the turn of the century the association of the arts with the broader cultural and political Catalanist movement continued, but the individualistic, sometimes Neo-Gothic or symbolist character of *modernista* art and architecture (as well as poetry and theatre) was succeeded by the idea of a return to order, especially in painting, sculpture and literature. A love of classical form and a renewed identification with Mediterranean tradition among artists and writers can be linked to a general, conservative 'return to order' in politics. The disillusionment with developments in the separatist movement – for example, the failure to embrace anarchist workers' movements – led to a revaluation of the Catalanists' goals and in general to a conservative political response.

Yet the artistic style that developed, which was called *Noucentisme*, and literally means 1900s style, was not just a regional expression, but a movement which can also be seen as part of the larger current of 'classicism' in the first part of this century in Europe, particularly in France. In the teens and twenties, Picasso, Matisse and Le Corbusier – to name only a few important examples – all shared in a search for a new twentieth-century form – not a reactionary or revival form, but one which expressed the new century, while still being based on classical ideals. The case of Picasso – to which we shall return – is a fascinating one, especially in connection with his Barcelona ties. For his six-month stay in the Catalan capital in 1917, following his first trip to Italy, resulted in a body of work which received important stimulation from the local *noucentista* art movement he found there.

A friend of Picasso's and one of the principal *noucentista* painters in Barcelona in the teens was Joaquim Sunyer, and his career provides an interesting example of an artist whose beginnings as a *modernista*, alternating residence between Barcelona and Paris, developed (as did Picasso's) into part of this new classical movement. Both Sunyer and Picasso had begun their careers as artists in similar fashion: first by rejecting the provincial academic training of the Barcelona art academy, and then associating with the second generation of *modernista* painters, such as Nonell and Mir, who had broken away from the academy and formed their own groups. Like Nonell, Sunyer left Barcelona for Paris in the nineties (in Sunyer's case in 1896), where he spent most of his time until the First World War; in fact, Sunyer was already in residence at the Bateau Lavoir when Picasso arrived there in 1904.

Sunyer's work of the turn-of-the-century years was principally devoted to the typically French and *modernista* subject of street and café life and was often done in the medium of pastel or occasionally prints. His source of inspiration in many instances was the contemporary drawing style of artists such as Steinlen and Forain.

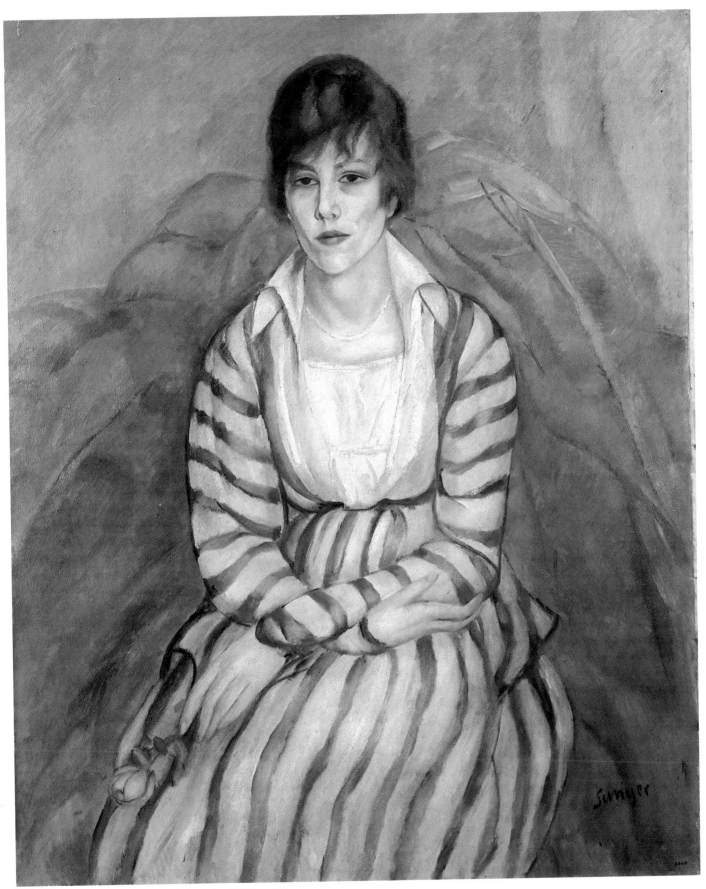

48. Sunyer. *Portrait of Maria Llimona de Carles*, 1917 (no. 250).
Oil on canvas, 100 × 81.5 cm. Museu d'Art Modern, Barcelona.

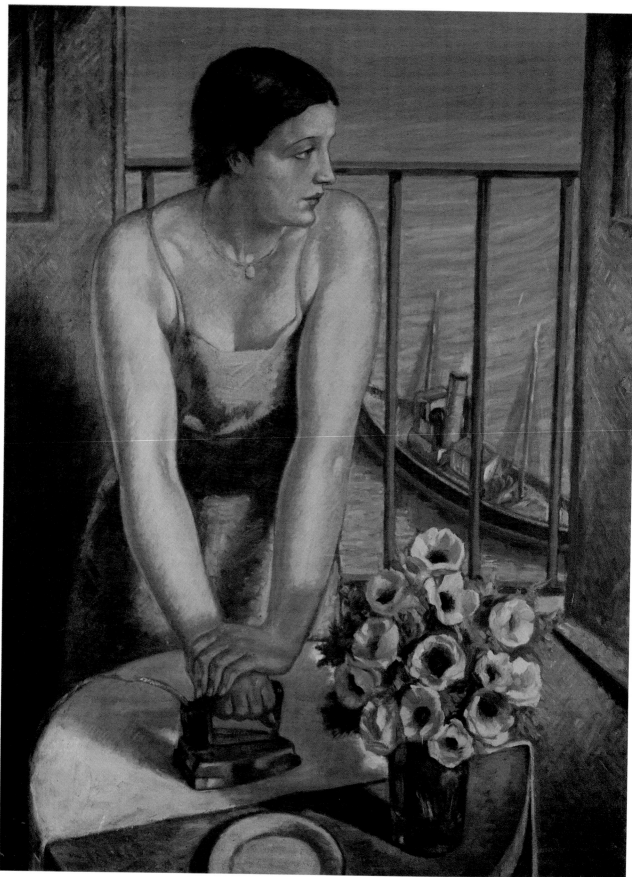

49. Galí. *Spring, c.* 1930 (no. 75).
Oil on canvas, 129 × 96 cm. Collection J.B. Cendrós, Barcelona.

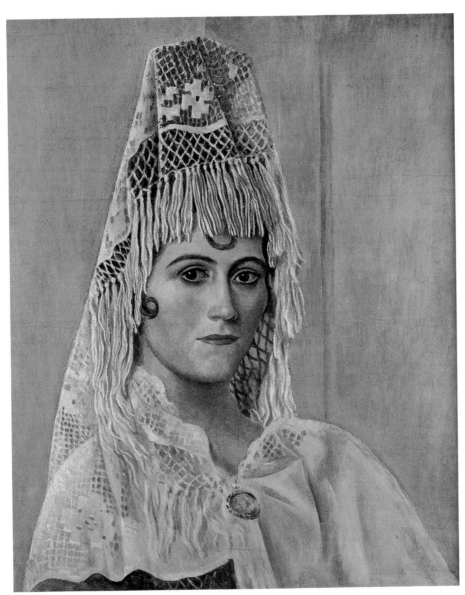

50. Picasso. *Olga in a mantilla*, 1917 (no. 188).
Oil on canvas, 64 × 53 cm. Private collection.

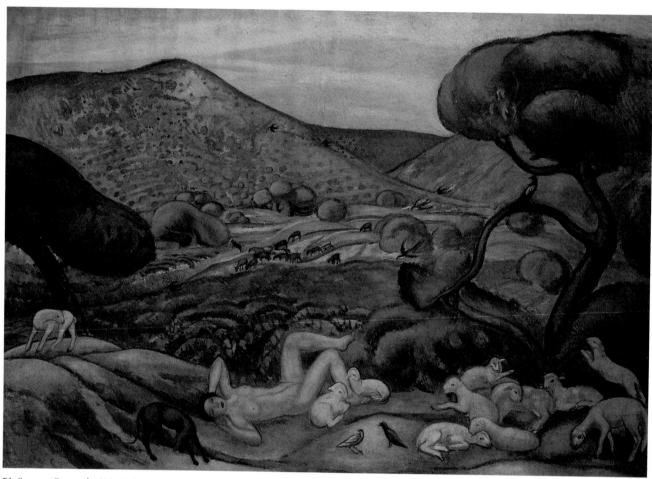

51. Sunyer. *Pastoral*, 1910–11 (no. 247).
Oil on canvas, 106 × 152 cm. Generalitat de Catalunya, Barcelona.

However, Sunyer became increasingly attracted to the canvases of Cézanne, especially after they were featured in the Salon d'Automne of 1904 and in the great retrospective of his work in 1907, the year after his death. While Picasso, who had by then essentially joined forces with Braque, saw in Cézanne the pictorial and perceptual problems that they had begun to tackle in their development of Cubism – itself a classical movement in the sense of a search for a new order – Sunyer responded to Cézanne's work in a manner which resulted in an attempt to give contemporary subjects expression in classical terms. To achieve this, Sunyer aimed to give a sense of harmony and structure both to the composition and to the forms, and to some degree to the nature of the brushwork itself.

Sunyer's shift in style essentially occurred around 1910–11 while he was still living in Paris, just at the time the idea of *Noucentisme* was gaining recognition as an artistic and literary movement in Barcelona. It was in 1911 that Eugeni d'Ors published the pieces that made up his novel *La ben plantada* (1912), which conveys the idea of the strength of Mediterranean tradition through the image of a woman. Moreover, in the same year he issued a celebrated publication, the *Almanach dels noucentistes* (fig. 175), with contributions by a whole range of writers (including Goethe as well as himself) and artists, such as Picasso, Gargallo and Torres García; but he failed to include Sunyer. Yet Sunyer's first major exhibition in Barcelona was held that same year in April at the Faianç Català, where his idyllic *Pastoral* (fig. 51) was admired by the great *modernista* poet Maragall (who died a few months later). Sunyer's landscapes particularly suggest a strong debt to Cézanne both in compositional structure and in the use of colour to create shifting planes. In subsequent years Sunyer made a great number of portraits of members of Barcelona bourgeois families (fig. 48), and these not only record the dominant level of society but also reflect its political and social attitudes in his *noucentista* style of painting.

One of the strongest expressions of *noucentista* art was in sculpture, a form in which classical references are obvious, and the use of the female nude parallels – and in part derives from – the Mediterranean image of Ors's *La ben plantada*. The sculptor Enric Casanovas, for instance, a great friend of Sunyer's, who like so many Barcelona artists had made various trips to Paris to become acquainted with the latest artistic developments, began as a *modernista* (his drawings were first exhibited at Els Quatre Gats in 1903). But in the teens he began to develop his personal approach to form – predominantly the female figure – which drew upon classical models for inspiration and at the same time reflected contemporary ideas about sculptural techniques. His treatment of the torso as a simplified columnar form (fig. 52) suggests the desire to purify form in a geometric, almost abstract, way, while the carving of the face and hair often echoes

the bold simplifications of primitive sculpture. In some instances Casanovas's busts even recall Picasso's paintings of 1906 and early 1907, themselves a response in part to Mediterranean or Iberian tradition.

The graphic style associated with *noucentista* art and publications also suggests an affinity with the sculptors' simplified classical approach. The floral, organic or arabesque line of *modernista* graphics is replaced by a bolder drawing style with greater emphasis on contour line and a tendency towards geometric typography. New journals which featured a new generation of writers began to appear in Barcelona during this period, and this again gave artists the opportunity to work with their literary counterparts in the development of a new style.

One of the most important of the new satirical journals to appear at the end of the first decade of the century in Barcelona was the Catalan-language weekly *Papitu*, which under the direction of Feliu Elias combined the best of contemporary cartoon drawing with political satire. His own cartoons, which he signed with the pseudonym Apa, were bold both in form and in political comment. Because of his own wide range of artistic interests and contacts, he invited a number of artists, including the young Juan Gris, to contribute to the journal in its first period of publication (1908–11), which is considered a high point in the history of Barcelona journals.

During this period and continuing until the thirties, Feliu Elias emerges as a kind of successor to Rusiñol (although he was a much more formal and cerebral individual), because of his varied and untiring activities in the arts and in the Catalan cultural world in general. As a young man, he followed the Barcelona pattern of living and working in Paris, where he contributed drawings to French journals such as *L'Assiette au Beurre*. There he became acquainted with many young artists as well as becoming a dedicated art historian. Elias also wrote art criticism under the name of Joan Sacs and in 1917 published an important study of modern French art, *La Pintura moderna francesa fins al cubisme*. (Later in that same year a fascinating letter from Robert and Sonia Delaunay to Sacs was printed in *Vell i Nou*, a journal Elias worked on in the teens, outlining the theoretical basis of *Simultanisme* in response to the book.)

Elias's own paintings of the twenties and thirties – such as *La Galeria* (fig. 65, which was exhibited at the 1929 International Exhibition) – are based on a firm commitment to the painting of reality. His sharply lit interiors heighten the realistic rendering of the various compositional elements and contribute to an overall unsettling mood. This is not unlike the sensation produced by the ultra-realistic depictions of surrealist artists of the twenties, such as Dalí, who admired Elias. In the portrait of his father (fig. 218), for example, Dalí used a kind of high-intensity lighting on the massive figure, which emphasises the rhythm of the folds of the jacket and accentuates the

strong facial features. But Elias's aims were much more in line with the Catalan tradition from which he emerged, and the enigmatic people and empty settings of his compositions recall the mood of many *modernista* paintings of the nineties, while the emphasis on realism and harmonious compositional structure derives from the *noucentistes*.

Barcelona galleries

After the demise of Els Quatre Gats in 1903, several new galleries had opened in Barcelona which offered comparable or alternative exhibition space to the official salons or to the well-established Sala Parés. We have already mentioned the Faianç Català, which had opened in 1909 as an expansion of a shop whose principal function had been to sell and exhibit work being produced in Sabadell at the ceramics studio of Marià Burguès. The gallery, run by Burguès's nephew Santiago Segura, not only featured the developing *noucentista* movement but also became a meeting-place for artists – the society Les Arts i els Artistes was formed here and held its first exhibition in 1910 – and a centre for the promotion of high-quality illustrated journals such as *Papitu* (first series 1908–11), *Picarol* (1912) *Revista Nova* (1914 and 1916) and *Vell i Nou* (1915–21).

In 1915 Faianç Català moved and was given a new name, Galeries Laietanes, and was now solely dedicated to the sale of works of art. The cellar of the galleries, where artists and their friends could foregather, was decorated with a series of frescoes by the popular *noucentista* artist Xavier Nogués (figs. 183–4), while the exhibitions held there featured the recent work of local artists in addition to group shows; the first Saló de Tardor (Autumn Salon), in 1918, included Anglada Camarasa, the sculptor Clarà, Picasso, Mir, the painter Josep Maria Sert and Sunyer. A second Saló de Tardor was held there in 1920 and featured members of the association of Amics de les Arts, the so-called *Evolucionistes*, representatives from the Cercle Artístic de Sant Lluc, the association Nou Ambient and a number of independents.

Another commercial gallery, opened in 1907 by the former Quatre Gats painter turned art-dealer Josep Dalmau, was his Galeries Dalmau. His first shows at the gallery represented foreign artists as well as the work of the second generation of *modernistes* (Nonell was one of the first artists he showed), and these were later followed by representatives of the developing *noucentista* movement. Dalmau was well acquainted with this artistic direction, because of his friendships among artists, notably the Uruguayan-born painter Torres García, who advised him on exhibitions for some years.

Torres García (who had started as a *modernista* painter and illustrator in Barcelona) began to show at Dalmau's in 1910, first as a leading *noucentista* with works inspired principally by Puvis de Chavannes. He received com-

missions from the Catalan authorities to do important mural decorations for the Generalitat, but despite his success in this style, he made a radical change in his work around 1916–17, when he and his fellow Uruguayan artist Rafael Barradas (also in residence in Barcelona at that time) articulated both in their work and in a manifesto (published in *Un Enemic del Poble*) a new form they named *Vibracionisme*, which was principally inspired by Italian Futurism. Their aim was to convey a dynamic view of urban life through fragmentation of forms and colours; the use of lettering and numbers was included to suggest sound, motion and something like cinematic vision.

Dalmau also played an important early role in the introduction of many of the latest international artistic currents to the Barcelona public, which, curiously, proved a fairly receptive audience in spite of the conservative bourgeoisie which made up so much of its art world. Part of the reason for this open attitude towards recent art (which began in the *modernista* period) lay in the willingness to incorporate what was new into the general cultural movement as a way of asserting Catalan separatism. Dalmau's first major exhibition of new art to test the bourgeois milieu of *noucentista* Barcelona was held in 1912.

In March of that year Dalmau had travelled to Paris to see the Salon des Indépendants. He was much impressed with the work of the Cubists, meeting a number of artists, including Marcel Duchamp, and he decided to bring back a selection of their work for an exhibition in Barcelona. The Exposició d'Art Cubista at Dalmau's, held the following month, has become almost legendary because in it he showed Duchamp's *Nude descending a staircase* for the first time. The work was commented upon in the press by several critics – notably the *noucentista* writer Eugeni d'Ors, who described the French artist as 'a sad case' whose attempt to convey movement led to monstrous results (*La Veu de Catalunya*, 27 and 29 April 1912). But as Duchamp himself remembered it, the painting actually caused little of the controversy it later raised in both Paris and New York. Instead, the Catalans, in spite of a reluctance on their part to buy the works (reportedly none sold), accepted Cubism, much as they had accepted symbolist art some years earlier, as a recent artistic manifestation which could be incorporated into the local style.

The war years

During the First World War Barcelona was turned into a temporary residence (because of Spain's neutral position) for a number of artist-exiles, who gravitated towards Dalmau and his support of the avant garde. There were several Russians who turned up during this time, most of whom had little if any political involvement in the revolutionary activities occurring in their homeland. The cubist painter Serge Charchoune and his wife the sculptor Hélène

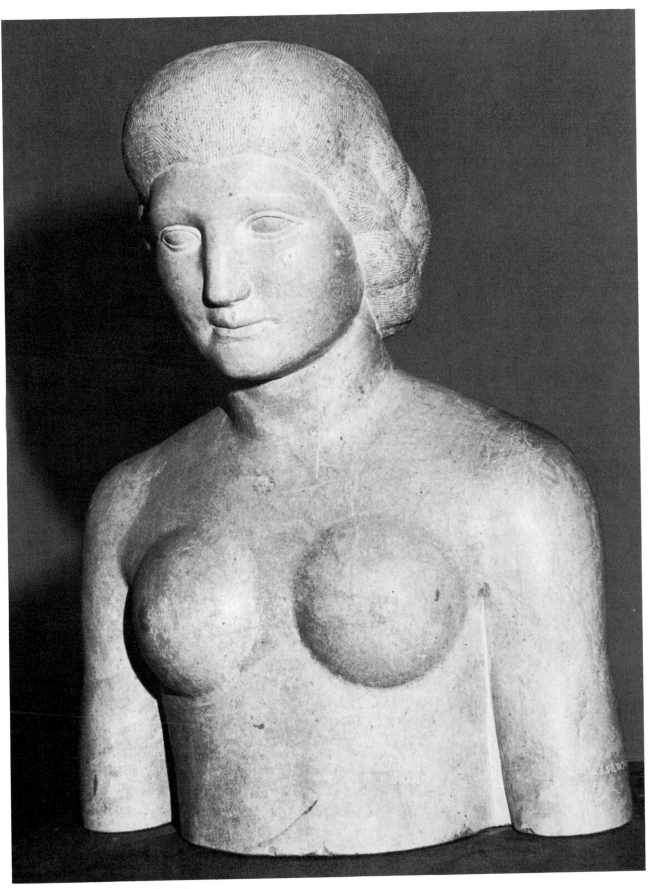

52. Casanovas. *Youth, c.*1917–18 (no.16).
Marble, 58 × 45 × 19 cm. Museu Municipal d'Art, Valls.

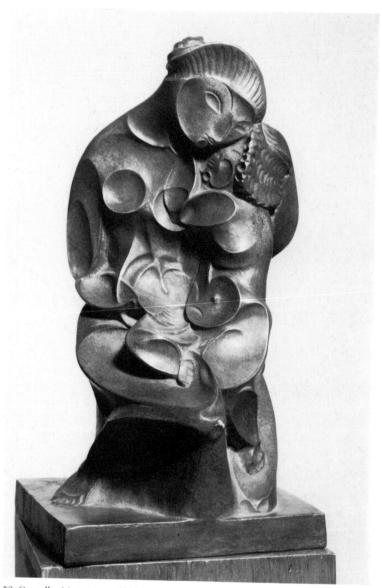

53. Gargallo. *Maternity, c.*1922 (no. 85).
Terracotta, 29 × 15 × 15 cm. Museu d'Art Modern, Barcelona.

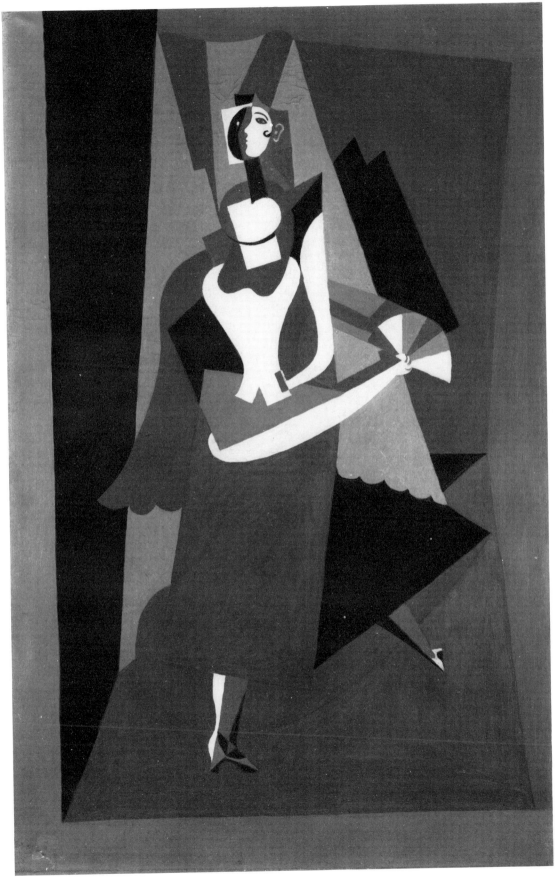

54. Picasso. *Blanquita Suárez*, 1917 (no. 187).
Oil on canvas, 73.3 × 47 cm. Museu Picasso, Barcelona.
Suárez was a celebrated operetta singer in Barcelona.

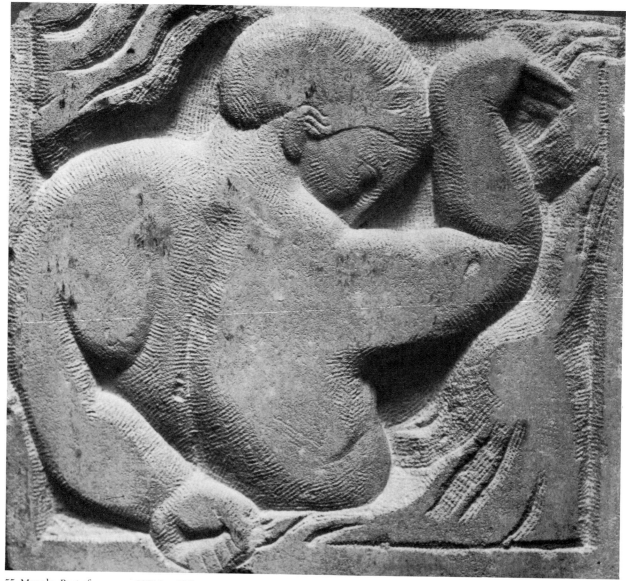

55. Manolo. *Bust of a woman*, 1922 (no. 132).
Stone relief, 55 × 62 cm. Galerie Louise Leiris, Paris.

Grunhoff were there, and their first joint exhibition was held at Dalmau's in April–May 1916. Sonia Terk and her French husband Robert Delaunay were also there for a short time in 1916 – long enough to have a joint exhibition at Dalmau's in early April. She was also a friend of Diaghilev and apparently entertained him and others from the Russian Ballet in Sitges.

The Russian Ballet had first gone to Madrid at the instigation of Diaghilev's friend King Alfonso XIII, and they had toured a number of cities in Spain. In 1917 they presented their new collaborative effort, *Parade*, to the King, primarily because the sets had been done by a Spanish artist – Picasso. The King apparently was amused, and the work had little of the shocking effect in Madrid that it had had for a war-torn Parisian audience earlier that year. *Parade* was brought to Barcelona in 1917 and performed once (in November, although the Russian Ballet had also been there in June) at the Liceu – certainly not an avant-garde locale – but its production there does seem to have made an impression on young Catalan artists, including Miró.

Another Russian painter, Olga Sackaroff, arrived in Barcelona in mid-1916, although she had already been in Catalonia (first in Mallorca and then in Tossa) since the previous year. She was with her Swiss-born English husband Otho St Clair Lloyd. His brother, Fabian Avenarius Lloyd, better known as Arthur Cravan, also arrived: apparently he had travelled across several European borders without a passport, disguised as a soldier, in order to get to Spain and avoid being drafted. Cravan had already won a notorious reputation as a poet-boxer and art critic in Paris, where he had published a little review called *Maintenant* from 1912 to 1915, in which he spoke out against artists he did not like. On the occasion of the 1914 Indépendants exhibition his attack on Marie Laurencin was so aggressive that Apollinaire, her protector, had challenged him to a duel (which was cancelled after Cravan apologised); and for a similar attack on Sonia Terk Delaunay, who took him to court, he ended up in prison for eight days. While in Barcelona Cravan worked principally as a boxing promoter, and if he contributed to artistic activities at all it was most likely to the aggressive spirit of Francis Picabia's journal *391*, the first four numbers of which were produced from Dalmau's gallery in 1917.

Picabia and his wife Gabrielle Buffet had arrived in August 1916, and by that time they found the exile colony already fairly well-established. Marie Laurencin, who became Picabia's constant companion in Barcelona, had come (because of her German husband, the painter-poet Otto van Watjen), and so had Albert and Juliette Gleizes, whose large apartment was often a social gathering place for the group. Gabrielle Buffet-Picabia recalled the insularity of the 'little nostalgic, uprooted group . . . who met every day at the café on the Rambla and dined at

56. Picabia and friends on the beach, 1916: (standing left to right) Picabia, Juliette Gleizes, Otto van Watjen, Marie Laurencin, Gabrielle Buffet, Olga Sackaroff; (seated) Albert Gleizes, Dagmar Monat (Sackaroff's best friend) and Béla and Andrée Szilard (no. 263). Original snapshot by Otho St Clair Lloyd. Private collection.

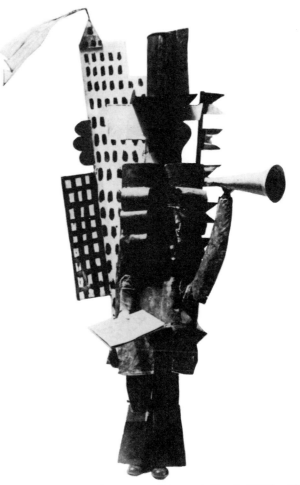

57. Picasso. Costume for American Manager in *Parade*, 1917 (no. 202). Paint on cardboard and other materials (reconstructed 1979), 339 × 244 × 113 cm. The Museum of Modern Art, New York.

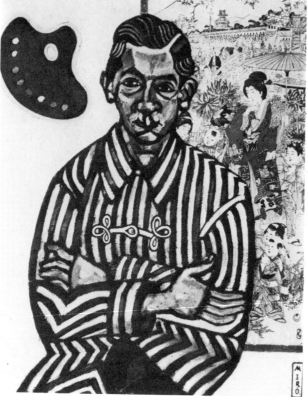

58. Miró. *Portrait of E.C. Ricart*, 1917.
Oil and printed paper on canvas, 81 × 65 cm. Private collection.

each other's lodgings' and, for distraction, 'went in for Spanish cooking'.

In addition to showing their work at Dalmau's, the artist exiles did collaborate on some of the Barcelona experimental journals that appeared during this period. Josep Junoy, the artist, critic and poet, produced a journal called *Troços* (one unnumbered issue in 1916 and a series in 1917–18, with the last two numbers spelt *Trossos*), in which the illustrations and texts suggest both actual contact between foreign and local artists and also the impact of foreign artistic tendencies on Catalan work. For example, issue no. 1 included experimental poetry and music by Junoy, which was inspired by Grunhoff and Charchoune's exhibition. Junoy's tribute to Grunhoff's sculpture *Jongleurs*, in particular, suggests not only the influence of Apollinaire's *calligrammes* but also the notion of 'psychotype' in the expressive arrangement of typography. The words to Junoy's music in the piece inspired by Charchoune's paintings describe the geometric structures and colours of the canvases, and the music itself suggests a formal agitation.

In the final numbers of *Trossos*, works by the young Catalans Joan Miró and Enric Cristòfor Ricart were also included, and in these, especially in the case of Miró, we see perhaps the best of the local absorption of outside artistic influences in the initial stages of a new form. In issue no.4, March 1918, a drawing by Miró (after a pastel of 1917, fig. 204) appeared facing a brief notice concerning his first exhibition in February–March at the Galeries Dalmau, in which Junoy (who undoubtedly wrote the notice) proclaimed Miró's work as a new form arising essentially from a Catalan base: '[Miró's works] attempt to awaken a new sensibility and to initiate a triumphal march towards a new classicism – the nerves or strength of the *noucentistes* and the blood of the future – we at *Trossos* claim him as one of ours.'

There is certainly a way in which Miró's early paintings – both the landscapes and portraits – are related to Sunyer's *noucentista* canvases derived from Cézanne, although the devices of shifting colour planes (inspired by the Delaunays' *Simultanisme*) and the rendering of space essentially through colour are much more radical. An interesting feature of the most recent works was his inclusion of representational forms which were both highly personal and specifically Catalan references; yet with their generally two-dimensional character these elements actually function more like cubist notations in abstract surroundings, and because of this Miró's work can be seen as a significant new departure.

Miró's great friend Ricart, who showed at Dalmau's for the first time in 1917, was also influenced by the Cubists, especially in the use of fractured forms and rhythmic spatial relationships (fig. 214). Curvilinear element (vases, glasses, fruit for instance) echo each other and set up repeated rhythms, which find a counter-

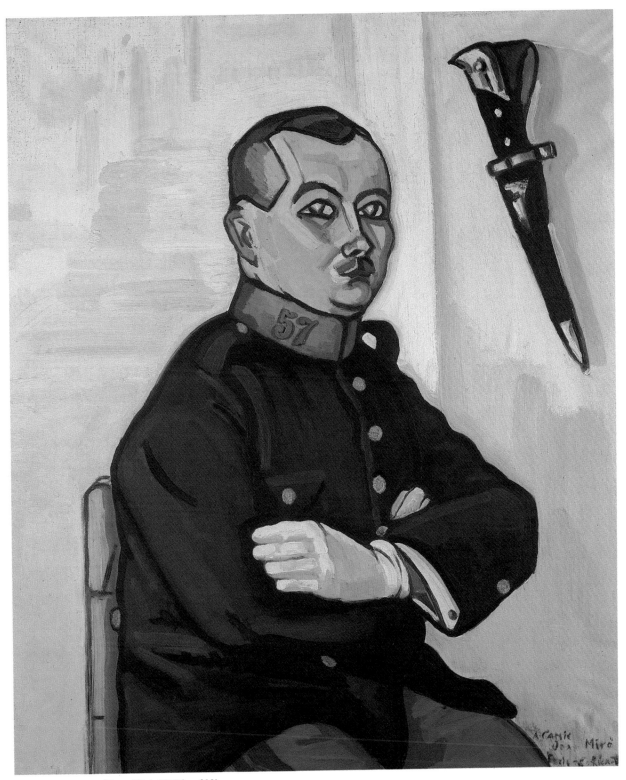

59. Ricart. *Portrait of Joan Miró*, 1916 (no. 219).
Oil on canvas with metal numbers, 84 × 71 cm.
Fundació Joan Miró, Barcelona.

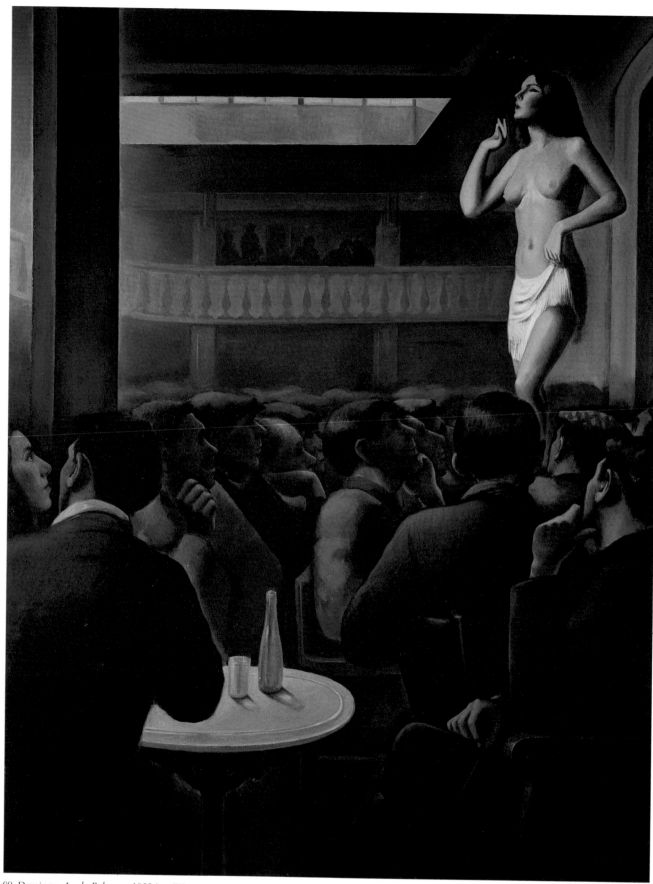

60. Domingo. *Apolo Palace*, *c*.1933 (no.71).
Oil on canvas, 146 × 113 cm. Collection J.B. Cendrós, Barcelona.

part in angular elements. But the use of colour and heavy outlining are closer to the playful and colourful formal rhythms of the works of his studio-companion Miró.

In 1918 Miró and Ricart made portraits of each other (figs. 58, 59), and in these remarkable works they combined collage elements with oil on canvas. In Ricart's portrait of Miró, he depicted his friend in his military uniform and used the metal numbers from the real uniform on the collar, while Miró painted Ricart in front of an actual Japanese print. Both artists at this point were also experimenting with the use of intense colour and pattern to create form; these two works suggest not only great sympathy between two painters sharing a studio, but also that they were working on very similar problems. The tendency in Ricart's work towards the decorative and linear developed into a particularly rich graphic style, which was to characterise much *noucentista* graphic design of the twenties and thirties with Ricart as one of its leading exponents (fig. 285). The case of Miró, of course, is quite different, and it was through his contacts in France (beginning in 1919), with Picasso and, later, the Surrealists, that he went on to develop his characteristic and personal form of Surrealism.

Before moving on to other artistic developments of the late teens and twenties, the return of Picasso to Barcelona in 1917 should also be mentioned. Although he had returned to Catalonia on a couple of occasions (most recently in 1910 when he was in Cadaqués) since his permanent move to Paris, his six-month stay, which more or less coincided with the presence of the Russian Ballet, was a different matter, because by now he was considered famous and was treated as something of a visiting celebrity. His principal reason for coming (in addition to seeing his sets and costumes set up and installed for *Parade*) seems to have been the presence in the troupe of Olga Khoklova, the Russian dancer he was to introduce to his family on this visit and to marry the following year. Her portrait in a Spanish mantilla, made during his Barcelona stay (fig. 50), is not only a 'realistic' tribute to her beauty but formally arises from a flirtation, beginning in 1915, with a graphic style which both reflects his admiration for the work of Ingres and betrays a new classicism in his work.

Picasso's developing 'neo-classical' style, which was especially inspired by his recent trip to Italy and was also a response – a kind of antidote – to his own cubist work, certainly found a sympathetic climate among the *noucentista* artists he found himself with on this trip to Barcelona. His *Harlequin* (fig. 198) shares many of their qualities of simplification of form and palette while still being based in a classical, more sculptural, tradition; and some of the cubist canvases produced on this visit also seem to become more ordered because of his use of broader planes of colour and shapes (fig. 54). Picasso, characteristically, was stimulated and fed, in a sense, by the artistic environment he found around him; and just

as he had developed as a *modernista* among his bohemian Barcelona friends, he found at this time a complementary artistic situation among the essentially bourgeois artistic circles there (made up of many of those same artists), which was best represented by the current of *Noucentisme*.

After the war

Among local artists, another group which formed for a short period, 1918–19, was the Agrupació Courbet. One of Picasso's friends, the sculptor Manolo, apparently had the idea to form an alternative association to the conservative artists' society, the Cercle Artístic de Sant Lluc, and the ceramist Llorens Artigas came up with the name as a tribute to one of their artistic heroes. They sponsored several exhibitions, including a group show in 1918 (actually held at the Cercle de Sant Lluc) which featured the work of Ricart, Miró, Domingo and Rafael Sala.

The case of Francesc Domingo is an interesting one, because he was a painter who began among the *noucentistes* and then responded to late Cubism (fig. 213), especially while he lived in Paris in 1922–7, but his own style became most characteristic and fully expressive as a kind of late *Noucentisme* in the late twenties and thirties, when he returned to a more traditional approach to form. In his *Apolo Palace* (fig. 60) Domingo used a dark, very limited palette to create a bleak mood and to unify the all-male audience who watch (with little expression) the striptease artist go through her motions. As with Elias, this period of Domingo's work is based upon a great concern for realism, but here realism also means the desire to convey social commentary.

Manolo Hugué, who had recently returned to Barcelona after some ten years as part of the 'bande à Picasso' in Paris, and other sculptors such as Gargallo, developed their sculpture very much in the spirit of *Noucentisme*, although their own contacts with French art continued to inspire some of the specific qualities of their techniques. Manolo gave his sculptural reliefs (fig. 55) an expressive, almost painterly quality by employing a hatched carving effect which follows the contours of the curves of the body. At the same time, he would twist the body in a way that reflected the fascination during the cubist period (on the part of sculptors who included both Matisse and Picasso) with multiple points of view in sculptural form.

Gargallo, who had begun as a flamboyant *modernista* sculptor and had worked with the architect Domènech on several buildings, notably the Palau de la Música, is another Catalan whose contact with Cubism affected his later work, which like that of many Catalan *noucentistes* was concerned with fuller, more traditional sculptural form (figs. 53, 179).

In the area of ceramics, one of the founding members of the Agrupació Courbet, Josep Llorens Artigas, emerged as the dominant figure of this period. As a young critic he had associated with the experimental circles around the

61. Gargallo. *Portrait of Pablo Picasso,*
*c.*1913. (no. 84).
Stone. 22.5 × 21 × 23 cm.
Museu d'Art Modern, Barcelona.

62. Llorens Artigas. Vase, 1924 (no. 125).
Glazed pottery, h: 30 cm.
Collection Jordi Serra, Cornellà.

poet Salvat-Papasseit, and his own early ceramic work reflects a fascination with avant-garde design and cubist inspiration (fig. 254). But as his style developed, particularly after he began to spend more time in France in the twenties, he aspired to a reduction of forms to the materials themselves, and in order to do this he felt the need to go back to the origins of ceramic form. This interest, especially in Egyptian glazes, led to a simplification which allowed for a sense of immediacy in his materials (fig. 62). Llorens Artigas worked and exhibited principally in Paris during the twenties, but beginning in 1929 he began showing in Barcelona. At the same time, he continued his associations with experimental artists, including Buñuel and Dalí (who made *Un Chien andalou* that year, in which Llorens Artigas played a small role), and much later he became Miró's collaborator on a number of ceramic projects.

One other important *noucentista* designer who should be mentioned is the exceptional jewellery-maker Jaume Mercadé. During the twenties he was principally responsible for introducing *Art Deco* stylistic features to *noucentista* design (fig. 264); and, in fact, he had himself exhibited in the celebrated Paris Exposition des Arts Décoratifs in 1925. At the 1929 Barcelona exhibition, which Mercadé commemorated with a superb painting of the city at the time of the fair (fig. 318), he was featured as one of Catalonia's leading silver designers, and on that occasion he was awarded both a gold medal and a grand prize for jewellery and silver design.

The International Exhibition of 1929

The occasion of the 1929 exhibition represented for the city of Barcelona the fruit of many years of planning, essentially as part of an urban expansion scheme and as a long-term political goal of the conservative Lliga Regionalista. Already in 1907 a working committee had been formed with representatives from various groups, including the leading industrialists' organisation, the Chamber of Commerce, the Cercle Artístic de Sant Lluc and associations of architects, engineers and decorative artists. Ideas ranged from an international exhibition of electrical industries (1913) to an international exhibition of furniture and interior design (1923). Changes in the Barcelona city government during the Dictatorship (1923–30) resulted in further modifications, but in 1926 the general character of the exhibition and plans for the architectural development of the hill of Montjuïc, which resulted in the 1929 event, were finally underway.

The exhibition occupied the area immediately below the north face of Montjuïc, and there an avenue of illuminated columns led up to an enormous fountain. On either side were the various national pavilions (including Mies's German Pavilion) and some of the large exhibition halls. The new National Palace overlooking this area had radiating search-lights behind it for the event (fig. 63). Other buildings were situated on the hillside itself, and

63. Avenue to the Palau Nacional with searchlights behind, 1929.

64. Gargallo. *Dancer (Gran Dansarina)*, 1929 (no. 87).
Iron, 123 × 70 × 50 cm. Museu d'Art Modern, Barcelona.
Exhibited in 1929 in the Pavelló dels Artistes Reunits (cf. illus. p. 304).

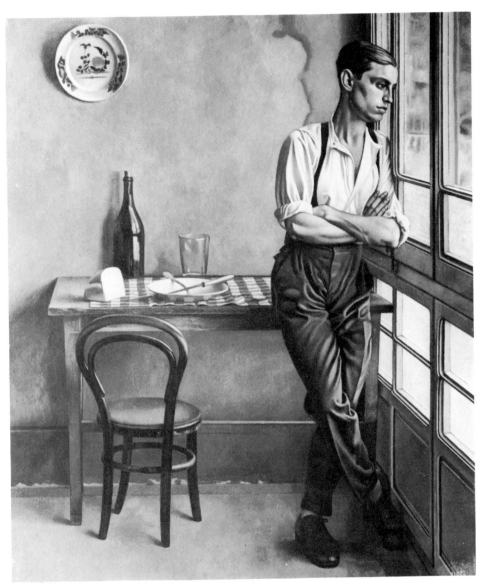

65. Elias. *La Galeria*, 1928 (no. 72).
Oil on canvas, 63 × 52 cm. Museu d'Art Modern, Barcelona.
Exhibited at the 1929 exhibition.

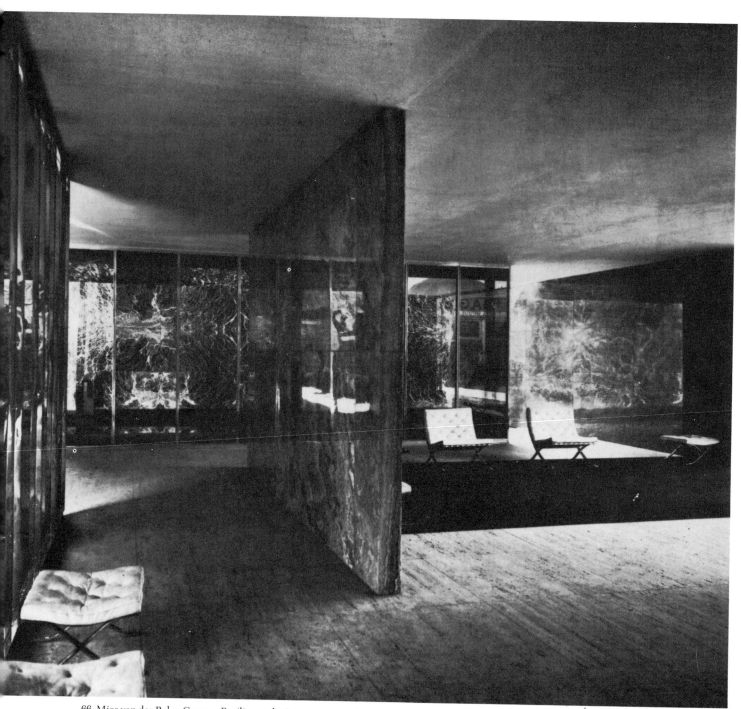

66. Mies van der Rohe. German Pavilion at the International Exhibition, 1929;
interior towards the onyx wall, showing his 'Barcelona' chairs.

on the western slope the so-called *Poble Espanyol* was created, a reconstruction of picturesque and touristic sites from all over Spain, for the entertainment of visitors to the exhibition.

In many ways the 1929 exhibition building programme once again illustrates the curious dual nature of the general Catalan cultural movement, which by this time had had its former separatist aspirations significantly tempered by the Dictatorship. On the one hand, the principal buildings, such as the monumental National Palace, were essentially reactionary in form. Moreover, the building of the *Poble Espanyol* can be viewed as a reflection of the kind of historicist point of view held by many of the exhibition designers (including the former *modernista* Utrillo); in political terms this seems to reflect the non-separatist spirit and the re-evaluation of Catalonia's role within Spain as a unified nation. On the other hand, the spectacular and impressive light and fountain displays (under the direction of Carles Buigas) were meant to be a symbolic proclamation of Barcelona as a city of the future and of international importance. The most remembered building of the exhibition was, of course, Mies van der Rohe's small German Pavilion (fig. 66), and even though it and his celebrated Barcelona chair, designed for the pavilion, are known today for their innovation in design and materials, they reportedly made little impact at the time among Barcelona architectural and design circles.

Nevertheless, the 1929 exhibition seems in retrospect to have been a kind of watershed for the direction of architecture and interior design which was to develop in the early thirties. With the end of the Dictatorship and the establishment of the Second Republic (1931) with Catalans in positions of power, a renewed sense of local pride and belief in a democratic future led to a burst of energy in artistic activities, particularly in architecture. By this time a new generation of architects had emerged – some of whom had trained outside Spain – and several important exhibitions of their projects and theoretical programmes were held, starting in 1929, which focused attention on the development of a new architecture. The first of these was an exhibition of architectural projects at the Galeries Dalmau in April 1929, and it included most of the group who the following year were to found the GATCPAC (Grup d'Arquitectes i Tècnics Catalans per al Progrés de l'Arquitectura Contemporània), in addition to Barcelona's leading exponent of *Art Deco* architectural design, A.Puig Gairalt.

The Second Republic

The GATCPAC, which essentially aimed to create a new architecture based upon rationalist ideals, began as an idea principally of Josep Lluís Sert, who had studied with Le Corbusier in France, with the collaboration of several of Sert's friends, Germà Rodríguez Arias, Ricard Churruca

and Francesc Fàbregas. They initially called themselves the Grup Català d'Arquitectes i Tècnics per a la Solució dels Problemes de l'Arquitectura Contemporània (GCATSPAC), but with the formation in October 1930 in Zaragoza of the GATEPAC (Grupo de Artistas y Técnicos Españoles para el Progreso de la Arquitectura Contemporánea), the Catalan wing representing Eastern Spain took on the name GATCPAC. In addition to Sert's original group (but not including Fàbregas), the other founding members included Manuel Subiño, Cristòfor Alsamora, Josep Torres Clavé, Pere Armengou and Sixt Yllescas; later members included Josep González Esplugas and Joan Baptista Subirana.

As part of the principal aims of the GATEPAC a new journal, *AC* (Documentos de Actividad Contemporánea), was published for the promotion of a humanist, rationalist architecture. It was written in Castilian to be an organ of the GATEPAC, but it was created and produced for the duration of its existence (1931–7) in Barcelona – twenty-five issues appeared. Theoretical articles, analyses of contemporary buildings, notices of international congresses of similar associations and, importantly, new photography, were included. Moreover, the design of the journal itself reflected not only the design principles of the GATCPAC but also their interest in the work of artists such as Theo Van Doesburg, who had been in correspondence with Dalmau in 1929 concerning plans for a journal based on the ideas of Neo-Plasticism.

One of the first projects (initiated in 1929) of the GATCPAC, was a plan for a Ciutat de Repòs i de Vacances (Leisure and Vacation City) in Castelldefels, some fifteen miles south of Barcelona on the coast (fig. 136). This plan was later incorporated into the large expansion and modernisation scheme of the city known as the Macià plan (fig. 137), named after Francesc Macià, the president of the Generalitat during the Republic. This and subsequent projects were published in issues nos.7–13 of *AC* and represent a collective plan to extend the whole idea of the city to include weekend life as well as to develop the coast.

The Macià plan, which was the result of a collaboration of the GATCPAC with Le Corbusier and P. Jeanneret, was developed, in a sense, as the architectural expression of the political optimism of this period. Le Corbusier himself officially presented the idea to Macià in March 1932 on the occasion of the meeting of the international architectural body CIAM in Barcelona, and in his speech he linked the future of the Republic with new ideas of urbanism; as a new city of the twentieth century, as Le Corbusier defined it, Barcelona would become 'une ville radieuse'. The basic features incorporated in the Macià plan included the creation of a new sanitation system, the construction of the Ciutat de Repòs i de Vacances (thus extending the city) and the remodelling of the *Eixample*. This last stage in the replanning of the city during our

Un concepto mezquino y miserable de la vida ha presidido la construcción de las viviendas obreras en nuestro país, dando por resultado un mínimo inaceptable.
La vivienda mínima puede tener pocos metros cuadrados de superficie, pero en ella no pueden excluirse el aire puro, el sol y un amplio horizonte. Elementos que necesita todo hombre, de los que la sociedad no tiene derecho a privarle.

67. Cover of the GATEPAC journal *AC* (no. 11, 3rd quarter 1933), showing a model of the 'Casa Bloc' with 'minimal apartments' for workers to be built in the suburb of Sant Andreu. The design provided a much more open use of the grid system of the *Eixample* than the familiar block built on four sides with an interior courtyard: 'The minimal apartment may have an area of only a few square metres, but it must not be without fresh air, sun and a wide view. Elements that every man needs, and that society has no right to deprive him of.' (no.299). Col.legi d'Arquitectes de Catalunya, Barcelona.

period was, however, never to be. With the Civil War and the dissolution of the GATCPAC, the unrealised plan became a document of the period in which it was conceived, expressing not only political optimism but once again the international aspirations of the Catalans.

Although the GATCPAC was short-lived – at the end of the war, in which Torres Clavé was killed, Sert left for Harvard, and although some of the members remained in Catalonia, the political climate was inauspicious for any continuation of the aims of the group – several building programmes were completed (both residential and public) in the early thirties. For example, a number of hospitals were planned and commissioned in 1934 by the Generalitat; one of these was the anti-tuberculosis unit, known as the Dispensari Central, designed by Sert, Torres Clavé and Subirana, which was actually finished during the War in 1938 (fig. 105). The building occupies an irregularly shaped site in an old section of the city, and the desire to create a sense of space and to incorporate light were principal concerns of its design, which was based on an L-shaped plan.

The optimistic mood and the desire to become a part of international artistic movements during the Second Republic was also shared by Catalan painters and writers, whose principal inspiration was the surrealist movement centred around André Breton in Paris. Of those who left Barcelona, the two who achieved the greatest international success were Joan Miró and Salvador Dalí. Both of them arrived in Paris (Miró in 1919, Dalí in 1929) imbued with the enthusiasm of their Barcelona experiences, and they developed their Surrealism with the stimulation of the French movement but without giving up the essentially Catalan nature of their distinctive approaches and attitudes (both political and artistic).

Dalí's super-realistic depiction of objects from the world of the subconscious in the twenties and thirties reflects an affinity with the highly objective character of late *noucentista* painters such as Elias. But the aggressive nature of his images reflects his involvement with avant-garde activity, principally among writers and critics he met at Dalmau's in Barcelona. For instance, along with the writers Lluís Montanyà and Sebastià Gasch, Dalí signed the *Manifest Groc* in 1928 (a kind of Dada manifesto), which called for the elimination of all literature and philosophy in favour of a new 'post-maquinista' spirit. The authors called for an attack on the false nature of contemporary Catalan culture and, instead, the championship of recent invention and modern production methods – even the nude in American music-halls. The manifesto denounced among many other things the cherished Catalan musical society, the Orfeó Català, as well as young artists trying to imitate older painters, contemporary critics, children's art magazines and architecture 'd'estil'. And, finally, among those who were claimed as 'the great artists of today' – and an impressive list it is in the context

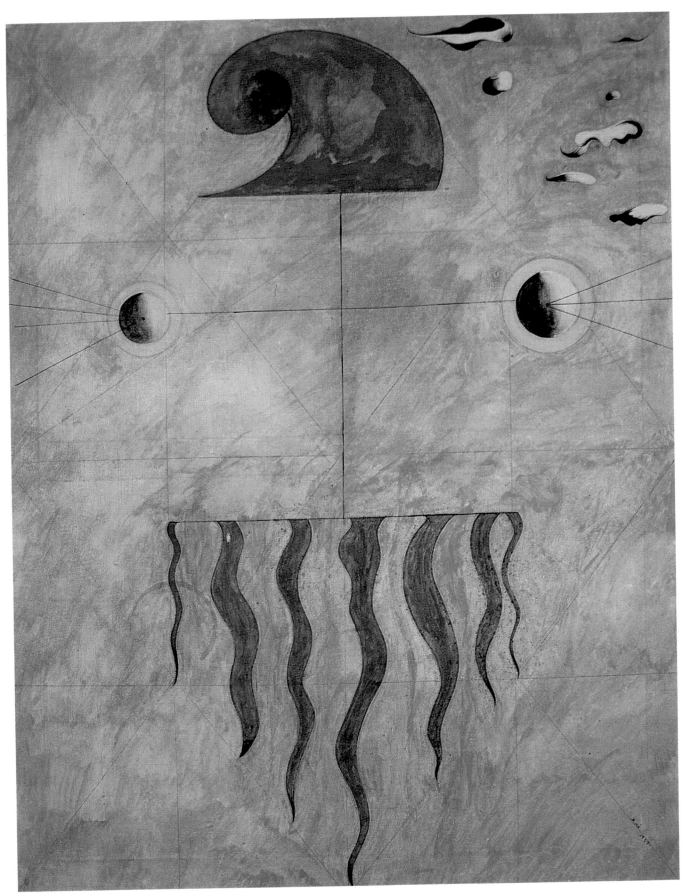

68. Miró. *Head of a Catalan peasant*, 1925 (no. 153).
Oil on canvas, 91 × 73 cm. Private collection.

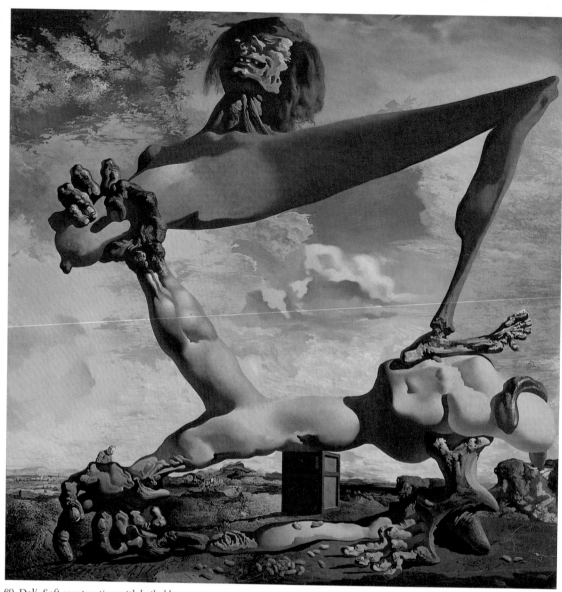

69. Dalí. *Soft construction with boiled beans;*
Premonition of Civil War, 1936 (no. 61).
Oil on canvas, 100 × 99 cm. Philadelphia Museum of Art,
The Louise and Walter Arensberg Collection.

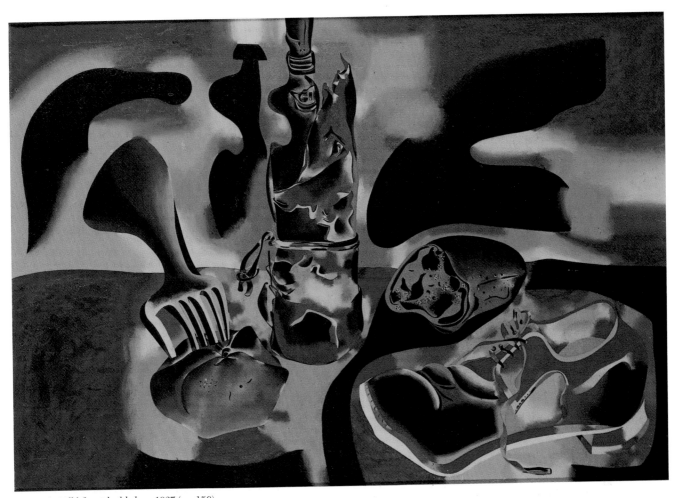

70. Miró. *Still life with old shoe*, 1937 (no. 156).
Oil on canvas, 81.3 × 116.8 cm.
The Museum of Modern Art, New York,
James Thrall Soby Bequest 1979.

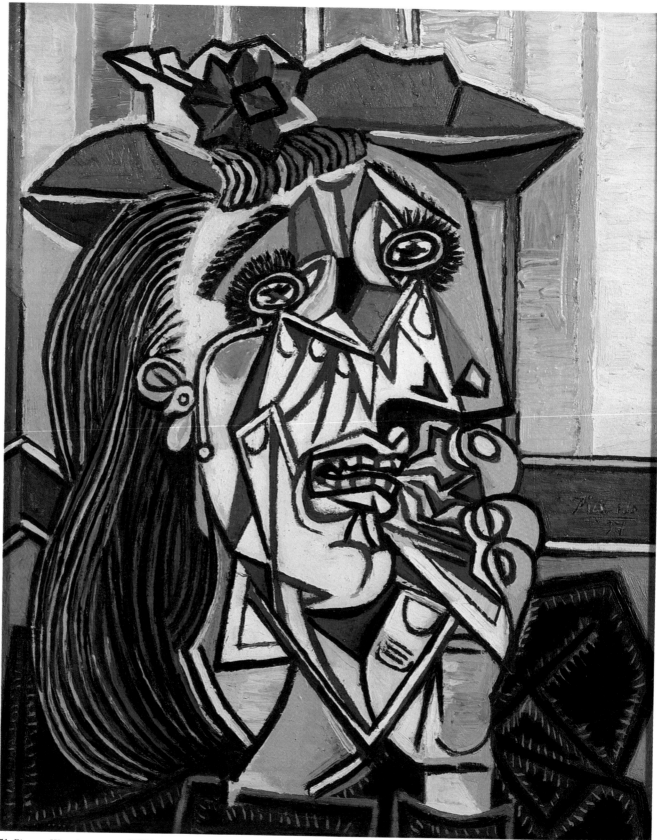

71. Picasso. *Weeping woman*, 1937 (no. 189).
Oil on canvas, 60 × 49 cm. Private collection.

of Surrealism – were: Picasso, Gris, Ozenfant, De Chirico, Miró, Lipchitz, Brancusi, Arp, Corbusier, Reverdy, Tzara, Eluard, Aragon, Desnos, Cocteau, García Lorca, Stravinsky, Maritain, Raynal, Zervos, Breton, etc., etc.

Dalí's participation in this late wave of Catalan Dada activity can be seen as a prelude to the disturbing and repulsive art he produced in the thirties, which in its essence represented an aggressive attack on the bourgeois character of Dalí's (and his generation's) Catalan origins. While in Paris in 1933, Dalí made an interesting link between *modernista* (i.e., Catalan bourgeois) architecture and Surrealism in an article he wrote for the magazine *Minotaur* entitled 'De la beauté terrifiante et comestible de l'architecture Modern Style', in which he described the organic, 'edible' sculptural forms of Gaudí's *modernista* architecture as premonitions of the ravenous, horrific images of Surrealism.

Miró's work of the twenties and thirties can certainly be seen as a phase in the development of his personal style, with its roots in his Barcelona work of the late teens as well as in Surrealism. By the mid-twenties, space in Miró's work becomes much emptier and tends to read as flat colour, and his personal notations (derived from his earlier, playful 'representational' forms) function as if they were images taken from the artist's inner vision and occupy a kind of dream space. The symbolism of some of the references, for example the ladder in *Dog barking at the moon* (fig. 220), certainly must have appealed to the surrealist vocabulary for its potential to be a psychological as well as a visual connecting device.

Not only was Miró embraced by the Surrealists in Paris, he was also championed, especially in the thirties, in Barcelona among the circle of artists who in 1932 founded the artistic association Amics de l'Art Nou (ADLAN). The idea to create ADLAN as a new artists' group at that time was in part a response to the formation of the GATCPAC, and although the artistic circle was small, its support of the avant garde and particularly of Miró was important to the emergence of a local surrealist movement, which was officially unaligned with Paris, although it received its artistic inspiration from France as well as from Miró.

Àngel Planells, for example, was a friend of Dalí's and through him had met Magritte in Cadaqués. Planells's paintings were exhibited both at Dalmau's (1926, 1929) and with the ADLAN-sponsored 'Logicofobistes' in 1936 at the Llibreria Catalònia (galleries then under the direction of Dalmau). Like Dalí, Planells was a great admirer of Elias as well as of Magritte, and his highly realistic paintings incorporate disturbing surrealist qualities, principally through scale and light. In some of his still lifes (fig. 230), objects are viewed at quite close range, and a kind of uniform, bright artificial light conveys an irrational feeling in spite of the great attention to realism in detail. In other works he draws on a kind of

dream imagery closer to compositions by Dalí (fig. 72).

Artur Carbonell, who was also shown by Dalmau and later by ADLAN, was closer in spirit to Miró. His compositions of the early thirties tend to feature empty fields of colour populated by either biomorphic abstract forms or disturbing single images such as the barren tree in a dark, inauspicious landscape (fig. 74) – a painting which now seems like a haunting premonition of the devastation of the Catalan countryside in the Civil War. Prior to the war Carbonell also worked as a theatre director and set-designer and was responsible for the presentation in Sitges and Barcelona of works by contemporary play-wrights such as Cocteau, O'Neill and Pirandello.

Connections with avant-garde movements outside Spain were maintained throughout the early thirties, principally by writers and artists and especially by the efforts of ADLAN members. The winter 1934 issue of the journal *D'Ací i d'Allà*, for example, was prepared by Sert (representing GATCPAC) and Joan Prats (representing ADLAN) and was devoted to art and architectural theories and specifically to the work of Fauves and Futurists, to Purism, Neo-Plasticism and Constructivism and to Dada. Then in 1936 ADLAN undertook to present Picasso once again to the country of his birth – but this time as a painter and poet of the thirties in a new, compelling and provocative form.

The Civil War

With the outbreak of war in that year, the optimism of GATCPAC, the international connections with Surrealism of ADLAN, the Catalan cultural movement in general came to a halt – or at least to what would be a long forty-year interruption – and the great period of artistic and architectural creativity and energy that had expressed the political, social and artistic aims of the Catalan people since the time of the 1888 exhibition ended. The present exhibition finishes with the artistic response to civil war on the part of three painters – Picasso, Miró and Dalí, who not only created powerful, compelling images of the horror of war but also, in the case of Picasso and of Miró (Dalí supported the Nationalists), were able through their art to turn world attention to the Republican cause.

Picasso's last visit to Spain and to Catalonia was in 1934; afterwards he lived in self-imposed exile in France until the end of his life. The distortions, sharp colour contrasts and expressive use of black line in his works after his return visit to Spain bring an element of new violence to his work of the thirties, which can be seen partly as a response to Surrealism but also by 1936 as a response to imminent war in his homeland. His *Weeping woman* of 1937 (fig. 71), related to the female victims in *Guernica*, is a specific image of the tragedy of civil war, but its impact is universal in its moving depiction of grief.

In Dalí's *Soft construction with boiled beans* (fig. 69), a horrific creature pulls herself apart as a country does to

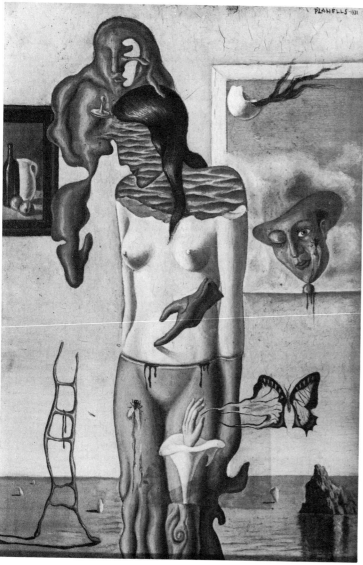

72. Planells. *Woman and man's head*, 1931 (no. 205).
Oil on wood, 40 × 28 cm. Private collection.

itself in civil war. The surrealist absurdity of soft beans spilling out on to the foreground is a disturbing element of contrast and of physical repulsion which makes this small painting into a monumental image of horror. In his image of Spain in *España* (fig. 75), painted during the war, the transparent creature occupies an obliterated landscape as if the idea of the country itself were on the point of disappearing.

Finally, two works by Miró communicate the nightmare quality of burning landscapes at night. The small painting *Man and woman in front of a pile of excrement* (fig. 73) is still typical of the strongly sexual, playful creatures who inhabit Miró's work of the thirties. Their gesticulations about the strangely illuminated monument of excrement on the horizon can thus be understood both as typically surrealist but also as a sign of impending conflict. The images in *Still life with old shoe* (fig. 70), by contrast, are larger-than-life references to the essentials of living. Their placement against an ominous and strangely lit landscape powerfully expresses Miró's indignation at the threat not only of the dissolution of his beloved Catalan countryside but to survival itself.

Today, with the distance of almost fifty years since the outbreak of war and the fall of the Second Republic, we can look back to the period that began with the optimism of the 1888 exhibition and consider how the city of Barcelona attained a unique position, not only as capital of Catalan separatism but also as a vital, stimulating centre for the emergence of rich and varied artistic production. The planning and actual building of the city itself encouraged several generations of architects who gave physical expression to the goals of the people. Innovation was mixed with the best of local tradition, and the revival of Catalan arts and crafts led in *Modernisme* to an architecture which embodied the political and cultural aspirations of that important moment when all of the arts were enjoying the most spirited renascence. The re-evaluation of Barcelona's political goals and the reassessment of the directions the arts were taking led to a broad Catalan movement which embraced a new twentieth-century classicism and reasserted Barcelona as a city in the great Mediterranean tradition. The cultivation of the avant garde and the emergence of artists of international standing in the twenties and thirties gave fresh artistic impulse to the city even when its political goals were severely restrained. While the renewed optimism of the thirties produced a brief yet extremely exciting view of a city of the future, especially in the arts, and plans for the extension of the city itself expressed confidence in a future that finds renewed expression once again today.

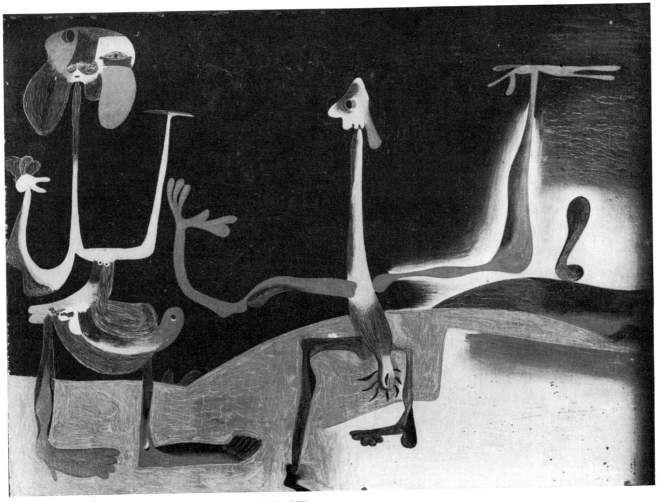

73. Miró. *Man and woman in front of a pile of excrement*, 1935 (no. 155).
Oil on copper, 23.2 × 32 cm. Fundació Joan Miró, Barcelona.

74. Carbonell. *Landscape*, 1935 (no. 13).
Oil on canvas, 48 × 72 cm. Private collection.

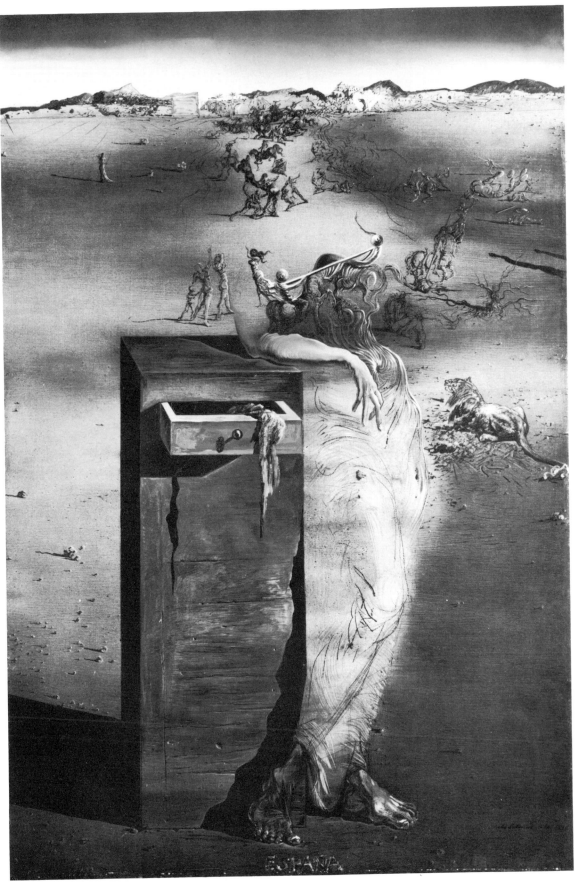

75. Dalí. *España*, 1938 (no. 62).
Oil on canvas, 91.8 × 60.2 cm.
Museum Boymans-Van Beuningen, Rotterdam.

76. Arnau. *Personification of Barcelona, c.*1898, made as a competition
entry for a monument to the mayor Francesc Rius i Taulet (no. 4).
Bronze, 49 × 68 × 35 cm. Museu d'Art Modern, Barcelona.

Barcelona, a European city

Isidre Molas

The development of modern Barcelona, as that of almost all cities, was a gradual process. But there are certain events in the history of the city which brought to a head the evolutionary forces at work, and which mark the beginning of a new period. The Universal Exhibition held in Barcelona in 1888 can be seen as one of these.

In the nineteenth century Catalonia was the most modern region in Spain, with an established industrial structure and the accompanying strata of a capitalist society, and Barcelona was determined to be its spiritual as well as its economic nerve centre. Thus, the forces and dynamics of the new society largely coincided with those of Barcelona. Barcelona was the leader in industrialist ideology, in opposition to agrarian interests and the forces of Carlism. Barcelona was liberal, innovative and revolutionary, and its ideas were supported by the ever growing power of the local press. The city was the capital of a new world, of a society intent on the struggle for growth.

As the real capital of Catalonia and the most advanced city in Spain, Barcelona had to assume the role of leader in a full sense and make its presence felt in every sphere. The 1888 exhibition was an expression of the determination of Barcelona to become a European capital, which implied its real function as capital of Catalonia. For although Catalonia had long ago lost its status as a nation and, with no administrative unity, lacked any independent political expression, it was now forging new strength and undergoing a renewal of its social being, its language and its identity. Barcelona was its light and hope. Here was a society in the throes of a return to life, which was conscious of its links with the European world, and which had the force and the will to match its desire to be in the vanguard and its eagerness to keep up with developments in the most advanced countries. This attitude has remained characteristic of Barcelona, which has been the door open towards Europe and the modern world, by means of which a people has been able to exercise its creativity and its determination to overcome all difficulties, without forfeiting its individuality, to be universal without ceasing to be Catalan. This perhaps helps to explain the modern life of the stateless nation of Catalonia within twentieth-century Spain.

Rapid economic growth during the reign of Alfonso XII (1875–88) had strengthened the new régime's ties with the industrial bourgeoisie and with Catalan business interests, stifling the recovery of both the Carlists and the Republicans, whose defeat had brought to an end a long period of civil strife. The reintroduction of restricted

77. Carrasco. Commemorative medal from the Universal Exhibition, 1888, showing the triumphal arch built by Josep Vilaseca (no. 14). Silver, diam: 6 cm. Museu d'Història de la Ciutat, Barcelona.

78. Mascaró. Medallion (made into a pendant) with the emblem of the Unió Catalanista – Sant Jordi and the dragon – designed by Alexandre de Riquer. These medallions were given by the Unió to the Orfeó Català in 1905, probably on the occasion of the laying of the foundation stone of the Palau de la Música Catalana on Sant Jordi's day, 23 April (no. 134).
Silver and enamel, 5 × 4 cm. Private collection.

suffrage (based on financial qualifications) reduced the size of the electoral register in Spain and led to the division of effective political forces into just two camps, conservative and liberal. In Barcelona two political groups, both rooted in bourgeois society, corresponded to the two Spanish parties, to which they were loosely affiliated. Access to power and decision-making was restricted, so that public opinion found little expression in political life, and the people as a whole were disregarded. Nevertheless, Barcelona's driving force was translated into the capacity to create and to advance, often despite the passivity, the red tape and the pretences of the official political world. Under the energetic guidance of the city's mayor, Francesc Rius i Taulet, this force was directed into the efforts to stage the Universal Exhibition. Barcelona had become a European city and asserted itself as a Catalan and Spanish capital.

The expansion of Barcelona took the form of demographic and industrial growth, and this was concentrated both in the city itself and in the townships on the surrounding plain. In several of these – Sants, Gràcia, Sant Andreu del Palomar and Sant Martí de Provençals – new industries were developed, and gradually they became satellite centres around the capital. In 1897, after a long and complex process, all the towns of the plain (industrial and non-industrial) were incorporated into Barcelona, with the exception of Horta (incorporated in 1904) and Sarrià. This increase in Barcelona's population and boundaries at the end of the century fulfilled the expectations implicit in Ildefons Cerdà's city plan of 1859 (fig. 99), the *Eixample* (extension), worked out on a rational and progressive model for growth at a time when there was as yet no urban development in the area surrounding the old city. The addition of the towns of the plain added 175,681 inhabitants to the 383,908 which the city already possessed, bringing the number of inhabitants to more than half a million, and it added a further twenty-four square miles to the six of the existing city. This extra land gave ample breathing space to Barcelona, and the incorporation of the municipalities made it more possible to accelerate the construction of the *Eixample*, even if Cerdà's plan suffered alterations and limitations, changes secured by landowners from the City Council in order to maximise their profits from *Eixample* lands.

The Universal Exhibition served as a strong stimulus to build the new city. It was not only the determination to confront an existing economic crisis, but also the desire to make a real leap forward. The Ciutadella Park had been built on the site of the old citadel, and monumental buildings had been erected, but, above all, Plaça de Catalunya and Passeig de Gràcia (which leads into it) were established as the backbone of the new city, taking over from Carrer Ferran in the centre of old Barcelona. An entire section of the right of the *Eixample* (the *Eixample* was divided into 'right' and 'left' districts) became a middle-class residential area, and this would continue to develop in future years.

All this construction, made possible by the growing prosperity of business in Barcelona, was responsible for the preponderance of *modernista* architecture in the present-day city, as landowners and shopkeepers followed the lead of industrialists, though on a smaller scale, and also became involved in property speculation and in building. The great *modernista* architects – Antoni Gaudí (who had completed the Güell Palace in old Barcelona before 1890), Lluís Domènech i Montaner, Josep Puig i Cadafalch and others – took advantage of this rapid growth, and the majority of their buildings were constructed in the *Eixample*. And this was only the beginning of a process which would continue for many years and would give a new face to twentieth-century Barcelona. In the new city apartment buildings stood side by side with factories and workshops with market gardens (though these were gradually disappearing), and in place of the innocuous classicism of the preceding period the artistic avant garde turned to *Modernisme*, which became the style of the rising bourgeoisie.

But beyond architecture and decoration, in which sculpture and stained glass played a notable part, *Modernisme* extended to other forms of culture. It favoured what was natural and rebelled against the restrictions of rationalism; it was a return to romanticism and a kind of medievalism, but it was also an eager desire for modernity, for an opening-up into Europe, for escape from routine. In painting, in literature, in music and in other fields, there was a universal sense of breaking with the past. Ibsen and Nietzsche were the most influential authors, and after 1882 the Liceu opera house (which was a private institution) gave precedence to Wagner at the expense of Italian opera, making Barcelona one of the world's capitals of Wagnerism. At the same time, entirely new activities were introduced: in 1897 Gelabert made the first cinematographic films using his own machine, and around 1895 football was introduced. This swiftly gained great popularity, and during the new century Barcelona took a place in the first rank in the world of sport. It was the dawn of a new era. Economic power led to the rise of a European city which seethed with inner vitality.

The dynamism of Catalonia, in its endeavour to keep pace with the progress of social renewal in Europe, left its mark in many fields, and Barcelona played a part of crucial importance. The revival of Catalan as a literary language, the recollection of a time when the country had been self-governing, the renewal and growth in Catalan consciousness, were all gaining in strength concurrently with the rise of the new capitalist society. The Catalan *Renaixença* never succeeded in becoming a political 'Risorgimento', but it formed the basis of a middle-class cultural movement which coincided with a more informal and spontaneous popular Catalanism.

79. Gaudí and Jujol. Tiled benches in Parc Güell, *c*.1909.

80, 81. Gaudí and Jujol. Details of tilework in Parc Güell, *c*.1909.

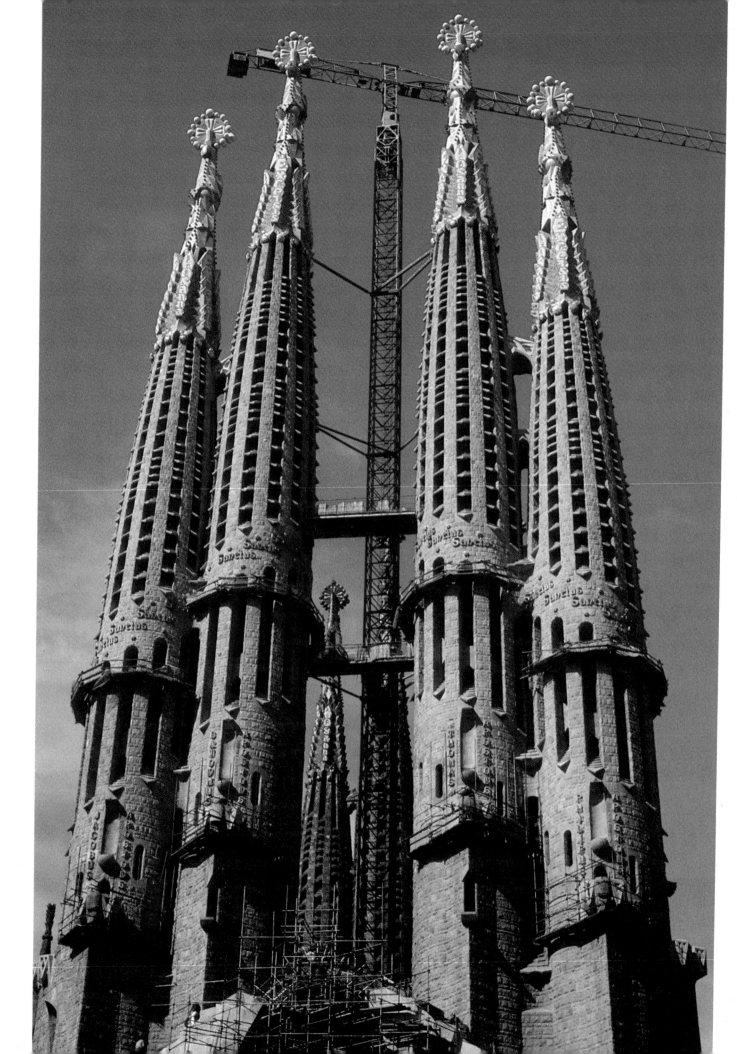

Both Carlists and Republicans were opposed to a centralist state, and under the restored monarchy certain groups from both parties saw an opportunity in the development of a political Catalanism, which would, for the moment, share some common ground both with popular sentimental Catalanism and with the cultural Catalanism of certain sections of the Barcelona bourgeoisie, who supported the oligarchic system of political bosses (*Caciquisme*). The recollection of former kings led to a hankering for self-government, and this desire, together with the popular use of the indigenous language, became a characteristic feature in a situation that was ripe for development.

The first impulse, then, for the political organisation of Catalanism came from republican and federalist circles. Valentí Almirall, a leading Federal Republican, an anglophile and a positivist, was responsible for the appearance of the first newspaper written in Catalan (*Diari Català*, 1879), and he convened the First Catalanist Congress in 1880. But he soon separated from the Federal Republican Party and in 1882 founded a new grouping in Barcelona, the Centre Català, which wanted to unite 'Catalans of all religious ideas or political affiliations, bringing together all who are interested in the regeneration of our character and the betterment of our land'. The year 1885 saw the first political act of Catalanism: the presentation of the so-called *Memorial de greuges* (Memorandum of grievances) to Alfonso XII, promoted by industrial interests and by those opposed to a unified civil code. However, uniting the conservative and the republican Catalanists was too ambitious a task, and in 1887 the conservatives founded the Lliga de Catalunya (League of Catalonia). The Centre Català soon failed, particularly as Almirall opposed the exhibition of 1888, which he criticised as a senseless adventure. In 1891 the Lliga de Catalunya united a number of different Catalan organisations, newspapers and individuals in the Unió Catalanista (Catalanist Union), which proposed a political scheme that may well have been inspired by the autonomous status of Hungary within the Austro-Hungarian Empire. The following year their proposal was set out in the *Bases de Manresa* (Manresa points), superseding the project of the Federal Republicans in 1883 for a Catalan state within a federal Spain. The new Unió, though its numbers were small and it provoked little activity within society, would nonetheless be one of the most influential elements in modernising political processes in Catalonia.

At the end of the century official political life was still founded on the two dynastic parties, and its sphere was narrow. But a real life existed, active outside official institutions, sometimes opposing them, sometimes supporting them, sometimes ignoring them. Universal male suffrage, reintroduced in 1890, had still not given political expression to this real Barcelona, since the cacique system continued, ensuring that official Barcelona got its way. A republican presence was at least in evidence, but the majority was not involved, and the opportunity for participation was limited, since with rigged ballots the political machines and their bosses made certain that the system continued. Political reform continued to be a necessity, and respect for the voting system was an essential element. The right put corporate suffrage before political suffrage, while the left made an effort to achieve democratic practice in order to destroy corrupt power, or, if need be, all power.

The middle classes, eager for the economic gain which was certain after the defeat of the Republicans in 1874 and the defeat and later accommodation with Carlism, stayed apart from day-to-day politics while protecting their immediate interest, the control of an expanding society. They placed themselves at a distance from the exercise of power, while never losing touch with it, to be certain that public order at home (and so the preservation of their own interests) was maintained and the American colonies protected. They ruled without exercising direct political power, and they exerted pressure and demanded protection against any movement which might be formed to try and combat or eliminate injustices and abuses. At the same time, they closed the open wound which had existed in their relations with the Catholic Church and began a slow movement towards a reconciliation: bishops became more compliant under the restored monarchy, and the religious orders devoted themselves to the education of the children of the upper classes. Those who exercised political control in Barcelona, through the City Council and the Provincial Assembly, worked out a system in which the positions of power were alternated and distributed among the various political groups, but the difference here was that power was not the result of fair elections, but rather of direct agreements among the political groups which exchanged and shared these positions. One sector of the ruling classes was controlled, in a way that almost amounted to political subversion, by a fiercely anti-liberal Catholic party, free now of any connection with Carlism.

The end of the six-year revolutionary period – which had started with the abdication of Queen Isabella in 1868 and continued until the demise of the Republic in 1874 – brought about a harsh change in the situation of organised labour, as the International Workers' Party was made illegal along with a number of the societies affiliated to it. In Barcelona there was a strong anarchist element in the workers' movement, and this co-existed with federal republican ideas. At the popular level there does not seem to have been any strong division between these two tendencies, which were indeed closely associated and flourished side by side among the workers of Barcelona.

A new workers' organisation with anarchist leanings, the Federació de Treballadors de la Regió Espanyola (Federation of Workers of the Spanish Region) was formed

82. Gaudí. Towers of the church of the Sagrada Família, begun 1901.

83. Casas. *Soldiers embarking for Cuba*, 1896.
Conté crayon on paper, 21.2 × 33.5 cm.
Museu d'Art Modern, Barcelona.

84. Rusiñol. *Heads of anarchists tried in connection
with the Liceu bomb*, 1893–4.
Conté crayon on paper, 20.5 × 27 cm.
Museu Cau Ferrat, Sitges.

in 1881. Although it began to disintegrate after 1884, it continued to maintain a local organisation, and in 1888, taking advantage of the activity stimulated by the Universal Exhibition, there was an attempt at reconstruction: the Unió General de Treballadors (UGT, General Workers' Union) was founded in Barcelona as a federation of the various workers' unions. With delegates from all parts of Spain present in the city, the socialist García Quejido succeeded in persuading them to form the Partido Socialista Obrero Español (PSOE, Spanish Socialist Workers' Party) at the same time. While the headquarters of the PSOE were based in Madrid, the only place where a nucleus of socialist ideology existed, the headquarters of the UGT remained in Barcelona, since it was the most important centre of industrial workers. However, in 1899 they were moved to Madrid, a fact that demonstrates the difficulties socialism had in taking root in Catalonia, which in turn accounts for the predominantly anarchist nature of the workers' movement in Barcelona during the first half of the twentieth century.

The popular movement in Barcelona was, then, federal republican and anarchist, and anarchism reached a high point in the last years of the century through active propaganda (the assassination attempt on Martínez Campos and the Liceu bomb of 1893, the Canvis Nous bomb of 1896, etc.), although these acts were not linked to the organised movement. At the same time, they reinforced the intransigence of employers and their strict insistence on order, which had caused the acts in the first place. The action taken against union leaders along with the terrorists, and the marginal position of the socialists, tightened the link between the anarchists and the workers. The working and living conditions of the working class, the lack of any political reforms and the attitude of the employers drove the workers' movement to look for hope in the great day which would see the destruction of the oppressive capitalist society and its three pillars: the church, the army and capital.

The twentieth century: Republicans and Regionalists

The loss of the Spanish colonies of Cuba and the Philippines in 1898 was a blow for Catalan industry, which during the nineties had intensified production for export. Capital was reinvested at home, and a substantial part was channelled into land investment and the construction of the new Barcelona. But the main effect of the colonial disaster was to provoke a profound crisis in the whole country, since it meant that Spain had to rely on its internal markets.

Demands for public reform, which had been growing over the last decade, were intensified. Conservative politicians such as Silvela became the spokesmen for the republican groups, while the military, whose appetite for intervention had been whetted, advocated a similar policy of reform, and men such as Polavieja, one of the generals

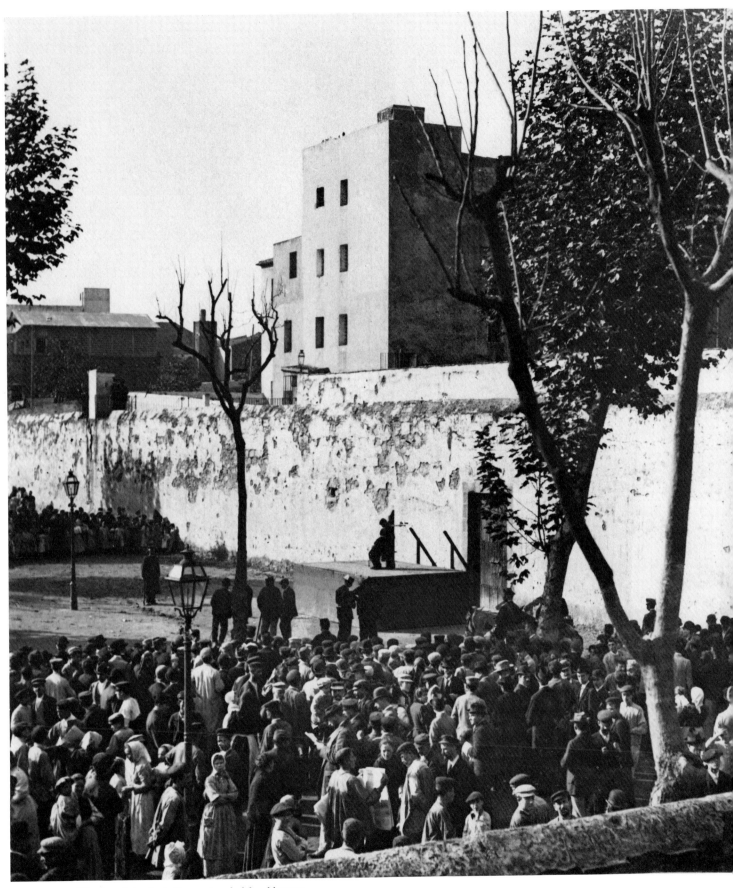

85. Execution of Santiago Salvador in the courtyard of the old prison
on Carrer d'Amalia, 21 Nov. 1893.

86. Forging floor of the Maquinista Terrestre y Marítima,
the great Barcelona railway and shipbuilding firm;
early twentieth-century photograph.

who had commanded in the Philippines, enjoyed the support of a good part of the Catalan bourgeoisie. For the first time in recent years a group of industrialists stood by the military, hoping for a coup that would change the political direction. They wanted to remove the obstacles which paralysed their initiatives, so as to be able to adapt to the opportunities for social expansion, more limited now since the loss of the colonies.

Criticism of official Spanish policies and, by extension, of the existing régime, and the confidence in their own power to achieve more favourable conditions, were the grounds which encouraged one sector of the Catalan bourgeoisie to propose a policy for state reform which would allow them enough freedom of action to create such conditions without hindrance. This led them to a standpoint of opposition, and if official policy were not changed they would be in open rebellion.

The 'revolució dels pares de família' (revolution of fathers of families), as it has been called, led the Catalan bourgeoisie to develop a policy of individualism – perhaps not yet fully consciously – in their mistrust of the existing system of government and their desire for reform. They wanted to intervene in Spanish policy but at the same time to keep the government from interfering in Catalan affairs. Their policy was, at root, an expression of their urge to reorganise Spain and of their effort to create the political conditions which would allow the new capitalist society of modern Europe to expand unhampered in Catalonia. In its first phase, this was an act of political pressure, an appeal for individual power and for the construction of Barcelona as a European capital. But this was a minimal policy, for as long as the crisis continued, power and projects did not exist. When their development began with the new century the crisis was already over: the cacique system survived in the rest of Spain, but not in Barcelona, where the flag of reform was now flown.

In effect, the downfall of the Barcelona political bosses occurred with the turn of the century. The real Barcelona fought to become the official Barcelona. In 1901, for the first time, the results of the parliamentary elections did not coincide with those prepared by the civil governor. The candidates of the Lliga Regionalista (Regionalist League) triumphed, with the Republicans in second place. The old monarchist parties, without enough supporters on an electoral register based on universal male suffrage, were crushed by the two main bodies of citizen opinion, which joined forces in their insistence on respect for the legitimacy of suffrage. When in the month of October some of the members of the City Council were due for re-election the results were the same. A new stage in the pattern of Barcelona politics had begun: the Regionalists and the Republicans formed the new basis of the city's party system, alternating in control, though with the Republicans having something of an advantage.

The Lliga Regionalista had been founded in 1901 by a Catalanist group which broke away from the Unió Catalanista because of their determination to become directly involved in politics. A tax revolt by businessmen caused the closure of the banks in 1899 and led to the resignation in sympathy of the mayor of Barcelona, Dr Robert, while the middle class generally felt a sense of alienation, as the Silvela government in Madrid failed to cope with the crisis caused by the loss of the colonies. It was amid these conditions that conservative Catalanism made its appearance, constantly alert to ensure that Barcelona became the leading voice in Catalonia. Lawyers, doctors, businessmen, property owners and industrialists joined forces in a plan to regenerate public life and modernise the country. The development of their policies (which were set out in two books, *La Nacionalitat catalana*, 1906, by Enric Prat de la Riba and *Regionalisme i federalisme*, 1905, by Lluís Duran Ventosa) went hand in hand with the reforming tendency of one sector of the ruling classes, though an underlying tension was always present between the more idealistic Catalanists and a core of Catholics and landowners who favoured a fiercely anti-liberal conservatism. Tension also existed between the view that saw the movement as the self-contained effort of Catalonia to govern itself and that which was conscious – and aware how powerless it was – that to achieve self-government it would be necessary to reform Spain. The Lliga Regionalista represented an urban movement in Barcelona which found the strength to oppose Republicanism by forging an alliance with the powerful landowning interests. It encouraged traditionalism and was a lever for the conservatives, who never identified fully with it but supported it as the strongest defence against movements of the left.

The Republicans, who were split into several groups, also made the effort at the turn of the century to reorganise and reach accord. Inspired by Alejandro Lerroux, they fostered a movement of mass opinion and became a vehicle for many of the aspirations of the working class, particularly in their opposition to the political involvement of the church. At elections the different Republican groups united, demonstrating the ascendency of left-wing opinion in Barcelona, in spite of their low turnout.

The political map of Barcelona after 1901, once corrupt electoral practices had been rooted out, has remained substantially unaltered throughout the twentieth century, and it shows the close ties between the different areas and the voting patterns of the people living there. The established conservative areas are the old city, the right of the *Eixample* (where the middle classes were now settling) and the left of the *Eixample*. The leftist districts are Barceloneta, Poble Nou, Clot, Sant Andreu and, on the other side of the city, Sants. Thus, after 1903 Barcelona showed a majority of the left, though this was not reflected in the appointment of the mayor, who was chosen by the Madrid government. Bastardas (1908–9), a Republican

Catalanist, was the first democratic mayor of Barcelona in the period, but his appointment was an accident, and the old system of choosing mayors was immediately resumed.

In 1905 there was a change in the situation, which brought Republicans and Regionalists closer together. This followed the attack by a group of officers on the offices of *La Veu de Catalunya* (The Voice of Catalonia), the Lliga's newspaper. The Spanish government, in order to deal with the brewing military crisis, enacted a law under which all insults, written or spoken, against the army, the country or their symbols were subject to military jurisdiction. At the same time, a soldier sympathetic to the military clique was appointed minister of war.

The resurgence of military power acting outside the law, the attack on the Regionalist movement, and the submission of political offences to military jurisdiction, united the leaders of the Regionalists, the Republicans and the Carlists in opposition to the new law, although Lerroux, because of differences with one of the other Republican leaders, withdrew his support. Thus Solidaritat Catalana was established; 11 February 1906 (the anniversary of the First Republic) was proclaimed Catalan Solidarity day, and on 20 May a large demonstration was held in Barcelona. The serious divisions in the Republican movement could not be overcome, but a surprising majority of the city of Barcelona came out for the politics of the common front.

Nevertheless, the parties were united only in their opposition to the government, and Solidaritat Catalana, which had awakened so many hopes, split during the municipal elections of 1909. It collapsed completely as a result of the protest in July 1909 against mobilisation for the colonial war in Africa, which is known as the *Setmana Tràgica* (Tragic Week). The people rose up and expected the Republicans to assume leadership of the rebellion. This never happened. In the event, a primitive anticlericalism was shown by the people, while the crushing of the revolt, in the course of which the rationalist educator Ferrer i Guàrdia was shot, demonstrated the intransigence of the affluent and the right – and this only strengthened anti-political tendencies within the working class.

It is easy to see in all this the origins of the workers' movement. There was increasing disillusion with the evasions and bickering of the Republicans and wholehearted opposition to Regionalism, and it was the Anarcho-syndicalists who established and guided Solidaritat Obrera (Workers' Solidarity), the embryonic confederation of workers' organisations. In 1910 this became the Confederació Nacional del Treball (CNT, National Confederation of Labour), with an anti-political orientation which established Barcelona as the capital of world anarchism until 1939. From being 'the city of bombs' at the turn of the century, Barcelona came to be one of the most important international centres for revolutionary syndicalism and the libertarian movement.

The thrust towards modernisation

The Lliga Regionalista, the party of business and industry, maintained its role as the principal party of the Barcelona right (although at times it was threatened by other groupings), and in the second decade of the century it was able to control a body that was of vital importance to the development of Catalonia and of Barcelona, the Mancomunitat of Catalonia.

This union of the four provincial assemblies of Catalonia, which ensured a measure of political unity in the region, was established in 1914, largely inspired by Enric Prat de la Riba, who had presided over the Provincial Assembly of Barcelona since the days of Solidaritat Catalana. Used as an alternative power base, the Mancomunitat put in hand a policy of modernisation which enhanced Barcelona's position as the capital of the nation of Catalonia, and it maintained its influence, as the social classes who supported the Lliga and the leadership of the Mancomunitat had no other channel of political expression. The City Council remained in the control of the Republicans, and the two authorities, by their complementary activities, contributed to making Barcelona a dynamic, open city, both economically and culturally, while the most active groups in society began to grow accustomed to making their own moves in the absence of any government presence or action. This explains not only the leading role which Barcelona assumed, but also the important part played by the City Council in the twentieth century as the driving force of a country without its own political structures.

The Catalan bourgeoisie, although its policies and opinions were quite varied, could always count on a broad if undeveloped band of support in the city, as well as a team of more forward-looking political leaders, who intended to make Barcelona a European city. When their leadership seemed threatened, the demand for social order took precedence over the demand for reform; when they felt more secure they put reform in first place. This explains some of their changes of policy.

The powerful Republican movement had split over the formation of Solidaritat Catalana. While one group had joined the common front, the other, led by Lerroux, opposed it. There was an intense confrontation between the two groups, and each formed its own organisation; Lerroux founded the Partit Republicà Radical in 1908, while the others joined together as the Unió Federal Nacionalista Republicana in 1910. But when the prospect of far-reaching political change began to recede, the anti-political orientation of the growing CNT gained ground, and the resulting increase in electoral abstentions badly hurt the Republicans.

The electoral system (for the City Council and for Parliament) was based on majority rule, with representation of the first minority party. This obviously weakened the third party. The split of Solidaritat Catalana had led

to a situation where there were three main parties, with two republican alternatives, but after 1906 one of these had to be squeezed out, and the Catalanist Republicans were not strong enough to stand up to Lerroux, nor were they able to maintain a viable position as a third party.

On the other hand, the creation of the CNT gave the workers' movement a new anarcho-syndicalist orientation, which gave expression to the revolutionary will of the proletariat, especially after 1914 when it was again legalised. Its anti-political stance, the employers' rejection of social reform in the protective shadow of wartime prosperity, the substitution of propaganda for action, or for a movement of the growing masses, all these created a ferment of social struggle which made Barcelona the most important city of the Spanish left.

The revolutionary crisis at the end of the First World War combined with the internal pressures already active in Catalonia and Spain, and Barcelona became the city where much of the force for change was concentrated. In general the city opposed the central government. The bourgeoisie, which controlled the government, fought for reform without putting their own territory at risk; the democrats looked for a course of action that would lead to the formation of a republic; the working class longed for social revolution.

In 1917 a group of members of parliament met in Barcelona, since both major parties wanted to see an end to the system of alternating in power and hoped to demonstrate the necessity of a national government in which the Regionalists would also participate. However, the government stifled this attempt at reform. In 1918, after the Revolution had taken place in Russia and as it was beginning in Germany, while Europe was in chaos at the end of the war, the Catalan bourgeoisie launched a general movement for autonomy in an attempt to reach agreement with the Republicans, encouraged, certainly, by the provisions for national autonomy contained in Woodrow Wilson's 'Fourteen Points'. But the strike at La Canadenca power station and its aftermath led to Barcelona being placed under military rule, and again the alliance fell apart. In their frustration at this new failure, some Catalanist groups now rejected the possibility of collaboration, while others committed themselves to it still more wholeheartedly. Some were deeply impressed by events in Ireland, and Ireland also became a symbol for the most radical workers of Barcelona. In 1922 the Joventut Nacionalista (Nationalist Youth) broke with the Lliga and joined with scattered Catalanist republican groups to form Acció Catalana (Catalan Action), while radical Catalanism was taking form with Estat Català (The Catalan State), also established in 1922.

The beginning of the First World War and Spain's neutral position had sharply divided opinion: while the right sympathised with the Germans, the left was for France. At the same time, Barcelona became a centre of world prosperity, for with France incapacitated it was able to capture markets which the war had caused to grow rapidly. It was a time of fast and easy business, of speculation and a rise in production, but also a time of union struggles. It was a period of profound change in Barcelona.

The construction of Barcelona continued. An attempt to co-ordinate all the activity was made in Léon Jaussely's plan of 1905, though this was only finally enacted in a revised form in 1917, and Sarrià was not incorporated into the Municipality until 1921. On the other hand, improvements to the old city were undertaken, with the construction of a new commercial street, Via Laietana, running from the *Eixample* to the port and the railway station. The construction of an underground system was also begun. Meanwhile, with a constant flow of immigration, population continued to grow, reaching 723,375 inhabitants in 1921.

Barcelona's booming economy encouraged the bourgeoisie to try once again to give a lead to the reform of Spain, while the Republicans hoped to provoke a constitutional crisis, and the anarchist unions were determined to change society. But official Spain firmly resisted any change at all, and the bourgeoisie was reluctant to make any concessions to the working class, while the left was not prepared to forfeit any of its aspirations. The complex of confrontations and tensions thus produced made Barcelona a focal point for continuous social and political struggle, but it also became a lively centre of varied and intense social effort and activity.

Several groups during these years shared a desire to come closer to the rest of Europe, to stop being different and become 'normal'. 'Normalise', a verb which defined an era, meant to modernise, to bring up to date. Initiatives from the Mancomunitat, from the City Council and, especially, from private individuals contributed to a broadly based movement that drew a parallel between the material re-creating of the city and Barcelona's rediscovery of itself and its determination to work to reduce the gap which separated it from the more advanced cities – the will to become one of them, 'normal'.

In this context, at the same time as the last great contributions to *Modernisme*, a new cultural movement, which was given the name of *Noucentisme* (culture of the 1900s), began to develop. This new tendency, whose theories were expounded daily for more than ten years (1906–1921) by Eugeni d'Ors in his column 'Glosari' in *La Veu de Catalunya*, the Regionalist newspaper, was claimed as the movement of the new century. It promoted a new classicism, derived from the spirit of Mediterranean culture, in which the order, measure and simplicity of forms were to conform to criteria derived from a pastoral version of *Modernisme*. The movement saw the creative artist or writer as a guide and educator, and culture as something to be disseminated, while the classical bias

took precedence over the natural, the romantic or the spontaneous.

The whole programme of *Noucentisme* rapidly gained influence in the second decade of the century. It was loosely associated with the activities of the Regionalist government through the Mancomunitat, and closely connected with an older effort to give Catalonia and Barcelona modern institutions of all kinds. The creation of the Institut d'Estudis Catalans (Institute of Catalan Studies) in 1907 and the standardisation of the Catalan language (carried out by Pompeu Fabra) were two acts of vital importance to the literary and scientific use of Catalan.

There was also intense activity in the educational field. Republican concern with education, and the Regionalist desire to modernise educational structures, managed to operate in the vacuum left by the state, and they created new initiatives. If culture is freedom, freedom demands culture, and that requires education. Thus the Universitat Industrial was created, satisfying the need for specialised studies of a technical nature, and rationalist schools were founded, or were created by the municipal schools, the first of which was the Escola del Bosc in 1910. In 1916 the City Council established a commission of culture which changed the school system, already one of the most advanced in Europe, by creating municipal schools based on *noucentista* ideas. This move was of great importance in the reform and extension of the educational network. A training college for teachers, founded in 1906, already promulgated the new educational philosophy. The preoccupation with education was intense and was the expression of a new determination to place the Catalan school system at the forefront of European education.

Other aspects of this concern with culture and education were the Mancomunitat's creation of a school for librarians and the City Council's setting up of a municipal laboratory. But the most remarkable aspect was the initiative of many social groups in opening up access to culture in all its forms. These efforts not only satisfied a great part of the continually growing need for education and training in the ever more populous city, but they were also adapted to the needs of an expanding country – an area totally neglected by central government.

After 1918 social conflict in Barcelona reached extreme levels, with terrorist acts and provocations, especially after the creation of the Sindicats Lliures (Free Trades Unions) set up with the support of the employers. The criminal underworld was swollen with bands of men who had fought in the war on one side or the other and were at a loose end once the war was over. There seemed to be no possibility of government reform, and the Catalanist movement was split between the interventionists and the radicals, while the workers' movement was intent on its struggle. It was a critical situation in which no party – supporters of the government, bourgeois reformers,

democratic groups, anarchist unions – had sufficient power to carry through its policies, nor was any so weak that it could be ignored. Under these circumstances the army, which after 1917 had again shown its willingness to intervene, was a force to be considered and enjoyed some support.

Miguel Primo de Rivera, Captain General of Catalonia, carried out a coup d'état in 1923, which served to distract attention from the concern as to where the responsibility lay for the military disaster of Annual in the Moroccan war. He counted on the support of Catalan bourgeois opinion, for they saw in him an enemy of the politicians, loyal to the King, who would preserve the social order. The result was that stern measures for public order were reimposed, the underworld was cleaned up and the war in Morocco was brought to an end. However, the Mancomunitat of Catalonia was disbanded, and the municipal leadership of Barcelona was turned over to the old party bosses. The work which had been begun forty years earlier and had continued turbulently ever since was halted, but its spirit stayed alive.

Since 1894 a project had been under consideration for the construction of a great park on the north slope of the hill of Montjuïc. There were thoughts of holding a Universal Exhibition of Electrical Industries, and in the years before the Dictatorship the French gardener Forestier had laid out the gardens. In 1929, on the occasion of the International Exhibition, some fifteen palaces, a large number of pavilions, a stadium, a swimming pool and the architectural reproductions known as the *Poble Espanyol* (Spanish Village) were constructed. At last the bourgeoisie's great ambition to hold another exhibition was realised, although in a form different from that originally envisaged. The display, the effort and the great extension of the urban plan were at odds with the current tide of opinion; but the energy of the city made its mark all the same. The severe economic strain and the overly monumental buildings could not dim the great impact the exhibition had both on the international reputation of Barcelona and on the pattern of the city itself. Public opinion, however, was deserting the Dictatorship, and when this lost the support of the King, it finally fell in 1930, opening the way for the proclamation of the Second Republic.

The Second Republic: democracy and autonomy

The disintegration of the monarchist government after 1930 sharply divided the citizens of Barcelona. The municipal elections called on 12 April 1931 turned into a plebiscite about the monarchy, concerned specifically with the issue of the King's responsibility for the Dictatorship. Now, for the first time, the Lliga saw a chance to assume the leadership of Spain. The old political machinery of alternating parties had fallen apart, and it was possible to build up a new conservative party with the Catalan

87. Aerial view of the International Exhibition on Montjuïc, 1929.

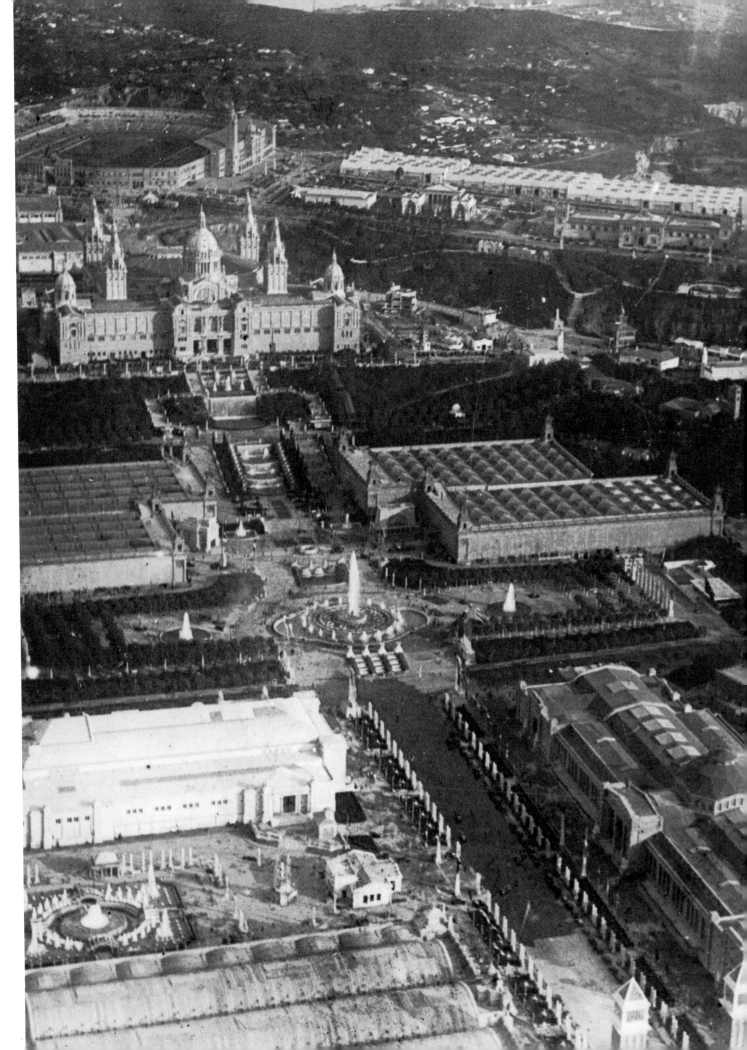

bourgeoisie taking the initiative supported by the veteran politician Maura and his adherents. The Spanish party Centro Constitucional was thus created in 1931, but it was unable to withstand the blow of Republican success in the principal centres of Spanish opinion.

In Barcelona a victory for the right had been taken for granted, and it was assumed that their main opponents (as in the period from 1909 to 1911) would be the Radical Republicans and Acció Catalana (who now had a Republican bias). Commentators certainly did not anticipate the success of the newly formed grouping of Radical Nationalists and Revolutionary Republicans, the Esquerra Republicana de Catalunya (Republican Left of Catalonia), which was also supported by the Anarcho-syndicalists.

But there was a new factor: the poll was very much higher than it had been in the past, higher even than it had been during the period of Solidaritat Catalana, and this changed the whole picture. Esquerra Republicana was victorious, and the Lliga came in second place, with the Radicals and Acció Catalana left out on a limb. The Republican majority in Barcelona was overwhelming.

When the results were known, the Republic was proclaimed in Barcelona on the morning of 14 April, before the revolutionary committee in Madrid had made its own proclamation. The change of régime occurred peacefully, without bloodshed, in an atmosphere of Republican and Catalanist euphoria. It brought with it the proclamation of the Catalan Republic under the presidency of Francesc Macià, though he later agreed to yield to the conclusions of a constitutional conference on the structure of Spain and to adopt the traditional name of Generalitat de Catalunya. In 1932 Catalan autonomy within the framework of an integral state, as defined by the Republican constitution, was established by statute. This set up an autonomous Catalan government in Barcelona for the first time and made Barcelona, for long the real capital of Catalonia, its official capital.

The period of peace during the Second Republic was marked by the interaction of the two major political camps into which Barcelona had been divided since the beginning of the century: the Lliga Regionalista, which was reorganised as the Lliga Catalana, and which adapted itself to popular democracy, and the Esquerra Republicana de Catalunya, which combined and led virtually the whole of the existing Republican and popular movement. Universal suffrage, which included women's suffrage for the first time, gave a majority to the left in Barcelona and in all Catalonia, while the Lliga maintained the support of the conservative sectors.

However, the political scenario would be incomplete without mention of the CNT, a political force active outside the electoral contest. The old anarcho-syndicalist leadership was supplanted by the more radical anarchist Federació Anarquista Ibèrica (FAI), which maintained a firm control of trade union leadership and practised the

89. Apa (Elias). *Barcelona 1930. 1,000,000 Habitts?*, 1930; poster urging citizens to fulfil their civic duty and register in the census. Institut Municipal d'Història, Barcelona.

90. Obiols. *Jordi. Setmanari Infantil*, 1927, poster advertising the children's weekly magazine *Jordi* (no. 172). 42.9 × 31.5 cm. Museu d'Art Modern, Barcelona.

88. Demonstration in Barcelona on Sant Jordi's day, 23 April, 1931. The once banned flag of the Unió Catalanista (decorated with Riquer's badge of Sant Jordi) is carried to the Palace of the Generalitat.

'revolutionary gymnastics' of insurrections. Various attempts by the Socialists and Communists to create a workers' party after 1931 were without success, and it was not until 1935, on the eve of the Civil War, that the Partit Obrer d'Unificació Marxista (POUM, Marxist Union Workers' Party) was formed. And the war had already begun when the Partit Socialista Unificat de Catalunya (PSUC), a union of Socialists and Communists, came into being in 1936, modelled on the unified parties developed by Communists in eastern Europe.

The anarchist revolts, general strikes and industrial strife which came to dominate the life of Barcelona were provoked in part by anticlericalism and, particularly, by the need for agrarian reform, and these became the great issues of the period, leaving their imprint on political life. The dispute of the Rabassaires (a left-wing agricultural union) led to a confrontation with central government after the right had gained power in Spain in 1933, for while there was now a centre-right government in Madrid, the Catalan Generalitat, presided over by Lluís Companys, continued in the hands of the left. In the general political conflict Companys took a federalist standpoint and on 6 October 1934 proclaimed the Catalan State in Barcelona, calling for a return to the pure Republicanism of 1931.

The success of the Esquerra Republicana in Catalonia and in Barcelona itself was based on its capacity to attract both the liberal and cosmopolitan centre-left and the working class which, while affiliated with the CNT, followed a more general left-wing ideology. This meant that there was no systematic electoral abstention by the majority of registered voters, but only by the Anarchists of the CNT, which was the principal though not the only leading group. This explains the electoral strength of the Esquerra Republicana in Barcelona in comparison with other parts of Spain, where the Socialist Party was one of its opponents in elections.

The Esquerra Republicana took its popular tone from the prevailing mood of the capital and from the popular tendencies towards social reform and a view of culture as a means of liberation, but it has to be seen in the context of the economic crisis faced by the City Council. This was caused in part by the financial consequences of the 1929 exhibition, for which some solution had to be found. One answer was to find alternative uses for the existing buildings rather than undertake any new construction. Thus one of the palaces of Montjuïc was converted to house the Museum of Catalan Art (opened in 1934),

which became the most important museum of Romanesque art in the world.

The city had continued to grow and the population had risen from 723,375 in 1921 to 1,007,820 in 1931, the main cause still being the immigration generated by the expansion of Barcelona. Organisations and projects continued to develop. The formation of the Grup d'Arquitectes i Tècnics Catalans per al Progrés de l'Arquitectura Contemporània (GATCPAC, Group of Catalan Architects and Technicians for the Progress of Contemporary Architecture), which planned the Ciutat de Repòs i de Vacances (Leisure and Vacation City) in Castelldefels, and of the Amics de l'Art Nou (ADLAN, Friends of New Art), was symptomatic of a general avant-garde attitude, so that in the field of art *Noucentisme* gave way to Surrealism and in architecture the Rationalism of Josep Lluís Sert and his associates superseded the former monumental Italianate styles. Thus the desire to make Barcelona a European city, a centre of culture in Spain and in Europe, was expressed in many ways.

The failure of the revolt of 6 October 1934 led to the trial and imprisonment of the Generalitat government and the suspension of the autonomous institutions of Catalonia. A government was appointed under a provisional régime in the hands of the right, and parliament was not allowed to convene. Thus, in the national elections of February 1936 opinion in Catalonia was divided not only between right and left but also between those who demanded an amnesty and the re-establishment of Catalan autonomy and their opponents. The triumph of the Front d'Esquerres de Catalunya, led by the Esquerra Republicana, united groups from the political centre on the one hand with the workers' parties on the other. This strong alliance made possible a significant victory for the forces of the left in the city of Barcelona, following a long tradition whenever there had been a high popular vote.

In 1936 social tensions increased in Spain as a whole much faster than in Catalonia, where in the spring a new attempt was made to stabilise the situation. But the military rising, the confusion of the conservatives in the face of events, the defence of the Republican constitution by the working class and the start of a revolutionary process in democratic Catalonia marked the beginning of the Civil War. During the war years, from 1936 to 1939, the city of Barcelona and the government of Catalonia, led by the democratic parties and the workers, remained one of the pillars of the Republic.

91. González. *Shouting head of Montserrat (no. 2), c.*1934/42 (no. 318).
Bronze, 32.5 × 30 × 20 cm. Museu d'Art Modern, Barcelona.

92. Vilaseca. *Arc de Triomf*, 1888.

The Universal Exhibition of 1888

Judith Rohrer

When the Queen Regent María Cristina officially opened Barcelona's Exposició Universal on 20 May 1888, to the accompaniment of a 432-gun salute from the international fleet of ships anchored in the harbour, it marked for the city the culmination of a year of feverish preparation. Symbolically heralding the entry of Catalan industry and commerce into the arena of European trade, this World's Fair stood also at the beginning of an architectural movement that Puig i Cadafalch would call the 'nova escola catalana' – a new school of Catalan architecture intent upon merging the forms and techniques of a noble regional building tradition with the advantages of modern technology.

Only a short year before the opening, the City Council, at the urging of its flamboyant mayor Rius i Taulet, had reluctantly agreed to assume responsibility for the floundering exhibition enterprise. At the time, work had scarcely begun at the fair site in the Ciutadella Park on the nothern edge of the expanding city, and the mayor's first move to salvage the project was to enlist the aid of the dean of the School of Architecture at the University of Barcelona, Elies Rogent. Rogent, in turn, assembled a design team of architects – most of them professors at the School – as well as a select group of recent graduates led by Antoni Gallissà to supervise day-to-day, on-site construction. At one point there may have been as many as thirty-three architects engaged on the project, prompting an anti-Exhibition humorous magazine to quip: 'In days of yore our leaders surrounded themselves with jesters for amusement; modern-day mayors surround themselves with architects.'

The grand semi-circular Palace of Industry designed by Jaume Gustà i Bondía was part of the earlier plan, and its foundations were already in place, but seven other major buildings and numerous smaller pavilions had yet to be designed and built on a budget that called for unprecedented resourcefulness. A particularly harsh winter and a strike by construction workers well into the project further complicated matters. That the fair opened on schedule with most of the buildings complete, or nearly so, was seen as little less than a miracle by some and a testament to Catalan enterprise by others. The majestic silhouette of Josep Vilaseca's *Arc de Triomf* (fig. 92), designed as the keynote monument, stood as the triumphant symbol of Rius i Taulet's vision and that of his politically conservative backers who had kept the faith despite a rising tide of scepticism and political opposition.

93. Domènech i Montaner. Gran Hotel Internacional, 1888.

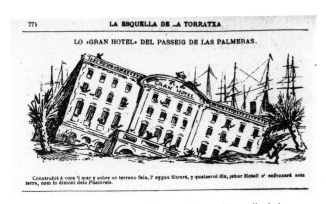

94. Cartoon satirising Domènech's Hotel, from *L'Esquella de la Torratxa*, Dec. 1888: 'Constructed beside the sea on artificial land, the water will seep through, and one day the Hotel will sink beneath the ground like the devil in a nativity play.'

97

Understandably, the fair architecture was generally undistinguished. Most of the structures were temporary and were simply ornamented in ways that vaguely recalled the exotic or the historic in keeping with the stylistic eclecticism current in Barcelona's architectural circles at the time. The poverty of materials and design was concealed by the addition of banners, festoons and flags, but most visitors who recorded their responses in the press agreed that the fair's greatest aesthetic asset was the Ciutadella Park itself. Josep Fontseré Mestres had landscaped the park in the early 1880s, elegantly combining a series of informal plantings, pathways and ponds with grand axial *allées*. Assisting Fontseré on the park project was the young Antoni Gaudí, who designed the iron sentinel gateways which would serve as entrances to the 1888 fairgrounds.

Exceptional among those structures built specifically for the Exposició, in terms of their originality and their impact on the future of architecture in Barcelona, were two buildings by Lluís Domènech i Montaner, a popular young professor at the School of Architecture specifically concerned with the assertion of regional particularities in architecture as a balance for the modern tendency toward universalism. The building that captured most of the limelight, in terms both of local and international interest, was his Gran Hotel Internacional on the palm-lined Passeig de Colom bordering the waterfront (fig. 93).

The construction of the hotel – a temporary, city-run hostel intended to accommodate up to two thousand visitors a day in luxurious fashion – was characterised at the time as a veritable 'Yankee' undertaking, and was completed 'with North American speed' in an incredible fifty-three days. Built on shifting infill ground, it was designed to 'float' on a reinforced concrete platform that broadened the foundation to stabilise the structure in a display of engineering bravado that was not without its sceptics (fig. 94). The building itself combined a light ironwork structure, visible on the interior amid the medieval tapestries and tilework, with hollow brick walls, which served to conceal the pipes, conduits, ducts and chimneys. Most of the structural and ornamental elements for the hotel were prefabricated. All of its dimensions were calculated to a single-brick module, eliminating the need for cutting at the site.

The hotel construction site, with its army of high-spirited workers one to two thousand strong, working day and night with the aid of novel electric lighting, soon attracted an admiring public, including the fifteen-year-old Puig i Cadafalch, who later recalled that it was there that he saw his 'first vision of that great Barcelona for which we are all working'. Gothic in style, but modern in spirit and construction, the hotel represented that mixture of conservative and progressive ideals that would guide both Catalanist politics and architecture well into the twentieth century.

Tradition and modernity were joined as well in the Café-Restaurant which Domènech designed for the fair (figs. 101, 102). To evoke a sense of a glorious Catalan history and tradition of commerce, he modelled this castle-like building on the medieval *Llotja*, or stock exchange, in Valencia, adding abundant sculptural ornamentation, ceramic tile inlay, ironwork filigree and festive awnings to complement the intricate brickwork patterning characteristic of Aragonese precedent. The progressive anti-Exhibition press mocked the medieval (i.e. backward) aspect of the Restaurant, suggesting that the waiters would have to wear chain mail and armour to feel at home; but despite the historically allusive exterior, the interior dining hall revealed a dramatic ironwork structure of diaphragm arches and suspended galleries.

The Restaurant was one of the few fair buildings meant to last, and Domènech's original design was far more elaborate than the building became as it was hastily prepared for opening day. Nevertheless, its castle-like massing and eloquent brickwork (along with that of Vilaseca's arch) became paradigmatic for a younger generation of architects in search of a locally (and politically) significant architectural language. Even more important to this generation was the workshop set up by Domènech and Gallissà in the north-west tower of the Restaurant building in 1890–2, with the idea of completing its decorative programme. While the building never attained the splendour of the original concept, the workshop became a focus for the arts and crafts revival in Barcelona, encouraging experimentation in ironwork, stained glass, ceramic tiles and decorative stone carving, which would be incorporated into both Catalanist and *modernista* architectural design for decades to follow.

95. Gaudí. Wrought iron entrance gate to the Guëll estate in Pedralbes,
made in the Barcelona workshop of Vallet y Piqué, 1885.

Architecture in the emerging metropolis

Oriol Bohigas

The principal theme in the history of the urban development of Barcelona between the two great exhibitions (1888 and 1929) is, without doubt, its transformation for the first time into a metropolitan conurbation and, through this, the change in the factors of its growth and configuration, the reversal in priority of its problems and the degree to which these were overcome by the solutions offered.

By 1888 Barcelona had already accepted and started to put into effect the scheme of expansion planned by Ildefons Cerdà in 1859, the *Eixample*, an essentially homogeneous plan – but subtly deliberate in its shaping of the social order – which transformed the small medieval walled town into a vast city which was to fill the whole plain – from the sea to the mountains and from river to river – in a clearly defined geographical unit (fig. 99). The planning control of the *Eixample* was naturally and clearly bound up with the prevailing system of building development and with the method of plotting the land. This meant a control which did not have to consider any revision of the urban design, because the street grid was sufficiently radical and the quantitative regulations precise. Exceptional problems – and as such, 'plannable' problems – were presented only at the boundary between the old town and the new *Eixample*, that is to say, in the urban restructuring of the old line of the city walls, not only because of their inherent form, but also because it was the hinge through which the inertia of the old centres of activity could be transferred effectively to the new town. The Rondes (boulevards on the line of the walls) and the Plaça de Catalunya were the two factors that modified Cerdà's scheme in order to realise this. The location of the 1888 exhibition in the Ciutadella, formerly the site of a military fortress, and the subsequent building of the park, was a response to the same concern to find a connecting hinge and to solve the problem of continuity; it was, therefore, to some extent, a project which, like the Rondes and the Plaça de Catalunya, contradicted the uniformity and the standardised generalisation of Cerdà's plan.

By 1929, on the other hand, there had already been distortions of scale, and the problem of the city was no longer basically that of controlling the extension and ensuring its bond with the centre, but that of grouping together autonomous units which had to be understood in absolutely new terms, in terms of metropolitan formation. Between 1897 and 1921 the successive incorporation of the eight surrounding towns – Gràcia, Sant Gervasi, Sants, Les Corts, Sant Martí, Sant Andreu, Horta

and Sarrià – into the Municipality of Barcelona was put into effect; these had formed the first circle of autonomous townships beyond the military posts outside the walls and had remained tied to the *Eixample* plan. However, the street pattern of the *Eixample* paid little attention – or was unrealistic in the face of the autonomous steps towards growth and integration – to the problems of joining up these centres, and often the real umbilical cords with old Barcelona, which followed lines based on historical usage and geographical disposition, had been erased or had lost their significance.

To tackle this, in 1903 – when the *Eixample* already contained almost four thousand buildings – the Barcelona City Council sponsored an international competition for a new town plan, which had to resolve the fundamental problem of adapting Cerdà's plan to the new metropolis as it actually existed. The French architect Léon Jaussely won the competition with a plan (1905) which attempted to impose, with a total unity of design, all such components and outward signs of a metropolitan centre as Paris, London, Berlin or Vienna had acquired over a whole century. These included elements that were highly superficial but were clearly intelligible to the new nationalist bourgeoisie, which was beginning to move from the aesthetic of the first phase of industrialisation towards one which reflected their claim that Barcelona had the status of a capital city. The ostentatiousness of Jaussely's style – and we should not forget how often he found the right answers to morphological and functional problems – was modified by Ferran Romeu and Ezequiel Porcel, who worked for the City, to a more modest 'Plan of Connections' (Pla d'Enllaços, 1917), which accentuated with greater realism the problem of the structural definition of a primary metropolitan area.

The International Exhibition of 1929 coincided with the presence of metropolitan problems, to which the long drawn-out preparations for the exhibition itself had also contributed. The vast demographic increase, due to the massive immigration of workers from the rest of Spain, especially from the less industrialised regions of the South, intensified the existing problems of housing and urban disintegration and the need for a new communications system. Perhaps the most significant elements in this new phase of growth were the installation of the first Metro line, the development of Cerdà's two great avenues, the Gran Via and the Diagonal – now given prime significance in the morphology of the metropolis, rather than fulfilling a purely local role – and the opening of the Via Laietana,

96. Sert and Yllescas. Apartment block, Carrer Muntaner 342–348, 1930–1.

97. Building the Via Laietana as part of the *Reforma* (improvement) of the city, 1909

98. Puig i Cadafalch. Project for replanning Plaça de Catalunya, 1922. Passeig de Gràcia leads from the top right-hand angle of the square.

cutting across a whole sector of the old quarter (fig. 97). This last development followed a tendency to remodel medieval structures which was common to the transformation of all the capitals of Europe at the turn of the century. The siting of the International Exhibition on Montjuïc, with its entrance opening on to Plaça d'Espanya, clearly emphasised this new reading of the town.

After the exhibition was over, Barcelona was faced with all the great problems of its suburban development, which extended far beyond the eight townships which had been incorporated into the municipality, and especially the problem of a lack of control over the outlying areas, where there was neither physical planning nor social organisation. There was now enough material to announce a new urban plan, with the theoretical formulation of radical solutions for the 'Functional City'. The architects of the GATCPAC, in collaboration with Le Corbusier, were responsible for the 'Macià' plan of 1934, which embodied the urbanistic theories of the CIAM set out in the Charter of Athens (1933): Cerdà's plan was supplanted not by Jaussely's stylistic surgery, but by changing the whole scale of the network in accordance with the ideals of the *Ville Radieuse* to cover the whole territorial complexity of the area (fig. 137).

But the essence of a city is not just its structural plan. Even looking at it from the point of view of a landscape, as an array of physical objects, there is the factor which denotes, as does the structure, the process of its social and cultural content: architecture understood in its typological development and in its stylistic evolution.

It has been suggested that the dates of the two exhibitions are also significant in this respect. For 1888 is the year in which – under the guidance of the venerable Elies Rogent, director of the Universal Exhibition – several young artists emerged who were later to form the *modernista* generation. 1929 is the year in which Mies van der Rohe built the famous German Pavilion at the International Exhibition (fig. 66), a key work in the history of European Rationalism. It is tempting, then, to see the two dates as points of departure for the two bursts of avant-garde architectural activity in Catalonia, that of *Modernisme* and that of Rationalism. However, this would be inaccurate. In fact at the 1888 Universal Exhibition there was still no work which might be considered as truly belonging to *Modernisme* – which did not come to maturity until the first decade of the twentieth century. The majority of the exhibition buildings still betrayed the uncertainties of historicism in search of a style. And at the 1929 exhibition the only modern building was the German Pavilion – and a few other examples which were also foreign – while the Catalan contribution was a confused showcase of a whole series of conservative or old-fashioned styles which had continued to survive throughout those years. Only with the Second Republic and the period of Catalan autonomy did the architects of

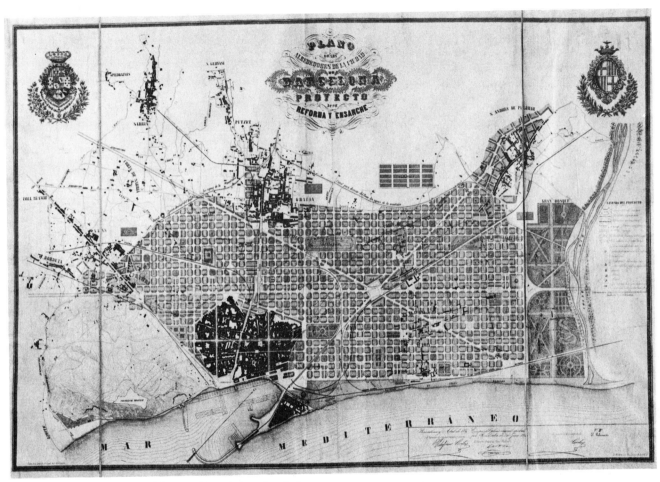

99. Cerdà. *Plan of the environs of the city of Barcelona and project
for its improvement and enlargement*, 1859 (no. 51).
Lithograph (1861), 77 × 115 cm. Museu d'Història de la Ciutat, Barcelona.
The Cerdà plan for the *Eixample* consists of a square grid 133 m × 133 m
with 20 m wide streets, cut through by two large diagonal avenues.
Despite its rigid formality, Cerdà allowed for extensive gardens and
parks, with buildings generally occupying only two sides of each
'island' – but this was the aspect of the plan that fell victim to the
interests of landowners and developers, so that most of the 'islands'
became built-up blocks with even the interior courts filled with
warehouses and other commercial buildings.

100. The 'Manzana' de la Discòrdia (Apple/Block of Discord – *Manzana* in Castilian has both meanings) on Passeig de Gràcia, which shows the variety of styles of the principal *modernista* architects. Domènech's Casa Lleó Morera (1905), now badly mutilated, is on the left of the block, the gabled front of Puig's Casa Amatller (1898–1900) is towards the right, with the Casa Batlló (1905–7) by Gaudí next to it.

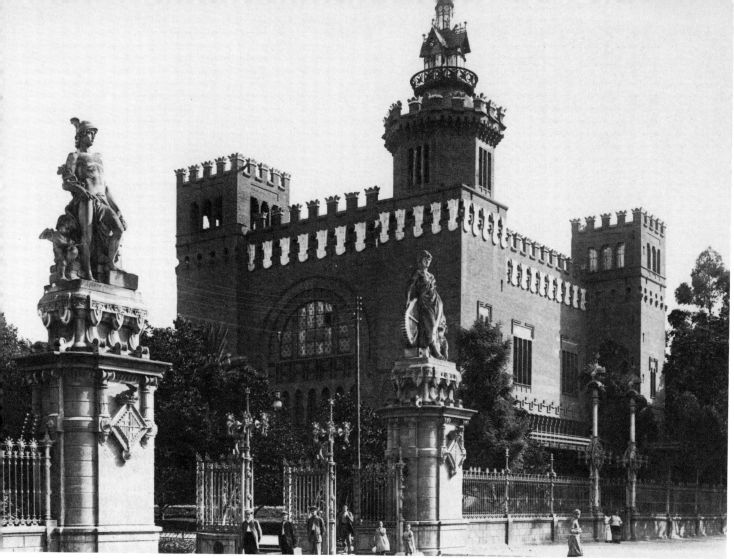

101. Domènech i Montaner. Café-Restaurant built for the Universal Exhibition, 1888.

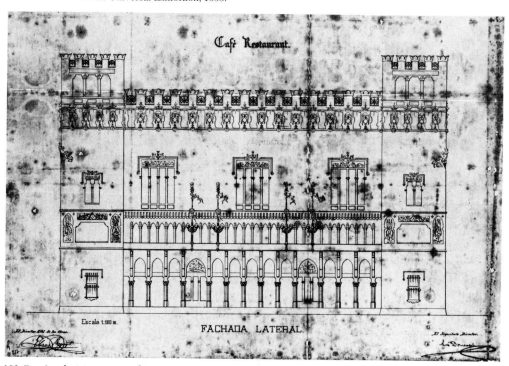

102. Domènech i Montaner. *Café-Restaurant (elevation)*, 1888 (no. 65).
Ink on paper, 42 × 60 cm. Col.legi d'Arquitectes de Catalunya, Barcelona.

the GATCPAC, led by Josep Lluís Sert, take up arms for modernity in Catalonia.

What is beyond question is that the central period between the two exhibitions is marked by the cultural imprint of *Modernisme*, especially during the first fifteen or twenty years of this century. And *Modernisme* – although it was not the exclusive style of the period – was its most significant and most original architectural achievement.

It is not a simple task to enumerate the stylistic characteristics of *Modernisme* in architecture, or to define clearly its significance and its cultural role, because it is easy to generalise and see it as a movement rather than as a style, embracing trends which have little in common, except that they share the same spirit of cultural unity and of progressive social and political ideas. To make a clear definition, we need to restrict the time-span and determine its original limits.

On the one hand there was the influence of both *Art Nouveau* from Brussels and Paris and of the Viennese *Sezession*, and this conditioned the whole outlook of the movement as much as it influenced the actual appearance of the less original and more mannered works. It can even be said that Secessionist principles can be found in Catalonia over a long period, especially, perhaps, in the more conformist works and those designed by architects most willing to compromise with tradition – a situation which does not in the least contradict the prescriptive spirit of the school of Otto Wagner. Indeed, many of those who were declared *Antimodernistes*, like Josep Domènech i Estapà, made polemical use of the Secessionist repertory without ever realising that it was a variant of the very movement they were attacking.

On the other hand, we must accept some original features in *Modernisme*, which distinguish it – in ways which correspond to the specific historical, geographical and cultural circumstances – from other European movements. These features fall into two related categories, which express respectively the spirit of rationalism and the spirit of expressionism. Both positions had already been present for some years – often in conflict despite their relationship – in the various stages of the avant garde. There is no need to define them in detail here; it is enough to say – despite what has too often been suggested in the past – that the rationalist line was presided over by Lluís Domènech i Montaner, with his insistence on modern structures and systems whose laws dictated form, while the expressionist line was represented by the genius of Antoni Gaudí, in whose work form is dictated by its own dramatic imperatives and by the vigorous redeployment of systems and materials.

However, there is a great deal of architecture which, although it is related to the two strains of *Modernisme* defined in this more narrow sense, comes closer to eclecticism.

103. Nebot. Cine Coliseum, 1923; photographed in 1927.

104. Goday. Collasso i Gil School, 1932; photographed in 1935.

105. Sert, Torres Clavé and Subirana. Dispensari Central
Antituberculós, 1934–8 (cf. no. 244).
The clinic stands next to the baroque church of the Mercè in the old
quarter of the city.

One kind of eclecticism, which is overtly historicist in character, is relatively easy to define. The superficial stylistic characteristics of Gothic, Egyptian, Romanesque or Islamic were brought into competitive equilibrium with the so-called classical repertory, and this phenomenon became characteristic of academic architecture in the second half of the nineteenth century, which sowed the seeds of a change in the direction of modernity, but still lacked a coherent stylistic formulation. There are not many examples of this kind of eclecticism in Barcelona, undoubtedly because this composite system was mainly used for the large, monumental buildings typical of European capital cities, buildings which, for obvious social and political reasons, were not common in Barcelona. The University and the new façade of the Cathedral are, however, good examples.

But there are many buildings to be found throughout Catalonia that embody the systematic use of types of façade which transcend the idea of *mimesis* and are adapted to the modesty of the buildings' functions – and even to the professional modesty of the architects – as well as to the potential of the new technology. Despite often being classified under the general heading of eclecticism, these buildings have nothing eclectic about them – and very little historicist – because they consolidated a systematic code of forms and relationships which had few historical precedents.

This stylistic repertory is found in the modest homes of the petit bourgeoisie, in houses in rural areas and in industrial buildings and civil engineering structures. While the architects of the urban élite continued with their interpretation of historical styles or involved themselves in the daring novelty of *Modernisme*, the more modest architects, the master builders, the engineers and country bricklayers accepted a formal code which was based originally on the art of good construction, the logic of old skills and new technologies and a repertory of plans more dedicated to construction than to functional innovation. That is to say, a code which provided immediate and stereotyped solutions and which emphasised, as such, the homogeneous features of the style.

This stylistic content has not been adequately studied, despite being one of the most typical elements in defining the image of the frontages of European – and also American – towns. This is because it has been underrated in the context of historicist eclecticism, *Art Nouveau* and its parallels and the monumental ostentation which culminated in the style of the Second Empire. If we were to attempt a philological analysis, we would certainly find the basis of its compositional grammar in the iconography of Arts and Crafts, in the graphic resources of the Aesthetic Movement, in the manuals and manifestos which stemmed from Muthesius's book *Das Englische Haus*, or in the vernacular references in European and American regional architecture.

This stylistic trend is frequently present in Catalonia – and, especially, in Barcelona – and its characteristics changed considerably over the course of a long period of development. At first it can be linked with the same historicist eclecticism, and it can even be defined as the somewhat romantic architecture of the *Renaixença*. Many works by Joan Martorell, for example, can be seen in this light. Later it has a more independent existence in the works of master builders and in many factory buildings, often with a highly traditional use of thick brick in walls and arches and of iron in supporting structures and roofs. It also influences that strain of *Modernisme* we have defined as rationalist. The early work of Domènech i Montaner is very close to it and it has affinities with the buildings of Joan Rubió i Bellver (fig. 114) or Lluís Moncunill (fig. 115). Finally, there is a whole area which is usually included within *Modernisme*, and which can only be explained by its relationship with the last sparks of historicism, combined with references to English and German architecture of the pioneering period and with the evident desire to express both good craftsmanship and the logic of materials. The group which was effectively led by Josep Puig i Cadafalch in his first period is a good example of this.

However, there is still more evidence of the stylistic complication of this period. Beside the progressive trends which, in various contradictory ways are expressed in *Modernisme* and eclecticism, there is the survival of a pseudo-classical language in the academic precepts and formulae of monumental buildings. The model is always French, and goes from *pastiche* of the Second Empire, to the more ostentatious buildings of the 1920s, which came to establish in Barcelona a kind of architectural testimony to the cultural level of the Dictatorship of Primo de Rivera. This is clearly exemplified in many of the palaces built for the 1929 International Exhibition – beginning with the one which presided over the monumental axial avenue, the Palau Nacional, by Pedro Cendoya and Enric Català – or by the body of work by Francesc de Paula Nebot (fig. 103) and Eusebi Bona. At the same time, more modest architecture also mimicked classical models, filling in the gaps in the *Eixample* between the ambitious showpieces of the *modernista* masters.

However, one short but significant phenomenon within this classicising tendency must be singled out: *Noucentisme*. The model for this was not Parisian splendour, but the restraint and good taste of the Italian tradition. The ideological basis was not the empty and insubstantial apparatus of a Spanish provincial capital, but the renewal of the great myth of the Mediterranean in the desire to create a *Catalunya-ciutat*, the capital of its own culture and politics. If in painting and literature *Noucentisme* assimilated elements of modernity – as, at the same time, the *Novecento* did in Italy – in architecture it was often confined to a few poorly defined experiments. On the one hand it remained attached to certain traits of *Modernisme*, while on the other it grasped intuitively some of the more dubious aspects of *Art Deco*. If in Girona this interesting mixture resulted in the magnificent work of Rafael Masó, in Barcelona it was almost entirely confined to the institutional architecture of Josep Goday (figs. 104, 186) and a few works by Josep Maria Pericas.

It is a varied and colourful picture, as we have seen. The *Eixample* was the framework on which the tangled stylistic web had to be organised, and this was in fact achieved, despite the fact that the new breed of speculators in apartment blocks, built to accommodate the new forms of urban production in the metropolis – had reversed many of the structural qualities of Cerdà's plan. Today, in the modified form in which his plan has survived and in the quality of many examples of Barcelona's varied architecture, we can read the exciting story of a city which, between the two exhibitions, established the basis of its metropolitan status.

106. Remains of the Roman walls of Barcino to the north east of the *oppidum*,
with the towers of the *Barri Gòtic* (medieval quarter of Barcelona) behind.

The rediscovery of ancient Barcelona

Josep Guitart

The city of Barcelona takes its origin from the colony *Iulia Augusta Paterna Faventia Barcino*, founded by Augustus shortly before the Christian era, possibly between 15 and 13 B.C. The present metropolis of Barcelona, therefore, has the good fortune to combine the dynamism and vitality of a modern city, designed for the future, with the perspective and sense of permanence gained from so many centuries packed with history. And its origins and history have left a clear imprint on the shape of the city and on the character of its citizens.

It was only to be expected that the surge of Catalan culture at the turn of the century would provoke an interest in the systematic study of ancient Barcelona. The historical interpretation of its origins and the recovery and evaluation of its archaeological remains at that time were made under conditions and within an institutional framework that encouraged proper scientific study, rather than the learned speculation that had been the norm in the past.

This is not to say that there had been no interest in Roman antiquities in Barcelona before that time. The careful study of the Roman temple and the survey of the fortified precinct carried out around 1835 by the architect Antoni Cellés and his pupils under the patronage of the Board of Commerce show clearly both the interest and the quality of archaeological analysis that were achieved.

However, despite the interest in many intellectual circles in the remains which illustrated the physical reality of the city in the first years of its existence, they had to accept the destruction of a good part of the Roman walls during the nineteenth century. Many sections were demolished in successive improvements to the planning or drainage of the oldest quarters, partly influenced by the campaign to demolish the more recent walls, which symbolised the oppression of the old régime. This led to Barcelona losing its traditional fortified appearance during the second half of the nineteenth century.

The methodical historical and archaeological investigation of Roman Barcelona did not in fact start until the *noucentista* period, as a result of the climate created by the Secció Històrico-arqueològica of the Institut d'Estudis Catalans, founded in 1907, a body which, from the first, embarked on the systematic organisation of the study of prehistory and archaeology in Catalonia. Their efforts in Barcelona are a token of the energetic and thoughtful approach they adopted in this field: F. Carreras Candi published a study in 1916 (in the first volume of his *Geografia General de Catalunya*), which was a serious

and original analysis, interpreting the historical and archaeological data available and giving a vivid picture of the earliest periods of the city; while a summary and study of the known architectural remains of old Barcino was included by Puig i Cadafalch in his work on Romanesque architecture in Catalonia.

But the first use of modern archaeological methods with scientific excavation was due principally to A. Duran i Sanpere, who had been associated with the Institut d'Estudis Catalans since 1912. Starting in 1920, while he was director of the Arxiu Històric de la Ciutat, he put in hand plans to explore the archaeological layers beneath Barcelona. The first excavations (the majority of them urgent rescue operations) were relatively limited and involved a number of different sites in the old centre, but there were also a number of important undertakings apart from these, including the exploration of the slopes of Montjuïc at the time of all the construction work in preparation for the International Exhibition of 1929.

The many city projects undertaken in the optimistic atmosphere prevailing during preparation for the exhibition also provided the occasion for the beginning of extensive archaeological work within the precinct of Roman Barcino. Thus, when a modern building in the Plaça del Rei was demolished, rather than leave an empty space, it was decided to preserve the appearance of the square by moving the Padellàs house, a fine old building, itself condemned to demolition by the works associated with constructing the Via Laietana. The work on preparing the foundations for rebuilding the house on the new site revealed extensive antique remains, and public opinion was quickly roused to ensure that a full archaeological exploration of the site was made before building work began. The excavation laid bare for the first time the interior facing of a long section of the Roman wall, showing a street, or *intervallum*, following the line of the wall within the city and extensive remains of buildings. As a result of this success, the project was extended over the whole of the Plaça del Rei, and despite much partial disturbance of the subsoil in medieval and modern times, the results were very positive: walls, columns, tiled pavements, storerooms and *dolia* (storage jars) enriched the archaeological and topographical evidence of old Barcino.

For the first time a full excavation on scientific principles had been possible in Barcelona, and even though the work was interrupted by the Civil War, and the remains which had so far been unburied were covered again to protect them, proof had been given that Roman Barcelona

The rediscovery of ancient Barcelona

107. Remains uncovered by excavations in the Plaça del Rei in 1934.

108. Map of Barcino by F. Pallarès (1975). It shows both the regular ground plan and walls of the Augustan city and the late Roman walls, part of which still survive. The section of the walls seen in fig. 106 appear at the upper left of the plan, and the excavated area in fig. 107 is shown immediately below this section of wall.

could be systematically revealed by archaeological methods, and that this could be rewarding and successful, and could make a valuable cultural contribution. One opportunity which might have been seized – and which time has shown could never now be realised – was to have allowed the Roman city to have its own monumental, cultural presence within the complex web of modern Barcelona. This could have allowed us to get to know the basic characteristics of the original centre and to try and understand the full significance of its origins and the factors which affected it.

Speaking about the origin of a city like Barcelona two thousand years ago may seem like nothing more than learned speculation, but when we look at the continuity maintained through all these centuries of history, there are grounds for believing that the basic conditions of the Augustan foundation which shaped the personality of the city are still alive today and continue to be effective, despite the colossal transformations of the past hundred years.

Archaeology shows that the original settlement was an *oppidum* fortified by a two-metre wall of average width, constructed by using the technique of *caementicium* with a facing of *opus vittatum*. The walls with their seventy-eight flanking towers are the most monumental survival from the Roman period, but in their present form (there are several sections that can be visited) they represent a strong fortification constructed at the end of the third century A.D. Until recently, scholars and archaeologists writing about the Roman city believed the whole fortified precinct to date from this period, and in the absence of firmer evidence presumed that the Augustan foundation had covered a larger area, with a longer perimeter. Recently, studies by F. Pallarès and O. Granados have shown that the third-century wall did in fact abut on to an earlier wall which belonged to the Augustan period of foundation, so that both follow exactly the same line (fig. 108). We now know that the original perimeter wall was 1,220 metres in length and described a slightly elongated obtuse-angled trapezoid. The whole walled area covered only just over twenty-five acres (10.4 ha.).

The interior of the city was reached through four gates placed on the two main axes, and the city plan seems to have been of regular axial type derived from the plan of a camp. The streets were designed on a grid plan with square blocks (*insulae*), and the intersection of the two main axes was slightly to one side of the centre.

The buildings of the city were dominated by the temple of Augustus, from which three original columns with their capitals are still preserved *in situ* at no. 10 Carrer Paradís. It was a peristyle temple with porticos of six columns and was of considerable size, particularly in relation to the total area of the *oppidum*.

We do not know the detailed arrangement nor the exact measurements of the forum, which according to the

plan of the city must have been on a site corresponding to the present Plaça de Sant Jaume. Pallarès has suggested that there was another temple placed symmetrically with the first one, both presiding over a large forum of regular plan which occupied the space of eight *insulae* and around which the main public buildings of the colony were arranged. To the north west of the forum, between the forum and the walls, lies the part of the city which has been most fully excavated and best preserved, beneath a group of medieval buildings: the chapel of Santa Agada, the Tinell, the Plaça del Rei and the Arxiu de la Corona d'Aragó. This whole archaeological layer is connected with a part that can be visited within the Museu d'Història de la Ciutat, installed in the Padellàs house, and it is a site of considerable interest, both for the pleasure of coming into direct contact with the archaeology of Roman Barcino and for the enjoyment of an ideal museum installation.

The foundation of the colony of Barcino has a clear place within the systematic reorganisation of the provinces of *Hispania* which was completed by Augustus. But as regards the population of the surrounding area, it appears rather to have been an assembly point than to have marked the beginning of a Roman presence imposing itself on the existing population. Indeed, the territory of the Laietani (which roughly covered the coastal strip and some inland areas of the present Region of Barcelona), in which the new colony of Barcino was founded, had been the scene of much activity during the first eventful centuries of Romanisation. The most recent investigations in this area of *oppida* and villas dating back to the Republican period suggest that Barcino was founded as the culmination of an intense Romanising process, which was already well developed, and which had been characterised by dense agricultural colonisation, in which large numbers of emigrants from Italy had taken part. Many of them were probably veterans of the Roman army, and the emigration took place in the context of the agricultural problems of the last century of the Roman Republic. The *ex novo* foundation of urban centres (*oppida civium Romanorum*, according to Pliny) such as *Baetulo* and *Iluro* from around the year 100 B.C, shows that there was already a considerable presence of Roman citizens in the region, but these urban centres lacked the legally constituted organisation which would ensure the Roman population remained tied to and able to participate in the Roman community as a whole.

The foundation of the colony of Barcino thus surely imposed a legal regularity on the situation, since apart from any new citizens whom Augustus may have assigned to the new colony, the numerous Roman citizens already present and settled in the region – who had formed communities in existing urban centres which continued to lead their own urban lives undisturbed during the early Imperial years – were legally attached to Barcino.

This relatively new interpretation, made possible by the rapid progress of field archaeology in the region in recent years, also helps to explain two important characteristics of the city of Barcino itself, which are of vital importance for the future history of the city: the modest dimensions of its fortified precinct, and the disproportionate monumentality of the city plan and of the public buildings at the time of its foundation. This is quite satisfactorily explained if we believe that the foundation of Barcino, rather than establishing a large new group of Roman citizens in the area, attempted to impose administrative control (within the legal colonial framework) and give constitutional rights to the numerous citizens who had probably been settled in the region for many years, without their having to take up residence within its fortified precinct.

Barcino, then, was founded in order to develop as a religious, political, and administrative centre for a colony whose territory covered all the land of the Laietani, and the structure of this territory was defined from the moment it received a capital – which accounts for the plan and monumentality of the city itself. Barcino continued in the same role without major changes throughout the high Imperial period, without developing into a residential centre, which would undoubtedly have produced considerable growth outside the walls. The fortifications of the third century A.D., on the site of the walls of the original foundation, are proof of that continuity.

The geographical situation of the territory of the Laietani as a meeting-point of the lines of communication of a large portion of the land that corresponds to present-day Catalonia must certainly have provided political and administrative reasons to persuade the Roman authorities to found the colony of Barcino. Consciously or unconsciously, they aimed at a division of functions between the two colonies in Catalonia: Tarraco (Tarragona) was essentially the capital of the *Provincia Hispania Tarraconensis*, while Barcino, with its immediate territory, soon assumed the leadership of a considerable part of the Catalan territories south of the Pyrenees.

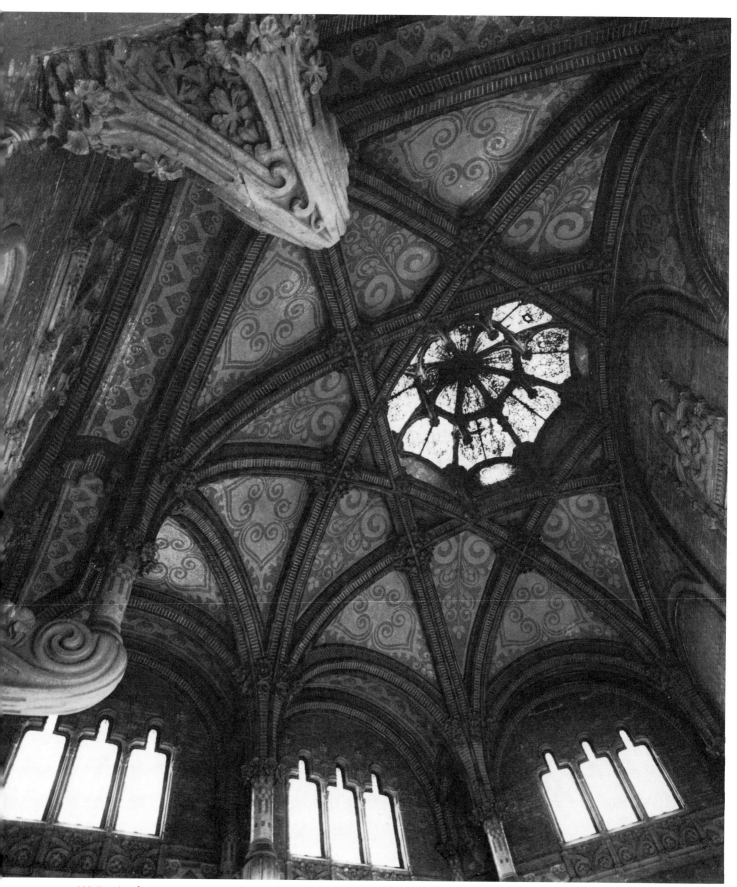

109. Domènech i Montaner. Interior of Hospital de Sant Pau, 1902–12.

Modernista architecture

Ignasi de Solà-Morales

A universal plan

The determination to supersede the eclecticism which characterised the architecture of the second half of the nineteenth century was shared by most of the architects who began to graduate from the new School of Architecture of Barcelona founded in 1875. On the one hand there were the calls to develop a 'national architecture', on the other an eager desire, common to all areas of artistic endeavour, to go beyond the classified repertory of styles laid down and approved by the positivism of the historicists.

Architecture shared in the general aspiration of Catalan society to express its greatness in the past and in the modern world. It sought to do this by recovering the exoticism of colour and light of oriental architecture and of the Moorish and Mozarabic traditions in Spain, in order to establish a repertory of images which were not only new themselves but were also capable of expressing the desire of the new industrial society of Catalonia to be both modern and cosmopolitan.

What is known as *modernista* architecture embraces several quite different intellectual and stylistic trends. It includes the work of almost three generations of architects, whose political positions and artistic convictions were often quite far apart, so that they do not appear to form a homogeneous group. However, the term is today so well accepted, despite problems of definition, that it is a useful label for a body of architecture which departed from pure eclecticism and from academic methods, and which, with the collaboration of artists and craftsmen of all types, unquestionably succeeded in achieving an indigenous character.

Strictly speaking, *Modernisme* was originally a theological movement, and the term then came to be applied to a literary movement, although its wider meaning is now clearly understood. However, there was little if any consciousness on the part of architects between 1888 and 1908 that they were *modernistes*, and it is only much later that parallels between architecture and contemporary literary and philosophical movements have led to the extended usage of the term.

But we can detect (even if this is a limited way of understanding artistic creation) a similar climate, whose common elements included a taste for expressive symbolism, a confidence in technology and modern scientific discoveries, the adoration of the art of Richard Wagner, and a leaning towards *fin-de-siècle* decadence, alongside an idealistic Catalanist nationalism.

In the cultural development of the progressive Catalan bourgeoisie in the last third of the nineteenth century two radically different attitudes can be identified. The first is represented in architecture by those architects who had unshaken confidence in the material and civic progress to be achieved by the economic development created by capitalism, and who were conscious of the significance of what was being achieved in Catalonia in the context of progress in other great European centres at the same time. They became involved in the growth of political Catalanism and contributed to the ever more rapid construction and enlargement of the city of Barcelona, and they developed a universal view of architecture: technically experimental; optimistic in its forms of decoration; expressing a positive conception of the totality of the work of art; and constructed specifically for the new institutions of society and for the new ruling classes. The principal architects of this school include Lluís Domènech i Montaner, Antoni Gallissà, Josep Vilaseca, Pere Falqués, the brothers Bonaventura and Joaquim Bassegoda, Josep Domènech i Estapà, Camil Oliveras, Josep Puig i Cadafalch, Joaquim Raspall, Salvador Valeri, Jeroni Granell and others.

But there was another group of architects whose social and ideological beliefs led them to a quite different attitude towards the practice of architecture. Influenced by the church's reaction to modern society and to changes in the patterns of urban life, they proposed visionary rather than radical solutions. Architecture was given a utopian significance and was proposed as a cure for what were considered the great errors of western civilisation. The inspiration for this point of view was ecclesiastical, and all the architects were moulded by the theological and aesthetic views of clerical circles, whose response to what little they understood of modern urban life was uncompromising rejection, expressed in sententious judgements and moralising precepts.

The central figure of this school is Antoni Gaudí, the outstanding architect of the period and the author of works of an unparalleled force and drama. Around this unique figure, whose personal life was also very unusual, was grouped a band of followers, fascinated by the persuasive manner of the master from Reus: Francesc Berenguer, Josep Maria Jujol, Joan Rubió, Bernardi Martorell, Jeroni Martorell, Cèsar Martinell, Lluís Moncunill and Manuel Sayrach are some of the outstanding names in the Gaudí circle.

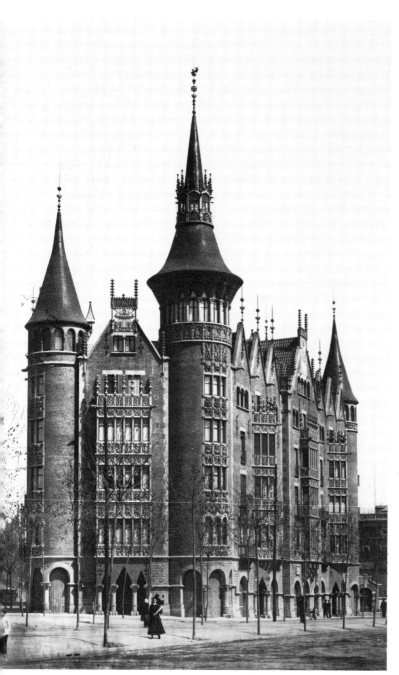

110. Puig i Cadafalch. Casa Terrades ('Casa de les Punxes' – House of spikes), 1904–5; photographed in 1906.

Architecture and industrial arts:
Lluís Domènech i Montaner and Antoni Gallissà

Lluís Domènech i Montaner (1850–1923) is the figure who best represents the first type of Catalan *modernista* architect. He received his diploma from the School of Architecture in Madrid in 1873 (the school in Barcelona had not yet opened) and soon gained a high professional reputation. At the same time his learning and his work as a historian led him into public life, where he was wedded to the cause of political Catalanism. The work of Domènech i Montaner has more affinities with other contemporary architecture than that of any of his fellows. Like Otto Wagner in Vienna, H. Petrus Berlage in Amsterdam, Victor Horta in Brussels or Louis Sullivan in Chicago, Domènech tried to find a point of synthesis between the incorporation of modern technology and invention on the one hand, and loyalty to the native vernacular tradition on the other, through the agency of an elegant and spectacular use of the decorative arts.

While he referred to historical styles, his architecture is never historicist, and Domènech's most impressive qualities are the solidity of his compositions and the clear articulation of his designs, which display a rational approach that comes from the best academic tradition without ever being rigid or mannered in the way that so much architecture had become.

The combination of this quality with bold technical innovation is demonstrated in his free use of great metal structures, as in the Palau de la Música (1905–8, figs. 123–5) or in the Café-Restaurant built for the Universal Exhibition of 1888 (figs. 101, 102). But we can also see it in his employment of traditional solutions, such as covered vaults, walls of structural brick or structures based on arches composed of stone and ceramic. In these, he takes the structural possibilities of the methods of construction to their limits, something that could only be done by an architect who had complete confidence in modern methods of static calculation as applied to construction.

Domènech's technical abilities were matched by his intellectual qualities as a historian. As Professor of Composition in the recently founded School of Architecture, his courses were remembered as illuminating by all of his students. He offered an unending fund of ideas in his personal synthesis of historical knowledge and his analysis of every major architectural topic as well as of the technical and ornamental details of architecture of all periods. He was also ready to consider a wide range of solutions and was able to employ his rigorous and disciplined method to unite in a single plan ideas that derived from widely different sources.

The Café-Restaurant for the 1888 exhibition, the Palau de la Música – his most innovative, successful and, as an architectural experience, most emotional work – the Hospital de la Santa Creu (1902–10), the Psychiatric Institute Pere Mata in Reus (1897/1919); the Thomas (1895–1910),

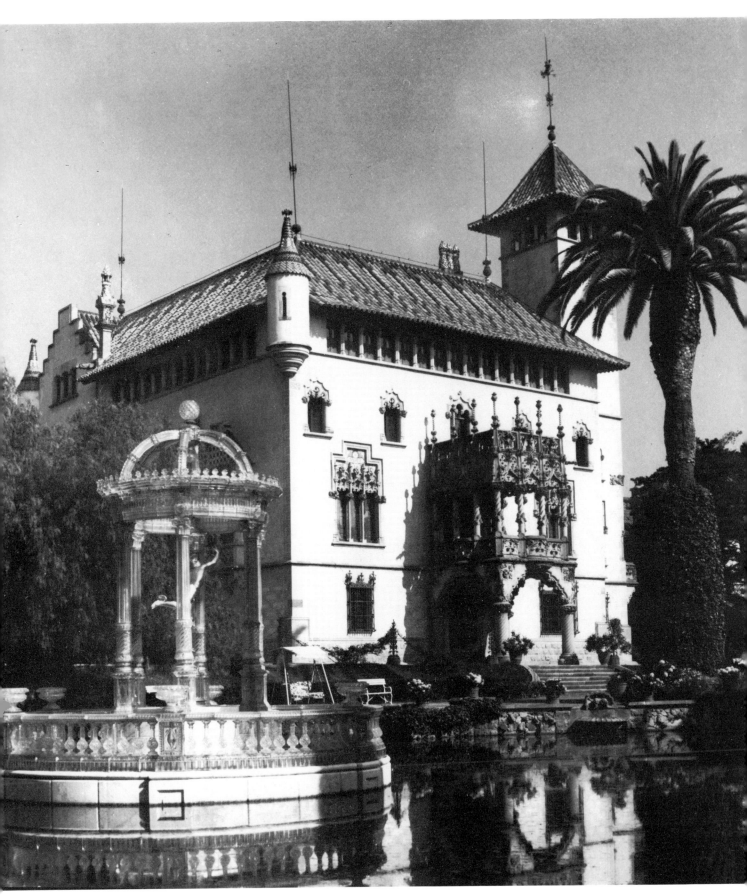

111. Puig i Cadafalch, Casa Garí ('El Cros'), Argentona, 1900.

112. Gaudí. *Casa Vicens (façade)*, 1883 (no. 89).
Ink on linen, 46 × 64 cm. Institut Municipal d'Història
(Arxiu Municipal Gràcia), Barcelona.

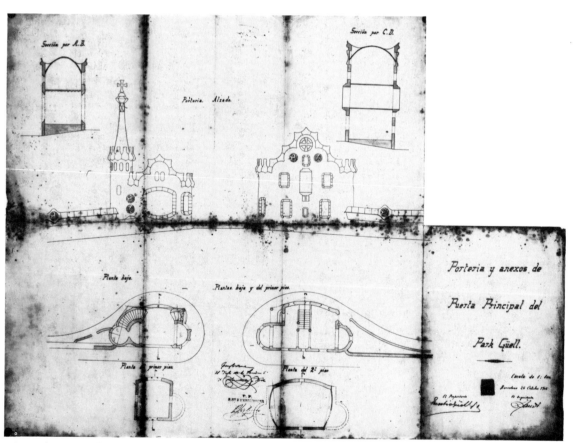

113. Gaudí. *Parc Güell, lodges by the main gate
(sections, plans and elevations)*, 1904 (no. 92).
Ink on linen, 63 × 85 cm. Arxiu Administratiu
de l'Ajuntament de Barcelona.

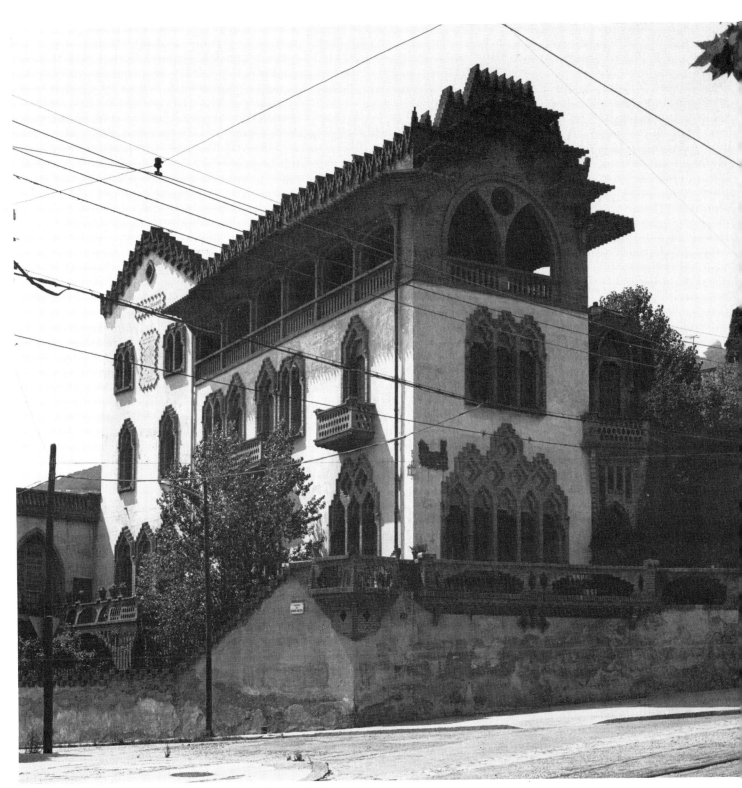

114. Rubió. Casa Roviralta ('El Frare Blanc' – The white friar), 1903–13.

116. Berenguer and Gaudí. Güell wine vaults at Garraf, 1895–*c*.1900.

115. Moncunill. Aymerich i Amat factory, Terrassa, 1907.

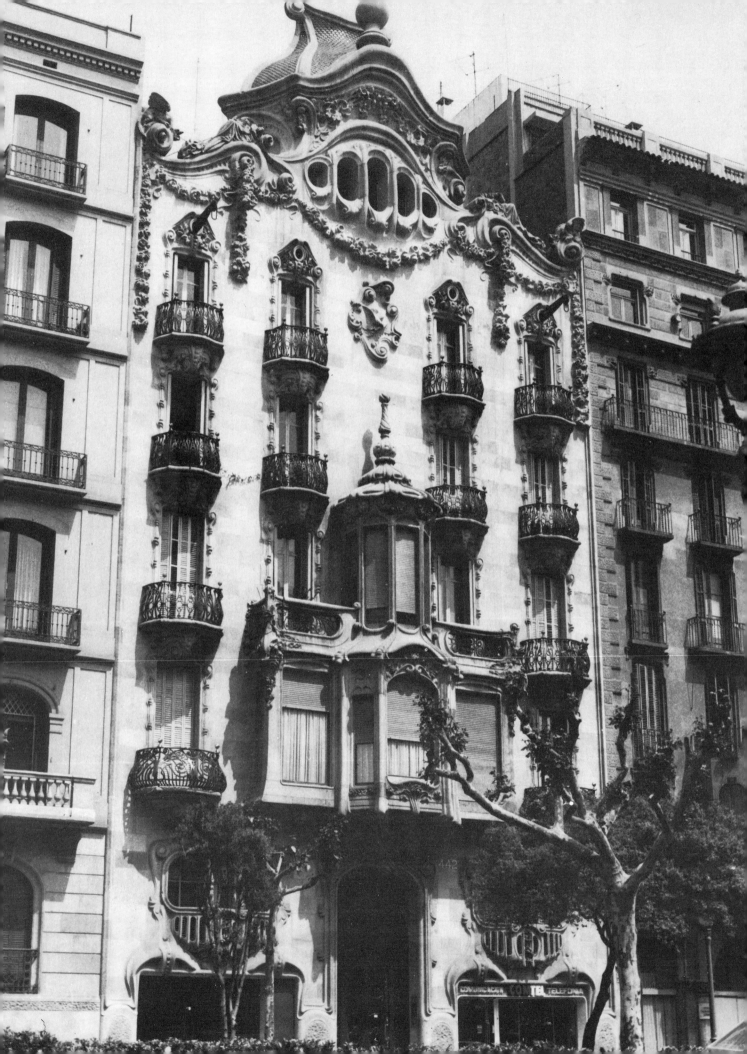

Lleó Morera (1905, fig. 100), Montaner (1895–6) and Fuster (1908–10) houses and others in Barcelona and in other Catalan cities, all demonstrate the force and imagination with which Domènech brought together and redeployed stylistic models, structural techniques and apparently heterogeneous ornamental elements.

His most immediate disciple and collaborator was Antoni Maria Gallissà (1861–1903), whose early death cut short a brilliant career. Author of numerous buildings in Barcelona (fig. 256) and in other towns, his work is generally on a smaller scale and often involved remodelling existing buildings, but it offers some of the most subtle solutions in all the architecture of the period.

In collaboration with Domènech, Gallissà organised a centre for the training of craftsmen and specialists in decorative arts in one of the 1888 exhibition buildings. It was installed in part of the unfinished Café-Restaurant, known popularly as the 'Castle of the Three Dragons' because it recalled a famous scene in a theatrical work of the period, and Gallissà organised an experimental studio for craftsmen in every field. There were many outstanding practitioners, including Eusebi Arnau (figs. 5, 76), who worked in sculpture and decorative relief, and Tiestos who as director of a studio for iron-working experimented with forms made of sheet iron joined and cut in a manner which anticipated the avant-garde work of Juli González. At the same time the old ceramist Casany, who was invited to come from Manises to participate in the workshop, brought with him all of his experimental knowledge of ceramic forms, glazes and textures, which must have had a strong influence on contemporary architecture. In addition, there were the somewhat more industrialised crafts of stained glass, lock-making, floor-tiling, and furniture-making, which produced craftsmen whose work added the brilliance of floral decoration and the dazzling designs which are a unique feature of this architecture. They included Escofet, Granell, Vidal, Homar, Serra, Masriera and many other important names.

Towards normalisation: Josep Puig i Cadafalch

The potent ideal of linking the creation of architecture with the desire to construct a modern and cosmopolitan Catalonia was invested with a new aesthetic sensibility by the next generation, those who graduated around the turn of the century. Here, the most respresentative figure is Josep Puig i Cadafalch (1867–1956), who graduated in 1891 and who was also instrumental in the creation of new Catalan institutions in the period between 1905 and 1923.

Like his master Domènech i Montaner, Puig i Cadafalch was also an important politician – he became one of the principal figures in the Lliga Regionalista – as well as an architectural historian (known internationally for his work on Romanesque art) and architect. Influenced in his youth by the two principal figures of those years – Gaudí

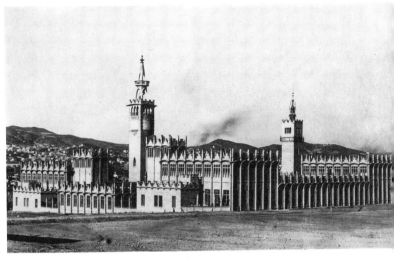

118. Puig i Cadafalch. Casarramona yarn factory (now police barracks), 1911.

119. Domènech i Montaner. Hospital de Sant Pau, 1902–12 (cf. no. 67).

117. Valeri. Casa Comalat, 1909–11.

120. Casas. Portrait of *Lluis Domènech i Montaner*, c.1906 (no.40). Charcoal and pastel, 62 × 48 cm. Museu d'Art Modern, Barcelona.

121. Casas. *Portrait of Josep Puig i Cadafalch*, c. 1899 (no. 36). Charcoal, pastel and powdered ground on paper, 62.6 × 28.8 cm. Museu d'Art Modern, Barcelona.

and Domènech – Puig's work soon developed qualities that were more balanced, elegant and cosmopolitan. His early work at the beginning of the century consisted largely of private houses and apartment buildings, in which the influence of the domestic architecture of Mackintosh and the Viennese Secessionists is modified by reminiscences of Catalan and Central European Baroque, combined with medieval civic architecture. This last tendency, derived especially from the civic architecture of the Spanish Renaissance, becomes increasingly dominant, and these works offer a fluid stylisation in which ornament is integrated by a unifying plastic treatment of colour and materials. Little survives of the eclectic origins of this picturesque architecture, as the taste for tense surfaces, monochromatism and planar decoration dominates the fluid and dynamic spaces in his buildings. The Trinxet (1904), Macaya (1901), Quadras (1904, fig. 138), Amatller (1898–1900, figs. 6, 9, 10), Puig (1903), Company (1911), Llorach (1904) and Muntadas (1901) houses are good examples of this first fertile phase of works of domestic architecture.

With time Puig i Cadafalch was converted – not rapidly but consistently – into a practitioner of the decorative and domesticated classicism which characterised Catalan architecture of the second and third decades of this century. His buildings and projects for the Central Post Office (1918), the Plaça de Catalunya (1922, fig. 98) and the Monument to Guimerà (1923), or the plan for the Universal Exhibition on Montjuïc (1914–23, figs. 128, 129) are examples of a type of work in which modernity of technical and typological design is combined with a modified classicism expressive of the ideals not of *Modernisme* but of normalcy, and institutional and cosmopolitan order.

Antimodernisme: Antoni Gaudí

Gaudí and his circle of followers would have liked nothing less than being called *modernistes*, since this would associate them with ideas with which they would under no circumstances have wanted to be identified – in the first line with the *modernista* heresy, condemned by ecclesiastical authority as dogmatic progressionism and impossible to reconcile with the official doctrine of the Catholic Church. In sociological terms this condemnation of *modernista* thinkers and theologians by the official church was a sign of its retreat in face of the difficulties of assimilating the ideas and customs of modern civilisation. Gaudí, whose intellectual life was spent in militant Catholic circles, joined in this rejection and aligned himself with the renewal of church intervention in civil life by means of projects of social paternalism and strong traditionalism in patterns of life.

Another of the associations of *Modernisme* for Gaudí would have been with the artists and writers of *fin-de-siècle* Barcelona, with their anarchistic view of life, their philosophical nihilism influenced by Ibsen, Tolstoy and

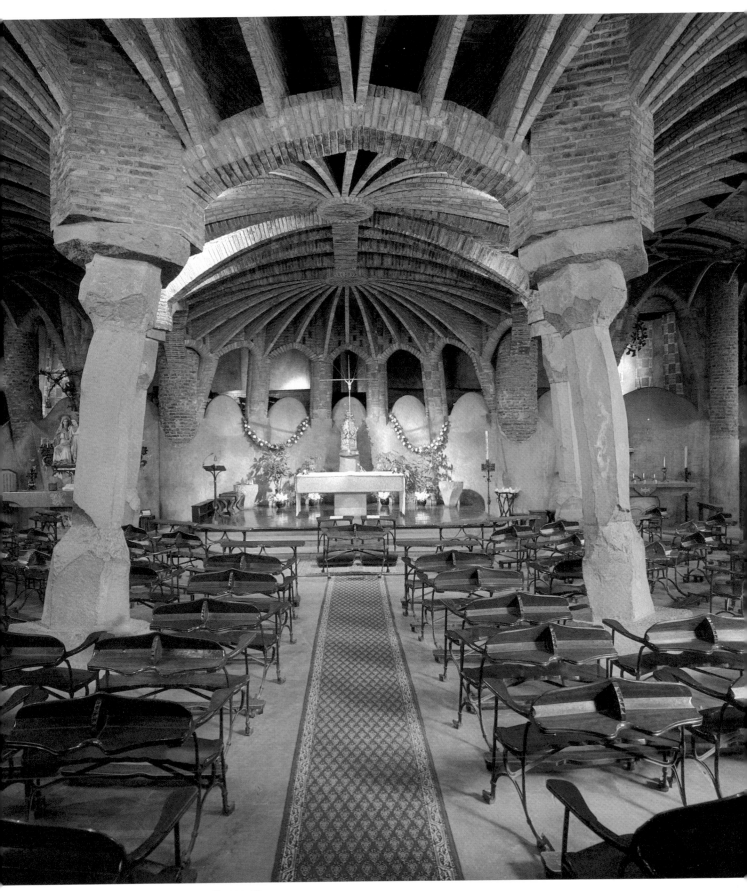

122. Gaudí. Interior of crypt of Colònia Güell, 1908–15.

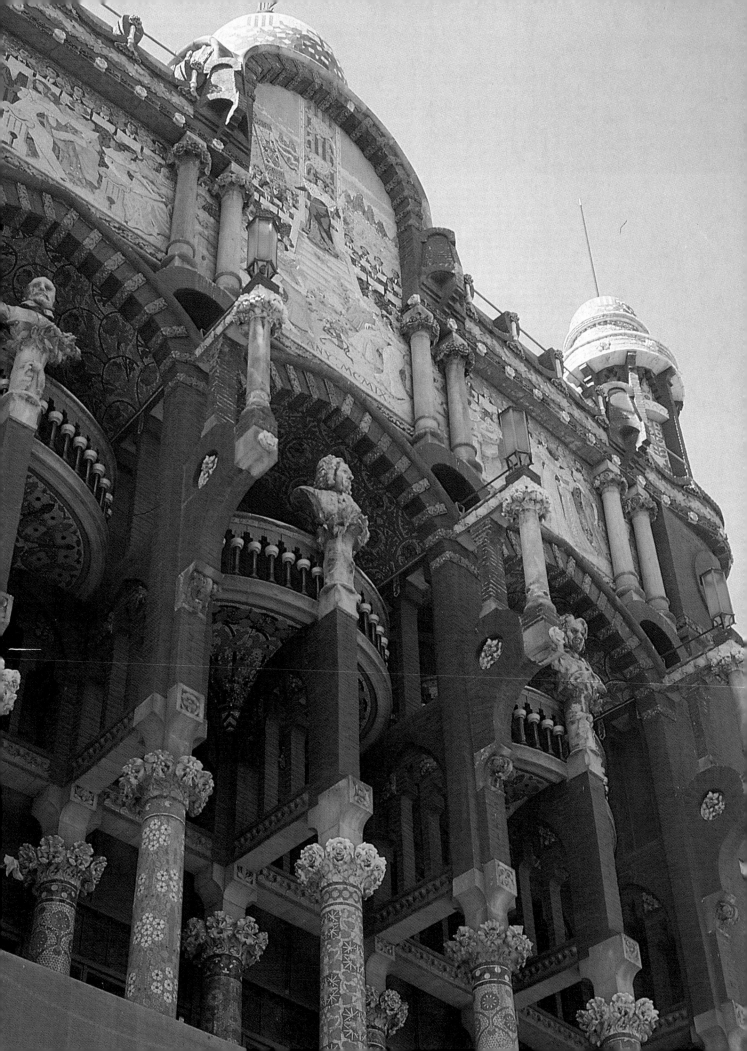

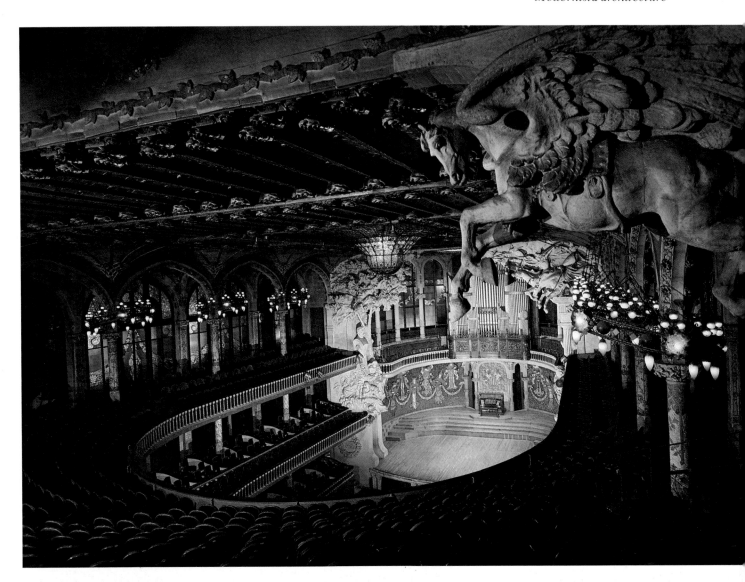

123, 124, 125. Domènech i Montaner.
Palau de la Música Catalana, 1905–8;
Detail of façade (*opposite*) with mosaics by
Bru (cf. nos. 10, 68); auditorium (*above*)
with sculpture by Gargallo (cf. no. 83);
entrance foyer (*left*).

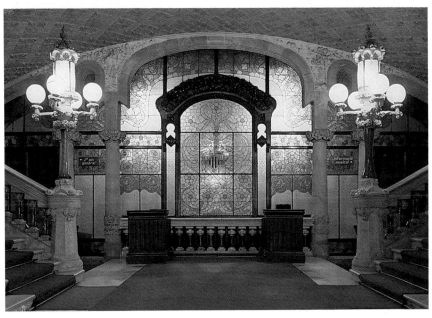

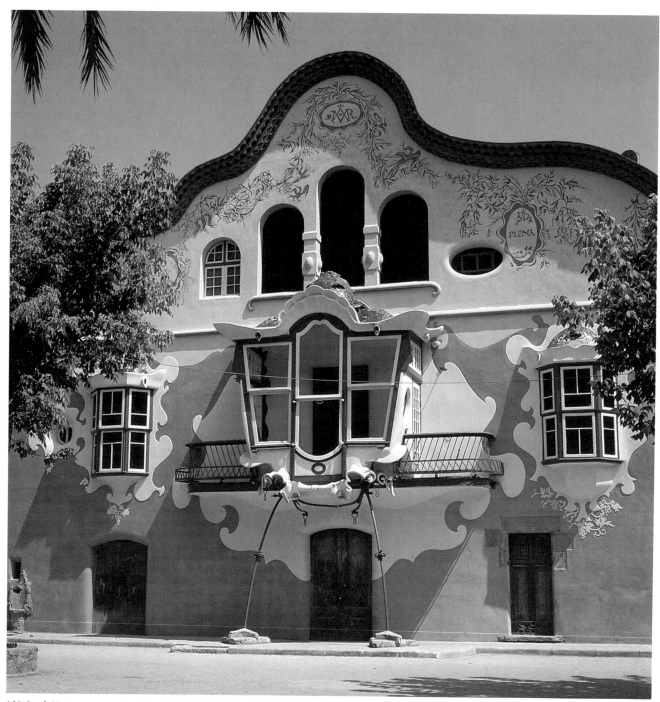

126. Jujol. Negre mansion, Sant Joan Despí, 1915–27.

Nietzsche and their libertarian outlook, which promoted a bohemian, happy-go-lucky and unconventional lifestyle.

The Cercle Artístic de Sant Lluc, of which Gaudí was one of the earliest members, was something very different. It was an organisation, based on the old medieval guilds, in which architects, painters and artists of all kinds joined together under the patronage of their painter saint and under the direction of a priest, Josep Torras i Bages, later to be appointed Bishop of Vich. The Cercle de Sant Lluc was created with the aim of using the example of morality and good works to fight the agnosticism and amorality of Barcelona *modernistes*.

Gaudí's architectural work was also a reaction against the new *fin-de-siècle* style, which appeared excessively eclectic, optimistic and confident. Gaudí's utopianism, to which we have referred earlier, had its origins in a fundamentalist vocation. The aim of Gaudí's life, which was lived away from the influence of fashions and trends, was a search for the essence – in the first place of the logic of structure. Influenced by the rationalism of Viollet-le-Duc, Gaudí wanted to achieve an essential architecture by a reconciliation of architectural and structural form. He examined the tradition of building in the West, concluding that Gothic should be awarded first place as the most advanced and freest system, and he attempted to pursue this to a logical conclusion using theoretical and experimental methods based upon the building of the Christian church.

His search for the essence can be seen too in his relationship with the European stylistic tradition. After experimenting in youthful works with the stylistic repertories derived from the Gothic, Moorish, Baroque and Classical traditions, Gaudí arrived, with maturity, at the formulation of a strongly personal language, essential and free, in which any reference to historical styles was obliterated in a fluid magma where the principal tectonic elements acquired new significance. The ornamentation of his works after 1900 is radical, hard, expressionist, archaic, but it reflects a fantastic re-creation of the cosmic cycle. The Parc Güell (1900–14, figs. 3, 79–81, 113), the Sagrada Família (1884–1926, fig. 82), the unfinished church of the Colònia Güell (1898–1915, fig. 122) and the Batlló (1905–6, figs. 7, 8, 100) and Milà (1905–11, figs. 11–13) houses in Barcelona, all bear the unmistakable mark of his own hand in the evolution of the ornament.

Gaudí's work is impressive because of the tenacity with which he followed his own paths. All of his work has an 'alternative' character, like the response of someone who is dissatisfied with established judgements and again and again expresses his own point of view to try and counter accepted ideas.

Experimenting to the limit: house, villa and church

Let us look first at the house. From around 1860 Cerdà's *Eixample* had established a standard type of town house:

an apartment building with two façades, on to the street and on to the exterior courtyard, and with a grid plan formed of load-bearing walls built around interior courtyards which provided ventilation.

Based upon this model Gaudí experimented with a series of solutions which increasingly opened up both the exterior and interior systems of the standard plan, by introducing hallways, stairwells, interior courtyards, galleries at the back and an endless range of elements with characteristics completely different from the norm. It was not just a question of ornament but a total redesigning of this kind of building, whose standard form had become established not only in Barcelona but in the other major European cities. The internal and external arrangements of the Milà, Batlló and Calvet houses clearly demonstrate the kind of critical reasoning which Gaudí exercised with passionate and tireless energy. The flowing corridors, the malleable spaces and the elasticity of both exterior and interior walls are all the result of the same obsessional plastic sense, which rethought the conventional form of the house and postulated structural, typological and configurational alternatives of great brilliance.

An equally radical revision was made in detached buildings such as villas or other small buildings. In the Bellesguard villas (1900–2), *El Capricho* at Comillas (1883–5), the Güell Palace (1885–9), the Güell stables (1887, fig. 95) or the Vicens house (1883–5, fig. 112), the common characteristic is something more than just a difference in purpose or place or stylistic reference; rather it is a special form of composition. The technique of collage was beginning to be developed at this time in other artistic fields, an aesthetic category in which heterogeneous and disparate materials are brought together, linked by laws of connection which are not academic but are based on effects of contiguity, juxtaposition or displacement. This same technique of composition is the determinant characteristic of the majority of these buildings, in which the different elements are like the pieces of an impossible puzzle, in that disparate elements are being joined, but each individual item retains its own coherence in the face of the unity of the whole. The design of these buildings, with all the diversity of the 'pieces' which form them – rooms, towers, galleries, arcades, domed spaces, all with profuse and varied ornamentation – tends to produce an effect of something like the sensation of chaos, of a kaleidoscopic world which has no beginning or end; but also a sensation of hard aggression if we see in the elemental association of heterogeneous fragments the best way of responding to the fossilised methods of academic composition.

But church architecture was undoubtedly the most important area to which Gaudí applied his experiments. Gaudí considered the church to be the paradigm of architecture: the essence of the architect's problem, which required the greatest creative concentration and the

clearest reasoning. It implies the problem of covering a space in its most patent form, the problems of lighting, of construction, of symbolism – and of the humble contribution of all the arts to the total work, at once the key to and the sum of all architectural aspirations.

We can now see how this conception is connected to the search for the essence which Gaudí pursued and how it reflects the Catholic intransigence which Gaudí shared. In common with the Ecclesiologists in England, Germany and France, Gaudí saw the problem of church architecture as the touchstone to test every age's response to the perennial problems of architecture.

The project for the Tangiers Missions, the church of the Colònia Güell – an experimental archetype of the theoretical problem of the church – but above all the unfinished expiatory church of the Sagrada Família, are clear examples of this way of confronting the problem. Conceiving his church as a workshop for constant reflection and labour, associating the work of architecture and of the architect with the daily task of building the church, Gaudí, hard at work, meeting his collaborators in the unfinished rooms of the crypt, offers us an image that well reflects the type of commitment that the author and his work succeeded in inspiring. In the radical efforts and plans, in the titanic attempt to make a work that would synthesise all artistic aspirations, we find the key to explain this building, which even in its fragmentary, unfinished state bears witness to its ambitious purpose.

Disciples and collaborators
In all of his works, but especially at the Sagrada Família, Gaudí had associates. Though he was against all schools, Gaudí was a great teacher and gathered around him a numerous group of architects, artists and craftsmen who worked with him and whose collaboration was essential to the final outcome of his projects. Among the architects perhaps the most important collaborators were Berenguer (1866–1914), Rubió (1871–1952), and Jujol (1879–1949).

Francesc Berenguer, who had no formal qualification as an architect, worked almost all of his life alongside Gaudí. He was a trustworthy man not only in the studio but also in his private life. Berenguer, at times in collaboration with Gaudí himself or with other colleagues, also carried out his own work in his birthplace in Gràcia, as well as in other areas of Barcelona. The Bodegas Güell in Garraf (1888–90, fig. 116), the Master's house and Schools of the Colònia Güell (1914) and the group of buildings of the Santuario de Sant Josep de la Muntanya (1910) give clear evidence of the skill and originality of this disciple and close associate of Gaudí.

Another architect who was a collaborator of Gaudí in his youth and later worked independently was Joan Rubió i Bellver, who had a special role in several of Gaudí's buildings, notably during the second phase of the Sagrada

Família (1891–1900), in the Parc Güell (1900–14), and in the remodelling of the interior of Palma Cathedral in Mallorca (1904–14). Rubió also carried out a number of notable works of his own, including small villas, mainly on the outskirts of Barcelona, where he showed outstanding ability in his use of ornament and of bold structural solutions and at the same time demonstrated a sense of composition which is close to Gaudí's own use of the techniques of collage, displacement and juxtaposition. The Golferichs (1901), Canals (1900), Alemany (1901), Roviralta ('El Frare Blanc', 1903–13, fig. 114), Dolcet (1906–7), Rialp (1908), Ripoll-Noble (1910) or Trinxet (1923–5) houses are some that demonstrate this structural and formal talent.

But without a doubt the most gifted of those who were close to and collaborated with Gaudí was the architect Josep Maria Jujol, whose participation was decisive in some of Gaudí's own works and whose later independent work must be considered as some of the most interesting in Europe during this period.

Jujol was an enormously gifted person when it came to the invention of decorative forms: a type of spontaneous design in which the accumulation of disparate elements is presented through a kind of viscous web which tends to amalgamate everything that happens to be present: colours, forms, rhythms, numbers, letters, symbols and pieces like *objets trouvés* are accumulated in Jujol's ornamentation, with brilliant and disturbing results.

The iron balconies of the Casa Milà and the painting of the vestibule there, the ornamentation of the façade of the Casa Batlló (fig. 100), the finishing of the ceiling of the hypostyle hall and the running benches of the great plaza in the Parc Güell (fig. 79), are all the unmistakable work of Jujol working alongside Gaudí.

But also when working as an independent architect, carrying out small commissions, often quite unpretentious, or making alterations to existing buildings, Jujol produced a series of works of genius. The Torre dels Ous (1913–16, fig. 127) or the Masia Negre (1914–30, fig. 126) in Sant Joan Despí, the churches of Vistabella (1918–23) or of Montferri (1926–9), and the alterations to the house of Els Pallresos (1920) must be recognised as extraordinary demonstrations of this fragile, associational all-inclusive architecture, which presents and develops themes of expressionism and of a surrealist architecture *avant la lettre*.

Conceiving of his work as an exercise in variations on a theme, in which ornamentation and structural form run a parallel course, Jujol at once demonstrated the disturbing nature of Gaudí's conceptual void and the greatness attained by the expression of this intimate experience of modernity. Liberating form to the limits of pure play, he made it at the same time wonderfully graceful and completely immaterial.

127. Jujol. Casa Guibert ('Torre dels Ous' – Tower of eggs), Sant Joan Despí, 1913–16.

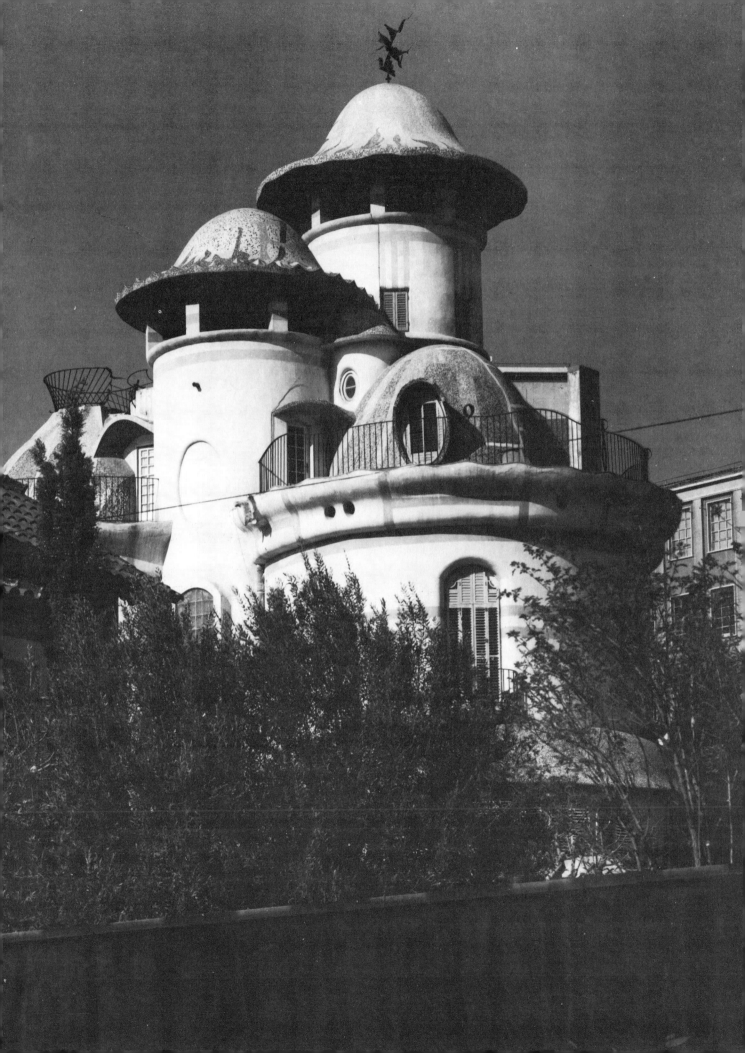

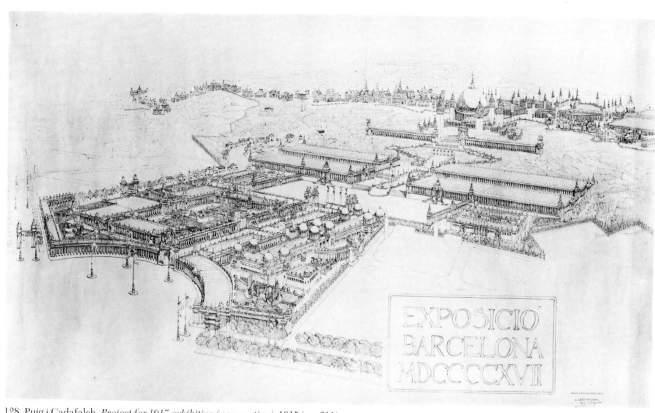

128. Puig i Cadafalch. *Project for 1917 exhibition (perspective)*, 1915 (no. 211).
Lithograph, 79 × 137 cm. Arxiu Administratiu de l'Ajuntament de Barcelona.

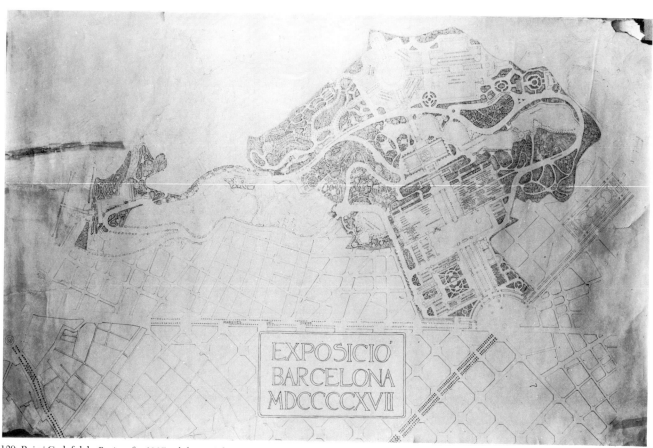

129. Puig i Cadafalch. *Project for 1917 exhibition (plan)*, 1915 (no. 211).
Lithograph, 100 × 160 cm. Arxiu Administratiu de l'Ajuntament de Barcelona.

From Montjuïc to the world

Francesc Roca

The International Exhibition of 1917–29

The International Exhibition of 1929 was a vital part of one of the three projects which together formed the overall scheme for a metropolitan Barcelona, a scheme which also included a general plan of infrastructures, the setting aside of green spaces, a construction programme for schools and technical institutions, the rationalisation of the urban transportation system, and other measures. From north to south, these three projects were: the renovation of the historic centre of the city, which meant principally the creation of a 'centre within a centre', the new Via Laietana, which connected the *Barri gòtic* (old quarter) with the seafront and with the *Eixample*; the transformation of the steep rocky hill of Montjuïc from a zone restricted to military use into a public area with a whole range of facilities; and the creation of an area for bonded goods between Montjuïc and the Llobregat delta, in connecton with the enlarging of the port.

The 1929 exhibition was the moving force in the transformation of Montjuïc. In 1901 the leaders of the Catalan industrial party (Lliga Regionalista) made a proposal for an international exhibition to be sited between the Ciutadella park (where the 1888 exhibition had been held) and the Plaça de les Glòries Catalanes to the north of the old city. The 1901 plan also made provision for the progressive transformation of Montjuïc into a city park, but at a certain point the two projects were combined, and a plan was formulated for a great exhibition on Montjuïc, to be held in 1917 to celebrate electricity, the wonderful new form of energy. Cebrià Montoliu, the translator of Ruskin and Morris into Catalan, called it 'Exposició Elèctrica', while Francesc Cambó, the leader of the Lliga designated it the 'Exposició d'Indústries Elèctriques'.

The project was seen within the general framework of the new city plan, which the City had opened to international competition in 1903. The winner had been Léon Jaussely, though the proposals of the other finalists – the Catalans Romeu, Vega i Marc and Armenter, and the Swede Peter O. Hollman – were still in the air in planning circles. On another front, the Canadian engineer, Frank S. Pearson, had visited Barcelona in July 1911, and by September the Barcelona Traction Light and Power Co. Ltd. – which became known as La Canadenca – was formed in Toronto. In addition, Cambó had the French engineer-gardener Jean-Claude-Nicolas Forestier come to Barcelona to plan the Montjuïc gardens. But all these initiatives were halted by the outbreak of war, and then by the post-war crisis and Primo de Rivera's coup d'état. Thus, although the works for the exhibition had been started in 1910, and some buildings had been erected – for example the palace for the second Saló de l'Automòbil in 1922 (fig. 131) – it did not finally open its doors until 1929.

Between 1917 and 1929 there had been great changes. It was now possible, for the first time, to talk of mass political movements – in other words of the participation of broad sectors of tradesmen and of the working class in political and trade union activity. Although universal male suffrage had been established in 1890, in 1901 only 20% of the total population of Barcelona was represented on the electoral register, and the poll never exceeded 10–15% of those registered. In 1933 as many as 60% of the population were registered to vote, and the poll reached 60–65%. Again, in 1907 the number of strikers in the province of Barcelona, was around 20,000, while in 1930 they numbered 287,000. Although these are small figures when compared with the more developed countries in Europe (Sweden, United Kingdom, Netherlands, Germany, France) the difference between 1900 and 1930 (and particularly between 1917 and 1929) in Barcelona was very great. In fact, a modern party (the Lliga Regionalista), a great industrial union (the CNT, Confederació Nacional del Treball) and other republican, anarchist and communist groups, injected great energy into Catalan life.

In this context, we can see that the 1929 International Exhibition was not only the motive force for the transformation of Montjuïc, but, together with the other major projects in the overall plan – the construction of the underground, the urbanisation of the *Eixample*, the redefinition of the modern centre of Barcelona, etc. – was a political response, which, since the first proposal of the Lliga in 1901, had one main goal: the mobilisation of the mass urban population.

After the exhibition: the other side of the coin

Critics of the model – and the reality – of the new metropolis were harsh. The weekly journal *L'Opinió* wrote: 'Barcelona is without schools, without hospitals, has only rudimentary public health services, is unable to tackle the problems of improving the outer areas and the communications system, has an appalling water service and is saddled with debt, deficit, galloping inflation and a catastrophic economic future'.

The exhibition stretched to its limits the plan for a metropolitan Barcelona first proposed in 1901, for there

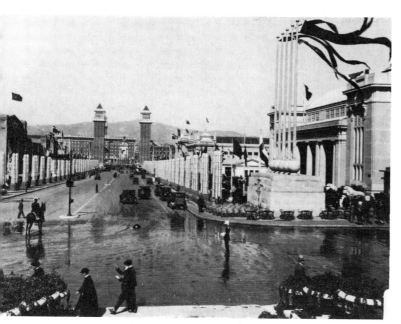

130. View from the Montjuïc fountains down Avinguda America towards Plaça d'Espanya, 1929.

131. Saló de l'Automòbil, 1922, held in one of the palaces on Montjuïc designed by Puig i Cadafalch.

were now several new factors to be considered: the city's financial crisis (which was not a national financial crisis); the concentration of investment in a few privileged sectors, where it remained unproductive; the imbalance between revenues and profits (or between the property-owning and industrial sectors); and the growth of a body of rigorous intellectual criticism, which proposed a different urban model – a movement started in the twenties by people like Jaume Aiguader, Emili Mira and Estanislau Ruiz i Ponseti.

In 1930 44% of the City's budget had to be used to reduce the public debt (as against 26% in 1920). This meant that investment had to be cut drastically, while resistance to the effects of the Depression was weakened. The imbalance between revenues and profits now took on a violent political character. At the same time technical and intellectual criticism of metropolitan Barcelona found media of expression, for example, GATCPAC's magazine *AC*, directed by Josep Torres Clavé and Josep Lluís Sert, but also *L'Hora*, *Front*, *La Batalla*, *Justícia social*, *Tiempos nuevos* and *Mañana*.

The situation was ripe for the appearance of alternative urban models (associated with both the artistic and the political avant garde). *L'Opinió* wrote (3 November 1928): 'The task of defending this mountain-garden falls first of all upon all our city's working class'.

In the short run, the proposed alternative was quite clear: the spaces (including the large spaces) of metropolitan Barcelona must be re-used and, if necessary, rehabilitated. It was, therefore, the other side of the old coin. Most of the palaces, pavilions and hotels of the exhibition – originally designed to be only temporary – were re-used, becoming schools, museums, kindergartens, exhibition halls, sports centres, etc. The private gardens of the royal palace of Pedralbes were made public, and the palace became a student residence. The new means of transportation (underground, funicular, cable car, escalators and moving walkways) were maintained and kept in use. The former arsenal of the Ciutadella was turned into the headquarters of the Catalan parliament. Work was begun on the cleaning of the city's long line of beaches.

The proposals of the GATCPAC went even further. They wanted a redistribution of land, both within the blocks of the *Eixample* but also within larger units, such as the *Eixample* itself or Montjuïc. They saw a need for a rationalisation of the whole communications infrastructure and for the co-ordination of city transport. They proposed the standardisation of housing and equipment, offering examples of 'minimal experimental housing', a 'block house', a 'portable beach house', a 'portable children's library', a 'standard hospital with a hundred beds', etc. They also wanted the beaches and pine groves to the south of Barcelona to be rehabilitated, and they proposed a project for major sanitary improvements.

132. Cover of *AC* no. 2 (2nd quarter 1931), incorporating a repeated
photograph of the offices of GATEPAC and GATCPAC.

133. Sert amd Yllescas. Detail of apartment block,
Carrer Muntaner 342–348, 1930–1.

International Barcelona

Léon Jaussely won the 1903 competition before setting foot in Barcelona, and Pearson put in hand the electrification of Catalonia on a visit of less than twenty-four hours. Cebrià Montoliu, the most international of all Catalan urbanists, went into voluntary exile in 1920 and died three years later in the United States, while he was planning a new city based on a unitary tax system.

In the thirties, the regaining of Catalan autonomy coincided with the international recognition of Barcelona, and the sense of freedom and progress there was in sharp contrast to the authoritarian régimes that had taken over in several other European countries. 'At last,' wrote Le Corbusier in *La Ville radieuse*, 'on one living point of the earth modern times have found an asylum.' In March 1932 a meeting of the CIRPAC, a preliminary to the congress in Moscow, was held in Barcelona, and lectures were given by Le Corbusier, Bourgeois, Gropius, Van Eesteren and Giedion. Accompanied by the members of the GATCPAC and by the Ateneu Enciclopèdic Popular, co-organiser of the meeting, they were received by Francesc Macià, the first president of the Generalitat.

Four months later, the members of the GATCPAC, on board the Patriks 2 en route to Athens for the Fourth CIAM, made a study of the urban crisis in thirty-two cities in the world. The conclusions of this analysis were particularly useful in the gradual working out of a new general plan for Barcelona (fig. 137), which Le Corbusier decided to call the 'Macià' plan in homage to the president of the Generalitat who had died at Christmas 1933.

A key element of the Macià plan was the project for a Ciutat Obrera de Repòs i de Vacances (Workers' Leisure and Vacation City) which was in the hands of the GATCPAC architect Francesc Fàbregas (fig. 136). To mark the start of work on this (1 May 1934), Josep M. de Sucre, commissioner of the Generalitat's public works department, sent invitations to Le Corbusier, and also to Lagardelle, Einstein, Romain Rolland and Barbuse. Le Corbusier wrote to Sucre (24 January 1934), 'How lucky our friends Sert and Torres are to have a supporter like yourself in a public body. This is one thing that, unfortunately, will never happen to me. I have the bad luck of almost always scandalising all authorities'.

The Macià plan

Many of the current ideas in Barcelona were gathered, examined, and reformulated in the Macià plan by Le Corbusier and the GATCPAC (and with the explicit support of the mayor Carles Pi i Sunyer). It was a conceptual plan, a schema, and in this formal sense had similarities to the Jaussely plan. However, the interests represented by the two plans were diametrically opposed. The Macià plan wanted to transform Barcelona into a city to serve the Catalan working classes. The means it adopted were to articulate in a single model solutions to

134. Illustration from *AC* no. 6 (2nd quarter 1932), showing a worker superimposed on a photograph of the old city of Barcelona: 'The black lines indicate a labyrinth of tainted little alleys, into which the relatively old buildings do not allow the rays of the sun to penetrate, and where no trees grow, for they are dead of disease or cut down to make way for new constructions; terraces serve as an enclosure or storehouse for old rubbish and little black dots indicate the presence of "courtyards for ventilation" as they are termed in the jargon of the city government.'

135. Sert, Torres Clavé and Subirana, Casa Bloc, 1932–6; the photograph shows the building nearing completion in 1935 (cf. fig. 67).

137. Torres Clavé. *Macià plan*, 1936–8 (no. 253). Gouache on paper, 150 × 700 cm. Collection R. Torres i Torres, Barcelona.

136. Torres Clavé and the GATCPAC. Aerial view of the proposed Ciutat de Repòs i de Vacances at Castelldefels, 1933, illustrated on the cover of *AC* no. 13 (1st quarter 1934). The accompanying quotation is from the Charter of Athens, containing the conclusions of the Fourth CIAM: 'We have to demand the creation of large zones of recreation near to the city (zones of leisure). These will occupy sites which combine the best conditions and most attractive surroundings, as well as having excellent communications with the city.' (no. 299; cf. no. 252).

the problems of unsatisfied collective demand, provisions for industrial growth and for the housing of the new working class, and creation of the spaces for political activity that Barcelona, now the capital of an embryonic state, required.

There were, in fact, two Macià plans, which dealt with the shorter and the longer term. The short-term plan contained the following provisions: first, a programme of public health works in the old city centre, where the mortality rate was very high (14–16 per thousand), clearing pockets of disease-ridden slums and replacing them with green spaces, nursery schools, libraries and clinics. The City Sanitation Law introduced by Pi i Sunyer, was approved by the Catalan parliament on 9 June 1936. The Collasso i Gil school (fig. 104) was built on the site of the Sant Pau barracks, and the most admired work of the rationalist architectural school, the Dispensari Central Antituberculós (fig. 105), was located in the middle of a very decayed area. Secondly, an immediate stop had to be put to the construction of any more of the standard units of the *Eixample*, to be replaced with a design more suited to contemporary requirements. The Casa Bloc on Avinguda de Torras i Bages (figs. 67, 135) is an example of the new buildings: it has no inner courtyards, and there are two-storey flats with common services – community dining room, games room and swimming pool.

Next, the city was divided into zones corresponding to different types of activity; this initial classification was supposed to give guidelines for future growth and gradually reduce the existing chaos.

Finally, the city was to be joined with the Llobregat plain. It was proposed that the Gran Via should be extended as far as Castelldefels with the construction of eight miles of motorway. The 'Extraordinary estimate for

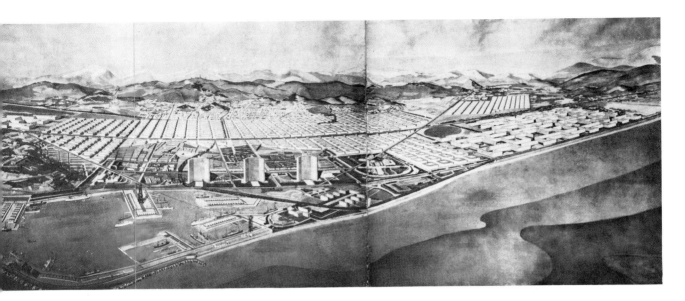

works and sanitation in 1936' (which might perhaps be called the Pi i Sunyer plan) included the costs of extending the road well beyond the city limits.

The long-term plan reorganised the whole urban system of Barcelona on the following model:

 Production: i. port; ii. industrial areas; iii. city.
 Civic centre.
 Housing: i. living units; ii. hotels.
 Leisure: i. green spaces; ii. beach area.
 Traffic and movement.

The urban system was spatially redefined on the basis of the theoretical elements of the 'functional city' (or 'future city'); production, traffic, housing and leisure – and, in response to the requirements of a political capital, the civic centre.

The plan contained a number of radical proposals, particularly concerning the main city centre and the beach area. The existing centre around Via Laietana and Plaça de Catalunya was held to be too extended and too congested, so a new centre was proposed to be built on land recovered by filling in a part of the old port, continuing Barcelona's long tradition of winning territory from the sea.

The other radically new proposal was for the Ciutat de Repòs i de Vacances (CRV) in the municipal districts of Castelldefels, Viladecans, and Gavà. The CRV was to have a maritime park, sports facilities, holiday areas for workers and weekend camps for school children, as well as semi-permanent camps for children, allotment areas and a hospital district. It was a different Barcelona, planned to provide the necessities of health and leisure for the urban working class and for children, the sick and the elderly. The CRV was to be a part-city from which the production element was excluded. It was not designed as a self-sufficient city like the ones proposed by the utopians in the nineteenth century but as an important element in a larger urban system.

To get it under way the Cooperativa La Ciutat de Repòs i de Vacances was legally constituted on 22 December 1933, with fifty cooperative members who together represented some 800,000 individual members. The official start of work on the scheme was 1 May 1934, but at the end of the summer of 1937 – in extremely difficult circumstances – the Generalitat of Catalonia had to give up responsibility for the Cooperative's plan of construction.

In the world

The Catalan urban model (and, generally, the Catalan model) was disseminated around the world after 1936 in a number of important publications. Josep Lluís Sert's paper at the Fifth CIAM (Paris, 1937) was a key work which set out the new idea of the relationship between city, nature, and society that had been developed in Catalonia in the thirties; while *Can our cities survive?* (1947), published during Sert's exile in the United States, was a charter for well-designed urban planning. In Cuba, Francesc Fàbregas, director of the CRV project, was the inspiration behind the urban reform of 1960, and in Mexico, Estanislau Ruiz i Ponseti (as well as Marí Civera, Miguel Ferrer and others) drew on the Catalan experience as a basis for his extensive theoretical writings. Finally, in Venezuela, Carles Pi i Sunyer, who had lived in exile in London for many years, produced a text of fundamental importance in *En el llindar del futur* (1970).

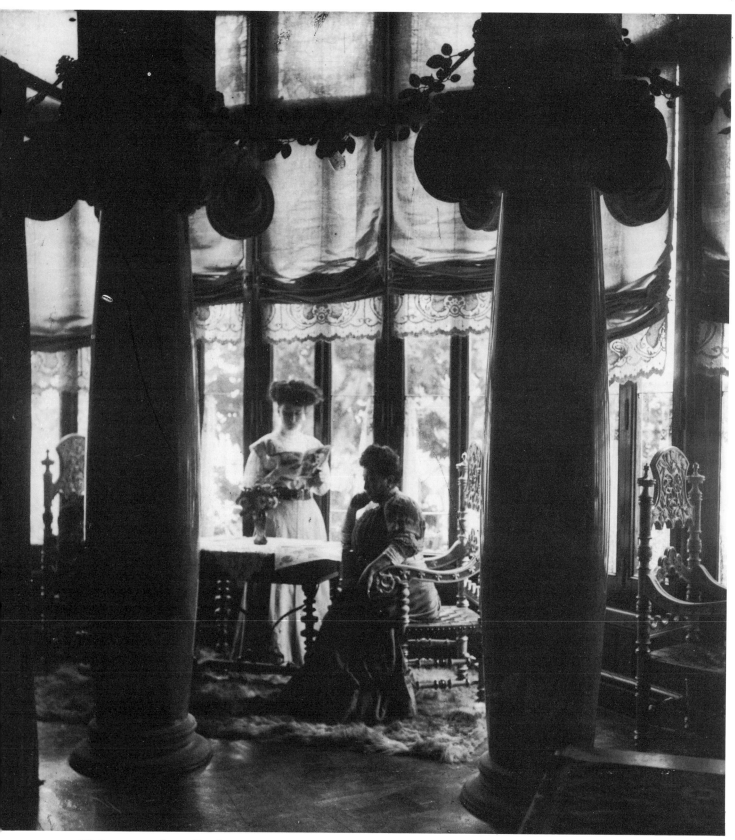

138. Baroness Quadras and her daughter in the drawing room of their
house built by Puig i Cadafalch in 1904–6; photograph taken in 1907.

Barcelona and its people

Salvador Giner

More than a mere bond of kinship unites Barcelona with Catalonia: there is communion. To this day, the great, cosmopolitan Mediterranean city draws its identity and strength from the small nation into which it sinks its roots. Its loyalty to the culture, the language and the long and often difficult past of Catalonia is the source of its inspiration and uniqueness. Far from being a hindrance upon its projection towards the outside world, that loyalty goes a long way to explain the city's remarkable will towards universality, its tireless love of work, its enterprising spirit. These features have blended with its people's cult of the creative. In their thirst for innovation they have built one of the most attractive, complex – and perhaps least known – of the great European cities.

Such is the image. Or at least such is one of the chief conceptions of the city, as rendered by its admirers. Cervantes, himself the greatest and soberest of realists, did not flinch from depicting Barcelona in similar terms in a burst of praise and love. But there are indeed other images. The city of revolutionary visionaries for instance, of unrealistic, dangerous dreamers, variously described by Thomas Mann in *The Magic Mountain* or George Orwell in his *Homage to Catalonia*, or even by Trotsky in reflections full of foreboding, where hope mixed with a fear of failure. And there is also Barcelona as the epitomy of the sinful city, of modern misery and moral decay, the home of gratuitous crime: Genet equivocally praised it for that. I am only referring to outsiders. The natives have also seen their city under many guises.

It may prove convenient to begin with the paradigmatic, admiring vision. Surprisingly, as idealised images go, it does not prove entirely misleading, as long as we leave room for qualifications. It stands up fairly well to close scrutiny, and it fits those features that have made up the modern Catalan image. Without an acceptance (albeit cautious) of that image, the place of the Catalans, and of Barcelona in particular, in European life and their notable contribution to it would perhaps become incomprehensible.

Modern Catalonia is the result of several lasting historical currents. The country grew out of a very powerful, rich and complex feudal society, in which equal importance was given to lord and peasant, king and vassal, guild and citizen, privilege and a commoner's rights.

During that period it developed its immediately distinguishable cultural identity, its separate language, a system of civil law and advanced institutions of representative government, all around its enterprising capital, Barcelona. For centuries, Catalonia's small size and

139. Ribera. *Leaving the ball, c.*1894 (no. 218).
Oil on canvas, 113 × 65 cm. Museu d'Art Modern, Barcelona.

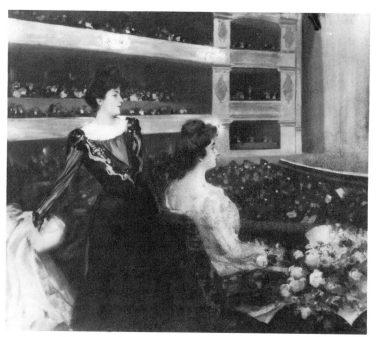

140. Casas. *The Liceu*, c.1898–1902.
Oil on canvas, 142 × 147 cm. One of the twelve paintings
by Casas in the Saló del Fumador of the Cercle del Liceu.

141. Mir. *Orfeó*; cover of *Hispania* no. 24, 15 Feb. 1900 (no. 304).
The British Library Board.
The singers are wearing the traditional Catalan cap (*barretina*).

geographical position made it part of larger political units and forced it into various forms of hypothetical or real subordination. (At one time this was not an obstacle to its overseas political expansion, and to the development of a considerable Mediterranean empire in competition with other powerful republics and principalities.) For centuries, Catalonia's political integration into the Spanish monarchy became compatible with a very substantial degree of political autonomy. When challenged, that autonomy encountered fierce resistance and gave rise to open war. The outcome, whether unfavourable to the Catalans or to their opponents, tended to be, sooner or later, mitigated and turned to everyone's advantage by that proverbial disposition of the Catalans: their spirit of compromise, their inclination to solve conflicts through negotiation, their insistence on looking for areas of agreement in every confrontation. It was thus, historians tell us, that they managed to keep intact their cherished independence, as well as their cultural and linguistic identities. Last, and certainly not least, another powerful historical fact came to give shape to contemporary Catalan society: practically alone in all the southern European lands (Lombardy and Piedmont in Italy were the other exceptions), the Catalans embarked upon the bourgeois and industrial revolution in the eighteenth century and developed it fully during the nineteenth. The capital, the enterprise, the labour were local. Their old industrial towns, factories and establishments along the river valleys of the interior and along the sea coast, and, of course, the city of Barcelona itself, were landscaped and sculpted, as it were, by that fact.

Catalan civil society

Catalonia's industrial and urban expansion in the nineteenth century was to be followed, at a later stage, by a similar development in another ethnically distinct part of Spain, the Basque country. Together, Catalans and Basques attempted to break the mould of a country which, somehow, did not appear to be able to rise to the challenge of modernity, despite its extraordinary past and cultural legacy. The Catalans, for their part, took to the tasks of modernisation as to the manner born. Capital accumulation, industrial investment, the first railways, a number of important inventions, all occurred simultaneously or succeeded each other in or around Barcelona at a remarkable pace. They invariably came from private initiative and flourished, more often than not, in the face of official incomprehension and even opposition. By modernising their own part of the world and only very slowly managing to penetrate or transform, if at all, the inherited patterns of Spanish society beyond the pale of their own homeland, the Catalans of the time paradoxically increased, rather than diminished, the distance and contrasts that separated them from the rest of Spain. It was thus that confrontations, divergent com-

mercial interests and political misunderstandings between the Barcelonese élites and the Madrid government became endemic and were to remain so for a very long time. Despite its constant crises (up to the Restoration period that began in 1874), the Madrid government held ultimate power and exercised control over an army and a police force that the Catalan bourgeoisie could ultimately not do without.

While Spain appeared unable to come to terms with the exigencies of the transformation towards modernity, the actual structure of Catalan society, especially in Barcelona and in the new industrial towns, recalled that of similar areas elsewhere in Europe. An apparently forever growing industrial proletariat, still recruited from Catalonia's own rural hinterland, became established and began to develop its own culture, as well as political and trade union organisations. Thriving and varied middle classes grew apace with the expansion of the city. An aggressive (and, in the early stages, politically quite radical) upper bourgeoisie took shape: it was made up of captains of industry, *parvenus* many of them, speculators, bankers, budding shipping magnates, entrepreneurs of all sorts and conditions. However, given the short-sighted central-ism of Spain's rulers and Catalonia's isolation from the political capital, there were surprisingly few bureaucrats, magistrates, civil servants, military men or politicians of Catalan origin. This only betrayed the grave divorce that arose between the leading classes of Barcelona and the state. In stark contrast to the situation in Italy, where the northern élites had initiated the *Risorgimento* and built the modern state, their Catalan counterparts felt impotent *vis à vis* an already existing political structure, which they saw as ailing, archaic and uncomprehending. And yet, with its economic expansion and the modernity of its mentality Catalonia had rapidly become crucial for the welfare and even the very destiny of Spain as a whole.

Catalonia's most outstanding feature at the time was, apart from its language, culture, and the spectacular profile of its industrial development, its civil society. It had a dense, thriving, and complex social tissue, based as much on an inclination towards private association and individual initiative as on the more traditional ties of family, locality and custom. It was this civil society as a whole, rather than any one class or social group within it, that made possible and called forth the cultural, artistic and intellectual renaissance of Barcelona, lasting in various guises from roughly the middle of the nineteenth century until the end of the Civil War in 1939. It was then wiped out by the Francoist dictatorship. Under its long rule, however, the civic and cultural life of Catalonia continued to show its traditional vitality, so much so that it became a constant challenge to autocracy and political repression, forms of government to which Catalans have been pro-verbially ill-suited.

The pronounced 'private associationism' of the Catalans is the backbone of their civil society. It became essential to the launching of the *Renaixença* cultural and political movement with which the recent modern age was in-augurated, as well as to the successive artistic, scientific and literary movements that followed it. It formed the basis of the growth of a remarkable working-class musical, literary and ideological culture. Some of its folk heroes (such as the cultural crusader and choir leader Anselm Clavé, 1824–74) characteristically became influential national figures. Private associations maintained and revived ancient traditions, introduced mountaineering, sports and games, inspired a discovery of the Catalan countryside, national history, literature, and, in the absence of adequate official institutions, science, technology and economics. Of course, some of these associations were related to the social anthropology of certain Mediterranean societies, where fraternities of a traditional kind have always existed. But the exceptional proliferation of voluntary associations – from cooperatives to theatrical societies, from small public libraries to amateur astron-omers' clubs, from pigeon-fancying groups to choirs and dancing societies – was, and still is, much more charac-teristic of the urban and industrial order of the Catalans. For its part, the upper Catalan bourgeoisie soon created its own exclusive institutions, where it could mirror itself and collectively assert its presence and its triumph. None more significant than the great Barcelona opera house, the Liceu, which opened in 1844 and was the only one in Europe never supported by public funds or by the state. Together with the later Palau de la Música Catalana – a key building in *modernista* architecture, the work of Domènech i Montaner – the Liceu soon became the emblematic centre of the *bourgeoisie conquérante* of Barcelona, so much so that it had the distinction of becom-ing the target for an anarchist bomb attack in 1893.

In a manner certainly not unrelated to these innate associational tendencies, there were attitudes which resulted in the active involvement of individuals in the public life of Catalonia through their particular field of endeavour. It was thus characteristic of the period after 1850 that architects should become national politicians (like Domènech) or visionaries (like Gaudí) or that a lexicographer such as Pompeu Fabra (1868–1948, an engineer turned philologist and grammarian) should become a key personality in the administrative and cultural reform of the country. Despite the strife and the acute social tensions created by rapid capitalist and industrial expansion, the four decades between the two Barcelona international fairs of 1888 and 1929 witnessed an un-paralleled intensification of this osmosis and cross-fertilisation between the diversity of talents, associations, movements and local institutions which made up the Catalan civil society. The result was an uncommon flour-ishing of creativity.

142. The distinguished engineer, geologist and excursionist Lluís Marià Vidal visiting the dolmen of Darlius on 10 July 1891. Vidal was later the president of the Centre Excursionista de Catalunya (1896–1900).

Barcelona and Catalanism

One movement successfully brought together most of the varied and divergent strands of the social, cultural and political life of the country: Catalanism. This imprecise but most effective ideology became the great catalyst of wills. Catalanism suddenly came to confer meaning and direction on the aspirations of Catalans for the hundred years leading up to 1936 and, even more so, it can clearly be argued, afterwards, when the threat to their identity was far more explicit. During the early phases of its expansion the great absentee from its ranks was the industrial working class. It felt much more attracted, instead, by Anarchism and was therefore even more hostile to the Spanish state than the Catalanists themselves. Workers thus paradoxically echoed the attitudes towards the political order that were already widespread among the middle and upper classes.

Catalanism was certainly a form of ethnic nationalism, characteristic of several small stateless nations in other parts of Europe at the time. But there were differences: the bulk of its supporters were in favour of some form of home rule and were therefore not separatist. It was a movement that was far more active in the educational reconstruction of Catalonia, its transformation into a wholly modern society, than in actively severing its ties with the Spanish state. It had, inevitably, its parochial, ultra-traditionalist and particularistic elements. Yet, what strikes any observer is the universalism of a great part of its ideology, the conscious efforts made by nearly all its leaders and representatives to avoid the pitfalls of a sordid provincialism, and to share in the civilisation of the wider world without restrictions. It has been rightly said that Catalanism owes this welcome trait to the city of Barcelona. Catalonia was lucky that at its core there was an open metropolis, ambitious, mercantile, eager to participate in the modern transformation. Other ethnic nationalisms have been far less fortunate.

Political abstention (i.e. withdrawal from intervention in national politics) combined with active participation at the local level in the early stage of Catalanism, during the *Renaixença* period. This cultural movement thus became inextricably linked with a certain conception of democracy. The supporters of both came at first from the middle classes of Barcelona. Now the Catalan middle classes were, and still are, a complicated affair. As elsewhere, they extended their upper reaches into the ranks of the prosperous bourgeoisie. Their lower ones, on the other hand, were firmly rooted in a ubiquitous and solid class, the Catalan *menestralia*, made up of artisans, shopkeepers, skilled workers, small entrepreneurs and workshop owners. Their links with the working classes were direct and intimate and so were their bonds with the countryside. Many enterprising younger brothers, deprived of inheritance by Catalan law but far from destitute, had emigrated to Barcelona in search of work and fortune.

143. Carrer Filateras in the medieval quarter of Barcelona; destroyed in 1908 to make way for the new Via Laietana, main artery of the *Reforma* (improvement) of the city.

144. Picasso. *Rooftops of Barcelona*, 1902 (no.181).
Oil on canvas, 57.8 × 60.3 cm. Museu Picasso, Barcelona.

145. Picasso. *Man leaning in gothic portal*, c.1896 (no.177).
Oil on wood, 20.2 × 12.8 cm. Museu Picasso, Barcelona.

146. Picasso. *Corner of cloister of Sant Pau del Camp*, 1896 (no.178).
Oil on wood, 15.5 × 10.1 cm. Museu Picasso, Barcelona.

There they filled the ranks of the *menestralia*, and later some of them rose to great heights. (This stream was not unlike that which once nourished the life of London in the pre-industrial and early industrial age.) The *menestralia* soon became a class in search of an ideology, a moral stance and an aesthetic. They found it in Catalanism. In their search for a style, those who succeeded were often disoriented – as *nouveaux riches* tend to be everywhere – and all too often were attracted to the *pompier*, the garish and the outwardly baroque. This tendency would affect Catalan art, especially in its *modernista* phase, in a strange and peculiar way. Perhaps even more so than in other parts of Europe, Catalan *Modernisme* strikes us as often combining truly original, beautiful and important statements with others that seem an affront to taste. Attraction and repugnance are felt by many who admire some aspects of the work of Antoni Gaudí, or even of much later Catalan artists, such as Salvador Dalí. In due course, *modernista* excesses called forth a reaction (the *noucentista* movement), which demanded an austere classicism of expression.

From 1874 until 1931 Spain enjoyed political continuity, if not peace. (It lost most of the remains of its overseas empire and witnessed important working-class uprisings, such as the Barcelona 'Tragic Week' of 1909.) Despite economic crises and social unrest, Barcelona managed more or less to achieve a position that matched the aspirations of her citizens. In the early stages of this uneven period the task was accomplished through the initiative of great individual industrialists and patricians, operating more as members of a social class than organised into any specific institution. Later, however, the innovators were more frequently middle-class politicians and intellectuals, dedicated to the task of institutionalising the aspirations of Catalanism into practical results through administrative and cultural reform.

To a certain extent, Barcelona entered this long period of political continuity after the restoration of the monarchy in 1874 with its future, as it were, already mapped out. The old city walls had been pulled down much earlier, and the remarkable gridiron pattern of its *Eixample* had been laid out after 1854: old and new citizens had, since that date, steadily proceeded to fill its vast expanse. Meanwhile, industry continued to diversify from textiles to machinery, electrification and chemicals. As the Spanish market began to show signs of saturation, manufactured goods had to find wider opportunities abroad. The patrician clans of Barcelona rose to that challenge in a manner that perhaps has never found its equal since. The 1888 Universal Exhibition, linked to the name of the city's mayor, Rius i Taulet (1833–89) epitomises that effort, emulated later by the 1929 International Exhibition. So did the extent of private patronage of the arts. The protection of Catalonia's chief poet of the *Renaixença*, Father Jacint Verdaguer (1845–1902) by the Marquis of

Comillas (a shipping magnate) remains the major example, despite its complications. Better known abroad is Count Eusebi Güell's patronage of Gaudí's architectural and landscaping mystical dreams. Nevertheless, as everywhere else, the relationship between patron and artist was not always a happy one. At the turn of the century a number of great artists – Casas, Nonell, Nogués, Picasso, and a whole school of major draughtsmen – lived a bohemian life of quiet rebellion and social criticism. It is to them that we owe poignant descriptions of poverty (Nogués), political repression against the workers (Casas), gypsies (Nonell), street artists and prostitutes (Picasso). At the same time, the older painter and writer Santiago Rusiñol wrote a play, *L'Auca del senyor Esteve*, destined to become a classic, which mercilessly castigated the narrow mentality of the shopkeeping Barcelonese *menestralia*.

While this generation was reaching maturity and its individual members went their own ways, the 'institutional' Catalanists came to the fore. The Madrid parliament had in 1912 approved a law which permitted the loose federation of provinces into regional communities. The Catalans wasted no time in returning their four artificially created provinces to the fold of a united administrative region which, for them, meant obviously much more than a mere region. The new Mancomunitat – today re-established with much greater powers in the form of the Autonomous Government of Catalonia, or Generalitat – was presided over by an exceptional man. President Enric Prat de la Riba (1870–1917) recruited linguists, administrators, engineers and intellectuals for the apparently modest task of creating a well-run local and 'regional' government, towards which people should not feel alienated or hostile. The spirit of the Mancomunitat contrasted with that of the *modernista* period in every way: it avoided stridency, spectacular promises, public gestures. Its elective affinity with *Noucentisme* in style and temper was obvious.

Both movements in the early decades of the twentieth century wanted to make the most of a virtue Catalans like to think is particularly their own: *seny*. *Seny* is an untranslatable word that simultaneously evokes common sense, prudence and wisdom. It refers to a sense of proportion in everything. The men behind the Mancomunitat and *Noucentisme*, as well as many of those who tried to keep the country on a steady course in the tragic circumstances that were to come later, wanted to avoid the opposite of *seny*, in Catalan, *rauxa*. This national weakness could be best translated as naïve and euphoric improvisation. Popular lore has it that Catalans often move from the one to the other in both their personal and their collective life. Perhaps. It is not for one of their number to say. Yet, looking at much of their modern artistic contribution, it may be sensible to conclude that both *seny* and *rauxa* blend in it in a manner that goes a long way to explain its uniqueness and charm.

147. Rusiñol. *Girl with a drum, c.* 1892 (no. 230).
Oil on canvas, 114 × 97 cm. Collection Enrique Torrelló Enrich, Barcelona.

Modernista painting

Cristina Mendoza

In Barcelona artistic *Modernisme* is so much a part of its time and, above all, present so richly in the environment that at first glance it seems like a homogeneous movement and one which is easy to define. It is often said that *Modernisme* is the Catalan version of *Art Nouveau*, of *Modern Style* or of *Jugendstil*, but although it shares some of the same formal characteristics, this is an incomplete definition.

Catalan *Modernisme* is something more complex and harder to encapsulate, largely because it was not just an artistic movement. Many of its other aspects – literary, political, architectural – are treated elsewhere in this catalogue, so this essay is confined to a discussion of *modernista* painting.

Chronologically, *Modernisme* was current in Catalonia during the last decade of the nineteenth century and in the first decade of the present century. Various dates have been proposed for its beginning: 1884, when 'modernista' was first used in the magazine *L'Avenç*; 1888, the year of the Universal Exhibition; 1892, the year in which the first *Festa modernista* was celebrated in Sitges. And its end has been placed by some in 1906, the date at which the 'Glosari' of Eugeni d'Ors, the ideologist of *Noucentisme*, began to appear; by others in 1911, the year in which Joan Maragall and Isidre Nonell died; and by a smaller number in 1914, when the last *modernista* works were produced, by which time the Mancomunitat had already been established. Although one cannot, of course, give firm dates to artistic movements, I would be inclined to locate *Modernisme* between the exhibition of 1888 and the first appearance of the 'Glosari' in 1906.

In any case, it is quite evident that *Modernisme* embraces a number of different styles, linked by their common search for something new, something 'modern' in the face of tradition – the factor which gave the movement its name. The original group to call themselves *modernistes* formed around the magazine *L'Avenç*, and although by the end of the nineties some of their contemporaries, ignoring the principles they had enunciated, used the term *modernista* in a pejorative sense, identifying it with decadence, this was never simply a provincial version of a foreign movement. Its constant aim was for the renewal of some indigenous quality, so that it was an attitude rather than a style.

The *modernista* artists came from various levels of society, but many of them – including the key figures, Rusiñol, Casas and Maragall – belonged to the bourgeoisie that had been enriched by the industrialisation of the region. Although there had been individual efforts in the past, the *modernistes* were the first who, as a group, tried to bring a breath of fresh air to Barcelona.

Paris, which had taken over from Rome as the artistic centre of Europe, was visited by the *modernistes*, and there were also visits to England, where Alexandre de Riquer (1856–1920), in particular, assimilated the influences of Pre-Raphaelitism and of William Morris and the Arts and Crafts movement. Paris showed them Impressionism and Symbolism, and, in a sense, Barcelona became the Paris of the peninsula.

One of the great contributions towards cementing the group were the *Festes modernistes* celebrated from 1892 to 1899 in Sitges, principally under the direction of Santiago Rusiñol. Several years earlier, Joan Roig i Soler (1852–1909) and Arcadi Mas i Fontdevila (1852–1934), the founders of the Luminist school of Sitges, had settled in this coastal village near Barcelona, and another member of their school was Eliseu Meifrèn (1859–1940), a painter whose works in the early years of the twentieth century were pure Impressionism. But the Luminists were, rather, followers of Marià Fortuny, choosing as their subject the light of the Mediterranean sea, and although they participated in the first of the *Festes modernistes* with considerable critical success, they belonged to an older generation than the key figures of *Modernisme* and remained closer to Fortuny and the Italians than to the French.

Rusiñol's arrival in Sitges in 1891 was extremely well received, as he already had a very high reputation. He himself responded enthusiastically to the village, which he converted into the real birthplace of *Modernisme*, through his organisation of the *Festes*.

The first of these was celebrated in 1892, on the initiative of several local painters who wanted to put on an exhibition of fine arts in which the household names of *Modernisme*, like Casas and Rusiñol, would participate. The second and third *Festes*, celebrated in Sitges in 1893 and 1894, confirmed the cohesiveness of the group and demonstrated their desire to promote a new openness towards Europe. At the second *Festa* Rusiñol's speech contained the following words: 'What we wish to present is an experiment, a trial undertaken by lovers of modern art who want to make a demonstration of it . . . Insincere art that is written for effect with rhetorical sighs and rented tears; inflated speeches with words falling like orator's cascades; shouted monologues . . . these will all be banished by modern art and put away in the attic . . . And if that all

148. Casas. *Portrait of Raimon Casellas, c.*1899 (no. 28).
Charcoal on paper, 40 × 36 cm. Museu d'Art Modern, Barcelona.

149. Rusiñol. *L'Alegria que passa*, 1898; poster advertising
his own play with music by Morera (no. 234).
85.5 × 55 cm. Museu de les Arts de l'Espectacle, Barcelona.

happens, it is thanks to men like Maeterlinck, who fight without taking account of popular applause, but direct their vision to wider horizons . . . as Casellas has said, ''the aesthetic form of this art is radiant and nebulous, prosaic and great, mystic and sensual, refined and barbaric, medieval and *modernista* at the same time.'''

These words were spoken before an audience of many Catalan intellectuals and artists who had come to Sitges to see Maeterlinck's *L'Intruse* performed in the Catalan translation by Pompeu Fabra, and they and the programme of this second festival are clear evidence of the *modernista* aim of renewal. On the same occasion, under the direction of Enric Morera, music by Popper, Goelard, César Franck and Morera himself was performed, again demonstrating how they wanted to create their own culture, while drinking from the fountain of the current European avant garde. This desire for modernity was taken still further in the third *Festa*, for which Rusiñol's inaugural speech concluded with the following words: 'Here we can unburden ourselves and voice what we have often not dared to say surrounded by the common herd: that we wish to be poets, and that we do not value nor sympathise with those who do not feel poetry; that a Leonardo da Vinci or a Dante counts for more with us than a province or a village; that we prefer to be symbolists and unbalanced, even crazy and decadent, rather than be weak and gentle; that common sense smothers us; that our country has more than enough prudence; that it does not matter that we are taken for Don Quixotes where there are so many Sancho Panzas grazing, nor that we read books of fairy stories in a place where no books are read at all.'

So the movement passed on from its support of the European avant garde to a position where its aims were to widen the horizons of Catalan culture and to end provincialism.

This introduction to *Modernisme* is necessary precisely because it was something more than an artistic movement, and it is no easier to give an all-embracing definition to *modernista* painting, except to say that it covers work done in various styles during the *modernista* period. It is worth noting that with the decorative arts, graphic arts and sculpture the situation is different, since all of these had a greater stylistic unity during the period, more closely comparable to developments in Europe.

Modernisme was, then, an attempt to introduce something 'new' and something 'modern' into what was traditional and what was academic, and it is logical that *modernista* painters should pursue what they saw as modern. At this time Paris was the centre of the artistic world, which is why the city became so remarkably important for *modernista* painters. For the majority of them a visit to Paris – even of short duration – was compulsory, and it allowed them to complete the training begun in Barcelona.

150. Casas. *The Bohemian (portrait of Erik Satie on Montmartre)*, 1891 (no.18).
Oil on canvas, 198.9 × 99.7 cm. Northwestern University Library, Evanston (Illinois).

151. Casas. *Portrait of Ramon Pichot*,
c. 1899 (no. 35).
Charcoal, pastel and watercolour on paper,
64 × 30 cm.
Museu d'Art Modern, Barcelona.

152. Casas. *Portrait of Isidre Nonell*,
c. 1899 (no. 34).
Charcoal and powdered ground on paper,
64 × 30 cm.
Museu d'Art Modern, Barcelona.

153. Casas. *Portrait of Manolo*
(*Manuel Martínez Hugué*), *c.* 1899 (no. 32).
Charcoal, wash and powdered ground on
paper, 62 × 28 cm.
Museu d'Art Modern, Barcelona.

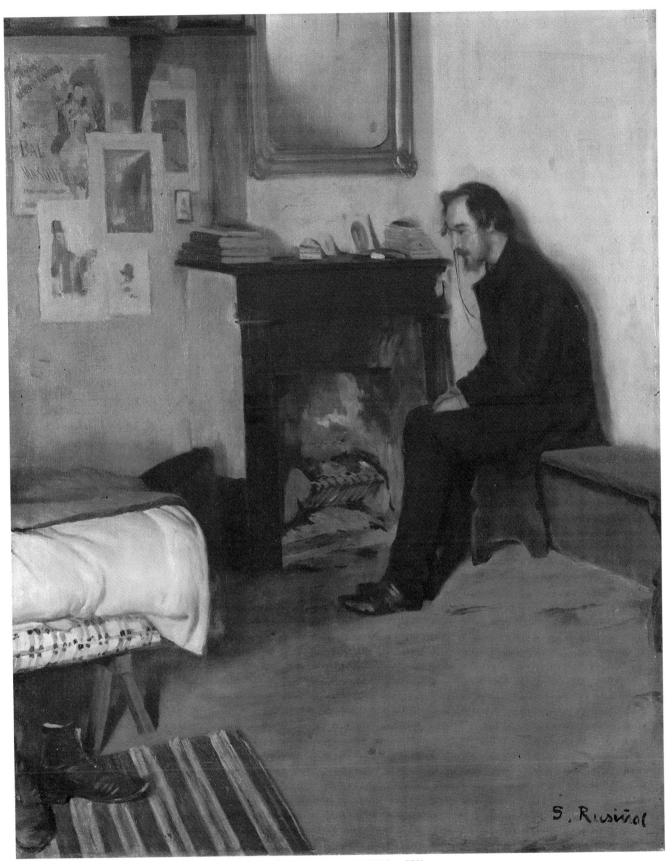

154. Rusiñol. *The Bohemian (portrait of Erik Satie in his studio in Montmartre)*, 1891 (no. 228).
Oil on canvas, 85 × 67 cm. Generalitat de Catalunya, Barcelona.

155. Rusiñol. *Interior with figures, c.* 1894 (no. 231).
Oil on canvas, 80.5 × 64.5 cm. Museu d'Art Modern, Barcelona.

An artistic revolution had already taken place in Barcelona, thanks to the efforts of Ramon Martí i Alsina (1826–94), the painter who undoubtedly established a solid base for the modern Catalan school. Professor at the Llotja (School of Fine Arts), where the majority of artists of this period trained, he introduced to Barcelona Courbet's innovative ideas of Realism. Through his teaching and in his studio, which was a meeting-place for artists and intellectuals, he made the breakthrough in rejecting academic rules in favour of the direct recording of reality. His teaching was to be decisive for many of his contemporaries, including not only Joaquim Vayreda (1843–94), founder of the school of Olot (which adopted the Barbizon style of landscape painting), but also the younger generation, who made his ideas the basis of *Modernisme*. Nevertheless, Martí i Alsina was trained in the Romantic tradition, which is fully reflected in his early work, and even his most realist paintings still fall between Romanticism and Realism. This meant that although his influence was decisive at a point when Catalan painting was bogged down in history painting and academicism it was some years before the real revolution took place. Martí i Alsina, as it were, set the task the performance of which would soon produce one of the most splendid periods of Catalan art. The decisive move was taken by two artists whose names are synonymous with *modernista* painting: Ramon Casas (1866–1932) and Santiago Rusiñol (1861–1931). Both belonged to the Barcelona bourgeoisie, which produced the first generation of *modernista* artists and intellectuals – who affirmed their vocation by rebelling against their own class.

Unlike most of their contemporaries, they both studied at private painting academies rather than attending the official school at the Llotja, and they were both able to spend long periods in Paris without economic restrictions – always a problem for the majority of their colleagues. However, despite the great friendship which united them all their lives, their personalities were quite different. Rusiñol was an intellectual who was active in every field – he was outstanding both as a painter and a writer and was the coordinating genius of the *modernista* movement. Casas, the finest painter produced by *Modernisme*, was, by contrast, a person of few intellectual aspirations who was exclusively interested in painting, drawing and graphic arts. In 1890, along with the critic Miquel Utrillo, another of the key figures of *Modernisme*, they moved into the Moulin de la Galette in Paris. All three had been in the city before. Casas had gone for the first time in 1881 to study for the winter at the academy of the painter Carolus Duran. In 1883 his self-portrait in flamenco costume (Museu d'Art Modern, Barcelona) had been accepted at the Salon des Champs Elysées. Rusiñol went to Paris for the first time in 1889, sending back his impressions to the Barcelona daily *La Vanguardia* under the title *Desde el molino*; these chronicles were illustrated by Casas.

156. Martí i Alsina. *View of Barcelona*, 1889 (no. 129). Oil on canvas, 44 × 57 cm. Museu d'Art Modern, Barcelona.

157. Mas i Fontdevila. *On the lake*, c. 1890. Oil on canvas, dimensions unknown.

158. Casas. *Plein air, c.* 1890–1.
Oil on canvas, 51 × 66 cm. Museu d'Art Modern, Barcelona.

159. Rusiñol. *Portrait of Miquel Utrillo at the Moulin de la Galette,*
1891 (no. 227).
Oil on canvas, 222.5 × 151 cm. Museu d'Art Modern, Barcelona.

Although, as evidenced by his showing at the Salon des Champs Elysées, Casas moved in academic rather than avant-garde circles, he got to know the work of the Impressionists, which undoubtedly left its mark on him. His *Bullfight* (Museu de Montserrat), painted in 1884, uses impressionist techniques and was criticised when it was exhibited the same year at the Sala Parés in Barcelona. Canibell, critic of *L'Avenç*, expressed his disappointment that such a gifted painter should exhibit a work which was only a sketch. However, impressionist facture with the use of touches of colour was not adopted by these artists in the paintings they executed in Paris between 1890 and 1894.

'Catalan Impressionism', as it has often been called, is a special, and only partial, version of French Impressionism, for while both Casas and Rusiñol, who first introduced it to Barcelona, shared some of the characteristics of French Impressionism, they rejected others. In their Paris works they adopted impressionist subject-matter rather than techniques. They were interested in painting figures out of doors (figs. 150, 159) and also ephemeral interior scenes (figs. 16, 160), but above all they incorporated the urban landscape – a favourite theme of the Impressionists – into their paintings.

In spite of the fact that the Impressionism which they imported to Barcelona was more theoretical than practical, these Paris paintings, so different from the anecdotalism current in Barcelona, were essentially well received. In 1890 Casas and Rusiñol held their first joint exhibition together with the *modernista* sculptor Enric Clarasó (1857–1941) at the Sala Parés in Barcelona, where other contemporary Catalan art was shown. It was only to be expected that these paintings, with their forms defined by colour, their *sfumato* line and 'modern' subject-matter, so close to the work of Degas and Whistler, would at first be rejected by the Barcelona critics and the public, who were used to the anecdotal realism promoted by Martí i Alsina. But, despite some opposition, there were from the outset several supporters, among whom the most outstanding was the critic and *modernista* novelist Raimon Casellas (1855–1910), who from the pages of *L'Avenç* and later *La Vanguardia* aligned himself with this new trend. The initial rejection also did not prevent some of their best works, such as *Plein air* by Casas (fig. 158) or the *Laboratory of la Galette* by Rusiñol, being acquired for the City Museum at the First Exposició General de Belles Arts, while Casas's *Interior in the open air*, 1892 (fig. 168), won a third prize at the 1892 International Exhibition in Madrid. In 1894 Casas left Paris and returned to Barcelona, though he went back each year to Paris to participate in the Salon de Champ de Mars. This date also marks a point at which the work of the two artists begins to diverge. Rusiñol leaned toward Symbolism, which is fully absorbed in the allegorical murals *Music, Poetry* (fig. 19) and *Painting*, 1894–5, which won a medal

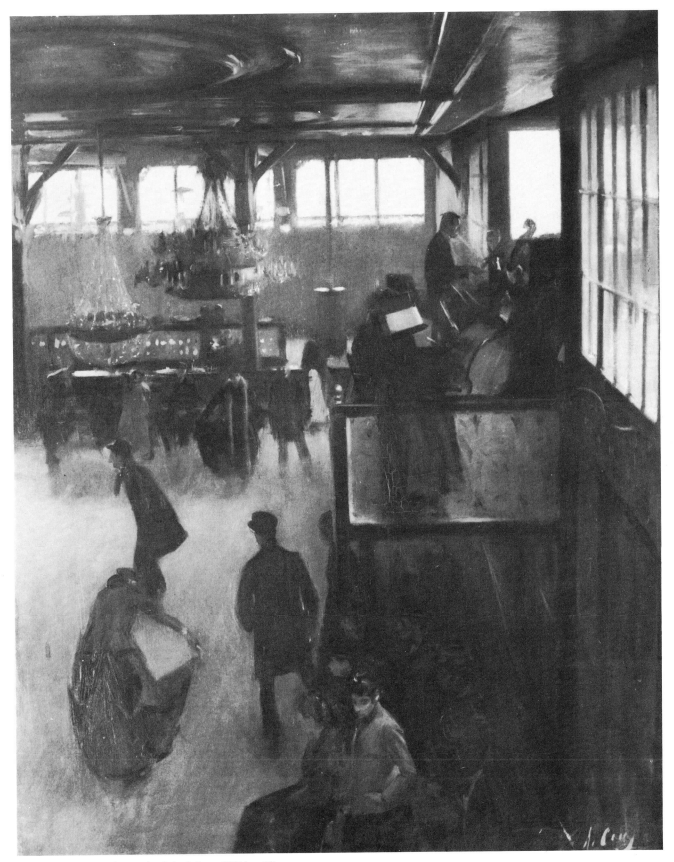

160. Casas. *Dance at the Moulin de la Galette*, 1890 (no. 17).
Oil on canvas, 100 × 81.5 cm. Museu Cau Ferrat, Sitges.

161. Mir. *Rock at l'Estany (Mallorca), c.* 1903. (no. 146).
Oil on canvas, 102 × 128 cm. Museu d'Art Modern, Barcelona.

162. Rusiñol. *Pine grove in Aranjuez, c.* 1930 (no. 233).
Oil on canvas, 124 × 154 cm. Collection J.B. Cendrós, Barcelona.

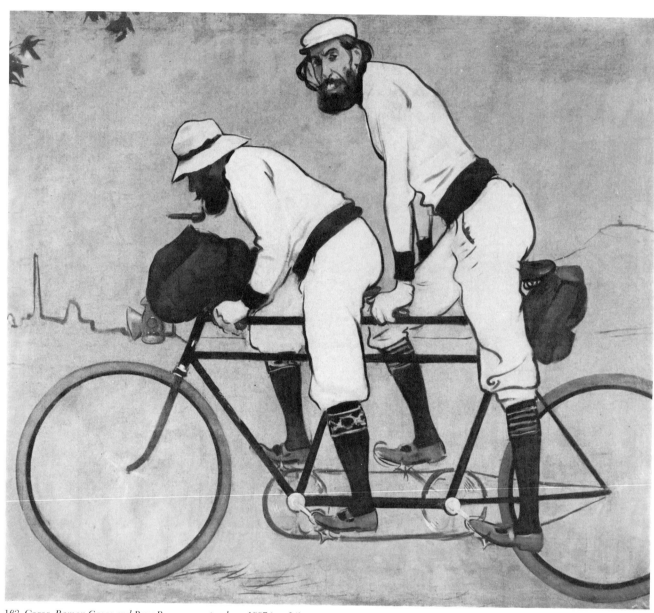

163. Casas. *Ramon Casas and Pere Romeu on a tandem*, 1897 (no. 24).
Oil on canvas, 191 × 215 cm. Museu d'Art Modern, Barcelona.

at the Third Exposició de Belles Arts in Barcelona in 1896. Casas, on the other hand, began to paint works with crowd scenes on topical subjects, such as *Garrote vil*, 1894 (fig. 23), which represents an execution at the Barcelona prison and which created a great stir in the city; the *Corpus Christi procession*, 1898 (fig. 169), a work which recalls the explosion of a bomb in the path of a procession; or the most popular of them all, *La Carga*, (fig. 22), a work which, though dated 1903, was actually painted in 1899 and was rejected by the selectors of the Spanish section of the Universal Exhibition in Paris in 1900. It was probably the general strike of 1902 that made Casas decide to redate the work and change the title to *Barcelona 1902*.

During the same period, in 1893, the Cercle Artístic de Sant Lluc was founded. This was an association of artists with strong Catholic beliefs, who decided to create their own group to encourage moral order and to combat the ideas and behaviour of the *modernistes*. Their founders were the brothers Joan Llimona (1860–1926) and Josep Llimona (1864–1934), and the members included Dionís Baixeras (1862–1943), Alexandre de Riquer (1856–1920) and Antoni Gaudí (1852–1926). The works of Joan Llimona and Dionís Baixeras, the outstanding members of the group, are characterised by a naturalistic realism which infuses their scenes of rural life and the sea.

As we have seen with Rusiñol, the influence of symbolist painting was also felt in the nineties. Academic symbolism arrived from France through the agency of Joan Brull (1863–1912), whose *Dream, c.* 1898 (fig. 166), won a first prize at the Fourth Exposició de Belles Arts in Barcelona in 1898, while English influence was transmitted principally through Alexandre de Riquer, who acquired first-hand knowledge of Pre-Raphaelite painting during his stay in London in 1894, as we mentioned earlier. Riquer's influence was most significant in the graphic arts, which are discussed elsewhere in this catalogue.

1897 was a year of special significance to our theme, for it saw the opening of the tavern 'Els Quatre Gats', which became a new meeting place for *modernista* artists and intellectuals. This establishment, in the style of the 'Chat Noir' in Paris, was founded by Rusiñol, Casas, Utrillo and Pere Romeu, and it translated to Barcelona the small group of personalities who only a few years before had met in Sitges at the first *Festa modernista*.

At Els Quatre Gats important avant-garde artistic and cultural events were held, such as exhibitions, concerts, readings, theatrical performances, etc. Maragall read his poems there, Albéniz and Granados gave concerts, and many of the artists who frequented the Quatre Gats *tertulia* held exhibitions there of their works. Els Quatre Gats gave Casas the opportunity to meet many of the personalities who, starting in 1897, made up the important gallery of charcoal portraits (figs. 151–3 etc.) in which he showed his extraordinary facility for drawing. The Quatre

164. Nonell. *Asking for charity*; cover of *Quatre Gats* no. 4, 2 March 1899 (no. 314). Biblioteca dels Museus d'Art, Barcelona.

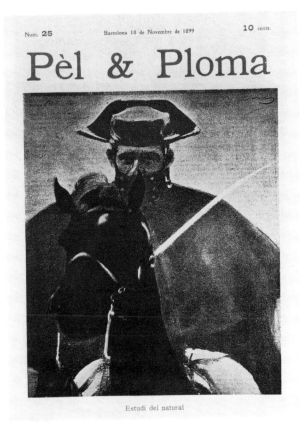

165. Casas. *Study from life*; cover of *Pèl & Ploma* no. 25, 18 Nov. 1899 (cf. no. 313). Biblioteca dels Museus d'Art, Barcelona.

166. Brull. *Dream, c.*1898.
Oil on canvas, 200 × 141 cm. Museu d'Art Modern, Barcelona.

167. Nonell. *Study*, 1908. (no.170).
Oil on canvas, 54 × 66 cm. Museu d'Art Modern, Barcelona.

Gats circle also produced several of the best *modernista* magazines, such as *Quatre Gats* (1899) and *Pèl & Ploma* (1899–1903), in both of which the leading spirit was Miquel Utrillo.

During the final years of the nineties, leadership of the artistic avant garde passed from the hands of Rusiñol and Casas to a second *modernista* generation, whose leaders were also part of the Quatre Gats circle, but Rusiñol and Casas went on painting until the ends of their lives. The former continued for some years in the vein of symbolism which informs the series of *Gardens of Granada*, concluding with the *Gardens of Aranjuez*, which mark the decline in his career as a painter. Casas, after 1900, concentrated on portraits, principally of women of the Catalan bourgeoisie, but he also produced some splendid paintings of 'Manolas' (girls of Madrid), and, finally, some local landscapes.

The second generation of *modernistes*, born in the seventies, gave Catalan painting new figures of great character, at least as much so as their predecessors. Among the most outstanding were Joaquim Mir (1873–1940), Isidre Nonell (1876–1911), Hermen Anglada Camarasa (1871–1959), Ricard Canals (1876–1931), Marià Pidelaserra (1877–1946) and Josep Maria Sert (1874–1945). Of these, it was Anglada, Nonell and Mir who, without a doubt, firmly established this brilliant phase of Catalan painting. They are very different artists, but all three had extraordinary artistic personalities which, though they cannot easily be grouped within a specific artistic school, merit the international recognition which only Anglada obtained. Both Anglada and Nonell, after a period of study in Barcelona, travelled to Paris. Nonell lived there between 1897 and 1898 and made a second trip in 1899, returning then to Barcelona where he lived until his death. Anglada, on the other hand, after a trip in 1894, took up residence there in 1898, with only intermittent stays in Spain until 1914, when he moved to Port de Pollença in Mallorca. In 1939, as a result of the Civil War, he went into voluntary exile in France until 1948, when he returned to Mallorca, where he lived until his death. Mir never visited Paris and always lived in Catalonia, spending the period between 1900 and 1903 in Mallorca.

Mir and Nonell began painting with the same group, known as the Colla del Safrà (1893–6), and in their first periods both executed subjects of social deprivation, but they then followed quite different paths. Nonell, from 1902, began to devote himself exclusively to paintings of gypsies, in which he was principally concerned with the problem of volume. Over the next four years his palette, which to start with was very dark, became progressively lighter, and he began to abandon the theme of gypsies, but continued to paint other female figures, and, right at the close of his life, which ended when he was only thirty-five, he painted several still lifes. Even though

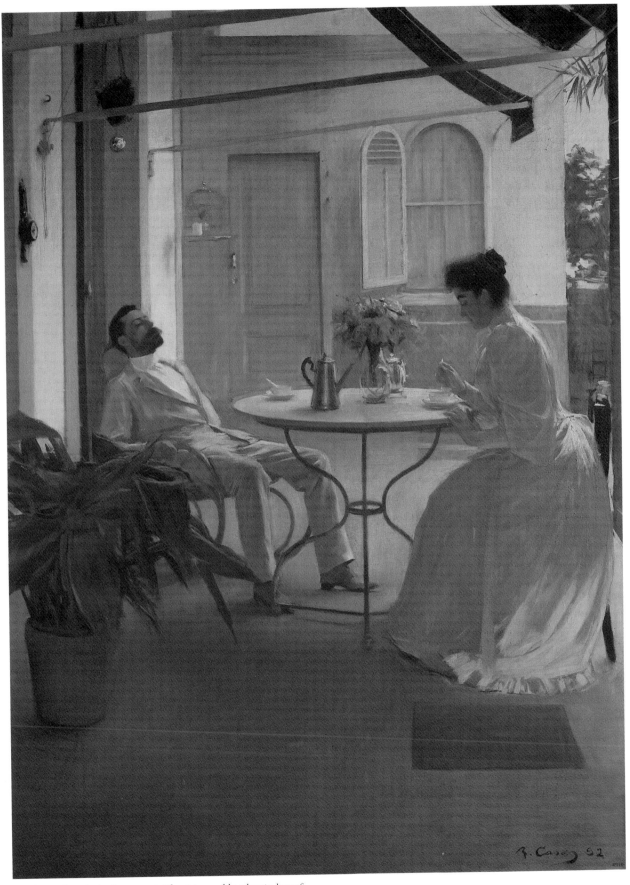

168. Casas. *Interior in the open air (the sister and brother-in-law of
the artist taking coffee on the terrace of their house)*, 1892 (no. 19).
Oil on canvas, 161 × 121 cm. Collection Marqués de Villamizar.

169. Casas. *Corpus Christi procession leaving the church of Santa Maria del Mar*, 1898 (no. 25).
Oil on canvas, 115.5 × 196 cm. Museu d'Art Modern, Barcelona.

170. Mir. *Terraced village (Maspujols, Tarragona)*, 1907 (no. 147).
Oil on canvas, 121 × 164 cm. Museu d'Art Modern, Barcelona.

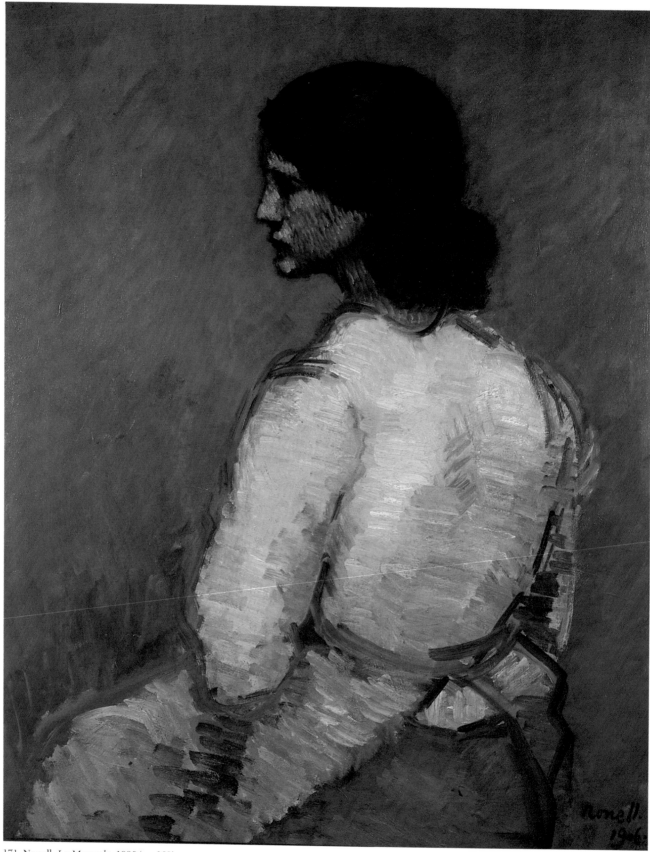

171. Nonell. *La Manuela*, 1906 (no. 169).
Oil on canvas, 100.6 × 80.5 cm. Museu d'Art Modern, Barcelona.

Nonell received no public or critical recognition until 1910, the year before his death, he can be considered one of the true geniuses of modern Catalan painting. Mir became the purest representative of Catalan landscape painting in this period, beginning with his Mallorcan paintings of 1900–3 (fig. 161). His personal and spectacular vision of landscape culminated in the canvases painted in Tarragona between 1906 and 1912 (fig. 170), where colour completely dominates form.

Colour was also the principal concern of Anglada. His own manner of painting began with subjects of Paris night life in the style of Degas and Toulouse-Lautrec, but his finest works were those on themes of Valencian folklore (*c.* 1904), and later he continued with his chromatism in his landscapes of Mallorca.

This brilliant new phase of Catalan painting had a decisive influence on the formation of the young Picasso (1881–1973), who had arrived in Barcelona with his family in 1895. Picasso regularly attended the *tertulias* at Els Quatre Gats, and he even illustrated the menu of the establishment (fig. 36). There in 1900 he had his first Barcelona exhibition, which largely consisted of portraits of his friends and members of the *tertulia*, and there he met the protagonists of *Modernisme* like Rusiñol and Casas as well as members of the second *modernista* generation. Of these, it was Isidre Nonell who exercised a special influence on Picasso. The themes of people on the fringe of society which Nonell explored, especially in his strongly expressive gypsies, were developed by Picasso during his Blue Period, especially in Barcelona in 1902 (figs. 35, 40).

Inevitably, in discussing the leaders of the *modernista* movement, it has been necessary to pass over many of the artists active during this period, but one who must be mentioned is Francesc Gimeno (1858–1927), a painter who was entirely self-taught and who achieved an extraordinary expressive force in both figure and landscape subjects. This work can be compared with the best painting of a movement which is still far too little known outside Barcelona, and which merits a place of honour in the panorama of European art at the turn of the century.

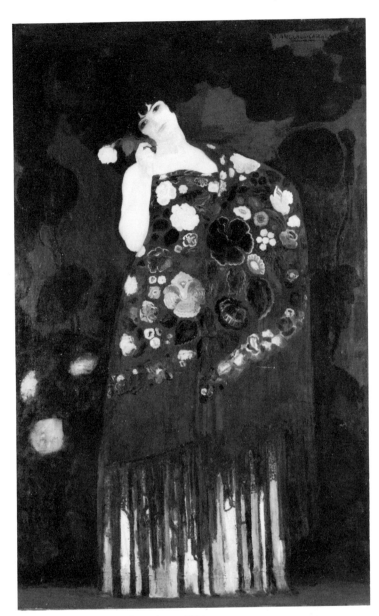

172. Anglada Camarasa. *Granadina, c.*1914.
Oil on canvas, 194 × 124 cm. Diputació de Barcelona.

173. Nogués. *La ben plantada*, 1912 (no.162).
Etching with aquatint, 17.7 × 15.9cm. Museu d'Art Modern, Barcelona.

The art of Noucentisme

Francesc Fontbona

174. Clarà. *Xènius*, 1910.
Bronze, h: 61 cm. Museu Clarà, Barcelona.

The year 1906 marks the emergence of a Barcelona intellectual who in a very short time was to show an extraordinary ability to muster a band of followers. His name was Eugeni d'Ors, and although he was already well known, this was the year that his column 'Glosari' first appeared in the Catalanista daily *La Veu de Catalunya*, winning him an enthusiastic audience and giving him great influence, especially over the young. His writings, signed with the pseudonym Xènius, expressed his determination to give a structure to the cultural unrest which was manifested in the work of a new generation of writers and artists. A highly gifted propagandist, Xènius coined the word *Noucentisme* to describe the spirit of the work created by the younger generation.

Noucentisme, then, originated from the desire to give a name to the brilliant work of a group of writers and artists whose only common link was to have come to the fore more or less with the opening of the new century. Ors called them *noucentistes* – just as the Italians of the 1400s or 1500s were known as *quattrocentisti* or *cinquecentisti* – in order to distinguish them from those who had shone at the close of the nineteenth century and in order to instil in them a group consciousness, so that the new society dreamed of by the Catalanists would have a 'cultural brigade' to support the political aspirations of a new Catalonia.

There was no sense at the beginning of a *noucentista* school or style, and Xènius accommodated artists as different as the refined and mannered decadents Ismael Smith, Laura Albéniz and Néstor, the caustic caricaturist Apa (Feliu Elias) – who later became a great theorist and painter – the exuberant cosmopolitan Josep Maria Sert, the intimist illustrator Pere Torné Esquius and the classicist sculptor Josep Clarà. All of them were ceremonially appointed *noucentistes* in the 'Glosari' between 1906 and 1909 – Ors knew the magical power of liturgical gestures – but what united them was no more than their youth, their recent appearance on the artistic scene and their departure from conventional styles. The list of Xènius's 'chosen ones', together with those not formally invested but favourably commented upon by him, was similar to that of the members of the association Les Arts i els Artistes, founded in 1910, which was to survive as a group for a quarter of a century.

To emphasise the solidarity – still more a wish than a fact – among young, intellectual artists of the new generation, Ors planned a remarkable publication, a luxurious almanac for 1911, prepared with much care, which would

175. Aragay. Cover of *Almanach dels noucentistes*, 1911 (no. 291). Biblioteca dels Museus d'Art, Barcelona.

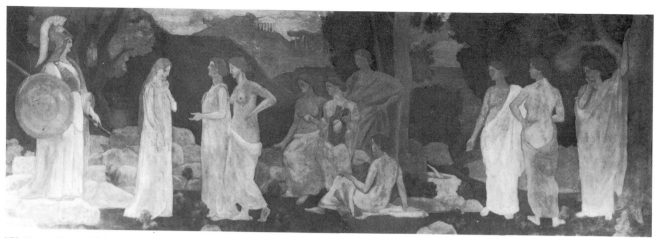

176. Torres García. *Philosophy presented by Pallas Athene on Parnassus as the tenth Muse*, 1911 (no. 254). Oil on canvas, 124 × 385 cm. Institut d'Estudis Catalans, Barcelona.

177. Sunyer, *Landscape at Fornalutx (Mallorca)*, 1916 (no. 248). Oil on canvas, 100 × 126 cm. Museu d'Art Modern, Barcelona.

serve as their practical manifesto. This was the *Almanach dels noucentistes*. In it was published, along with texts by various young writers and scientists, a series of reproductions of recent works by a number of artists, including some of those who had been 'appointed' *noucentistes* by Ors in his 'Glosari' – Smith, Clarà, Torné Esquius – and also most of the members of the second generation of *modernistes* – Nonell, Mir, Canals, Gargallo and Nogués as well as Picasso (whose move to Paris the organisers deliberately saw as only temporary) – for although most of these had started their careers in the last years of the nineteenth century, it was in the first decade of the twentieth century that their personalities really became established. Joaquín Torres García, then an apostle of Mediterranean classicism, and Josep Aragay, who was to take over the artistic direction of the group, completed the list of *noucentistes* in the *Almanach*. Its philosophy was clearly defined by the critic Joaquim Folch i Torres, writing under the pseudonym of Flama,[1] according to whom *Noucentisme* would be the real culmination of the process initiated earlier by the *modernistes* of rejecting the conventional anecdotalism which reigned at the Sala Parés (the gallery which dominated the Catalan artistic scene).

The appearance of the *Almanach dels noucentistes* was an important landmark in the development of a coherent *noucentista* spirit, and it was the last time the movement showed this eclectic character within the context of modernity. The death that year of Nonell – the charismatic painter of the second generation of *modernistes* – weakened the 'modern' option within *Noucentisme*, and with Nonell dead, Mir had less militant enthusiasm, while it was quite evident that Picasso was settled in Paris and far removed from the nerve centre of Catalan art; Canals was converted to full *Noucentisme*, Gargallo clearly decided to alternate between the fashion for classicism and extreme modernity, and Smith left Barcelona to move permanently to New York.

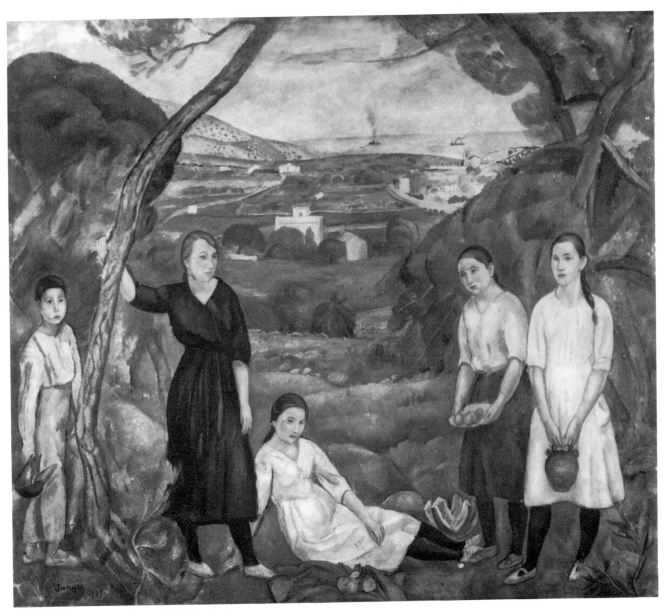

178. Sunyer. *Forn Bay (Cala Forn)*, 1917 (no. 249).
Oil on canvas, 120 × 140 cm. Museu d'Art Modern, Barcelona.

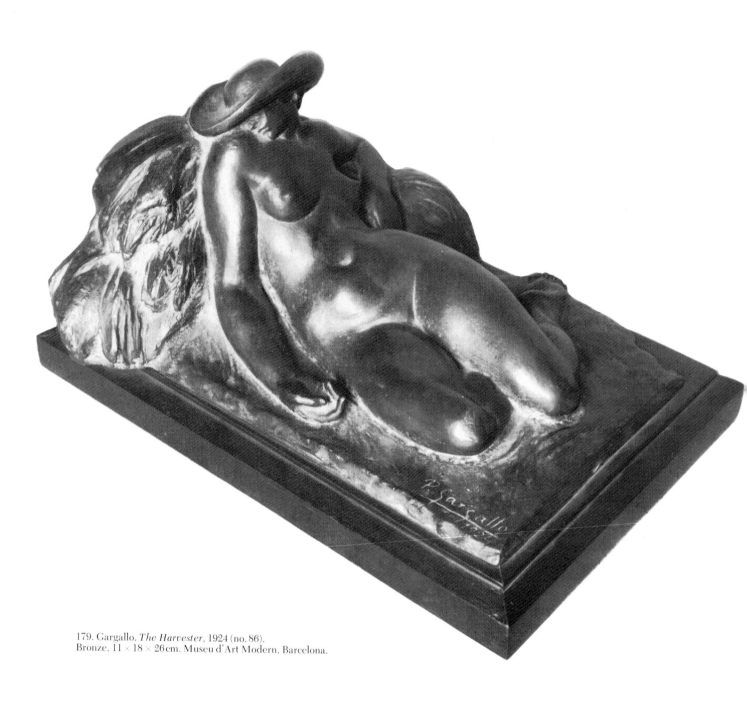

179. Gargallo. *The Harvester*, 1924 (no. 86).
Bronze, 11 × 18 × 26 cm. Museu d'Art Modern, Barcelona.

As a result, *Noucentisme* after the *Almanach* recognised only classicism as the correct style. This established the direction set by Torres García and, to a lesser extent, by Clarà, which was reinforced by the important archaeological finds at Empuries on the northern coast, near the French border. However, the classicism adopted by the *noucentistes* was not a simple copy of Graeco-Roman classicism, like the Neoclassicism of the late eighteenth and early nineteenth centuries, and it reflected very different attitudes to those of the academies of the past. The *noucentistes* were convinced of the necessity for reforging links with the Mediterranean tradition, after a period in which modernity had been synonymous with the inspiration of Parisian or generally northern models. It has to be remembered that the *noucentistes* were strongly rooted in Catalan nationalism, and Catalonia recognised that it was a part of a tradition that was essentially Mediterranean, tied logically to the art of Italy, Languedoc and Provence. As Torres García had said several years earlier, 'It would be appropriate, perhaps . . . to turn to the tradition of art which belongs to Mediterranean lands; to abandon French Impressionism, English Pre-Raphaelitism and German Symbolism . . . which are still in fashion, though they are alien to us here.'[2] Torres García also set an example for paintings that would be ambitious both in conception and dimensions in his great group of frescoes painted in the Saló de Sant Jordi in the Palace of the Generalitat in Barcelona (1913–18).

The appearance of the mature work of Joaquim Sunyer in painting and Enric Casanovas in sculpture was now a decisive step. Neither had appeared in the pages of the *Almanach*, but they soon became the two most characteristic representatives of the new movement. In the case of Sunyer, whose age and background placed him in the second generation of *modernistes*, it was as a result of the exhibition of his paintings in April 1911 at the galleries of the Faianç Català in Barcelona that he took over as leader of new young Catalan painting less than two months after the death of the former leader Isidre Nonell.

That historic exhibition marked the emergence of a pastoral Sunyer, tranquil author of serene landscapes that were simplified in a way that showed the distant influence of Cézanne, but it was a Cézannism with smooth contours and of a gentle cheerfulness. Sunyer had given up painting in a Parisian post-impressionist manner – at times rather like Bonnard – in order to create these distinctive compositions, which were compact and solid within their slightly archaising execution. The secret of Sunyer's success was that he interpreted what Catalan intellectuals felt; he described an earthbound Mediterranean world, and he created a new, secular, mythology, which spoke in plain language and which removed from Catalan art the northern influence that had characterised *Modernisme*. Sunyer showed how the Catalan spirit could break with the system of values that until then had meant that

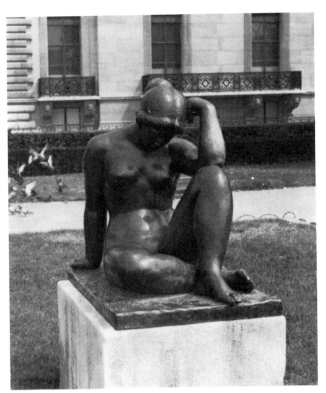

180. Maillol. *La Méditerranée*, 1902–5. Bronze, h: 110 cm. Jardins du Louvre, Paris.

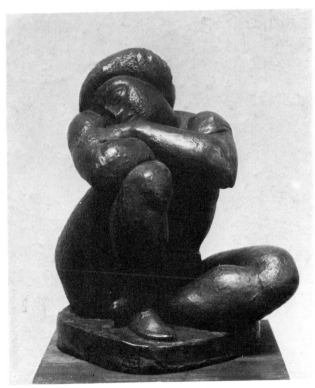

181. Manolo. *Crouching woman*, 1914 (no. 131). Bronze, h: 22 cm. Galerie Louise Leiris, Paris.

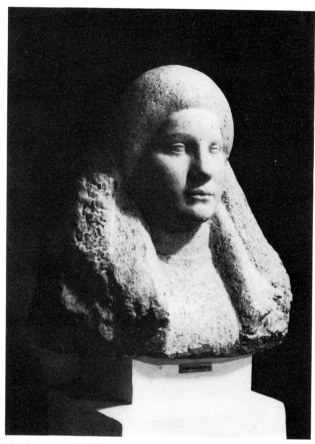

182. Casanovas. *Mallorcan peasant woman, c.*1916 (no. 15).
Stone, 50 × 47 × 40 cm. Museu Municipal de Tossa.

modernity in art was synonymous with similarity or
dependence on what was created in Germany, England,
Belgium and, above all, Paris. And what was still more
remarkable was that he succeeded in winning over the
most respected *modernista* intellectual of the period, the
poet and essayist Joan Maragall, who gave him enthusiastic
recognition in an outstanding article.[3]

Maragall came to have a still more important role in
the consecration of the new *noucentista* style, as he was
soon also to give an appreciation of the work of the
principal sculptor of this movement in Spanish Catalonia,
Josep Clarà. At a banquet in Clarà's honour he dedicated
a poem to him in which, referring to his works, he said
that 'they are brothers of those immortal daughters on
the other side of our sea' and concluded with the words,
'Brother: you have become the prophet of your people'.
Nevertheless, the great propagandist of the new movement
remained Eugeni d'Ors. In 1912 he published his novel
La ben plantada, in which the heroine symbolises the
spirit of the new movement. *La ben plantada* became the
bible of the new Catalanist mythology, and the physical
characteristics of the heroine – strength, tall stature,
serenity – were treated sculpturally by Clarà and Enric
Casanovas in many of their works. These concentrated on
female nudes of classic simplicity, and indeed Casanovas
was specifically commissioned to give a form to *La ben
plantada*, designed to preside over the façade of the
building of the Societat Athenea in Girona, a body which
was the focus of the *noucentista* spirit in the city under
the presidency of the architect and poet Rafael Masó.[4]
Perhaps the most extraordinary aspect of this development
is that exactly the same subject-matter and the same
aesthetic were being cultivated in the part of Catalonia
under French rule in the work of Aristides Maillol. Maillol
was outside the ambit of Ors's movement, and his work
was still not known at all in Barcelona, so we can discount
the possibility of any mutual influence. But he became
one of the greatest exponents of a new timeless classicism,
common not only to the two parts of Catalonia but to all
the countries of Mediterranean Europe. For this reason,
it is not surprising that an English publisher wanted to
produce an edition of *La ben plantada* with illustrations
by Maillol, but the project did not go ahead, apparently
because of Maillol's reaction to the supposedly pro-
German sympathies of Ors.[5]

Noucentisme was not, then, a school apart, isolated
from the common trunk of European culture at the time,
but the conscious development in Catalonia of a natural
sensibility which had parallels in other neighbouring
countries. There is a distinctive common quality which is
also to be found in the mature work of the native Provençal
Cézanne, or in that of Renoir, who was more and more
attracted to Provence and finally settled in Cagnes in
1907; it can be seen, too, in the work of some of the Fauves
– Matisse, Dufy, Gauguin – who found on this same

183, 184. Nogués. *Two cloaked men with a large glass of wine,*
and *Coastal landscape seen through an arcade*;
frescoes, 1915, from cellar bar of Galeries Laietanes (no.161).
Distemper panels, 109 × 150.5, 190 × 320 cm. Museu d'Art Modern, Barcelona.

185. Elias. *Woman with a vase of flowers, c.* 1929 (no.73).
Oil on canvas, 61 × 52 cm. Collection J.B. Cendrós, Barcelona.

coast, or further down in French Catalonia, at Cotlliure (Collioure) and Ceret, a new inspiration for their art; or later among the Italian group known, coincidentally, as the *Novecento*. It is a quality which is clearly Mediterranean, sometimes expressed as sensuality and warmth, at other times in a sense of volume or in vivid colour; and there is often a feeling of the Virgilian world in the subject-matter. There was never any united group – although many of the artists were associated with Maillol in Roussillon – but together they all demonstrated a real alternative art of southern Europe, which was very different from that dictated by Paris. However, because it was the art of a geographical area that had no concerted political expression, it never became a decisive influence on contemporary movements in western art as a whole. In Catalonia, *Noucentisme* did assume a dominant role in Catalan cultural life of the period: sculptors like Esteve Monegal, Joan Borrell Nicolau and Fidel Aguilar, among many others, were fully committed to the movement. Others, without being really 'militant' *noucentistes*, were affected by the movement in some of their work; this is true of Pau Gargallo and Manolo Hugué, the first of whom continually alternated between experimental, avant-garde figures and ample Venuses, while the second sought for a balance between classical mythology and popular figurines. Julio Antonio, another Catalan, who became part of the Castilian artistic world, also produced extremely *noucentista* works, such as his *Venus Mediterránea* of 1912.

Nevertheless, to reduce *Noucentisme* to a re-creation of classicism would be to give only a partial view of the movement. Although Ors's original broadly based idea had, between 1906 and 1911, yielded to the classicism already described, mature *Noucentisme* also embraced other trends that were not strictly classicistic. Thus one of the key names of the movement, Xavier Nogués, a survivor of the aesthetic of second-generation *Modernisme*, embodied an aspect which was also an important ingredient in *Noucentisme*, the satirising of popular taste. As an illustrator, engraver and painter, Nogués created an entirely personal style, which is perhaps summed up in his extraordinary collection of drawings for the album *La Catalunya pintoresca* (1919). This contains grotesque figures, expressionistic in a way that is far removed from the horrific tradition of Spanish caricature, who make up satirical scenes which, without imitating them, were done in the spirit of traditional popular Catalan prints, a spirit which they enriched both technically and conceptually. The characters on whom the greater part of Nogués's work is based are the same as the dwarf-like figures in his key etching (fig. 173) threatening *La ben plantada* of Ors's myth, who stands serenely above their petty aggression. For this reason, Nogués can be defined as a focus and synthesis of *Noucentisme*, because just as his work is a middle point between the classic and the realistic, so it

also lies between Ors and Feliu Elias, who were both friends of Nogués although enemies themselves – almost since the time of Ors's *noucentista* 'appointments' – and who were the major representatives of the two main tendencies outlined.

Feliu Elias was to be the real rival of Ors. He was a painter of obsessional objectivity, recalling the German *Neue Sachlichkeit* (fig. 185), while under the pseudonym Apa he was also a prolific political caricaturist in *Papitu*, the aggressive and caustic magazine he founded (in 1908) and directed, which attacked the right-wing Catalanist Lliga Regionalista; his fanatically anti-German caricatures collected in 1917 as *Kameraden* won him the French Légion d'Honneur. He was, in addition, an art historian and a theorist of great influence, opposed both to *Modernisme* – as would be expected in someone of his generation – and to the main movement of *Noucentisme*, which he described as 'pedantic transcendentalism', while at the same time he was bitterly opposed to the avant garde. In fact – leaving aside the personal dispute with Ors – Elias's work represents a critical version of *Noucentisme*, the equivalent in art to the politics represented by Catalanist parties of the bourgeois left.

On occasions, a certain tendency towards the Baroque can also be detected in *Noucentisme*. It is a restrained Baroque, never frenzied, and was not a response by *noucentistes* to a sense of identification with the style itself, so much as a desire to relate to what was in a certain way a popular aesthetic in Catalonia. So we can see that, in its eagerness to rediscover its roots in Catalonia, *Noucentisme* did not just turn towards the imprint that had been left by the Greek world, but also towards a more recent art which had been the characteristic style of the country for more than two centuries: it was the art of a Catalonia culturally and politically confined – that of the period in which the country had lost its power – but which still seemed to contemporary eyes to be part of a past with its own essential identity. It was the aesthetic of old baroque altars that survived in practically all the churches and chapels of the country, as well as the style of the buildings which contained them; the aesthetic of the old prints which appeared in books of hymns or romances, religious or profane pages through which the popular culture of the country had been transmitted and which formed part of a very deeply rooted tradition.

Some of the artists most firmly committed to *Noucentisme* made use of this Baroque. Josep Aragay did illustrations for books and publications of all kinds, and he also made ceramic pieces which never aimed – like modern ceramics – at a refined and elitist aestheticism but rather at presenting a familiar image for the man in the street. Vessels of all kinds and Valencian ceramic murals with little decorative scenes – which are deliberately naïve – are reminiscent of indigenous pottery but without slavish imitation.

186. Goday. Design for the Baixeras School, 1918–22.

187. Puig i Cadafalch. Doorway of Casa Pich, 1921.

This spirit was taken up by the Escola Superior dels Bells Oficis, a body created in 1914 by the regional authority of Barcelona and later maintained by the Mancomunitat of Catalonia for the training of new generations of Catalan craftsmen, so that they could get away from the vulgarity that was inescapable when the decorative arts were stuck in an utterly complacent routine of production. The guilding spirit of this school was the painter Francesc d'Assís Galí, who until then had run a private art academy in which some of the best Catalan artists of the next generation received their training. Galí gave a new impetus to the study of ceramics at the school (under Aragay, Antoni Serra and the Frenchman Alexandre Bigot), and also to woodworking, landscape-gardening (under Nicolau Maria Rubió), jewellery (Ramon Sunyer) and tapestry (Tomàs Amat), as well as producing an important body of work of his own, which ranged from neo-baroque book illustration to posters whose schematic compositions showed cubist influence (figs. 275, 284).

The refined Baroque mentioned earlier also appeared in the architecture of this period. The outstanding examples were a series of primary schools, and the most representative architect was Josep Goday, whose buildings incorporated not only applied sculpture but also *sgraffito* (fig. 186) – a decorative technique which had flourished conspicuously in Catalan architecture of the eighteenth century. Goday was in fact a disciple of Puig i Cadafalch, one of the great names in *modernista* architecture – as well as an art historian and Catalanist politician – who had developed a popular baroque style at the beginning of the century, inspired by the farmhouses in his native district of the Maresme.

However, the classicising tendency of *noucentista* architecture was perhaps still stronger than the baroque influence. Rafael Masó, whose work is characterised by a personal blend of Greek and secessionist influences, has already been mentioned. He was largely active in the region of Girona, and his work was contemporary with that of followers of Gaudí such as Josep Maria Jujol or Cèsar Martinell, while it anticipated the arrival of a new group of architects – Adolf Florensa, Nicolau Maria Rubió, Raimon Duran Reynals – whose refined transcriptions of Brunelleschi and Italian Renaissance architecture in general were infused with a Mediterranean fervour (fig. 188).

The association of *Noucentisme* with the avant garde came about as a result of the work of a new generation of artists, the generation of 1917. This was a key year in the political as well as the cultural development of Catalonia, and indeed of all Spain. It was a year of great conflicts – in political life, in organised labour and in the army – and it was the year of the death of Prat de la Riba, president of the Mancomunitat of Catalonia, who had succeeded in uniting the efforts of bourgeois intellectuals across a broad ideological spectrum. It was thanks to him that

188. Rubió and Duran Reynals. Parish church of Maria Reina, Pedralbes, 1922–36.

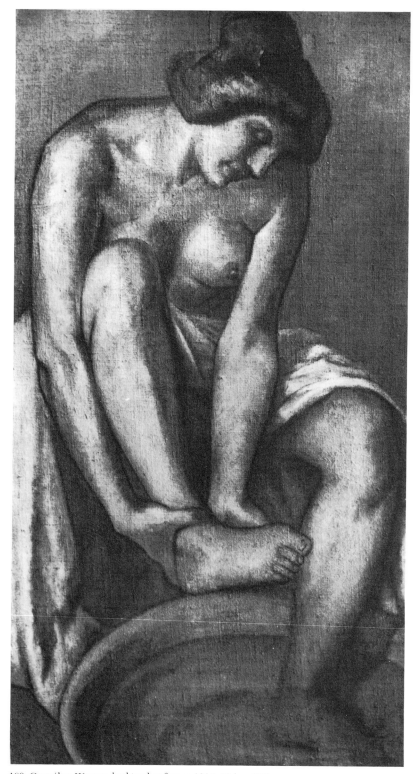

189. González. *Woman bathing her feet, c.* 1914–18 (no. 106).
Oil on canvas, 110 × 60 cm. Museu d'Art Modern, Barcelona.

Noucentisme became an instrument in the optimistic task of a Catalan awakening. His successor, the architect and historian Puig i Cadafalch, was president of the Mancomunitat during a more difficult period and was less capable of uniting opinion, so that the harmony that had existed until then between politics and culture in Catalonia was undermined. Moreover, new influences made a strong impression on Catalan culture: a number of European avant-garde artists and intellectuals took refuge from the First World War in Barcelona, among them Francis Picabia, Albert Gleizes, Marie Laurencin, Olga Sackaroff – who settled in Barcelona – and Arthur Cravan, who promoted his totally iconoclastic vision of culture. Their influence was associated with a constant succession of exhibitions of new avant-garde trends, especially at the Galeries Dalmau, and although they appealed to a minority, they came to disrupt the idyllic, and perhaps illusory, equilibrium of *Noucentisme*.

The new artists of the generation of 1917 were disciples of the *noucentistes*, whom they criticised, some with more, others with less respect, questioning the idealism of the preceding generation. Although there were some who became excellent exponents of a prolongation of *Noucentisme* – the painter Josep Obiols, or the wood engraver E.C. Ricart – in general most of them moved away from classicism and from popular imagery, preferring to depict the reality of the landscape, often suburban, with earthen tones, consciously removed from any kind of brilliance or any awareness of Cézanne's influence. The principal names were Joan Serra, Alfred Sisquella, Emili Bosch-Roger, Rafael Benet, Francesc Domingo, Josep Mompou – painters, and Josep Granyer, Apel.les Fenosa and Joan Rebull – sculptors, the last a great searcher for the purest and most forceful forms without abandoning the real model. Some of them felt themselves attracted to the avant garde, but in general this attraction was a passing phase, and several of them ended up by destroying their own avant-garde works after a first stage of optimistic experimentation. Others who became associated more or less with the School of Paris (which included Modigliani, Soutine and Pascin) were Pere Pruna, Josep de Togores, Manuel Humbert and Pere Creixams.

There is only one case of an artist of the generation of 1917 who remained faithful to the avant garde, a disciple of Galí who also went to Paris. There he became a protagonist in one of the most important movements of new painting in the twentieth century. His name was Joan Miró.

190. Humbert. *Exposició d'Art Primavera*, 1921 (no.118). Poster, 76 × 54.8 cm. Museu d'Art Modern, Barcelona.

NOTES

1 Flama, 'Al començar l'Història dels Noucentistes', *La Veu de Catalunya*, 16 November 1911.
2 Joaquín Torres García, 'La nostra ordinació i el nostre camí', *Empori* no. 4, April 1907.
3 Joan Maragall, 'Impresión de la exposición Sunyer', *Museum* no. 7, 1911, pp. 251–9.
4 Nevertheless, the statue on which Casanovas was working in the summer of 1914 seems never to have been installed in the niche on the façade of the Societat Athenea which appears in Rafael Masó's drawing; see Teresa Camps, 'Notes biogràfiques' in the catalogue of the exhibition, *Enric Casanovas*, Palau de la Virreina, Barcelona 1984–5, p. 22.
5 As recollected by Ors himself in his old age: Eugeni d'Ors, 'Maillol', *Revista* no. 74, September 1953.

191. Gleizes. *Bullfighter*, 1916 (no. 105).
Ink on paper, 24.4 × 19.7 cm. Guggenheim Museum, New York.

The foreign avant garde in Barcelona, 1912–1922

Christopher Green

It is tempting to sum up the position and character of the 'foreign avant garde' in Barcelona, especially at the climax of its activity (1916–17), thus: a small, highly energised cluster of artists, writers and ideas, spinning like a satellite around the Barcelona social and cultural world, occasionally beaming ideas outwards for it to receive; never touching down. Such a metaphorical description might serve as a reductive caricature of all avant-garde activity in relation to cultural and social life everywhere in the West during this century, but it comes close to the facts of the matter in the case of Barcelona, a point to which this essay will repeatedly return.

1912 was the date of a remarkable exhibition in Barcelona, the Exposició d'Art Cubista held in the Galeries Dalmau on Portaferrissa between 20 April and 10 May. This might not have been the first introduction of recent Parisian art to the Catalans, but it marked a change of dimension in what was known, and it was remarkable as one of the earliest mixed displays of cubist work to be held outside Paris.[1] What the Catalans saw was not the hermetic Mallarméan cubist painting of Picasso and Braque (kept out of the Parisian Salons with the encouragement of their dealer D.-H. Kahnweiler), but the more legible, more public Cubism of those who had shown at the Salon d'Automne of 1911 and the Indépendants of 1912: Gleizes, Metzinger, Marie Laurencin, Duchamp, Gris, Le Fauconnier, Léger and the sculptor Agero. The flattening-out of forms, the breakdown of clear distinctions between figures, objects and settings, changes of viewpoint, all these central cubist features were to be found in the paintings on show (most quintessentially in Gris's). Yet, significantly, the range of cubist work there (with the exception of Gris's) represented a *widening* of the scope for subject-matter and connotational meanings in painting, not the narrowing that went with Picasso's and Braque's then current loyalty to still life and the seated model. Gleizes, Le Fauconnier, Léger and Duchamp had all recently developed themes whose contexts were philosophical and literary, drawn to subjects which could communicate such concerns. The central notions of Henri Bergson's philosophy, flux and the continuity of relationships in space and time, were central to them too, and Duchamp's contributions, *Sonata* and *Nude descending a staircase II* (fig. 192), were especially eloquent of this. In *Nude descending* bodily motion becomes the pretext for an exploration of interpenetration, the movement of the figure being denoted by the schematic repetition of contours so that the successive position of body parts in

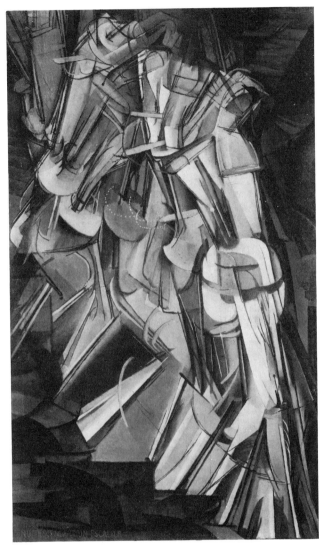

192. Duchamp. *Nude descending a staircase II*, 1912. Oil on canvas, 147 × 89 cm. Philadelphia Museum of Art. Louise and Walter Arensberg Collection.

193. Lloyd. Drawing reproduced in *391* no. 2, 10 Feb. 1917 (no.315). Biblioteca dels Museus d'Art, Barcelona.

194. Lagar. Drawing reproduced in *Troços* no. 3, Nov. 1917 (no.316). Biblioteca dels Museus d'Art, Barcelona.

space slide, as it were, one into another. In *Sonata* cubist 'passage', the opening of contours and merging of surfaces, becomes a visual metaphor for the fusion of sound achieved by Duchamp's musically gifted mother and sisters.

Josep Junoy's *Arte y Artistas*, published in Barcelona at the time of the exhibition, included an informed introduction to cubist theories as well as a commentary on Picasso's early development as a Cubist, and the show was provided with a preface by Jacques Nayral, a writer close to Gleizes in particular, which displayed a sophisticated awareness of current French thinking on Cubism.[2] The full richness of the philosophical and literary connotations around the work seen there might not have been absorbed, but possibilities were opened up, and the reverberations were still detectable years afterwards. It is easy to see, for instance, Celso Lagar's drawing published in *Troços* no. 3 in 1917 (fig. 194) as, partly at least, a late response to the *Nude descending*'s Catalan moment. What is more, the future exposure of foreign avantgardism to the Catalans was, broadly speaking, to reinforce any tendency to avoid a strictly 'retinal' formalism that the 1912 cubist exhibition might have encouraged. Barcelona's foreign avant garde was consistently to promote an alliance between the literary and the visual, word and image.

The Parisian vanguard artists only arrived in Barcelona in significant numbers four years after the cubist show, and certainly the loudest arrival was a one-time associate of the Cubists who had not been included, Francis Picabia. If the foreign avant garde in Barcelona can seem a caricature of all modern avant gardes, Picabia can seem almost to satirise in himself the phenomenon of the vanguard artist. His private wealth freed him from a dependent relationship with the art market; at the same time, he wanted no working niche in any particular society and was instead a mobile cosmopolitan willing to write and produce images anywhere (besides Paris, he had spells in New York (1915–16 and 1917), Geneva, Lausanne and Zurich (1918–19), as well as Barcelona); his audience was his own small circle and a few selected targets for attack (there were always targets). However impossible it might be, his career stands for the aspiration to live as if above the social realities of place and time. In Barcelona his foreign status merely accentuated his habitual stance as a cultural figure.

With Europe at war and others too avoiding the consequences, Picabia found a colony of foreign artists and writers already recently installed in Barcelona when he disembarked in August 1916; the city's neutrality gave it attractions not unlike the Zurich of Dada's beginnings, with the added benefit of Josep Dalmau's energetic commercial support. Robert and Sonia Delaunay were there, though not for long,[3] so were Albert and Juliette Gleizes (both Pacifists), Marie Laurencin (who had arrived in 1914) and her German husband Otto van Watjen, the

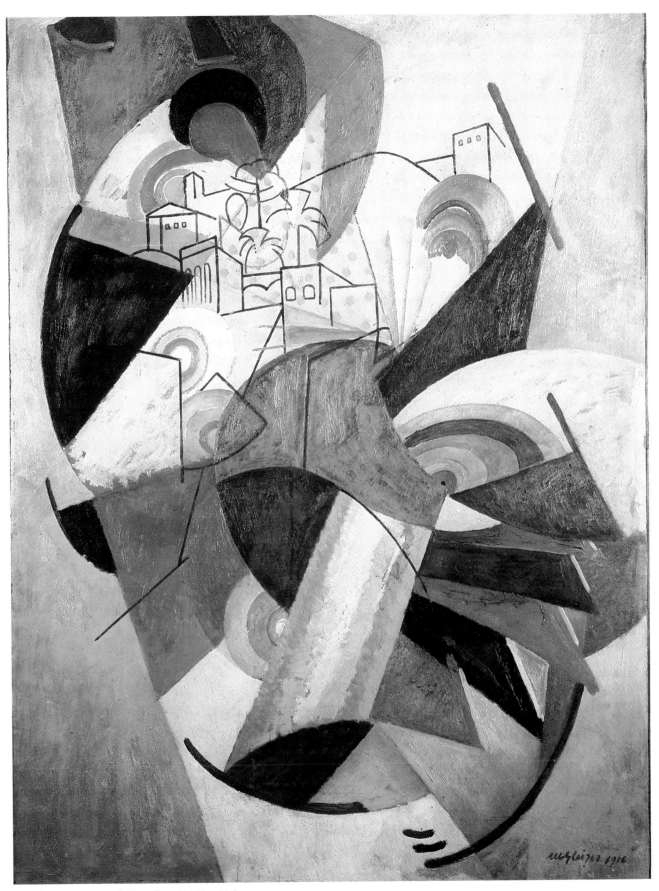

195. Gleizes. *Danseuse de Barcelone*, 1916 (no. 104).
Oil on paper, 102 × 77 cm. Collection Mizné-Blumental.

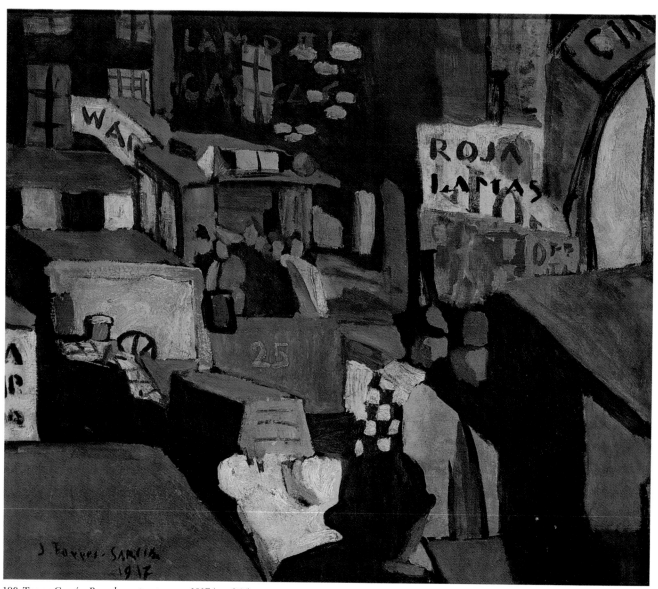

196. Torres García. *Barcelona street scene*, 1917 (no. 255).
Oil on canvas, 61.6 × 72.4 cm. Collection J.B. Cendrós, Barcelona.

197. Miró. *Hermitage of Sant Joan d'Horta*, 1917 (no. 150).
Oil on cardboard, 52 × 57 cm. Fundació Joan Miró, Barcelona.

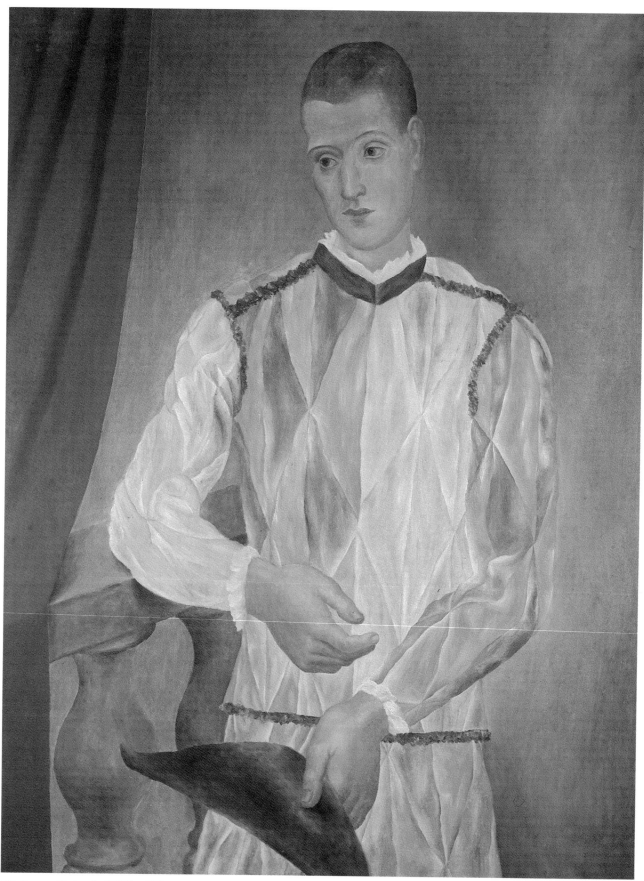

198. Picasso. *Harlequin*, 1917 (no. 185).
Oil on canvas, 116 × 90 cm. Museu Picasso, Barcelona.
The model for the painting was Léonide Massine.

Russian painter Olga Sackaroff with her husband Otho St Clair Lloyd and his brother Fabian Avenarius Lloyd (better known as Arthur Cravan, the writer, boxer and troublemaker), Maximilian Gauthier (who published as Max Goth), and the Russian artist Serge Charchoune with his wife Hélène Grunhoff. The Delaunays, Charchoune together with Grunhoff, and Gleizes all showed with Dalmau in 1916, Gleizes making a noticeable impression in November. Picabia spent the summer enjoying himself with this tiny uprooted community, but by the turn of the year growing boredom forced him to found his own little magazine, *391* (a cheaper variant of Alfred Stieglitz's New York periodical *291*).[4] The first four numbers of *391* appeared in Barcelona between January and March 1917; Dalmau's backing made it possible.[5] Picabia's initiative was to be of sustained importance, but far more to other cultural histories than to Barcelona's.

On the cover of *391* no. 2 (10 February 1917) was a photograph of the inside of a grand piano which was captioned allusively 'Peigne' (comb). Beneath were the following words of advice: 'Look at from a distance, do not look at backwards/It is nonsensical always to want to understand the reasons why' (fig. 200). There was little obscure or offensive about the contributions to *391* of, say, Otto Lloyd (fig. 193) or Marie Laurencin, but Picabia's were always either subversive, nonsensical or so personal as to be incomprehensible to all but his closest friends. He cultivated offensiveness and obscurity. *Novia*, 'au premier occupant' (fig. 199) was the cover to no. 1; it fused the image of a purposeless mechanism and allusions to his wife Gabrielle Buffet (*novia* means bride). The 'first occupant' was, of course, himself, and by signing himself 'Saint des Saints', he introduced further sexual innuendo, since the French 'sein des seins' (breast of breasts) is instantly evoked.[6] Such intricate and intimate meanings were obscure indeed. The poems he published (among his first) were often semi-automatic: they resisted all interpretation.[7] And he was not averse to undermining the contributions of others by simple obscenity: Marie Laurencin's coy illustration *Janine et Marie* in no. 1, all delicacy and innocence, confronts his poem 'Revolver', whose last line is: 'Virgins do not cure syphilis'.[8]

The obscene and the obscure were to become crucial to Picabia's later Dada tactics in New York, Switzerland and Paris; here in Barcelona they simply underlined his alien position. Further, he did not disguise the fact that *391* was above all addressed outside Barcelona to such as Duchamp and Stieglitz in New York (from where Picabia had come in 1916), and Jacob, Apollinaire, Reverdy and Picasso in Paris (the real centre of his attention). The pages devoted by Picabia and 'Max Goth' to current arts affairs said nothing at all about indigenous Catalan culture, but were always in touch with things in New York and especially Paris. Picasso's move into 'Ingriste' portraiture,

199. Picabia. *Novia*; cover of *391* no. 1, 25 Jan. 1917 (no. 315). Biblioteca dels Museus d'Art, Barcelona.

200. Picabia. *Peigne*; cover of *391* no. 2, 10 Feb. 1917 (no. 315). Biblioteca dels Museus d'Art, Barcelona.

201. Miró. Cover for *Arc-Voltaic* no. 1, Feb. 1918 (no. 301). Institut Municipal d'Història de Barcelona.

202. Barradas. *Portrait* (1918); drawing reproduced in *Un Enemic del Poble* no. 16, March 1919 (no. 303). Biblioteca dels Museus d'Art, Barcelona.

for instance (known from the Parisian periodical *L'Elan*), brought instant reprimand by ridicule from Picabia.[9]

The unconcealed foreignness of *391* meant that, for all its vigour and later wide significance, it made relatively little immediate impact in Barcelona. Yet, it is worth stressing the point that Picabia's enterprise sustained the broad thrust of foreign avant-gardism in the city, continuing as it did that playing down of cubist formalist tendencies which was introduced by the 1912 cubist exhibition. Picabia's covers *depend* on the interaction of word and image, while no. 4 included Apollinaire's *calligramme* of 1916, 'L'Horloge de demain' (fig. 289), an especially arresting demonstration of visual and verbal fusion.[10] In Paris between 1916 and 1918 the leading Cubists (especially Gris, Metzinger and Lipchitz) were moving towards a distilled 'synthetic' Cubism, which more consciously limited the subject-matter of Cubism, which gave increasing priority to pictorial or sculptural form as such, and which categorically divided visual art from poetry; significantly, Barcelona's foreign avant garde rejected all this without compromise.[11] The impetus it provided was overwhelmingly away from the univalency of late cubist art. It is interesting that the first clear-cut statement of late cubist theory in France, Pierre Reverdy's essay 'Sur le cubisme' of March 1917, was written as a formalist's answer to the implications of Picabia's *391* covers (copies of the periodical reached Paris fast).[12]

After the production of *391* no. 4 Picabia left Barcelona to return to New York, where he was to be involved in the proliferation of scandal around the First American Independents Exhibition and Duchamp's notorious urinal, *Fountain*. Albert and Juliette Gleizes had left earlier, so had Arthur Cravan (after his legendary boxing match on 23 April 1916 with Jack Johnson in Barcelona); the Delaunays were in Lisbon. But the high period of the foreign avant garde in Barcelona was still not quite over, for in 1917 Picasso returned to the city as designer of the costumes and sets for Diaghilev's Ballets Russes production of *Parade*. There was only one performance of the ballet (at the Liceu on 10 November), but Picasso, who had arrived in June, was treated as a star, and yet another powerful avant-garde stimulus was given to the idea of an alliance between the arts: *Parade* had brought together Picasso the painter, Erik Satie the composer and Jean Cocteau the poet.

As suggested above, the impact of the foreign avant-garde in Barcelona during 1916–17 was neither great nor very obvious, but there is evidence of some interest. Young Catalans did take up stances in relation to it, stances that sometimes involved a reaction against the dominant nationalism and Mediterranean classicism of the *noucentista* artists. A positive response is clearest in the pages of the indigenous experimental periodicals, in particular Josep Junoy's *Troços* (1916–18), Salvat-Papasseit's *Un Enemic del Poble* (1917–19) and the one

issue of his *Arc-Voltaic* (February 1918).[13] It is not the cliquish obscurity of *391* nor Picabia's taste for gratuitous insult that finds echoes here; in the visual sphere, the impact of Gleizes's exhibition at Dalmau's is the most marked, along with that of pre-war Cubism and Futurism, while in the literary sphere, it is that of Apollinaire's *calligrammes*.

Gleizes's *Portrait of Cocteau* had excited special comment in 1916, and this as much as memories of Duchamp's *Nude descending* lies behind Celso Lagar's drawing for *Troços* no. 3 (fig. 194).[14] Again, Gleizes was the major stimulus behind the portrait by the Uruguayan Rafael Barradas which appeared on the first page of *Un Enemic del Poble* in March 1919 (fig. 202). Barradas had earlier made contact with the Futurists in Milan, and brought to what he learned from French Cubism a futurist stress on urban modernity and belief in the possibility of creating equivalents for the energy of urban life by the action of lines and planes. His priorities as what he called a 'Vibrationist' were very much those of his compatriot Joaquín Torres García when he turned away from *noucentista* classicism around 1917 (fig. 196). Gleizes's writings of the war years reveal a tendency to acknowledge the precedence of formal values, the cause of recurrent tensions between himself and Picabia, but his subject-matter was wide-ranging, often urban, and his use of line and colour was given point by that subject-matter: he too stood against the isolation of form as an autonomous pursuit and against too rigid a division of the pictorial from the literary.[15]

But the commitment of Catalan avant-gardists to an alliance of the literary and the pictorial at the expense of a strictly visual formalism is most obvious in the pervasiveness of the influence of Apollinaire's *calligrammes*, certainly in part because of the publication of 'L'Horloge de demain' in *391*, but also because of the availability of the Parisian periodical *S.I.C.* From its first numbered issue (September 1917), a feature of *Troços* were Josep Junoy's *calligrammes* (early in 1918 he made personal contact with Apollinaire); and the portrait by Barradas in *Un Enemic del Poble* for March 1919 is surrounded by the Catalan *calligrammes* of Joaquim Folguera. It is a

further interesting mark of the distinctness of Parisian and Catalan developments that, as the avant-gardist Catalans plunged into typographical experiment, Pierre Reverdy led a decisive reaction *against* the *calligramme* in Paris.[16]

The circles from which Joan Miró first emerged were those of Dalmau and the little Barcelona-based periodicals, and the peculiarities of the response to foreign avant-gardism articulated in *Troços* or *Un Enemic del Poble* leave clues as to how he responded. Early in 1917 Miró met Picabia, but very little of Picabia's mischievousness seems to have stuck; Miró too looked more in the direction of Gleizes and especially Apollinaire. Colour was of particular importance to him in 1916–17 – a concern encouraged by the Delaunays' exhibition at Dalmau's in April 1916 – but the drawing he published in *Trossos* (as it was now spelt) in March 1918 and the related pastel (fig. 204) construct a distorted space by the tilting and piling up of fragmentary elements in a way very much akin to Gleizes's landscape practice of 1910–12 and 1917.[17] More important, he was already reading Apollinaire, not only in translation but in the original French as well.[18] When he exhibited with Dalmau early in 1918 (February–March), the catalogue contained a *calligramme* by Junoy (fig. 216), and in February that year the cover he provided for *Arc-Voltaic* uncompromisingly confirmed his own willingness to make word and image work together (fig. 201). There is a persuasive case for seeing Miró's resistance to late Cubism in its most distilled 'synthetic' form, and his aspiration, alongside Masson in Paris, to be a 'painter-poet', as something initially determined at this time, in the context of the first Catalan response to the foreign avant garde. Certainly, between 1924 and 1927, however low Apollinaire's reputation had fallen in the estimation of André Breton, Miró was to remain a painter more attuned to the *calligrammes* and *L'Enchanteur pourrissant* than to *Les Illuminations* or *Les Chants de Maldoror*.[19]

After the Armistice on 11 November 1918 contacts between Barcelona and Paris multiplied, and October 1920 saw Dalmau present a wide-ranging exhibition of current French art organised by the pro-Cubist critic Maurice Raynal, *Art francès d'avantguarda*, with

203. Picabia. *Hache-paille (Chaff-cutter), c.*1922. Watercolour and gouache on paper, dimensions unknown. One of the works in Picabia's Barcelona exhibition in Nov. 1922.

Picasso, Braque, Gris, Léger, Lipchitz, Gleizes and many more conservative artists included (interestingly, Miró was one of them).[20] There was, however, another visit that makes a better end to this essay. In November 1922 Francis Picabia returned for his show at Dalmau's, and with him came André Breton to deliver a lecture at the Ateneu Barcelonès. Picabia was still unashamedly obscure and foreign. The abstract watercolours he showed were provocative very specifically in a Parisian context, their point vis-à-vis then current prejudices against abstraction in Paris would have been as lost on a Catalan audience as the secret allusions carried by some of their verbal accompaniments (fig. 203).[21] Breton had been briefed on his audience, since he knew its enthusiasms well enough to begin by attacking the Catalans for their worship of Apollinaire. But his lecture too must have seemed almost entirely foreign to those who understood his elegant French; it was packed with judgements of artists and writers virtually unheard of in Barcelona, from Max Ernst to Man Ray, from Robert Desnos to Benjamin Péret. Once again, French avant-gardism hardly touched down in the city. And yet, what was central to Breton's lecture was something that had been central to each previous foreign avant-garde manifestation in Barcelona: it was the point that the work of visual artists and of writers belonged together as the facets of a single cultural phenomenon.[22] The year before, in Paris, Maurice Raynal had dismissed the very idea that there could be a 'Catalan Cubism'.[23] With the French Cubism of the early twenties so committedly univalent, such an idea must have seemed far-fetched indeed; but everything about the activities of the foreign avant garde in Barcelona had prepared the way already for a 'Catalan Surrealism'.

NOTES

I am grateful to Dr Marilyn McCully, without whose help this article could not have been written. Material that she has made available to me has proved crucial.

1 Spring 1907 saw the Fifth Exposición Internacional de Bellas Artes e Industrias Artísticas at the Palau de Belles Arts, with work by Rodin, Manet, Cassatt, Pissarro, Sisley, Renoir, Aman-Jean and Denis. Pre-cubist painting by Picasso was shown at the Galeries Dalmau in February 1912. cf. Enric Jardí, *Els Moviments d'Avant-guarda a Barcelona*, Barcelona, 1983, pp. 15–18.

2 In particular, the recent ideas of Jean Metzinger on shifting viewpoints and duration in painting are fully grasped by Nayral and concisely articulated. Nayral had been involved with Gleizes in the short-lived community of poets and artists at the Abbaye de Créteil.

3 The Delaunays were in Barcelona for their exhibition in April 1916 at the Galeries Dalmau. Their departure is reported in ribald fashion by Picabia in *391* no. 1, 25 January 1917, p. 4. The reason given is their failure to find a large enough studio and the desire to decorate all the house-fronts of Lisbon, the city for which they were headed.

4 *291* no. 1 appeared in New York in March 1915. There were twelve issues between March 1915 and February 1916. It was large in format and expensively produced. Picabia, who was based in New York, was involved throughout and saw *391* as its successor.

5 Cf. Michel Sanouillet, *Francis Picabia et 391*, vol. II, Paris, 1966, pp. 45–6. The printer was Oliva de Vilanova.

6 Cf. *Ibid.*, p. 48. Sanouillet refers to the maquette for this cover in the Fonds Doucet, Paris, which bears the inscription by Picabia:

'Le Saint des Saints, c'est de moi qu'il s'agit dans ce portrait'. Camfield elaborates the interpretation to involve Eve, 'sweetheart of the first occupant, Adam' (William A. Camfield, *Francis Picabia: his Art, Life and Times*, Princeton, N.J., 1979, pp. 94–5. Camfield's is by far the fullest monograph on Picabia.).

7 The poems published in the early issues of *391* (up to no. 7) were all included in the collection *Cinquante-deux miroirs* published in October 1917 in Barcelona.

8 Marie Laurencin's drawing *Musique* was published in no. 4 opposite Picabia's 'Bossus'.

9 See: Pharamousse [Picabia], 'Picasso repenti', *391* no. 1, 25 January 1917, p. 4.

10 'L'Horloge de demain' was the only *calligramme* by Apollinaire published in colour. Sanouillet convincingly dates it to early 1916. It is likely that Apollinaire sent the poem to Picabia in New York before the latter's departure for Barcelona, and that it was intended for publication in *291*. Cf. Sanouillet, *op.cit.*, pp. 63–4.

11 For an account of this centred on Gris, see Christopher Green, 'Synthesis and the "synthetic process" in the painting of Juan Gris, 1915–19', *Art History*, London, March 1982, and 'Purity, poetry and the painting of Juan Gris', *Art History*, London, June 1982.

12 Pierre Reverdy, 'Sur le cubisme', *Nord-Sud* no. 1, Paris, 15 March 1917. Cf. Etienne-Alain Hubert, in *Pierre Reverdy, Oeuvres Complètes, Nord-Sud, Self-Defence et Autres Ecrits sur l'Art et Nord-Sud (1917–1926)*, Paris, 1975, pp. 238–9.

13 For an account of these periodicals and for further details of the contacts between Barcelona and Paris, see Jardí, *op.cit.*

14 Cf. Josep Junoy, in *Troços* (first issue) n.n., 1916, cited by Jardí, *op.cit.*, pp. 31–2; and Pharamousse [Picabia], 'Odeurs de Partout', *391* no. 1, 25 January 1917, p. 4.

15 Gleizes set out his position in 'La Peinture moderne', *391* no. 5, New York, June 1917, pp. 6–7. Already Picabia had revealed a certain ambivalence in his attitude to the painter by referring to him as 'Juge au Tribunal Cubiste' in *391* no. 1.

16 For an early demonstration of this, see Reverdy on punctuation in 'Note', *Nord-Sud* no. 8, Paris, October 1917, in *Pierre Reverdy, op.cit.*, pp. 62–3. See especially, however, Reverdy in *Self-Defence*, Paris, 1919, in *Pierre Reverdy, op.cit.*, pp. 125–6: 'Tandis que d'autres pratiquaient des dispositions typographiques dont les formes plastiques introduisaient en littérature un élément étranger, apportant d'ailleurs une difficulté de lecture déplorable, je me créais une disposition dont la raison d'être purement littéraire était le nouveauté de rythmes, une indication plus claire pour la lecture, enfin une ponctuation nouvelle, l'ancienne ayant peu à peu disparu par inutilité de mes poèmes.'

17 Especially relevant are *Landscape at Meudon*, 1911, in the Musée National d'Art Moderne, Paris, and certain Bermudan landscapes of 1917 (though Miró, of course, could not have seen the latter). See the catalogue *Albert Gleizes, 1881–1953*, Solomon R. Guggenheim Museum, New York, 1964, nos. 23, 107 and 109.

18 Cf. Joan Miró, *Ceci est la couleur de mes rêves: Entretiens avec Georges Raillard*, Paris, 1977, p. 49. Miró claims to have read *Le Poète assassiné* while in the army in 1918.

19 Few claims have been made for the influence of Lautréamont on Miró, but Margit Rowell has claimed Rimbaud as a significant influence. However, she accepts that Apollinaire was 'probably Miró's broadest source of inspiration' in the mid-twenties. See Margit Rowell, 'Magnetic Fields: The Poetics', in the catalogue *Magnetic Fields*, Solomon R. Guggenheim Museum, New York, 1972, p. 55.

20 Blanchard, Dufy, Derain, Friesz, Herbin, Lhote, Rivera, Severini, Signac, van Dongen, Vlaminck, Survage, de Segonzac, Marchand and Moreau were among the others included.

21 The works were inscribed with such words and phrases as 'Astrolabe' or 'Culotte tournante'. They were largely the product of 1921–2, and fit into the context of the challenge mounted both to Naturalism and Cubism in Paris by Picabia's friend Jean Crotti, who showed abstract work at the Salon d'Automne of 1921.

22 See André Breton, 'Caractères de l'évolution moderne et ce qui en participe', in *Les Pas perdus*, Paris, 1924, pp. 148–174.

23 Maurice Raynal, 'Les Arts', *L'Intransigeant*, Paris, 9 September 1921.

204. Miró. *Untitled drawing*, 1917 (no. 157).
Pastel on paper, 56 × 44 cm. Fundació Joan Miró, Barcelona.

205. Ricart. *Joan Miró in the studio he shared with Ricart*, 1917 (no.220).
Oil on canvas, 47 × 59 cm. Collection F.X. Puig Rovira, Vilanova i la Geltrú.

Avant-garde painting in Barcelona, 1912–1930

Alícia Suàrez

Just as *Modernisme* had looked outwards towards Europe, so contact with the new European, mainly French, avant-garde movements gave impetus to works which put together ideas bound up with Cubism, Futurism and Surrealism, in some cases in such original ways that several artists of the time would have international renown, as did Joan Miró or Salvador Dalí. At the same time, critics, galleries and periodicals emerged to diffuse and give support to the new trends. Now all this occurred in a particular society and culture, that of Catalonia, which gave it a rhythm and momentum of its own.

As a result of the reaction against *Modernisme*, a cultural programme was established based on moderation, balance, order, on the search for the quintessential, on Mediterraneanism, which penetrated so deep that it came to the surface even in the figures and events with strongest leanings towards the avant garde. This resulted in some highly individual hybrid developments. Josep Maria Junoy, Joan Salvat-Papasseit, Josep Dalmau and Sebastià Gasch provide good examples of such *volte-faces* and changes of mind. Junoy was a poet and critic at the forefront of Cubism and Futurism and at the same time a defender of Mediterraneanism and classicism; Salvat-Papasseit, the poet, promoted journals in which he drew on cubist and futurist sources and where he brought together *noucentista* and avant-garde contributions; the dealer Dalmau promoted avant-garde and *noucentista* artists alike; while Gasch, a critic who pledged his support to Miró, Dalí and Surrealism from their early days, had moved a long way from his own original stance in order to do so. A conciliatory tone, hardly appropriate to the avant garde, is also often encountered in Barcelona avant-garde publications. And the figure of Picasso, one of the most frequent references in Catalan art of the period, is used in such a way as to give an extremely incomplete view of his work; so that when in 1920 Dalmau included him in his exhibition of French avant-garde art, the most important work (*The Sick Child*, now in the Museu Picasso) dated from 1903.

There are two factors which help to explain this ambiguous situation. An important aim of the *noucentista* cultural programme was that of placing Catalan culture within reach of Europe; even with Eugeni d'Ors himself, the greatest ideologist of Mediterranean classicism, one can detect some receptivity to modern trends. On the other hand, exactly at the time the avant garde began to gather momentum in Barcelona, the trend known as the *rappel à l'ordre* evolved in France, which with its emphasis on nationalism was readily absorbed into Catalan culture. For example, it clearly influenced Junoy, and, through *L'Esprit Nouveau*, this trend also reached Gasch and Dalí, who cited this journal as one of their sources.

Cubism in Barcelona

The presence of works of the newest kinds of art in Barcelona was extremely influential in creating an awareness of avant-garde movements and in spreading the word about them. In this respect, reference to Josep Dalmau, the most important dealer of modern art in Catalonia, is indispensable; his gallery was an open window to Europe. In 1912 he organised the Exposició d'Art Cubista in Barcelona, the first to take place outside Paris. The exhibition was well received by the *noucentista* contingent; thus, Joaquim Folch i Torres, reviewing it, credited Dalmau with the initiative, and described it as a 'truly artistic event', speaking of the splendour 'of this exhibition which we are to take as proof of our artistic pre-eminence'.[1]

Eugeni d'Ors and Josep Maria Junoy dealt with the subject in considerable depth. Ors had gained a good knowledge of the latest French artistic trends from his visit to Paris, and he spoke of them in the 'Glosari', while Junoy, too, was acquainted with the cubist movement in Paris; he certainly also came into contact with the Cubists in Ceret, and in 1912 he published a paper entitled 'From Paul Cézanne to the Cubists'.[2]

The impact of Cubism on the painters themselves was undoubtedly considerable, though earlier more attention was paid to Cézanne, as is apparent in the painting of Joaquim Sunyer, who had spent some time in Paris and worked with the Cubists in Ceret. In fact, in the Catalan context of the period, Cézanne combined ideal conditions: he was a painter in whose works one could appreciate order and compositional structure, the most outstanding feature of Cubism, and the search for a balance between feeling and intellect; he also presented the modern approach to the consideration of the picture as an autonomous pictorial event, and, moreover, he was a Mediterranean painter.[3] Cézannism was a trend which spread widely in Catalonia amongst the restless, progressive artists, and it soon became apparent in the work of young painters like Joan Miró and E. C. Ricart who, again in 1912, began to attend art school together.

Francesc d'Assís Galí's art school

The art school founded by Galí became one of the most

206. Lluís Bagaria. Caricature portrait of Dalmau.

207. Lagar. *Adam and Eve*; cover illustration for the catalogue of his exhibition at Galeries Dalmau, 28 Jan.–12 Feb. 1915 (no.265). Institut Municipal d'Història de Barcelona.

important alternatives in the cultural world of Barcelona to the official institutions, as much for its methodology as for its being included in the cultural programme of *Noucentisme*. At Galí's school, not only were drawing and painting practised, but there were also introductions to music, literature and excursionism. Concerts and literary meetings were arranged, and Xènius's 'Glosari' was discussed. One of his pupils tells how Galí accompanied them on visits to museums, to exhibitions at the Galeries Dalmau, where – according to him – all the latest trends were to be found, and also to exhibitions of a documentary kind (Persian miniatures, oriental drawings), and to the Exposicions Internacionals de Belles Arts organised by the City Council (where, in 1907 and 1911, impressionist, symbolist and naïve works were shown). They also went on walks through the town and on excursions to the mountains, to Gòsol, Núria and above all to Montseny, where they made mental paintings, enjoyed nature and played games.[4]

Galí's teaching avoided the repetition and the mechanical copying of models that were the stock-in-trade of academic training, being directed rather towards a universal and active education of sensitivity.

Joan Miró attended this school from 1912 to 1915 and often emphasised its crucial importance for him. Sebastià Gasch commented that 'at that time [Miró] only saw coloured designs and lines. Form slipped through his fingers. To remedy this, his teacher made him draw objects which he could not see, but only feel. For the same reason, Galí made him make pottery, which would accustom him to form'.[5] And Miró himself referred to this, adding that 'I began to read the poets in the Academy, and not at home. And I have never stopped since. I used to read both foreign and Catalan poets'.[6] Galí's attention to exercises in the observation of nature was also congenial to that attitude of Miró's that made him pay attention to 'the music emanating from tiny flowers and grasses', or to be fascinated by 'the calligraphy of a tree or the tiles of a roof, leaf by leaf, branch by branch'.[7]

The response to Futurism and Dadaism in Barcelona

Following the 1912 exhibition of Cubist Art many young artists began to seek stronger structural lines in painting, although they still looked to Cézanne, and they also began to sense the uneasiness and to immerse themselves in the controversy generated by the avant-garde.

Enric Cristòfor Ricart, one of Galí's pupils, with whom Miró had struck up a close friendship, spent almost half a year in 1914 in Florence in the company of Rafael Sala. There they came into contact with Futurism: they knew the journal *Lacerba*, they frequented the haunts of the Futurists, they got on well with Papini and Tavolato, and they even had news of the Russian Futurists, since Marinetti passed through Florence on his return from Moscow.[8] On their return, the two painters, with a friend,

208. Barradas. *The Dancer (futurist drawing)*, *c.*1917 (no. 7).
Ink and crayons on paper, 32 × 28 cm. Collection Pere Aguirre Gili, Barcelona.

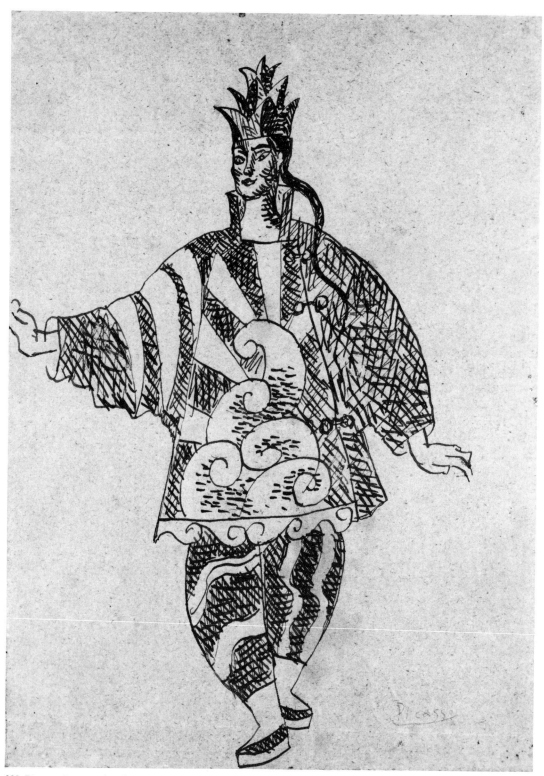

209. Picasso. Costume for Chinese conjuror in *Parade*, 1917 (no. 199).
Ink on paper, 26 × 19.5 cm. Lent by the Trustees of the
Theatre Museum, Victoria and Albert Museum, London.

initiated the publication of a periodical, *Themis*, which came out in Vilanova in 1915. The journal displayed signs of this contact with Futurism and even published the 'Manifesto of the futurist woman' by Valentine de Saint-Point. This avant-garde direction reached Miró through Ricart, since the friendship they had established at the Escola Galí persisted, and they both frequented the Cercle Artístic de Sant Lluc.

However, Futurism also reached Barcelona by other routes. Rafael Pérez Barradas, a painter from Uruguay, who had left Montevideo in 1911 and had passed through Milan, where he became acquainted with Marinetti and Futurism, came to Catalonia in 1913 and settled in Barcelona in 1916, making contact with both Joaquín Torres García and Josep Dalmau. Barradas's painting, which he called 'Vibrationism', is another expression of futurist dynamism. It was also at this time that Torres García changed direction, abandoning his Mediterranean classicism and following a similar path to Barradas. The poet Joan Salvat-Papasseit also moved in this direction, and his journal *Un Enemic del Poble* (March 1917–May 1919) became the most typical product of this avant-garde phase. Torres García collaborated on it with texts and drawings that had nothing in common with his earlier painting (fig. 210): within a geometric structure, like a collage, fragments of the urban background with mechanical elements (wheels, clocks, cars) can be seen. Similar drawings by Barradas with cubist tendencies (fig. 211) were also published there and in *Arc-Voltaic*.

In no. 8 of *Un Enemic del Poble*, Torres García published 'Art-Evolution (By way of a manifesto)', in which he expounded on evolution versus immobility, and where he said that 'nothing that has already been realised can be of any use to us', ending 'Our motto must be: individualism, the here and now, inter-nationalism'. This text marks the emergence of one of the most typical documents of the avant garde and especially of Futurism: the manifesto.

In the same year, 1917, two more journals came out in Barcelona: *Troços* (Fragments) and *391*. In *Troços*,[9] which was initiated by Junoy and written from the avant-garde point of view, we find, side by side with experimental poetry, references to Futurists (Boccioni, Balilla Pratella), cubist illustrations (Gleizes, Celso Lagar) and drawings by Miró and Ricart. Miró splinters images, uses zig-zags and obliques, as in a cubist-futurist outburst; Ricart is more restrained; he plays only with simple geometry and a slight distortion of perspective.

During the years of the First World War other events would be important for the Catalan avant garde. The neutrality of the Spanish state attracted a series of foreign artists who exhibited in the Galeries Dalmau and left their mark in the journal *391*, the first four numbers of which were published by Picabia in Barcelona. The activities of the cubist and dadaist group did not really make a broad impression, and they would only have

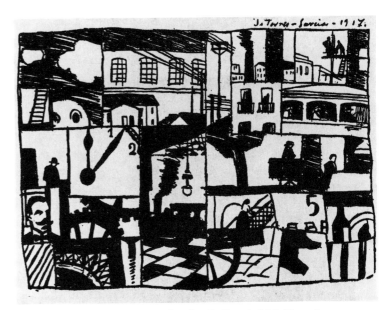

210. Torres García. Drawing reproduced in *Un Enemic del Poble* no. 3, June 1917.
Biblioteca dels Museus d'Art, Barcelona.

211. Barradas. Drawing reproduced in *Arc-Voltaic* no. 1, Feb. 1918 (no. 301).
Institut Municipal d'Història de Barcelona.

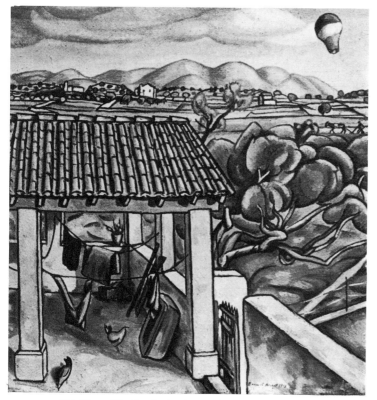

212. Ricart. *The Porch*, 1918 (no. 221).
Oil on canvas, 56 × 54 cm. Museu Balaguer, Vilanova i la Geltrú.

reached the relatively select circle of the Galeries Dalmau, which was regarded as the home of *391*. However, over half a century later Miró remembered the great impact produced on him by Picabia and his journal.[10]

In 1917, and also as a result of the war, a great exhibition of French art was mounted in Barcelona, at the instigation of a considerable number of Catalan artists. It is worth remembering that a strong division between the pro-French and the pro-Germans existed in Barcelona. The French side was generally identified with Catalan interests, and one of Galí's pupils has explained that those who attended his school had a strong regionalist, federal and pro-French sympathy, as opposed to the other schools which tended towards uniformity, central-isation and pro-German attitudes. There was even a journal of propaganda for the allied cause, *Iberia*, published in Barcelona, and this is depicted in the painting which Ricart did of Miró in the studio they shared (fig. 205).

The Exposició d'Art Francès was a real event. The number of works presented was extraordinary (more than 1,450). All the trends developed in France since the end of the century could be seen in Barcelona: Impressionism, Post-impressionism, Fauvism and Cubism. Fauvism, and Matisse in particular, was of great interest to the many restless artists. Joan Miró in an interview of 1960 asserted that this was when he saw Fauve paintings for the first time and that the contact with modern painting struck him like a thunderbolt.[11]

In the same year, 1917, Diaghilev's Ballets Russes presented *Parade*, with costumes and décor by Picasso, at the Liceu theatre. The work shook the audience as it had done in Paris, and it was to be another stimulation for those Catalans most aware of the new art, accentuated by the fact that Picasso, who came to stay in Barcelona, arrived with the aura of the brilliant artist who had triumphed in Europe. Amongst those who admired *Parade* was the young Miró; he was introduced to Picasso, who was later to be one of his first ports of call in Paris.[12]

The Agrupació Courbet

Avant-garde contacts and events had created a climate in which some of the young Barcelona artists adopted innovatory attitudes. Josep Dalmau, who continued his job as a promoter, came to know these artists, and he organised the first one-man exhibitions of E. C. Ricart (1917), Rafael Sala (1917) and Joan Miró (1918).

Miró, whose show was announced by Junoy with a *calligramme* (fig. 216), displayed works done between 1914 and 1917. There were landscapes, still lifes and portraits. The outlines of the forms are generally thick and bold, distortions appear expressed with a kind of agitation, as well as decorative graphic elements based on angular and parallel lines; the colours are intense, bright; the viewpoint is generally from above, tending to create a flat plane; even an element of collage is included.

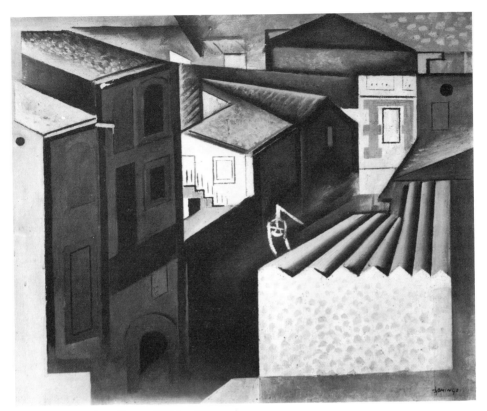

213. Domingo. *Cubist village*, c.1920 (no. 70).
Oil on canvas, 50 × 62 cm. Private collection.

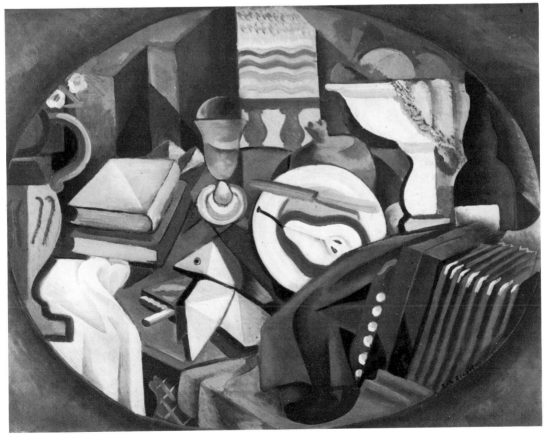

214. Ricart. *Still life*, c.1920 (no. 222).
Oil on canvas, 55 × 72 cm. Private collection.

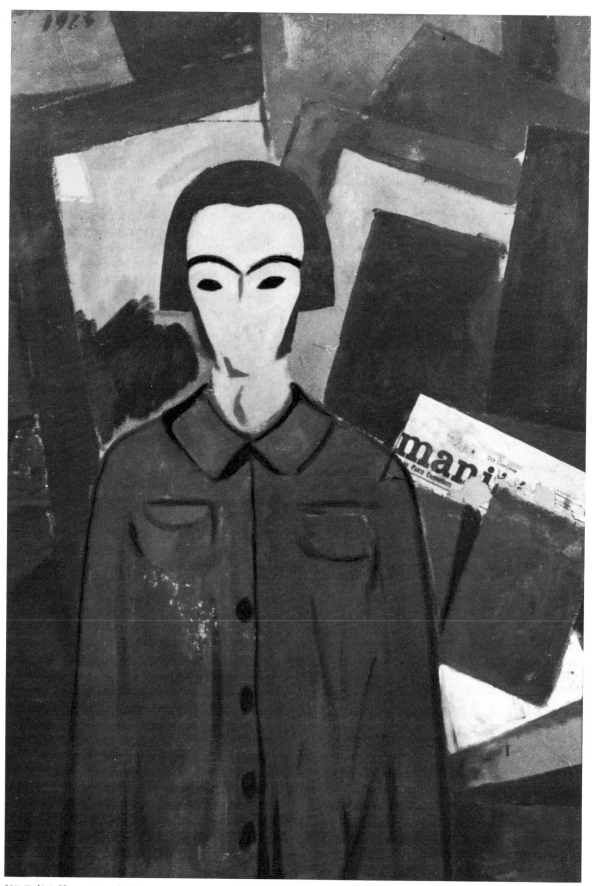

215. Dalí. *Self-portrait with L'Humanité*, 1923 (no. 57).
Oil and gouache with collage on cardboard, 105 × 75.4 cm.
Fundación Gala–Salvador Dalí; Teatro Museu Dalí, Figueres.

Here was a fusion of all that Miró had assimilated: Cézanne, Cubism, Futurism, also an element of Van Gogh, whose work he knew from reproductions,[13] and a primitivist tone which stemmed particularly from his interest in spontaneity and the simple poetry of popular art and the naïve painters, which with his friend Gasch he delighted in discovering in the popular districts of Barcelona.[14] One of the critics stressed Miró's primitivism, his idiosyncratic colouring and his anti-academic stance and, while admitting that he was baffled, expressed confidence in the painter's potential.[15]

In this first exhibition Miró exhibited, amongst other works, the portraits of Ricart and Josep F. Ràfols, two friends of that time, who with Rafael Sala, Francesc Domingo and Josep Llorens Artigas formed the Agrupació Courbet in 1918. The members were a group of painters who were contemporaries at the Cercle Artístic de Sant Lluc together with Llorens Artigas, who at that time was writing art criticism and had just taken up ceramics, the field in which he would excel and in which, much later, he would have a fertile collaboration with Miró.

The group had in common only its youth and a desire for innovation. Joan Sacs, discussing an exhibition of drawings by the group, found them to be 'representative of the newest developments', and they gave him 'the impression of modernity in the same way as the school of Ceret, or rather of Cotlliure', which was a way of saying that they were Cubists or Fauvists.[16] The life of the Courbets was very brief; they mounted a couple of exhibitions of paintings and one of drawings. The original group, which had expanded with Marià Espinal, Rafael Benet, Josep Obiols, Josep Togores and Joaquín Torres García, disbanded at the end of 1919, because many of its members left for Paris: Miró, Llorens Artigas, Ricart, Espinal, Togores.

The Agrupació Courbet, despite its brief existence, was highly significant in the Catalan avant-garde of this period. It initiated group action, it placed itself in opposition to the established and the accepted, but as it had no clearly defined programme and amongst its members there was that unique compromise between tradition and avant garde, it broke up, and some ended by joining the ranks of the *noucentistes*, while others stayed in the legendary city of Paris, where they made their mark on the international scene.

Joan Miró initially felt so disorientated in Paris that he could not even paint. In the summer, when he returned to the Tarragona area, to Montroig, he took up painting again. In 1920 he visited Paris for the second time and from then on alternated the summers at Montroig with sojourns in Paris, where he was soon held in esteem by the poets and painters of dadaist and surrealist circles. Josep Dalmau organised his next one-man exhibition, this time in Paris, at the Galerie La Licorne, in 1921. Although it was a commercial failure, Miró's career, with the initial support of Dalmau and the tenacity and creative force of the painter, was established in Paris. He did not have a one-man show again in Barcelona until much later, but Dalmau included him in his avant-garde collections. Miró never broke his ties with Catalonia; he had friends, like Joan Prats, who remained loyal,[17] and during these years Montroig was his constant place of shelter, as he himself said, 'where I am happiest is in Catalonia . . . all I have done in Paris was conceived in Montroig'.[18] In fact, there, with the countryside, the animals and the familiar objects, he would create his personal vocabulary and his own magical atmosphere.

Towards a second avant-garde phase

Josep Dalmau continued his efforts to create a market for contemporary art and in 1920 mounted an exhibition of French avant-garde art, which included cubist works (Braque, Metzinger, Herbin, Léger), pointilliste works (Cross), Fauvist works (Matisse), and works by two Catalans: Sunyer and Miró. In 1922 he organised an exhibition of Picabia's works, presented by André Breton, who came to Barcelona to give a paper outlining the search for an alternative to Dadaism. In 1926 he put on an exhibition of 'Catalan pictorial modernism confronted with a selection of works by foreign avant-garde artists', introduced by Sebastià Gasch. While the Cubists stood out amongst the foreigners, the Catalans included, among others, Barradas, Torres García, Miró and Dalí. The last important international show by Dalmau was that held in 1929. This was also a confrontation of local and foreign art. In the foreign section, works by the Dutch neo-plasticist group (Mondrian, Van Doesburg, Vantongerloo) were presented as a great novelty, together with works by Hans Arp, amongst other cubist and abstract artists.

In addition to his pioneering role for Miró, Dalmau undertook to act in the same way for another young artist, Salvador Dalí, organising his first one-man show in 1925, his second in 1926–7 and a third in 1928–9. Dalí, before bursting upon Barcelona with the exhibition at Dalmau's (when he was only twenty-one), had served his apprenticeship in the places where he had grown up (Figueres and Cadaqués) and in Madrid with its academic ambiance and its avant-garde circles. He began to paint and draw in Figueres and Cadaqués, where his family ties with Ramon Pichot had a decisive influence on his early works, which were imbued with a kind of Impressionism.[19] In 1921 Dalí went to Madrid to study at the Escuela Especial de Pintura, Escultura y Grabado,[20] and he took up residence in the student hostel, where he made friends with Federico García Lorca and also with Luis Buñuel. His friendship with the former was closest between 1925 and 1927 when García Lorca stayed in Cadaqués and in Barcelona, where he met Dalmau – who mounted an exhibition of his drawings – and

216. Junoy. *Calligramme* (Dec. 1917) on catalogue of Miró exhibition at Galeries Dalmau, 16 Feb.–3 March 1918 (no. 270). 17.5 × 12.3. Institut Municipal d'Història de Barcelona.

217. Ricart. *Portrait* (1917); reproduced on cover of *L'Instant* Any II, no. 2, 31 Aug. 1919 (no. 306). Biblioteca dels Museus d'Art, Barcelona.

the group which Rafael Barradas brought together in gatherings known as the *Ateneillo*.[21] Dalí worked with Buñuel – of whom he did a portrait in 1924 – on the film *Un Chien andalou* (1929), the best surrealist work for the cinema.

At this time, Dalí was especially involved with writing, particularly in the journal *L'Amic de les Arts*, but also in *Hèlix*, together the two most noteworthy periodicals as regards Surrealism in Catalonia.[22] As for painting, Dalí displayed great versatility. An article dated 1924, written in Barcelona and published in La Coruña, which synthesises his development, begins, significantly, with a quotation from Matisse referring to receptivity to the influence of other artists. It affirms that in Dalí's work, impressionist, pointilliste, Fauvist and cubist influences can be found, while he was working at the same time on 'aseptic' still lifes; it discusses how he has made forays into Futurism and, in reaction to this, into *peinture pure*; how he was interested in Juan Gris and Derain, and how he had returned to Raphael, Poussin and Ingres.[23]

In fact, at this time Dalí had been experimenting in a great variety of ways and at certain times with an exaggerated mimicry. There are works which could be attributed to Aragay, Nogués and, in a series from 1923, to Derain, with whom he even shared a subject: *Cadaqués* (1910) by Derain (who stayed the summer with Picasso, at Pichot's invitation) and *Cadaqués* (1923) by Dalí. The painter made no attempt to conceal this, and in a still life of the same year 'Derein' (*sic*) can be read on a book. Barradas's 'Vibrationism' is also reflected in some works from 1922. Purism is apparent in works from 1924.

When Dalí had his early exhibitions in the Galeries Dalmau he was already working on a series of works realistic in character, between *Neue Sachlichkeit* and the *Valori Plastici*, a development which lay closest to Feliu Elias. It shows a Dalí fascinated by Vermeer and one who has discovered, as he explains in a letter, the poetic feeling that stems from the purest objectivity.[24]

As a result of his second exhibition at Dalmau's and the review by Sebastià Gasch in the *Gaseta de les Arts*, the two men began a friendship which would be of great importance for this second avant-garde period. Gasch wanted to be a painter and had frequented the Cercle Artístic de Sant Lluc, where he became friendly with Miró. He had been brought up speaking French, and followed the innovations in Paris in his reading; like Dalí, he read *L'Espirit Nouveau*, and when they got to know each other they found they had an extraordinary number of interests in common. From 1925, when he devoted an article to Miró, Gasch had taken on the role of art critic in defence of the avant garde.[25] He followed Miró's development closely and publicised it in Barcelona; he also became involved with Barradas's group, and with the circle in Sitges which initiated the journal *L'Amic de les Arts*, which was to be the most important platform for

218. Dalí. *Portrait of Salvador Dalí i Cusí (father of the artist)*, 1925 (no. 58).
Oil on canvas, 100 × 100 cm. Museu d'Art Modern, Barcelona.

219. Miró. *Garden with donkey*, 1918 (no. 151).
Oil on canvas, 64 × 70 cm. Moderna Museet, Stockholm.

220. Miró. *Dog barking at the moon*, 1926 (no. 154).
Oil on canvas, 73.5 × 92 cm. The Philadelphia Museum of Art,
A.E. Gallatin Collection.

221. Dalí. *Thumb, beach, moon and rotting bird* (also known as *L'Oiseau blessé*), 1928 (no. 60).
Oil and sand on board, 55 × 65.5 cm. Collection Mizné-Blumental.
Shown at the third of the Sala Parés Autumn Salons (1928).

Dalí and Surrealism, and which was responsible for a famous document of the Catalan avant garde.

In 1928 Salvador Dalí, Lluís Montanyà and Sebastià Gasch signed the *Manifest Groc* (Yellow Manifesto, so called because of the colour of the paper). The Manifesto attacked Catalan culture of the time calling it 'artistically negative', 'useless' and 'shut in a blocked and stagnant atmosphere'. It asserted the need for a new art for a new period revolutionised by machinery. It affirmed that modern art and poetry was not to be found in classical Greece, but in the sportsman, in an aeroplane engine, in an American music-hall. They called attention to the cinema, sports, jazz, the car, aeronautics etc. They denounced subjects of sensibility, imitation, and the lack of youth, boldness and decision. Finally they 'invoked' the great artists of the day from the most varied trends and categories: Picasso, Gris, Ozenfant, De Chirico, Miró, etc. It is a tract full of the ideas of *L'Esprit Nouveau* and Futurism, with a hint of Surrealism, for example: 'THERE IS at last, an immobile ear over a small puff of smoke'.

The Manifesto spread through Catalonia by correspondence and also reached Valencia, Mallorca, Madrid and Andalusia, where the progressive journals discussed and reproduced it. In Catalonia the press reacted as Dalí had foreseen: the provocation resulted in remarkable signs of hostility.[26] Dalí's active role was established, in addition to his written contributions, in some lectures which attracted the intrigued crowds and disturbed the atmosphere of Barcelona. The Dalí in love with provocation and exhibitionism was beginning to emerge.

Another of Dalí's platforms at this time was the Sala Parés. This gallery, the oldest in Barcelona, began a new phase, and for three consecutive years it organised an Autumn Salon in which Dalí was involved. Two works shown there, *The Girl sewing*, which was exhibited the first year (1926), and *Honey is sweeter than blood*, from the second (1927), illustrate the change that had come about in his work: surrealist painting makes a resounding public appearance.

Surrealism was already present in the writings of *L'Amic de les Arts* and in the poetry of Foix; Miró had put it forward in the plastic arts, but he had done so in France; and Dalí would also end up following his career in Paris. Very different from each other, they would be protagonists of the international avant garde, but they were so strongly moulded in the Catalan environment that this element of their work can never be overlooked, and they will never be diminished to mere followers of foreign movements.

NOTES

1 J. Folch i Torres, 'Els cubistes a can Dalmau', *La Veu de Catalunya*, 18 April 1912. On Dalmau the best source is the catalogue of the exhibition *Dalmau*, Colegio Oficial de Arquitectos de Cataluña y Baleares, Barcelona, 1969, with text by Alexandre Cirici and an excellent collection of facsimiles.

2 J. M. Junoy, 'De Paul Cézanne a los cubistas', *Arte & Artistas*, Barcelona, 1912. Junoy's involvement with the Cubists is discussed in great detail by Jaume VallcorbaPlana in his *Josep Maria Junoy. Obra poètica*, Barcelona, 1984.

3 Miralles has noted with accuracy the importance of Cézanne for Catalan painting of the period. See Francesc Miralles, *L'època de les avantguardes 1917–1970*, Barcelona, 1983, pp. 30–32.

4 Joan Bergós, 'El pintor Galí, in the catalogue *Francesc Galí*, Colegio Oficial de Arquitectos de Cataluña y Baleares, Barcelona, 1965.

5 See Sebastià Gasch, *L'expensió de l'art català al món*, Barcelona, 1953, p. 89.

6 Georges Raillard, *Conversaciones con Miró*, Barcelona, 1978, p. 23.

7 Excerpts from letters from Miró to Ràfols and Ricart, cited by Sebastià Gasch in his *Joan Miró*, Barcelona, 1963, p. 9.

8 Josep F. Ràfols, *E.C. Ricart* (ed. X. Puig Rovira), Vilanova i la Geltrú, 1981, pp. 71 ff.

9 Three issues (in addition to a preliminary number in 1916) were brought out from September to November 1917, directed by Junoy, with the name *Troços*, and two more in March and April 1918, directed by Josep V. Foix, entitled *Trossos*.

10 G. Raillard, *op. cit.*, pp. 24–5.

11 Collected in Dora Vallier, *L'intérieur de l'art*, Paris, 1982, p. 140 (Miró was mistaken in the date of the exhibition).

12 Mentioned by Miró to Pierre Cabanne, who includes it in *Le Siècle de Picasso*, vol. 2, Paris, 1975, p. 85.

13 D. Vallier, *op. cit.*, p. 140.

14 See S. Gasch, *Joan Miró*, Barcelona, 1963, pp. 8 ff.

15 Pere Oliver, 'Sala Dalmau: Joan Miró', *Vell i Nou* no. 62, 1 March 1918, p. 82

16 Joan Sacs, 'L'istil', *Vell i Nou* no. 92, 1 June 1919, p. 209.

17 The 'Sala Joan Prats' in the Fundació Miró bears witness to this friendship.

18 Cited in S. Gasch, *op. cit.*, p. 36.

19 Ramon Pichot, actively involved in the *modernista* period, was a friend of Picasso's and in 1910 had had Picasso and Derain to stay in Cadaqués. In 1915 Pichot had exhibited at the Galeries Dalmau.

20 In 1923 he was expelled for a year and in 1926 for good. Dalí himself describes the events in *La vida secreta de Salvador Dalí*, Figueres, 1981.

21 Barradas resided in Madrid from 1918 to 1925 and had met Dalí and García Lorca in the student hostel. In 1925 he had returned to Barcelona, where he stayed until the end of 1928, then going to Montevideo where he died a few months later. During his last sojourn in Catalonia he stayed at L'Hospitalet de Llobregat, where every Sunday artists and writers interested in the most recent artistic developments gathered. Antonina Rodrigo has studied this subject in her book *García Lorca en Cataluña*, Barcelona, 1975.

22 *L'Amic de les Arts* came out in Sitges from 26 April 1926 to 31 March 1929, and *Hèlix* in Vilafranca del Penedès from February 1929 to March 1930.

23 J. Subias, 'Salvador Dalí', *Alfar* no. 40, May 1924, pp. 14–18.

24 S. Gasch, *L'expansió de l'art català al món*, Barcelona, 1953, p. 145.

25 See Alexandre Cirici, 'L'aportació de Sebastià Gasch', *Serra d'or* no. 140, May 1971, pp. 41–3.

26 Sebastià Gasch tells of the production and diffusion of the Manifesto as well as of its effect, in *op. cit.*, pp. 149 ff.

222. Ortiga. *ADLAN exhibition poster: Marinel.lo, Sans, Serra*, 1935 (no. 174).
Collage/montage, 50 × 36 cm. Private collection.

ADLAN and the artists of the Republic

Rosa Maria Subirana

'ADLAN
a group of friends open to all new forms of spiritual disquiet.
ADLAN will interest you
1. if you are temperamentally disposed to follow the trajectory of the arts of today.
2. if you respectfully protect (selecting with passion) all efforts towards the unknown.
3. if you maintain an open mind in the face of dogma and accepted values.
4. if you wish to march to the rhythm of the discoveries of the spirit of today (alongside the discoveries of genius).
5. if you wish to be receptive to the latest manifestations in all the arts.
6. if you wish to fight for a totalitarian art in accord with the universal aspirations of the moment.
7. if you wish to save what is *living* within *the new* and what is *sincere* within *the extravagant*.
ADLAN calls you
to protect and to encourage *all enterprises of risk accompanied by a desire to excel.*

With this well structured manifesto the recently founded association Amics de l'Art Nou (ADLAN, Friends of New Art) began its activities and meetings, having had its statutes officially approved by the civil governor of Barcelona on 9 November 1932.

The association wanted to assemble and institutionalise the achievements of the Catalan avant garde up to that point and to give it a continuity within the new political and cultural régime. It aimed to maintain the dynamic of contemporary arts by taking on the role of the Galeries Dalmau, which had closed, and by continuing the programme of research and publication embarked upon by the Sitges magazine *L'Amic de les Arts*, which had ceased publication, and also to function as a unifying body just as the GATCPAC did for architecture.

At the same time, it wanted to bring together young artists and people interested in the imaginative and the unfamiliar in order to find ways of reaching a wider audience. The reality, however, in spite of ADLAN's numerous activities, was to be quite different, since it never achieved either popular success or acceptance in the general artistic atmosphere of the time. (It is worth noting that later, after the Civil War, its activities did profoundly influence the formation of many artists, as Antoni Tàpies has recalled.)[1]

Creation, organisation and members of the group

The point of departure for the group was the *tertulia* of the Cafè Colón, where a great variety of personalities gathered, especially those of the GATCPAC and the *L'Amic de les Arts* group, and where the leading lights were Joan Prats and Carles Sindreu. To start with, they wanted to call the association 'Club dels esnobs', because this was the type of person who would probably more readily accept all types of innovation. However, the name was dismissed because it seemed frivolous. Carles Sindreu remarked: '[ADLAN] had to be situated in the prevailing climate: at that time to fight on behalf of art was like becoming a missionary. Everyone knew each other, and it was easier to establish international relations.'[2] He and Joan Prats met one Sunday morning in his studio to decide on the aims of the group, to draft statutes and draw up a list of members, thinking of all the artists and people whose position or economic status would make the creation of the group possible. They included: Joaquim Gomis, Adelita Lobo, Mercè Ros, Josep Maria Junoy; the silversmiths Ramon Sunyer and Rogeli Roca; the sisters Montserrat and Núria Isern, who ran the Galeria Syra; Antoni and Miquel Albareda, owners of the Hotel Brístol; artists and musicians – Joan Miró, Salvador Dalí, Roberto Gerhard; writers and critics – Sebastià Gasch, Magí A. Cassanyes, J.V. Foix, Lluís Montanyà; and architects of the GATCPAC – Josep Lluís Sert, Josep Torres Clavé, Germà Rodríguez Arias.

The first meeting took place at the Hotel Brístol, where the statutes of the ADLAN Group were presented on 23 October 1932, and a number of points were established. The addition of the words 'ADLAN has no political affiliation of any kind' were among the changes made to the manifesto. It was agreed that the registered office of the group should be the shop at 99 Passeig de Gràcia, where GATEPAC (the Spanish body to which GATCPAC was affiliated) had its offices and published the magazine *AC*, and where it held its meetings and had a permanent exhibition. Various classes of membership were set up, and all members were to be given discounts for performances, publications or exhibitions which were organised by ADLAN. An executive committee was elected, whose original members were Joan Prats, Eduard Montenys and Daniel Planes, but the last two were soon replaced by Joaquim Gomis and Josep Lluís Sert, who remained in office until the Civil War. The organising secretary was Adelita Lobo.

Events and exhibitions

The events realised by the group were initially fairly simple, and they did not embark on any large-scale plans or projects. Sebastià Gasch, in an article about the group in *La Publicitat*, commented: 'A number of people sympathetic towards art which attempts to say something new have grouped together under the name of ADLAN. Books which cannot find a publisher, exhibitions for which there is no space, anything that is only supported by a select minority will be taken up with pleasure. . . .'[3]

To start with, this closed and select circle staged its events in private performances, often for just one night, with all members appearing dressed according to strict etiquette. After some time, ADLAN acquired a certain prestige and at this point the group's exhibitions were made public. The closed attitude in the beginning had been a response to the negative way in which the public had reacted towards the dealer Josep Dalmau, turning their backs on him from the start and considering his activities suitable only for 'initiates'.

It seems that one of the first events put on by ADLAN, on 23 December 1932, announced by a small invitation, was a competition of fairground objects, accompanied by a recital of records of Negro music and readings of black theatre and literature in the Barcelona Lawn Tennis Club in Turó Park. In March 1933, on the initiative of ADLAN, a body called Amics del Circ was organised, which made an excursion accompanied by the clown Antonet to the town of Mataró to attend the Frediani Circus there. Several days later, on 24 March, also at the Tennis Club, there was a display of comparative dancing: gypsy dances interpreted by one of the best flamenco troupes, and classical dances performed by Joan Magrinyà, first male dancer at the Liceu. On 25 June 1934, at the Roca jewellery shop, Carles Sindreu presented 'Perfumed essences retrospective to 1900' assembled in an 'Album-Salon'. In this event many other persons collaborated, as always: 'Víctor Sabater (speaker), Jaume Alorda (phonograph), and Roberto Gerhard, Lluís Montanyà, Joaquim Gomis, Joan Prats, Rogeli Roca, Artur Carbonell and J.V. Foix (poetry).' On 7 May 1934 Joaquim Gomis showed postcards and photographs (1888–1914) from his collection, again at the Roca jewellery shop, an event which was afterwards repeated at the 'Foment' in Vilanova i la Geltrú, and which, judging by the reaction in the press, seems to have been a great success.

There were also literary events, such as the recital of unpublished poems by J.V. Foix on 4 March 1936, and of works by García Lorca; the reading of Carles Sindreu's book *Darrera el vidre* (Behind the glass); musical recitals, including the first performance of Roberto Gerhard's *Quintet for wind instruments*; songs based on texts by López Picó sung by Conxita Badia; and excursions to attend performances of the Xiquets of Valls or the Patum of Berga, both Catalan popular festivals.

But the activities of ADLAN that received most attention in the city were the art exhibitions. These were not always received with general enthusiasm, because of the academic control of the press and the museums, but it must be noted that in its last days the government of the Generalitat did its best to help the group. There were different kinds of exhibitions with different objectives, depending on their intentions: re-evaluation, irony, or the presentation of new talent. Among the exhibitions of ironic character was the 'Objects of bad taste' show in 1934, organised by the members themselves, which consisted in great part of *modernista* objects; popular arts and crafts were re-evaluated in the exhibitions of toys and of *siurells* (Mallorcan clay figures painted white with decorations in blue, green and red); while 'Primitive art of today' (1935) was a new presentation of examples of Negro, Oceanic and Precolumbian art from the collection of Ignasi Bruguera. ADLAN also looked to underrated areas of artistic production; as in the exhibition of 'Drawings of the insane' at the Catalan Society of Psychiatry, and that of 'Children's drawings' held in May 1935 at the Galeries Catalònia.

However, the most important exhibitions were those dedicated to artists of the avant garde, both local and international. Some of these had the character of world premières, and they were always complemented with poetry-reading or recitals. In the case of Joan Miró, the group attended a private exhibition of his work – prior to its being sent to France – at his house on the Passatge del Crèdit in 1933, and another in the Galeries Catalònia in 1934. They also went as a group to the performance on 21 May 1933 by the Ballets Russes de Monte Carlo of the work *Jeux d'enfants*, for which Miró had designed the décor and some objects.

Alexander Calder showed his *Circus* in the GATEPAC premises in September 1932, and Sebastià Gasch wrote that 'the little figures of Calder's Circus are a prodigy of form and colour. They are pure sculptural delicacy, and their mechanism is the product of a formidable engineer. But above all we must cite the fresh and infinite poetry of this spectacle . . . and his very open, American humour.'[4] In January 1933 the Galeria Syra exhibited a dozen *Objectes* by the sculptor Àngel Ferrant, whose teaching at the Escola d'Arts Aplicades i Oficis Artístics had such an influence on Serra, Marinel.lo and Sans; and the following year thirty people of the group attended a dinner in his honour at the '7 Portes' café, before his move to teach in Madrid. Artur Carbonell, the Sitges painter, presented, in good ADLAN tradition, an exhibition that lasted only a few hours at the Galeria Syra in March 1933; and it should not be forgotten that Salvador Dalí had his highly controversial exhibition at the Galeries Catalònia that same year.

But the exhibition *3 escultors: Ramon Marinel.lo, Jaume Sans, Eudald Serra* at the Galeries Catalònia

223. Sans. *Camagüey*, 1935 (no. 239).
Oil on canvas 101 × 128 cm. Collection Jaume Sans, Barcelona.

224. Sans. *Forma*, 1934 (no. 238).
Oil on wood, 13.5 × 14.5 cm. Collection Jaume Sans, Barcelona.

225. Serra. *Guitars*, 1934 (no. 243).
Collage, 82 × 113 cm. Collection of the artist, Barcelona.

226. Cristòfol. *Lyric construction*, 1934 (no. 54).
Steel and wood, 85 × 59 cm. Collection of the artist.

227. Marinel.lo. *Figures beside the sea*, 1936 (no. 128).
Plaster attached to wood, 27 × 46 × 12 cm.
Collection Marinel.lo, Barcelona.

228. Carbonell. *Two figures*, 1931 (no. 11).
Oil on canvas, 67 × 79 cm. Private collection.

229. Carbonell. *Constellation*, 1933 (no. 12).
Oil on canvas, 55 × 46 cm. Private collection.

230. Planells. *Still life*, *c.* 1925 (no. 204).
Oil on canvas, 45 × 53.5 cm. Collection J.B.Cendrós, Barcelona.

(27–30 March 1935) inaugurated a new type of show – more public and not so restricted. The three young artists prepared the catalogue and had individual posters made (fig. 222), and, following their master Àngel Ferrant, they showed unusual objects and sculptures realised in a diversity of materials, which astonished the Barcelona public.

Hans Arp (9–14 March 1935) and Man Ray (29 May–30 June 1935) showed their works at the Roca jewellery shop, whose enterprise was mentioned by the painter Luis Fernández in the magazine *AC*; and it was Fernández who prepared the Picasso exhibition for ADLAN (13–18 January 1936) at the Sala Esteva, a show which later travelled to Madrid and Bilbao. This was the exhibition that excited most comment both in the press and in other quarters in the city. Several leaflets were printed and signed by PAC (Pro Art Clàssic) which criticised it violently (fig. 244); they suggested it was doing a disservice to Picasso, because it consisted entirely of more recent works (1909–25), which most of the public considered less orthodox. The opening of the exhibition, which was to attract 8,000 visitors, was broadcast on the radio, and Joan Miró, Juli González, Salvador Dalí and Luis Fernández all spoke; Jaume Sabartés read a poem by Picasso, and on 24 January Paul Eluard gave a lecture on Surrealism.

The last exhibition ADLAN presented was that of the Logicofobista group at the Galeries Catalònia (4–15 May 1936). The show was organised by M.A. Cassanyes, whose plan was to mount a great exhibition of surrealist art, but he adopted a new word, 'Logicofobisme', which in its etymological sense means antipathy towards the logical. In it were Artur Carbonell, Leandre Cristòfol, Àngel Ferrant, Esteve Francès, Andreu Gamboa-Rothwoss, Antoni G. Lamolla, Ramon Marinel.lo, Joan Massanet, Maruja Mallo, Àngel Planells, Jaume Sans, Remedios Varo and Joan Ismael.

Expansion, connection and reaction

From its very beginning ADLAN was tied to GATCPAC, and for that reason it had always been able to use the GATEPAC premises for meetings and its magazine, *AC*, to comment on events and exhibitions. In 1934, in the luxuriously produced special Christmas issue of the magazine *D'Ací i d'Allà*, both organisations together summed up and evaluated the situation of international avant-garde art and architecture. The issue was directed by Josep Lluís Sert and Joan Prats and was profusely illustrated. Not satisfied with that, ADLAN prepared some *pochoirs* in editions of two hundred by Miró, Kandinsky, Helion and Calder, with a view to collecting enough money to publish a magazine to be called *Síntesi*.[5]

Because of the success of ADLAN in Barcelona, especially the Picasso exhibition, and with a view to exchanging events and exhibitions, Guillermo de la Torre

231. Planells. *Untitled*, 1935 (no. 206). Oil on wood, 17 × 14 cm. Private collection.

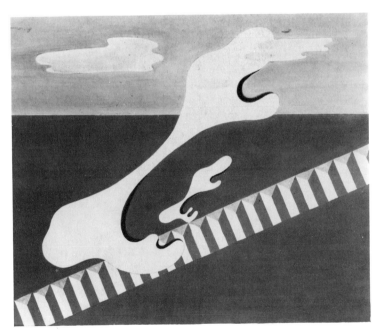

232. Serra. *The Ladder*, 1934 (no. 242). Collage, 35 × 40 cm. Collection of the artist, Barcelona.

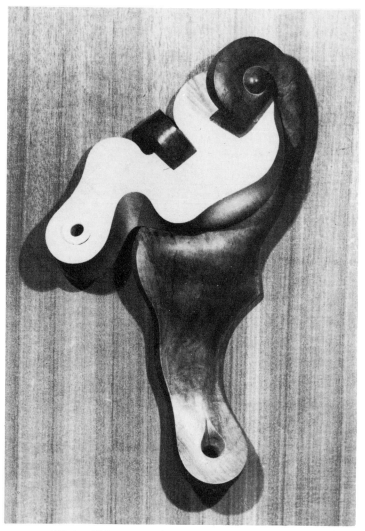

233. Cristòfol. *Imprisoned forms*, 1936 (no. 55).
Wood and porcelain, 62 × 42 cm (replica). Collection of the artist.

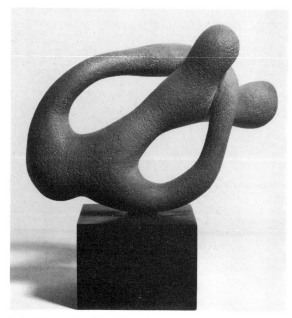

234. Marinel.lo. *Acrobat (Equilibrista)*, c. 1936 (no. 127).
Terracotta, 16 × 24 × 11 cm. Private collection.

started ADLAN-Madrid and Eduardo Westerdahl, creator of the magazine *Gaceta de Arte*, created ADLAN-Tenerife. Thus the work of this initially small group was gradually acquiring a broader audience, and, in fact, when the Civil War broke out, Joan Prats was preparing an International Congress of Artists, which would certainly have mobilised the whole city.

As we have seen, the ADLAN group not only promoted local art and artists but also brought foreign artists to the notice of the Barcelona public. In this connection it is interesting to observe the connections of several of its members with Surrealism, a spirit very much related to Catalonia, where international surrealist connections had existed for a number of years. It is, therefore, not surprising that J.V. Foix prepared a book on the sources of Surrealism, and even though the original text has been lost, drawings are still preserved which a number of the leading Surrealists made as illustrations for the book: Ernst, Miró, Tanguy, Magritte, Giacometti, Marcel Jean, Valentine Hugo and, perhaps, Man Ray. And at the *Exposition Surréaliste d'Objets* organised by André Breton at the Galerie Charles Ratton in Paris in May 1936, which was fully discussed in *Cahiers d'Art*, the participants included Gala Dalí, Salvador Dalí, Àngel Ferrant, Oscar Domínguez, Picasso, Marinel.lo and Miró.

We should also remember that the artists who participated in the Spanish Republican Pavilion at the Paris Exhibition in 1937 had all collaborated with ADLAN; and that after the Civil War the active Club 49 was, during the Franco era, the continuation of the select minority who had formed ADLAN in 1932. All these things demonstrate the way in which a consciousness of avant-garde art was for the first time concentrated in a group with the coherent objective of defending new art.

However, there were many other events going on in parallel beyond the scope of this minority group. The proclamation of the Second Republic on 14 April 1931 initiated a period of active cultural politics. In Catalonia there was a strong awareness of the need to preserve and publicise the common cultural and artistic heritage, something which had already encouraged the Catalan people to identify with their origins. One of the priorities was the creation of the Museu d'Art de Catalunya, which was installed and inaugurated in the Palau Nacional on Montjuïc in 1934.

Salons and exhibitions were also put on, organised by various groups or magazines: the three Festivals of Drawing (1932, 1933 and 1934) were intended to provoke interest among collectors of work in this medium; the magazine *Mirador* supported two retrospective exhibitions of Catalan art, '100 years of female portraits in Catalan painting' and 'Graphic painting in Catalonia', while several artists formed groups which supported their own exhibitions, among them the Grup d'Artistes Independents (1932) and the Associació d'Artistes Independents (1936).

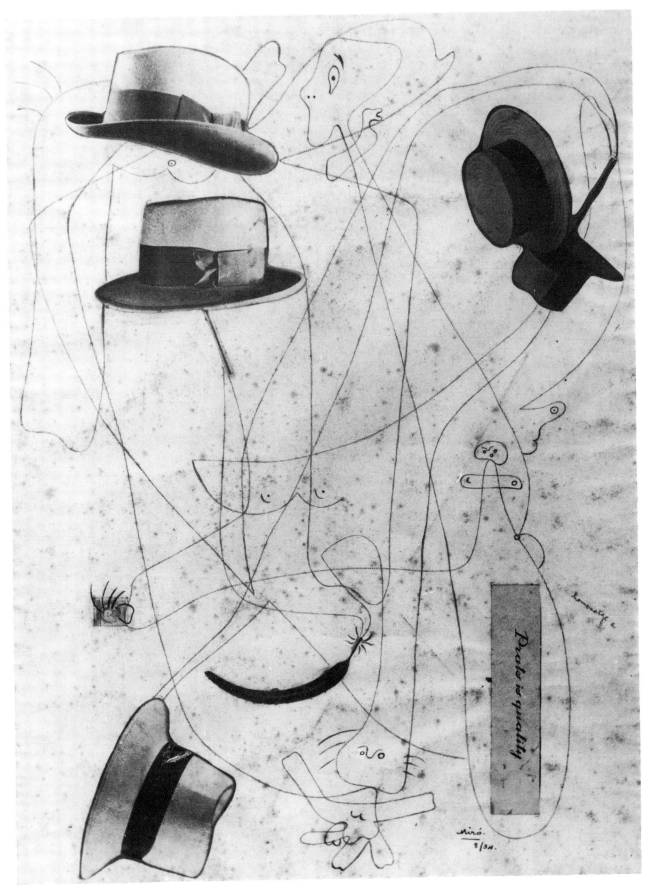

235. Miró. *Homage to Joan Prats*, 1934 (no.160).
Lead pencil and collage on paper, 63 × 46.5 cm.
Fundació Joan Miró, Barcelona.

Drawings (1933–4) collected as illustrations
for a book on Surrealism by J.V. Foix, written
but never published. Private collection.

236. Ernst. *Untitled* (no. 74).
Pencil on paper, 22.5 × 19 cm.

237. Miró. *Untitled* (no. 159).
Pencil on paper, 21 × 15 cm.

238. Tanguy. *Untitled* (no. 251).
Ink on paper glued on wood, 35 × 20 cm.

239. Jean. *Untitled* (no. 119).
Ink on paper glued on wood, 30 × 25 cm.

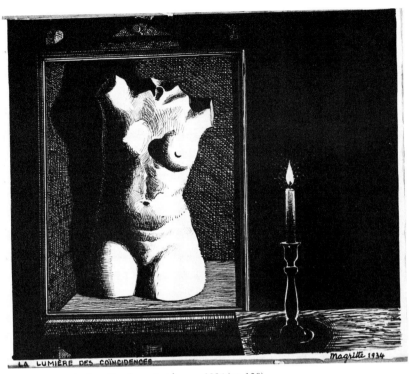

240. Magritte. *La Lumière des coïncidences*, 1934 (no. 126).
Ink on paper glued to wood, 18 × 22 cm.

241. Attributed to Man Ray. *Untitled* (no. 217).
Pencil on paper, 24.5 × 15.5 cm.

242. Giacometti. *Untitled* (no. 103).
Paper glued on wood, 27 × 23 cm.

243. González. *Tunnel head*, *c*.1933–5 (no.107).
Bronze, 46 × 32 × 23 cm. Museu d'Art Modern, Barcelona.

Yet, in this atmosphere, which had initially seemed willing to accept Surrealism, a crisis arose, and a return to a more or less academic realism resulted. It should not be forgotten that in the preceding period neither the bourgeoisie nor the cultural institutions recognised the work of Dalmau, and that *Noucentisme* had for many years been accepted as the official art. In the artistic press of the time and because of artists and critics like Guillem Díaz-Plaja, Eusebi Busquets, Rafael Benet and Joan Merli, great controversies about figurative and academic art arose. Their violent reaction to the avant garde was summed up by Sebastià Gasch in 1935: 'At the present time, we are witnessing the resurrection of the depiction of subject-matter. The return to realism is the only thing that is discussed, and the majority of artists profess a fanatical cult, an extreme and religious veneration for subject-matter. At present, there is a fetish for realism and the depiction of subject-matter'.[6]

A violent and highly politicised Expressionism also existed, which first appeared in publications, and which continued during the Civil War; the artists concerned had formed the Associació d'Escriptors i Artistes Revolucionaris in 1933. Finally, in the theoretical field we should mention the book by Ferran Callicó, *L'Art i la Revolució Social*, 1936, which is a first attempt to deal with the economic aspects of art, especially as regards the relationship between artist and art gallery.

NOTES
1 A. Tàpies, *Memòria personal*, Barcelona, 1977.
2 Unpublished, unsigned letter from the former archive of Carles Sindreu.
3 S. Gasch, 'Amics de l'Art Nou', *La Publicitat*, 30 November 1932.
4 S. Gasch, 'El circ d'un escultor', *Mirador* no.191, 29 September 1932.
5 All that survives is an original drawing by Calder; the *pochoir* was never issued.
6 S. Gasch, 'El retorn al realisme', *Art*, April 1935, pp.194–6.

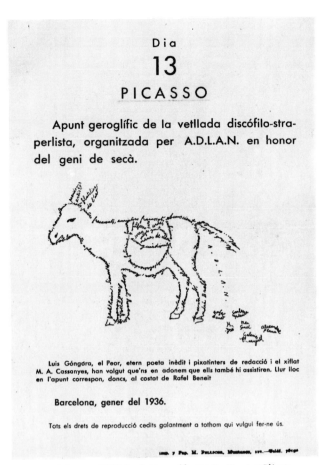

Dia
13
PICASSO

Apunt geroglífic de la vetllada discófilo-straperlista, organitzada per A.D.L.A.N. en honor del geni de secà.

Luis Góngora, el Peor, etern poeta inèdit i pixatinters de redacció i el xiflat M. A. Cassanyes, han volgut que'ns en adonem que ells també hi assistiren. Llur lloc en l'apunt correspon, doncs, al costat de Rafel Beneit

Barcelona, gener del 1936.

Tots els drets de reproducció cedits galantment a tothom qui vulgui fer-ne ús.

244. *Dia 13 Picasso*, 1936; leaflet issued by PAC – Pro Art Clàssic – attacking the avant garde (no. 282).
22.2 × 16 cm. Biblioteca dels Museus d'Art, Barcelona.

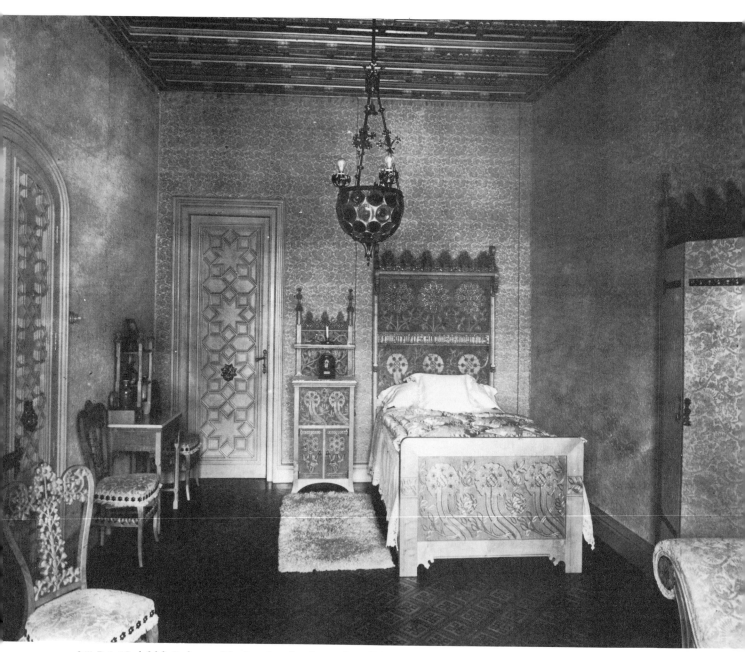

245. Puig i Cadafalch. Bedroom of the Casa Amatller, designed in collaboration with the decorators Casas y Bardés, 1900.

The decorative arts in everyday life

Daniel Giralt-Miracle

As a result of the gradual industrialisation of its country, nineteenth-century Catalan society developed a standard and a way of life distinctly different from those of the rest of Spain, which was for the most part still determined to maintain the ideal of an empire which no longer existed.

The expansion of the city of Barcelona contributed to a great extent to the creation and maintenance of its own artistic market, which directed its tastes towards European models. As regards the decorative arts, throughout the second half of the eighteenth century a gradual increase in the activity of the local workshops became evident, as did the preoccupation with the question of the relationship between arts and industry. In fact, the Llotja school (founded in 1775 and from then on the centre of Catalan artistic life) consistently promoted the study of design applied to the textile industry, although there were attempts on the part of the public authorities to bring a greater consistency and range to these studies. Thus, between 1871 and 1873, the City Council of Barcelona commissioned the historian and politician Salvador Sanpere i Miquel to go to the main centres of Great Britain, France and Germany to study the way institutions devoted to the encouragement of relations between art and industry were run and how they might be emulated in Catalonia.

The introduction of the ideas of Ruskin and Morris and the aesthetic that followed from them – characterised by the curved line and a repertory of naturalist ornament, as opposed to the straight line and the artificiality of the machine – came rather belatedly, through the architect Lluís Domènech i Montaner. He adapted the ideals of the Arts and Crafts movement to the conditions of a society in which a *Renaixença* was restructuring its social and cultural fabric. A direct consequence of Domènech i Montaner's plans was the important enterprise which was initiated in the building known as the 'Castle of the Three Dragons', the former Café-Restaurant of the Universal Exhibition of 1888, which he himself had designed. Under the direction of his collaborator, Antoni Maria Gallissà, also an architect, Domènech established a workshop there to bring together craftsmen – some from outside Catalonia – who still practised old techniques, some almost forgotten. The basic aim was to revive these techniques and to put them to use in the new forms of architecture that were being developed. Some outstanding results were achieved in both wrought ironwork and in ceramics with metallic glazes. In connection with the latter, it is interesting to recall the journey

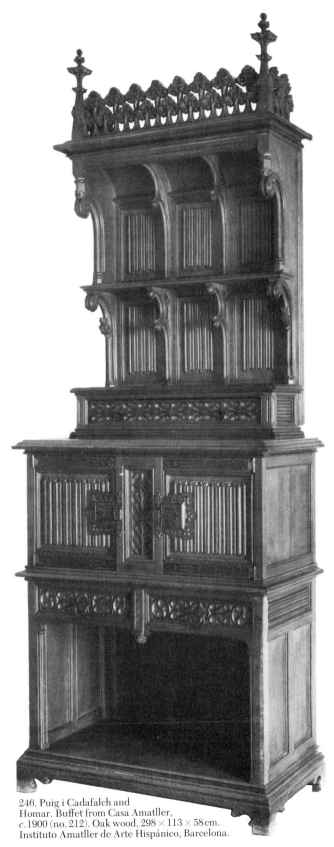

246. Puig i Cadafalch and Homar. Buffet from Casa Amatller, *c.*1900 (no. 212). Oak wood, 298 × 113 × 58 cm. Instituto Amatller de Arte Hispánico, Barcelona.

227

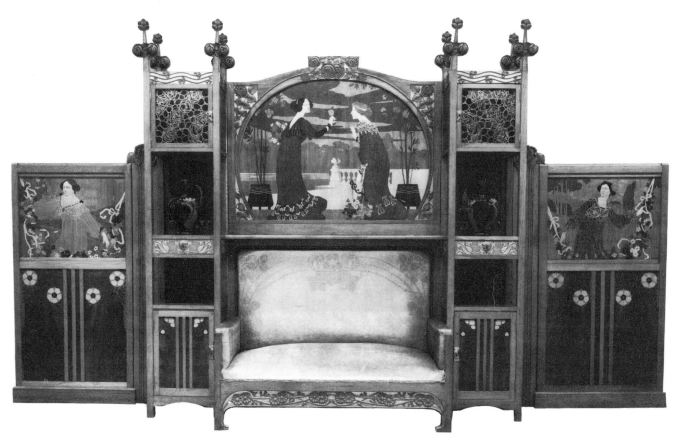

247. Homar. Sofa-cabinet with marquetry panels (designed by Pey)
from Casa Lleó Morera, *c.*1904 (no.116).
Wood and other materials, 268 × 259 × 50 cm;
side panels each 176 × 91 cm. Museu d'Art Modern, Barcelona.

undertaken together by Domènech i Montaner and Gaudí
to Manises in the Valencian region to seek out the last
practitioners of traditional ceramic techniques there.

Long before this enterprise was begun, something
similar, and undoubtedly of great influence on the dec-
orative arts, was being undertaken in the workshop of the
cabinet-maker Francesc Vidal. Vidal, who was also a
noted patron (for example, of both Pau Casals and Isaac
Albéniz), built his own workshop in the *Eixample*. Under
his direction furniture of various styles – eclectic, his-
toricist, aesthetic, etc. – with all the accessories of interior
decoration (metalwork, lighting, glasswork, cast iron, etc.)
was produced there. Vidal's workshop brought together
some of the greatest exponents of these specialist skills in
Catalonia, thus enabling them to play a significant role in
the development of the decorative arts.

Both experiments, one in the theoretical field – and, as
such, having a well-defined aesthetic – and the other
purely practical, had the immediate effect of reviving
crafts which had fallen into disuse and of bringing these
special skills into the orbit of serious artistic consideration.
New techniques and costly materials were introduced on
the artistic scene, and the 'industrial arts' – which basically
consisted of the production of objects without con-

sideration of their context – were distinguished from a
more integrated idea of the 'decorative arts'. The cabinet-
maker Eusebi Busquets wrote a theoretical piece on this
subject in the journal *Joventut* in 1903. In the same year
the Foment de les Arts Decoratives (FAD) was founded
in Barcelona, as the result of various initiatives previously
developed along the same lines. The FAD was to become
the institution which would uphold tradition and continuity
in the cultivation of these specialist skills in Catalonia, as
an alternative to the defunct guild system. Among the
other factors that also contributed to the increased
reputation of the decorative arts was the interest aroused
by art dealers (M. Utrillo), collectors (principally Rusiñol
with his Cau Ferrat in Sitges, and collectors of ceramics)
and scholars (Lluís Labarta, Font i Gumà etc.)

Thus, the introduction of the naturalistic aesthetic
appears to have been inextricably linked with the raising
of the qualitative and conceptual level of the decorative
arts (a fact which is more obvious, as is logical, in revived
processes than in those which had enjoyed an uninter-
rupted tradition) and with the appearance of interior
design – the decorative art par excellence, which results
from the integration of all the different components.

It was through interior design, which was in its turn

fully integrated with architecture, that *modernista* taste achieved a universal dimension. It is worth noting the close relationship that existed between interior design and graphic art, in that the latter for the most part stemmed from the formal repertory used by the designers. The reason for this is clear; those who practised as interior designers were not so much cabinet-makers as draughtsmen and illustrators. Among these we should mention Josep Lluís Pellicer, who designed the Arús Library, and Josep Pascó – professor of design – who with Pellicer developed more stylised forms. Alexandre de Riquer is the most important figure in this respect, as he was in the field of graphic arts; after his visit to England in 1894, during which he came into contact with the Arts and Crafts movement, he adopted all the techniques of *Art Nouveau* in its most European dimension, executing many drawings and ornamental works in this style. We should also mention Adrià Gual, poet, man of the theatre and graphic artist, who was an ardent supporter of Japanese culture, and the painter Jaume Llongueras.

Of the *modernista* interior designers Gaspar Homar, a pupil of Francesc Vidal, was particularly important, precisely because he was not merely an executant of other people's designs. One of his principal works was the design of the house of Lleó Morera (figs. 247, 255), with beautiful marquetry based on drawings by Josep Pey. Another important interior designer in Barcelona was Joan Busquets, who drew on many European influences. Lastly, there is the remarkable design work of the painter Aleix Clapés and the architect Josep Puig i Cadafalch in the vast collection of their plans for the decoration of the rooms in the Amatller house (fig. 245).

The names of craftsmen and designers of decorative objects are many, the most important of them being Lambert Escaler. Although he has been considered of secondary importance, precisely because of his dedication to decorative art, his greatness as a sculptor is obvious, and entirely comparable to that displayed by Pau Gargallo in the same field. Carrying on from a family business, Dionís Renart carried out comparable work, moving into the field of religious ornament.

The potter Antoni Serra also devoted himself to the production of decorative objects. Well practised in the techniques of that art, which he strove to perfect, he also undertook the production of porcelain figurines. For these he used models by sculptors like Ismael Smith or Gargallo. Josep Pey also provided him with some excellent designs which he executed in vases of the purest *modernista* invention (fig. 249).

The most important of the techniques specifically linked with architecture was stained glass making, where new developments had recently brought about considerable improvements. In this area the outstanding craftsman was Antoni Rigalt, who worked with Domènech i Montaner on the Palau de la Música Catalana (figs. 124,

248. Serra. *Designs for porcelain, c.*1904–8 (no. 241).
Ink and lead pencil on paper, 13 × 20.5 cm.
Museu d'Art Modern, Barcelona.

249. Pey. Vase, *c.*1907, made by Antoni Serra (no. 175).
High-fired porcelain, h: 14 cm. Museu d'Art Modern, Barcelona.

250. Riquer. *Crisantemes*, 1899 (no. 295).
Book binding, 20 × 10cm. Museum für Kunst und Gewerbe, Hamburg.

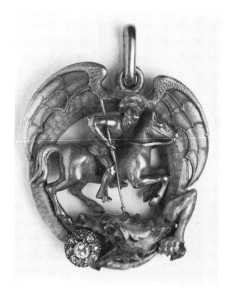

251. Masriera. Pendant: *Sant Jordi, c.* 1905
(no. 135).
Gold, enamel and diamonds, 4.5 × 3.6cm.
Museu d'Art Modern, Barcelona.

125), and who founded a stained glass factory, which is still active today. Frederic Vidal (the son of Francesc Vidal), who took over the family workshop, made some interesting stained glass using the *cloisonné* process.

Metalwork and ironwork centred mainly around the Masriera i Campins foundry, which introduced the 'lost wax' process, and executed designs by most of the sculptors, architects and interior decorators (Homar, Busquets, etc.). Perhaps the most important work in this field, apart from the innumerable wrought iron grilles, are the lamps designed by Pere Falqués for the Passeig de Gràcia in Barcelona.

In the field of more industrialised production, the spread of *modernista* forms through the medium of tiled pavements, found in almost all the houses in the *Eixample* of Barcelona, should be stressed. The main factories devoted to its production (Butsems, Escofet etc.) included designs by Domènech i Montaner and Puig i Cadafalch in their catalogues.

Because of the attention it has received, the work of Antoni Gaudí and his collaborator Josep Maria Jujol as designers deserves to be considered separately. Conceptually, their starting-point was no different from that of their contemporaries – the search for a 'naturalist' idiom for the arts – although aesthetically their work is characterised by greater freedom and creative force, which gave birth to a repertory of strictly personal forms. It covered practically every field, based on a profound knowledge of the materials and their applications. It is fascinating to study in depth the exchange of influences between Gaudí and the craftsmen who worked with him, although this falls outside the scope of this study.

The art of jewellery also followed the same path as the other decorative arts. Catalonia had a long tradition of goldsmiths, culminating in the *modernista* period in the figure of Lluís Masriera. A member of a great family of artists, and himself a man of many talents, he was trained in the principal European centres, where he learnt the techniques he later brought to Catalonia. Of these the main one was the application of translucent enamels to jewellery, using plant or animal forms conceived in the *Art Nouveau* style, and he received international recognition for his work of this kind (fig. 251). Amongst the *modernista* artists who designed jewellery were Riquer, Llimona, Gargallo, Renart and others.

To sum up, *Modernisme* was the product of the interaction between Catalan society and front-line European cultural movements, a process which had gathered momentum throughout the second half of the nineteenth century. In this sense, the significance generally given to the date 1888 must be reconsidered, since this was no more than one of the many steps towards the expansion of the city of Barcelona. *Modernisme* coincided with the period of greatest building activity, and this led to the revitalisation of old techniques, particularly those of service

to architecture. The other decorative arts rested on a well established tradition, although at this period they began to be integrated in a new total concept of interior decoration: the figure of the interior designer (who was not necessarily a craftsman) appeared, and a new type of professional association took over the function of the old guilds.

Ideologically, *Modernisme* was inextricably linked to Catalanism, so that its spread was accompanied by a very concrete message to the citizens of Barcelona, which was, in my view, the most important aspect of its influence on daily life.

Although originally conceived in purely cultural terms, the Catalan movement attained sufficient political power, with the election in 1907 of Enric Prat de la Riba as president of the Provincial Assembly of Barcelona and the consequent formation of the Mancomunitat, to develop its own plans for Catalonia. Prat de la Riba and his colleagues made an enormous effort to give Catalan society the necessary infrastructure to convert it into a modern society, comparable to any of the more advanced industrial societies. This desire graphically expressed the idea of Catalonia as a city (*la Catalunya-ciutat*), as against the traditionalism of the rural world.

In this context, *Noucentisme* was nothing other than the cultural and aesthetic doctrine evolved in the wake of Prat de la Riba. Aesthetically, *Noucentisme* favoured a formalism which was manifested in the arts in various kinds of realism (objective, classicist, baroque etc.), over which reigned a formal, didactic ideal of purity which was summed up in the motto of *Obra ben feta* (Work well made). It was undoubtedly a reforming, modern, 'rational' movement, which contrasted its normative character with the waywardness of *Modernisme*, and which followed the same lines as other European realist movements. Because it appealed to the tastes of the Catalan bourgeoisie and had been initiated by a younger generation, the *noucentista* aesthetic survived beyond the actual movement itself.

In the light of their ideals, one of the first objectives of the *noucentistes* was the reform of higher education, including artistic techniques and skills. In an article published in *La Veu de Catalunya* (16 June 1909), Prat de la Riba himself expressed the need to create a school of arts and crafts as an integral part of an industrial university. Even so, the Provincial Assembly's Escola Superior dels Bells Oficis did not begin to give classes until the beginning of the academic year 1915–16. Its director was Francesc d'Assís Galí, who through his own art school had already become the prime mover in the reform of art teaching in Barcelona. The special subjects taught at the new school were pottery, woodwork, textile and leather crafts and gardening. The curriculum also included the special studies of metalwork and architectural sculpture, which were, however, of less significance. Later a sculpture class was included under the direction of Esteve Monegal.

252. Gaudí. Door from Casa Batlló, *c.* 1906 (no.97).
Oak wood, 287 × 141 × 22cm. Collection Amics de Gaudí, Barcelona.

253. Dalí. Screen, *c.* 1923 (no. 63).
Gouache on parchment with mixed media, mounted on four panels with
linen backing, each 155 × 54.5, overall 218cm. Private collection.

254. Llorens Artigas. Plate, 1921 (no. 124).
Decorated pottery, diam: 25 cm.
Collection Jordi Serra, Cornellà.

The Escola Superior dels Bells Oficis and its comple-
mentary Escola Tècnica d'Oficis d'Art responded to the
aims for which they had been created – to perfect tech-
niques and change social attitudes towards craftwork.
The later avant-garde movements in these fields, like the
existence of important Catalan schools of ceramics and
weaving, can only be understood in the context of the
tradition established by both schools.

The field of pottery was the first to get underway.
Josep Aragay was the principal figure to start with,
although his activity in ceramics needed the technical
assistance of others who were actual potters (Quer, Serra,
Ugarte etc.), and he must be considered the leader of the
noucentista revival in this area. He conceived forms and
designs in his own Mediterranean style, and he tried to
evoke the popular characters of Catalan baroque ceramics
(fig. 260).

Tomàs Aymat, head of the school's textile department,
was at the same time the principal figure in the art of
tapestry in twentieth-century Catalonia. In order to intro-
duce this craft into the school's curriculum, Barcelona's
Provincial Assembly had supported Aymat's visits to the
Gobelins and to the royal carpet factory in Madrid. His
teaching was highly influential, although Aymat's greatest
contribution is generally agreed to be the founding in
1920 of a factory in Sant Cugat del Vallès, near Barcelona,
which was to become the main centre for the present
Catalan school of tapestry. There he produced carpets
and tapestries based on his own designs or on those of
Galí, Obiols and others. The most characteristic subject
was that of a female figure surrounded by nature.

It was also through the school that the art of Japanese
lacquer was introduced into Catalonia and Spain. It was
Lluís Bracons who learnt this skill in Paris with J. Dunand
(who had himself introduced it into Europe), and who
later spread it throughout Catalonia as a teacher in the
school. Bracons collaborated actively with the decorator
Santiago Marco, and his pupils and followers included
Pere Brugués, Ramon Sarsanedas and his wife Enriqueta
Pascual Benigani.

The goldsmith and painter Jaume Mercadé also taught
at the Escola Tècnica d'Oficis d'Art, and he and Ramon
Sunyer, his colleague at the school, were the main rep-
resentatives of *noucentista* jewellery (figs. 262–4).
In contrast to *modernista* exoticism, they introduced
a repertory of forms based on the popular and Mediter-
ranean tradition of Galí and Aragay. Their jewellery
designs were based on geometric structures and closed
forms, which later evolved and became *Art Deco* in style.
The sculptor Manolo Hugué also designed jewellery in
his own personal style. Although he was not directly
connected with the schools of the Provincial Assembly,
Xavier Nogués had enormous influence on all spheres of
Noucentisme through his personality and his work. He
should perhaps be considered the most complete artist of

255. Marquetry panel by Pey from Homar's sofa-cabinet
from the Casa Lleó Morera, *c.*1904 (no.116).
176 × 91 cm. Museu d'Art Modern, Barcelona.

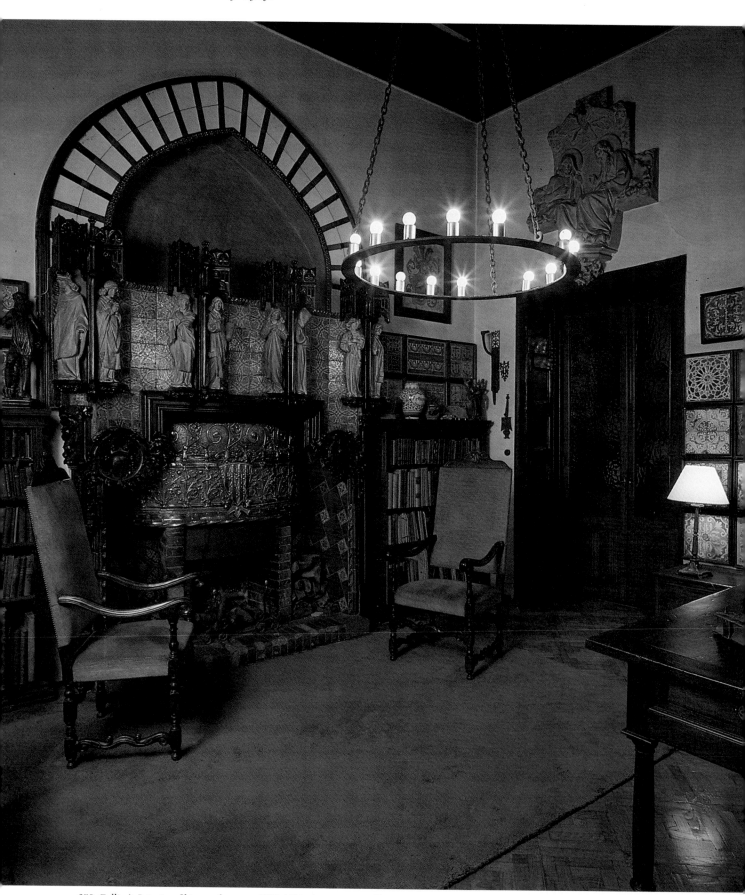

256. Gallissà. Interior of his own house, *c.*1895–1900, showing part of his collection of tiles.

257. Nogués. Vase, *c.*1928–32, made by Antoni Serra (no. 165). Pottery decorated in blue and green on a white ground, h: 24.5 cm; diam: 12 cm (at mouth). Museu de Ceràmica, Barcelona.

258. Nogués. Vase, 1935, made by Llorens Artigas (no. 167). Pottery decorated in brown, blue, green and pink on a white ground, h: 19.5; diam: 6 cm (at mouth). Museu de Ceràmica, Barcelona.

259. Nogués. Vase, *c.*1930 (no. 166). Pottery decorated in blue, sepia and yellow on a white ground, h: 28; diam: 12.5 cm (at mouth). Museu de Ceràmica, Barcelona.

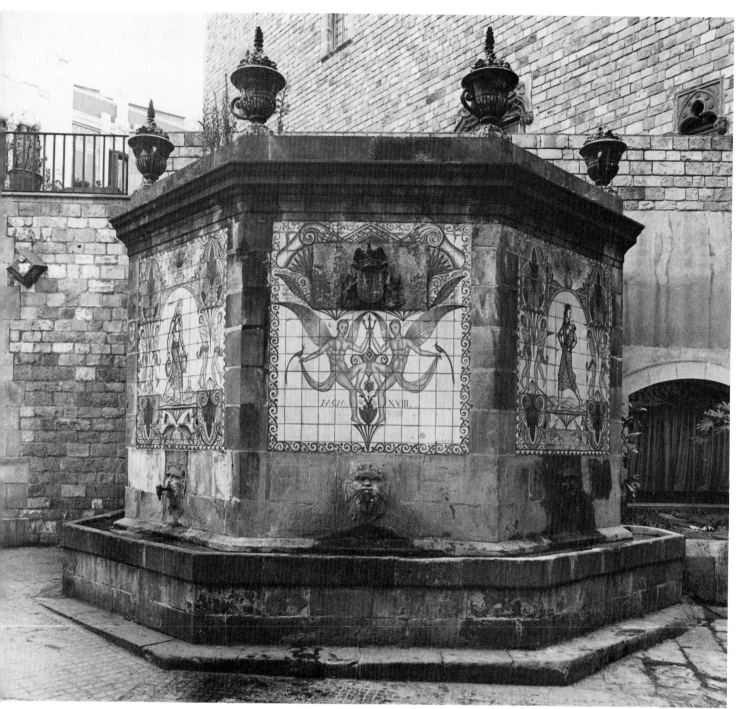

260. Aragay. Tiled fountain at Portal de l'Angel, 1918.

the movement, with a constant interest in the decorative arts. In this area he experimented with popular themes and caricature types, but always with a restraint that was dictated by his serious approach. In 1915 he completed the decoration of the Galeries Laietanes (figs. 183, 184) – the main exhibition centre for the work of *noucentista* artists – and later he undertook many other projects, several of them interpreted in ceramics. The theme of play is also found in the enamelled glasses executed for him by R. Crespo and J.M. Gol.

With the Dictatorship of General Primo de Rivera (1923) came the interruption of the institutional activities begun by the *noucentistes*, and the artists involved directed their energies elsewhere. The FAD now entered a new phase and became the main cohesive force. In its first years the FAD had confined its activities for all practical purposes to the organisation of small exhibitions, design competitions and conferences, and it entered this new period of its history in 1921 when Santiago Marco, a pupil and collaborator of Francesc Vidal, accepted its presidency. In 1923 Marco organised an International Exhibition of Furnishing and Interior Design in Barcelona, which, precisely because of its international character, was highly influential. Perhaps its most important result was the awakening of interest in *noucentista* interior design, which till then had barely existed. The height of the FAD's interest in establishing international contact was reached with its collective participation in the International Exhibition of Decorative Arts in Paris in 1925, through which it gained wide recognition. It was this event that consolidated the taste for ornamentation based on geometric shapes and designs influenced by Cubism, *Art Deco*.

Another of the FAD's important initiatives was the foundation of a college which came to fill, as far as was possible at that time, the gap left by the Escola Superior dels Bells Oficis. It was made feasible by the legacy of the collector Agustí Massana to the city of Barcelona (1921), although the Escola Massana foreseen by him did not begin teaching until 1929. Meanwhile, the FAD organised in its own centre – around which the Escola Massana was initially based – courses in several specialist subjects, which formed the basis for the curriculum in the new school.

To gain international leadership was one of the long-standing concerns of Catalanism, and from an early date there had been a plan to mount a new international exhibition in Barcelona. The political developments of the country determined that in the end it was to take place under the Dictatorship, but the 1929 exhibition was a highly influential event for both the arts and for the urbanisation of the new districts included in Barcelona. Not only was an unrepeatable display of 'Spanish art' assembled (which occupied almost the whole Palau Nacional), but it signified the end of eclecticism in the

261. González. Cup and saucer, *c.*1915–25 (no.109). Silver, 5 × 6.8 × 9.5 cm (cup); diam: 13.3 cm (saucer). Museu d'Art Modern, Barcelona.

262. Mercadé. Box in the form of a pumpkin, 1932 (no.140). Silver and coral, h: 17; diam: 18 cm. Collection Gustau Camps, Barcelona.

263. Mercadé. Collar, 1934 (no. 141).
Silver, length: 40 cm. Collection Jaume Mercadé, Barcelona.

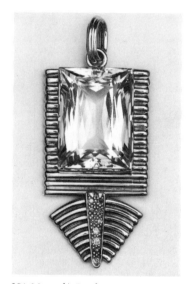

264. Mercadé. Pendant, 1925 (no. 139).
Gold, aquamarine, diamonds, 7 × 3 cm.
Collection Jaume Mercadé, Barcelona.

265, 266. Jener. *Maderas de Oriente* and *Bleu Or*, 1929;
perfume bottles designed for Myrurgia (no. 120).
Glass with printed labels. Collection Myrurgia Factory, Barcelona.

face of the united character of 'modern' styles. These were displayed through the various pavilions, the best known of which was that of Germany designed by Mies van der Rohe, while the display of waterfalls and light created by Carles Buigas (fig. 63) belonged to the purest *Art Deco* aesthetic.

It could be said that from the time of the 1929 exhibition Catalan art, still dominated by the period of *Noucentisme*, renounced once and for all its traditionalist and popularist tendencies to seek its full international position. The clearest sign of this was concentrated in the display of the Artistes Reunits. The participation of the FAD as a body had been ruled out for political reasons, and as a result a group was formed under the title Artistes Reunits in order to present their work, in a pavilion of their own, which would constitute the real display of progressive Catalan art (of course, excluding ultramodern works). Once again Santiago Marco was the main protagonist. In this display the *Art Deco* character was dominant, although in some cases strongly influenced by the legacy of *Noucentisme*.

Although it is easy to find a large number of *Art Deco* elements in houses and buildings in the *Eixample* of Barcelona, the style was only fully developed in Catalonia in the field of the graphic arts and jewellery (Emili Store). As far as I know, there was no interior decoration that was truly *Art Deco* in style. The interiors that were carried out are closer in style to the final phase in the gradual purification of *noucentista* forms, which began to merge into what became known as Rationalism. Josep Mainar did well to emphasise how objects designed by Santiago Marco and shown in the 1929 exhibition had conceptual affinities with those of the Bauhaus. On the other hand, it is also significant that some of the main achievements in the decorative arts realised in Barcelona during those years were to be found in jewellery (Sunyer, Mercadé, Cabot, Palou, Roca etc). In addition to Marco, the activity of designers like Antoni Badrines or Ramon Rigol is also noteworthy.

The real avant garde had only a marginal effect on the decorative arts. Here, the contribution of Josep Llorens Artigas, who combined the technical training he had received at the Escola Superior dels Bells Oficis with long European experience, should be particularly emphasised. Llorens Artigas went beyond the traditional idea of ceramics as a basis for pictorial compositions to create vases whose forms had their own aesthetic value (fig. 62), although this did not prevent him from collaborating with other artists, such as Raoul Dufy. There was an analogous avant-garde style of jewellery, principally represented by Manuel Capdevila. His creations are similar to those of Arp (whose work was exhibited in 1935 in the Roca jewellery shop in Barcelona), while we should also remember the designs of the sculptor Juli González (fig. 261), who came from a family of goldsmiths.

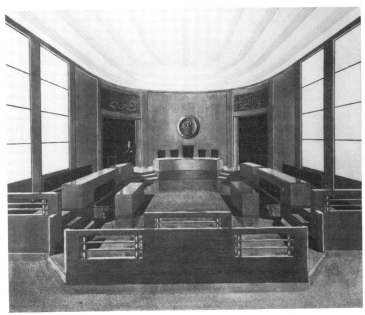

267. Santiago Marco. Design for the interior of the court room of the Tribunal de Cassació de Catalunya, 1934.

From the time Catalonia achieved political autonomy within the framework of the Second Spanish Republic, the remodelling of the buildings that housed the various public institutions (Parliament, Law Courts, etc.) became necessary. Santiago Marco – who at that time had introduced the use of chrome in his furniture – took over this task, working in the spirit of the GATCPAC (fig. 267). There were now several collaborative efforts between the architects' group and the FAD, as, for example, in the Salon of Decorative Artists from Barcelona at the Milan Triennale (1936) or the celebrated Spanish display at the International Exhibition in Paris in 1937.

Alongside the development of forms, the installation of a Museum of Decorative Arts also took place during the Republic (1932) in the Pedralbes Palace in Barcelona, where the collections gathered together from 1888 onwards in the museums of the Ciutadella were well displayed, as was the very important collection of Lluís Plandiura which was acquired and which complemented the basic collections of the Museum of Ceramics. The force behind these museum policies was Joaquim Folch i Torres, who came from a family of cabinet-makers and was closely linked to the FAD.

The Civil War put a dramatic end to this period. The subsequent reconstruction of the cultural fabric of Catalonia attempted to establish a continuity with the movements of the past, but it was carried out in an atmosphere and with an outlook which were already radically different.

To sum up, during the period 1888–1936 the city of Barcelona placed itself at the head of an extensive cultural area, aware of its own historical experience and determined to claim it as a contribution to a new conception of Spain, to supersede the outworn imperial and Castilian-centred ideals. This development went hand in hand with the economic expansion of Catalonia and the urban development of Barcelona, factors which made possible the emergence of an indigenous artistic market. This acquired much more importance than those in the rest of Spain and differed from them in as much as it abandoned its provincial outlook – whose highest aspiration was the upset of political power – to identify its artistic models with those of the European bourgeoisie (taking Paris as the main model).

This tuning into Europe had already been apparent throughout the nineteenth century and culminated in *Modernisme*, the first products of which can be dated around the Universal Exhibition of 1888. For the decorative arts it involved the revival of old processes that could be of service to architecture, and, in this connection, the emergence of the interior designer. This revival has sometimes been overvalued by those who want to extend it to all the decorative arts, ignoring the fact that some of them enjoyed an uninterrupted continuity. Despite this, it is clear that with *Modernisme* they entered a period of increased brilliance. This continued and was even intensified with *Noucentisme*, which, gradually stripped of its historical, traditionalist and popularist elements, came close to Rationalism; *Noucentisme* meant moreover the beginning of an institutional and educational continuity which was achieved through the Foment de les Arts Decoratives.

The wealth of design, tapestry, ceramics, jewellery and other processes in contemporary Catalonia is undoubtedly the legacy of the exceptional social and artistic flowering in the years between 1888 and 1936.

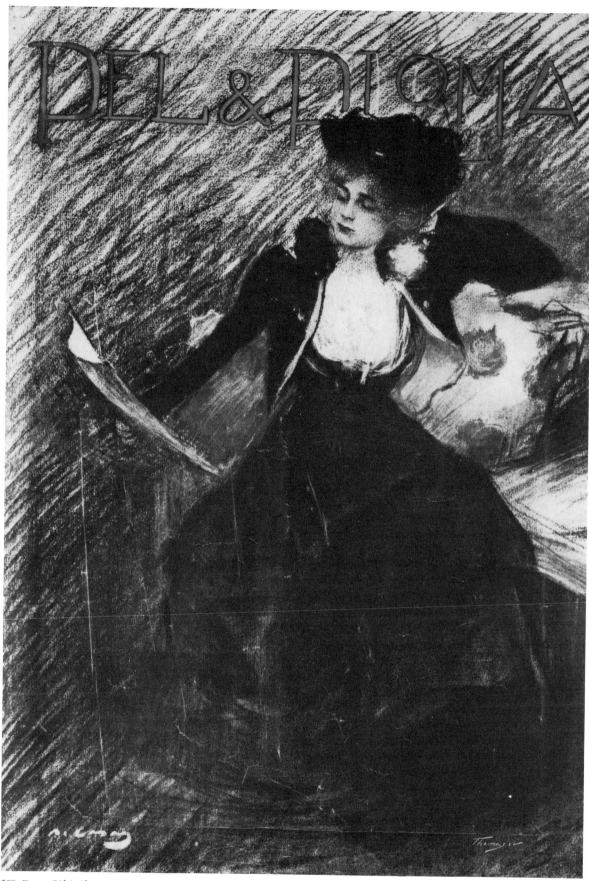

268. Casas. *Pèl & Ploma*, 1899 (no. 47).
Poster, 44 × 31 cm. Museu d'Art Modern, Barcelona.

Graphic arts in Catalonia, 1888–1936

Eliseu Trenc Ballester

The extraordinary development of the graphic arts in Catalonia, especially in Barcelona, in the late nineteenth century, when it changed from a professional, domestic activity to an essentially industrial process, was due to the advent of mechanisation and the technical and scientific progress which revolutionised the techniques of production in the printing industry. Paper mills were converted into factories for mechanically produced paper, the important ink-making company of the French printer Lorilleux was established around 1890 in Barcelona, while the German foundry Bauersche Giesserei of Frankfurt set up a branch, the Neufville foundry, in Barcelona; the modern printing equipment (rotary letterpress machines, lithographic presses and photogravure machinery) was principally German, while typography and typesetting were modified by the introduction of a mechanical type-setter, the Linotype, in 1884; finally, photogravure came into general use in the eighties and three- and four-colour printing in the nineties, revolutionising the reproduction of images, and in the same years industrial binding was mechanised. Around 1890 Catalan graphic arts had achieved a technical level equivalent to that of other European countries, thanks to the rapid introduction of these latest developments, while Barcelona became one of the most important publishing centres in Europe because of its role as the principal supplier to both the Iberian peninsula and all Latin America, a role which it maintained until 1936. This Catalan graphic arts industry, complete and poised, was extremely productive both in the art of the book and in publicity, and its beginnings coincided more or less with the brilliant era of *Modernisme*.

Modernista typography was characterised on the one hand by the revival of a Catalan gothic type (the incunabula gothic of Eudald Canivell) – whose form compares with the types introduced by William Morris – and the use of German gothic types, and on the other by the adoption, principally in titles, covers, commercial advertisements and ephemera, of *Art Nouveau* modern types of German origin derived from a baroque version of grotesque. The use of ornamental borders with arabesque decoration was the typographical practice most strongly influenced by *Art Nouveau*, along with decorated capital letters, which often incorporated floral motifs.

The revival of free and asymmetrical layouts, above all in covers; new formats for books, elongated or square; the general introduction of colour printing; the use of tints and coloured paper – all these changed the appearance of books and magazines. With its fantasy, formal

269. Josep Maria Roviralta. Masthead design for *Luz*, Dec. 1898 (no. 308).
Biblioteca dels Museus d'Art, Barcelona.

270. Bonnín. *La mala nova*, 1898 (no. 9).
Song book (one of Morera's Catalan song arrangements published by *L'Avenç*), 27.1 × 18.6cm. Private collection.

241

271. Gual. *Orfeó Català*, 1904 (no.111).
Poster, 77 × 111 cm. Museu d'Art Modern, Barcelona.

272. Joaquim Renart. Cover for *Catalunya Artística* no. 7,
25 Aug. 1904 (no. 302).
Private collection.

freedom, asymmetry and novelty, this typography perfectly reflected the revolutionary spirit of *Modernisme*. The most progressive printing-houses were L'Avenç, the J. Thomas studio and Oliva de Vilanova; the most beautiful, Fidel Giró, La Acadèmia, the Imprenta Elzeviriana, Tobella i Costa and Octavi Viader of Sant Feliu de Guixols. The most important *modernista* draughtsmen contributed to the illustration of books and magazines, favouring a type of illustration conceived as decoration. This decorative function of illustration was introduced by Apel.les Mestres, whose compositions in the eighties already showed a lack of balance, asymmetry and the influence of Japonisme. Alexandre de Riquer (fig. 287) was the artist most influenced by British *Art Nouveau* in his intimist and elegant books of poems, *Crisantemes* (1899) and *Anyoranses* (1902). Adrià Gual shared in the symbolist tendency, searching for the inexpressible with delicacy and mystery in his book *Nocturn, Andante morat* (1896) and in his vignettes for the translation of Oscar Wilde's *Salomé* (1908). Other *modernista* illustrators who should be mentioned include Triadó, Bonnín (fig. 270; and *Boires baixes*, 1902), Renart (fig. 272), Pascó, M. Utrillo (illustrations for Rusiñol's *Oracions*), Pichot and Opisso.

Of these, Riquer, Triadó and Renart were, with Casals i Vernis, the principal designers of ex-libris, one of the most characteristic media of the *modernista* aesthetic. Turning to illustrated journals, alongside this group of decorative symbolist artists who worked for publications of the *Art Nouveau* type, such as *Luz* (1897–8, fig. 269), *Joventut* (1900–6) and *Garba* (1905–6), we find in three magazines of the Parisian type – *Quatre Gats* (fig. 164), *Pèl & Ploma* (fig. 165) and *Forma* – the synthetic and realistic style of which Ramon Casas was the master.

In the area of the modern poster, which was born with the technique of chromolithography on zinc, the same division into two groups can be noted – on the one hand the decorative symbolist style of *Art Nouveau*, influenced by British and Belgian posters and the designs of Mucha; on the other, a more realistic, schematic type influenced by Toulouse-Lautrec and Steinlen. The first group includes Riquer (fig. 273), Gual (fig. 271) and Rusiñol (figs. 20, 21, 149), and the second Casas (figs. 268, 276, 278–81 etc.), Antoni Utrillo, Llaverias and Cidón (fig. 282). Commercial announcements and printed ephemera are, with artistic postcards, the forms of graphic arts where the influence of *Art Nouveau* was strongest in a popular form that was full of vitality, though less refined and symbolist than in the fine arts.

Modernisme was prolonged by certain printing houses into the twenties, but from 1906–7 it ceased to be the leading movement, and the graphic arts also changed. The disappearance of traditional formulae allowed typographic art in the twentieth century to assume a modern character, parallel to the general development of art once freed of all historical tradition.

273. Riquer. *Mosaicos Escofet-Tejeray y Cª, c.* 1902 (no. 225).
Poster, 180 × 103.5cm. Museu d'Art Modern, Barcelona.

274. Miró. *Aviat L'Instant*, 1919; project for poster announcing
L'Instant as 'coming soon' (no. 152).
Oil on cardboard, 107 × 76 cm. Private collection.

275. Galí. *Orquestra Pau Casals*, 1931 (no. 76).
Poster, 53.3 × 37.1 cm. Museu d'Art Modern, Barcelona.
This design was the winning entry in a competition organised at the Sala Parés
in May 1930.

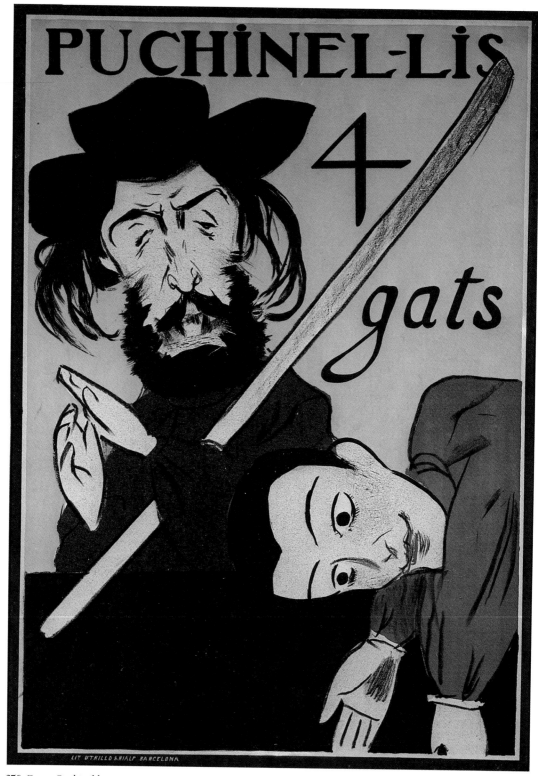

276. Casas. *Puchinel.lis 4 gats*, 1898 (no. 45).
Poster, 54.5 × 37.5 cm. Museu de les Arts de l'Espectacle, Barcelona.

277. Picasso. *Project for a carnival poster*, 1899 (no.191).
Black pencil and oil on paper, 48.2 × 32cm. Musée Picasso, Paris.

278. Casas. *Young girl leaning on a sofa with a glass of champagne in her left hand* (poster design for Codorniu Champagne), 1898 (no. 26). Conté crayon, pastels, watercolour, wax crayons and gum tempera on paper, 129 × 197 cm.
Collection 'Cartells d'Ahir', Casa Codorniu, Sant Sadurní d'Anoia.

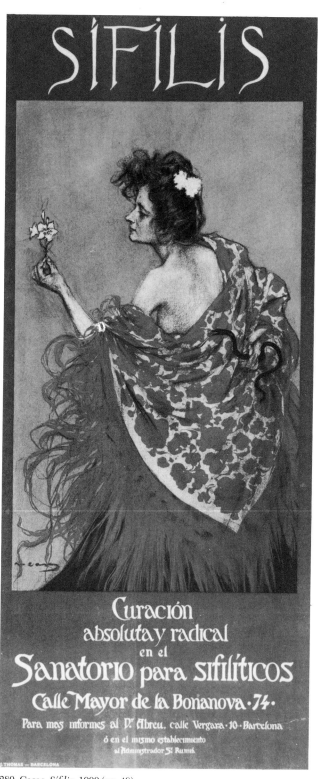

279. Casas. *Antiquarum artium barcinonensis exhibitio*, 1902 (no. 49). Poster, 70 × 48.5 cm. Museu d'Art Modern, Barcelona.
The poster, advertising the first important exhibition in Barcelona of art of the Middle Ages and Renaissance, shows Lluís Dalmau's celebrated *Virgin of the counsellors* (1445) in the background.

280. Casas. *Sífilis*, 1900 (no. 48). Poster, 80 × 34.3 cm. Museu d'Art Modern, Barcelona.

Between 1906 and 1911 there was a period of transition between *Modernisme* and *Noucentisme* which was especially noteworthy in the magazines *Or y Grana* (1906–8), *Empori* (1907–8) and *Futurisme* (1907). In the early years exuberant decoration generally did not disappear, but its style was altered: it became more symmetrical and balanced, and the floral motifs were now more geometric and repetitive. Soon, however, the reign of sobriety began, with a clarity that was the antithesis of *modernista* profusion. *Noucentista* typography is characterised by a return to roman typefaces, above all of a refined character, and this is what gives elegance to the page, just as there was a certain taste for italic fonts, generally to be found in little publications. Borders are rectilinear, and German types prevailed, in particular the designs of Kleukens of the Neufville foundry. The sobriety and simplicity of the *noucentista* book mark a return to classicism. The most characteristic *noucentista* printers were La Neotipia, a co-operative workshop founded in 1905; Joaquim Horta, who in 1911 printed the key book of the movement, the *Almanach dels noucentistes* (fig. 175) and the weekly *Papitu* (first series); Altés; Avelí Artís; and Sallent and Joan Comas in Sabadell. The publisher Gustau Gili produced a remarkable series of bibliophile books, *Les Edicions de la Cometa*.

A new generation of illustrators replaced the *Modernistes*, of whom only Triadó went on to *Noucentisme*, a transition which is reflected in the decoration of one of the most perfect books of the period, Miquel i Planas's 1908 edition of *Dafnis y Cloe*. The outstanding *noucentista* illustrators were Apa (Feliu Elias), Aragay (fig. 300), Joan d'Ivori, Esteve Monegal (figs. 299, 301), Junceda, Lola Anglada, Nogués with his etchings (fig. 173), Torres García, E.C. Ricart, who revived the technique of wood-engraving (fig. 285) and Torné Esquius (fig. 298) with his delightful book *Els dolços indrets de Catalunya* (1910). These illustrators worked for the principal illustrated magazines, whether of humorous character such as *Papitu* (founded 1908) and *Picarol* (1912), art journals like *Vell i Nou* (1915–21), or in the European style like *D'Ací i d'Allà* (1918–24, first series) and *Bella Terra* (1923–7).

Although *Noucentisme* survived up to the Civil War, by the end of the twenties it was being overtaken by the new movements of Surrealism and Functionalism. In the graphic arts, the unity of the movement had already been shaken in 1917 by the avant garde and in much the same period by *Art Deco*. Avant-garde art burst upon the graphic arts in January 1917 with the first number of *391* (figs. 199 etc.), Picabia's Dada magazine printed by Oliva de Vilanova, which broke with the classicism of *noucentista* typography, a trend carried on, in a way that was formally less revolutionary but with the same rejection of classicism, by *Troços* published by Josep Junoy (1917–18) and *Un Enemic del Poble* (1917–19) and *Arc-Voltaic* (1918, fig. 201) by Salvat-Papasseit. The impact of Cubism and of

281. Casas. *4 Gats*, 1898 (no. 44).
Poster, 58 × 34.5 cm. Museu d'Art Modern, Barcelona.

282. Cidón. *Exposición Meifrén*, c. 1905 (no. 52).
Poster, 88 × 64.4 cm. Museu d'Art Modern, Barcelona.

283. Helios Gómez, *Sleep*; cover illustration for
L'Hora Any I, no.1, 10 Dec. 1930 (no.305).
Institut Municipal d'Història de Barcelona.

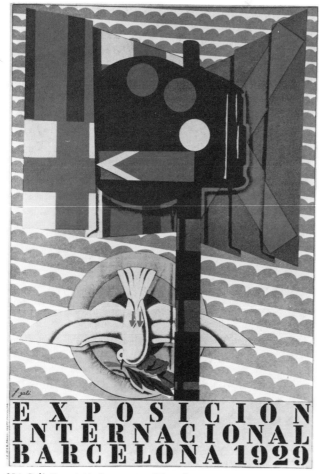

284. Galí. *Exposición Internacional Barcelona 1929*, 1929.
Poster, dimensions unknown.

Art Deco was to be particularly strong in publicity material (advertisements and ephemera), but above all in the poster art of the twenties with Segrellés, Pasqual Capuz, Josep Alumà, Ricard Fàbregas, Evarist Mora and Galí (figs. 275, 284) who designed the posters for the 1929 International Exhibition.

The International Exhibition of 1929 marks more or less the end of the predominance of *Noucentisme*, which was attacked by Surrealism (the *Manifest Groc* of 1928 and *Fulls Grocs* of 1929) and the architectural Rationalism of the GATCPAC. Similar changes can be noted in the graphic arts with the influence of Functionalism or elemental typography coming from Russia and Germany. A heavier typography, above all in titles and in graphic publicity, and a more dynamic conception, with the composition based on asymmetrical groups or on the diagonal, are characteristics of the new style. The journal that most fully reflects this new typography is one of the best printed magazines of the period, the third series of *D'Ací i d'Allà* (1932–6), with its predominance of the image and the photograph over the text and its reforming typography, for which the photographer Josep Sala and the painter Will Faber, who had just arrived from Germany, were responsible. The style was generally adopted and is found in political journals such as *L'Hora* (1930, fig. 283), in humorous journals like *El Foc* (1930), or even in the children's magazine *Junior* (1928–32). A journal which was outstanding for its graphic quality and its typographic invention was *Art* (1933–4), published in Lleida by the publicist Enric Crous Vidal. But this functional typography was still more widely used in advertising and particularly in poster design, where a number of artists deserve mention – Lluís Muntané, Fulgenci Martínez Surroca, Jan (Joan Seix), Lau (Nicolau Miralles) and Helios Gómez – while Josep Morell, the best poster artist of his time, and Antoni Clavé added to this style a certain naïve quality, which also was cultivated by Grau-Sala.

The war did not interrupt this publishing activity, and indeed it produced an intense movement of propaganda posters, which took advantage of the schematic design and the strength of the functional poster. All of this ended with the defeat of 1939, when there was a return to classicism, including a *Neo-Noucentisme*.

In general, Catalan graphic arts during our period reflect the general development of the visual arts, and I believe that they made a special contribution by giving *Noucentisme* a more modern, less classical aspect than was possible in the fine arts. Similarly, in the twenties, their ability to absorb cubist and *Art Deco* influences gave them a modern and reforming character which allowed them to pass, without too much difficulty and without anything which represents a break or complete rupture, to the Functionalism of the thirties, a reforming movement, full of vitality, which would be brutally broken by the war and above all by Franco's dictatorship.

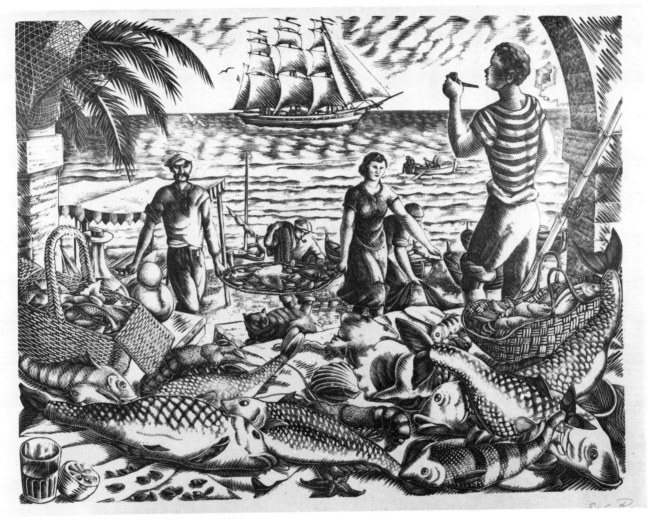

285. Ricart. *Fishermen on the beach, c.*1934 (no. 223).
Wood engraving, 28.5 × 41 cm. Museu d'Art Modern, Barcelona.

286. Apel.les Mestres. Illustration for *Liliana*, 1905 (no. 143).
Ink on paper, 32 × 22 cm. Museu d'Art Modern, Barcelona.
The book (1907), written by Mestres himself, and his stage version
(1910) are representative of the fantastic strain of *Modernisme*.

Catalan literature between Modernisme and Noucentisme

Alan Yates

The problems affecting Catalan as a 'minority' culture within the 'official' culture of the Spanish state converge ultimately on questions of the status and conditions of the Catalan language, a language which, like the community who speak it, can claim to be both normal and unique. The sense of identity through language, within the volatile Catalonia-Spain relationship, has been a crucial factor in shaping the development of modern Catalan literature. *Modernisme* and *Noucentisme*, which established the terms and the direction of this development in the period across the turn of the century, must be seen, from the literary perspective, not as conflicting 'schools' or contrasting aesthetic 'styles', but rather as alternative expressions of Catalan-ness, generated by divergent concepts of the relationship between literature and society in a phase of rapidly intensified national consciousness.

The *modernista* writers took up more or less explicitly an intellectual legacy that encouraged adoption of the role of individualist outsider, either as bohemian rebel or as genius and prophet, exponents of the superior values of a transcendental Art which challenged mediocrity and philistinism either through aesthetic sublimation or through preaching regeneration of a society paralysed by bourgeois materialism. Commitment to the cause of Catalanism tended to be assumed in the complementary cults of individualism and universalism. The energies of *Modernisme*, despite a phase of association with radically progressive movements, prove ultimately unsusceptible to political channelling.

Noucentisme, on the other hand, entailed subordination of the creative freedoms exalted by *Modernisme*. It called for obedience to an 'order' and service to the prospect of a culture, coordinated with a nationalist ideal and political programme, in which the interests of the artist and those of society would coincide. *Noucentisme* operated from the power-base of the most influential and assertive sectors of the Catalan middle classes, whose nationalism was massively stimulated by the failures and crises of the Spanish political system over the turn of the century.

Such a view of *Modernisme* and *Noucentisme*, however, should not lead into a simplistic interpretation of them in terms of clear opposition between idealism and pragmatism, anarchy *versus* order, Romanticism *versus* Classicism, or even noble sincerity *versus* servile compromise. The fact is that the two 'movements' coincided in their fundamental purpose and motivation: the urge to project a modern, autonomous and *normal* Catalan culture. Similarly, in chronological terms, they were not separate and successive but rather continuous and overlapping phases, many strands of which were tightly intertwined. What differentiated them, and what accounts for the apparent contrasts in their literary manifestations, were alternative interpretations, applied in rapidly evolving political circumstances, of the social relevance and function of literature.

Modernisme

Industrialisation and growth in the middle decades of the nineteenth century accentuated the already existing differentials between Catalonia and the rest of Spain. The Universal Exhibition of 1888 put Barcelona on the map of Europe at the same time as the literary products of the *Renaixença* revival movement (the forceful voice of the poet-priest Verdaguer, the metropolitan novels of Narcís Oller, the plays of Guimerà) were attaining a measure of international acclaim and showing that Catalan literature could stand again on its own two feet. The Catalan middle classes were beginning timidly to harbour cosmopolitan aspirations and to consider for themselves a place in the European family of national bourgeoisies.

It took a sort of cultural revolution, spearheaded by offspring of this bourgeoisie, to galvanise all the potential of this situation. From the early 1890s, centred on the journal *L'Avenç* and then on the five *Festes modernistes* organised in Sitges by the artist and writer Santiago Rusiñol, a campaign gathered momentum to enact the spirit expressed in Jaume Brossa's stirring call: 'A èpoques noves, formes d'art noves' – each new era demands its own new forms of art. The name *Modernisme* itself conveys the essential motivation, which was to *modernise* all aspects of Catalan culture, to open it up to Europe, in a way that would both reflect and enhance the autonomous character and cosmopolitan qualifications of Catalan society. It was thus a two-fold reaction, against the stagnation of the official Spanish culture of the Restoration period and, locally, against the nostalgia and parochialism of the mid-century *Renaixença*, entailing a confrontation with the perceived indifference and insensitivity of the Catalan middle classes.

A specific collective image – conceived of as progressive and outward-looking – was to be projected through assimilation into the Catalan ambit of the most vital and innovative currents moving in those national cultures with which the *modernistes* wished to align their own. What they contemplated, in their gaze towards Europe and away from Spain, was a ferment of modes and styles,

287. Massó i Torrents. *La Fada*, 1897, with music by Morera, published by *L'Avenç*; cover design by Riquer. Biblioteca de Catalunya, Barcelona.

shot through with a sense of crisis, the gamut of '-isms' which characterised the turn-of-the-century artistic and literary panorama. The spirit of crisis, in itself a symptom of modernity, had deep philosophical or ontological connotations associated with the discrediting of positivism, whose attendant insecurities the *modernistes* also translated into their own context. Indeed, the whole experience of *Modernisme* can be understood in this light as the accelerated assimilation of the most significant discoveries and the deepest currents of European cultural sensitivity, from Romanticism onwards, that the *Renaixença* had merely skimmed. This is exemplified in many individual cases, but the outstanding one is the poet Joan Maragall, who absorbed so fully and so genuinely the import of German Romanticism, from Nietzsche back through Novalis and Heine to Goethe.

Maragall's writing gave poetic status to the everyday language of Barcelona, an important stage in superseding rhetorical tendencies inherited from the *Renaixença*. His diverse subjects – landscape, political themes, legend and folklore, lyrical contemplation – are unified by the poet's vision (sight and perspective having a key function in his work, opening out into a 'visionary' dimension) and by the sincerity of his voice, in a constant movement from direct experience towards a sense of wholeness which is at once vital, moral, spiritual and aesthetic. Personal sensitivity and cultural receptivity were united in Maragall and attuned to the preoccupations of the day, in a way that gave him considerable moral authority among his contemporaries and also directed his poetic underwriting of concepts of nationhood – basically deriving from the idea of *Volksgeist* – that were being consolidated as political Catalanism gained momentum around 1900. The strong Romantic legacy is particularly active in Maragall's profession of the spiritual essence of poetry and in his theory of inspiration – 'la paraula viva', the living word – an exaltation of spontaneity and sincerity that harmonised so readily both with attitudes towards language and with the several aesthetic influences embraced by *Modernisme*.

In the fertile context of *fin-de-siècle* Catalonia such theories confirmed in the *modernistes* a messianic spirit and faith in the transcendental value of literary creativity. With Art elevated to the status of secular religion, they claimed an imperative vocation and a creative 'professionalism' (in the sense of an exclusive dedication) which could not in fact be satisfied materially in the contemporary cultural economy. The fervour, though, and the idealism explain the significant quantitative boost in literary productivity around 1900 (just as the realities of the cultural economy explain many individual frustrations and tragedies), when, for the first time since the Renaissance, Catalan literature displays a repertoire that can be called complete and dynamically in tune with the spirit of the age. In qualitative terms, the expressive

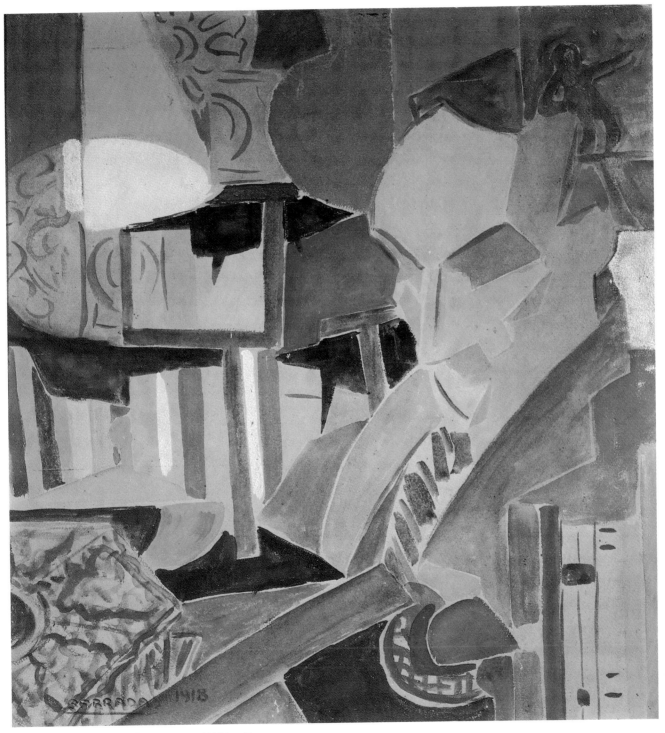

288. Barradas. *Portrait of Salvat-Papasseit*, 1918 (no. 8).
Watercolour on cardboard, 50 × 47 cm.
Collection Gustau Camps, Barcelona.

289. Apollinaire. *L'Horloge de demain*;
calligramme published in *391* no. 4, 25 March 1917 (no. 315).
Biblioteca dels Museus d'Art, Barcelona.

outpouring and the urgent eclecticism are related to the diversity and the apparent contradictions visible in the available models: late Naturalism, Pre-Raphaelitism, decadent exquisiteness, Parnassianism, Symbolism

Two major features require comment. First, literary developments were deeply affected by and cross-fertilised with movements in all the other arts, under the general sign of symbolist aesthetics and of the aspiration to 'the condition of music'. Jaume Massó i Torrents used a Pyrenean legend as the basis for a specifically Catalan version of Wagnerian lyrical drama, *La Fada* (1897), with music by Enric Morera. Felip Pedrell set to music Maragall's sustained reworking of the legendary subject of *El Comte Arnau*. The art-critic Casellas translated Pre-Raphaelite motifs into prose, before evolving towards a synthetic and highly stylised realism. The painter Rusiñol wrote almost pure symbolist prose poems (*Oracions*, 1897) and drama, then drifting towards colourful satire, in plays and novels (*L'Auca del senyor Esteve*, 1907, adapted for the stage in 1917), where nevertheless *modernista* values remain prominent. Two other representative figures – Alexandre de Riquer and Apel.les Mestres – worked as confidently with words as they did in draughtsmanship. Other examples of this versatility and diversification – in effect a 'unification' encouraged by the breakdown of generic categories – are numerous. They reflect the powerful impulse of *Modernisme*'s cultural revolution and the creative enthusiasm it engendered. It was *Noucentisme* which came to challenge the exorbitance of some of this enthusiasm and to deflate, then redirect, part of the inspiring idealism.

Second, there was a distinct shift within the *modernista* cycle itself which in effect anticipated and conditioned this latter reaction. The translation of Maeterlinck's *L'Intruse*, produced at the Sitges festival of 1893, had been a symbolic call-to-arms for *Modernisme*, and the prevailing tone of the 'new art' was initially one, justified by ideas of Art for Art's sake, of refined asetheticism, Pre-Raphaelite artificiality or decadent morbidity. There was in this, no doubt, a significant element of what might be called market cultivation, in the elevation of artistic values and in the fostering of a certain snob appeal. But the tendency corresponded also to a genuine and genuinely modernising creative experience for Catalan literature, continuing to exercise a strong pull through into the twentieth century. There is a direct line running from the *Festes modernistes*, through the early writing of Maragall, Rusiñol and Casellas, through the symbolist drama of Adrià Gual (*Nocturn*, 1896; *Silenci*, 1898), to the suggestive decadent novel *Camí de llum* (1909) by Miquel de Palol, the high point in a wave of this kind of mood-painting in prose, which offered an alternative to the conventional schemae of realist narrative. However, the social concern and regenerationist commitment which *Modernisme* carried from the start were quick to question the relevance

of the evasive and morbid aspects of this aestheticism. Maragall's criticisms of Rusiñol in this respect are typical. Nietzsche, Ibsen and D'Annunzio offered vitalist involvement as an antidote to ivory-tower renunciation, while preserving the messianic status of the artist-intellectual in the nationalist enterprise. The reaction was an important one, which tied in with the new impetus acquired by political Catalanism in response to Spain's foreign and internal crisis of 1898. The ideological orientation of Maragall's *Visions i Cants* (1901) accorded with other movements in the sphere of literary theory that impinged directly on production. Casellas in particular, closely engaged in the culture-society dialectic, produced a subtle synthesis of realist and symbolist concepts that provided the stimulus for a late flourish of *modernista* fiction.

With Casellas's own *Els Sots feréstecs* (1901), with *Solitud* (1905) by Víctor Català (pseudonym of Caterina Albert), P. Bertrana's *Josafat* (1906) and *Nàufrags* (1907), Palol's *Camí de llum* (1906), J.M. Folch i Torres's *Aigua avall* (1907) and J. Pous i Pagès's *La Vida i la mort d'en Jordi Fraginals* (1912), attended by a host of satellite works, there was a distinct boom in novel production, which constitutes an interesting and original Catalan response to the apparent disablement of realist-naturalist conventions. Based more of less explicitly on a philosophy of subjective relativism, with interest transferred from causality and social relationships to states of mind, the suggestion of mood and exploration of the limits of individual consciousness, this repertoire inevitably displays a diversity of approaches and voices.

Behind this, though, there lies a coherence of fundamental concerns and motifs (frequently focused on a highly stylised and symbolic rural setting) which makes this the most intensive part of *Modernisme*'s renewal of the Catalan literary panorama. Essentially what is seen is a stylisation of reality, subject to the fragmentariness of symbolist perception, through which a series of key confrontations are symbolically expressed (artistically experienced) and patterned: the subjective self and individual will confronting an alien reality, felt as physical, social and cosmic; the hostilities encountered in the quest for personal fulfilment; self-awareness *versus* stultifying indifference; the spirit *versus* matter; the transference of these concerns into an open-ended series of reflexive metaphors related to artistic perception and to the artist-outsider's social function. These multiple antitheses are constantly resolved in terms of sacrifice and defeat, but only after their challenge has been intensely experienced through the imagination, and *re*-created. It is above all through these novels that one can follow the process by which the *modernista* temper moves through claims of extreme subjectivism back into collision with the objective constraints upon its own ideals and enterprise.

A similar evolution can be traced, in the very broadest terms, in *Modernisme*'s substantial renewal of Catalan

theatre. One immediate effect here was the eager adoption of new staging and scenographic techniques – electric lighting and Wagnerian 'total spectacle' in particular. As regards literary character, the basic coordinates of *modernista* drama were, on the one hand, Maeterlinck and Symbolism, and on the other, slightly later, the influence of Ibsen and Hauptmann. Again the tendencies were interacting, but the first strain dominated in important works by Rusiñol, Adrià Gual and Apel.les Mestres, while Ibsen, translated and imitated by Jaume Brossa among others, was strongly present in the work of two outstanding playwrights, Ignasi Iglésias and Joan Puig i Ferreter, both of whom dramatised contemporary social issues from the perspective of *Modernisme*'s ideological and ethical concerns. Such a schematisation, however, does not do justice to the excitement and diversity of theatrical activity in Catalan over the turn of the century, when, in an atmosphere of enthusiasm for novelty and experimentation, avid incorporation of the international repertoire was accompanied by a revaluation of popular modes and traditional forms (mime, puppetry, pantomime, review, circus), leading towards interest in mechanical innovations (light shows, magic lantern, etc.) and ultimately to early experiments with cinema. It was another moment when a branch of Catalan literature was fully abreast of the times.

The social nature of theatrical activity naturally entailed organisation and a certain degree of institutionalisation. Independent theatre groups and centres for dramatic experimentation were established, notably Gual's *Teatre Íntim* (1898–1907). Converging economic and cultural factors – combined in the impact of the cinema – put an end, in fact, to the theatre boom of *Modernisme*, as *Noucentisme* made a very half-hearted contribution to continuity, seeing its cultural priorities as lying elsewhere. One such priority was precisely the concerted institutionalisation of Catalan culture, an undertaking to which forces were mobilised on a scale which *Modernisme* had envisaged but with a discipline and resources the *modernistes* did not possess.

Noucentisme

The name *Noucentisme* (the movement of the 1900s, of the new century) clearly implied the claim to go one better, to be a step on in modernity from *Modernisme*. For strategic reasons the *noucentistes* themselves insisted that they stood for a radical new departure from what they saw as anarchy and chaos in the immediate past. Their view of history has had a persistent and distorting influence that has encouraged the sort of misinterpretation referred to earlier. It is only relatively recently, thanks largely to the scholarship of Marfany and Castellanos, that we have come to appreciate how the true relationship between *Modernisme* and *Noucentisme* was one of concerted reorientation within a continuous process.

In denying this continuity the *noucentistes* were aided by the fact that it was anyway obscured from the outset by the effects of two crucial factors. First, *Noucentisme* operated a recruitment of cultural collaboration in the service of a nationalism created in the image of the most powerful sectors of Catalan society and expressed through effective political structures. The circumstances of Catalonia-Spain relations after 1898 consolidated the only apparently paradoxical phenomenon of revolutionary conservatism, that is of a bourgeois Catalanism out to affirm nationhood on the internal basis of the established social values and hierarchy, directed towards modification of the political structure of the Spanish state. After the Spanish elections of 1901, with the rise to power of the conservative Lliga Regionalista under the dynamic leadership of Prat de la Riba, the foreground of social and cultural life in Catalonia would be consistently shaped by these forces for two decades. The transformation of society that *Modernisme* had conceived as culturally *and* politically necessary was now in train, but with priorities inverted and with specific limitations on both fronts. With a hegemonic party organisation and from achievement then domination of semi-devolved government in the form of the Mancomunitat, *Noucentisme* transmuted cultural revolution into an efficient programme of cultural institutionalisation: from an official academy of sciences to museums, schools and a network of libraries; from patronage of publications and cultural foundations to reform and standardisation of the 'natural' institution of the Catalan language. The latter two aspects would impinge immediately on directions taken by literary production.

Second, a restraint on creative freedom was necessarily entailed in the instrumentation of this vision of a triumphant bourgeois culture, as was unequivocally declared by one of its guiding spirits, the poet Carner, as early as 1905. (Another version of this theme was expressed satirically in the sub-heading of a spoof journal, *El Noucentista* (1914), mischievously declaring its coverage to be 'Arts, Sciences, Philosophy, Commissions and Commercial Agencies'!) A certain *dirigisme* was the corollary of the new status conferred on what was now an authentic intelligentsia. *Noucentisme* demanded of its intellectuals a comportment that made them fit to be seen abroad with. Control, refinement, formality, discretion, moral scrupulousness were ethical values that had to be given literary equivalence. Such a posture accorded naturally with the classical spirit of a new Mediterraneanism, cultivated in all artistic spheres, that the *noucentistes* set up in opposition to their own polemical interpretation of *modernista* romanticism.

It is thus that the literature of *Noucentisme* demands to be read in its own terms as the articulation of a social vision. The legitimation of creative activity comes now not from within itself but from service to an ideal Catalonia

of which the written word can be both example and propaganda. From whichever angle *Noucentisme* is viewed, the presence and influence of an imposing quadrumvirate dominate the picture. Prat de la Riba actively delegated authority for the direction of cultural institutions to an 'essayist' and thinker (Eugeni d'Ors), to a poet and man of letters (Josep Carner) and to a linguist (Pompeu Fabra). The activities of these three were seen as complementary.

As head of the Philological Section (founded 1911) of the Institut d'Estudis Catalans, Fabra supervised a project dating back to his own collaboration in *modernista* regenerationism, but only now feasible through the organisation achieved by *Noucentisme*: orthographical reform and grammatical standardisation, representing the patents of the Catalan language's *normality*. Linguistic considerations shaded over into stylistic criteria, into promotion of a literary idiom that bodied forth the *noucentista* image of correctness and finesse.

A real danger of elitism was inherent in this situation. Those, mainly self-taught, who were unable or unwilling to comply with the new norms, whose writing was informed by *modernista* impulses of sincerity and spontaneity, tended to be left out in the cold and to suffer hostility or neglect from powerful opinion-makers enjoying official sanction. A younger wave of university-educated writers, readily amenable to calls for commitment to the militant orthodoxy, found favour. It suited the 'party line' to present this situation as the spent forces of old age superseded by the vigour of youth, but a considerable degree of image-making was involved. Ors (b. 1881), Carner (b. 1884) and Fabra (b. 1868) had started out as *modernistes*. Three figures that enjoyed promotion as paragons of the new perfectionism were anything but youthful: the fastidious prose-writer Joaquim Ruyra (b. 1858), and two Mallorcans, M. Costa i Llobera (b. 1854) and J. Alcover (b. 1862), both of whom embodied classical serenity and decorum in poetry. What these three shared, as well as seniority, was formality underpinned by an explicit confessional orthodoxy, whose importance cannot be overlooked as a credential of *Noucentisme*.

It was Ors himself, under his pseudonym 'Xènius', who arbitrated on the *noucentista* line (and adjudicated on membership of the company, as though dispensing civic honours) from his column, the 'Glosari', which appeared regularly from 1906 to 1921 on the front page of *La Veu de Catalunya*, the organ of the Lliga. The individual *glosa* was a highly distilled essay or intellectual exercise, on 'pretexts' ranging from personal caprices through current affairs to literature, aesthetics and philosophy. The message conveyed, the style deployed, elliptic and tending towards effeteness, and the posture demonstrated were all directed to the same end of setting the tone for *noucentista* behaviour, and the influence of the 'Glosari' was cardinal. Certain series or cycles of *gloses* turned on

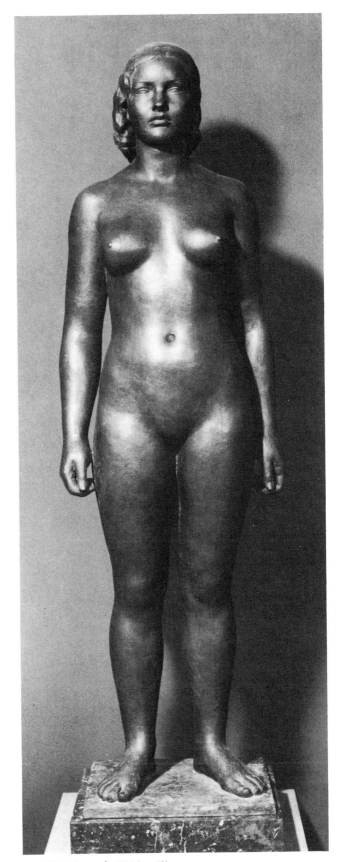

290. Clarà. *Strength*, 1936 (no. 53).
Bronze, h: 166 cm, base: 42 × 37 cm. Museu Clarà, Barcelona.

specific themes, and, when threaded together with a minimal plot, lent themselves to publication as independent 'fictions'. Such was the case with *La ben plantada* (1912), which, through the eponymous protagonist, Teresa, evoked the character, presence and circumstances of a Mediterranean ideal of Catalan femininity. The text quickly established itself as the epitome of *Noucentisme*'s politico-aesthetic doctrine according to Xènius. Together with other subsequent Orsian fictions it is interesting now not so much for any intrinsic relevance as for what it represents as *Noucentisme*'s closest approach to a recognisable novel. As against *Modernisme*'s diverse attempts to pick up and reconstruct the pieces exploded in the crisis of conventional realism, the *noucentistes* tended to despise the genre for its inability to mirror their civic ideals and to accommodate their concept of style. The symbolic 'ruralism' of the major novels of *Modernisme*, basically misunderstood by the *noucentistes*, became a central target for hostility.

The model offered by Orsian prose contributed strongly to the preference for the miniaturist approach of the finely wrought prose piece or the short story, of which some gifted exponents emerged: Carner, López Picó, C. Soldevila, E. Martínez Ferrando, Duran Reynals. In this sense *La ben plantada* is the exception that proved the rule, in that it is a profoundly 'anti-novelistic' text not least because of its controlling idealisation which disqualifies all *imitation* or exploration of experience in favour of a deliberate separation of art and life. Nothing was more repugnant to Ors than the 'anecdote'.

Xènius's system in the 'Glosari' was to hammer out the doctrinal import of a set of key concepts: *Noucentisme* (the total programme), *imperialisme* (the organic expansion of a dynamic nationalism, applicable also as the imposition of authority); *civilitat* (centre of a network of related notions, deriving from *civitas*, *urbs* and *polis*, ministering to the image of the ideal City); *classicisme* (tradition, decorum, the new order); *arbitrarisme* or *arbitrarietat*. The latter terms were the ones that related most directly to literary activity. What was meant was not 'arbitrariness' in the sense of the capricious, but rather the opposite, in the idea of willed control over the form and the raw material of art, over reality itself. The *antimodernista* connotations of this were clearly spelt out by Ors himself on numerous occasions. His prologue to the collection of poems by Guerau de Liost (J. Bofill i Mates), *La Muntanya d'ametistes* (1908), contains the telling pronouncement that Maragall's 'living word' was a deception. What Ors was promoting and what Guerau de Liost's writing exemplified, in this and in the significantly titled later collection, *La Ciutat de vori* – The Ivory City – (1918), was an almost sculptural approach to poetry, expressive of the domination of all tendencies to disorder.

As indicated, a conscious classicism was inherent in this poetics. Consistent with *Noucentisme*'s focusing of so many concerns upon the Catalan language itself, the *word* was paramount in an expressly 'man-made' poetry, paradigm of the *obra ben feta* (equivalent to the idea of perfectionism as civic responsibility). Control banished effusion; rigorous prosody accompanied select diction and polished effects; the sonnet achieved emblematic status. It should be remarked that this whole tendency was not the exclusive creation of *Noucentisme*, however much Ors and company might have so pretended. Parnassianism and even certain elements of the *estètica arbitrària* were present in the creative ferment of *Modernisme*, where the 'battle of the sonnet' had already been enacted. What *Noucentisme* did was to take over this line, claim it as its own to the exclusion of virtually all other aesthetic options, and inject it with very particular ideological connotations.

While Xènius pontificated, it was the prolific and highly talented 'prince of poets', Josep Carner, who gave real consistency to the new sensibility. Technical and verbal adroitness, apparent nonchalance and the insinuation of a very specialised irony are the hallmarks of a poetry whose basic scheme is the sketch of scenes from popular or middle-class urban life, gently refracted through classical inferences and a deliberately angled gentility. The overall achievement is inseparable from the high degree of subtlety and ductility that the poet instils into a fully accessible literary language. Carner's writing became markedly more compassionate and meditative after his departure in 1921 on a diplomatic career, which after 1939 became an exile lasting until virtually the end of his life. In his Barcelona period he personified *Noucentisme*'s ideal of the poet as citizen, and it was his influence that did so much to establish the 'sacrosanct' (Carner's own term) generic superiority of poetry during this time.

All the circumstances were propitious for the emergence of an impressive *pléiade* of young poets for whom the discipline of the *noucentista* formulae represented both opportunity and stimulus: J. López Picó, Marià Manent, T. Garcés, Clementina Arderiu, J.S. Pons, J.M. Sagarra (conditionally) and, pre-eminently, Carles Riba, who would gain recognition as a major poet of European stature. While their subjects and poetic voices displayed clearly individual character or preferences, these writers were united by integration in *Noucentisme*'s design for culture as well as by their participation in the refinements of intellect and sensitivity (notably the adventure of 'pure' poetry) being cultivated in contemporary post-symbolist poetry abroad. Collectively they represent the defined head-waters of a substantial modern tradition, widened in the 1930s with the confluence of M. Torres, J. Teixidor, J. Vinyoli and B. Rosselló-Pòrcel, and flowing through as a mainstream into the post-war era when, with Riba's outstanding literary and ethical example, they came to stand for continuity and affirmation through language of Catalan cultural identity.

291. Josep Carner.

292. Carles Riba.

One must return again to Carner for the main point of reference in the parallel evolution in *noucentista* prose-writing. His example was probably even stronger than that of Xènius in determining particular achievements and limitations in an area where the most prominent feature was the short-story vogue referred to above. As a resourceful and prolific translator (especially from English) and as the author of several collections of stories whose design and effects coincide basically with those of his verse, Carner made a most significant contribution to the sophistication of Catalan wit and to maturing all the resources of the language. However, his temperamental incompatibility with the demands of the full-scale novel form, a private aversion which *Noucentisme* permitted to become collective orthodoxy, served to intensify the disregard from which the genre in Catalan suffered after 1911, by when the novels of *Modernisme* had burrowed obsessively into their own crisis. After 1917, though, a pronounced shift in Carner's professed attitude towards the novel, although unaccompanied by examples from his pen, can be followed as an index of an ever more generalised dissatisfaction with the one-sidedness and aloofness, ultimately the 'abnormality', of *Noucentisme*'s literary repertoire. Economic and market factors (the inability of the officially protected publishing concern to compete with the popularity increasingly being enjoyed by 'inferior' fiction), reasons of cultural strategy (the need to connect with a wider public) and artistic considerations converged in an extended debate which articulated a demand for 'normal' novels, expressly recalling *Modernisme*'s contribution here, bound up in a critique of the élitist, dehumanised consequences of *Noucentisme*'s literary praxis and total *Kulturkampf*. By the mid-1920s the process was consummated, and the Catalan literary panorama had assumed an altogether more balanced and variegated appearance, not least because of the restored presence of 'standard' novels. A new wave of writers was emerging (simultaneously with the rehabilitation of some *modernistes*) who were able to avail themselves of all *Noucentisme*'s cultural and linguistic attainments, while standing at a clear distance from the fixations of the former militancy. As in poetry, the origins of the post-war mainstream (J. Pla, Mercè Rodoreda, Pere Calders, Espriu) arise out of this situation.

Some participants in these developments were already aware of what is today very sharply evident: that the specialisation, the sacrifices and the silences were the price to be paid, in the historical circumstances, for *Noucentisme*'s overall restructuring of Catalan culture and, in particular, for the thoroughgoing linguistic normalisation of which its concentrated poetics had been the key agent. The recovery of the novel and, partially at least, of the theatre, which had suffered its own 'structural' crisis, was symptomatic of a more advanced stage of the sought-for normality in the relationship between the writer and society, each on a sounder footing, the fruits of which would be enjoyed, all too briefly, during the 1930s.

The dynamics of *Noucentisme* related to a utopian cosmopolis – the new Athens, *Catalunya-ciutat* – whose illusory nature history quickly denounced. 1918 marked the end of the *belle époque* and the real crisis, duplicated in the spectre of the October Revolution, of those national bourgeoisies from which Prat de la Riba and his followers had taken their example. The strategy of confusing national interest with sectional interest could hold only for so long against internal pressures. The 'Tragic Week' of Barcelona in 1909 showed that social tensions and violent frustrations were seething behind the façade of solidarity and normality that was being erected by the Lliga. A whole phase of political appropriation of culture is resumed in the way the establishment (including Xènius) reacted to these events, confusing reprisal with 'civilising

order', in contrast with Maragall's humane plea for understanding that was censored by Prat.

The *noucentistes* shunned realism and directed their gaze to the ideal City, because to contemplate the city as it was would have been to acknowledge a turbulent reality of which class conflict was the root. The death of Prat de la Riba, in the critical year 1917, allowed internal stresses in his party to surface, coinciding with a re-crudescence of labour unrest and revolutionary strikes. Inability to cope with this situation would send the Catalan bourgeoisie into alignment with Primo de Rivera's dicta-torial solution, a solution that was turned eventually, in 1925, against the Mancomunitat itself. By then Ors was in Madrid and Carner was in Costa Rica.

The ephemeral revolt

The seismic strains affecting the national establishment around the time of the First World War had a discernible equivalent in literature. The situation must be assessed, though, with a particular awareness of context and sense of proportion.

The literary vanguard did not coalesce as a sharply defined force in Catalonia: *Noucentisme*'s absorbing concerns and efficient mobilisation of cultural efforts were at their height when the first ripples of Futurism were felt in Catalonia after 1914. The atmosphere in Barcelona, nevertheless, was certainly propitious to their reception: the real social ferment and dynamic agitation of city life, the openness to foreign innovation and the undertow of cultural radicalism carried through from *Modernisme*. R. Nogueras Oller's eccentric anticipation of the *calligramme* in *Les Tenebroses* (1905) and the polemicist Gabriel Alomar's coining in the same year of the term *futurisme*, albeit with quite different connotations from those of Marinetti's manifesto of four years later, now appear curiously symptomatic. The Paris-Barcelona axis, which *Modernisme* established, later brought art exhibitions and Diaghilev's Russian ballet (with Picasso as designer) to the Catalan capital. This was also the route taken by some members of the international van-guard (notably Picabia), exiled by the Great War, who established at least some contact with local artists through activities centred on Dalmau's gallery. It should not be forgotten that this same scenario had launched a Picasso and would produce a Dalí and a Miró. Quite explicit affinities between the work of the latter and that of the poet J.V. Foix indicate that the expressions of the literary avant garde in Catalonia, although relatively fragmentary and side-lined, deserve serious attention in their own right. The phenomenon is significant, moreover, in that it was generated within and thus disclosed certain major contradictions in *Noucentisme*'s grand design.

The influence of Apollinaire and of Marinetti's Futurism coloured the first phase of Catalan vanguard writing from roughly 1916 to 1924. The device of the *calligramme*

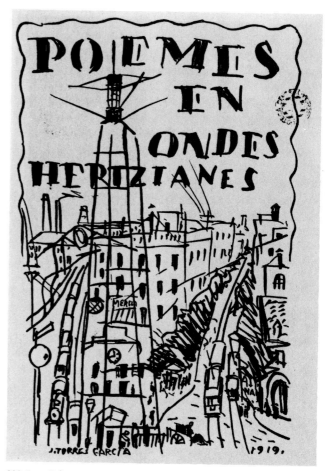

293. Joan Salvat-Papasseit. *Poemes en ondes hertzianes*, 1919; cover design by Torres García (no. 297). Biblioteca de Catalunya, Barcelona.

ART POÈTICA

294. Junoy. *Calligramme*, from *Poemes i cal.ligrames*, 1920.

was introduced in the *Oda a Guynemer* (1915) by J.M. Junoy, although this author, the founder of the important journal *Troços* (later edited by J.V. Foix), did not go beyond a dilettante interest in experimentalism. The excitement of the machine age, the flavour of a popular culture referring to the everyday specifics of modern urban life, cubist perspectivism and the new taste for syncopation contributed to further visual disjunction of poetic etiquette and of conventional syntax, translated in a range of typographic effects that were closely related to experiments in other arts. In its context this was an interesting retort to *noucentista* literary formality. The movement was deprived of direction and of intellectual leavening by the premature death of the bright young poet-critic J.M. Folguera, and it is the work of Joan Salvat-Papasseit (whose proletarian origins weighed considerably in his outlook) which represents the only substantial corpus of authentic vanguard poetry from this period. The bulk of his poetry (*Poemes en ondes hertzianes*, illustrated by Torres García, 1919; *L'Irradiador del port i les gavines*, 1920), combined with his short-lived militant publications (*Un Enemic del Poble, Arc-Voltaic* and *Proa*) and manifestos, evince Salvat's commitment to vanguard expression of rebellion as a creative and spiritual adventure. His early death from consumption, in 1924, left open the question of how this poet might have evolved towards accommodation with the values of a literary establishment which, recognising his original talent, was moving towards embracing him.

A second phase of the total cycle can be associated with the reverberations of Breton's *Surrealist Manifesto* of 1924. Here a more aggressive version of Futurism, tending towards destructive Dadaism, was swept up in the surrealist surge. The interesting Sabadell group – Armand Obiols (i.e. Joan Prats), Francesc Trabal and the versatile Joan Oliver, who adopted the pseudonym Pere Quart for his poetic guise – cultivated an idiosyncratic and quite sophisticated humour of the absurd, aimed at challenging both literary conventions and the dullness of their own middle-class background.

More geared into the international current were the activities of the group centred on the Sitges-based journal *L'Amic de les Arts* (1926–9), which brought the poet J.V. Foix and Salvador Dalí into close contact. Foix's work in verse and prose-poetry, continuous over more than half a century, has been, in Arthur Terry's words, 'a steady unfolding of possibilities implied in his very earliest work' (the date 1918 manifestly holding a special significance for the author himself). It is an imposing *oeuvre* which stands as one of the fundamental achievements of twentieth-century Catalan literature. The surrealist ingredient in Foix's vision and expression is unmistakable, but it comes across as integral to the working of a 'poetic investigation' fixed on a precarious sense of individual personality within a natural universe of whose mysteries

poetry is a sort of analogue. Foix's dreamscapes, full of magical transitions and metamorphoses, visual and plastic mutations, his sense of wonderment, fear and elation, are combined in an extended metaphor of intercommunication between all elements of a single Creation of which the poet acts as demiurge.

The very consistency of Foix's work has aligned him with that strong mainstream referred to above which has been so crucial to the post-war survival and continuity of Catalan literature. The terms of this identification were already established, in fact, in his earliest affirmation of principles. It is a case which shows up clearly, in several ways, the constraints and compromises naturally bearing on attitudes of serious intellectual iconoclasm within the Catalan context. Foix did not sign the Dadaist *Manifest Groc* issued by Dalí, Gasch and Montanyà in 1928. From a position of committed nationalism the poet recognised the perils of provocative intellectual terrorism inside a culture as vulnerable as Catalan, particularly as it affected the hard-won prestige of the language. Thus, from the front line of revolt, whose creative possibilities he assimilated totally, Foix reached across to the *Kulturkampf* of *Noucentisme* to which even his most extreme 'investigations' are ultimately related. Tradition and discovery become interactive. His posture is well summed up in his famous line: 'M'exalta el nou i m'enamora el vell' – 'I am exalted by the new and in love with the old'. Where his contemporaries were moving consistently on a post-symbolist bearing, with references back to Mediterranean classicism, Foix, for whom the sonnet is as natural a mode as 'automatic writing', short-circuited the movement by invoking the troubadours and the great classics of the home tradition, Ausias March and Ramon Llull. The unexpected but authentic recipe, 'effort in discord' as the poet Francesc Vallverdú has recently expressed it, is what gives cultural representativeness to Foix's arresting vision and inimitable voice.

The flurry of surrealist agitation, protagonised mainly by Dalí, between 1929 and 1931 produced ripples in various literary spheres and certainly familiarised the Catalan public with the international phenomenon. Already by the early 1930s, though, the 'ephemeral revolt' was perceived as burnt out, turned into the subject of historical analysis, fashionable reminiscence or even satire, recurring occasionally as an assimilated ingredient in broader designs. The advent of the Republic (and, more diffusely, the effects of the Great Depression) created alternative commitments and possibilities for Catalan authors. The 1930s indeed constitute a new and very full chapter, a period of plenitude, in the development of modern Catalan literature. As has been indicated in these pages, the fundamental conditions of this growth were the terms of a relationship – between the writers, their language and their society – worked out between *Modernisme* and *Noucentisme*.

295. Casas. *Portrait of Joan Maragall, c.*1906 (no. 41).
Charcoal and light touches of pastel on paper, 61.1 × 47.3 cm.
Museu d'Art Modern, Barcelona.

Joan Maragall

The 'Festa Modernista' (1893)

The first part of the programme, devoted to music, was another triumph for Morera, the young composer whose recent reputation is increasing so rapidly. The three pieces of his which comprised it were listened to with pleasure and warmly applauded.

The great attraction of the second part, also musical, was a powerful piece [the *Piano Quintet*] by César Franck, a French composer who died a few years ago, whose fame is spreading internationally, and who until now was unknown to audiences here . . .

However, it would be fair to say that the main interest of the evening was the third part of the programme, which consisted of the first performance of the play *L'Intruse* by the Belgian writer Maeterlinck, by a group of dedicated artists well able to appreciate what they were about.

The theatre, or rather, the dramatic writing of Maeterlinck is of a kind which allows the translator no compromise or possibility of adaptation, but demands the full resources of a creatively gifted linguist, capable of transposing the nervous tensions of one language into those of another. This has been achieved by Pompeyo Fabra, another young man of talent, to whom the audience assembled at Sitges owed its first experience of the Maeterlinckian *frisson*.

The strange poetry of Maeterlinck's dramatic tableau, powerfully conveyed by the writer Casellas in the role of the blind octogenarian, with masterly restraint by Rusiñol, and with great instinct and discretion by the rest of the improvised cast; that vague poetry, taking shape in a setting devised by the hand of an artist, which as the curtain rises possesses both eyes and soul, immersing them in the general feeling of the work; that morbid poetry imposed itself on the audience, on every member of the audience, from the first moment, keeping it in suspense, with hardly a break, until the tremendous final scene, which roused it to nervous acclamation followed by thunderous applause.

And how splendid to be able to savour and fill out one's impressions of the memorable evening, to share one's feelings of enthusiasm, to prolong them afterwards beside the sea; the sea which perhaps gave birth to the majestic sound of César Franck, which Maeterlinck at times brings into his plays like a mysterious, awe-inspiring character; the sea of which Morera is conscious, and beside which, on a headland of the coast of Sitges, Rusiñol has raised the banner of artistic faith and independence.

The Last Whistle (1905)

The other evening, it must have been about a quarter past nine, we suddenly said: 'Oh, what a funny whistle that train's making!' It was a desperate whistle, travelling in the direction of Sarrià . . . My heart gave a leap. It was the last train of the last day. The train to Sarrià wouldn't be running any more. The next day – I'd read it in the paper – they were going over to 'electric traction'. We would never hear that whistle again from the train to Sarrià: it was a farewell; the train wasn't going to Sarrià, but to eternity: we would never hear it again.

And how often we'd heard it in the past! How often my father had heard it, and my grandfather, and so many fathers and grandfathers and children who were now grown up. Our children would now never know the joy of the train to Sarrià; they would know other joys, but not that one. That thin whistle of the train which took people to their weekend villas!

It's like something from a fairground, we used to say when we were small, watching it go past, so tiny, with its thin whistle, running so lightly, as if someone were blowing it along from behind.

It was a toy of the citizens of Barcelona, who watched it go by with a tender smile, knowing there was no wickedness in that train. It whistled away, occasionally panting, occasionally running along like a real train; no matter: the people of Barcelona smiled tenderly at it, as at a child who charges ahead, but knows that it won't get beyond the garden gate. Thus the people of Barcelona, seeing it shuttle off towards the mountain which encircles the city, smiled contentedly, saying: 'You won't get any further'.

It even had a tunnel. Heavens! But that tunnel didn't go through any mountains; in order not to disturb the sleep of a certain respectable little street in Sant Gervasi, it went humbly beneath it, so as not to be noticed. The people of Barcelona knew all that, which is why they smiled so tenderly. They knew where that tunnel went to; they knew where it took that train, panting and all; and so they smiled contentedly . . .

Speech delivered at the Homage to Guimerà (1909)

Then Guimerà appeared in our midst and we took as our leader that man of immense faith and few words, childlike and strong, humble and stubborn, who, forging ahead with the greatest simplicity imaginable, among threats and indignities, insults, mockery and violent political passions, endured everything without hesitation or grand

gestures, without a moment's weakness or a word of provocation; and, confident in his cause, crossing that vast hall packed to the doors with a seething crowd, he walked calmly up to the President's rostrum, certain of raising a storm, as if he were going about the most ordinary task of his life. And that, clearly, was how he regarded it; for a man of profound faith, for a lyric poet, what could be more normal than to speak in Catalan from such a Catalan place of authority?

As soon as he opened his mouth, protest broke out: first an abrupt cry of derision like a pistol shot, followed immediately by a great roar of anger. Everywhere there was shouting, waving of arms and general panic; opponents coming to blows and friends trying to separate them; chairs out of place and people out of their minds; the dome of the old Ateneu must remember that evening of the 30th of November 1895. I presume to remember it now since, although most of those who went into action there are still alive and well, many passions have cooled since then, many who were on opposing sides are now united, and all that remains of the battle is the glory of those who took part, above all the glory of those who publicly maintained their serenity under fire. Standing with his papers in one hand, our President quietly waited for the uproar to die down, which it eventually did, with much applause for one who had stood his ground so resolutely. He then went on reading his speech as though nothing had happened, as if the reader had merely paused for a moment to rest. With the same voice of firm moderation, he continued to read in his simple intonation, singing the praises of our language, demonstrating its right to a full life based on a glorious past and predicting for it a still more glorious future. Without extremes, without arrogance, Guimerà went on reading his speech quite unpretentiously, pausing only for the loud applause which frequently greeted his ideas or some fine expression; until, as he ended with the great curse of Dante Alighieri on those who prefer the language of others to their own, the entire audience burst into the ovation which crowned the first victory – a political victory, one might say – of Catalanism . . .

At the Sagrada Família (1906)

Thus I made my way there as if impelled by a duty, not one of those duties we fulfil, but the kind which fulfils itself within us. I went down the wide roads of the unfinished city, all filled with pale March sun; a slight breeze raised little eddies of dust, and tattered clouds were racing across the sky. And the temple seemed to me, as always, as it does to so many people, like a vast ruin; or like a huge dovecote, as one little girl said when she saw it for the first time. And, to be sure, there are doves flying up among the spires and the scaffolding of the bell-towers. But I am more deeply impressed by the feeling of ruin; and this pleases me, since, knowing that

this ruin is a birth, it preserves me from the sadness of all ruins; and ever since I came to know this construction with its air of destruction, all destructions can seem like constructions . . .

I began my visit, as usual, by going down to the crypt, as if searching for the seed of the temple, in order to return with greater knowledge to that which lies exposed to the sun and the open air; to stroll behind the apse in the shade of its vertical stones, where one is most assured of coolness, and then to glimpse from one side the amazing movement of the stones of the porch, so as not to be too quickly overwhelmed. Then timidly to seek the front of the porch and to take it in with one's eyes; and immediately to find oneself facing its centre, and to feel the powerful attraction of any true porch as it utters its loving imperative: 'Come in!' But this time, I have no idea why, I did what I had never done before and stopped at the threshold to look up; and I saw it all above me, as if it had sprung from the ground that very instant; and human heads peered out and gazed at me, and the Star of Bethlehem spread its stone rays above my head; I had never seen stone turned into light, and this was a torrent of light. I looked down, utterly dazzled. I had never heard stone sing, but I felt that the whole porch was singing in stone with a deafening harmony. And I went in . . . or out, I don't know which; for in this temple there is more light inside than outside.

After that I crossed the precinct, looking straight ahead of me until I was outside. Then I looked round and saw once again the huge outstretched wing lit by the pale March sun, beneath the tattered clouds which raced across the sky; I saw once more the dovecote – as the little girl said – and two white bell-towers which are rising from either side of the porch.

The Burnt-out Church (1909)

I had never heard a Mass like that one. The vaulting of the damaged church, the crusted, smoke-stained walls, the vanished altars, above all that great dark void at the back where the High Altar had stood, the floor tiles invisible beneath the dust of wreckage, no benches to sit on, and everyone standing or kneeling before a wooden table with a crucifix, and a torrent of sunlight streaming through the gap in the roof, with a swarm of flies dancing in the harsh light which filled the entire church and made us feel as though we were hearing Mass in the middle of the street. The sun fell directly on the wooden table where the roughly dressed priest was officiating; while in the choir, now without railings, the others were singing, pressing their backs against the wall in order not to fall forward . . .

I had never heard a Mass like that one. The Sacrifice was present there, alive and bleeding, as though Christ had died once again for Man, and once again at the Last Supper had left his Body and Blood in the Bread and

Wine. The Bread and Wine seemed newly created: the Host appeared to vibrate, and when, in the sunlight, the wine was poured into the chalice, it was like a stream of blood. I had never heard a Mass like that one.

And I am certain that all of us who were present at the Sacrifice celebrated on that simple deal table, before the injured crucifix which was its only ornament, among the dust and debris and the sun and wind which entered from outside, and feeling still around us the trail of destruction and blasphemy which had so recently passed through that very air where once again Sacrifice was present, I am certain that we all heard it as never before, and that it filled us with a new, active virtue, as only the first Christians could have experienced it, persecuted and hiding in a corner of the Catacombs, delighting above all, amid danger and denial, in the beginnings of the mystery of redemption . . .

Joan Maragall (1860–1911), the leading poet and essayist of his generation, was acutely aware of both the strengths and the weaknesses of Modernisme. *His eye-witness account of the* Festa modernista *held at Sitges in September 1893 records a crucial moment in Catalan cultural life, when poetry and the other arts seemed to be merging in a new kind of synthesis, in which Pre-Raphaelite painting, the theatre of Maeterlinck and the music of Wagner were important ingredients. Maragall's own enthusiasm for* Modernisme, *however, was tempered – though never completely extinguished – by the social and ethical concerns which feed into his later poetry and give a peculiar authority to his journalism and critical writings. While working as private secretary to Mañé i Flaquer, the editor of the* Diario de Barcelona – *a post which he held from 1890 to 1903 – Maragall wrote regularly on political and social questions, and seldom failed to comment on important cultural events of the time. Later, in his vivid evocation of Àngel Guimerà (1845–1924), the one nineteenth-century Catalan dramatist of European stature, he was to re-create one of the great landmarks in the history of* Catalanisme: *the occasion on which Guimerà became the first President of the Ateneu Barcelonès – then the main centre of Barcelona intellectual life – to deliver his inaugural address in Catalan.*

Like the poems he wrote in response to the events of 1898, Maragall's later essays mark a new, and more public, phase in his writing, an attempt to involve himself in the contemporary debate over the future of Catalonia. Though his engagement takes many forms, his underlying sense of poetry as an instrument of metaphysical exploration is never allowed to exclude an awareness of the immediate problems of his own society. In his essays and correspondence, one is continually struck by his feeling for the texture of city life, as in his elegy on the last steam train to Sarrià, which registers with obvious affection one of the small but significant losses which any growing community must endure.

The finest of Maragall's 'public' poems, the Oda Nova a Barcelona *(1909), ends with a vision of the Sagrada Família, Gaudí's great unfinished church, then still on the outskirts of the city. In the poem, completed shortly after the* Setmana Tràgica – *the anarchist rising of July 1909 – the Sagrada Família becomes a 'mystical example' for future generations, rising above the present atmosphere of conflict and suffering. In the essay of 1906, Maragall recounts with Proustian accuracy his impressions of a visit to a building he clearly admired and which was still under active construction. (The 'two bell-towers', eventually to become four, had just reached the level of the base of the spires.) After the disturbances of 1909, however, the contrast between the serenity of Gaudí's masterpiece and the violence of the city becomes more intense. Nevertheless, in a remarkable series of articles written during the following months, Maragall returns again and again to the theme of civic responsibility and to the need to assimilate, rather than ostracise, the discordant elements of Barcelona society. His plea for mutual forgiveness, however, shocked many of his contemporaries, and his great essay* La Iglésia Cremada *('The Burnt-out Church'), in which contemporary violence is seen in the context of early Christianity, was published only in a severely censored version.*

Characteristically, Maragall's vision of a city based on mutual tolerance and moral understanding takes full account of the weaknesses and contradictions of existing society. For Eugeni d'Ors (1882–1954), the chief interpreter of Noucentisme, *such a vision was incurably Romantic; for Maragall, on the other hand, the* noucentista *conception of an archetypal 'ideal city', to be willed into existence by cultural* dirigisme, *was excessively abstract, not to say élitist. Allowing for the circumstances of the time, it is Maragall, with his instinctive sense of the real powers which shape a community, who seems the more realistic; hardly surprisingly, perhaps, given his unwavering belief in the importance of poetry and in its power to influence human conduct at the deepest level.*

Arthur Terry

296. Casas. *Portrait of Eugeni d'Ors, c.*1906 (no. 42).
Charcoal and touches of pastel on paper, 56 × 43.8 cm.
Museu d'Art Modern, Barcelona.

Poetry from Modernisme to Noucentisme

J. Vidal Alcover

When in 1906 – on the first of February, according to the colophon of the book – *Els Fruits saborosos* (The delicious fruits) appeared, the cultural authorities of the time hailed, in this collection, the first sign of a new aesthetic, which, from then on, would determine which poetry would be considered acceptable. Its author, Josep Carner, born on 4 February 1884, was almost twenty-two. At that time his literary and personal prestige were in their ascendency. The image of the young Carner that has come down to us is that of a sympathetic boy, writing a good deal, inventing pseudonyms, publishing often in periodicals and newspapers, entering the *Jocs Florals* and winning prizes, working regularly, from 1902, for *La Veu de Catalunya*, presenting and determining cultural events, critiques of authors and works, choices that must be followed, carrying conviction. He did not put a foot wrong, and his judgement in the branch of culture was more telling and more influential than the preaching of Xènius in his rhetorical and pontifical commentaries. He it was who turned for his models to the Mallorcans – the respective authors of *Cala gentil* (Lovely bay) and of *Dol* (Grief), J. Alcover and M. Costa i Llobera, as he makes clear in a 'Conversation' with Tomàs Garcés published in the *Revista de Catalunya* (August 1927) – rather than to Verdaguer or Maragall, who until then had been universally recognised and accepted as the models of good writing: 'I am much closer to the Mallorcan school,' he says, having given his opinion on Maragall. 'In it I see two distinct strands: *Dol* is one thing and *La Serra* [Mountain range] another; *Cala gentil* one and *De l'agre de la terra* [The bitterness of the earth] the other. Alcover and Costa are, alternately, classicists and folklorists. In some of their works formal beauty dominates. Sometimes, on the other hand, they seem transported by an earthy, picturesque inspiration. I must confess that it was the classical strain which ensnared me. Instinctively I joined the bank farthest from that on which Maragall brandished his torch alight for the romantic cause. I do not repent the choice. 'El Pi de Formentor' [The Pine of Formentor] and 'Cala gentil', are they not perhaps now the pine and the bay?'

One of the fine complimentary responses that *Els Fruits saborosos* received was the poem entitled *Al poeta que em féu present de fruites saboroses* (To the poet who gave me delicious fruits) by M. Costa i Llobera, included in the collection *Horacianes* (1906). This shows that the enthusiastic reception of Carner's collection was immediate: the publication of the book and the response of the Mallorcan poet date from the same year, even

though several of Carner's works had been known from at least 1904, when a group of five poems, entitled *Les Fruites savoroses*, won the *Englantina* (Dog rose) prize at the *Jocs Florals* in Mallorca. The warm reception of *Els Fruits saborosos* is not, however, an indication that there was any awareness of having entered the period of *Noucentisme*; the only person who we can be sure was aware of *Noucentisme* is Eugeni d'Ors, because for him, as with Naturalism for Zola, '*Noucentisme c'est moi*'. But this does not mean the literature of the *noucentista* period did not have its own characteristic traits.

In 1910 Carner won the *Flor Natural* in the *Jocs Florals* with the poem *L'estranya amor* (The strange love), included in the collection *Verger de les galanies* (Orchard of ornaments), published the following year. In this we can definitely see the beginning of the path to a new aesthetic, in both theme and mode of expression. *Els Fruits saborosos* still has a *modernista* tone: the vocabularly borrowed from Greek idyllic poetry – which Marià Manent points out as a characteristic of Albert Samain – can also be found in the paradigmatic representative of *modernista* poetry in Castilian, Rubén Darío. The path followed by Catalan poetry of the *noucentista* period, and thereafter, starts with *Verger de les galanies*. Certainly, it did not begin with *La Muntanya d'ametistes* (The mountain of amethysts), as Ors seems to prophecy at the end of his prologue to this collection of poems by Guerau de Liost: '. . . I greatly fear a prodigious germination of these words of yours, beautiful as they are, in the barren medium of our nation of plagiarists'. Eugeni d'Ors's pedantry, with his precious-stone imagery – reminding us of Gautier's *Emaux et camées* – and his allusion to the temptation of St Anthony – remember Flaubert – betrays his *modernista* affiliation: Ors was a *modernista* who preached *Noucentisme*, in the same way, without realising it, that Joan Alcover was a *noucentista* who defended *Modernisme*; and *La Muntanya d'ametistes* is a *modernista* book: no poet of *Noucentisme*, Guerau de Liost is the writer in whose works one can best find a Gothic element that compares with the architecture of Puig i Cadafalch.

There is, however, another path of poetic expression, which is not usually considered, or only fleetingly, in the definition of the literature, and especially the poetry, of the Catalan *noucentista* period: that which in other languages was called 'pure poetry' and which, because of its origin in Mallarmé, by way of Valéry, incurred the wrath of the Russian formalist Victor Sklovski, who admitted that he was tired of the metaphysical perusals

297. Celebration of the fiftieth anniversary of the reintroduction of the *Jocs Florals*, 1908. The decorations in the Palau de Belles Arts were designed by Puig i Cadafalch.

298. Josep Carner. *Verger de les galanies*, 1911; cover by Torné Esquius.

of the Symbolists. It is the line marked out by López Picó and taken to a noted fulfilment and assurance by Carles Riba. Riba's *Elegies de Bierville* (1942), as I have said elsewhere, are poems written in capital letters; on the other hand, Carner's poetry tends towards small letters. This is not the only difference between these two modes of poetic expression. López Picó also notices and gathers together in his poetry the motives of intimate, domestic, daily, routine, trivial life. Poetry always presupposes an act of transcendency; however, Carner and López Picó transcend reality in different ways: the former, universalising the anecdotal to make it stand out sufficiently from the chaos of reality and place it in a suitable place where it will be clearly defined, heightened with traits of tenderness or irony; the other, assuming it in his intellectual thoughts, finding a significance and a value in the world of abstract considerations. Taking these suggestions as a starting point, we can find the precise correct reason for the difference between Carner's *Nabí* (1941) and the *Elegies de Bierville*, two poems on religious themes, hatched in the crucible of war and exile.

However, I am digressing and must conclude. Two types of poetry are to be found in the period of Catalan *Noucentisme*: that of Carner and that of López Picó; the former early, the other later (*Intermezzo galant* and *Turment-Froment* date from 1910); thus, perhaps, we should not be surprised that the *modernista* beginnings of the first are not to be found in the second. The *Modernisme* we find in the first collections by Carner – *Llibre dels poetes* (1904), the two collections of sonnets (1905 and 1907) and *Els Fruits saborosos* – cannot be considered belated, given the *modernista* tone of *La Muntanya d'ametistes* (1908) and other collections by Guerau de Liost such as *Somnis* (Dreams) (1913). And I must also stress that I have only considered, in such a brief note, a few poets, in that they have seemed significant. However, I believe that the emulators of the Horatianism of Costa de Llobera, all poets of the height of the *noucentista* period, provide utterly *modernista* imitations, beginning with Gabriel Alomar, who, for all his political, social and moral ideas, far removed from those of the illustrious Mallorcan canon, had lessons by correspondence on the treatment of classical metres in Catalan. *Modernisme* and *Noucentisme*, then, as regards poetic expression, mingled over a long period, in the same way that the colours of the rainbow mingle in wider or narrower strips, but are very different when they can be separated. To define clearly who followed *Modernisme* and who *Noucentisme* in poetry, we must bear in mind these warnings and, above all, look more closely at the work of art itself rather than concentrating on the historical moment in time when it was composed.

299. Eugeni d'Ors. *Oració de l'Institut*, 1914; cover by Monegal (no. 293). Biblioteca de Catalunya, Barcelona.

300. Josep Maria López Picó. *Poemes del port*, 1911; cover by Aragay (no. 288). Biblioteca de Catalunya, Barcelona.

301. Guerau de Liost. *La Muntanya d'ametistes*, 1908; cover by Monegal (no. 286). Biblioteca de Catalunya, Barcelona.

302. Josep Maria Millàs-Raurell. *Trente poemes*, 1919; title-page illustration by Ricart (no. 290). Biblioteca de Catalunya, Barcelona.

303. Miquel Utrillo. *Teatro Lírico, c.* 1900 (no. 257).
Poster, 122 × 71 cm. Collection Utrillo,
Biblioteca Popular Santiago Rusiñol, Sitges.

Theatrical life in Barcelona, 1888–1939

Guillem-Jordi Graells

This half-century, probably the most fruitful and hectic in so many areas of Catalan cultural history, was equally so in the theatrical world, both in the formal theatre and in other types of performance. The beginning of the period coincides with the consolidation of the *Renaixença*, while each succeeding decade saw a renewed effort to adapt to international movements, while witnessing the rise of rich new forms, many of them indigenous. All of this was violently interrupted in 1939 (not in 1936, which was in many ways a beginning rather than an end).

The last great success for one of the 'founders' of modern Catalan theatre was *Batalla de reines* (Battle of Queens, 1887) by Frederic Soler (1839–95), known as 'Serafí Pitarra', and the last decade of the nineteenth century saw the arrival of a new generation, headed by Àngel Guimerà (1845–1924). He had started by writing historical tragedies in late romantic verse, but he now began to develop a more personal contribution, the realistic rural drama, and his works include *Maria Rosa* (1894), *Terra baixa* (Marta of the Lowlands, 1897) and *La Filla del mar* (The Daughter of the Sea, 1900). These years were also marked by a new realism in production, scenery and acting – of which the actor-director Antoni Tutau (1838–98) was a leading exponent – giving new opportunities for innovation to the coming generation of playwrights.

This was the period which saw the rise of *Modernisme*: the 1893 *Festa modernista* in Sitges began with the first Catalan performance of *L'Intruse* by Maeterlinck (see p.265), while the same year saw the first productions of Ibsen's plays under Tutau's direction – *An Enemy of the People* in Castilian and *A Doll's House* in Catalan. The following year *L'Escurçó* (The Viper) had its première, a first success for Ignasi Iglésias (1871–1928), whose plays were to be concerned with the problems of the urban working classes. Also characteristic of the *modernista* period were the works of Rusiñol and Apel.les Mestres, which bridge the gap between symbolism and the comedy of manners, and those of Adrià Gual (1872–1943), a versatile man of the theatre and an important innovator.

For twenty years *modernista* theatre rose, flourished and declined, incorporating a wide variety of theatrical trends, but united in a common concern. New theatres, including the Teatre Íntim, the Vetllades Avenir, the Espectacles i Audicions Graner and the Teatre Líric Català, gradually took over from the older, more traditional houses, and writers worked in a whole range of genres – realist dramas, one-act farces, plays influenced by symbolism, decadent drama or social naturalism –

304. Casas. *Portrait of Ignasi Iglésias*, *c.*1899 (no. 30). Charcoal, wash, touches of pastel and greenish powder on paper, 60 × 27 cm. Museu d'Art Modern, Barcelona.

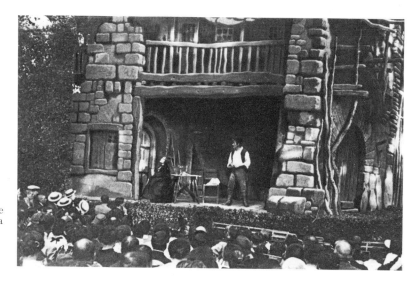

305. Outdoor performance by the Teatre de la Natura of Angel Guimerà's *Terra Baixa* at Sabadell, 1915. The sets were designed by Salvador Alarma.

just as their models were extremely varied, including Ibsen, Hauptmann, Maeterlinck, Wagner, Carlyle, Schopenhauer, Antoine, Lugné-Poë and D'Annunzio.

Parallel with the traditional dramatic genres, other forms of entertainment experienced a notable revival, particularly mime (the Italo-Catalan family Onofri and Enric Adams), puppet shows and marionettes (Juli Pi), non-academic dance (Tórtola València and Àurea de Sarrà) and impersonation (the Italian Leopoldo Fregoli). These are also the first years of Catalan cinema, pioneered especially by Fructuós Gelabert (1874–1955), who filmed both *Terra baixa* (1907) and *Maria Rosa* (1908).

Between 1913 and 1917 the Catalan theatre went through a crisis unprecedented since 1866. The protagonists of *Noucentisme*, who had now taken over from the *modernistes*, were not interested in the theatre, and it was an impresario, Josep Canals, who encouraged new authors and established the two leading genres after 1917: bourgeois high comedy and sentimental costume drama. Several *modernista* authors tried to adapt to the new tastes, of whom Josep Pin i Soler (1842–1927) was the most successful, but again the scene was held by new authors, and in particular by Josep Maria de Sagarra (1894–1961) and Carles Soldevila (1892–1967).

Sagarra, more influenced by the aesthetics of *Modernisme*, soon found a formula which brought him great success, that of sentimental comedies set in the two previous centuries, idealised, clothed in rich verse and written with a sure theatrical sense. Until 1936 these plays totally dominated the Barcelona stage, and Sagarra scored success after success. Soldevila wrote bourgeois high comedies, set in the urban environment, whose mild criticism only served to disguise the vices and excesses of the ruling classes. Many other authors followed in their footsteps, both *Modernistes* trying to adapt to the new conditions and those, particularly in the thirties, who tried to give bourgeois comedy a more modern tone. Others remained faithful to *Modernisme*, with mixed fortunes, while another group concentrated its efforts on

the popular genres performed in the theatres on the Paral.lel, including comedies of all kinds, revues, *zarzuelas*, music-hall, popular cinema and all the frivolities that flourished in the years before the economic and political crisis of the late twenties.

There were attempts at a more serious approach to the theatre, particularly by Adrià Gual, with his foundation of the Escola Catalana d'Art Dramàtic and repeated revivals of the Teatre Íntim, by Lluís Masriera, the jeweller, whose Companyia Belluguet (later the Teatre Studium) flourished from 1921 to 1936, and through such organisations as the Teatre dels Poetes, Cresta d'Argent, the Associació de Teatre Selecte and, following a quite different line, the Associació Obrera de Teatre. At the same time, amateur theatre grew tremendously, and there were some three thousand different groups, many of which joined together in the Federació Catalana de Societats de Teatre Amateur.

During the Republic and following the Statute of Autonomy there were a number of initiatives to form public theatrical institutions, for the theatre until then had relied entirely upon private support. But only after the Revolution of 19 July 1936 were the Teatre Nacional de Catalunya (in the Gran Teatre del Liceu) and the Teatre Català de la Comèdia created, while the other theatres were made collective. A restructuring was begun under the control of the anarchist union, the CNT, but internal disagreements among the Republicans and the unfavourable development of the war brought their efforts to a halt. In January 1939 all the theatres in Barcelona were closed.

After the entrance of Franco's troops the theatres were reopened with a new policy and with new basic conditions: the Catalan language was prohibited in any type of public art and so, consequently, was Catalan theatre. After 1946 it slowly began to recover its vitality, despite constant battles with censorship, and still today it has not ceased to share in the struggle for the normalisation of the collective life of the Catalan people.

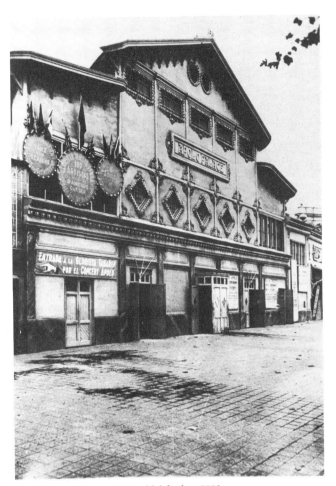

306. Teatre Apolo on the Paral.lel, built in 1903; photographed *c*.1920–30 (cf. fig. 71).

307. Cine Salón Doré on Rambla de Catalunya, built in 1910 by Alarma and Miquel Moragas (now demolished); photographed in 1918.

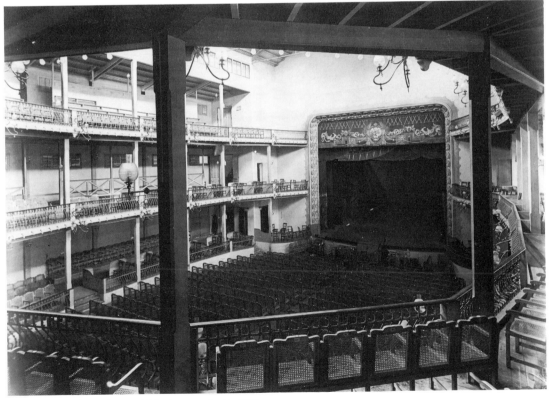

308. Teatre Onofri on the Paral.lel; photographed in 1905.

LA JUTGESA

CANÇO POPULAR CATALANA

309. Gual. *La Jutgesa, c.*1913 (no.112).
Song cover (no.95 from third series of *Cançoner Popular,*
published by *L'Avenç*), 23.8 × 17 cm. Private collection.

Musical life in Barcelona, 1888–1936

Roger Aliér

In the years leading up to the 1888 exhibition, opera retained its long-standing primacy in the musical life of Barcelona. For more than a hundred years Barcelona had enjoyed an operatic tradition second to none in Spain and among the best in Europe, while its orchestral concerts, despite some attempts after the 1840s at organising a Philharmonic Society, could scarcely be compared with those of many other European cities of its size. Its musical situation was thus similar to that of many important Italian cities at the end of the nineteenth century.

During the 1880s the main innovation was the gradual acceptance of Wagner's 'easier' operas by the patrons of the two main opera houses, the Gran Teatre del Liceu (built in 1847) and the old Teatre de la Santa Creu (opened in 1603; with regular operas since 1750), now rebaptised as the Teatre Principal. Other houses, like the Teatre Líric, the Teatre del Bosc, the Tívoli and the Novetats, also occasionally staged opera performances, especially during the summer. Prior to 1888 there had been performances of *Lohengrin*, *The Flying Dutchman* and *Tannhäuser*, and 1888 was the year in which the Catalan tenor Francesc Viñas had made his début. His contribution to Wagner's recognition in Barcelona was to be extremely important, beginning with his performance of *Lohengrin* on the eve of the opening of the Universal Exhibition.

Catalan musicology was also beginning to exist in the climate of the *Renaixença* of Catalan culture. Baltasar Saldoni was at work on the last and most important edition of his remarkable, if unreliable, *Diccionario de músicos españoles* (1890), but the principal figure was Felip Pedrell, whose many activities ranged from the rediscovery and publication of ancient Spanish music to the advocacy of musical nationalism. Pedrell's position in this field was in 1888 already becoming obsolete, for he had a traditional point of view of Spanish music as a whole, without quite grasping that Catalan music had sources of its own; these could not be reconciled with his own music, which tried to amalgamate a remote Moorish past and the new Wagnerian credo in a series of operas which were never completely successful.

However, Pedrell was indeed the father of Catalan musicology, and he also had a strong influence on the principal Catalan composers of these years, Isaac Albèniz (1860–1909) and Enric Granados (1867–1916), both prominent pianists. In their own works they tended to follow Pedrell's pan-hispanic brand of nationalism, but both of them had a certain feeling for Catalan folk music

310. Casas. *Portrait of the composer and musicologist Felip Pedrell, c.1906.*
Charcoal on paper, 28 × 24 cm. Museu d'Art Modern, Barcelona.

311. Casas. *Atelier Casas & Utrillo*, 1898 (no. 46).
Invitation to an evening of flamenco dancing
presented in honour of Vincent d'Indy.
28.5 × 24 cm. Museu d'Art Modern, Barcelona.

312. Cover of *Revista Musical Catalana*
Any VI, no. 61, Jan. 1909.

as well as a remarkably broad outlook, which led them to establish firm links with the main musical circles of France and other countries.

Albèniz had a curious musical relationship with an eccentric English patron, Mr F. Money-Coutts, a banker, who encouraged him to write several operas. These have not really held the stage at any time, and Albèniz's main contribution to Catalan music was his wonderful series of piano pieces (among them the celebrated *Suite Ibèria*), in which, besides Pedrell's influence, traces of Catalan folk-lore can sometimes be found, together with a certain feeling for the latest developments in French piano music (Debussy, Fauré etc.).

Granados developed a rather more eclectic style, and he was also a prominent teacher: as founder of his Acadèmia Granados, he exerted a lasting influence on the next generation of Catalan pianists, partly through his disciple, Frank Marshall, who took over his teaching acitivity after Granados's premature death while returning from the première of his opera *Goyescas* at the Metropolitan Opera House in New York.

Even though Albèniz and Granados were quite active during the years of *Modernisme*, their music is only partially related to the movement, whose Catalan nationalism differed markedly from Pedrell's position, and even from their own. In a certain way, Pedrell's attitude was like that of the *Renaixença* generation, which had become conservative and which had never really been nationalist, in spite of having fostered the revival of Catalan as a literary language. The *modernistes*, headed by Enric Morera (1865–1942), had freed themselves of the Italian influence that had been so strong in Catalonia in the previous decades, only to fall under the spell of Wagnerism. Morera's group had excellent relationships with the Franco-Belgian school of composers known as *la bande à Franck*, including Vincent d'Indy (who attended the *Festes modernistes* at Sitges), Ernest Chausson, Eugène Ysaÿe, Matthieu Crickboom (who became the regular conductor of the Barcelona Societat Filharmònica concerts) and several lesser composers and players. Morera had known them all as teachers or fellow-pupils at the Brussels Conservatoire, which in those days was considered to be the best in Europe and was regarded in Catalonia as the place where every musician ought to study (although the Paris Conservatoire also drew many Catalan students).

Enric Morera, besides gaining a solid reputation as the founder (1895) of a workers' choir, the Societat Coral Catalunya Nova, was its efficient leader for a decade. This choir and the Orfeó Català, founded in 1891 by Lluís Millet and Amadeu Vives – which was rightly regarded as more conservative and bourgeois – were the *modernista* versions of the Cors de Clavé, a series of choral groups founded during the *Renaixença*. The renewed interest in choral singing was kindled by a visit of the Russian Chapel to Barcelona.

Morera became the main representative of *modernista* music through his participation in the *Festes modernistes* organised by the painter and playwright Santiago Rusiñol at Sitges. At the fourth of these events, on 14 February 1897, Morera's opera *La Fada* received its first performance in front of an audience which included several members of the Franco-Belgian school as well as the main representatives of Catalan cultural life.

Morera then tried to build up a repertory of real Catalan light opera and lost almost all his money in the foundation of a Teatre Líric Català at the Tívoli, where he started a season with other composers in February 1901. It was mainly ignored by the public, who prefered traditional opera or the Spanish *zarzuela*. In spite of this lack of success, Morera persevered, and in later years he reaped a measure of success with a series of works which are of considerable musical interest, though they are now seldom performed.

The new choral societies, in addition to their concerts, assumed an educational role, using methods unknown to the official conservatories, and the Orfeó Català was in due course to develop an extensive programme of musical training for children, as well as building Barcelona's best concert hall, the Palau de la Música Catalana, with a capacity of 2,200, which opened in 1908 – and which was, incidentally, one of the architectural masterpieces of *Modernisme* in Barcelona. The Orfeó also launched the first long-lived (1904–36) and scientific music magazine in Catalan, the *Revista Musical Catalana*. All these achievements by Orfeó Català were modelled on similar activities by Vincent d'Indy's Schola Cantorum in Paris, with which close ties were kept for several years. In this connection, the Orfeó Català also performed the great masses and oratorios by J.S. Bach, Haydn, Beethoven, etc. for the first time in Barcelona.

Orchestral music was still much less developed, despite the appearance of several concert organisations, among them the Societat Catalana de Concerts, led by Antoni Nicolau, and the Societat Filharmònica de Barcelona, led by Matthieu Crickboom. On the other hand, in 1901 the Associació Wagneriana had been founded at the Els Quatre Gats tavern by a group of ardent Wagnerites. This group, besides organising series of concerts and lectures on Wagnerian and other subjects, left Barcelona a unique legacy in the publication of all Wagner's libretti in Catalan (rhythmically adapted to the German pronunciation and with detailed analysis of the main *leitmotifs*) and even a few scores in Catalan/German versions, as well as libretti of Mozart's main operas. It also published essays on music, etc. The Associació Wagneriana had a tremendous influence in Barcelona, which became a famous Wagnerian city: the Gran Teatre del Liceu gave series of Wagner operas in remarkable versions. By 1910 all the significant Wagner operas had been performed at the Liceu except *Parsifal*, which was solemnly added to

313. Rusiñol. *Morera conducting the 'Catalunya Nova' choir*, 1896. Oil on canvas, 150 × 100 cm. Museu Cau Ferrat, Sitges.

314. Rusiñol. *El Rossinyol*, 1911 (no. 237). Song book (one of Morera's Catalan song arrangements published by *L'Avenç*, original edition 1897–8), 27 × 18.6 cm. Private collection.

the repertory on 31 December 1913, with Viñas in the title-role.

It was at this time, during the early years of *Modernisme*, that Pau Casals (1876–1973) made his début as a cellist, embarking on a brilliant international career, including many appearances in chamber and orchestral concerts in Barcelona throughout this period. He later became an important force in the development of orchestral music in Barcelona, through the foundation, in 1920, of the Orquestra Pau Casals, which continued to bear his name until the end of the Civil War. It was a modern orchestra, with an efficient organisation, which confirmed Barcelona's international standing in the concert field. The Orquestra Pau Casals not only put on a remarkable and extremely active season every year, but also brought to Barcelona some of the foremost composers and conductors of those years. Stravinsky, for example, conducted his own works at the Liceu in 1924 and 1925 with Pau Casal's orchestra (and again in 1928 with the Liceu orchestra).

But Pau Casals was not yet entirely satisfied with the turn he had given to musical events in Barcelona: he felt something must be done to let music reach those layers of society where it could seldom be heard, and in 1926 he founded the Associació Obrera de Concerts, which gave low-priced concerts for the working classes and published a magazine of its own in Catalan.

As in so many other fields, *Noucentisme* saw the establishment of a number of important musical institutions, including the Orquestra Simfònica de Barcelona, founded in 1910 by Joan Lamote de Grignon (1872–1949), and the Associació de Música 'da Camera', which was formed in 1913. This organisation developed several branches and promoted series of concerts, among them several series devoted to chamber music and contemporary works. The Associació was to introduce many international composers to Barcelona as guest conductors or pianists, including Prokofiev, Respighi, Bartók, Pizzetti, Milhaud, De Falla, Webern and many others. In 1925 the association organised two concerts to honour Manuel De Falla (1876–1946), who had established a firm and friendly relationship with several Catalan musicians and was soon to begin work on an opera based on one of the main Catalan epic poems of the *Renaixença*, Jacint Verdaguer's *L'Atlàntida*. The décor was to be designed by the *noucentista* painter J.M. Sert, with whom De Falla carried on a correspondence about the work until the painter's death in 1938, but *L'Atlàntida* was left unfinished when De Falla died. He did, however, complete a work of homage to Pedrell (*Pedrelliana*, 1935), with whom he had studied composition in Barcelona, based on themes from the older composer's opera *La Celestina*.

Barcelona's musical horizons had been broadened by visits during the First World War, in 1917, from Diaghilev's Ballets Russes, with Vaslav Nijinsky, Léonide Massine and Lydia Lopokova among them. Their performances were a huge success and opened the eyes of Barcelona to the world of Russian music, which became a real craze. The Liceu staged operas by Tchaikovsky, Musorgsky, Borodin and Rimsky-Korsakov in the following seasons, and Russian opera and ballet were frequently performed in the twenties and thirties, enhanced by the presence of world-famous singers such as Feodor Chaliapin.

The *noucentista* generation produced a bright, young composer whose work seemed able to combine the traditions of Catalan music with contemporary interests and needs, Jaume Pahissa (1880–1969). His first opera at the Liceu, *Gal.la Placídia* (1913) had sufficient success to enable him to write further operas – *La Morisca* (1919), *Marianela* (1923) and *La Princesa Margarida* (1928), all of which were first performed at the Liceu and enjoyed a few revivals. However, Pahissa went into exile after the Civil War, and none of his operas has been staged in Barcelona or elsewhere since 1937. In addition, Pahissa wrote vocal and choral music, symphonic poems, chamber music etc., much of which found its way into Barcelona's musical life, though it has also virtually disappeared today.

Juli Garreta (1875–1925)was another important composer of these years. Although he was only composing part-time, his works for small orchestra reveal a very interesting personality. He also wrote successful *sardanes*, which are still in the repertory.

The remarkable career of Frederic Mompou (b. 1893) was divided between Barcelona and Paris, where he was influenced by Fauré, Debussy, Albèniz and Granados. After some years as a concert-pianist, he devoted himself to composing, and much of his most important work was produced during the years of *Noucentisme*. At ninety-two, Mompou is today the greatest living Catalan composer.

But the foremost composer of the *noucentista* generation, whose influence extended beyond the years of the Civil War, was Eduard Toldrà (1895–1962). In the early stages of *Noucentisme* Toldrà founded the Quartet Renaixement, a classical-minded chamber group. He wrote chamber music for this quartet, as well as many song cycles, which are still very popular, and an opera, *El Giravolt de maig* (1928), based on a libretto by Josep Carner. This opera, which is generally considered to be the best Catalan opera and a quintessence of *Noucentisme*, has a distinct parallel in Wolf-Ferrari's operas in eighteenth-century mood, although it is by no means certain that Toldrà, who had travelled little, ever had the opportunity of knowing Wolf-Ferrari's operas, of which only *Il Segreto di Susanna* had been performed in Barcelona by 1928.

With the activities of Pau Casals and of the Associació de Música 'da Camera', musical life was now thriving in Barcelona, and there were many other organisations which made their own contributions to musical events, such as the Associació d'Amics de la Música and the

Orfeó Gracienc, while there were concert seasons and a newly formed ballet season at the Liceu – where further spectacular performances by Russian ballet companies fulfilled the eager expectations of the public.

However, from 1923 to 1930 Catalan cultural life was menaced by the Dictatorship; the Orfeó Gracienc was closed for a long time, and there was strict censorship of musical activities and magazines. But the main features of Barcelona's musical life went on undisturbed, and the 1929 exhibition was celebrated musically with special performances at the Liceu and with a remarkable festival of Spanish and Latin American music. This was the occasion for the début of a seven-year-old pianist – Alicia de Larrocha – whose international career would start after the Civil War.

In the 1930s the effects of the economic crisis were felt at the Liceu, which in 1932 was unable to open until a committee had been formed by the patron Felip Bertran i Güell, which made possible a normal opera season with the support of the new autonomous government of the Generalitat of Catalonia.

During these years the Associació de Música 'da Camera' founded a new section, called Audicions Íntimes, which ventured into the hitherto little heard contemporary repertory. Bartók's quartets, the latest works of the Viennese School and recent music by Roberto Gerhard, Manuel Blancafort, Eduard Toldrà, Joan Gilbert-Gamins, Frederic Mompou, etc., shared the programmes of the Audicions Íntimes with early and romantic chamber music, and special concerts were devoted to Ildebrando Pizzetti, Darius Milhaud and Federico García Lorca, who sang and recited to the delight of the audience.

These years were the most important ones in Roberto Gerhard's Catalan career. Born in Valls in 1896 of Swiss parents, he was one of Felip Pedrell's last pupils. After Pedrell's death in 1922, Gerhard travelled to Vienna, where he became one of Schönberg's disciples. His enthusiasm for Schönberg's reforms made him an apostle of twelve-tone music, and after his return to Barcelona he devoted himself to expanding this new musical system. In spite of some opposition (there was scandal and almost a riot after one of his concerts in 1929) he managed to make his works gradually acceptable to the more progressive musical circles, and his *Six popular Catalan songs* (1932) and other early works in the new style were appreciatively received.

Roberto Gerhard became, besides, a music critic of great prestige through his articles in *Mirador*, a new, cosmopolitan magazine which was one of the most remarkable cultural publications of the pre-war years. He was also in charge of the music section of the Biblioteca de Catalunya, the main Catalan library, where he undertook musicological research of the greatest importance, which led to his publication of *La Merope*, an opera (1743) by the Catalan composer Domènec Terradelles

315. Ferran Callicó. *Portrait of Roberto Gerhard, c.*1933. Pencil on paper, dimensions unknown.

(known as Domenico Terradellas or Terradeglias), and of P. Antoni Soler's *Six Quintets* for harpsichord and strings. His work was cut short by the Civil War, which forced him to emigrate to England, where he died in Cambridge in 1970.

Other musicologists of note in these years were Father Higini Anglès (b. 1888), who was to become Gerhard's unofficial successor at the Biblioteca de Catalunya after the Civil War, and Josep Subirà (1882–1980), who, although living in Madrid, was an important contributor to the *Revista Musical Catalana* and published several of his works in Barcelona, including his edition of *Celos aún del aire matan*, the first extant Spanish opera (music by Juan de Hidalgo and text by Calderón de la Barca), published by the Biblioteca de Catalunya in 1933. Subirà's most important work was his thesis on the *tonadilla escénica*, a kind of *intermezzo* that flourished on the Spanish stage from around 1750 to 1825.

In April 1936 Barcelona was host to the Fourteenth Festival of the International Society for Contemporary Music, which introduced many international composers to Catalan audiences. They included Benjamin Britten, whose *Suite for violin and piano* (op. 6) was performed in the second chamber music concert on 21 April, at which the composer himself played the piano part; Ernst Křenek, who gave the first performance of excerpts from his opera *Karl V*, which was planned to be performed at the Liceu the following season, though this was prevented by the war; Lennox Berkeley, Frank Martin and Egon Wellesz; and, most important, Alban Berg, whose *Violin Concerto* received its world première on 19 April, with Louis Krasner as soloist, conducted by Anton von Webern. In addition, the orchestral interludes from Berg's *Wozzeck* were included in the same concert. The concerts also included many new works by Catalan composers, such as Roberto Gerhard (his ballet *Ariel*), Ricard Lamote de Grignon, Manuel Blancafort etc., and by the main international composers of these years and of the recent past, including some Spanish composers (De Falla, Òscar Esplà, Ernesto Halffter, Joaquín Turina etc.). At the same time, as one of the main events of the Congress of the International Musicological Society, a performance of Vicent Martín i Soler's opera *Una Cosa rara* (1786) was staged by the opera group of the Junior Football Club.

When the concert and opera season ended in June 1936 ambitious plans were being made for the following season, but the next month saw the outbreak of the Civil War, and Catalan musical life had to face a series of unexpected vicissitudes. But the seeds that had been planted in those almost fifty years between 1888 and 1936 were not without effect; even in the darkest years of Franco's dictatorship, Barcelona remembered its musicological achievements, the body of musical knowledge gathered in the thirty-odd years of the *Revista Musical Catalana*, the long-standing Wagnerian tradition, the wonderful legacy of the Orfeó Català and the Palau de la Música Catalana, and with a new generation of composers headed by Xavier Montsalvatge, Josep Valls, Joaquim Homs and others who had started their careers on the eve of the Civil War, Catalan musical tradition not only survived but was able to look with confidence into the future.

316. Apa (Elias). *Alicia de Larrocha, enfant prodige*, 1932. Drawing in *Mirador*, 2 June 1932.

317. Casas. *Portrait of Pau Casals, c.*1906 (no. 39).
Charcoal on paper, 62.6 × 46 cm. Museu d'Art Modern, Barcelona.

318. Mercadé. *Zeppelin over Barcelona*, 1930 (no.138).
Oil on canvas, 110 × 143 cm. Collection J.B. Cendrós, Barcelona.

Not at all modern and very twentieth-century

Maria Aurèlia Capmany

'No gens modern i molt segle XX'; with these few words Ortega i Gasset sums up the attitude of the new generations at the turn of the century. This was not so much an aesthetic point of view as a response, a deliberate choice on the part of the writers and artists of the time to turn their backs on and leave the preceding century behind. There is an added touch of irony in the very need to emphasise the decision not to be 'modern' and the way in which the statement is made. It expresses a mistrust of the concept of modernity and, above all, a conscious choice not to feel part of a continuum. We might even say that underlying this new way of thinking, which was, in part, shaped by the war in Europe, was the feeling that *Modernisme* represented nothing more than the remains of certain romantic ideas. Ortega i Gasset's words reflect more of a desire to disconnect, to break ties with the past, than to find new points of reference.

If we wish to look at *Noucentisme* within Catalan culture – both the creative role it played and its role as censor of other aesthetic points of view – it is important to understand from the outset that *Noucentisme* was not solely a Catalan cultural phenomenon. No culture, in fact, can ever be so insulated as to exist entirely independent of its environment. Quite a different issue, however, is the way in which each culture adjusts to the historical challenges with which it is confronted. We can easily find parallels with what was happening in Catalonia and recognise the attitude so well described by Ortega in other centres of European culture. After the First World War, there was a sense of conviction which was expressed in a complete rejection of nineteenth-century tradition. One thing was certain, and that was that the factors which influenced intellectual activity in the nineteenth century were no longer applicable, particularly in what might be considered a transitional period, when vestiges of the old values were still to be found. From our distant perspective we can imagine how the new attitudes might have been influenced by the old aesthetic values, but it is clear that the conscious decision to break with the past rendered these useless. The new generations of the twentieth century detested the attitude of their predecessors; they rejected their naïve optimism, their conviction that the world must necessarily be progressing towards an ideal future; they treated the idea of progress with contempt; they mistrusted the future; and faith in mankind ceased to be upheld as a sacred value. The political consequences of this intellectual pessimism are not difficult to identify: if man cannot be educated, if the voice of the people is neither just nor valid, if the people are incapable of leading themselves towards greater happiness, then man has every right to find refuge in order and perfection and free himself from the shackles of passion and uncertainty.

But what, in fact, does Ortega mean when he says 'very twentieth-century'? He is not defining a particular aesthetic or political stance but describing a response to concrete circumstances and a trust in man's capacity to reason, to find order in the chaos of life, to select those elements which will make his life ordered and pleasant. In other words, the twentieth-century man will have lower expectations, expectations which are more accessible, more closely tied to everyday existence, and he will abandon absolute ideals and ecstatic experiences. And so art, too, must be well thought out, worked and reworked daily in order to achieve a 'work well made', which will also have a universal dimension. Paradoxically, this new attitude turns a deaf ear not only to the voice of the masses, but also to the defence of the rights of the individual.

Within this framework literature tended, as a result, towards becoming an art of 'saying the right thing', of linking old ideas together and, in effect, of avoiding the passion and adventure of life. Once again, Ortega's words express this tendency: 'What do I care about what happens to John or Jane Citizen?' And, once again, the door is shut on the adventuresome spirit that characterised a large part of nineteenth-century literature.

These ideas, which were in evidence in the neighbouring Castilian, Italian and – particularly through the *Nouvelle Revue* group – French cultures as well, profoundly changed the political and cultural panorama in Catalonia. The *noucentistes* were driven by the idea of entering a new era. For them, being 'very twentieth-century' meant more than a simple rejection of *Modernisme*, it meant building a new country – ordered, rational and safe; one without great aspirations to absolute justice; a product of hard, daily work and discipline; in short, a product of professionalism. It meant not believing in genius or inspiration, it meant a thoughtful and careful rebuilding which could free the personality of an entire country from its heritage of indecision and chaos.

Seen from other perspectives, the importance placed by this new generation upon such a specific and concrete task as a formal structuring of the language may seem exaggerated. The heated and impassioned discussions sparked off in 1913 by Pompeu Fabra's rules of written

Catalan may seem, with the distance of time and from the point of view of other cultures, to be irrelevant. They were not, however, for the rules of the language were more a symbol than an end. The acceptance of clearly defined rules represented both an aesthetic and political ideal for the *Noucentistes*. For those who worked closely with Pompeu Fabra, deciding once and for all whether the conjunction 'and' should be written as 'y' or 'i' was not simply a decision about a letter, but rather a statement about entering a new era where every aspect of the culture could be ordered, from the letters of the alphabet to the functioning of the most sophisticated scientific laboratory. The priority placed upon striving for and achieving rigorous scientific standards is representaive of a whole generation.

It is interesting to note that even those writers and artists who felt compelled to rebel, to be avant-garde, tried, nonetheless, to unite their iconoclastic revolt with a reverent respect for simple grammar. They, too, clearly expressed their determination to make a clean break with the immediate past. J.V. Foix once explained that having fully accepted the need to 'clean up' the Catalan language that had been handed down over the years, he realised that it was necessary to go back past the centuries of decadence, during which the language had been corrupted, and to join his own literary work directly on to that of Ausiàs March and Jordi de Sant Jordi. His two weapons were a remote language lost across the centuries and a new grammar which would settle things once and for all.

It is tempting to consider to what extent this new attitude stunted and changed the creative capacity of a whole generation. Perhaps in the spirit that drove them towards order and science there remained a trace of that age-old drive towards absolute creativity. In one given moment these same individuals tried, in a sense, to re-channel their lost heritage. I find one particular anecdote very revealing as to the nostalgia felt by this new generation and indeed of their awareness of the limits they had placed upon themselves. In 1929 Joan Puig i Ferrater won the 'Joan Creixell' prize for his novel *El Cercle màgic*, and Carles Soldevila's *Fanny* was runner-up for the same prize. A reporter for the newspaper *La Veu de Catalunya* questioned the judges, many of whom – Carles Riba, Pompeu Fabra and López Picó, among others – were *noucentistes*. This reporter must have believed that with their open affiliation to *Noucentisme* they should have voted for Soldevila rather than Puig i Ferrater. And he was obviously not mistaken, for the judges found it necessary to justify their choice. Carles Riba, avoiding the issue, said that Carles Soldevila's novel was more along the lines of a '*nouvelle*' (novella) while Puig i Ferrater's work, not as well written, was clearly a '*roman*' (novel), choosing words for which there was no proper equivalent in Catalan, since both words would have been translated as '*novel.la*', although '*nouvelle*' might also be translated '*novel.leta*'.

We could draw the conclusion that these twentieth-century artists felt a certain dichotomy within themselves; they were one thing when they theorised and another when they read. Perhaps it is, as Ortega i Gasset said, more a question of taste. We must not forget that good taste is a true *noucentista* weapon and, therefore, difficult to define. Alexandre Cirici i Pellicer, the great expert on *Modernisme* once said that it is easy to recognise a *noucentista* in Barcelona: he always turns the other way when passing the Sagrada Família, for he cannot bear the sight of it.

319. J.V. Foix. *Krtu*, 1932; illustration (8 Dec. 1931) by Miró. Private collection.

Chronology

Julia Engelhardt, Michael Raeburn and Pilar Sada

1875

In January Alfonso XII returns from exile, following the pronouncement of the Restoration of the monarchy (Dec. 1874). The next year sees the end of the chaos caused by the Third Carlist War (the Carlists supported the claim to the throne of Don Carlos of Bourbon), which had continued throughout the period that began with the abdication of Queen Isabella in 1868 and included the short-lived First Republic (Feb. 1873–Jan. 1874). A new constitution is adopted, which remains in force until 1923.

The Escola Superior d'Arquitectura is founded in Barcelona; Lluís Domènech i Montaner (1850–1923), later its director, starts teaching there in 1877.

1877

The Catalan epic poem *L'Atlàntida* by the poet-priest Jacint Verdaguer (1843–1902) is published and wins first prize at the *Jocs Florals*. This annual poetry competition, of medieval origin, had been revived in 1859 as part of the renascence of Catalan as a language of high culture; and *L'Atlàntida* inspires the novelist Narcís Oller (1845–1930) to start writing in Catalan rather than Castilian. Verdaguer's second epic, *Canigó*, about the legendary origins of Catalonia in a Pyrenean monastery, is published in 1885.

Juan Bautista Parés (1847–1926) opens Barcelona's first major commercial art gallery, which grows in importance after moving to larger premises in 1884.

1878

Domènech i Montaner publishes 'In search of a national architecture' in *La Renaixença*; under the editorship of the poet Àngel Guimerà (1845–1924), this fortnightly magazine (first published 1871) devoted to literature, science and art, becomes a focus for moderate Catalanist opinion.

Antoni Gaudí (1852–1926) starts his architectural career.

1879

Valentí Almirall (1841–1904) founds the first Catalan daily newspaper, *El Diari Català*, to promote the ideas of both Catalanism and Federal Republicanism among the working classes. The paper

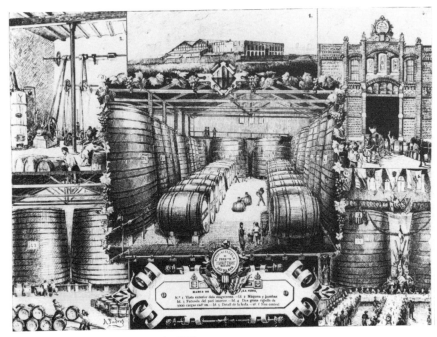

Views of the Maristany winery in the 1880s.

starts publication on 4 May, the day the *Jocs Florals* are celebrated in Barcelona.

The humorous Republican weekly *L'Esquella de la Torratxa* (first published 1872–4) starts a second series, which continues to 6 January 1939.

Almirall as president of the Jocs Florals, *1886.*

Phylloxera reaches Catalan vineyards. As the disease spreads during the early 1880s, it is an important factor in halting the economic expansion of the previous decade. The boom years (which lasted until around 1885), marked by the intense financial speculation known as *La Febre d'or* (Gold fever), were the result of industrial development, particularly in the iron and textile sectors, and had been fuelled by the appearance of phylloxera in France.

1880

Almirall organises the First Catalanist Congress in Barcelona, to bring together the different currents of Catalan opinion and form a common defence of Catalan civil law, which is under threat of being subsumed under a national civil code. As a result of discussions at the Congress between Almirall's progressive group and the more moderate group of *La Renaixença*, Almirall falls out with his more radical fellow Federalist Francesc Pi i Margall (1824–1901), the former president of the First Republic, and their paper *El Diari Català* closes in June 1881. *La Renaixença* starts publication as a daily from 1 January 1881.

1881

The journal *L'Avenç* and the Liberal Castilian-language newspaper *La Vanguardia* also start publication.

The Anarcho-syndicalist weekly *La Tramontana*, a satirical, anti-clerical and republican magazine written in Catalan, starts publication in Barcelona (16 Feb.). Often banned, it is finally closed down in the wake of anarchist repression in June 1896.

Domènech starts work on the building for the Montaner i Simon publishing house (completed 1885), which combines an iron frame with glass and patterned brickwork.

The painter Ramon Casas (1866–1932) goes to Paris, where he attends classes in Carolus Duran's studio.

1882

The Centre Català, a pre-political association, is founded (June), and Almirall is elected its secretary.

The artistic café *Le Chat Noir* is opened in Montmartre; Miquel Utrillo (1862–1934), who was living in Paris as an engineering student, joins the circle of young painters and poets who frequent the café.

Wagner's *Lohengrin* has its first performance at the Liceu opera house (17 May) and is enthusiastically received. The Wagnerian movement becomes increasingly influential in Barcelona, and Wagner's other operas enter the repertory: *Der fliegende Holländer* (1885), *Tannhäuser* (1887), *Die Walküre* (1899), *Götterdämmerung* (1900).

1883

The Congress of the Federal Republican Party in Catalonia approves a draft constitution for a Catalan state within a federal Spain.

The Second Catalanist Congress, organised by Almirall and the Centre Català, agrees that no individuals or groups should participate in political parties controlled from Madrid.

Gaudí starts work on his first major commissions, the Casa Vicens in Barcelona, the villa 'El Capricho' at Comillas (Santander) – both completed 1885 – and the stables and estate buildings at Pedralbes (Barcelona) for Count Eusebi Güell (1846–1918), who is to become his lifelong patron. These are completed 1887, while the Palau Güell in the city is built 1886–9. In November 1883 Gaudí is appointed architect of the Sagrada Família church.

1884

The Federació de Treballadors de la Regió Espanyola (FTRE), founded in 1881 and directed from Barcelona, is effectively dissolved at their Extraordinary Congress because of increasing disputes between its two main currents: the Anarcho-syndicalists, who support trade-unionism and renounce violence, and the Anarcho-communists, who are anti-union and in favour of small activist groups to fight bourgeois society by violent means. The disintegration of the FTRE leaves the workers' movement with no organisation to lead it.

The painter Santiago Rusiñol (1861–1931) exhibits at the Barcelona headquarters of the Excursionists' Society, of which he is a member. Reflecting the revival of interest in Catalan culture and conservation, two 'excursionist' societies had been founded – in 1876 and 1878. These encouraged amateur (and later professional) geologists, botanists, geographers, historians, archaeologists, philologists, folklorists etc. to travel through Catalonia and gather material for private study, which was often published subsequently in magazine articles or lectures.

1885

In January, as the first political act organised by the Centre Català, Catalan industrialists join with the intellectuals of *La Renaixença* and other Catalanist interests to present Alfonso XII with the *Memorial de greuges* (Memorandum of grievances), which demands the recognition of Catalonia's special position within Spain and the protection of her economy, civil rights, language and culture.

Rusiñol and the sculptor Enric Clarasó (1857–1941) take a studio together in Barcelona, which becomes a meeting-place for young Catalan artists and critics, including Casas and Raimon Casellas (1855–1910). The studio, the original 'Cau Ferrat' (Den of iron), also houses Rusiñol's growing collection of antique ironwork brought back from excursions into rural Catalonia.

With the death in November of Alfonso XII the Regency of Queen Maria Cristina begins.

1886

Almirall publishes *Lo Catalanisme*, which sets out his liberal and democratic regionalist ideas and proposes a federal solution. A Catholic conservative reaction to this appears in a series of articles in *El Diario de Barcelona* by Joan Mañé i Flaquer (1823–1901), which are published in book form the following year under the title *El Regionalismo*.

1887

Guimerà, Domènech, Güell and other conservatives – who approve of the project for the 1888 Universal Exhibition in Barcelona, whereas Almirall and others in the Centre Català oppose it – split off from the Centre to form the Lliga de Catalunya; *La Renaixença* becomes their principal organ. The Centre Escolar Catalanista, founded the previous year as a student organisation affiliated to the Centre Català and comprising young intellectuals like Enric Prat de la Riba (1870–1917), associates itself with the Lliga.

Masthead of the Organo Oficial *of the 1888 Universal Exhibition.*

1888

On 20 May the Exposició Universal de Barcelona is inaugurated in the presence of the Queen Regent Maria Cristina and the infant King Alfonso XIII. Initially a private project to help Catalan industry at a time of crisis and due to open in 1887, its direction was taken over in February 1887 by the energetic Liberal mayor of Barcelona, Francesc Rius i Taulet. Construction work on the site of the old citadel is directed by Elies Rogent, and two of the major buildings are designed by Domènech – the Café Restaurant and the International Hotel, the latter being erected in only 83 days. The exhibition (which closes 9 Dec.) features 12,000 stands from 25 countries.

The exhibition is inaugurated with a gala performance at the Liceu of Wagner's *Lohengrin* (19 May). Other musical events include a series of recitals by the young Catalan composer and pianist Isaac Albéniz (1860–1909) and the unveiling of a monument to Anselm Clavé (1824–74), founder of the workers' choral movement, which has been growing in strength since the mid-century.

During the *Jocs Florals*, the date of which has been postponed to 27 May to coincide with the exhibition, the Lliga de Catalunya presents the Queen Regent, who has been elected Queen of the competition, with a memorandum demanding autonomy for Catalonia while assuring her of the party's pro-monarchist stance.

Balloon over Barcelona at the time of the 1888 Universal Exhibition.

Almirall organises rival *Jocs Florals* on their traditional date, the first Sunday in May, but he becomes increasingly isolated and embittered.

The exhibition attracts a large number of immigrant workers, and the Spanish Socialist Party (PSOE) holds its first Congress in Barcelona; at the same time the Unió General de Treballadors (UGT) is founded.

Emblem of the Associació Protectora de l'Ensenyança Catalana.

1889

The Associació Protectora de l'Ensenyança Catalana is founded as a private organisation to fund a wide range of educational activities (including grants to schools for the teaching of Catalan language, history, geography etc.). In 1898 the association founds the first Catalan-language school, the Escola Sant Jordi.

The literary magazine *L'Avenç*, founded by Jaume Massó i Torrents (1863–1943), starts its second term of publication (the first, 1881–4, had been devoted primarily to works by the Catalan naturalist writers). With Casellas as editor-in-chief until 1892, the

new *L'Avenç* becomes a forum for emerging *modernista* writing, introduces European avant-garde thinkers (through translations of works by Baudelaire, Ibsen, Maeterlinck, Leconte de Lisle, Nietzsche etc.) and is in the forefront of the campaign for the renewal of literary Catalan; Rusiñol and the young chemical engineer and amateur linguist Pompeu Fabra (1868–1948) are among the contributors. With Joaquim Casas (1858–1943), the painter's brother, Massó i Torrents also starts a publishing and printing house of the same name (1891), which, through its use of modern typesetting and printing machinery, makes a great contribution to typographical innovation and to the gradual normalisation of Catalan orthography and grammar.

Utrillo, Rusiñol, Clarasó and Casas go to Paris, the first two as cultural correspondents of *La Vanguardia*.

1890

Universal male suffrage is reintroduced in Spain.

The first 1 May demonstration takes place in Barcelona to commemorate the Chicago martyrs as well as to demand an eight-hour day and other social reforms. As the strike, which attracts a large part of the workers' movement, continues the following day, a state of emergency is declared in the city. Coinciding with the strike, a bomb explodes at the headquarters of the Foment de Treball, the leading industrialists' organisation.

Domènech and Antoni Maria Gallissà (1861–1903) set up an arts and crafts workshop in the 'Castle of the Three Dragons', the former Café-Restaurant of the Universal Exhibition; this brings together masters of the principal crafts from all over Catalonia with the aim of promoting a revival of decorative arts in association with architecture. The workshop continues until Gallissà's death in 1903.

Rusiñol, Casas and Clarasó have their first joint show at the Sala Parés (Oct.),

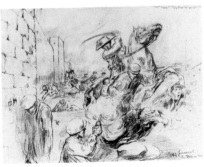

Scene during the General Strike of May 1890; drawing by P. Febrés Yll.

Painting by Rusiñol with a menu for a banquet to celebrate one of his joint exhibitions with Casas and Clarasó and satirising the rush for gold medals at the official exhibitions inaugurated in 1891.

and the emergence of the *modernista* school of painting and sculpture is confirmed by further joint shows there in 1891 and 1893 (the latter described as 'pictorial, anarchist, anti-historical').

Oller's realist novel about the boom years, *La Febre d'or*, starts publication (the final part is completed in 1893).

Rusiñol, Casas, Utrillo and the engraver Ramon Canudas (d.1892) share an apartment above the Moulin de la Galette in Montmartre. A series of letters written by Rusiñol and illustrated by Casas are published in *La Vanguardia* as 'Desde el molino' (from Jan. 1891); they describe Paris bohemian and cabaret life and introduce the work of artists living there to the Barcelona public. Utrillo, who also writes features for *La Vanguardia* about the Paris art world, runs a shadow-puppet theatre in Montmartre and introduces the composer Erik Satie to Rusiñol and Casas.

The two excursionist societies merge to form the Centre Excursionista de Catalunya. Publishing its own magazine as well as guide books, the society (of which the leading *modernista* artists and architects are members) makes an

Excursionists on the top of Costabona in the Pyrenees, with Canigó, symbol of the national mythology of Catalonia, in the distance.

important contribution to linguistic and cultural developments, to the study and conservation of historical monuments and to the foundation of libraries and museums. The Centre Excursionista also promotes sports such as mountaineering – enabling members to discover their cultural heritage in the Pyrenees – as well as a new means of transport: the bicycle.

The composer Enric Granados (1867–1916), who returned from two years study in Paris the previous year, gives his first piano recital in Barcelona and embarks on a career as a pianist.

1891
A campaign for the defence of Catalan civil law, which has been conducted by the Lliga de Catalunya and the Centre Escolar Catalanista since 1889, results in the formation of the Unió Catalanista, a confederation of Catalanists of various political orientations. The leadership includes Domènech (Lliga), Prat de la Riba (Centre Escolar) and the young architect Josep Puig i Cadafalch (1867–1957).

The Foment del Treball succeeds in having protectionist legislation reintroduced to support the flagging industrial economy.

Casellas's review in *L'Avenç* of the second Casas–Rusiñol–Clarasó exhibition becomes the credo of the *modernista* school of artists.

A first volume of poems and translations by Joan Maragall (1860–1911) is published as a wedding gift to the poet. Maragall, a journalist and art critic on the Castilian-language paper *Diario de Barcelona* since 1890, is to become a major exponent of *modernista* poetry as well as an important commentator on the new movement's artistic activities.

The first official fine arts exhibition (with nearly 1,400 works) is held at the Palau de Belles Arts (built for the 1888 exhibition). Further exhibitions are held in 1892 (industrial arts), 1894, 1896 and 1898, in which all the principal *modernista* artists show their work alongside more traditional Catalan art and contributions by foreign artists. Several important works are acquired at these exhibitions for the municipal collections.

Faianç Català is created, which comprises the workshop in Sabadell of the potter Marià Burguès (1851–1935) and a shop in Barcelona.

The fourteen-year-old cellist Pau Casals (1876–1973) gives his first public recital in Barcelona (23 Feb.). Albéniz

subsequently discovers him playing in a Barcelona café and introduces him to the Comte de Morphy, who enables him to study abroad. Casals's world career as a cellist begins with a solo performance in a Lamoureux concert in Paris in 1898. Albéniz himself, after years of concert touring, settles in Paris in 1893.

Inspired by a competition of foreign choirs, the collector of Catalan folk songs Lluís Millet (1867–1941), with the composer Amadeu Vives (1871–1932), founds the choral society Orfeó Català, which gives its first concert the following year (31 July). It develops into a centre of musical culture, with a library and musicological magazine (*Revista Musical Catalana*, 1904–36); initially a male choir, it admits women from 1896 and provides musical training for children.

1892
The Assembly of the Unió Catalanista approves the *Bases de Manresa* (29 March), which propose the separation and regionalisation of legislative, executive and judicial powers within the Spanish state, while leaving the central legislative power in the hands of a king or head of state and an assembly of regional representatives.

The first *Festa modernista* takes place in the coastal village of Sitges (Aug.–Sept.). The main feature is an exhibition of painting, including works by Casas and Rusiñol. Rusiñol has an old house in Sitges remodelled as the new 'Cau Ferrat'.

1893
The main event of the second *Festa modernista* in Sitges (10–11 Sept.) is the first Catalan performance of *L'Intruse*, Maeterlinck's controversial play about death, in Fabra's translation; Rusiñol designs the sets, directs and plays the role of the father, with Casellas in the leading role of the grandfather. The composer Enric Morera (1865–1942) also conducts a concert at the festival of works by himself and César Franck; the same

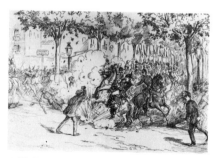

Pallàs's attempt on the life of General Martínez Campos, 24 September 1893.

year his symphonic poem *L'Introducció a l'Atlàntida* is first performed in Barcelona by the newly founded Societat Catalana de Concerts.

On 24 September the anarchist Pauli Pallàs makes an attempt on the life of General Martínez Campos, Captain General of Catalonia; Pallàs makes no attempt to escape and is executed eleven days later. In reprisal for this, Santiago Salvador drops two bombs (7 Nov.) from the balcony into the auditorium of the Liceu opera house, killing twenty people and wounding many others.

'Orsini' bomb (no. 261), thrown in the Liceu 7 November 1893, which failed to explode.

The Cercle Artístic de Sant Lluc is formed by a traditionalist Catholic group of artists and architects – including Gaudí – who oppose the 'decadent' and anti-clerical *modernistes*. They hold their first exhibition this same year at the Sala Parés. The group's religious adviser is Josep Torras i Bages (1846–1916), later appointed bishop of Vich, who is also responsible for religious affairs in the Unió Catalanista and whose *La Tradició Catalana*, published the previous year, is a key work of Catalan political regionalism.

A group of art students dedicated to painting outdoors – Isidre Nonell (1873–1911), Ricard Canals (1876–1931), Juli Vallmitjana (1873–1937), Adrià Gual (1872–1944) and Joaquim Mir (1873–1940) – form the Colla del Safrà.

The journal *L'Avenç*, which over the past year has become increasingly polemical in the anarchist cause, ceases publication; but the publishing house and bookshop continue to be one of the principal centres for *modernista* writers and artists.

1894
Casas, who had attended the trial and execution of Pallàs and also the execution by garrotting of the murderer Peinador the previous year, depicts the latter event in his *Garrote vil*, which causes a sensation when first exhibited at the Sala Parés in March.

Alexandre de Riquer (1856–1920), who worked as a decorative artist with Domènech at the Universal Exhibition and is a founder member of the Cercle Artístic de Sant Lluc, visits London (May–June), where he gains first-hand knowledge of the Pre-Raphaelite and Arts and Crafts movements; through him, these become a strong influence on many aspects of *modernista* art in Barcelona.

Joaquim Vayreda (1843–94) dies. The founder of the 'School of Olot', which revived landscape painting in Catalonia, Vayreda was also an active Catalanist, playing a leading role in the foundation of the cultural Centre Catalanista in 1887 and presiding over the Assembly of the Unió Catalanista in Manresa in March 1892.

The third *Festa modernista* is celebrated (6 Nov.) at the Cau Ferrat in Sitges with the formal installation of two paintings by El Greco and an important literary event, at which prizes are awarded to Maragall, Casellas and Puig i Cadafalch. Rusiñol's house becomes the prime centre of the *modernista* movement's artistic and social activity, whilst his brother Albert Rusiñol (1862–1928), an industrialist and Catalanist politician, also uses the building for entertaining. Following the exhibition of Rusiñol's *La Morfina* (The Morphine Addict) at the Sala Parés, the concept of *fin-de-siècle* decadence becomes associated with *modernista* painting.

Members of the rebel government in Cuba, 1898; President Masó is seated centre.

1895
The slump in sugar prices leads to an insurrection in the Spanish colony of Cuba, and this develops into a guerrilla war. Barcelona industrialists side with the Spanish colonialists, while the Federal Republicans and the Catalanist press take an anti-colonialist stance. Prat de la Riba condemns the attitudes of the Catalan bourgeoisie in *La Renaixença*, to which he and Puig i Cadafalch become regular contributors and which develops close links with the Unió Catalanista. In 1897 the paper is suspended for several months because of its anti-colonialist stance on the Cuban war.

Guimerà, newly elected president of the Ateneu Barcelonès – an influential body that promotes cultural activities – gives his inaugural speech (30 Nov.) in Catalan, an unprecedented use of the language in this context. Guimerà, who early in his career had become a successful poet, is at the height of his powers as a dramatist during this decade, when his output includes the realist rural dramas *Maria Rosa* (1894) and *Terra Baixa* (1897).

Morera founds the workers' choral society Catalunya Nova, which gives its first public performance the following March with works by Mendelssohn and Clavé. From the 1890s on, Morera's transcriptions of Catalan folk songs are published by *L'Avenç*, who also issue 100 songs collected by Aureli Capmany (1868–1954) in the *Cançoner Popular* (1901–13).

The French composer Vincent d'Indy gives a concert cycle with the Societat Catalana de Concerts, thus strengthening the connections between the *modernistes* and the Franco-Belgian school of musicians.

In September Pablo Picasso (1881–1973) moves to Barcelona, where he attends the art school for two years.

1896
A bomb explodes in the Carrer de Canvis Nous in Barcelona as the Corpus Christi procession from the church of Santa Maria del Mar is passing (7 June); twelve people are killed and many wounded. Although anarchist responsibility is not proved, the incident is followed by a wave of repression: closure of workers' centres, the arrest and detention of some four hundred anarchist militants and sympathisers and the suspension of several publications. The famous Montjuïc trial of the anarchists begins in

Allegory of Barcelona, from the cover of L'Esquella de la Torratxa, 12 June 1896: 'War . . . crisis . . . bombs! . . . I can stand no more!'

Journalists conducting an interview at the Montjuïc trials; drawing by Casas, 1896.

December. As confessions are extracted under torture, eight (later reduced to five) are condemned to death, and sixty are deported to penal colonies in Africa. An international campaign for a retrial is supported by the progressive republican paper *El Progreso*, which is edited in Madrid by Alejandro Lerroux (1864–1949).

The Sala Parés holds two shows of work by foreign poster artists; the local competition responds with a show the following year at the Palau de Belles Arts.

Nonell has a first one-man show of drawings at the Saló de *La Vanguardia*.

The painter Joaquim Sunyer (1874–1956) leaves for Paris, returning permanently to Barcelona only at the outbreak of the First World War.

A year after the first cinematographic performance in Paris, the Lumière cinema opens in Barcelona in December. The following year Fructuós Gelabert (1874–1955), founder of Catalan cinema and one of the great pioneers of the medium, builds his first cine-camera.

1897
The surburban townships around Barcelona are incorporated in the Municipality, with the exception of Horta (incorporated 1904) and Sarrià (1921). This reflects the growth of the city, which has followed the pattern set by the Cerdà plan of 1859 known as the *Eixample* (extension).

The fourth *Festa modernista* in Sitges (14 Feb.) is devoted to Catalan music and features Morera's *La Fada*, a Wagnerian fairy opera, set in the Pyrenees, with libretto by Massó i Torrents.

Puig i Cadafalch completes his first architectural commission, the Casa Martí. On the ground floor the artistic tavern 'Els Quatre Gats' is opened (11 June), taking its name from its four founders, the cabaretier Pere Romeu (1862–1908), Casas, Rusiñol and Utrillo, and from its Parisian model, 'Le Chat Noir' in Montmartre. A group exhibition of works by Casas, Rusiñol and Utrillo and by the younger generation of *modernista* painters – Nonell, Canals, Mir and Ramon Pichot (1871–1925) among others – opens at the tavern in July. On 29 December a shadow-puppet theatre, founded and directed by Utrillo, gives its first performance there.

Nonell and Canals go to Paris, returning to Barcelona the following year; in 1899 Nonell again spends most of the year in Paris.

In reprisal for the Montjuïc sentences, an Italian anarchist assassinates the leader of the Spanish Conservative government, Canovas de Castillo (8 Aug.).

1898
Following the mysterious explosion of the US warship 'Maine' in the port of Havana in Cuba (15 Feb.) and the subsequent declaration of war by the USA (which sides with the guerrillas), the Spanish fleet suffers total defeat outside Santiago de Cuba (3 July). With the surrender of Cuba, Puerto Rico and the Philippines (where an insurrection had begun in 1896) to the USA by the Treaty of Paris (10 Dec.) Spain ceases to be a colonial power, and the Catalan industrial bourgeoisie is heavily hit by the loss of the colonial markets.

The literary and artistic journal *Catalònia* is published (25 Feb.–31 Nov.), as a successor to *L'Avenç*, and includes Maragall, Casellas, Rusiñol and Riquer among its contributors.

Casas exhibits his *Corpus Christi procession leaving the church of Santa Maria del Mar*, painted in response to the 1896 bomb.

Els Quatre Gats becomes the locale for frequently changing one-man exhibitions (from Nov.) as well as poetry readings and informal concerts, in which Granados, Albéniz, Morera and Joaquim Nin (1879–1949), a Cuban composer who is studying in Barcelona, take part. It also features a new children's puppet theatre, *Putxinel.lis*.

The Teatre Íntim, a new company founded by the poet and artist Gual, opens with his own play *Silenci*; Rusiñol's *L'Alegria que passa* with music by Morera has its first performance on 16 Jan. 1899.

1899
Pressure for decentralisation grows in the wake of the colonial disaster, and the new Conservative government in Madrid, formed in March, includes two Catalan ministers and appoints a leading Catalanist, Dr Bartolomeu Robert (1842–1902), as mayor of Barcelona. However, the Catalan middle classes, backed by leaders of industry, protest against the imposition of a profit tax to help state finances recover from the loss of the colonies; they refuse to pay the tax and close their businesses (the *Tancament de Caixes*). The Catalan ministers and Robert support the protest, but are forced to resign, and the Madrid

Return of the wounded from the Cuban war, 1898.

Shops in Barcelona closed in protest at the dismissal of Dr Robert, 20 October 1899.

government declares a state of war. The affair goes no further, but it strengthens Catalanist opinion and leads to the foundation of the Unió Regionalista, as some of the leading industrialists break away from the Conservative Party. At the same time, a group dedicated to political action on the lines of the *Bases de Manresa* [see 1892], led by Prat de la Riba, breaks away from the Unió Catalanista to form the Centre Nacional Català. To support their cause, Prat de la Riba transforms the literary and political weekly *La Veu de Catalunya* (founded 1891) into a daily paper (first published 1 Jan.); contributors include Domènech, Puig i Cadafalch, Casellas and the politician Francesc Cambó (1876–1947). The Unió Catalanista subsists, and some of its members later contribute to the foundation of Catalan nationalist parties on the left. Its paper, *La Renaixença*, goes into decline and closes in 1905.

Propaganda stamp for the Unió Catalanista, designed by Gual.

A poster exhibition is held in January at Els Quatre Gats. Picasso, who had left Barcelona in 1897, returns in February and begins to frequent the tavern. The magazine *Quatre Gats* is published (15 issues, Feb.–May) by the leading circle at the tavern, to be replaced by *Pèl & Ploma* (100 issues, June 1899–Dec. 1903); Casas is art editor, Utrillo literary editor, and contributors include Maragall and the young writer Eugeni d'Ors (1881–1954).

The fifth and last *Festa modernista* (5 July) comprises a piano recital by Nin and the performance of two works by Ignasi Iglésias (1871–1928) and Rusiñol's *L'Alegria que passa*.

In October an exhibition of Casas drawings and paintings is mounted by *Pèl & Ploma* at the Sala Parés; the portrait drawings feature Barcelona notables in arts and letters, many of them the artist's friends.

Rusiñol's play *El Jardí abandonat* has its première at the Teatre Principal, and in November he shows paintings at Bing's 'Art Nouveau' in Paris under the title *Jardins d'Espanya*, the subject in painting to which he devotes himself for the rest of his life. A show with the same title is held at the Sala Parés the following year.

The Barcelona Football Club (constituted 29 Nov.) plays its first match (8 Dec.), against an English team.

1900
In a climate of economic crisis, as a consequence of the loss to Catalan industry of its colonial markets, the first social legislation is passed since 1873 – the time of the First Republic: a workers' compensation act and laws limiting women's working days to eleven hours and prohibiting work for children under fourteen. A lock-out over the lowering of salaries leads to a general strike in the Catalan textile industry.

The Barcelona population has grown from 336,000 in 1877 to 544,000.

The weekly *Joventut* starts publication (15 Feb.–31 Dec. 1906). Affiliated with the Unió Catalanista, the journal becomes a major forum for presentation and reviews of *modernista* literature, criticism, theatre, music and art, while also discussing current aesthetic trends in Europe.

Inspired by the English concept of the Garden City, Count Güell commissions Gaudí to plan the Parc Güell in what is at this time an outlying district of the city. Lodges and a large covered market area with communal open space above are completed by 1914, but as it fails to attract buyers for the sixty sites available, the project is turned into a public park after Güell's death in 1918.

Gual's cover for Joventut, *no.151, January 1903 (no.307).*

The rebuilding of the Casa Amatller by Puig i Cadafalch is one of the most important of the series of villas and town houses built by the architect between 1895 and 1911.

Picasso's first one-man show in Barcelona is mounted at Els Quatre Gats (Feb.), featuring portrait drawings of his bohemian friends who frequent the tavern and three paintings. Picasso shares a studio with Carles Casagemas (1880–1901), who also exhibits at the tavern (March), and they visit Paris together on the occasion of the Universal Exhibition; Picasso returns to Barcelona on 20 December.

1901
Casagemas commits suicide in Paris (17 Feb.). After short stays in Madrid and Barcelona, Picasso, who is deeply affected by his friend's death, moves to Paris. At the initiative of Casas and Utrillo some of his pastels are exhibited at the Sala Parés (opening 15 May), jointly with a group of drawings by Casas. Utrillo writes the first extensive article on Picasso, in *Pèl & Ploma* (no.77, June).

The painter Xavier Nogués (1873–1941) pays his first visit to Paris.

In order to fight the national elections on 19 May, the Centre Nacional Català joins the Unió Regionalista to form the Lliga Regionalista, the first Catalanist political party. At the election, with an attendance of 20% (abstentionism traditionally being very high due to the corrupt voting system), the Lliga wins four seats out of seven for Barcelona, their successful candidates being the

'four presidents', who include Domènech, Albert Rusiñol and Dr Robert. Two of the other seats are won by the Republicans Lerroux and Pi i Margall, while the last goes to a Liberal. The election thus marks, on a small scale, the end of the two-party system under the Restoration. The Lliga repeats its success in the municipal elections which are held in October.

A tram drivers' strike turns into a general strike in Barcelona (1–7 May). Francesc Ferrer i Guàrdia (1854–1909) founds the periodical *La Huelga General* (15 Nov.–1903), which advocates general strike as a prelude to social revolution. Ferrer i Guàrdia also founds the Escola Moderna (Sept.), the first 'rationalist' school for working-class children in Catalonia: laicism, coeducation, involvement of parents, active teaching are the main underlying ideas. By 1905, forty-seven schools in Barcelona base their teaching on the same principles.

The Associació Wagneriana is founded at Els Quatre Gats; it undertakes an energetic programme of publication and promotion.

Granados founds his own music academy, which has an important role in the training of pianists.

Casellas's *modernista* novel *Els Sots foréstecs* is published.

1902

Alfonso XIII comes of age and assumes the throne.

A metalworkers' strike, demanding the reduction of the working day from twelve to nine hours, widens into a general strike (17–24 Feb.). In clashes between the Civil Guard and strikers, ten die, many are injured and more than 350 arrests are made. The socialist union UGT opposes the strike. The authorities declare a state of emergency and close workers' centres.

Following the creation of a Ministry of Public Instruction in 1900 as a concession to Catalanists' demands, the Minister of Education in Madrid prohibits by decree (23 Nov.) the use of any language other than Castilian in schools or for religious education.

A large exhibition of historic art of Catalonia is shown at the Palau de Belles Arts, and Puig i Cadafalch, newly elected as a city councillor representing the Lliga, initiates the formation of a new body in charge of museums. A Museum of Fine Arts is installed in the Palau de Belles Arts, while a new Museum of Reproductions and Archaeology is installed in the Royal Pavilion in the Ciutadella Park; this becomes an important centre of

art-historical and archaeological research.

Building work starts on the Hospital de Sant Pau (completed 1912), designed by Domènech as a group of separate buildings with open space between them.

1903

The first Catalan University Congress (31 Jan.–2 Feb.), with 1,280 delegates, is convened to discuss the organisation of an autonomous university for Catalonia. Several courses to be taught in the Catalan language are proposed, but as the Barcelona University administration refuses to include them in the curriculum, these 'Estudis Universitaris Catalans' are held at the Ateneu Barcelonès (starting 16 Oct.) and, later, at the Biblioteca de Catalunya and other institutions.

Caricature of the coronation of Lerroux as 'Alexander I, Emperor of the Paralelo', 14 November 1903.

In the national elections (26 April) Lerroux and the Republican party win five of the Barcelona seats, with the other two going to the Lliga Regionalista.

Urged by Puig i Cadafalch, the City Council organises a competition for an alternative city plan to replace Cerdà's plan of 1859, which has been the basis for the expansion of the city up to this point but is criticised for its 'democracy' and 'holy equality'. The competition is won in 1905 by the French architect Léon Jaussely, who, while allocating special zones reserved for production and for leisure (parks etc.), reintroduces a hierarchical division of the city in social terms. A modified version of his plan is put into effect in 1917.

In July Els Quatre Gats closes, and the premises are taken over by the Cercle Artístic de Sant Lluc for use as an exhibition gallery and headquarters of the society.

The sculptor Pau Gargallo (1881–1934), one of the Els Quatre Gats group, makes his first visit to Paris, where he later lived for several years (1912–14, 1923–34).

The Foment de les Arts Decoratives (FAD) is founded as a society for the

promotion of decorative arts; it organises its first exhibition the following year.

Casas leaves Barcelona to spend a year in Madrid, where he is commissioned to paint a portrait of the King.

1904

Cambó reads an address from the Lliga to the King on the occasion of his visit to Barcelona (6 April), thus breaking a boycott against the monarchist state, previously agreed upon by the party. As a result, a group of liberal nationalists, including Domènech and Jaume Carner (1867–1934), leave the Lliga. They found the weekly magazine *El Poble Català*, whose contributors include Fabra, Maragall and Ors.

Picasso moves to Paris in the autumn.

1905

While the Unió Republicana again wins five seats to the Lliga Regionalista's two in the national elections, the Lliga gains a majority over the Republicans in the municipal elections.

The Lliga politician and lawyer Lluís Duran Ventosa (1870–1954) publishes *Regionalisme i federalisme*, a key text in which he contrasts the Federalism of Pi i Margall with Catalan Regionalist policies.

Puig i Cadafalch's apartment building, the Casa Terrades ('Casa de les Punxes') is completed; medieval in inspiration, it features rich iron and tile decoration, including an image of St George (Sant Jordi) with the inscription 'Holy patron of Catalonia, return our liberty to us'.

On 23 April (Sant Jordi's day) the foundation stone is laid for the Orfeó Català's Palau de la Música Catalana, designed by Domènech. His collaborators include the sculptors Gargallo, Eusebi Arnau (1863–1933) and Miquel Blay (1866–1936), the mosaicist Lluís Bru (1868–1952) and many other artists and craftsmen.

Funeral of the flower-sellers killed by a bomb on the Rambla de les Flors, 3 September 1905.

Work begins on Gaudí's remodelling of the Casa Batlló (completed 1907), next to Puig's Casa Amatller; here the design of the roof and richly tiled façade symbolises the St George legend. Josep Maria Jujol (1879–1949) plays a major role in the decorative design of both exterior and interior.

Domènech is the architect of a third building, the Casa Lleó Morera, in this same block, which becomes known as the '*Manzana' de la Discòrdia* in reference to the different styles shown in the façades of the three buildings.

Gual directs the first of a series of performances and concerts (1905–7) at the Teatre Principal promoted by the painter Lluís Graner (1863–1929), who collaborates with the leading artists, poets, playwrights and musicians of the day, and is also involved in experiments with cinema.

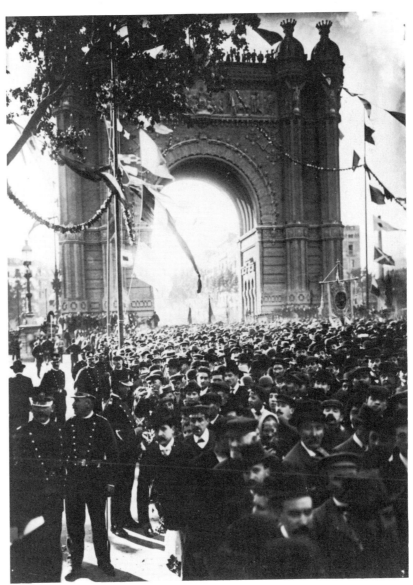

The cartoon in Cu-cut! (23 November 1905), referring to the Lliga's election victory, which provoked the raid on its offices:

'On the Barcelona front
– What's being celebrated here, why are there so many people?
– The Victory banquet.
– Victory? Oh, then they must be civilians.'

A caricature in *Cu-Cut!*, a satirical magazine which supports the Lliga, is the pretext for an attack (25 Nov.) by Barcelona garrison officers on the offices of both *Cu-Cut!* and *La Veu de Catalunya*, the party's principal organ. The military view the rise of Catalanism, combined with anti-militarist tendencies in Catalonia, as the beginning of separatism and thus a threat to the Spanish state and its army. No action is taken against the officers involved.

1906

As a result of the *Cu-Cut!* raid, a bill is presented to parliament in Madrid giving military courts the right to try spoken

and written offences against the unity of the nation and the honour of its armed forces and their symbols: any manifestation of Catalanism could thus be termed an offence. This 'law of jurisdictions' is passed without debate, but it is opposed by a newly formed alliance of the principal Catalan political parties, Solidaritat Catalana, formed at the suggestion of the leader of Spanish Republicanism, Nicolás Salmerón (1830–1908); its executive committee includes Cambó for the Lliga and Jaume Carner for the newly formed Centre Nacionalista Republicà. Lerroux's party is the main absentee from the alliance. Solidaritat's opposition to the law is celebrated by a demonstration in Barcelona (20 May) attended by over 200,000 supporters.

Prat de la Riba publishes his most influential book, *La Nacionalitat Catalana* (May), proposing a Catalan state within a Spanish or Iberian federation.

A series of terrorist acts which began in 1904 culminates in an attempt on the King's life carried out by an anarchist associated with Ferrer i Guàrdia's school (31 May); the attempt fails, both the anarchist and Ferrer are arrested, and the school is closed.

Joan Rull, paid by the police as a 'mole', starts planting bombs in Barcelona which he then 'discovers'; he is detained in June 1907 and later executed; his detention leads Solidaritat Catalana to demand a police force that is controlled by the local authorities.

Els Fruits saborosos, a collection of poems by Josep Carner (1884–1970), is

Demonstration in support of Solidaritat Catalana near the Arc de Triomf, 20 May 1906.

published (Feb.). Carner is to become one of the leading literary figures of *Noucentisme*.

El Poble Català is turned into a daily to express the views of the new Centre Nacionalista Republicà, in opposition to the Lliga's *La Veu de Catalunya*. Ors, who fails to be appointed editor of the new paper, joins *La Veu de Catalunya*, where he starts writing his daily 'Glosari' column on the front page under the pen-name 'Xènius'; these 'glosses' become the principal theoretical basis for the emerging *noucentista* movement.

The First Congress of the Catalan Language, held in Barcelona (13–17 Oct.) is attended by more than 3,000 people; among the speakers are Fabra, Maragall and Prat de la Riba, and the delegates include Joan Alcover (1854–1926) and Miquel Costa i Llobera (1854–1922), the two leading Mallorcan poets, whose works are to become models for the *noucentistes*.

Souvenir postcard from the First Congress of the Catalan Language, October 1906. It depicts a miracle of resurrection with the words 'Arise and speak'.

Francesc Galí (1880–1965) founds a private art school based on humanistic principles. His pupils will include Josep Aragay (1889–1973), the silversmith Jaume Mercadé (1887–1967), Enric Cristòfor Ricart (1893–1960), Joan Miró (1893–1983) and Josep Llorens Artigas (1892–1980).

Josep Dalmau (1867–1937), a painter and former member of the Els Quatre Gats circle who has spent the past five years in Paris, opens the Galeries Dalmau in Barcelona (moving into new premises in 1910). He provides exhibition space for both foreign artists and the *noucentistes*, and from 1912 he follows a policy of showing avant-garde as well as established artists.

1907

Having won the municipal elections (10 March), Solidaritat Catalana enters the national elections on 21 April as an electoral alliance with a platform (the *Programa de Tivoli*, agreed upon on 14 April) which demands the repeal of the 'law of jurisdictions' but is not specific in its regionalist demands. On 18 April supporters of Lerroux attempt to assassinate Solidaritat's leaders. At the national elections, with a record turn-out of 50% of the electorate in Catalonia, Solidaritat wins 41 out of 44 seats for the region; 21 of these are won by Republicans. The new members of the Cortes include Cambó and Puig i Cadafalch for the Lliga and Francesc Macià (1859–1933), an independent Catalanist and former army lieutenant, who, having been outspokenly critical of the *Cu-Cut!* raid and its consequences, had been forced to resign his commission.

The new City Council puts in hand plans for the *Reforma* of the old city, including the building of a new main thoroughfare, the Via Laietana.

The official exhibitions of fine arts are resumed at the Palau de Belles Arts (they continue there, with some interruptions, until 1923); among the artists in the international section this year are Rodin, Manet, Cassatt, Morisot, Sisley, C. Pissarro, Renoir, Puvis, Aman-Jean, Denis and Bourdelle.

Prat de la Riba is elected president (25 April) of the Diputació Provincial de Barcelona, of which he has been a member since 1905 (he is re-elected president in 1909, 1911, 1913 and 1917). He founds the Institut d'Estudis Catalans, an academic body dedicated to scientific research in the fields of Catalan history, literature, archaeology, art history and law; the initial group of eight academics is enlarged to twenty-one by 1911 to include Catalan-language studies in natural science, physics, chemistry, philosophy and political science.

The Institut joins the Commission for Barcelona Museums to finance excavations at Empúries; three Greek sculptures are found in 1908, proving the existence of a Hellenistic settlement in Catalonia – a fact specially celebrated by Ors.

Puig i Cadafalch, who is a founder member of the Institut and who has been collecting medieval frescos from Pyrenean churches for preservation in the Barcelona museums, embarks on *L'Arquitectura romànica a Catalunya*, which establishes his reputation as an archaeologist and is later published by the Institut.

A union of workers' associations, the Solidaritat Obrera, is founded (3 Aug.) by socialists, trade-unionists, anarchists and Catalanist republicans, i.e. the forces in the workers' movement opposed to Lerroux's policies. The periodical *Solidaridad Obrera*, initially financed by Ferrer i Guàrdia and the most important publication of trade-unionism, starts publication (19 Oct.), and the union holds its first Congress in 1908.

Rusiñol's *L'Auca del Senyor Esteve* is published, satirising the rise to prosperity of a petit bourgeois family; it is turned into a successful play in 1917.

1908

Having been expelled from the Unió Republicana the previous June, Lerroux founds the Partit Republicà Radical (Santander, 6 Jan.) with the aim of broadening the base of his support, although he continues to rely mainly on Barcelona voters.

A proposal by Catalanist Republicans to found the first four municipal schools in Barcelona run on non-denominational lines to help cope with the problem of illiteracy, is approved by the City Council, but in the face of strong opposition from the church, its implementation is vetoed by the mayor.

The Palau de la Música Catalana, Barcelona's first large-scale concert hall, is inaugurated (15 Feb.).

Building work starts on Gaudí's church for the Colònia Güell, an estate to house workers at a textile plant owned by Count Güell; the crypt is completed in 1915.

Casas travels to the USA in the company of the American businessman and art enthusiast Charles Deering, who introduces him to wealthy families, for whom Casas paints portraits, in New York, Chicago and Washington.

La Muntanya d'ametistes, a first volume of poems by Guerau de Lliost (the medievalising pen-name of Jaume Bofill i Mates, 1878–1933), is published with a laudatory introduction by Ors.

The satirical illustrated magazine *Papitu* is founded by Feliu Elias (1878–1948); it comes to represent the Catalanist left's version of *Noucentisme* and includes Nogués, Nonell, Josep Maria Junoy (1887–1955) and Juan Gris among its regular contributors. After Elias leaves the magazine at the end of 1911, it changes editorial character.

1909

To protect mining interests in Morocco, which are under serious threat from local tribesmen, the Spanish government calls up (11–18 July) 40,000 troops (mainly from Barcelona) to fight an undeclared colonial war. The protest in Barcelona against their mobilisation, initially supported by Solidaritat Obrera and by both Radical and Catalanist Republicans, gains strength every day as police and

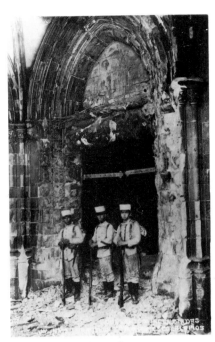

Soldiers outside a burned out convent during Setmana Tràgica, *July 1909.*

demonstrators clash, culminating in a general strike on 26 July. This degenerates into an uncontrolled burning of churches, convents and Catholic schools (over eighty buildings are destroyed in total), the *Setmana Tràgica* (Tragic Week) as it is later called. Lerroux's supporters play a major part in the events but dissociate themselves from them during the subsequent trials. On 1 August, the armed forces suppress the uprising, which leaves 116 dead (three priests, nine of the armed forces and 104 civilians) and over 300 injured. As lay schools, 150 workers' centres, and left-wing papers are closed and more than 2,000 people stand trial, Maragall writes (in an otherwise heavily censored article in *La Veu de Catalunya*) that Barcelona should be a 'city of pardon'. Casellas, who has been editor of that paper since 1899 and was the principal art critic and promoter of *Modernisme*, is deeply disturbed by the events and commits suicide the following year.

The execution of Ferrer i Guàrdia (13 Oct.), unjustly accused of being the instigator and leader of the July events, triggers a European campaign of condemnation and leads to the fall of the Spanish government.

The Faianç Català shop is turned into an exhibition space for paintings and sculpture under the direction of Burguès's nephew Santiago Segura (1878–1918). During this year it mounts important exhibitions of work by Casas (200 portrait drawings) and by Mir.

At the municipal elections (Dec.) Lerroux's anti-Catalanist Partit Republicà Radical wins an absolute majority, while a new republican alliance, the Esquerra Catalana (consisting of the Unió Republicana, the Centre Nacionalista Republicà and Federalists), beats the Lliga Regionalista into third place. Several points of policy had separated the Lliga from its partners in Solidaritat Catalana, so that they fielded separate candidates, and the alliance is now effectively dissolved.

1910
For the national elections (8 May) the parties of the Esquerra Catalana form the Unió Federal Nacionalista Republicana, which wins 13 of the 44 seats for Catalonia, more than either the Partit Republicà Radical (5) or the Lliga Regionalista (8).

The newly formed artists' association Les Arts i els Artistes, whose secretary is Francesc Pujols (1882–1962), mounts its first group exhibition (April–May, at the Faianç Català). It becomes the leading association of *noucentista* artists, holding exhibitions regularly into the 1930s.

Nonell has his first one-man show at the same gallery, but after this first success in Barcelona the leading painter of his generation dies of typhoid at the start of the following year (21 Feb. 1911).

Elias, convicted of offences under the 'law of jurisdictions', flees to Paris, where he stays for two years.

Picasso, who has spent the summers of 1906 and 1909 in Catalonia (in Gòsol and in Horta, with brief visits to his family in Barcelona on each occasion), spends this summer with Pichot in Cadaqués, where they are joined by André Derain and his wife. The coastal villages of both French and Spanish Catalonia have become favoured summer resorts for both the Fauves (from 1905) and the Cubists, and for the next three years Picasso spends his summers at Ceret, staying with the sculptor Manolo Hugué (1872–1945). Manolo moves from Paris to Ceret in 1910 (living there until 1915 and again 1919–27), and his summer visitors in the pre-war years also include Braque, Gris and other Cubists as well as Sunyer.

Work is completed on Gaudí's large luxury apartment building, the Casa Milà (started 1906). Gaudí leaves the project after a dispute with the commissioning client, when the latter decides, in the wake of Setmana Tràgica, not to include religious sculpture on the façade; Jujol, largely responsible for the decorative work, takes over as architect; the interior decoration is in the hands of Aleix Clapés (1850–1920), who has worked with

Gaudí on the Palau Güell, and whose principal painter since 1906 has been Nogués. Gaudí becomes increasingly isolated and now devotes himself almost entirely to work on the Sagrada Família, which by the time of his death in 1926 is still far from completion.

1911
The four Diputacions (Provincial Assemblies) in Catalonia – Barcelona, Girona, Tarragona and Lleida – agree in principle to the suggestion made by the Barcelona Assembly, of which Prat de la Riba is president, to form a new administrative body covering the whole region, the Mancomunitat; a group of area representatives works out a detailed proposal, which is approved by all Assemblies (17 Oct.) and submitted to the national parliament.

Following the decision (1 Nov. 1910) of Solidaritat Obrera to form a nationwide workers' federation, the Confederació Nacional del Treball (CNT) is constituted at a Congress of workers' organisations representing some 30,000 members, mostly from Catalonia. The Congress, which is held in Barcelona (8–10 Sept.), immediately calls for a general strike in protest against the continuing Moroccan war. As a result of the strike, which takes place on 18–21 September and is boycotted by Lerroux's supporters, the CNT is banned.

Puig i Cadafalch's award-winning textile plant, the Fàbrica Casarramona, is completed.

Sunyer has a first one-man show at the Faianç Català (from 10 April), which establishes him as the leading *noucentista* painter, while Enric Casanovas (1882–1948) has his first one-man show of sculpture there (Oct–Nov.).

The *Almanach dels noucentistes* is published by Ors; it includes works by Mir, Canals, Nogués, Picasso, Aragay, Gargallo and the Uruguayan Joaquín Torres García (1874–1949).

1912
Approval of the Mancomunitat proposal by the Madrid parliament is held up because the prime minister, Canalejas, is assassinated (12 Nov.), but it finally receives assent (18 Dec.).

Ors's prose work *La ben plantada* is published, its heroine symbolising the values of the *noucentista* movement's Mediterranean classicism; Unamuno describes it as a 'concise aesthetic-political gospel'.

Dalmau puts on an exhibition of Blue Period drawings by Picasso at his gallery, which he follows immediately with a show of Cubist Art, thus introducing foreign

avant-garde painting to the Barcelona public; the show includes work by Gleizes, Metzinger, Marie Laurencin, Gris, Léger and Duchamp (*Nude descending a staircase II*).

L'Avenç publishes Junoy's *Arte y artistas*, which includes a study of Picasso's Cubism.

Miró, who after overcoming a serious illness in 1911 has decided to become a painter, takes up studies at Galí's art school, where he makes friends with Ricart and Llorens Artigas.

1913

Fabra, whose work as head of the philological section of the Institut d'Estudis Catalans has received the support of the Diputació de Barcelona, publishes the first results of his studies into the codification of the Catalan language, the *Normes ortogràfiques*, which, in 1916, are adopted as official by the Mancomunitat; the work is followed by the publication of Fabra's *Diccionari ortogràfic* in 1917.

The Escola Catalana d'Art Dramàtic is founded by the Mancomunitat with Gual as its director.

Prat de la Riba commissions Torres García to paint patriotic murals in the Sala de Sant Jordi at the Palau de la Generalitat (seat of the Diputació of Barcelona).

Rafael Barradas (1890–1929), another Uruguayan painter, who has had contact with the Futurists in Italy, arrives in Barcelona.

Parsifal receives its first performance in Barcelona at the Liceu on 31 December, in commemoration of the centenary of Wagner's birth.

Enric Prat de la Riba.

1914

In face of the increasing success of the Lliga in municipal elections (1911, 1913), the Catalanist Unió Federal Nacionalista Republicana forms an alliance with Lerroux's Republicans (the *Pacte de Sant Gervasi*) to fight the national elections (8 March), but they win only two of the Barcelona seats to the Lliga's five. The alliance does not survive the defeat, and the Unió Federal disintegrates.

The Mancomunitat is constituted, and Prat de la Riba is elected president (6 April). It sets up councils in Barcelona to run departments of transport, infrastructure and communications, culture and education, agriculture and forestry, public health, social services and finance. Until its abolition under the Dictatorship in 1925, the Mancomunitat proves highly effective in these fields, financing an intensive programme of public investment mainly by floating bonds (1914, 1920).

On the Catalan national holiday (20 May) the Institut d'Estudis Catalans opens the doors of its library to the public as the Biblioteca de Catalunya, the first large secular public library.

The Diputació of Barcelona founds the Escola Superior dels Bells Oficis, which with Galí as its director becomes the leading school of decorative arts and design in Catalonia; classes begin in the academic year 1915–16.

The first municipal school, an open-air school on Montjuïc, is opened.

The art dealer Segura founds *Revista Nova* (published April–Nov. 1914, March–Dec. 1916); Pujols is editor and Elias and Nogués are close collaborators. The review is largely devoted to modern art and has a strong international bias, including Pierre Reverdy and André Lhote among its regular contributors.

With the outbreak of war (Aug.) Spain remains neutral. Between 1914 and 1918 15,000 Catalan volunteers – Catalanists of the left and Republicans – fight in the French army, while the political right is pro-German; the Lliga remains officially neutral. Barcelona, as a major port on the Mediterranean, attracts large numbers of refugees, deserters, spies and visitors.

1915

As a number of Catalan artists return from Paris because of the war, followed by some of the foreign avant garde, Dalmau's gallery becomes increasingly important; his wartime exhibitions start with the work of two expatriates: 'planist' paintings by the Madrid artist Celso Lagar (1891–1966) and sculptures by Gargallo.

Escola del Bosc, the first municipal school, opened on Montjuïc in 1914.

Segura's Faianç Català moves to a new location on Corts Catalanes, from where he starts publication of *Vell i Nou* (13 March 1915–1921). Directed first by himself, then by the art historian and critic Joaquim Folch i Torres (1886–1963) and in its last years by Elias, it becomes one of the principal *noucentista* art journals. The cellar bar of the new gallery, known at first as the Salas del *Vell i Nou*, is decorated with frescos by Nogués, and it stages an inaugural exhibition (opening 30 Aug.) which includes Picasso as well as leading *noucentistes*, devoting two rooms to Sunyer. Its name is soon changed to Galeries Laietanes. The following year Segura also opens an antique shop, La Basílica, in partnership with Dalmau.

Miró leaves Galí's school and takes drawing lessons at the Cercle Artístic de Sant Lluc, which he had joined in 1913. He shares a studio with Ricart.

1916

Following the national elections (9 April) in which the Lliga wins five and Lerroux's Radical Republicans the remaining two seats for Barcelona, Cambó demands autonomy for Catalonia, arguing in the Cortes (7–8 June) that the Catalan problem is not a question of administrative decentralisation but of nationalism; he bases his argument on the Lliga's published election manifesto *Per Catalunya i l'Espanya Gran*, edited by Prat de la Riba, which proposes a Catalan state within an Iberian federation (which is to include Portugal). A motion (8 July) by all Catalanist members of parliament to make Catalan the second official language in Catalonia is rejected in the Cortes.

In the wake of great industrial expansion combined with high inflation due to Spain's neutrality in the war, social unrest is on the increase. The CNT (legally re-constituted the previous October) and the Spanish Socialists'

union UGT form an alliance, and a wave of strikes to protest against the increase in the cost of living culminates in a general strike in the whole of Spain (18 Dec.). As the influence of the CNT is growing steadily, Catholic workers' organisations form the Confederació de Sindicats Catòlics in Barcelona.

The Barcelona City Council initiates a building programme for 37 municipal schools. The designs of Josep Goday (1882–1936), who is placed in charge of the project, reflect a progressive attitude to education, allowing space for the development of social skills alongside conventional instruction for the children. Five schools are opened in 1922–3 and a further eight under the Generalitat (after the fall of the Dictatorship).

A petition signed by many artists is published in *La Veu de Catalunya* (23 March) asking the municipal authorities to mount a major exhibition of French art, since the regular Salons cannot be put on in war-stricken Paris.

The Galeries Dalmau embark on an ambitious programme of exhibitions, featuring many of the foreign artists who have taken refuge from the war in Barcelona: in April they show a number of 'simultaneist' paintings by Robert and Sonia Delaunay, who had arrived in Spain in 1914; an exhibition of paintings by Serge Charchoune and sculptures by Hélène Grunhoff follows in April–May (both also have individual exhibitions there the following year); the joint exhibition of Barradas and Torres García is the first time their work has been shown together; while at the end of the year (29 Nov.–12 Dec.) there is an exhibition of works by Albert Gleizes, who had come to Barcelona with his wife Juliette Roche.

The boxing match between the European champion Jack Johnson and the eccentric poet-boxer Arthur Cravan – often labelled the first Dada event – takes place on 23 April.

Junoy publishes no. '0' of his avant-garde magazine *Troços*, which includes a review of the Gleizes show and introduces *calligrammes* to Barcelona; nos. 1–5 follow (Sept. 1917–April 1918). Clearly pro-French politically, the magazine introduces Catalan as well as foreign avant-garde writers and artists; Josep Vicenç Foix (b.1893) is editor of the last two issues.

1917
In the wake of the February Revolution in Russia, the CNT-UGT alliance decides to adopt a policy of indefinite general strike to bring about fundamental changes in the Spanish system.

Celebration lunch in the Parc Güell for the Lliga's election victory in April 1916.

In June a government crisis is precipitated by the refusal of the Liberal prime minister García Prieto to recognise the *juntas de defensa*, set up the previous year by the lower and middle ranks of the Spanish military as unions to safeguard their professional circumstances, under the direction of a *Junta Suprema* in Barcelona. As they become more political, the *juntas* are dissolved, and the members of the *Junta Suprema* are imprisoned (26 May); however, pressure from the army forces their release a week later and the resignation of the prime minister (9 June). The new Conservative government gives in to the military (the *juntas* remain in existence until November 1922), but lacking the necessary majority in parliament, suspends the sessions of the Cortes (25 June), introducing government by decree and press censorship.

On 5 July, an Assembly of Catalan members of parliament, meeting in Barcelona at the Lliga's initiative and embracing most political parties including the Radical Republicans, demands autonomy for Catalonia and that all members of parliament should be convened immediately. As the Spanish government remains unyielding, another meeting is held on 19 July, which is attended by 69 deputies and senators (46 of them from Catalonia) of all anti-monarchist parties; this demands far-reaching political, military and social reforms, autonomy for Catalonia and the formation of an all-party government to supervise fair parliamentary elections.

There is a strong military presence in Barcelona on the day of the meeting, which is broken up by the Civil Guard.

Prat de la Riba, president of the Mancomunitat, dies on 2 August.

At the beginning of August, a strike demanding the reinstatement of workers sacked during an earlier strike widens into a general strike (13–20 Aug.). A state of emergency is declared in Barcelona, and the military successfully crushes the strike; 32 people are killed, many are injured and some 2,000 arrested (including Lluís Companys, 1883–1940, a leading member of the newly formed Partit Republicà Català).

Puig i Cadafalch is elected president of the Mancomunitat (29 Nov.; he is re-elected with increasing majorities in 1919, 1921 and 1923).

Josep Puig i Cadafalch.

Francis Picabia, who had collaborated with Alfred Stieglitz in New York on the magazine *291* and had arrived in Barcelona with his wife Gabrielle Buffet the previous August, starts publishing *391* using the Galeries Dalmau as an editorial office; four issues appear in Barcelona (25 Jan.–25 March). The 'anti-art' magazine, produced in French for the foreign community, features drawings by Picabia, Laurencin, Olga Sackaroff and Otho Lloyd, with texts by Max Jacob, Apollinaire and Picabia himself, among others.

Ricart has his first one-man show at Dalmau's, and Torres García, whose subject-matter and style have undergone a transformation from *noucentista* classicism to 'evolutionism' – the dynamism of big city life – exhibits on four occasions during the year.

The major exhibition of French art, mounted by the City Council in conjunction with the principal French Salons at the Palau de Belles Arts (23 April–5 July), includes impressionist, symbolist and Fauve works among the 1,458 exhibits and is a sensational success. In May the Paris art dealer Ambroise Vollard gives lectures on Renoir and Picasso at the Ateneu Barcelonès.

Manolo has his first one-man show in Spain at the Galeries Laietanes (Oct.).

Diaghilev's Ballets Russes, who give a first season at the Liceu during the French exhibition, return in November and include *Parade* (a collaboration between Cocteau, Satie, Picasso and Massine) in their repertory (10 Nov.). Picasso arrives with the ballet company

in June and introduces the dancer Olga Khoklova, whom he is to marry, to his family. He returns with Olga to Paris after the *Parade* performance.

Elias publishes a collection of anti-German cartoons (which appeared under his pen-name 'Apa') as *Kameraden*.

The journalist (pen-name 'Gorkiano') and poet Joan Salvat-Papasseit (1894–1924) starts publication of the experimental journal *Un Enemic del Poble* (18 issues, March 1917–May 1919), which he describes as a 'paper of spiritual subversion' and which becomes the first important forum for the Catalan literary and artistic avant garde. He also publishes a single number of *Arc-Voltaic* (Feb. 1918, with cover by Miró), and he develops his concept of 'vibrationism of ideas' in his *Poemes en ondes hertzianes* (published 1919 with illustrations by Torres García).

1918

In the parliamentary election (24 Feb.), the Lliga win 21 of the 44 seats for Catalonia and the new republican alliance (Partit Republicà Català) 12. Following a government crisis over the Lliga's demand to include a passage about constitutional reform in the Crown's speech (28 Feb.), Cambó accepts an appointment as minister in the coalition monarchist government led by the Conservative Antoni Maura, despite the Lliga's continuing policy of non-participation in central government.

A reorganisation of the CNT, agreed at its Regional Congress (June–July) leads to a vast increase in membership (from 73,860 to 345,000 by the end of the year), aided by the recommendation of the National Conference of Anarchists (Dec.) that its members should join the CNT.

Continuing demands for Catalan autonomy, which include a draft Statute of Autonomy presented to parliament by Catalanist members with the support of Spanish Socialists and Republicans, lead to a new government crisis in Madrid. In December the Catalanists stage a walk-out from parliament, and on his return to Barcelona Cambó declares in a memorable speech (16 Dec.): 'Monarchy? Republic? Catalonia!'.

The artists' association Agrupació Courbet is formed at the beginning of the year with the encouragement of Manolo by a group of former pupils of Galí's art school who want to break away from the conservative Cercle Artístic de Sant Lluc: Llorens Artigas, Rafael Sala (1891–1925), Ricart, Miró and Francesc Domingo (1893–1974). Torres García is among those who join

the group the following year.

Llorens Artigas visits Paris with a grant from the Mancomunitat to study Egyptian pottery. He returns there in 1920–1 and in 1923 settles in France, where he remains until the outbreak of the Second World War.

Miró's first one-man exhibition is held at the Galeries Dalmau (16 Feb.– 3 March). Miró (together with Ricart) visits Paris the following year, and when he returns there to live, Dalmau helps arrange his one-man show at the Galerie La Licorne (1921), which establishes his international reputation.

A number of associations of Catalan artists together form the Associació d'Amics de les Arts, which develops strong ties with the Mancomunitat and the City Council. Its first exhibition is held at the Galeries Laietanes (Dec.).

Barradas has a one-man show of 'vibrationist' paintings at the Galeries Laietanes in March, while Dalmau holds the first Salon of Evolutionists the same month.

The Franco-Catalan art review *L'Instant* appears in Paris (8 issues, July 1918–Feb. 1919, of which no. 6 is devoted to Apollinaire); the following year five further issues are published from Barcelona (Aug.–Nov.); no. 5 is devoted to the *noucentista* poetry of the classical scholar Carles Riba (1897–1959). The review is directed in Paris by Joan Pérez Jorba (1878–1928), who is living in exile because of his anarchist connections; the Barcelona editor is Josep Maria Millàs-Raurell (1896–1971). Pérez Jorba's *Divagacions sobre art d'vantguarda* (Aug. 1919) is one of the earliest manifestos of avant-garde art in Spain.

Apollinaire's *Les Mamelles de Tirésias* reputedly receives a private performance in Catalan translation.

1919

The Statute of Autonomy, having by now been worked out in detail, is approved by the Catalan city councils with an overwhelming majority (26 Jan.). As the Catalans return to Parliament, a referendum on the issue is proposed, but the government preempts any vote on the referendum by closing the Cortes (27 Feb.) at a time when a major strike in Barcelona is widening.

A speech by Macià linking the Catalan aspirations for autonomy with the workers' demands coincides with the beginning of this strike (21 Feb.), organised by the CNT at the country's biggest hydro-electric power station, La Canadenca in Barcelona, over the issue of unionisation (opposed by the management). This widens into a general

Cover of Apa's Kameraden, *1917.*

strike (lasting until 7 April), which does achieve the introduction of the eight-hour day (from 1 Oct.) but ends with the disbanding of unions and the arrest of many of their leaders. As the employers found their own organisation, the Federació Patronal de Catalunya (April), the government legalises the CNT on condition that it will participate in a joint arbitration committee. The committee fails to reach agreement on the issues of unionisation and other social reforms, and in the climate of recession caused by the end of the war the employers decide on a lock-out (26 Oct.); this affects 140,000 workers between November and January 1920.

Throughout the summer there is a succession of political murders carried out by gangsters in the employers' pay and by CNT extremists. In October, a new trade union organisation, the Unió

Casals conducting his orchestra in the Palau de la Música Catalana.

Cover of L'Esquella de la Torratxa *celebrating the approval of the Statute of Autonomy, 24 January 1919.*

La Canadenca power station occupied by troops, February 1919.

de Sindicats Lliures, is formed to challenge the CNT (which at this point represents around 25% of the Barcelona workers); the Sindicats Lliures, which approve the use of violence, have the financial and moral support of the employers, and their actions are tolerated by the Barcelona authorities.

In December, a CNT congress in Madrid rejects participation in arbitration committees and adopts the goal of libertarian Communism for the first time.

Ors resigns from his official posts in the Mancomunitat and Institut d'Estudis Catalans over political differences with Puig i Cadafalch; he leaves *La Veu de Catalunya* the following year and continues his career in Madrid.

Primer Llibre d'Estances, Riba's first book of poems is published.

1920
Subjected to prosecution and acts of terrorism, the CNT, still led by the moderate Salvador Seguí (1886–1923), and the socialist union UGT sign a new pact of alliance (Sept.).

The Spanish general Martínez Anido is appointed Civil Governor of Barcelona; he immediately bans unions and has 64 of their leaders deported (from 20 Nov.), including Seguí as well as Companys of the Partit Republicà Català. Francesc Layret (1880–1920), the leader of this party and lawyer for members of the CNT, is shot dead (30 Nov.) as he is about to protest against their deportation. The CNT-UGT pact breaks over a protest strike against the arrests.

Pau Casals founds the Orquestra Pau Casals with an initial group of 84 musicians (some of them non-professionals), financing the project himself as he fails to find sponsors. He conducts the orchestra's first concert at the Palau de la Música Catalana in October.

Carner founds the Amics de la Poesia, which organises poetry readings, in an attempt to re-Catalanise the upper bourgeoisie of Barcelona; Riba becomes a leading promoter of the society.

Torres García leaves Barcelona (May), not to return to Spain until 1932, when he settles in Madrid. Miró takes up residence in Paris, where he stays until 1932, returning to Catalonia during several summers.

Dalmau mounts a major exhibition of 'French avant-garde art' at his gallery (26 Oct.–15 Nov.), including both contemporary French art and a number of works by Spanish artists living in Paris (Miró, Picasso, Gris); the French critic Maurice Raynal writes the catalogue introduction.

Dalmau and Junoy are named among the presidents of the Dada movement in Barcelona in *Bulletin Dada (Dada no.6)* (published by Tristan Tzara from Picabia's apartment in Paris).

1921
As the gang warfare between CNT activists and the Sindicats Lliures intensifies, and a number of anarchists are shot by guards 'while escaping' (in application of a new law), three Catalan

anarchists assassinate the prime minister Eduardo Dato (8 March) as an act of reprisal.

The Sindicats Catòlics join the Unió de Sindicats Lliures.

In the Moroccan war Spanish troops suffer a disastrous defeat at Annual at the hands of the Rif chieftain Abd el-Krim (21 July); 15,000 Spanish soldiers and civilians die in battle and a badly organised retreat. In the wake of the catastrophe a new Spanish government is formed, in which Cambó again holds a ministerial post, but the wide-reaching implications of Annual also lead to this government's fall (7 March 1922).

Josep Carner enters the consular (and later the diplomatic) service. He is absent from Catalonia throughout the twenties and thirties and goes into exile in Mexico in 1939.

Salvat-Papasseit publishes a new periodical, *Proa* (2 issues only), and a further volume of experimental poetry. Another three volumes of poems, more conventional in style, are published before the poet's death of tuberculosis in 1924.

1922
A Catalan National Conference (June), organised at the initiative of the Joventut Nacionalista de la Lliga and of leading intellectuals who are unhappy about Cambó's collaboration with the Madrid government, leads to the formation of two new parties: the first is Acció Catalana, composed of Lliga dissidents and some former members of the now defunct Unió Federal Nacionalista Republicana; the party acquires the republican paper *La Publicitat* and turns it into a daily of intellectual Catalanism which starts publication on 1 November (contributors include Guerau de Lliost, the sculptor Àngel Ferrant, 1891–1961, Foix and Sebastià Gasch, 1897–1980). The other party to emerge from the conference is the Estat Català, a militant

Cover of La Campana de Gràcia, *5 Aug. 1922, referring to the continuing gang warfare promoted by the Sindicats Lliures.*

Scene of the assassination of Salvador Seguí, 10 March 1923.

separatist organisation based on the Irish nationalist model, led by Macià.

Between 1917 and 1922 the social conflict has claimed 809 victims, the majority of them killed by the Sindicats Lliures.

Antoni Rovira i Virgili (1882–1949), one of the founders of Acció Catalana, begins publication of his *Història Nacional de Catalunya*, a massive work (the last volume, published in 1934, goes up to 1621) which brings together the political, social, cultural, economic and institutional history of Catalonia.

Felip Pedrell (1841–1922) dies; his many compositions, including several operas and four Catalan *sarsuelas*, are outweighed in importance by his prolific activity as a musicologist and his significance as the teacher of Granados, De Falla and Roberto Gerhard (1896–1970).

Picabia has a one-man exhibition at the Galeries Dalmau (18 Nov.–8 Dec.); the catalogue has a preface by André Breton, who also gives a lecture at the Ateneu: 'Caractères de l'évolution moderne et ce qui en participe'.

Domingo leaves for Paris; he settles in France, returning to Barcelona only in 1931.

1923
The Unió de Rabassaires (Union of Wine Growers), founded the previous year, whose 20,000 members are led by Companys, holds its first Congress (2 Jan.); its programme combines the demand for access to ownership of land with the struggle for Catalan autonomy.

The moderate CNT leader Seguí is assassinated by a member of the Sindicats Lliures (10 March).

Following the defeat of the Lliga at the provincial elections (June) in both

Barcelona districts – at the hands of the Acció Catalana and the Partit Republicà Radical – the party's leader, Cambó, resigns.

Dissidents from the Spanish socialist party PSOE found the first Catalanist socialist party, the Unió Socialista de Catalunya per Justicia Social (8 July).

On 13 September, the Captain General of Catalonia, José Primo de Rivera (1870–1930) stages a successful coup d'état in Barcelona, following the

Primo de Rivera driving to the palace, September 1923.

example of Mussolini's seizure of power in Italy the previous year; two days later – with the King's approval – he sets up a military directorate in Madrid, which immediately suspends the government and introduces rigid press censorship. A decree (18 Sept.) orders the repression of separatism: military tribunals are to deal with attacks on national unity; the display of the Catalan flag is banned, and the use of the Catalan language is restricted to family life.

The Escola Superior dels Bells Oficis, run by the Mancomunitat, is closed by the authorities.

The Grup de Sabadell start their activities, led by Joan Oliver ('Pere Quart', b. 1899), Francesc Trabal

(1899–1957) and Joan Prats ('Armand Obiols', 1891–1970), who are in contact with Jean Cocteau and French musicians of the avant garde. They organise acts of provocation, including anti-banquets, anti-lectures and literary anti-contests; however, from 1925 they also start a publishing venture, *La Mirada*, which over the next ten years issues works by Carner, Riba, Elias and Rovira i Virgili among many others.

In December Dalmau moves his gallery to new premises on the elegant Passeig de Gràcia.

The architect and politician Domènech dies (30 Dec.).

1924

The Lliga Regionalista refuses to cooperate with the Dictatorship, and with the abolition of all provincial councils in Spain (9 Jan.) the Mancomunitat is effectively dissolved.

In March 119 Spanish writers (including Ortega y Gasset) publish a manifesto in Madrid protesting at the suppression of the Catalan language.

Following the assassination of Barcelona's executioner, the CNT is declared illegal (May) and goes underground, while the UGT and the Sindicats Lliures are tolerated and greatly increase their membership until the end of the Dictatorship in 1930. Most political parties are by now prohibited; the Unión Patriótica Española is formed as a party of unity, but it fails to attract a mass following.

The monthly *Revista de Catalunya* is founded by Rovira i Virgili; it serves as a forum for the defence and diffusion of Catalan culture during the Dictatorship.

The fortnightly art magazine *La Mà Trencada* is published (16 issues until 1925); directed by the art dealer and promoter Joan Merli (b.1901), it includes reproductions of works by Gargallo, Nogués, Picasso and Casanovas and regular articles from Paris by Llorens Artigas. Another art journal, *Gaceta de les Arts*, directed by Joaquim Folch i Torres, also appears (ending in 1927; a second series, 1928–30 was directed by both Folch i Torres and Rafael Benet, 1889–1979).

1925

Macià, in exile and tried by court martial for his written attacks on the Spanish nation (14 March), floats bonds (dated 23 April 1925) from Paris to raise money for a small army, the main subscribers being Catalans in America. Members of an activist group within his party plant a bomb to kill the Spanish King, but the attempt fails (24 May). In the wake of

Bond issued by Francesc Macià as president of the provisional government of Catalonia, 23 April 1925.

this, Masonic lodges are closed in Spain, while Catalanist demonstrations cause the closure in June of the Barcelona Football Club stadium and the Orfeó Català.

The Mancomunitat is abolished (20 March).

A Schoenberg festival is held at the Palau de la Música.

Salvador Dalí (b.1904) has his first one-man show at the Galeries Dalmau (14–27 Nov.); it is small but very successful and is followed by second (31 Dec. 1926–14 Jan. 1927) and third (from 31 Dec. 1928) shows at the same gallery.

1926

Having failed to get Soviet support on a visit to Moscow the previous autumn, Macià leads a band of some 200 volunteers of the Estat Català, aided and trained by a group of Italian anti-Fascists, on an attempted invasion of Catalonia from France. They are betrayed by an agent of the Italian government and are arrested by French police as they reach the border at Prats de Molló (5 Nov.). The ensuing trial in Paris, at which the defendants receive nominal sentences but are expelled from France, brings international publicity to the Catalan cause.

The weekly *L'Amic de les Arts* starts publication in Sitges (26 April), directed by Josep Carbonell (1897–1979); Foix, Gasch and Lluís Montanyà (1905–85) are among the contributors, and the magazine features articles about and works by the artistic avant garde, including Miró and Dalí.

On 10 June Gaudí dies after being run over by a tram.

At the suggestion of Casals, a workers' society is organised to give subscription concerts for people below a minimum wage; 2,000 people attend the first concert, which is given by the Casals Orchestra (Oct.). The society starts its own journal and, under the Republic, a music school with library and a workers' orchestra, which performs in industrial

communities in Catalonia, as well as in hospitals and prisons.

There are exhibitions at the Galeries Dalmau of works by Torres García and by two young artists, Àngel Planells (b.1901) and Helios Gómez (1905–53). The Sala Parés organises a first Autumn Salon (there are two more in 1927 and 1928), opening its doors to the avant garde, including Dalí, whose work causes considerable stir.

At a De Falla festival in the Palau de la Música, Wanda Landowska gives the first performance of the composer's *Harpsichord Concerto*.

1927

At a secret anarchist conference in Valencia (July), the Federació Anarquista Ibèrica (FAI) is founded, and the decision is taken to reorganise the CNT and gain control of its leadership.

The treaty ending the war in Morocco is finally signed in October.

Dalí, who has been expelled from the Madrid art school the previous year, develops increasingly close links with the group of *L'Amic de les Arts*; he starts to contribute drawings and what are later to be considered surrealist texts. These include an illustration accompanying a poem by Federico García Lorca (1898–1936), whom he had befriended in Madrid in 1922, and a text devoted to the poet. He also designs sets for the Barcelona première of Lorca's *Mariana Pineda* (24 June).

Dalmau organises an exhibition of paintings by Barradas (May), another friend of Lorca's, and one of drawings by the poet himself in June.

1928

In February Marinetti, who is on a visit to Spain, gives a lecture in the Teatre Tívoli; Dalmau organises an exhibition of homage to the Italian Futurist, which includes works by Gleizes, Picabia, Ricart, Barradas, Dalí, Miró and Lorca, among others.

An anti-establishment pamphlet, the *Manifest Anti-artístic Català*, signed by Dalí, Gasch and Montanyà, is circulated in Barcelona (March); it is popularly known – from the colour of its paper – as the *Manifest Groc* (Yellow Manifesto). Dalí goes to Paris for the first time.

Stravinsky conducts the Barcelona première of his *Sacre du Printemps* at the Liceu (22 March).

The quintessential *noucentista* opera *El Giravolt de Maig*, a setting by Eduard Toldrà (1895–1962) of a libretto by Carner, is first performed at the Palau de la Música; sets and costumes are by Nogués.

On the initiative of the young architect Josep Lluís Sert (1902–83), Le Corbusier gives two lectures in Barcelona on rationalist architecture (15, 16 May).

Following the rejection of one of his two paintings submitted to the Autumn Salon at the Sala Parés (the gallery buys both to prevent Dalí withdrawing altogether), Dalí gives a provocative lecture at the gallery on 'Catalan art in relation to the most recent art of the young intelligentsia', which is fully reported in *La Publicitat*.

An assembly of Catalan separatists approves a provisional constitution for a Catalan Republic at a Congress in Havana, Cuba (30 Sept.–1 Oct.), presided over by Macià.

1929

On 18 May, the Exposició Internacional de Barcelona, situated on part of the hill of Montjuïc, is inaugurated in the presence of the King. Both Puig i Cadafalch and industrialists of the Foment del Treball had had projects for an international exhibition of science, art and industry as early as 1905–6, to take place in 1914; and later an exhibition of electrical industries was planned for 1917, on which work started in 1915 on the basis of plans drawn up by Puig i Cadafalch. On 13 September 1923, hours after Primo de Rivera's coup, two halls designed by Puig had been inaugurated in the presence of the Dictator for an exhibition of furniture and interior design. To relieve unemployment, a major programme of urbanisation was put in hand from 1924

Politicians and journalists inspecting work on the Metro at Plaça de Catalunya station, where two lines intersect, March 1925.

(including the building of the Metro) in preparation for the exhibition; the building works for the exhibition itself provided employment for some 40,000 workers, a large number of them immigrants from other parts of Spain. Architects for further development of the exhibition site had been chosen after a competition in 1925, and buildings erected in a variety of conservative architectural styles, dominated by the monumental Palau Nacional, decorated with mural paintings by Galí. A notable feature of the exhibition is the *Poble Espanyol* (Spanish Village), the planning of which has involved both Utrillo and Nogués (who undertook research journeys throughout Spain from 1925 to 1928), while the two German pavilions designed by Mies van der Rohe and the functionalist Swedish and Yugoslav pavilions are in marked contrast to the official Spanish architecture. The Pavelló dels Artistes Reunits displays work by contemporary Catalan artists, particularly members of the decorative arts group FAD.

The exhibition, which attracts a huge number of visitors, closes on 15 January 1930 in the presence of both Primo de Rivera and the King. It has cost 180,500,000 pesetas (52,000,000 contributed by the government of the Dictatorship), and the economic consequences for the city at a time of world recession (the Wall Street crash occurs in October 1929) are severe; funds are not available for further public

investment, and many of the immigrant workforce are now left unemployed.

As *L'Amic de les Arts* closes (last issue published March), Gasch and Montanyà collaborate on a new magazine, *Hèlix* (10 issues, Feb. 1929–March 1930), which becomes a forum for the discussion and promotion of Surrealism.

In April–June Dalí's articles from Paris about surrealist art appear in *La Publicitat*.

Alfonso XIII accompanied by Francesc Cambó inspecting the plans for the exhibition of Electrical Industries on Montjuïc, July 1920.

Gargallo's Gran Dansarina (no. 87) exhibited in the pavilion of the Artistes Reunits at the 1929 International Exhibition.

A group of rationalist architects led by Sert exhibit a number of architectural projects at the Galeries Dalmau (from 27 April). Le Corbusier's 'Esprit Nouveau' is cited as a motto in the catalogue, and the works include projects for a holiday village, a clinic, a sports club, an airport terminal etc.

An exhibition of abstract art at Dalmau's (19 Oct.) causes such a scandal that it remains open for only one day; among the exhibits are works by Planells, Artur Carbonell (1906–73) and Miró. An exhibition of 'national and foreign modern art', which opens at Dalmau's on 31 October, includes works by Carbonell, Planells and Torres García as well as Mondrian, Van Doesburg and Arp.

1930

Dalí gives a lecture on the moral position of Surrealism at the Ateneu (22 Jan.), at a time when Buñuel's film *Un Chien andalou* (on which Dalí has collaborated) is first shown in Barcelona.

Failing to get a vote of confidence from the military, Primo de Rivera resigns (29 Jan.); he dies in exile six weeks later. With the formation of a new government under General Berenguer (2 Feb.), press censorship is lifted, freedom of association granted, political prisoners are released and, following a promise of national and municipal elections, Ajuntaments (city councils) and Diputacions (provincial assemblies) are reinstated.

On 17 August, representatives of six Spanish republican parties as well as the Estat Català, the Acció Catalana and the Acció Republicana de Catalunya (a group of republican dissidents from the Acció Catalana), who had been invited by the Spaniards, sign a pact of alliance at San Sebastián: in return for the Catalans' support of the republican cause, Catalonia is promised autonomy by the republican leaders – subject to a referendum in the region and approval by the Cortes. A plot to stage a republican revolution, supported in Catalonia by all nationalist republican parties, the Communists and both CNT and UGT, fails, as both a general strike in Barcelona (17–19 Nov.) and the rising of republican soldiers in Aragon (12 Dec.) occur prematurely.

In December, two Catalan Marxist (anti-Stalinist) groups, founded in 1924 and 1928 respectively, unite to form a new party, the Bloc Obrer i Camperol, which is led by Joaquim Maurín (1896–1973).

The architects involved in the rationalist exhibition at Dalmau's the previous year form an association, the GATCPAC (Grup d'Arquitectes i Tècnics Catalans per al Progrés de l'Arquitectura Contemporània), affiliated to the International Movement centred on Le Corbusier and Gropius and to the GATEPAC (Grupo de Arquitectos y Técnicos Españoles para el Progreso de la Arquitectura Contemporánea), of which they are also prime instigators. Leaders of the group are Sert and Josep Torres Clavé (1906–39), who edits their magazine *AC* (nominally published by GATEPAC; 25 issues, Jan. 1931–June 1937); this publishes the group's own projects – mostly collective work – and those of modern architects abroad, and discusses the social problems that contemporary architects have to tackle: housing, public health, schools etc.

Sert and his partner Sixt Yllescas (b.1903) design their first major building, a block of duplex flats on Calle Muntaner (completed 1931).

By the end of the year Barcelona has 1,005,000 inhabitants.

1931

Opposition by the Republicans to the planning of the elections topples the government, and a coalition government is formed (19 Feb.), which again includes Lliga members led once more by Cambó. The Estat Català, led by Macià, the Partit Republicà Català, led by Companys, and the group from the paper *L'Opinió* (founded in 1928) unite to form a new Catalan political party, the Esquerra Republicana de Catalunya, while Cambó is one of the founders of a new Spanish party, the Centro Constitucional.

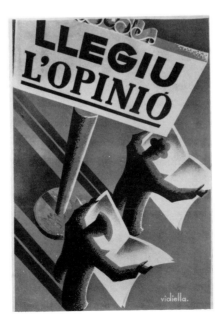

Poster for L'Opinió, *1932.*

Cover of L'Hora, *preparing for the elections on 12 April 1931.*

At the municipal elections on 12 April, Republican parties gain overwhelming majorities in the big Spanish cities. In Catalonia, with electoral participation at 69%, more than three-quarters of council seats go to Republicans, with the Esquerra Republicana de Catalunya winning 25 of the 47 seats for Barcelona. As the election results become known on 14 April, Companys proclaims the Republic from the balcony of the Ajuntament building on Plaça Sant Jaume, and shortly afterwards Macià proclaims the Catalan Republic within the Iberian Federation from the balcony of the Generalitat building across the square. Several hours later the Republic is proclaimed in Madrid, and the Royal family goes into exile.

On 16 April, Macià proceeds to form a provisional Catalan government with himself as president; it is a coalition of parties of the left, although the CNT refuses to participate. Following consultations with ministers of the provisional government of the Spanish Republic, Macià agrees that Catalonia should not be constituted as a republic, but should be governed by an autonomous Generalitat – a name taken from a body that ruled Catalonia in the Middle Ages. A provisional government of the Generalitat is formed before the end of the month, and by mid-June a Statute of Autonomy (the 'Statute of Nuria') has been drafted.

Primary education in Catalan language is legalised (1 May).

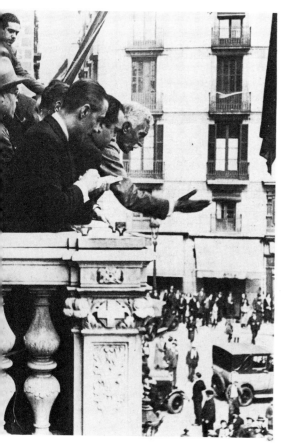

Francesc Macià proclaiming the Catalan Republic, 14 April 1931.

There is a large Republican and Socialist majority in both Catalonia and Spain as a whole in the national elections (28 June), for which proportional representation is introduced.

On 7 July, the only Catalan bank, the Banc de Catalunya, ceases trading.

The Catalan town councils are overwhelmingly in favour of the proposed Statute of Autonomy (2 Aug.), and in a popular referendum 75% of the male population of Catalonia vote, of whom 99% are in favour of the Statute; 400,000 women's signatures are also collected in its support (women's suffrage

Car with posters urging approval of the Statute of Autonomy at the referendum of 2 August 1931.

is only legalised on 1 October).

Moderate syndicalists in the CNT (which has around 250,000 members in Catalonia) issue a manifesto (1 Sept.); they oppose the Anarcho-bolshevists in their organisation, who want spontaneous social revolution.

The first constitutional government of the Spanish Republic (15 Nov.) is led by the Left Republican Manuel Azana; it includes the Socialists but not Lerroux's Partit Radical.

Companys founds the daily *La Humanitat* (9 Nov.), which becomes the unofficial organ of the Esquerra Republicana.

Casals conducts a performance of Beethoven's *Ninth Symphony* given by his own orchestra to celebrate the new Republic; it is attended by Macià and other leading politicians. Casals becomes president of the Generalitat's Junta de Música.

Gerhard, Pedrell's last pupil, who had later studied with Schoenberg in Berlin (1923–5), is appointed professor of music at the Generalitat's Escola Normal and also music librarian at the Biblioteca de Catalunya. The 1930s are a very fruitful period for him, and many of his works bear specific Catalan references. In 1939 he goes into exile in England.

Rusiñol dies in Aranjuez (16 June).

In September Dalí takes part in an event organised by the communist journal *L'Hora* to discuss the relationship between Marxism and Surrealism. Having been taken up by the Surrealists in Paris, Dalí becomes estranged from the *L'Amic de les Arts* group.

1932

An anarcho-bolshevist uprising in the Alt Llobregat valley near Barcelona (18–22 Jan.) ends without bloodshed.

At the CNT Congress (April), the anarchist radicals of the FAI finally succeed in taking over the leadership of the organisation.

The new Spanish constitution (Nov. 1931) has opened the way for granting autonomy to the regions, and the draft Statute of Catalan Autonomy is first debated by the Cortes in May; finally, in September, the Statute is passed, though with significant modifications. Nevertheless, the powers of the Generalitat are more extensive than those of the former Mancomunitat, including control of the forces of public order and legislative powers in the areas of Catalan civil law and the internal administration of Catalonia. Catalan is recognised as a second official language.

The coalition led by the Esquerra Republicana de Catalunya wins a

Train which brought the Spanish prime minister to Barcelona for approval of the Statute of Autonomy, 27 September 1932.

Cover of the official edition of the Statute of Autonomy.

resounding victory at the elections for the Catalan parliament (20 Nov.), and on 14 December, Macià is elected president of the Generalitat and forms his first constitutional government.

At the invitation of the GATCPAC, the Generalitat and the Barcelona City Council, Le Corbusier and other prominent architects belonging to the International Movement visit Barcelona (29–31 March) to prepare for a forthcoming conference. The outcome of the latter is the 'Charter of Athens' (1933), which outlines principles for a functional city. One important document is the 'Pla Macià', a futuristic plan for Barcelona on which the GATCPAC architects, Le Corbusier and P. Jeanneret collaborate (1932–4). The Generalitat commissions the GATCPAC to build one of the new housing blocks envisaged by the plan (Casa Bloc, completed 1936).

Ramon Casas dies (1 March).

Laia, a novel by Salvador Espriu (1913–85), is published; it marks a complete break with the aesthetics and ideals of *Noucentisme*.

L'Amic de les Arts publishes Foix's *Krtu*.

The association ADLAN (Amics de l'Art Nou) is formed (Nov.) on the initiative of Joan Prats to promote avant-garde art in Barcelona; its members

include the writer Carles Sindreu (1900–74), the critic Magi Cassanyes (1893–1956) and the photographer Joaquim Gomis (b.1902) as well as Sert, Montanyà, Gasch, Foix and Gerhard. The first events it sponsors are a showing of Alexander Calder's miniature circus, a reading of Lorca's *A Poet in New York* and a day devoted to black music, literature and theatre.

Miró returns to Barcelona and remains in Catalonia until the summer of 1936.

1933

Further anarcho-bolshevist uprisings occur in Catalonia (9 Jan.) and neighbouring Aragon (8–12 Dec.) but fail. In Barcelona the economic situation has deteriorated further since the end of the 1929 exhibition, and there has been a series of strikes; this year around 20% of the registered workforce are involved in strikes.

Important educational reforms are introduced by the Generalitat, following the creation of the Institut-Escola for teacher training the previous year: primary education is made free and compulsory, with teaching given in Catalan; hotels built for the 1929 exhibition are turned into schools; and the University becomes autonomous, as demanded by the University Congress in 1918. President of the new university board, which is made up of representatives from both Madrid and Barcelona, is Fabra, whose *Diccionari de la Llengua Catalana* had appeared the previous year.

Events organised by ADLAN include an exhibition of objects (Jan.) by Ferrant (1891–1961) and one of paintings (March) by A. Carbonell.

The ballet *Jeux d'enfants*, designed by Miró for the Ballets Russes de Monte Carlo, has its first Barcelona performance at the Liceu (3 May).

Dalmau, whose own gallery has been forced to close for economic reasons, organises an exhibition of recent paintings by Dalí and photographs by Man Ray at new exhibition galleries at the Llibreria d'Art Catalònia; the show causes much controversy. The following October Dalmau exhibits more of Dalí's latest paintings at the same locale.

At the national election (19 Nov.) a new right-wing party, the Confederación Española de Derechas Autonomas (CEDA), wins most seats, but a minority government is formed by Lerroux's Partit Radical with CEDA support.

Following the death of Macià (25 Dec.), Companys is elected president of the Generalitat and forms a new coalition government.

1934

At the Catalan municipal elections (14 Jan.) there is a strong revival in the fortunes of the Lliga, which with its partners wins control of 442 councils, while the Esquerra Republicana and its allies hold 580. Four days later all the Lliga deputies begin a boycott of the Catalan parliament, which lasts until 22 September.

A number of socialist and communist groups in Catalonia join together to form the Alliança Obrera (March).

The Generalitat commissions (Feb.) the GATCPAC architects Sert, Torres Clavé and Joan Baptista Subirana (1904–79) to build a tuberculosis clinic (the Dispensari Central) in the old city of Barcelona (completed 1938). On 1 May building work starts on the GATCPAC's Leisure and Vacation City at Castelldefels, which was an integral part of the Macià plan; it is backed by a cooperative formed the previous year which has around 800,000 subscribers, but political events as well as lack of finance cause the project to be abandoned in 1937.

The Generalitat carries out a reorganisation of museums, and the Museu d'Art de Catalunya is opened (Oct.) in the Palau Nacional built for the 1929 exhibition. Picasso visits the installation shortly before it opens in the course of the last visit he pays to Barcelona – or Spain.

ADLAN organises an exhibition of recent works by Miró at the Galeria Syra.

A special Christmas issue of the magazine *D'Ací i d'Allà* is devoted to the work of GATCPAC and ADLAN and to international Dada and Surrealism; it is edited by Sert and Prats, representing the two Barcelona groups.

Conflict arises between the Generalitat and the Madrid government over new legislation passed by the Catalan parliament (11 April) which enables tenant wine-growers to acquire smallholdings. There is strong opposition from landowners, many of whom leave the Lliga to form Acció Popular Catalana as a regional branch of CEDA; 5,000 of them attend a rally in Madrid (8 Sept.). Although the Generalitat gets a modified version of the legislation agreed by the prime minister Ricard Samper, this loses him CEDA's support in parliament, and he resigns. Lerroux then forms an administration in which CEDA holds three ministerial posts.

The Alliança Obrera organises strikes throughout Spain to protest at CEDA's participation in government; in Barcelona this leads to a general strike, and in Oviedo to a revolutionary uprising of

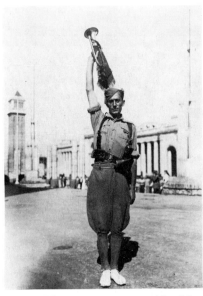

Bugler of the Tercio Extranjero on Montjuïc, 8 October 1934.

Asturian miners (5–18 Oct.), which is put down by Tercio (Foreign Legion) troops trained in Morocco.

On 6 October Companys proclaims the Catalan Republic within the Spanish Federal Republic, and encourages opposition leaders in Madrid to form a provisional government. The army responds immediately, arresting Companys and the members of his administration; a state of emergency is declared, most town councils and political centres are closed, there are many arrests, and press censorship is introduced. On 6 June 1935 the members of the Generalitat government are sentenced to thirty years in prison.

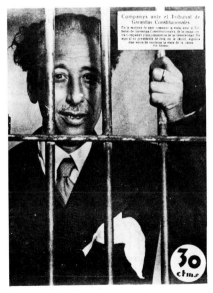

Companys in prison.

307

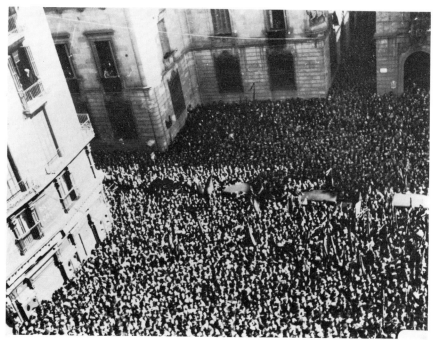

Crowd welcoming the return of Companys and his colleagues, 1 March 1936.

1935
On 2 January the Statute of Autonomy is suspended indefinitely. The state of emergency is lifted (3 April), and a new Generalitat government is formed by the Partit Radical in alliance with CEDA and the Lliga. In Madrid Lerroux's new coalition administration appoints General Francisco Franco army chief-of-staff.

In the wake of a corruption scandal involving members of the Partit Radical, the president of the Generalitat and Lerroux are both forced to resign (Oct.). A new council of the Generalitat is formed by the Lliga (Dec.) composed exclusively of members of its own party.

The periodical *Quaderns de Poesia* starts publication (8 issues, April 1935–March 1936); under the editorial direction of Foix, it becomes a forum for publication and discussion of the latest trends in Catalan and European poetry.

ADLAN organises shows of works by Arp (March) and Man Ray (May–June) at the Roca jewellery shop (built the previous year by Sert), while Dalmau puts on an exhibition of surrealist objects at the Galeries d'Art Catalònia (March) featuring work by Raimon Marinel.lo (b.1911), Jaume Sans (b.1914) and Eudald Serra (b.1911).

1936
The Madrid parliament is dissolved (4 Jan.), and there is a regrouping of political parties in preparation for the national elections: the Spanish parties of the left form the Frente Popular, while in Catalonia the Lliga, CEDA, Partit Radical and monarchists form the Front d'Ordre, while the left forms the Front d'Esquerres. At the elections (16 Feb.), the Frente Popular wins an overall majority, while 41 of the 54 seats for Catalonia are won by the Front d'Esquerres. The new Madrid government declares an amnesty of political prisoners and reinstates the Statute of Autonomy (21 Feb.); the Catalan parliament reconvenes and Companys is re-elected president of the Generalitat (29 March).

ADLAN organises a Picasso exhibition at the Sala Esteva (13–18 Jan.), which attracts some 8,000 visitors and is later shown in Madrid and Bilbao. Paul Eluard, who is in Barcelona for the exhibition, gives a lecture on Communism and Surrealism (24 Jan.).

The International Society for Contemporary Music (ISCM) holds its Fourteenth Festival in Barcelona (18–25 April). Alban Berg's *Violin Concerto* receives its world première with Louis Krasner, who had commissioned it, as soloist, and other concerts during the festival introduce works by Gerhard, Benjamin Britten, Ernst Křenek, Lennox Berkeley, Frank Martin, Egon Wellesz and Karel Szymanowski. In 1937 Britten and Berkeley compose a suite of Catalan dances entitled *Montjuïc*, the third of the four movements a lament, *Barcelona, July 1936*.

Ariel (music, models and ideas for a ballet) by Gerhard, Miró and Foix is published.

Dalmau organises a De Chirico exhibition at the Sala Esteva (May), and ADLAN with Dalmau's collaboration mounts a group show at the Galeries Catalònia (also May) of works by the 'Logicofobistes', young surrealist painters and sculptors including Carbonell, Leandre Cristòfol (b.1908), Ferrant, Marinel.lo, Planells and Sans. The following year Dalmau dies (21 Nov. 1937).

On 17 July, a military uprising, led by Spanish anti-republican forces, starts in the Moroccan protectorate and spreads to the Spanish mainland (18 July), where General Franco assumes command. In the early morning of 19 July, the majority of the Barcelona garrison rebel against the Republican government and the Generalitat and march towards the city centre, but by the following morning their attack has been defeated by Security and Civil Guards helped by militant workers and some soldiers. As civilians, led by the CNT and FAI, capture 30,000 rifles from the main Barcelona armoury during that day, Companys encourages anarchist leaders to set up the Central Committee of Anti-fascist Militias (21 July) to mobilise voluntary militias, since the Republicans have no support from the regular army in Barcelona. Neither Companys nor the Committee seeks approval from the government in Madrid.

While the military rebels gain control over wide areas of Spain, the Republican security forces, with the help of armed militants from the unions and the political parties of the left, successfully defend vital strongholds, including Madrid, Valencia, the Basque country and Asturias as well as Catalonia. The Spanish Civil War has begun.

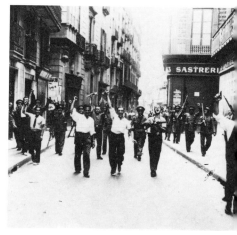

Civilian volunteers and Republican guards in the streets of Barcelona, 19 July 1936.

Catalogue

The works of each artist are arranged by medium (paintings; watercolours and drawings; printed graphic work; sculpture; objects etc.) and within these categories in approximate chronological order. Following the listing by artists are anonymous works and then publications (catalogues – in chronological order; invitations; manifestos; programmes; books – alphabetically by author; newspapers and journals – alphabetically by title). Works in the postscript to the exhibition are listed at the end.

Titles have normally been translated into English, but in a few instances more familiar original titles are also given.

Dimensions are given in centimetres; height precedes width.

Artists' biographies have been written by Pilar Velez, Josep Maria Trullén, Marilyn McCully and the editor.

Anglada i Camarasa, Hermen
Barcelona 1872–Pollença, Mallorca 1959

Painter. He studied at the Llotja and in Paris, where he lived – though travelling extensively – until 1914, taking French nationality. He returned to Barcelona and had an important exhibition at the Palau de Belles Arts in 1915 and another in Madrid the following year. Later he went to Valencia and Mallorca, returning to Barcelona and Paris before finally settling in Mallorca. A special room was devoted to his work at the 1929 International Exhibition.

1
Night butterflies, c. 1900
Oil on panel, 26.5 × 35 cm
Museu Cau Ferrat, Sitges (30666)

2
Parisian nocturne, c. 1900
Oil on panel, 25 × 34 cm
Museu Cau Ferrat, Sitges (30705)

Aragay i Blanchart, Josep
Barcelona 1889–Breda 1973

Painter, ceramist and theorist. He attended Galí's art school 1907–11 and was a member of Les Arts i els Artistes. He was artistic director of the *Almanach dels noucentistes* (1911) and contributed cartoons to *Papitu* (from 1908) and

Picarol (1912). His first one-man show as a painter was at Dalmau's in 1913 and as a ceramist at the Galeries Laietanes in 1915. He taught ceramics at the Escola Superior dels Bells Oficis (from 1919) and in 1920 published *El Nacionalisme de l'art*. In 1922 he moved to Breda, where he founded a ceramics studio.

See nos. 288, 291

Arnau i Mascort, Eusebi
Barcelona 1863–1933

Sculptor. He studied at the Llotja and abroad and worked at the 'Castle of the Three Dragons' with Domènech and Gallissà. The majority of his sculpture was done for *modernista* architects, including Puig i Cadafalch (Casa Amatller, 1898–1900), Domènech (Palau de la Música, 1905–8, etc.), Falguera (Casa de Lactància, 1910), etc. He was also an engraver of medals.

3
Prizewinner's medal from Universal Exhibition, 1888
Copper, diam: 4.9 cm
Signed on obverse and reverse
Museu d'Història de la Ciutat, Barcelona (892)

4
Personification of Barcelona, c. 1898
Bronze, 49 × 68 × 35 cm
Signed bottom right
Museu d'Art Modern, Barcelona (10732)
Illustrated p. 78 (fig. 76)

5
Capital on circular base, c. 1900, from Casa Amatller
Plaster, 49.5 × 65 × 65 cm
Museu d'Art Modern, Barcelona (71001)
Illustrated p. 17 (fig. 5)

Barradas, Rafael Pérez
Montevideo 1890–1929

Painter. He moved to Barcelona in 1913 from Milan, where he had been in contact with the Italian Futurists, and developed a style he called 'Vibrationism'. He exhibited at Dalmau's with Torres García in 1916 and collaborated on *Un Enemic del Poble*. In 1918 he moved to Madrid, where in 1922 he met Dalí, Buñuel and García Lorca. He moved back to Barcelona in 1925, where his

Sunday-afternoon *tertulia* was known as 'El Ateneillo' or 'Los Catorce'. In 1928 he returned to Uruguay as director of the Museo Nacional.

6
Apartment house, 1919
Tempera on canvas, 79 × 59 cm
Signed and dated bottom right
Museo Nacional de Artes Plásticas, Montevideo

7
The Dancer (futurist drawing), c. 1917
Ink and crayons on paper, 32 × 28 cm
Signed bottom left
Collection Pere Aguirre Gili, Barcelona
Illustrated p. 197 (fig. 208)

8
Portrait of Salvat-Papasseit, 1918
Watercolour on cardboard, 50 × 47 cm
Signed and dated bottom left
Collection Gustau Camps, Barcelona
Illustrated in colour p. 255 (fig. 288)

See also no. 303

Bonnín i Martí, Lluís
Barcelona 1873–Nice 1964

Jeweller and graphic artist. He first studied jewellery-making at the Llotja and during the 1890s contributed drawings to various Barcelona journals, including *Barcelona Còmica*, *Catalònia* and *Hispania*. He also illustrated J.M. Roviralta's *modernista* poetic evocation *Boires baixes* (1902). In 1900 he settled in Nice, where he worked as a jeweller.

9
Bad tidings (La mala nova), 1898
Song book (one of Morera's Catalan song arrangements published by *L'Avenç*), 27.1 × 18.6 cm
Signed centre right
Private collection
Illustrated p. 241 (fig. 270)

Bru i Salelles, Lluís
Ondara, Marina Alta 1868–Barcelona 1952

Mosaicist and designer. He started his career as a stage designer, but was encouraged by Domènech to take up mosaics and travelled to Venice to learn the craft. He collaborated with Domènech on several works, including the Palau de la Música (1905–8), the Hospital de Sant Pau (1902–12) and the exterior of the Casa Lleó Morera (1905), and with Puig i Cadafalch on a number of houses (Garí, Amatller, Quadras). He also worked in Mallorca and is said to have sent an entire mosaic façade to Buenos Aires.

10
Design for columns on Palau de la Música Catalana, c. 1905–8
Watercolour on paper, 45.5 × 30.5 cm
Collection Sr Jordi Muñoz, Barcelona
Cf. illustration p. 126 (fig. 123)

Carbonell i Carbonell, Artur
Sitges 1906–73

Painter, producer and theatre director. He studied with Joaquim Sunyer. Around 1928 he joined the surrealist group around *L'Amic de les Arts*, and his work was included in two group shows at Dalmau's in 1929. ADLAN put on his first one-man show in 1933 and included his work in the 'Logicofobistes' exhibition in 1936. From 1930 to 1936 he directed a theatre group in Sitges, which included works by Cocteau, O'Neill and Pirandello in its repertory.

11
Two figures, 1931
Oil on canvas, 67 × 79 cm
Signed and dated bottom right
Private collection
Illustrated p. 216 (fig. 228)

12
Constellation, 1933
Oil on canvas, 55 × 46 cm
Signed and dated bottom right
Private collection
Illustrated p. 217 (fig. 229)

13
Landscape, 1935
Oil on canvas, 48 × 72 cm
Signed bottom right
Private collection
Illustrated p. 76 (fig. 74)

Carrasco i Castell, Anastasio
Madrid 1831–?

Medal engraver. He settled in Barcelona in 1867.

14
Commemorative medal from Universal Exhibition, 1888
Silver, diam: 6 cm
Signed on obverse
Museu d'Història de la Ciutat, Barcelona (893)
Illustrated p. 79 (fig. 77)

Casanovas i Roy, Enric
Poble Nou, Barcelona 1882–Barcelona 1948

Sculptor. He studied with Josep Llimona and later at the Llotja, exhibiting drawings at Els Quatre Gats in 1903. He travelled often to Paris (for the first time in 1900). He was a founder member of Les Arts i els Artistes and participated in their first

exhibition (1910) at the Faianç Català, where he had his first one-man show the following year.

15
Mallorcan peasant woman, c. 1916
Stone, 50 × 47 × 40 cm
Museu Municipal de Tossa, Tossa de Mar
Illustrated p. 174 (fig. 182)

16
Youth, c. 1917–18
Marble, 58 × 45 × 19 cm
Signed on left arm
Museu Municipal d'Art, Valls
Illustrated p. 53 (fig. 52)

Casas i Carbó, Ramon
Barcelona 1866–1932

Painter and graphic artist. He studied in Barcelona with Joan Vicens Cots and in 1881 went to Paris and entered the *atelier* of Carolus Duran; he also attended classes at the Académie Gervex (1884). In 1890 he lived with Rusiñol at the Moulin de la Galette. He exhibited regularly in Barcelona (jointly with Rusiñol and Clarasó) and in Paris throughout the 90s, and by the end of the decade had won a reputation as the leading portraitist and poster artist in Barcelona; his paintings on political subjects also date from these years. He was one of the founders of the Els Quatre Gats tavern and was artistic director of the journals *Quatre Gats*, *Pèl & Ploma* and *Forma* (1899–1907). Later he worked in Madrid and in America at the invitation of Charles Deering, principally as a painter of society portraits.

17
Dance at the Moulin de la Galette, 1890
Oil on canvas, 100 × 81.5 cm
Signed bottom right
Museu Cau Ferrat, Sitges (32032)
Illustrated p. 157 (fig. 160)

18
The Bohemian (portrait of Erik Satie on Montmartre), 1891
Oil on canvas, 198.9 × 99.7 cm
Signed bottom right
Northwestern University Library, Evanston (Illinois)
Illustrated p. 151 (fig. 150)

19
Interior in the open air (the sister and brother-in-law of the artist taking coffee on the terrace of their house), 1892
Oil on canvas, 161 × 121 cm
Signed and dated bottom right
Collection Marqués de Villamizar
Illustrated in colour p. 163 (fig. 168)

20
The Garroting (Garrote vil), 1894
Oil on canvas, 127 × 166.2 cm
Signed and dated bottom left
Museo Español de Arte Contemporáneo,
Madrid (P.1637)
Illustrated p. 31 (fig. 23)

21
Nude, 1894
Oil on canvas, 46 × 54.7 cm
Signed and dated bottom left
Museu Cau Ferrat, Sitges (30268)
Illustrated p. 26 (fig. 17)

22
Nude, 1894
Oil on canvas, 50.5 × 61 cm
Signed bottom right
Museu Cau Ferrat, Sitges (30271)

23
*Portrait of Rusiñol, palette in hand,
seated on an iron lamp*, c. 1895
Oil on canvas, 200 × 100 cm
Museu Cau Ferrat, Sitges (32008)
Illustrated p. 33 (fig. 25)

24
*Ramon Casas and Pere Romeu on a
tandem*, 1897
Oil on canvas, 191 × 215 cm
Museu d'Art Modern, Barcelona (69806)
Illustrated p. 160 (fig. 163)

25
*Corpus Christi procession leaving the
church of Santa Maria del Mar*, 1898
Oil on canvas, 115.5 × 196 cm
Signed and dated bottom right
Museu d'Art Modern, Barcelona (10903)
Illustrated in colour p. 164 (fig. 169)

26
*Young girl leaning on a sofa with a glass
of champagne in her left hand* (poster
design for Codorniu Champagne), 1898
Conté crayon, pastels, watercolour, wax
crayons and gum tempera on paper,
129 × 197 cm
Signed bottom centre
Collection 'Cartells d'Ahir', Casa
Codorniu, Sant Sadurní d'Anoia
Illustrated p. 248 (fig. 278)

27
Young woman seated on a sofa (poster
design for *Pèl & Ploma*; cf. no. 47), 1899
Conté crayon, gouache and pastel on
paper, 59 × 40 cm
Signed bottom left and bottom right
Collection Delmiro de Caralt, Barcelona

28
Portrait of Raimon Casellas, c. 1899
Charcoal on paper, 40 × 36 cm
Signed bottom right
Museu d'Art Modern, Barcelona (27332)
Illustrated p. 150 (fig. 148)

29
Portrait of Pompeu Gener, c. 1899
Charcoal with touches of white wash on
paper, 64.5 × 34 cm
Signed bottom left
Museu d'Art Modern, Barcelona (26928)

30
Portrait of Ignasi Iglésias, c. 1899
Charcoal, wash, touches of pastel and
greenish powder on paper, 60 × 27 cm
Signed bottom left
Museu d'Art Modern, Barcelona (27543)
Illustrated p. 273 (fig. 304)

31
Portrait of Eduard Marquina, c. 1899
Charcoal and pastel on paper,
53.5 × 34 cm
Signed bottom left
Museu d'Art Modern, Barcelona (27566)

32
*Portrait of Manuel (Manolo) Martínez
Hugué*, c. 1899
Charcoal, wash and powdered ground
on paper, 62 × 28 cm
Signed bottom right
Museu d'Art Modern, Barcelona (27274)
Illustrated p. 152 (fig. 153)

33
Portrait of Lluís Millet, c. 1899
Charcoal, watercolour and pastel with
powdered ground of ultramarine blue on
paper, 59.3 × 27 cm
Signed bottom right
Museu d'Art Modern, Barcelona (27618)

34
Portrait of Isidre Nonell, c. 1899
Charcoal and powdered ground on
paper, 64 × 30 cm
Signed bottom left
Museu d'Art Modern, Barcelona (27322)
Illustrated p. 152 (fig. 152)

35
Portrait of Ramon Pichot, c. 1899
Charcoal, pastel and watercolour on
paper, 64 × 30 cm
Signed bottom right
Museu d'Art Modern, Barcelona (27316)
Illustrated p. 152 (fig. 151)

36
Portrait of Josep Puig i Cadafalch,
c. 1899
Charcoal, pastel and powdered ground
on paper, 62.6 × 28.8 cm
Signed bottom right
Museu d'Art Modern, Barcelona (26929)
Illustrated p. 124 (fig. 121)

37
Portrait of Joaquín Torres García, c. 1899
Charcoal on paper, 64 × 30 cm
Signed bottom right
Museu d'Art Modern, Barcelona (27317)

38
Portrait of Pablo Picasso, 1901
Charcoal and conté crayon heightened
with pastel on paper, 69 × 44.5 cm
Museu d'Art Modern, Barcelona (27264)
Illustrated p. 32 (fig. 24)

39
Portrait of Pau Casals, c. 1906
Charcoal on paper, 62.6 × 46 cm
Signed bottom right
Museu d'Art Modern, Barcelona (27622)
Illustrated p. 283 (fig. 317)

40
Portrait of Lluís Domènech i Montaner,
c. 1906
Charcoal and touches of pastel on paper,
62 × 48 cm
Signed bottom right
Museu d'Art Modern, Barcelona (27294)
Illustrated p. 124 (fig. 120)

41
Portrait of Joan Maragall, c. 1906
Charcoal and light touches of pastel on
paper, 61.1 × 47.3 cm
Signed bottom left
Museu d'Art Modern, Barcelona (27609)
Illustrated p. 264 (fig. 295)

42
Portrait of Eugeni d'Ors, c. 1906
Charcoal and touches of pastel on paper,
56 × 43.8 cm
Signed bottom right
Museu d'Art Modern, Barcelona (27305)
Illustrated p. 268 (fig. 296)

43
Self-portrait, 1908
Charcoal and pastel on paper, 55 × 42 cm
Signed and dated bottom right
Museu d'Art Modern, Barcelona (27268)
Illustrated p. 33 (fig. 26)

44
4 Gats, 1898
Poster, 58 × 34.5 cm
Signed bottom right
Museu d'Art Modern, Barcelona
(RG 1046)
Illustrated p. 249 (fig. 281)

45
Puchinel.lis 4 gats, 1898
Poster (printed by Utrillo & Rialp),
54.5 × 37.5 cm
Signed bottom left
Museu de les Arts de l'Espectacle,
Barcelona (25221)
Illustrated in colour p. 246 (fig. 276)

46
Atelier Casas & Utrillo, 1898
Invitation (printed by A. Gual),
28.5 × 24 cm
Museu d'Art Modern, Barcelona
(RG 1648)
Illustrated p. 278 (fig. 311)

47
Pèl & Ploma, 1899
Poster (printed by J. Thomas), 44 × 31cm
(cf. no. 27)
Signed bottom left
Museu d'Art Modern, Barcelona (RG425)
Illustrated p. 240 (fig. 268)

48
Sífilis, 1900
Poster (printed by J. Thomas),
80 × 34.3cm
Signed bottom left
Museu d'Art Modern, Barcelona
(RG360)
Illustrated p. 248 (fig. 280)

49
*Antiquarum artium barcinonensis
exhibitio*, 1902
Poster (printed by J. Thomas),
70 × 48.5cm
Signed bottom right
Museu d'Art Modern, Barcelona
(RG362)
Illustrated p. 248 (fig. 279)

See also nos. 200, 313

Caula Cornejo, Antonio
La Coruña 1847–?

Painter, specialising in maritime and
harbour views. He attended the opening
of the Suez Canal (1869) as a newspaper
correspondent and in 1878 was appointed
curator of the Barcelona Museu Naval.

50
*Panoramic view of Barcelona from the
harbour*, 1888
Gouache on paper, 95 × 156cm
Signed and dated bottom left
Museu d'Història de la Ciutat, Barcelona
(874)

Cerdà i Sunyer, Ildefons
Centelles 1815– Caldas de Besaya 1876

Engineer, planner and politician. He
studied in Vich, Barcelona and Madrid
and began his career as a civil engineer
in Catalonia, settling in Barcelona in
1849. He was a member of the
Progressive Party, which he represented
in the Cortes from 1850. In 1859 he was
commissioned to prepare a plan for the
improvement and expansion of Barcelona,
the Cerdà plan. In 1867 he published his
Teoría General de la Urbanización.

51
*Plan of the environs of the city of
Barcelona and project for its improvement
and enlargement*, 1859
Lithograph (1861), 77 × 115cm
Signed by Cerdà and dated (April 1859)
Museu d'Història de la Ciutat, Barcelona
(709)
Illustrated p. 103 (fig. 99)

Cidón Navarro, Francisco de
Valencia 1871– Tarragona ?

Painter and graphic designer. He studied
with Sorolla in Madrid. He lived and
worked in Barcelona until 1928, when he
was appointed professor of drawing at
the Institut de Tarragona.

52
Exposición Meifrén, c. 1905
Poster (printed by Affiches Barral
Hermanos), 88 × 64.4cm
Signed top right
Museu d'Art Modern, Barcelona
(RG374)
Illustrated p. 249 (fig. 282)

Clarà i Ayats, Josep
Olot 1878– Barcelona 1958

Sculptor. He studied drawing at Josep
Berga's academy in Olot, and in 1897
moved to Toulouse to study sculpture at
the Ecole des Beaux Arts. In 1900 he
went to Paris, where he worked in the
studio of Louis Barrias and met Maillol,
Bourdelle and Rodin; he also became a
friend of Isadora Duncan, of whom he
made many drawings. From 1910 his
work gained international fame, while
he remained an important link between
Paris and Barcelona, where he was a
founder member of Les Arts i els
Artistes – and took part in their first
exhibition (1910) at the Faianç Català –
and was acclaimed as a model *noucentista*.
In 1932 he left Paris and settled
permanently in Barcelona.

53
Strength, 1936
Bronze, h: 166cm, base: 42 × 37 cm
Signed and dated on right side of base
Museu Clarà, Barcelona (90017)
Illustrated p. 259 (fig. 290)

Cristòfol i Peralba, Leandre
b. Os de Balaguer 1908

Sculptor. He studied furniture-making in
Lleida and at the Llotja in Barcelona.
His work was included in the ADLAN
'Logicofobistes' exhibition (1936), and
he took part in the 1938 surrealist
exhibitions in Paris and Tokyo.

54
Lyric construction, 1934
Steel and wood, 85 × 59cm
Collection of the artist
Illustrated p. 215 (fig. 226)

55
Imprisoned forms, 1936 (replica)
Wood and porcelain, 62 × 42cm
(Original in the Departament de Cultura,
Generalitat de Catalunya)
Collection of the artist
Illustrated p. 220 (fig. 233)

Dalí i Domènech, Salvador
b. Figueres 1904

Painter. He studied drawing in Figueres
and at the Escuela de Bellas Artes in
Madrid (1925–6). His first one-man
show was at Dalmau's in 1925, and he
exhibited frequently in Barcelona during
the next few years. He was associated
with the Sitges *L'Amic de les Arts* group
and was a signatory of the *Manifest
Groc*. In 1928 he paid his first visit to
Paris, making contact with the Surrealists,
and in 1929 Eluard, Magritte and the
dealer Goemans spent the summer with
him in Cadaqués. That autumn he
moved to Paris, where he resided until
the end of the Spanish Civil War. He
maintained contact with Barcelona,
where he lectured and his work was
exhibited, and he was included in the
ADLAN-Tenerife show (May 1935)
sponsored by the *Gaceta de Arte*.
Articles by Dalí appeared in several
Catalan journals, including *L'Amic de
les Arts*, *Hèlix* and *La Revista*.

56
View from Llaner, c. 1920
reverse: *Cadaqués*, c. 1920
Oil on canvas, 39.5 × 52.2cm
Signed bottom right (later signature
bottom right on reverse)
Private collection

57
Self-portrait with L'Humanité, 1923
Oil and gouache with collage on
cardboard, 105 × 75.4cm
Signed and dated top left
Fundación Gala-Salvador Dalí;
Teatro Museo Dalí, Figueres
Illustrated p. 202 (fig. 215)

58
*Portrait of Salvador Dalí i Cusí (father of
the artist)*, 1925
Oil on canvas, 100 × 100cm
Signed and dated top right
Museu d'Art Modern, Barcelona (68839)
Illustrated in colour p. 205 (fig. 218)

59
Harlequin, 1927
Oil on canvas, 195.5 × 150cm
Signed and dated bottom right
Museo Español de Arte Contemporáneo,
Madrid

60
Thumb, beach, moon and rotting bird
(also known as *L'Oiseau blessé*), 1928
Oil and sand on board, 55 × 65.5cm
Signed and dated lower right
Collection Mizné-Blumental
Illustrated in colour p. 208 (fig. 221)

61
Soft construction with boiled beans;
Premonition of Civil War, 1936
Oil on canvas, 100 × 99 cm
Philadelphia Museum of Art, The Louise
and Walter Arensberg Collection
Illustrated in colour p. 70 (fig. 69)

62
España, 1938
Oil on canvas, 91.8 × 60.2 cm
Signed and dated bottom right;
inscribed bottom centre
Museum Boymans-Van Beuningen,
Rotterdam
Illustrated p. 77 (fig. 75)

63
Screen, c.1923
Gouache on parchment with mixed
media, mounted on four panels with
linen backing, each 155 × 54.5 cm
Private collection
Illustrated p. 232 (fig. 253)

See also nos. 274, 275, 276, 278, 280, 310

Domènech i Montaner, Lluís
Barcelona 1850–1923

Architect, historian and politician. He
studied at the Escuela de Arquitectura
in Madrid (qualified 1873) and in 1877
began teaching at the Barcelona Escola
Superior d'Arquitectura, of which he
later (1901) became director. In 1890,
with Gallissà, he set up an arts and crafts
workshop in the 'Castle of the Three
Dragons'. His principal buildings include
the Editorial Montaner i Simon offices
(1881–5), the International Hotel and
Café-Restaurant for the 1888 exhibition,
the Hospital de Sant Pau (1902–12), the
Casa Lleó Morera (1905) and the Palau
de la Música Catalana (1905–8). He
wrote an *História General del Arte*
(1886–97) in collaboration with Puig i
Cadafalch and contributed articles to
various journals, founding *El Poble
Català* in 1904. He was president of the
Lliga de Catalunya (1888) and of the
Unió Catalanista (1892) and was twice
elected to the Cortes (1901, 1903).

64
*Editorial Montaner i Simon (drawing of
decorative details)*, c.1881
Ink on paper, 44 × 22 cm
Collection Domènech Family, Barcelona
Illustrated p. 17 (fig. 4)

65
Café-Restaurant (elevation), 1888
Ink on paper, 42 × 60 cm
Signed by the architect (Domènech) and
director general of works (Elies Rogent)
Col.legi d'Arquitectes de Catalunya,
Barcelona
Illustrated p. 106 (fig. 102)

66
Palau Montaner (interior design), c.1890
Ink on paper, 26.8 × 32.4 cm
Collection Oriol Bohigas, Barcelona

67
*Hospital de Sant Pau (perspective and
elevation)*, c.1902–10
Ink on paper, 57 × 81; 83 × 125 cm
Collection Domènech Family, Barcelona
Cf. illustration p. 123 (fig. 119)

68
Palau de la Música Catalana (elevation),
1905
Ink on paper, 80 × 63 cm
Collection Domènech Family, Barcelona
Cf. illustration p. 126 (fig. 123)

69
*Decorative elements from Palau de la
Música Catalana*, c.1908
Glazed ceramic, 40 × 40 × 3 (4 tiles);
34 × 34 × 34; 17 × 17 × 17;
55 × 55 × 4 cm
Palau de la Música Catalana, Barcelona
Cf. illustrations pp. 126–7

See also no. 40

Domingo i Segura, Francesc
Barcelona 1893–São Paulo 1974

Painter. He studied at the Escola Superior
dels Bells Oficis and was a member of
Les Arts i els Artistes and the Agrupació
Courbet. He had his first exhibitions
(c.1918) in the offices of *La Publicidad*.
He lived in Paris (1922–7) and Brittany
(1927–9), returning to Barcelona in 1931.
In 1927 he had a one-man show at the
Sala Parés and again in 1929, and
he became one of the artists closely
associated with the gallery. After the
Civil War he lived in Argentina and later
settled in Brazil.

70
Cubist village, c.1920
Oil on canvas, 50 × 62 cm
Signed bottom right
Private collection
Illustrated p. 201 (fig. 213)

71
*Apolo Palace (also known as Eden
Concert, Music Hall)*, c.1933
Oil on canvas, 146 × 113 cm
Collection J.B. Cendrós, Barcelona
Illustrated in colour p. 60 (fig. 60)

Elias i Brancons, Feliu
Barcelona 1878–1948

Painter, critic ('Joan Sacs'), caricaturist
('Apa'), decorative arts designer and art
historian. He studied at the Hoyos
Painting Academy and the Cercle

Artístic de Sant Lluc. His caricatures
were included in the *Cu-cut!* show at the
Sala Parés (1908) and in that year he
founded *Papitu*, which he directed until
1911. From 1910 to 1912 he lived in exile
in Paris, and his anti-German cartoons
published as *Kameraden* (1917) won him
the Légion d'Honneur in 1919. He was a
member of Les Arts i els Artistes and
was included in their first group show
(1910) at the Faianç Català, where he
had his first one-man show in 1914. He
was one of the principal collaborators on
the journals founded by Santiago Segura,
Picarol, *Revista Nova* and *Vell i Nou*, of
the last of which he became editor. He
taught art history at the Escola Superior
dels Bells Oficis and the Escola Elemental
del Treball (1920–23) and organised
exhibitions of Catalan art in Portugal
(1922) and Holland (1923). He again went
into exile in France in 1936.

72
La Galeria, 1928
Oil on canvas, 63 × 52 cm
Signed and dated on reverse
Museu d'Art Modern, Barcelona (11022)
Illustrated p. 65 (fig. 65)

73
Woman with a vase of flowers, c.1929
Oil on canvas, 61 × 52 cm
Signed bottom left
Collection J.B. Cendrós, Barcelona
Illustrated in colour p. 176 (fig. 185)

See also nos. 273, 312

Ernst, Max
Brühl 1891–Paris 1976

Painter and sculptor. A pioneer of Dada
and early member of the surrealist group,
he was associated with Miró in the late
1920s, despite a legendary rivalry, and
they collaborated on a ballet – *Romeo
and Juliet* – for Diaghilev. He appeared
in the Buñuel-Dalí film *L'Age d'or* (1930)
and was represented with fifteen works
in the ADLAN-Tenerife show (May 1934)
sponsored by the *Gaceta de Arte*, where
L'Age d'or was again shown. Ernst's
drawing for Foix's unpublished book on
Surrealism is a version of *Third visible
poem no. 2*, one of the collages in his *Une
Semaine de bonté*, published in 1934;
the 184 collages for this work were
included in the large show of Ernst's
work in Madrid in March–April 1936.

74
Untitled drawing, 1934
Pencil on paper, 22.5 × 19 cm
Private collection
Illustrated p. 222 (fig. 236)

Galí i Fabra, Francesc d'Assís
Barcelona 1880–1965

Painter, graphic artist and teacher. He studied at the Llotja and the Hoyos Painting Academy and was a member of the Cercle Artístic de Sant Lluc. In 1906 he founded his private art school, and he became first director of the Escola Superior dels Bells Oficis (1915–24). He painted the interior of the central cupola of the Palau Nacional built for the 1929 exhibition. His work was only rarely exhibited. He was the representative for the fine arts on the Council of the Escola Nova Unificada from 1936. After 1939 he lived in exile in England.

75
Spring, c.1930
Oil on canvas, 129 × 96 cm
Signed bottom right
Collection J.B. Cendrós, Barcelona
Illustrated in colour p. 48 (fig. 49)

76
Orquestra Pau Casals, 1931
Poster (printed by Artes Gráficas S.A.),
53.3 × 37.1 cm
Museu d'Art Modern, Barcelona (RG 947)
Illustrated in colour p. 245 (fig. 275)

Gallissà i Soqué, Antoni Maria
Barcelona 1861–1903

Architect, designer and politician. He studied architecture in Barcelona (qualified 1885) and later taught at the Escola Superior d'Arquitectura; with Domènech he set up the arts and crafts workshop in the 'Castle of the Three Dragons' (1890). His work included the design or remodelling of private houses and the design of family tombs as well as furniture, ceramics, tiles and banners. He had an important collection of medieval tiles. He took part in the formulation of the *Bases de Manresa* and was president of the Unió Catalanista.

77
La Riva tomb, Cementeri Nou, 1891
Ink on paper, 61.2 × 74 cm
Private collection

78
Can Camps (elevation), c.1890–5
Ink and pencil on paper, 43.5 × 54 cm
Private collection

79
'El Globo' shop, Granollers, c. 1890–5
Ink on paper, 28.2 × 41 cm
Private collection

80
Design for banner of Orfeó Català, 1896
Watercolour on paper, 42.5 × 18.3 cm
Private collection

81
Banner of Orfeó Català, 1896
Silk and velvet, 140 × 40 cm
Palau de la Música Catalana, Barcelona

Gargallo i Catalán, Pau
Maella 1881–Reus 1934

Sculptor. He studied at the Llotja with Arnau and V. Vallmitjana. With Blay and Arnau he was one of the sculptors employed on the decoration of the Palau de la Música (1905–8), and he collaborated with Domènech on several other *modernista* buildings. He first went to Paris in 1903, returning there in 1907, and the city later became his home (1912–14, 1923–34). He was a member of Les Arts i els Artistes and took part in their first group exhibition at the Faianç Català (1910), and he was included in the *Almanach dels noucentistes*. He was head of the sculpture department at the Escola Superior dels Bells Oficis (1917–23). He had one-man shows at the Galeries Laietanes in 1916 and at the Sala Parés in the year of his death.

82
Leda, c.1903
Marble, 25 × 26.2 × 18.5 cm
Private collection
Illustrated p. 34 (fig. 28)

83
Model for proscenium, Palau de la Música Catalana, 1908
Plaster (2 pieces),
150 × 196 (91 + 105) × 20 cm
Palau de la Música Catalana, Barcelona
Cf. illustration p. 127 (fig. 124)

84
Portrait of Pablo Picasso, c.1913
Stone, 22.5 × 21 × 23 cm
Museu d'Art Modern, Barcelona (11012)
Illustrated p. 62 (fig. 61)

85
Maternity, c.1922
Terracotta, 29 × 15 × 15 cm
Museu d'Art Modern, Barcelona (71473)
Illustrated p. 54 (fig. 53)

86
The Harvester, 1924
Bronze, 11 × 18 × 26 cm
Signed and dated on right of base
Museu d'Art Modern, Barcelona (65587)
Illustrated p. 172 (fig. 179)

87
Dancer (Gran Dansarina), 1929
Iron, 123 × 70 × 50 cm
Signed and dated on circular base
Museu d'Art Modern, Barcelona (108413)
Illustrated p. 64 (fig. 64)

GATCPAC
See under Sert, Torres i Clavé

Gaudí i Cornet, Antoni
Reus 1852–Barcelona 1926

Architect and designer. He studied architecture in Barcelona (qualified 1878) and in 1883 was appointed architect of the Sagrada Família. In 1878 he met Count Eusebi Güell, who became his principal patron. He was a founder member of the Cercle Artístic de Sant Lluc. He designed domestic and religious architecture, as well as furniture, interior lighting, etc., working with a small group of associates, who included the architects Berenguer, Jujol and Rubió and the painter Aleix Clapés. His principal works are the Sagrada Família, Casa Vicens (1883–5), Finca Güell (1883–7), Palau Güell (1885–9), Colònia Güell (1898–1915), Parc Güell (1900–14), Casa Batlló (1905–7) and Casa Milà, 'La Pedrera' (1906–10)

88
Rendering of the project by Joan Martorell for the completion of Barcelona Cathedral, 1882
(lettering and heraldic device executed by Domènech i Montaner)
Ink and watercolour on paper,
100 × 51 cm
Col.legi d'Arquitectes de Catalunya, Barcelona (1000)

89
Casa Vicens (façade), 1883
Ink on linen, 46 × 64 cm
Dated (15 Jan. 1883); signed by the architect (Gaudí) and owner (Vicens)
Institut Municipal d'Història (Arxiu Municipal Gràcia), Barcelona
Illustrated p. 118 (fig. 112)

90
Casa Batlló (floor plans, elevation and section of façade), 1904
Ink on linen, 47 × 96 cm
Dated (26 Oct. 1904); signed by the architect (Gaudí) and owner (Batlló)
Arxiu Administratiu de l'Ajuntament de Barcelona (9612 OP)
Cf. illustrations pp. 18 (fig. 7), 19 (fig. 8), 104–5 (fig. 100)

91
Casa Milà (plan of basement and section), 1906
Ink on linen, 47 × 80; 48 × 38 cm
Dated (Feb. 1906); signed by the architect (Gaudí) and owner (Milà)
Arxiu Administratiu de l'Ajuntament de Barcelona (10526)
Illustrated p. 22 (figs. 12, 13)

92
*Parc Güell, lodges by the main gate
(sections, plans and elevations)*, 1904
Ink on linen, 63 × 85 cm
Dated (26 Oct. 1904); signed by the
architect (Gaudí) and owner (Güell)
Arxiu Administratiu de l'Ajuntament de
Barcelona (2882 4P)
Illustrated p.118 (fig.113)

93
*Project for a bridge over the river
Pomeret in Sarrià*, 1906
Ink on linen, 64 × 210 cm
Dated (1 Aug.1906); signed by Gaudí
Institut Municipal d'Història (Arxiu de
l'Hospital, Sarrià), Barcelona

94
Part of railing from Casa Vicens, c.1885
Wrought iron, 228 × 252 cm
Ajuntament de Barcelona

95
Chair from Casa Calvet, c.1904 (copy,
c.1950)
Oak wood, 96 × 55 × 62, seat h:49 cm
Casa Museo Gaudí, Barcelona

96
*Pair of 5-panel screens from Casa Milà,
c.1906–9*
Oak wood and rose coloured glass,
208 × 178.5; 196.5 × 200.8 cm
Collection Allan Stone, New York

97
Door from Casa Batlló, c.1906
Oak wood, 287 × 141 × 22 cm
Col.legi d'Arquitectes de Catalunya
(Collection Amics de Gaudí), Barcelona
Illustrated p.231 (fig.252)

98
Chair from Casa Batlló, c.1906
Oak wood, 74 × 52 × 47, seat h:45 cm
Casa Museo Gaudí, Barcelona

99
Double chair from Casa Batlló, c.1906
Oak wood, 103 × 170 × 81, seat h:42 cm
Casa Museo Gaudí, Barcelona

100
Bench from Colònia Güell, c.1915
Eucalyptus wood and wrought iron,
84 × 113 × 68 cm
Church of Colònia Güell, Santa Coloma
de Cervelló
Cf. colour illustration p.125 (fig.122)

101
*Model of two nave bays of the church of
the Sagrada Família*
Plaster, 470 × 470 × 250 cm (1/10 scale),
made by Motlles Gaudí
Generalitat de Catalunya, Barcelona

102
*Photographs by Eikoh Hosoe:
Casa Batlló, Casa Milà, Parc Güell,
Sagrada Família, Colònia Güell*
Colour prints
Collection of the photographer

Giacometti, Alberto
Stampa 1901–Chur 1966

Sculptor. He was a member of the
surrealist group from 1929 to 1936. Work
by Giacometti was included in the
ADLAN-Tenerife exhibition (May 1935)
organised by the *Gaceta de Arte*.

103
Untitled drawing, 1933
Paper glued on wood, 27 × 23 cm
Signed and dated bottom right
Private collection
Illustrated p.223 (fig.242)

Gleizes, Albert
Paris 1881–Avignon 1953

Painter and theorist of Cubism. With
Metzinger he wrote *Du Cubisme*
(published 1912), and works by both
were included in Dalmau's Exposició
d'Art Cubista the same year. He arrived
in Catalonia in 1916 with his wife Juliette
Roche, and their apartment on Rambla
de Catalunya was a gathering place for
artist-exiles during the First World War.
He showed at Dalmau's in 1916 and
1917, when he left for New York.

104
Danseuse de Barcelone, 1916
Oil on paper, 102 × 77 cm
Signed and dated bottom right
Collection Mizné-Blumental
Illustrated in colour p.185 (fig.195)

105
Bullfighter, 1916
Ink on paper, 24.4 × 19.7 cm
Signed and dated bottom left
Guggenheim Museum, New York (38767)
Illustrated p.182 (fig.191)

See also no.267

González i Pellicer, Juli
Barcelona 1876–Arcueil 1942

Sculptor, painter and jeweller. He learnt
welding and jewellery design with his
father Concordi González and studied at
the Cercle Artístic de Sant Lluc. In 1899
he went to Paris for the first time,
returning to Barcelona with Picasso in
1902. However, for the rest of his life he
lived and worked primarily in France,
with frequent return visits to Barcelona.
In 1912 he opened a jewellery shop in
Barcelona with his brother-in-law Bassó.

106
Woman bathing her feet, c.1914–18
Oil on canvas, 110 × 60 cm
Museu d'Art Modern, Barcelona
(113503)
Illustrated p.180 (fig.189)

107
Tunnel head, c.1933–5
Bronze, 46 × 32 × 23 cm
Museu d'Art Modern, Barcelona (113419)
Illustrated p.224 (fig.243)

108
Seated woman (no. 2), c.1935/37
Bronze, 86.5 × 34 × 22 cm
Museu d'Art Modern, Barcelona (113407)

109
Cup and saucer, c.1915–25
Silver, 5 × 6.8 × 9.5 cm (cup);
diam: 13.3 cm (saucer)
Museu d'Art Modern, Barcelona (113595)
Illustrated p.237 (fig.261)

110
Ring, c.1915–25
Gilded iron and chalcedony,
2.5 × 2.2 × 1.9 cm
Museu d'Art Modern, Barcelona (113590)

See also nos. 318, 319, 320

Gual i Queralt, Adrià
Barcelona 1872–1944

Playwright, theatre director, painter and
graphic artist. He studied painting and
drawing with Pere Borrell and was a
member of the Colla del Safrà. He
worked in his father's lithography studio,
which he later ran, forming a partnership
in 1901 with Lluís Barral; the same year
he left the company (which became
Barral Hermanos) to devote himself to
the theatre, although continuing to design
posters and theatrical sets etc. He
founded and ran the Teatre Íntim (from
1898) and from 1913 was director of the
Escola Catalana d'Art Dramàtic.

111
Orfeó Català, 1904
Poster (printed by Henrich & Cia.),
77 × 111 cm
Signed bottom left
Museu d'Art Modern, Barcelona
(RG 1769)
Illustrated p.242 (fig.271)

112
The Judge's wife (La Jutgesa), c.1913
Song book (no.95 from third series of
Cançoner Popular, published by
L'Avenç), 23.8 × 17 cm
Private collection
Illustrated p.276 (fig.309)

See also no.307

Guardiola i Bonet, Josep
Barcelona 1869–1950

Ceramist and painter. He studied with Lluís Rigalt and Ramon Amado and at the Llotja. His first one-man show of ceramics was in 1918 at the Sala Parés. He worked at Sèvres from 1934 to 1937.

113
Vase, 1934
Polychrome pottery, h: 46 cm;
diam: 25 cm (at mouth)
Signed and dated (17 July 1934) on base
Museu de Ceràmica, Barcelona (8705)

Homar i Mezquida, Gaspar
Bunyola, Mallorca 1870–Barcelona 1953

Designer and furniture-maker. He came from a family of cabinet-makers, and from an early age worked in Barcelona with Francesc Vidal. He set up his own cabinet-making business in 1893. In addition to the complete decoration of the Lleó Morera house (1905) for Domènech, he undertook the decoration of several other *modernista* houses, collaborating with Riquer, Bru, Serra and, in particular, Josep Pey. After 1918 he concentrated on the production of commercial furniture.

114
Casa Lleó Morera, designs for decoration of drawing room: side panels with mirrors; side panel with marquetry design of girls playing; light fixture; ceiling; sofa-cabinet (see no.116) and wallpaper patterns, c.1904
Ink and watercolour on paper,
26.3 × 63.5; 24.4 × 49; 35.5 × 14.5;
31.5 × 48.7; 42 × 47
Museu d'Art Modern, Barcelona
(107374, 107405, 107419, 107425, 107458)

115
Drawings for furniture: fireplace; cupboard; chair; armchair, c.1905–10
Watercolour on paper, 20 × 23; 24 × 26;
6 × 12; 8 × 14 cm
Private collection

116
Sofa-cabinet with marquetry panels from Casa Lleó Morera, c.1904
(marquetry designed by Josep Pey)
Wood and other materials,
268 × 259 × 50 cm; side panels each
176 × 91 cm
Museu d'Art Modern, Barcelona
(71703, 71719–20)
Illustrated p.228 (fig.247);
colour detail p.233 (fig.255)

See also no.212

Hugo, Valentine
Boulogne-sur-mer 1887– Paris 1968

Painter and designer. She worked with the Ballets Russes (1908) and was a friend of Satie and Cocteau, and later of Breton and the Eluards. She took part in the ADLAN-Tenerife show (May 1935) sponsored by the *Gaceta de Arte*. The painting on which her drawing for Foix's unpublished book on Surrealism was based was shown there and in New York at *Fantastic Art, Dada and Surrealism* (1936–7).

117
Rêve du 17 janvier 1934, 1934
Ink on paper, 50 × 32 cm
Signed and inscribed top left
Private collection

Hugué, Manolo
See Martínez i Hugué, Manuel

Humbert i Esteve, Manuel
Barcelona 1890–1975

Painter and graphic artist. He studied at the Llotja and Galí's art school. He contributed to *Papitu* (as 'Isaac') and *Picarol*. He visited Paris in 1909–10 and 1913, and lived there 1917–27 and 1935–9. In 1916 he collaborated with Nogués on the decoration of 'La Basílica', the antique shop run by Segura and Dalmau, and in 1929 with Galí on the cupola frescoes of the Palau Nacional.

118
Exposició d'Art Primavera, 1921
Poster (printed by Henrich & Cia.),
76 × 54.8 cm
Signed bottom right
Museu d'Art Modern, Barcelona (RG 621)
Illustrated p.181 (fig.190)

Jean, Marcel
b. La Charité-sur-Loire 1900

Painter and writer, member of the surrealist group from 1932–50. Drawings by Jean were included in the ADLAN-Tenerife exhibition (May 1935) sponsored by the *Gaceta de Arte*.

119
Untitled drawing, 1933–4
Ink on paper glued on wood, 30 × 25 cm
Signed top right
Private collection
Illustrated p.222 (fig.239)

Jener i Casellas, Eduard
Gràcia, Barcelona 1882–Barcelona 1967

Designer, graphic artist and painter. He studied at the Academy of Sant Carles in Valencia. For more than thirty years he worked as chief designer at Monegal's Myrurgia perfume factory.

120
Maderas de Oriente and *Bleu Or*, 1929
Glass perfume bottles with printed labels designed for Myrurgia
Collection Myrurgia Factory, Barcelona
Illustrated p.238 (figs.265, 266)

Jujol i Gibert, Josep Maria
Tarragona 1879–Barcelona 1949

Architect and designer. He studied at the Escola Superior d'Arquitectura from 1901 and during this period worked in the studios of Gallissà and Font y Gumà; he qualified in 1906 and returned to teach at the school from 1910. He collaborated with Gaudí on the Casa Batlló, Casa Milà, Parc Güell and restoration of Palma Cathedral, and his own principal works include the Mañach shop (1911) in Barcelona, the Casa Guibert ('Torre dels Ous', 1913–16) and Masia Negre (1914–30) in Sant Joan Despí and the Vistabella church (1918–23). His later career was principally dedicated to work for the church. He also designed ecclesiastical and domestic furniture.

121
*Lettering for safe from Mañach shop,
c.1911*
Bronze, 2.3 × 11 cm
Collection Oriol Bohigas, Barcelona

Llimona i Bruguera, Joan
Barcelona 1860–1926

Painter, brother of Josep Llimona and brother-in-law of the composer Enric Granados. He studied at the Llotja and in Rome and first exhibited in Barcelona in 1882. Both brothers were ardent Catholic converts and were the founders of the Cercle Artístic de Sant Lluc.

122
Lament (Plany), 1911
Song book (one of Morera's Catalan song arrangements published by L'Avenç; original edition 1897), 27.2 × 18.6 cm
Private collection

Llimona i Bruguera, Josep
Barcelona 1864–1934

Sculptor. He attended the Llotja and in 1880 won the Pensión Fortuny, which allowed him to study for four years in Rome. He showed his work in the official exhibitions at the Palau de Belles Arts, in the fifth of which (1907) *Desconsol* won the prize of honour. Many of his works have a religious theme, and he also executed a number of public monuments in Barcelona, including the figures for the monument to Dr Robert (1903–10), on which he collaborated with Gaudí.

123
Grief (Desconsol), 1907
Marble, 67 × 76 × 80 cm (third version)
Signed bottom left
Museu d'Art Modern, Barcelona (10861)
Illustrated p. 27 (fig. 18)

Llorens i Artigas, Josep
Barcelona 1892–1980

Ceramist and critic. He studied at the
Llotja, the Cercle Artístic de Sant Lluc
and the Escola Superior dels Bells Oficis.
He took up pottery *c.*1915, and his first
cricitisms appeared in *La Veu de
Catalunya* in 1917; he was also a principal
contributor to *L'Instant* and *La Mà
Trencada*. He was a founder member of
the Agrupació Courbet in 1918, and the
same year paid his first visit to Paris,
where he was to live from 1923 to 1940.
In 1919 he became secretary and assistant
director of the Escola Tècnica d'Oficis
d'Art, and after his move to Paris he
showed in Barcelona with the Artistes
Reunits at the 1929 exhibition and at the
Sala Parés in 1932. He collaborated with
Dufy, and later with Braque and Miró
on large ceramic projects.

124
Plate, 1921
Decorated pottery, diam: 25 cm
Signed and dated on base
Collection Jordi Serra, Cornellà
Illustrated p. 232 (fig. 254)

125
Vase, 1924
Glazed pottery, h: 30 cm
Signed on base
Collection Jordi Serra, Cornellà
Illustrated p. 62 (fig. 62)

See also no. 167

Magritte, René
Lessines 1898– Brussels 1968

Belgian surrealist painter. He met Dalí
in Paris in 1929 and visited him that
summer in Cadaqués, where he was to
meet other local artists, including Planells,
whose work strongly suggests his
influence. Magritte's drawing for Foix's
unpublished book on Surrealism relates
to a painting of the same title of 1933.
He had one work in the ADLAN-Tenerife
exhibition (May 1935) sponsored by the
Gaceta de Arte.

126
La Lumière des coïncidences, 1934
Ink on paper glued to wood, 18 × 22 cm
Signed and dated bottom right;
inscribed bottom left
Private collection
Illustrated p. 223 (fig. 240)

Marinel.lo i Capdevila, Ramon
b. Terrassa 1911

Sculptor and designer. He studied at the
Llotja with Àngel Ferrant and had a joint
exhibition with Sans and Serra in 1935
organised by ADLAN at the Galeries
Catalònia. In 1936 he showed with
Breton's surrealist group in Paris and in
the 'Logicofobistes' exhibition also
organised by ADLAN. He later devoted
himself to industrial design.

127
Acrobat (Equilibrista), *c.*1936
Terracotta, 16 × 24 × 11 cm
Private collection
Illustrated p. 220 (fig. 234)

128
Figures beside the sea, 1936
Plaster attached to wood,
27 × 46 × 12 cm
Collection Marinel.lo, Barcelona
Illustrated p. 215 (fig. 227)

See also no. 174

Martí i Alsina, Ramon
Barcelona 1826–94

Painter. He studied at the Llotja and
taught there from 1852. He travelled to
France on several occasions and later
(*c.*1879) established a popular private
academy in Barcelona, which was
particularly influential for its introduction
of the realist ideas of Courbet.

129
View of Barcelona, 1889
Oil on canvas, 44 × 57 cm
Signed and dated bottom right
Museu d'Art Modern, Barcelona (4095)
Illustrated p. 155 (fig. 156)

Martínez i Hugué, Manuel
(Manolo Hugué)
Barcelona 1872–Caldes de Montbui 1945

Sculptor and jewellery designer. He
assisted Juli Pi in the puppet theatre at
Els Quatre Gats and in 1900 went to
Paris, where he became a part of the
bande à Picasso. In 1910 he moved to
Ceret, where he lived until 1915 and in
1919–27. He had his first one-man show
in Spain at the Galeries Laietanes in 1917
and in 1918 promoted the foundation in
Barcelona of the Agrupació Courbet.

130
Crouching figure, 1907–9
Bronze, h: 7 cm; base: 18.5 cm
Collection Arturo Ramón, Barcelona

131
Crouching woman, 1914
Bronze, h: 22 cm (no. 15 of edition of 20)
Galerie Louise Leiris, Paris
Illustrated p. 173 (fig. 181)

132
Bust of a woman, 1922
Stone relief, 55 × 62 cm
Galerie Louise Leiris, Paris
Illustrated p. 56 (fig. 55)

133
Bacchante, 1934
Bronze, 50 × 80 × 16 cm
Signed bottom left
Museu d'Art Modern, Barcelona (113762)

See also no. 32

Mascaró, Pere
fl. Barcelona *c.*1900

Silversmith, best known for the works he
executed for the Orfeó Català.

134
Pendant: Sant Jordi, 1905 (emblem of
Unió Catalanista, designed by Riquer)
Silver and enamel, 5 × 4 cm
Private collection
Illustrated p. 79 (fig. 78)

Masriera i Rosés, Lluís
Barcelona 1872–1958

Painter, silversmith, jeweller, theatre
director and set designer. He was a
third-generation member of a family of
Barcelona jewellers. He studied
jewellery design in Paris, London and
Geneva (1889) and introduced
translucent enamels to Spain. He first
exhibited his *modernista* jewellery in
Barcelona in 1901. He was awarded the
grand prize for set design at the Paris
1925 *Arts Décoratifs* exhibition.

135
Pendant: Sant Jordi, *c.*1905
Gold, enamel, diamonds, 4.5 × 3.6 cm
Museu d'Art Modern, Barcelona (71983)
Illustrated p. 230 (fig. 251)

136
*Pendant: Aeroplane over the city of
Barcelona*, 1905
Gold, enamel, diamonds, diam: 3.2 cm
Private collection
Illustrated in colour p. 1 (fig. 1)

Meifrèn i Roig, Eliseu
Barcelona 1859–1940

Painter, principally of landscape and
marine subjects. He studied with Caba
at the Llotja. He spent time in Paris in
the 1870s and was a restless traveller
throughout his life; he took part in
numerous exhibitions in Madrid,
Barcelona, Europe and America. He
participated in the *Festa modernista* of
1894 (as one of the artists ceremonially
carrying the paintings by El Greco) and
was one of the circle at Els Quatre Gats.

137
(Attributed)
*Eleven shadow puppets from Els Quatre
Gats: caricatures of Àngel Guimerà,
Pompeu Gener, Maurici Vilomara,
'Mossèn Pollastre', a critic, a woman
(with heaving breast), a cellist and other
local figures, c.1897*
Black card, metal rods and wire,
h: approx. 20 cm
Collection Carolina Meifrén de Jimenez
Illustrated p. 42 (fig. 41)

See also no. 52

Mercadé i Queralt, Jaume
Valls 1887–Barcelona 1967

Jewellery designer and painter. He
attended Galí's art school and had his
first one-man exhibition at the Galeries
Laietanes (1916). He taught jewellery
design at the Escola Superior dels Bells
Oficis from 1919. In 1925 he won a gold
medal for his jewellery at the Paris *Arts
Décoratifs* exhibition, and his work
was featured in the Barcelona 1929
International Exhibition. His later
paintings were devoted to evocations of
the Catalan countryside.

138
Zeppelin over Barcelona, 1930
Oil on canvas, 110 × 143 cm
Signed and dated bottom right
Collection J.B. Cendrós, Barcelona
Illustrated p. 284 (fig. 318)

139
Pendant, 1925
Gold, aquamarine, diamonds, 7 × 3 cm
Collection Jaume Mercadé, Barcelona
Illustrated p. 238 (fig. 264)

140
Box in the form of a pumpkin, 1932
Silver and coral, h: 17 cm; diam: 18 cm
Collection Gustau Camps, Barcelona
Illustrated p. 237 (fig. 262)

141
Collar, 1934
Silver, length: 40 cm
Collection Jaume Mercadé, Barcelona
Illustrated p. 238 (fig. 263)

142
Six-branched candlestick, 1935
Silver, h: 24 cm; diam: 24 cm
Collection Jaume Mercadé, Barcelona

Mestres i Oños, Apel.les
Barcelona 1854–1936

Illustrator, writer, playwright and
musician. He studied at the Llotja and
later worked in the studios of Lorenzale
and Martí i Alsina. From 1872 he began
working as an illustrator with the
publisher Innocenci López, contributing

to *La Campana de Gràcia* and *L'Esquella
de la Torratxa*; he also worked on the
Madrid paper *El Globo* (1883–93). He
was a prolific illustrator and produced a
great body of literary and theatrical
works from 1876 to the end of his life.

143
Drawings for Liliana, 1902–7
Ink on paper, approx. 32 × 22 (9 full-page
designs and borders); 26.8 × 16.5 (Ex
Libris; 23.8 × 20 (printer's imprint);
19.2 × 14 (author's monogram);
11.5 × 33.2 (3 decorative headings);
21.2 × 30, 18 × 26 cm (2 decorative
devices)
Some signed or monogrammed and dated
(between 1 July 1902 and 2 March 1907)
Museu d'Art Modern, Barcelona (46443,
46445–6, 46492, 46496, 46500–1, 46507,
46509; 46444; 46447; 46448; 46468–70;
46461–2)
Illustrated p. 252 (fig. 286)

See also nos. 289, 307

Mies van der Rohe, Ludwig
Aachen 1886–Chicago 1969

Architect; director of the Bauhaus
(1930–33). He visited Barcelona in
connection with his design of the two
German pavilions at the 1929
International Exhibition, for which he
also designed the 'Barcelona chair'.

144
*Model of German Pavilion at Barcelona
International Exhibition*, 1929
Wood, glass and metal, 35 × 100 × 75 cm
(1/100 scale), made 1985 by Juan Pablo
Marin
Ajuntament de Barcelona
Cf. illustration p. 66 (fig. 66)

145
Barcelona chair, 1929 (reproduction)
Chrome-plated steel and latex foam
covered in plastic, 76 × 76 × 76 cm
Victoria and Albert Museum, London
(Circ. 84–1969)
Cf. illustration p. 66 (fig. 66)

Mir i Trinxet, Joaquim
Barcelona 1873–1940

Painter. He studied with Graner and at
the Llotja. He was a member of the Colla
del Safrà and of the Els Quatre Gats
circle, and during this early period, when
he was showing works at the official
exhibitions, he painted some subjects of
social concern, but for the rest of his life
he was almost exclusively a landscape
painter. He was supported for some time
by his uncle, the industrialist Avelino
Trinxet, in exchange for his work, and he
had his first one-man show at the Sala
Parés in 1901. He first visited Mallorca

in 1899, returning from 1901 to 1903,
when, while recovering after an accident,
he worked in the country around
Tarragona. He had a major exhibition in
1909 at the new Faianç Català gallery
and was a founder member of Les Arts i
els Artistes. In 1913 he moved to Mollet,
in 1919 to Caldes de Montbui, and in
1921 he settled permanently in Vilanova
i la Geltrú. He contributed drawings to
several journals, including *Quatre Gats,
Hispania* and *L'Esquella de la Torratxa*,
and he was included in the *Almanach
dels noucentistes*. He also undertook
decorative work, including murals and
stained glass (1913) for the house of his
uncle (Casa Trinxet) built by Puig i
Cadafalch.

146
Rock at l'Estany (Mallorca), c.1903
Oil on canvas, 102 × 128 cm
Signed bottom left
Museu d'Art Modern, Barcelona (10891)
Illustrated p. 158 (fig. 161)

147
*Terraced village (Maspujols,
Tarragona)*, 1907
Oil on canvas, 121 × 164 cm
Signed lower right
Museu d'Art Modern, Barcelona (4633)
Illustrated in colour p. 165 (fig. 170)

148
Blue gorge, c.1911
Painted and leaded stained glass triptych,
222 × 98 cm (each panel),
made by Rigalt, Granell & Cia.
Museu d'Art Modern, Barcelona (17439)

See also no. 304

Miralles i Galup, Francesc
Valencia 1848–Barcelona 1901

Painter, mainly of portraits and
fashionable scenes. He studied with
Martí i Alsina. In 1863–6 he lived in
Paris and thereafter alternated between
Paris and Barcelona until 1893, when he
settled permanently in Barcelona.

149
Count Güell with his family, 1877
Oil on canvas, 16 × 22 cm
Signed and dated (Paris 1877) bottom
right
Private collection, Barcelona

Mirambell i Ferrer, Joan
Barcelona 1895–1981

Graphic artist and landscape gardener.
He studied at Galí's art school and was a
member of the Cercle Artístic de Sant
Lluc.

See no. 296

Miró i Ferrà, Joan
Barcelona 1893–Ciutat de Mallorca 1983

Painter and sculptor. He studied at the Llotja and Galí's art school and attended classes at the Cercle Artístic de Sant Lluc. He shared a studio with E.C.Ricart and was a founder member of the Agrupació Courbet. His first one-man show was at the Galeries Dalmau in 1918, and the following year, with Ricart, he made his first trip to Paris. Dalmau organised his first Paris exhibition at the Galerie La Licorne in 1921. He lived mainly in Paris from 1920 to 1932 (though he often spent the summers in Montroig) and during the Civil War. He joined the surrealist group in 1924, and on his return to Barcelona in the 1930s he collaborated with ADLAN. In 1937 he designed the poster *Aidez l'Espagne* and painted a mural (*The Reaper*) for the Spanish Republican pavilion at the Paris exhibition. In 1940 he settled in Mallorca.

150
Hermitage of Sant Joan d'Horta, 1917
Oil on cardboard, 52 × 57 cm
Signed bottom left
Fundació Joan Miró, Barcelona (4658)
Illustrated in colour p. 187 (fig. 197)

151
Garden with donkey, 1918
Oil on canvas, 64 × 70 cm
Signed and dated bottom left
Moderna Museet, Stockholm (6078)
Illustrated in colour p. 206 (fig. 219)

152
Aviat L'Instant, 1919 (project for poster announcing *L'Instant* as 'coming soon')
Oil on cardboard, 107 × 76 cm
Signed and dated bottom left
Private collection
Illustrated in colour p. 244 (fig. 274)

153
Head of a Catalan peasant, 1925
Oil on canvas, 91 × 73 cm
Signed and dated bottom right
Private collection
Illustrated in colour p. 69 (fig. 68)

154
Dog barking at the moon, 1926
Oil on canvas, 73.5 × 92 cm
Signed and dated lower left
The Philadelphia Museum of Art,
A.E. Gallatin Collection ('51–61–82)
Illustrated in colour p. 207 (fig. 220)

155
Man and woman in front of a pile of excrement, 1935
Oil on copper, 23.2 × 32 cm
Signed centre right; dated (15–22 Oct. 1935) on reverse
Fundació Joan Miró, Barcelona (4676)
Illustrated p. 75 (fig. 73)

156
Still life with old shoe, 1937
Oil on canvas, 81.3 × 116.8 cm
Dated (24 Jan.–29 May 1937) on reverse
The Museum of Modern Art, New York, James Thrall Soby Bequest 1979
Illustrated in colour p. 71 (fig. 70)

157
Untitled drawing, 1917
Pastel on paper, 56 × 44 cm
Signed bottom right
Fundació Joan Miró, Barcelona (4659)
Illustrated p. 193 (fig. 204)

158
*Untitled drawing, c.*1931
Ink on card, 19 × 30 cm
Signed bottom right
Private collection

159
Untitled drawing, 1933–4
Pencil on paper, 21 × 15 cm
Private collection
Illustrated p. 222 (fig. 237)

160
Homage to Joan Prats, 1934
Lead pencil and collage on paper,
63 × 46.5 cm
Signed and dated ('8/34') bottom right
Fundació Joan Miró, Barcelona (4674)
Illustrated p. 221 (fig. 235)

See also nos. 219, 220, 270, 301, 321, 322

Monegal i Prat, Esteve
Barcelona 1888–1970

Sculptor, writer and graphic artist. He studied at Galí's art school and worked on various publications including *Art Jove* (as 'Complese', 1905–6), *La Publicidad* and *Or y Grana* (as 'Emili Montanér'). In 1908 he was secretary of the Cercle Artístic de Sant Lluc, and he was a member of Les Arts i els Artistes. He studied sculpture with Clarà in Paris (1911–12) and was first director of sculpture at the Escola Superior dels Bells Oficis (1915). In 1917 he founded the Myrurgia perfume company, to which he devoted himself thereafter.

See nos. 286, 293

Nogués i Casas, Francesc Xavier
Barcelona 1873–1941

Graphic artist and painter. He studied at the academies of Martínez Altés and Borrell and in 1901 went to Paris, where he attended classes at the Colarossi and Vity academies. He was a founder member of Les Arts i els Artistes and took part in their first exhibition at the Faiança Català (1910), and he was included in the *Almanach dels noucentistes*. He contributed drawings to *Papitu* (as 'Babel') and was involved in the direction of Segura's magazines *Picarol* (with Aragay) and *Revista Nova* (with Elias) as well as the short-lived satirical *Cucu Fera* (1917). In 1915 he was commissioned by Segura to decorate the cellar of the Galeries Laietanes. He was known for his collections of drawings of popular Catalan life, many of which figured in the decorations he executed for glass and ceramic ware. He was one of the planners of the *Poble Espanyol* at the 1929 exhibition.

161
Coastal landscape seen through an arcade; Two cloaked men with a large glass of wine, 1915
(from Galeries Laietanes cellar)
Distemper panels, 190 × 320;
109 × 150.5 cm
Museu d'Art Modern, Barcelona (42406, 42425)
Illustrated in colour p. 175 (figs. 184, 183)

162
La ben plantada, 1912
Etching with aquatint, 17.7 × 15.9 cm
Signed and dated bottom right
Museu d'Art Modern, Barcelona (R 4918)
Illustrated p. 168 (fig. 173)

163
Glass decorated with hunting scenes, 1924 (made by Ricard Crespo)
Enamelled glass, h: 13; diam: 8 cm
Signed and dated on base
Museu d'Arts Decoratives, Barcelona (4960)

164
Glass decorated with couple walking and birds in flight, 1929 (made by Ricard Crespo)
Enamelled glass, h: 13; diam: 5 cm (at base)
Signed and dated on base
Museu d'Arts Decoratives, Barcelona (65664)

165
*Vase, c.*1928–32 (made by Antoni Serra)
Pottery decorated in blue and green on a white ground, h: 24.5; diam: 12 cm
(at mouth)
Museu de Ceràmica, Barcelona (112889)
Illustrated p. 235 (fig. 257)

166
*Vase, c.*1930
Pottery decorated in blue, sepia and yellow on a white ground, h: 28;
diam: 12.5 cm (at mouth)
Museu de Ceràmica, Barcelona (107540)
Illustrated p. 235 (fig. 259)

167
Vase, 1935 (made by Llorens Artigas)
Pottery decorated in brown, blue, green
and pink on a white ground, h: 19.5;
diam: 6 cm (at mouth)
Museu de Ceràmica, Barcelona (107543)
Illustrated p. 235 (fig. 258)

Nonell i Monturiol, Isidre
Barcelona 1873–1911

Painter. He studied with Mirabent, at
the academy of Martínez Altés, with
Graner and later at the Llotja. He was a
member of the Colla del Safrà. He
showed drawings in 1896 at the salon of
La Vanguardia, for which he was
working, and his first one-man show of
paintings was at Els Quatre Gats in 1898.
He visited Paris with Canals in 1897–8
and returned there for most of the year
in 1899. He exhibited at the Indépendants
from 1902 to 1910 and at the Libre
Esthétique in Brussels (1903), but his first
real success in Barcelona came only with
his exhibition at the Faianç Català in
1910, the year before his death. He was
also a founder member of Les Arts i els
Artistes and showed in their first group
exhibition at the same gallery that year.
He contributed drawings to various
publications including *La Vanguardia*,
L'Esquella de la Torratxa, *La Campana
de Gràcia*, *Quatre Gats*, *Luz*, *Papitu* (as
'Noé' and 'Josué') etc.

168
Two gypsy women, 1903
Oil on canvas, 136 × 136 cm
Signed and dated bottom right
Museu d'Art Modern, Barcelona (4650)
Illustrated in colour p. 37 (fig. 34)

169
La Manuela, 1906
Oil on canvas, 100.6 × 80.5 cm
Signed and dated bottom right
Museu d'Art Modern, Barcelona (10930)
Illustrated in colour p. 166 (fig. 171)

170
Study, 1908
Oil on canvas, 54 × 66 cm
Signed and dated bottom right
Museu d'Art Modern, Barcelona (4658)
Illustrated p. 162 (fig. 167)

171
Seated woman, c. 1899
'Fried' drawing, 28 × 22.5 cm
Signed bottom right
Collection Sr Antoni Argullol, Barcelona
Illustrated p. 46 (fig. 47)

See also nos. 34, 314

Obiols i Palau, Josep
Sarrià 1894–Barcelona 1967

Painter and graphic artist. He studied at
Torres García's Escola de Decoració in
Sarrià and showed with the Agrupació
Courbet in 1919. In 1920–2 he travelled
to Italy with the poet Carles Riba. He
worked as a muralist as well as an
illustrator and poster designer,
particularly on projects associated with
education.

172
Jordi. Setmanari Infantil, 1927
Poster (printed by Tip. Occitania),
42.9 × 31.5 cm
Signed and dated top right
Museu d'Art Modern, Barcelona
(RG 1253)
Illustrated p. 93 (fig. 90)

Oriol i Ballvé, Antoni
Barcelona 1867–1940

Gold- and silversmith. He took over the
jewellery workshop founded in 1850 by
his father Antoni Oriol i Buxó.

173
Pair of cufflinks, 1908
Gold and diamonds, each 1.5 cm
Private collection

Ortiga, Josep
Barcelona 1910–39

Painter. He studied at the Llotja, where
he later taught composition.

174
*ADLAN exhibition poster: Marinel.lo,
Sans, Serra*, 1935
Collage/montage, 50 × 36 cm
Signed lower right
Private collection
Illustrated p. 210 (fig. 222)

Pey i Farriol, Josep
Barcelona 1875–1956

Designer, painter and graphic artist. He
studied at the Llotja and became a
restorer and copier of old master
paintings. He worked with various
Barcelona designers, including Vilaró,
Valls, Busquets, Antoni Serra, Santiago
Marco and, principally, Gaspar Homar,
the majority of whose marquetry panels
he designed. He also collaborated with
the set designer Oleguer Junyent and
worked as a perspectivist for architects.
He illustrated books, designed ex-libris
and contributed drawings to publications,
including *D'Ací i d'Allà*, *La Vanguardia*
and *Mercurio*.

175
Vase, c. 1907 (made by Antoni Serra)
High-fired porcelain, h: 14 cm
Museu d'Art Modern, Barcelona (1579)
Illustrated p. 229 (fig. 249)

See also no. 116

Picabia, Francis
Paris 1879–1953

Painter. Associated principally with
Dada (from 1913) and Surrealism in New
York and Paris. With his wife Gabrielle
Buffet, he arrived in Barcelona in 1916.
In 1917 he produced the first four issues
of *391* with the support of Dalmau; he
left for Zurich later in the year. He
returned to Barcelona for an exhibition
of his work at Dalmau's in 1922.

176
Spanish woman with a rose, 1916
Watercolour and pencil on paper,
54 × 42.5 cm
Signed bottom right and dated ('Seville,
1916') bottom left
Collection S. Romain, Paris

See also no. 315

Picasso, Pablo Ruiz
Malaga 1881–Mougins 1973

Painter, sculptor and poet. Studied with
his father in La Coruña, then at the
Llotja (1895–7) and in Madrid (1897–8).
His first one-man show in Barcelona was
at Els Quatre Gats in February 1900.
From 1900 to 1904 he alternated his
residence between Paris and Barcelona,
then settled permanently in France. He
returned to Catalonia in 1906 (Gòsol),
1909 (Horta), 1910 (Cadaqués) and 1917
(Barcelona). Several further brief visits
to Barcelona followed, the last in 1934,
and his work was exhibited, notably by
Dalmau in 1912 (Blue Period drawings),
in Dalmau's exhibition of avant-garde
French art (1920) and by ADLAN
(1936). He was included in the *Almanach
dels noucentistes* and contributed
drawings to various Barcelona journals
including *Joventut*, *Catalunya Artística*,
El Liberal, *Auba* and *La Mà Trencada*.

177
Man leaning in gothic portal, c. 1896
Oil on wood, 20.2 × 12.8 cm
Museu Picasso, Barcelona (110.203)
Illustrated p. 146 (fig. 145)

178
Corner of cloister of Sant Pau del Camp,
1896
Oil on wood, 15.5 × 10.1 cm
Dated ('diciembre 96') on reverse
Museu Picasso, Barcelona (110.195)
Illustrated p. 146 (fig. 146)

179
Portrait of Carles Casagemas, 1899–1900
Oil on canvas, 55 × 45 cm
Museu Picasso, Barcelona (110.022)
Illustrated p. 45 (fig. 44)

180
Crouching woman, meditating, 1902
Oil on canvas, 63.5 × 50 cm
Signed top right
Private collection
Illustrated p. 41 (fig. 40)

181
Rooftops of Barcelona, 1902
Oil on canvas, 57.8 × 60.3 cm
Museu Picasso, Barcelona (110.020)
Illustrated p. 146 (fig. 144)

182
The Soup, 1902
Oil on canvas, 38.5 × 46 cm
Signed lower right
Art Gallery of Ontario, Toronto, Gift of
Margaret Dunlap Crang, 1983 (83/316)
Illustrated in colour p. 38 (fig. 35)

183
The Blind man's meal, 1903
Oil on canvas, 95.3 × 94.6 cm
Signed top right
The Metropolitan Museum of Art,
New York, Gift of Mr and Mrs Ira Haupt,
1950 (50.188)
Illustrated p. 44 (fig. 43)

184
Portrait of Jaume Sabartés, 1904
Oil on canvas, 49.5 × 38 cm
Signed, dated and inscribed ('Al amigo
Sabartés') top left
Private collection
Illustrated p. 45 (fig. 45)

185
Harlequin, 1917
Oil on canvas, 116 × 90 cm
Museu Picasso, Barcelona (10.941)
Illustrated in colour p. 188 (fig. 198)

186
El Passeig de Colom, 1917
Oil on canvas, 40.1 × 32 cm
Museu Picasso, Barcelona (110.028)
Illustrated in colour p. 2 (fig. 2)

187
Blanquita Suárez, 1917
Oil on canvas, 73.3 × 47 cm
Museu Picasso, Barcelona (110.013)
Illustrated p. 55 (fig. 54)

188
Olga in a mantilla, 1917
Oil on canvas, 64 × 53 cm
Private collection
Illustrated in colour p. 49 (fig. 50)

189
Weeping woman, 1937
Oil on canvas, 60 × 49 cm
Signed and dated centre right
Private collection
Illustrated in colour p. 72 (fig. 71)

190
Portrait of Lola, 1899
Ink and watercolour on paper,
16.5 × 11.5 cm
Signed top left
Private collection

191
Project for a carnival poster, 1899
Black pencil and oil on paper (black
pencil on verso), 48.2 × 32 cm
Musée Picasso, Paris (427)
Illustrated p. 247 (fig. 277)

192
Portrait of Rusiñol, c. 1900
Charcoal and watercolour on paper,
33 × 23 cm
Signed bottom left
Collection Francisco Godia Sales,
Barcelona
Illustrated p. 36 (fig. 33)

193
Portrait of Joan Vidal i Ventosa,
1899–1900
Charcoal and watercolour mixed with
coffee on paper, 47 × 27 cm
Signed top left
Museu Picasso, Barcelona (70.802)
Illustrated p. 36 (fig. 32)

194
Portrait of Ramon Reventós, 1899–1900
Charcoal, conté crayon and watercolour
on paper, 66.5 × 30.1 cm
Signed below left
Museu Picasso, Barcelona (110.872)
Illustrated p. 36 (fig. 31)

195
Portrait of the tailor Soler, 1900
Gouache, ink and watercolour on paper,
22.2 × 10.8 cm
Signed bottom left
Private collection
Illustrated p. 40 (fig. 38)

196
Portrait of Jaume Sabartés seated, 1900
Charcoal and watercolour on paper,
50.5 × 33 cm
Signed bottom left
Museu Picasso, Barcelona (70.228)

197
Crouching woman, 1903
Gouache on paper mounted on canvas,
55 × 38 cm
Signed top right
Collection Max G. Bollag, Zurich

198
Blind man and a girl, 1904
Ink and watercolour on paper,
46 × 31 cm
Signed bottom right
Collection Max G. Bollag, Zurich
Illustrated p. 40 (fig. 39)

199
*Costume design for Chinese conjuror in
Parade*, 1917
Ink on paper, 26 × 19.5 cm (pencil study
for back of costume on verso)
Trustees of the Theatre Museum,
Victoria and Albert Museum, London
Illustrated p. 198 (fig. 209)

200
*Front cover of menu from Els Quatre
Gats*, 1899–1900 (with portrait of Pere
Romeu by Casas on back cover)
Printed card, 21.8 × 32.8 cm
Signed bottom left of front cover
Museu Picasso, Barcelona (110.995)
Illustrated p. 39 (fig. 36)

201
(Attributed)
Sign for Els Quatre Gats, c. 1899
Painted metal, 35 × 34 cm
Manuel Rocamora Foundation,
Barcelona
Illustrated p. 39 (fig. 37)

202
*Costume for American Manager in
Parade*, 1917 (reconstruction realised
1979 by Kermit Love)
Paint on cardboard, wood, fabric, paper,
metal and leather, 339 × 244 × 113 cm
The Museum of Modern Art, New York
Illustrated p. 57 (fig. 57)

203
*Costume for Chinese Conjuror in
Parade*, 1917
Silk
Trustees of the Theatre Museum,
Victoria and Albert Museum, London
Cf. illustration p. 198 (fig. 209)

See also nos. 38, 84, 277, 282, 284, 309,
317, 323, 324

Planells i Cruanyes, Àngel
b. Cadaqués 1901

Painter and lithographer. He studied
lithography in Barcelona, but resided
primarily in Cadaqués, where through
Dalí he met Magritte and other
Surrealists. He had one-man shows at
Dalmau's in 1926 and 1930; in 1929 he
was included in Dalmau's abstract art
exhibition, and in 1936 he took part in
the 'Logicofobistes' exhibition organised
by ADLAN and in the first international
exhibition of Surrealism in London.

204
Still life, c.1925
Oil on canvas, 45 × 53.5 cm
Signed bottom left
Collection J.B.Cendrós, Barcelona
Illustrated p.218 (fig.230)

205
Woman and man's head, 1931
Oil on wood, 40 × 28 cm
Signed and dated top right
Private collection
Illustrated p.74 (fig.72)

206
Untitled, 1935
Oil on wood, 17 × 14 cm
Signed bottom left
Private collection
Illustrated p.219 (fig.231)

Puig i Cadafalch, Josep
Mataró 1867–Barcelona 1957

Architect, art historian and politician.
He studied in Barcelona and Madrid
(qualified 1888) and later (1901–2)
taught at the Barcelona Escola Superior
d'Arquitectura. His principal buildings
include the Casa Puig (1897–1900) and
Casa Garí (1900) in Argentona, and in
Barcelona the Casa Martí (1896–7),
Casa Amatller (1898–1900) – where his
collaborators included Casas y Bardés,
Gallissà, Arnau, Juyol, Homar and
Ballarín, decorative artists with whom
he was to collaborate on other buildings
– Casa Macaya (1901), Codorniu cellars
(1902), Casa Terrades (1903–5), Casa
Trinxet (1904), Casarramona factory
(1911), plan (1915) and palaces
(completed 1923) for the Montjuïc
exhibition site, etc. He was one of the
founders of *La Veu de Catalunya* and
was a co-founder of the Lliga
Regionalista (1901). He was elected to
the Cortes (1907) and was second
president of the Mancomunitat (1917–24). In 1936 he
left Barcelona for exile in France. With
Folguera and Goday he published
L'Arquitectura romànica a Catalunya
(1909–18).

207
Project for main staircase of Casa Amatller, 1900
Ink and watercolour on paper,
26.2 × 28.5 cm
Instituto Amatller de Arte Hispánico,
Barcelona
Illustrated p.21 (fig.10)

208
Design of fireplace for dining room of Casa Serra, c.1900–7
Pencil, ink and wash on paper,
41.5 × 75 cm
Private collection

209
Studies for furniture, c.1900–10
Pencil and ink on paper, 23 × 25 cm
Private collection

210
Perspective of Casarramona factory, c.1911
Pencil and watercolour on paper,
57.5 × 81 cm
Private collection
Cf. illustration p.123 (fig.118)

211
Project for 1917 exhibition (perspective and plan), 1915
Lithographs, 79 × 137; 100 × 160 cm
Dated (30 April 1915)
Arxiu Administratiu de l'Ajuntament de
Barcelona (44301)
Illustrated p.132 (figs.128, 129)

212
(with Gaspar Homar)
Buffet from Casa Amatller, c.1900
Oak wood, 298 × 113 × 58 cm
Instituto Amatller de Arte Hispánico,
Barcelona
Illustrated p.227 (fig.246)

213
Stand from Casa Amatller, c.1900
Oak wood, 119.5 × 41.5 cm
Museu d'Art Modern, Barcelona (114833)

214
(with Manuel Ballarín)
Hanging gas lamp from Casa Amatller, c.1900
Metal and coloured glass,
h: 247; diam: 50 cm
Instituto Amatller de Arte Hispánico,
Barcelona

215
Decorative tiles from Casa Amatller, c.1900
Lustre-glazed ceramic made by Pujol i
Baucis, 20 × 20 × 10 (4 square tiles);
20 × 22 × 22 × 7 cm (2 triangular tiles)
Museu d'Art Modern, Barcelona
(114823–6; 114821–2)

216
Stained glass ceiling above stairwell of Casa Amatller, c.1900
Glass and metal panels attributed to
Rigalt, Granell & Cia., 350 × 450 cm
Instituto Amatller de Arte Hispánico,
Barcelona
Illustrated p.18 (fig.6)

See also nos. 36, 294

Ray, Man
Philadelphia 1890–Paris 1976

Photographer and painter. He was
associated with Dada and surrealist
groups in New York and Paris. He visited

Barcelona in 1933 for a joint exhibition
of his photographs with paintings by
Dalí at the Llibreria Catalònia, and his
photographs of the city appeared with
Dalí's article on *modernista* architecture
in *Minotaur* no.3–4 (Dec. 1933). A
further exhibition of his photos, organised
by ADLAN, was held at the Roca
jewellery shop in May–June 1935. He
was also represented in the ADLAN-
Tenerife show (May 1935) sponsored by
the *Gaceta de Arte*.

217
(Attributed)
Untitled drawing, 1933–4
Pencil on paper, 24.5 × 15.5 cm
Private collection
Illustrated p.223 (fig.241)

See also no.310

Ribera i Cirera, Romà
Barcelona 1849–1935

Painter. He studied at the Llotja and in
Rome (1873–6). He travelled to England
and then settled in Paris. In 1885 he
returned to Barcelona, where he exhibited
with success in various galleries and
official exhibitions.

218
Leaving the ball, c.1894
Oil on canvas, 113 × 65 cm
Signed bottom right
Museu d'Art Modern, Barcelona (10781)
Illustrated p.141 (fig.139)

Ricart i Giralt, Enric Cristòfor
Vilanova i la Geltrú 1893–1960

Painter and engraver. He studied at
Galí's art school and at the Escola
Superior dels Bells Oficis, where he later
taught. He was a close friend of Miró,
with whom he shared a studio (from 1915)
and whom he accompanied on their first
visit to Paris (1919). He also travelled to
Italy (1914) with Rafael Sala and to
London (1921). His first one-man show
was at Dalmau's in 1917, and he was a
founder member of the Agrupació
Courbet. In 1929 he settled permanently
in Vilanova i la Geltrú, making a weekly
visit to Barcelona. He was responsible
for the revitalisation of the technique of
woodblock engraving in Catalonia.

219
Portrait of Joan Miró, 1916
Oil on canvas with metal numbers,
84 × 71 cm
Signed and inscribed ('A l'amic Joan
Miró') bottom right
Fundació Joan Miró, Barcelona (9902)
Illustrated in colour p.59 (fig.59)

220
Joan Miró in the studio he shared with Ricart, 1917
Oil on canvas, 47 × 59 cm
Signed and dated bottom left
Collection F.X. Puig Rovira, Vilanova i la Geltrú
Illustrated p.194 (fig.205)

221
The Porch, 1918
Oil on canvas, 56 × 54 cm
Signed and dated bottom right
Museu Balaguer, Vilanova i la Geltrú
Illustrated p.200 (fig.212)

222
Still life, c.1920
Oil on canvas, 55 × 72 cm
Signed lower right
Private collection
Illustrated p.201 (fig.214)

223
Fishermen on the beach, c.1934
Wood engraving, 28.5 × 41 cm
Signed below plate on right
Museu d'Art Modern, Barcelona (RG 20603)
Illustrated p.251 (fig.285)

See also nos.268, 290, 306, 311

Riquer i Inglada, Alexandre de
Calaf 1856–Ciutat de Mallorca 1920

Painter, graphic artist, designer and poet. He studied at the Llotja, went to Rome (1879), and later to Paris and London. He was a founder member of the Cercle Artístic de Sant Lluc. In 1894 he returned to London and in same year opened his studio in Barcelona, which promoted the design of ex-libris and posters (and which now houses the Arxiu Mas). He executed a number of decorative projects for the 1888 exhibition and designed the decoration for the entrance to the Cercle del Liceu (1901) and other architectural projects. He also made designs for lamps, furniture, tiles, jewellery etc. He contributed drawings to various journals, including *Luz*, *Joventut* (of which he was the first artistic director) and *La Ilustración Artística*, and books, and he undertook the complete design (including bindings) of his own books of poems. He was the most prolific designer of *modernista* printed ephemera. His first one-man show was in 1890 at the Sala Parés, and he continued to exhibit regularly until his death.

224
Salón Pedal, c.1897
Poster, 139.4 × 48.5 cm
Signed lower right
Museu d'Art Modern, Barcelona (RG 365)

225
Mosaicos Escofet-Tejera y Cᵃ, c.1902
Poster (lithography by Antoni Nadal, printed by J. Thomas), 180 × 103.5 cm
Signed lower right
Museu d'Art Modern, Barcelona (RG 383)
Illustrated in colour p.243 (fig.273)

226
Musa Catalana, 1908
Song book (one of a series of Catalan song arrangements published by Bartolomeu Baxarias), 27.7 × 19.5 cm
Signed centre right
Private collection

See also nos.134, 295, 307, 308

Rusiñol i Prats, Santiago
Barcelona 1861–Aranjuez 1931

Painter, writer and playwright. He studied with T. Moragas and lived in Paris (first visit 1889), where he attended classes at the Académie Gervex. In 1884 he exhibited at the Excursionists' Society and the following year took a studio with the sculptor Clarasó. His first joint exhibition with Casas and Clarasó was held in 1890 at the Sala Parés, and these became regular events. He collected medieval ironwork and ancient glass, which were housed with his collection of paintings in the Cau Ferrat in Sitges. He made this house a centre for the promotion of *modernista* painting and theatre at the *Festes modernistes* (1892–9). He was one of the founders of Els Quatre Gats. He wrote for *La Vanguardia* in the 1890s and produced a large body of literature in the first decade of this century. After 1899 he devoted himself in painting to the subject of the gardens of Spain.

227
Portrait of Miquel Utrillo at the Moulin de la Galette, 1891
Oil on canvas, 222.5 × 151 cm
Signed bottom right
Museu d'Art Modern, Barcelona (11384)
Illustrated p.156 (fig.159)

228
The Bohemian (portrait of Erik Satie in his studio in Montmartre), 1891
Oil on canvas, 85 × 67 cm
Signed bottom right
Generalitat de Catalunya, Barcelona
Illustrated in colour p.153 (fig.154)

229
Interior of a café, 1892
Oil on canvas, 100.3 × 81.9 cm
Signed bottom right
John G. Johnson Collection at the Philadelphia Museum of Art (J.1078)
Illustrated p.25 (fig.16)

230
Girl with a drum, c.1892
Oil on canvas, 114 × 97 cm
Signed bottom right
Collection Enrique Torelló Enrich, Barcelona
Illustrated p.148 (fig.147)

231
Interior with figures, c.1894
Oil on canvas, 80.5 × 64.5 cm
Signed bottom right
Museu d'Art Modern, Barcelona (4051)
Illustrated in colour p.154 (fig.155)

232
Poetry, 1895
Oil on canvas, 140 × 194 cm
Signed bottom right
Museu Cau Ferrat, Sitges (32007)
Illustrated p.28 (fig.19)

233
Pine grove in Aranjuez, c.1930
Oil on canvas, 124 × 154 cm
Signed bottom left
Collection J.B. Cendrós, Barcelona
Illustrated p.159 (fig.162)

234
L'Alegria que passa, 1898 (advertising his own play with music by Morera)
Poster (printed by Utrillo & Rialp), 85.5 × 55 cm
Signed bottom left
Museu de les Arts de l'Espectacle, Barcelona
Illustrated p.150 (fig.149)

235
Fulls de la vida, c.1898 (advertising his own book)
Poster (lithography by M.Utrillo, printed by Henrich & Cia.), 102 × 72 cm
Signed by artist and monogrammed by lithographer centre right
Museu d'Art Modern, Barcelona (RG 400)
Illustrated p.29 (fig.20)

236
Teatro artístio, 1900 (advertising the first Catalan production of Maeterlinck's *Interior*)
Poster (printed by A.Gual), 85.5 × 58.5 cm
Signed lower left
Museu de les Arts de l'Espectacle, Barcelona
Illustrated p.29 (fig.21)

237
The Nightingale (El Rossinyol), 1911
Song book (one of Morera's Catalan song arrangements published by L'Avenç, original edition 1897–8), 27 × 18.6 cm
Signed lower left
Private collection
Illustrated p.279 (fig.314)

See also nos.23, 192

Sans, Jaume
b. Sitges 1914

Painter and sculptor. He studied with
Àngel Ferrant at the Llotja. In 1935 he
had a joint exhibition with Marinel.lo
and Serra organised by ADLAN at the
Galeries Catalònia, where he also took
part in the ADLAN 'Logicofobistes'
exhibition the following year.

238
Forma, 1934
Oil on wood, 13.5 × 14.5 cm
Collection Jaume Sans, Barcelona
Illustrated p. 214 (fig. 224)

239
Camagüey, 1935
Oil on canvas, 101 × 128 cm
Signed and dated top right
Collection Jaume Sans, Barcelona
Illustrated p. 213 (fig. 223)

See also no. 174

Serra i Abella, Josep
b. Hospitalet del Llobregat 1906

Ceramist. Worked with his father Antoni
Serra and with his brothers, with whom
he had a joint exhibition at the Galeries
Syra in 1934 and showed at the Sixth
Milan Triennale (1936)

240
*Bell-shaped vase with metallic lustre
glaze*, 1933
Glazed earthenware, h: 14; diam: 17 cm
(at mouth)
Signed on base
Collection Jordi Serra, Cornellà

Serra i Fiter, Antoni
Barcelona 1869–Cornellà del Llobregat
1932

Ceramist and painter. He started his
career as a painter and took up ceramics
around the turn of the century,
specialising in high-fired porcelain. He
collaborated with a number of painters
and sculptors, notably Pey, Nogués,
Ismaël Smith, Casanovas and Gargallo.
In 1921 he became professor of ceramics
at the Escola Superior dels Bells Oficis,
and he established his studio in Cornellà
del Llobregat in 1928.

241
Designs for porcelain, c. 1904–8
Ink and lead pencil on paper,
13 × 20.5 cm
Museu d'Art Modern, Barcelona (108232)
Illustrated p. 229 (fig. 248)

See also nos. 165, 175

Serra i Güell, Eudald
b. Barcelona 1911

Sculptor. He studied at the Llotja with
Àngel Ferrant and had a joint exhibition
with Marinel.lo and Sans in 1935
organised by ADLAN at the Galeries
Catalònia.

242
The Ladder, 1934
Collage, 35 × 40 cm
Collection of the artist, Barcelona
Illustrated p. 219 (fig. 232)

243
Guitars, 1934
Collage, 82 × 113 cm
Collection of the artist, Barcelona
Illustrated p. 214 (fig. 225)

See also no. 174

Sert i López, Josep Lluís
Barcelona 1902–1983

Architect. He studied at the Escola
Superior d'Arquitectura (qualified 1928),
and in 1927 travelled to Italy with Torres
Clavé. In 1929 he set up office with Sixt
Yllescas, though he spent much of
1929–30 working in Le Corbusier's studio
in Paris. He was one of the creators of
the GATCPAC, and his principal works
of this period (executed in collaboration
with other members of the group) include
several municipal projects related to the
Macià plan – the Casa Bloc, Dispensari
Central and plans for the Ciutat de Repòs
i de Vacances – as well as an apartment
house on Carrer Muntaner. In 1937 (with
Luis Lacasa) he designed the Spanish
Republican pavilion at the Paris
exhibition, in which *Guernica* and Miró's
Reaper were displayed. After the Civil
War he lived in exile in the USA, where
he succeeded Gropius as head of the
department of architecture at Harvard.

244
(with Torres Clavé and Subirana)
*Model of Tuberculosis Clinic
(Dispensari Central)*, 1934–8
Plaster, 18 × 63.5 × 36 cm (1/100 scale),
made 1980 by Juan Pablo Marin
Collection Juan Pablo Marin, Barcelona
Cf. illustration p. 108 (fig. 105)

See also nos. 252, 253, 325

Subirana i Subirana, Joan Baptista
Rosario de Santa Fe, Argentina 1904–
Barcelona 1979

Architect and designer. He studied in
Barcelona, Madrid and Berlin (qualified
in 1930) and was a member of the
GATCPAC.

See no. 244

Sunyer i Clarà, Ramon
Barcelona 1889–1963

Jewellery designer. He attended Galí's
art school and later taught at the Escola
Superior dels Bells Oficis. His work was
shown in numerous exhibitions, including
the 1925 *Arts Décoratifs* exhibition in
Paris and the Sixth Triennale in Milan
(1936), and he exhibited with the Artistes
Reunits at the Barcelona 1929 exhibition.
He founded the Amics de l'Art Litúrgic
and the Amics de Gaudí.

245
Photograph frame, 1920
Silver and glass, 10.5 × 5.1 × 2.5 cm
Collection Sunyer Family, Barcelona

246
Jewellery box, 1920
Silver and enamel, h: 9;
base: 12.5 × 12.5 × 12.5 cm
Collection Sunyer Family, Barcelona

Sunyer i de Miró, Joaquim
Sitges 1874–1956

Painter. He studied at the Llotja and in
1896 went to Paris, where he contributed
drawings to *Le Cri de Paris* and other
publications and illustrated various
books, including Jehan Rictus's *Les
Soliloques du pauvre* (1897). From 1905
he was supported by his dealer
Barbazanges, who enabled him to return
regularly to Sitges and to exhibit his work
in Paris and Brussels; he also became
friendly with Picasso and Manolo and
with Renoir (around 1909). In 1911 he
had his first one-man exhibition in
Barcelona at the Faianç Català, and he
returned to the city at the outbreak of
war. He continued to travel, though he
made his home in Sitges from 1919. He
was included in Dalmau's exhibition of
avant-garde French art (1920) and
exhibited regularly in Barcelona. He
went into exile during the Civil War,
returning to Sitges in 1942.

247
Pastoral, 1910–11
Oil on canvas, 106 × 152 cm
Generalitat de Catalunya, Barcelona
Illustrated in colour p. 50 (fig. 51)

248
Landscape at Fornalutx (Mallorca), 1916
Oil on canvas, 100 × 126 cm
Signed bottom left
Museu d'Art Modern, Barcelona (3848)
Illustrated p. 170 (fig. 177)

249
Forn Bay (Cala Forn), 1917
Oil on canvas, 120 × 140 cm
Signed and dated bottom left
Museu d'Art Modern, Barcelona (11004)
Illustrated p. 171 (fig. 178)

250
Portrait of Maria Llimona de Carles, 1917
Oil on canvas, 100 × 81.5 cm
Signed bottom right; dated on reverse
Museu d'Art Modern, Barcelona (3840)
Illustrated in colour p. 47 (fig. 48)

Tanguy, Yves
Paris 1900–Woodbury, Conn. 1955

Painter. He was a member of the
surrealist group from the outset. Several
of his works were shown at the ADLAN-
Tenerife exhibition (May 1935) sponsored
by the *Gaceta de Arte*.

251
Untitled drawing, 1933–4
Ink on paper glued on wood, 35 × 20 cm
Private collection
Illustrated p. 222 (fig. 238)

Torné i Esquius, Pere
Poble Nou, Barcelona 1879–
Flavancourt 1936

Painter and graphic artist. He studied
at the Llotja and had three one-man
shows at the Sala Parés in 1903–5,
but then left for France, where he lived
for the rest of his life. However, he
maintained close links with Barcelona,
exhibiting regularly and furnishing
illustrations for journals such as *Papitu*
(as 'Jafet') and for books, including his
own *Dolços indrets de Catalunya* (1910)
and Josep Carner's translation of Hans
Andersen's *Fairy Tales* (1918)

See no. 298

Torres i Clavé, Josep
Barcelona 1906–Ebro Front 1939

Architect. He studied at the Escola
Superior d'Arquitectura (qualified in
1929) and attended drawing classes at
the Cercle Artístic de Sant Lluc. He met
Sert in 1926–7 and visited Italy with him
in 1927. He was a leading member of the
GATCPAC and was involved in all their
principal projects and directed the
publication of *AC*. He was also one of
the creators (and general secretary) of
the Sindicat d'Arquitectes de Catalunya.
His last collaboration with Sert was on
the Hospital del Valle de Hebron (1936).
In 1937 the Generalitat appointed him
cultural commissar for architecture and
director of the School of Architecture.

252
(with the GATCPAC)
*Barcelona Zona de Repòs (Ciutat de
Repòs i de Vacances)*, 1933
Ink and wash on paper, 103 × 189 cm
Col.legi d'Arquitectes de Catalunya,
Barcelona
Cf. illustration p. 138 (fig. 136)

253
(with the GATCPAC, Le Corbusier and
P. Jeanneret)
Macià plan, 1936–8
Gouache on paper, 150 × 700 cm
Collection R. Torres i Torres, Barcelona
Illustrated pp. 138–9 (fig. 137)

See also no. 244

Torres García, Joaquín
Montevideo 1874–1949

Painter and theorist. He studied at the
Llotja and at the Baixas Academy and
frequented the Cercle Artístic de Sant
Lluc. He became an illustrator and did
mural paintings for churches and public
buildings, collaborating with Gaudí in
1904–5 on window designs for Palma
Cathedral and for the Sagrada Família.
His first one-man show was in 1900 at the
salon of *La Vanguardia*. He taught at the
progressive Mont d'Or school and became
interested in the theory and teaching of
art, founding an Escola de Decoració of
his own and writing articles and books
on the psychology of art (including *Notas
sobre art*, 1913). He was included in the
Almanach dels noucentistes and in 1913
was commissioned to paint murals in the
Palace of the Generalitat. During the
teens he joined the artistic avant garde,
contributing drawings to various
publications including *Un Enemic del
Poble*. He left Barcelona for New York
in 1920 and lived in the USA, Italy,
France and Spain before returning to
Uruguay, though he continued to exhibit
his new work in Barcelona.

254
*Philosophy presented by Pallas Athene
on Parnassus as the tenth Muse*, 1911
Oil on canvas, 124 × 385 cm
Signed bottom left
Institut d'Estudis Catalans, Barcelona
Illustrated p. 170 (fig. 176)

255
Barcelona street scene, 1917
Oil on canvas, 61.6 × 72.4 cm
Signed and dated bottom left
Collection J.B. Cendrós, Barcelona
Illustrated in colour p. 186 (fig. 196)

See also nos. 37, 297

Triadó i Mayol, Josep
Barcelona 1870–1929

Graphic artist and painter. He studied at
the Llotja and in Madrid (1890–1) and
later learned the techniques of engraving
from Riquer. He participated in the
official exhibitions in Barcelona from 1894
and in 1897–8 became interested in
English types of industrial art. His
speciality was the art of the book in all
its aspects (illustration, typography,
cover and ex-libris design etc.), but he
also made designs for posters, fabrics,
ceramics and jewellery. He contributed
to many journals, including *El Gato
Negro*, *La Ilustración Artística*, *Album
Salón*, *Hispania* etc., and taught drawing
at the Llotja from 1902 until his death.

256
Our ship (La nostra nau), 1897–8
Song book (one of Morera's original
Catalan songs published by *L'Avenç*),
26.2 × 17.6 cm
Monogram at bottom left of illustration
Private collection

See also no. 307

Utrillo i Morlius, Miquel
Barcelona 1862–Sitges 1934

Critic, art historian and graphic artist.
He studied engineering in Barcelona and
Paris (1880), where he later worked as
art correspondent for *La Vanguardia*
(1889–93). He was one of the founders
of Els Quatre Gats, where he introduced
shadow-puppet theatre, and in the late
1890s he wrote art criticism (as 'A.L. de
Baran', 'P. de X.', 'Pinzell') for journals
such as *Luz*, *Pèl & Ploma* and *Forma*
(the last two of which he edited). He was
the cousin of Antoni Utrillo, the most
prolific poster artist of the period and a
partner in the lithographic studio Utrillo
i Rialp, and he himself designed posters
and illustrated Rusiñol's *Oracions* (1897).
Later he directed the *Enciclopèdia
Espasa*, and in 1929 he was one of the
planners of the *Poble Espanyol*.

257
Teatro Lírico, c. 1900
Poster (printed by Jacinto Benavente),
122 × 71 cm
Monogram at lower right
Collection Utrillo, Biblioteca Popular
Santiago Rusiñol, Sitges
Illustrated p. 272 (fig. 303)

See also nos. 227, 235

Vallvé i Ventosa, Andreu
Barcelona 1918–1979

Set designer. He worked for the theatre
and cinema and taught at the Institut del
Teatre.

258
*Diorama showing opening of the Sala
Parés, 15 Jan. 1884, attended by the
Infanta Doña Paz, the Prince of Bavaria,
the Mayor of Barcelona, Rius i Taulet,
and other personalities*, 1958
Wood and cardboard,
104 × 70 × 95 × 95 × 90 cm
Museu d'Història de la Ciutat, Barcelona
(10826)

ANONYMOUS

259
*Official key used for the opening and
closing of the Universal Exhibition*, 1888
Metal, 12.5 × 4.5 × 0.8 cm
Museu d'Història de la Ciutat, Barcelona
(878)

260
Plan of the Universal Exhibition, 1888
Colour lithograph (printed by Forasté),
59 × 41.4 cm
Dated (Sept. 1887–April 1888)
Institut Municipal d'Història de
Barcelona (B–IV. Inv. G. 7339)

261
*'Orsini' bomb, thrown in the Liceu
on 7 Nov. 1893, which landed under a
lady's skirt and failed to explode*
Metal, d: 9 cm
Museu d'Història de la Ciutat, Barcelona
(855)
Illustrated p. 291

262
*Souvenir medal of the International
Exhibition*, 1929
Gilded metal, d: 3.4 cm
Museu d'Història de la Ciutat, Barcelona
(7412)

PHOTOGRAPH

263
*Picabia and friends on the beach, 1916:
(standing left to right) Picabia, Juliette
Gleizes, Otto van Watjen, Marie
Laurencin, Gabrielle Buffet, Olga
Sackaroff; (seated) Albert Gleizes,
Dagmar Monat, Béla and Andrée Szilard*
Original snapshot by Otho St Clair Lloyd
Private collection
Illustrated p. 57 (fig. 56)

CATALOGUES

264
Exposició d'Art Cubista
Galeries Dalmau, 20 April–10 May 1912
21.4 × 15.6 cm
Institut Municipal d'Història de
Barcelona

265
Celso Lagar
Galeries Dalmau, 28 Jan.–12 Feb. 1915
Cover (*Adam and Eve*) by the artist
20 × 14 cm
Institut Municipal d'Història de
Barcelona
Illustrated p. 196 (fig. 207)

266
Charchoune and Grunhoff
Galeries Dalmau, 29 April–14 May 1916
12.8 × 19.3 cm
Institut Municipal d'Història de
Barcelona

267
Albert Gleizes
Galeries Dalmau, 29 Nov.–12 Dec. 1916
11.8 × 14.9 cm
Institut Municipal d'Història de
Barcelona

268
E.C.Ricart
Galeries Dalmau, 10–25 Jan. 1917
17.4 × 12.7 cm
Institut Municipal d'Història de
Barcelona

269
Exposició d'Art Francés
Palau de Belles Arts, 23 April–July 1917
17 × 11 cm
Biblioteca dels Museus d'Art, Barcelona

270
Joan Miró
Galeries Dalmau, 16 Feb.–3 March 1918
Calligramme by J.M. Junoy on verso,
dated Dec. 1917
12.3 × 17.5 cm
Institut Municipal d'Història de
Barcelona
Illustrated p. 204 (fig. 216)

271
1ª Exposició del Saló Noucentista
Galeries Dalmau, 1–15 May 1922
16.1 × 11.8 cm
Institut Municipal d'Història de
Barcelona

272
*3ª Exposició del 'Saló dels
Evolucionistes'*
Galeries Dalmau, 1–15 May 1924
16.4 × 10.9 cm
Institut Municipal d'Història de
Barcelona

273
Feliu Elias (Apa)
Galeries Dalmau, 2–15 May 1925
14.2 × 10.9 cm
Institut Municipal d'Història de
Barcelona

274
Salvador Dalí
Galeries Dalmau, 14–27 Nov. 1925
18.9 × 13.4 cm
Institut Municipal d'Història de
Barcelona

275
Salvador Dalí
Galeries Dalmau, 31 Dec. 1926–14 Jan.
1927
19 × 13.5 cm
Institut Municipal d'Història de
Barcelona

276
Salvador Dalí: five latest paintings
Galeries d'Art Catalònia (presented by
Josep Dalmau), 2–4 Oct. 1934
8.3 × 3.6 cm
Institut Municipal d'Història de
Barcelona

277
Adlan presents Picasso
Sala Esteva, 13–18 Jan. 1936
26.5 × 17 cm
Museu Picasso, Barcelona (1614)

INVITATIONS

278
To Salvador Dalí exhibition,
31 Dec. 1926, at the Galeries Dalmau
14.6 × 9.9 cm
Institut Municipal d'Història de
Barcelona

279
*To a lecture by Walter Gropius on
'Modernes Bauen' (with slides),*
1 April 1932, at the Col.legi Alemany,
from the Comitè Hispano-Alemany
10 × 14 cm
Col.legi d'Arquitectes de Catalunya,
Barcelona

MANIFESTOS

280
Manifest Groc, 1928, 'Yellow manifesto',
signed by Salvador Dalí, Lluís Montanyà
and Sebastià Gasch
56 × 39 cm
Biblioteca dels Museus d'Art, Barcelona

281
Manifest dels Amics de l'Art Nou, 1932
26.3 × 21.1 cm
Private collection

282
Dia 13 Picasso, 1936, leaflet issued by
PAC – Pro Art Clàssic
22.2 × 16 cm
Biblioteca dels Museus d'Art, Barcelona
Illustrated p. 225 (fig. 244)

283
*Manifest No.1 a la intelectualitat
artística*, 1936, announcing foundation of
the Associació d'Artistes Independents;
signed by Josep Dalmau
30 × 22 cm
Biblioteca dels Museus d'Art, Barcelona

PROGRAMME

284
Performance of Parade *by Diaghilev's
Ballets Russes*
Gran Teatre del Liceu, 10 Nov. 1917
24.4 × 16.3 cm
Institut Municipal d'Història de
Barcelona

BOOKS

285
Pompeu Fabra. *Gramática de la Lengua Catalana*, L'Avenç, Barcelona 1912
Biblioteca de Catalunya, Barcelona

286
Guerau de Liost (Jaume Bofill i Mates).
La Muntanya d'ametistes, Octavi Viader, Barcelona 1908
Illustrations by Monegal
Biblioteca de Catalunya, Barcelona
Illustrated p. 271 (fig. 301)

287
Le Corbusier (Charles-Edouard Jeanneret). *La Ville radieuse*, Editions de l'architecture d'aujourd'hui, Paris 1933
Private collection

288
Josep Maria López Picó, *Poemes del port*, F.X.Altés, Barcelona 1911
Illustrations by Aragay
Biblioteca de Catalunya, Barcelona
Illustrated p. 271 (fig. 300)

289
Apel.les Mestres. *Liliana*, Oliva, Vilanova i la Geltrú 1907
Illustrations by the author
Biblioteca dels Museus d'Art, Barcelona
Cf. illustration p. 252 (fig. 286)

290
Josep Maria Millàs-Raurell. *Trente poemes*, Barcelona 1919
Illustrations by Ricart
Biblioteca de Catalunya, Barcelona
Illustrated p. 271 (fig. 302)

291
Eugeni d'Ors (ed.). *Almanach dels noucentistes*, Joaquim Horta, Barcelona 1911
Cover by Aragay
Biblioteca dels Museus d'Art, Barcelona
Illustrated p. 169 (fig. 175)

292
Eugeni d'Ors. *La ben plantada*, Joaquim Horta, Barcelona 1912
Biblioteca de Catalunya, Barcelona

293
Eugeni d'Ors. *Oració de l'Institut*, Edició de la Revista 'Ars' (Joan Comas), Barcelona 1914
Illustrations by Monegal
Biblioteca de Catalunya, Barcelona
Illustrated p. 271 (fig. 299)

294
Josep Puig i Cadafalch. *L'Oeuvre de Puig i Cadafalch Architecte 1896–1904*, M.Parera, Barcelona 1904
Instituto Amatller de Arte Hispánico, Barcelona

295
Alexandre de Riquer. *Crisantemes*, A.Verdaguer (J.Thomas), Barcelona 1899
Binding (20 × 10 cm) by Riquer
Museum für Kunst und Gewerbe, Hamburg (1900.474)
Illustrated p. 230 (fig. 250)

296
Josep Maria de Sagarra. *El mal caçador*, F.X.Altés, Barcelona 1916
Illustrations by Mirambell
Biblioteca de Catalunya, Barcelona

297
Joan Salvat-Papasseit. *Poemes en ondes hertzianes*, E. Mar Vella, Barcelona 1919
Illustrations by Torres García.
Biblioteca de Catalunya, Barcelona
Illustrated p. 262 (fig. 293)

298
Pere Torné Esquius. *Els dolços indrets de Catalunya* (introduction by Joan Maragall), Oliva, Vilanova i la Geltrú 1910
Biblioteca de Catalunya, Barcelona

NEWSPAPERS AND JOURNALS

299
AC (Documentos de Actividad Contemporánea), Barcelona 1931–7
Nos. 10, 11, 13, 15, 18, 25 (2nd and 3rd quarters 1933, 1st and 3rd quarters 1934, 2nd quarter 1935, June 1937)
Col.legi d'Arquitectes de Catalunya, Barcelona
Illustrated pp. 68 (fig. 67), 138 (fig. 136)

300
D'Ací i d'Allà, Barcelona 1918–36
No. 179 (Winter 1934)
Institut Municipal d'Història de Barcelona

301
Arc-Voltaic, Barcelona Feb. 1918
No. 1
Cover by Miró
Institut Municipal d'Història de Barcelona
Illustrated pp. 190 (fig. 201), 199 (fig. 211)

302
Catalunya Artística, Barcelona 1900–5
No. 7 (second series), 25 Aug. 1904
Cover by Joaquim Renart
Private collection
Illustrated p. 242 (fig. 272)

303
Un Enemic del Poble, Barcelona 1917–19
No. 16 (March 1919)
Cover with drawing (1918) by Barradas and *calligrammes* by Joaquim Folguera
Biblioteca dels Museus d'Art, Barcelona
Illustrated p. 190 (fig. 202)

304
Hispania, Barcelona 1899–1902
No. 24 (15 Feb. 1900)
Cover (*Orfeó*) by Mir
The British Library Board
Illustrated p. 142 (fig. 141)

305
L'Hora, Barcelona 1930–4
Any I, no. 1 (10 Dec. 1930)
Cover (*Sleep*) by Helios Gómez
Institut Municipal d'Història de Barcelona
Illustrated p. 250 (fig. 283)

306
L'Instant, Paris 1918–Barcelona 1919
Any II, no. 2 (31 Aug. 1919)
Cover (*Portrait*, 1917) by Ricart
Biblioteca dels Museus d'Art, Barcelona
Illustrated p. 204 (fig. 217)

307
Joventut, Barcelona 1900–6
Set of bound volumes
Covers by Riquer, Triadó, Gual, Mestres, Sebastià Junyent, Anfós Monegal and Modest Urgell
Private collection
Illustrated p. 293

308
Luz, Barcelona 1897–8
No. 9 (2ª semana, Dec. 1898)
Cover by Riquer
Biblioteca dels Museus d'Art, Barcelona
Illustrated p. 241 (fig. 269)

309
La Mà Trencada, Barcelona 1924–5
No. VI (31 Jan. 1925)
Cover illustration by Picasso
Institut Municipal d'Història de Barcelona

310
Minotaure, Paris 1933–9
No. 3–4 (14 Dec. 1933)
Includes Dalí's article 'De la beauté terrifiante et comestible, de l'architecture Modern style', with photographs of Barcelona by Man Ray
The British Library Board

311
La Nova Revista, Barcelona 1927–9
Vol. VIII, no. 29 (May 1929)
Cover illustration by Ricart
Biblioteca dels Museus d'Art, Barcelona

312
Papitu, Barcelona 1908–11 (first series)
Any II nos. 23, 25, 26 (28 April, 12 May, 19 May 1909)
Covers by Apa (nos. 23, 25) and Juan Gris
Institut Municipal d'Història de Barcelona

313
Pèl & Ploma, Barcelona 1899–1901 (first series)
No. 11 (12 Aug. 1899)
Cover by Casas
Biblioteca dels Museus d'Art, Barcelona
Cf. illustration p. 161 (fig. 165)

314
Quatre Gats, Barcelona 1899
No. 4 (2 March 1899)
Cover (*Asking for charity*) by Nonell
Biblioteca dels Museus d'Art, Barcelona
Illustrated p. 161 (fig. 164)

315
391, Barcelona 1917 (first series)
Nos. 1–4, (25 Jan., 10 Feb., 1 March, 25 March 1917)
Covers (*Novia, Peigne, Flamenca, Roulette*) by Picabia; Apollinaire's *calligramme, L'Horloge de demain*, in no. 4
Biblioteca dels Museus d'Art, Barcelona
Illustrated pp. 184 (fig. 193), 189 (figs. 199, 200); in colour p. 256 (fig. 289)

316
Troços, Barcelona 1916, 1917–18
No. 3 (Nov. 1917)
Biblioteca dels Museus d'Art, Barcelona
Illustrated p. 184 (fig. 194)

317
Vell i Nou, Barcelona 1915–21
Nos. 46, 47 (July, August 1917)
Private collection and Museu Picasso, Barcelona (1614)

POSTSCRIPT

Juli González

318
Shouting head of Montserrat (no. 2),
c. 1934/42
Bronze, 32.5 × 30 × 20 cm
Museu d'Art Modern, Barcelona (113413)
Illustrated p. 95 (fig. 91)

319
The raised hand (no. 1), *c.* 1937/40
Bronze, 44.6 × 16 × 16 cm
Museu d'Art Modern, Barcelona (113431)

320
The raised hand (no. 2), *c.* 1937/40
Bronze, 34 × 20 × 12 cm
Museu d'Art Modern, Barcelona (113432)

Joan Miró

321
Aidez l'Espagne, 1937
Broadsheet, 31.5 × 25 cm
Inscribed and signed bottom
Private collection

322
Barcelona series, 1944
Lithographs, 70 × 53 (1–41);
44 × 56 (42); 48 × 60 (43);
35.5 × 47 (44); 35 × 47.5 (45);
35.5 × 48 (46); 34 × 47 (47);
35 × 46 (48); 35 × 48 (49);
47 × 35 cm (50)
All signed and dated
Fundació Joan Miró, Barcelona

Pablo Picasso

323
Dream and lie of Franco, 1937
Etchings with aquatint, 31.4 × 42.1 cm
Dated on plates (8 Jan.; 8–9 Jan., 7 June)
Trustees of the British Museum, London

324
Weeping woman, 1937
Etching, aquatint and drypoint,
72.3 × 49.3 cm (second state)
Dated 2 July 1937
Private collection

Josep Lluís Sert

325
(with Luis Lacasa)
Model of Spanish Republican pavilion at Paris Exposition, 1937
Methacrylate, wood, copper wire, natural sponge, 56 × 100 × 10 cm (1/100 scale), made 1978 by Jorge Brunet under Sert's direction
Museo Español de Arte Contemporáneo, Madrid